ISBN 978-1-332-41794-0
PIBN 10424516

English
Français
Deutsche
Italiano
Español
Português

www.forgottenbooks.com

Mythology Photography **Fiction**
Fishing Christianity **Art** Cooking
Essays Buddhism Freemasonry
Medicine **Biology** Music **Ancient**
Egypt Evolution Carpentry Physics
Dance Geology **Mathematics** Fitness
Shakespeare **Folklore** Yoga Marketing
Confidence Immortality Biographies
Poetry **Psychology** Witchcraft
Electronics Chemistry History **Law**
Accounting **Philosophy** Anthropology
Alchemy Drama Quantum Mechanics
Atheism Sexual Health **Ancient History**
Entrepreneurship Languages Sport
Paleontology Needlework Islam
Metaphysics Investment Archaeology
Parenting Statistics Criminology
Motivational

THE 'OLD WATER-COLOUR' SOCIETY

VOL. II.

PRINTED BY
SPOTTISWOODE AND CO., NEW-STREET SQUARE
LONDON

A HISTORY

OF THE

'OLD WATER-COLOUR.' SOCIETY

NOW

The Royal Society of Painters in Water Colours

WITH BIOGRAPHICAL NOTICES OF ITS OLDER
AND OF ALL DECEASED MEMBERS
AND ASSOCIATES

PRECEDED BY AN
ACCOUNT OF ENGLISH WATER-COLOUR ART AND ARTISTS IN THE
EIGHTEENTH CENTURY

BY

JOHN LEWIS ROGET

///

IN TWO VOLUMES

VOL II.

LONDON

LONGMANS, GREEN, AND CO.

AND NEW YORK : 15 EAST 16th STREET

1891

CONTENTS OF VOLUME II

———◆◇◆———

BOOK VII

THE PRESIDENCIES OF FIELDING AND HIS SUCCESSORS

———

CHAPTER I

THE PRESIDENCY OF FIELDING, 1832–1855

CHAPTER II

DEATHS AND RETIREMENTS, 1838–1847

CHAPTER III

DEATHS AND RETIREMENTS, 1848-1855

CHAPTER IV

THE PRESIDENCY OF LEWIS, 1855–1858

CHAPTER IV

EXITS, 1866–1889

BOOK IX

ACCESSIONS UNDER FIELDING

CHAPTER I

NEW ASSOCIATES, 1832–1837

CHAPTER II

NEW ASSOCIATES, 1838–1847

CHAPTER III

NEW ASSOCIATES, 1848–1849

CHAPTER IV

NEW ASSOCIATES, 1850–1854

BOOK X

LATER MEMBERS AND ASSOCIATES DECEASED

CHAPTER I.

DEATHS, 1855–1881

CHAPTER II

DEATHS SINCE 1881

APPENDIX

Corrigenda and Addenda.

In vol. i. p. 78 *n* 2, *add* 'A replica is at the British Museum.'
 ,, 118, lines 6 and 7 ; *for* 'J. C. Lewis,' *read* 'F. C. Lewis.'
 ,, 507, in contents of chapter v. ; before '*W. A. Nesfield*' insert '*F. O. Finch.*'
 ,, ·552, lines 4 and 5 from bottom ; note that Mrs. Fielding appears to have exhibited sixteen drawings in all at Spring Gardens from 1815 to 1820 ; those to 1819 being under her maiden name of Walton (see pp. 396, 418, 420), with the address '4 Downing Street, Ardwick, Manchester.'
In vol. ii. p. 7, in schedule ; for '*J. M. Richardson*,' read '*T. M. Richardson*,' and insert date of last exhibit '1889–90.'
 ,, 12 *n* 2, *for* 'fifteen' *read* 'fourteen,' and *dele* 'Gilbert.'

THE

'OLD WATER-COLOUR' SOCIETY

BOOK VII

THE PRESIDENCIES OF FIELDING AND HIS SUCCESSORS

CHAPTER I

THE PRESIDENCY OF FIELDING, 1832–1855

From 1831 to 1855—National events—Encouragement of art and its institutions—Great Exhibition of 1851—Ruskin's criticism—Pre-Raphaelite movement—Illustrative drawing and engraving—Transitional period of water-colour art—The Society prospers—Recognized representative of the school—Early troubles of New Society—Secessions therefrom —Exits and entrances.

THE space of time, nearly twenty-four years (1831 to 1855), during which Copley Fielding occupied the Society's chair, was a period of note in the national history, wherein important events occurred and changes took place, both political and social. Before one half of his presidential course had run, the first Reform Act had been passed (1832), slavery had been abolished (1833), the Atlantic was bridged by steam (the 'Great Western' crossed in 1838), a network of railways was crystallizing over the map of England, our postage had been reduced to a penny (1840), even the electric telegraph was already in action. The Queen's accession (1837) had been followed in three years by her Majesty's happy marriage (1840), and in due course by the births of the Princess Royal (1840), and the Prince of Wales (1841).

In the second half of this President's career the effects of the broadening views under which the country had been governed became apparent in the greater attention paid to the fine arts, and, to use a

II. B

compound name which then came into use, the 'art-manufactures.' As early, indeed, as 1836, a Select Committee of the House of Commons had issued their Report on the 'Arts and their connexion with Manufactures,' a result whereof had been the founding of a Government School of Design, which was the germ of the 'Science and Art Department' now established at South Kensington. The Museum there, though of later date, is also connected with the Art movement that took place in these early years of Queen Victoria's reign, the period of her Majesty's married life; a movement in a great degree spontaneous, but fostered at the same time by the Government, and more especially by the Court, under the Prince Consort's enlightened guidance. In 1838 the Royal Academy, removed from Somerset House, and the National Gallery, from Pall Mall, were housed, each in one of the exactly symmetrical halves of the building designed by Wilkins, and erected in Trafalgar Square, on what has been called 'the finest site in Europe.' There was elbow-room then for the national collection within its allotted space in the structure since so much enlarged to make room for its sole reception and continuing growth. The rebuilding of the Houses of Parliament, burned down in 1834, was made the occasion of an effort to raise the aspirations of British artists, by a competition of cartoons for the historic decoration of the new Palace of Government, the erection of which began in 1840. The Royal Commission 'for Promoting and Encouraging the Fine Arts in the Decoration of the New Houses of Parliament' began its sittings at Gwydyr House, Whitehall, in March 1842; and the cartoon designs were exhibited in Westminster Hall in 1847. Side by side with these measures, taken in the interests of fine art, were others directed as much to the improvement of the industrial arts, including those the advance whereof involved a joint development. The culmination of such efforts was the great International Exhibition in Hyde Park in 1851, the first of the long series of similar shows which have been held ever since from time to time all over the world. The Exhibition of 1851 was not primarily designed for the promotion of art as distinguished from manufacture; but its partial and more permanent resuscitation in the form of the Crystal Palace at Sydenham, which was opened in the year 1854, had a more definitely artistic aim, as evinced in the series of courts designed to illustrate the history of architecture and sculpture. This was in the last year of Fielding's reign. The annals

of the time were darkened then by the reopening for a limited
period of the temple of Janus. But in this chronicle of peaceful
Art little note need be taken of the direful history of the Crimean
War, which was still raging, though near its close, when our President
died.

While these events were stirring in the outer world of politics, and
exercising their influence, designedly or not, upon the inner world of
Art, the latter sphere was passing through successive phases of its
own. Its native current flowed, indeed, with undiminished stream,
but its course was changing. It is only so far as the general occur-
rences above referred to affected the development of water-colour
painting, that they concern us here. But their influence thereon will
be recognized from time to time in various ways, in the course of the
narratives hereinafter given of the careers of individual members of
the Water-Colour Society. This body of artists were still, to a great
extent, a school unto themselves, with principles based on those of
their founders, adhering to their own traditions, and relying on the
qualities and capabilities peculiar to the medium in which they
painted. More modern theories of art, accompanying, and in some
respects connected with, if not originating in, the advance of applied
science, had as yet exerted but small apparent influence either on
their artistic motives or on their forms of pictorial speech. The
newer and more observant criticism, whereof the first and greatest
leader was the 'Oxford Graduate,' whose book on *Modern Painters*
first set the world of Art a-thinking in 1843, and opened British eyes
to the freshness and truth of our living school, dealt mostly then
in its praise. A reforming age came later, an age in some respects
of revolution, aided and abetted by the same eloquent and per-
suasive pen. But the so-called 'pre-Raphaelite' movement, which
began to show itself some half-dozen years before Fielding's death,
had but little influence on the water-colour painters, as a school, until
after the date of that event.

In the lives and works of the Members and Associates of the
Water-Colour Society will further be found an illustration, not only of
the progress of the department of art exhibited in its gallery, but also
of the concurrent advance of another, with which they were still, as
they had been from the earliest times, intimately connected, that of
designing for the press, wherein they worked hand in hand with the
engraver, and were employed by the publisher, as well as the patron.

Considered from this point of view, the history of the Society during the presidency of Fielding continued to be intimately allied to that of the literature of the age, both by virtue of the illustrations afforded to standard authors, and of embellishments of more ephemeral works and serial publications. The period was one of marked developments in this department of art, arising from altered circumstances both of demand and supply ; the one being enlarged by social expansion, the other facilitated by novel or improved processes. The reign of Fielding witnessed the superseding of copper plates, which, in the hands of the able artists who translated Turner, had attained to a climax of perfection, by the steel plates of the later Annuals. Already a new class of topographic works had arisen more suited to the cosmopolitan taste of the age. These were no longer confined as of yore to ' gentlemen's seats ' and ' beauties ' of Britain, but depicted scenes in foreign lands more or less remote. With the facilities afforded by steel printing, volumes of this class, got up more for the drawing-room table than the library shelf, bred and multiplied, taking the place of the more sober ' Landscape Annuals,' which were issued between 1830 and 1839, with illustrations furnished, for the most part, by Members of our Society. There arose eventually a special class of travelling artists who devoted their talents exclusively to the supply of drawings for these publications. Their dependence upon the group of draftsmen represented at Pall Mall East was then much reduced ; and the octavos of Prout and Harding and Holland gave place to the more showy quartos of Bartlett and Allom, and other artists outside the Society. But the Annuals were always largely supplied with designs by the figure painters in water-colours who exhibited at Pall Mall East in Fielding's time. The extent to which this was the case may be estimated from the accounts to be given of the works of J. W. Wright, Chisholm, Mrs. Seyffarth, Cattermole, Richter, J. M. Wright, Eliza Sharpe, Stephanoff, Stone, Jenkins, and Bostock. Series of views at the Universities by F. Mackenzie, separately published, and a few Venice interiors in the *Keepsake* by Lake Price, represent nearly the whole of the purely architectural contingent furnished by the Society to the line engravers during this waning period of their now all but extinct branch of chalcographic art. Architectural engraving succumbed at last to the photographer. In these its latter days it had also a rival in lithography, an art largely practised by several distinguished Members of our Society at this period ; and, in

its application to architecture, by none more successfully than Joseph Nash. It was employed also by Prout, Lake Price, and others; but the prince of draftsmen on stone was the landscape painter, J. D. Harding. Lists of the lithographic publications of these artists will be given in their biographical memoirs. Towards the end of this period a third art of reproduction began to compete with both the above as a means of illustrative embellishment. That wood-engraving came to be so extensively employed as it has since been for this purpose, was in the first instance due in a great measure to the talent of a few draftsmen, who formed a style peculiarly adapted to the purpose. The chief of these was the figure painter, John Gilbert (now Sir John Gilbert, R.A., and President of our Society). He began to draw on wood about the year 1838, and was largely engaged in such designing when and after he joined the Society in 1852. A nearly correlative position in respect of landscape art may be assigned to his contemporary Birket Foster, who was then working in the same field, though he did not become an Associate until 1860. The late Edward Duncan and George Dodgson were also doing much drawing on wood in the latter part of Fielding's time for the illustrated press; and so were some younger artists, still or recently, Members of the Society.[1]

Apart from external influences and connexions such as these, the Society pursued a steady course throughout the period of Fielding's presidency. It was a time of peace and harmony within, as well as one of unexampled prosperity. The gallery was supported by a phalanx of talent that included, during a great part of the time, all the honoured names of old, and most of them even to the end, its strength being also well supplied from without as occasion required. The twenty-four years[2] which saw Fielding at the head of affairs may, for the purpose of general review, be conveniently broken into three subdivisions of six, ten, and eight years respectively, by the two epochs of the Queen's accession in 1837, and the death of Joshua Cristall in 1847. This last date may be taken for a landmark in the independent annals of the Society, as that of the close of a period during which the earlier and the later generations of water-colour painters coexisted, and in a measure coalesced, so as to form a middle

[1] For example, W. Collingwood Smith, Sir Oswald Brierly, and Edward Goodall.
[2] This period includes only twenty-three exhibitions, for the President died before that of 1855.

school which held to the traditions of the past, and at the same time contained the germs of a subsequent development, and also in some respects a subsequent decline. The after years of Fielding's term of life and office are more nearly connected with the age that was to follow. Cristall outlived all the remaining founders and first Members who were still in the Society. Barret had died in 1841, J. Varley in 1842, Hills in 1844, all in the middle period of Fielding's presidency. In the third and last subdivision thereof, namely that from 1848 to 1854, we come to the closing years of De Wint and Prout, as well as Fielding himself, and to the retirement, though not the death, of Cattermole. In this period also we miss the presence of Harding in the gallery, he having retired from the Society in 1846 for a period of ten years. The members of Cristall's flock of 1831 who still remained in the Society after Fielding's death in 1855 were, Turner, F. Nash, Cox, Richter, Stephanoff, Gastineau, Finch, J. M. Wright, Hunt, Lewis, Evans (of Eton), Eliza Sharpe, and Frederick Tayler. All have since died; the last survivor, Tayler, in 1889.

In the first year, 1832, there were twenty-five male and five female[1] Members, and fifteen Associates, making an aggregate of forty-five exhibitors, which number was not raised above forty-nine throughout the President's term of office. In November 1838 and 1841 resolutions were passed extending the limit in the body of Associates to eighteen and twenty respectively, though the full number was not reached until 1858. But the fluctuations were such that no fewer than forty-three new Associates were elected, eight during the first period (1832–37), twelve during the second (1838–47), and twenty-three in the third (1848–55), of whom, however, three did not exhibit until after Fielding's death. All but seven continued to send works to the gallery to the end of the term. The following chronological schedule of exits and entrances during the first and second of these periods, with dates of election to full Membership, will give a general view of the changes in the body of actual exhibitors to the year, 1847, of Cristall's death. Names of Associates who attained to full Membership are printed in italics.

[1] 'Ladies' were placed in a separate list in the catalogue from 1850 to 1860, since which date they have been classed as Associate Exhibitors, which virtually they were from the beginning.

*	Exit	Enter	Elected Member	Last Exhibit
1832	*Pugin*			
1833	*Robson*	*Frank Stone*	1842	1846
—	*Wild* }			
—	Williams }			
1834	*Austin* }	*George Chambers*	1835	1840
—	Mrs. Fielding }	*Charles Bentley*	1843	1854
—		*Joseph Nash*	1842	1879-80
1835	*Mrs. Barret* }	V. Bartholomew	—	1876-7
—	Essex }	*James Holland*	1857	1869-70
1837	T. Fielding	*Arthur Glennie*	1858	1889-90
—		Lake Price	—	1852
1838	Mrs. Brookbank	*William Callow*	1848	—
1839	*Chambers* }			
—	Cotman }			
1841		*George A. Fripp*	1845	—
1842	*Barret* }	*Octavius Oakley*	1844	1867-8
—	Mrs. Seyffarth }			
1843	*J. Varley* }	*Samuel Palmer*	1854	1881-2
—	G. Pyne }	*J. M. Richardson*	1851	—
—		*W. C. Smith*	1849	1887-8
1844	*Hills*	*Alfred D. Fripp*	1846	—
—		Douglas Morison	—	1846
1845		Wm. Evans (of Bristol)	—	1859
—		George Harrison	—	1846
—		Samuel Rayner	—	1850
1846	*Stone* }			
—	*Harding* }			
—	J. Byrne }			
—	W. Walker }			
—	Morison }			
1847	Chisholm }	Maria Harrison	—	—
—	*Cristall* }			

* N.B. The dates in the first column are those of last and first appearance as exhibitors in the Gallery, not those of exit from, or entrance into, the Society.

It is of the first division of Fielding's presidency that Ruskin has written so charmingly in the following passage: ' I cannot but recollect with feelings of considerable refreshment, in these days of the deep, the lofty, and the mysterious, what a simple company of connoisseurs we were, who crowded into happy meeting, on the first Mondays in Mays of long ago, in the bright large room of the old Water-Colour Society; and discussed, with holiday gaiety, the unimposing merits of the favourites, from whose pencils we knew precisely what to expect, and by whom we were never either disappointed or surprised. Copley Fielding used to paint fishing-boats for us, in a fresh breeze, "Off Dover," "Off Ramsgate," "Off the Needles"—off everywhere on the south coast where anybody had been last autumn, but we were always kept pleasantly in sight of land, and never saw so much as a gun fired in distress. Mr. Robson [1] would occasionally

[1] Robson, however, as we know, died in 1833.

paint a Bard, on a heathery crag in Wales ; or—it might be—a Lady of the Lake on a similar piece of Scottish foreground—" Benvenue in the distance." A little fighting, in the time of Charles the First, was permitted to Mr. Cattermole ; and Mr. Cristall would sometimes invite virtuous sympathy to attend the meeting of two lovers at a Wishing gate or a Holy well. But the furthest flights even of these poetical members of the Society were seldom beyond the confines of the British Islands ; the vague dominions of the air, and vasty ones of the deep, were held to be practically unvoyageable by our un-Dædal pinions, and on the safe level of our native soil, the sturdy statistics of Mr. De Wint, and blunt pastorals of Mr. Cox, restrained within the limits of probability and sobriety, alike the fancy of the idle, and the ambition of the vain.' Prout alone was privileged ' to introduce foreign elements of romance and amazement into this—perhaps slightly fenny—atmosphere of English common sense.' [1]

To this description of the *spectacle* related by a critic in the ' front ' may fitly be appended the following sketch in the green room drawn from memory by a living Member who entered the Society during this period. Mr. Alfred Fripp writes that ' Of all the kindly grand old Members constituting the Society,' when he and his brother joined it, ' the one who impressed ' them ' most was silver-haired old Joshua Cristall, whose simplicity of character, courteousness, and quiet dignity of manner endeared him to all who knew him. Still there was dissension in the camp occasionally, and the irritability of De Wint was fired by the complacency of Harding and the strong language of Evans, and it was no easy task for Fielding or Cristall to quench it. But these occasional scenes only served to emphasize by contrast the quiet inoffensive spirits who formed the great majority ; chief among whom were Finch, Mackenzie, Cristall, and the two Wrights, with whom it was impossible to " fall out." ' [2]

Notwithstanding these occasional differences of opinion, and ebullitions arising from a common zeal for the Society's interests, the period seems to have been in the main one of general concord among the Members. Its archives are brightened by the register of ' scarlet ' days, whereon the gallery was honoured by royal visits. In July 1834 arrangements are being made to receive, at her desire, H.R.H. the Duchess of Kent, accompanied by the Princess Victoria, on the Monday after the Exhibition's close. In 1836 there is a similar re-

[1] *Notes on Samuel Prout and William Hunt* (1879-80), pp. 27, 28. [2] MS.

ception of Queen Adelaide 'and other branches of the Royal Family.'
A more detailed account is given in the Minutes of the Committee of
a visit paid by the young Queen Victoria in the year of her coronation,
namely in April 1838, and of a step consequent thereon taken by the
Society, which acquires some importance in the light of recent events.
The account[1] runs as follows :—

'VISIT OF THE QUEEN TO THE GALLERY.

'Her Majesty arrived about half-past two, accompanied by the
Duchess of Kent, and was received at the steps by the President and
other officers of the Society standing behind and at the entrance on
each side till the Queen and party had passed. Her Majesty having
been pleased to express herself in most gracious terms respecting the
Exhibition, and the Lord Chamberlain (the Marquis of Conyngham)
having returned to the gallery to announce her Majesty's purchase
of certain pictures in the Exhibition, and his Lordship having in a
conversation with Mr. Evans appeared favourable to the hope of her
Majesty's becoming Patroness of the Society, the following letter was
drawn up, agreed to, and despatched to the Marquis. Members
of Committee in consultation, Messrs. Fielding, Evans, Gastineau,
Mackenzie, and Hills; Messrs. Cattermole, Harding, and Tayler
being also present.

'" My Lord,—The Society of Painters in Water-Colours, now
about to open their 34th Exhibition, have long held an anxious wish to
stand recognized as a body who in their peculiar department have
endeavoured to extend the credit of British Art ; and the present
appears to them a time favourable to this their desire.

'" The highly gratifying terms in which her Majesty has been so
graciously pleased to express her approbation of this Exhibition en-
courages them to aspire to the honour of her Majesty's patronage ; and
they have therefore directed me to solicit your Lordship's good offices
in submitting to the Queen an expression of their hope that they may
have her Majesty's permission to call themselves for the future the
Royal Society of Painters in Water-Colours.

(Signed) " R. HILLS." '

Of the immediate result of this application there is no report ; but
the honour sought was not granted until more than forty years after.

One more such reference to a royal visit is made at the end of
Fielding's time ; in his last year, when he was unable to do the

[1] From the Committee Minute of 27 April, 1838.

honours himself. But his absence was the occasion of a letter to Mr. Jenkins, then new to his office of Secretary, which at the same time evinces the President's kindly considerateness, and is a pleasant record of the nature of such receptions. 'My dear sir,' writes Fielding from Worthing on the 10th of May, 1854, ' I am very sorry for my absence from London just now, as I fear it will have occasioned you some additional trouble to your kind but already overtaxed ministrations in the service of the Society. I trust that you were able to procure a colleague to assist in receiving the Queen and the Royal party, and thus being more at your ease with regard to the arrangements. I think you must have found it an office of interest and pleasure, as her Majesty has always been so very gracious in her manner of receiving any attentions which we have been able to shew, and Prince Albert never fails to make it agreeable to those who accompany him through the Exhibition.'

On the death of Hills in May 1844 his office of Secretary was conferred on John William Wright, and on his death in January 1848 it was undertaken by George A. Fripp, who retained it until February 1854, when he was succeeded by J. J. Jenkins. Mackenzie continued to be Treasurer until his death in April 1854. His successor was W. Collingwood Smith. Notwithstanding a loss incurred in the year 1840 by the failure of its bankers (Hammersleys & Co.), the condition of the finances was such that the Society was able in 1844 and 1845 to raise the salaries attached to both offices to 60l. The system of thirty-guinea premiums given annually to the Members in rotation was continued, the number voted each year after the close of the exhibition, and dependent on the surplus resulting therefrom, varying from four to ten. The average was more than seven, and the amount distributed about 240l. a year. On the 28th of July, 1854, the Finance Committee reported to a general meeting that the Society's funds 'exhibited an increase over any previous year.' From the average of the sums paid over to the representatives of four Members who died within the first twelve years of this period, the pecuniary value of a share in the Society appears to have been about 86l. The Society was also in the habit of voting sums out of its funds to alleviate distress in the families of Members, beyond their apportioned shares. These gifts of mutual charity amounted in the fifteen years from 1841 to 1855 to about 400l. There are further items in the accounts of 15l. to the widow of a late clerk, and 10l. for

a testimonial inkstand to another on his departure. And although the charity began at home, it did not end there; for the Minutes record donations not only to the Artists' General Benevolent Institution, but also to the Sick and Wounded Relief Fund for Soldiers in the Crimea. The accumulation of means which· enabled this expenditure was due to a prudent economy in husbanding the resources derived from a successfully attractive series of summer exhibitions. In the first twelve years of Fielding's presidency, the average number of paying visitors was upwards of 19,000 in a season, the annual admissions varying from 16,166 in 1834 to 21,569 in 1837.

By the time when her Majesty mounted the throne, the Society of Painters in Water-Colours had come to be recognized, both at home and abroad, as the established representative of their branch of the British School of Art. Thus in February 1839 we find the Secretary answering in that behalf a formal invitation from Professor Hensel, in the name of the Royal Academy of Berlin, to the English Artists in Water-Colours to send works there for exhibition. The old Water-Colour Society was not, however, free from fresh and wholesome competition. The attempt made in 1831, as before mentioned, to found a free exhibition to which all painters in that material were invited to send drawings, had, after a period of stormy contention, taken a settled shape, fashioned precisely on the model of the original body whose 'exclusive system' it had been the main object to uproot. The 'New Society,' as it was called, held its first experimental exhibition (as has been already stated) at its prototype's old rooms at 16 Old Bond Street, in 1832. There were 120 exhibitors and 330 drawings; and the show was so far successful that visitors and sales were alike numerous. The next year it took the old name of 'The Associated Painters in Water-Colours,' possibly with the intention of upholding it as a revival of the body which collapsed as aforesaid in 1812, but with the result of complicating still more an existing nomenclature, and presenting a confusion worse confounded to the chronicler of Art societies. The number of exhibitors in 1833 increased to 170. But the first succeeding years of the association's life were anything but peaceful. Serious dissension arose among the members, and a struggle for power ensued, which ended in the resignation of half a dozen of the promoters. Then came financial troubles and a lawsuit, and in 1834 a reconstruction. Three annual exhibitions had been tried on the 'free' plan. They

were partly supported by amateurs, and were managed by a committee elected for the purpose. But the twenty-five artists, most of them among the original promoters, who now restarted the association under the first title, the 'New Society of Painters in Water-Colours,' found it expedient to abandon the liberal programme of a general admission, and adopt a plan of selection and membership similar to that already tried and found successful by the leading body, of which it remained for many years a close imitation. The first three exhibitions, in 1835, 1836, and 1837, were held in a room at Exeter Hall. In the last-named year this society moved to No. 38 Pall Mall, next door to the British Institution, where the exhibitions were held from 1838.[1] During the first ten years in its new home the young society comprised a number of artists of talent and distinction, who gave it representative importance ; and its gallery became one of the stock exhibitions of the London art season. But at the end of that period internal dissension arose once more, and caused a secession which reduced its strength while making it for the time a valuable feeder of the old Society. This secession occurred in the year that we have taken as a divisional epoch, 1847. At that time four artists, Dodgson, Duncan, Jenkins, and Topham, left the 'new' society in a body, and in the course of the next two years they were received into the 'old.' Other similar transfers took place before the end of Fielding's term, as well as afterwards.[2]

This infusion of new blood, at a time when the Society was losing so many of its great leaders of old combined with other causes to change the character of the exhibitions, and form a transitional period connecting, but also in a great degree impeding the union of, the past with the present age of art. It was mainly in landscape that old principles, now much forgotten or ignored, had still been recognized. But the body of artists admitted during the concluding division of Fielding's presidency contained a larger proportion than before of figure painters.

[1] See W. B. Sarsfield Taylor's *Fine Arts in Great Britain and Ireland*, ii. 362, 363 ; and *Art Union*, iv. 60 (March 1842).

[2] The following fifteen of our Members or Associates had exhibited at the junior society before their election into ours. The dates are those of such election : Morison (1844); Cox *iunior*, Duncan, Dodgson, Topham (1848); Jenkins, J. Callow (1849); Gilbert, Riviere (1852); Davidson, Collingwood (1855); Deane (1870); Brierly (1872); Mrs. Angell (1879); Beavis (1882). Against these there has to be set one case of transfer from the former to the latter body, that of Macbeth, whose exit from the one was in 1879, and entrance into the other 1882.

The changes in the *personnel* in the Exhibitions from 1848 to 1854 are noted in the following schedule ; the principal dates, as before, referring to the artists' contributions to the gallery.

	Exit	Enter	Elected Member	Last Exhibit
1848	*J. W. Wright*	George F. Rosenberg	—	1870
—		*George H. Dodgson*	1852	1880-1
—		*Edward Duncan*	1849	1882-3
—		*F. W. Topham*	1848	1877-8
1849	*De Wint*	David Cox (junior)	—	1886
—		*Joseph J. Jenkins*	1850	1883
—		Charles Branwhite	—	1862
—		Mrs. Criddle	—	1880
1850	Scott	John Callow	—	1878-9
—	S. Rayner	Nancy Rayner	—	1855
—	*Cattermole*	*Carl Haag*	1853	—
—	*Nesfield*	*Paul J. Naftel*	1859	—
1851	*Prout*	John Burgess	—	1874
1852	Price	John Bostock	—	1854
—		*John Gilbert*	1854	—
—		Henry P. Riviere	—	1888-9
—		Margaret Gillies	—	1887
—		*Walter Goodall*	1861	1884
1853	*Mackenzie*	Samuel P. Jackson	1876	—
1854	*C. Fielding*	Henry Brandling	—	1856
—	*Bentley*			

To the above have to be added the changes which occurred in the short interregnum after Fielding's death, during which the exhibition of 1855 took place. They were as follows :

	Exit	Enter	Elected Member	Last Exhibit
1855	Nancy Rayner	*Frederick W. Burton*	1855	1869
		William Collingwood	1884	
		Charles Davidson	1858	

CHAPTER II

DEATHS AND RETIREMENTS; 1838–1847

Final biographies—Members : *Cristall—Barret—Hills—J. Varley—J. W. Wright—* Associates : *Cotman—G. Pyne—Byrne—Chisholm—Mrs. Seyffarth* (Louisa Sharpe)— *Mrs. Brookbank* (Miss Scott)—*W. Walker.*

REFERRING to the lists contained in the foregoing chapter, it is now proposed to end the biographical accounts of Members and Associates who were lost by the Society during Fielding's presidency, before proceeding further with the general history. Detailed notices, both of those of the old stock who survived that period and of artists whose connexion with the Society began during its progress, will be deferred until an outline shall have been given of the Society's transactions as a whole during the presidential terms which succeeded. In arranging both series of biographies it will be convenient to adhere to the same subdivisional arrangement of time which served us in the foregoing general narrative, viz. : (1) 1832 to 1837 (six years) to the Queen's accession ; (2) 1838 to 1847 (ten years) to the death of Cristall ; (3) 1848 to 1855 (eight years) to the death of Fielding.

The final years of those artists who made their exit from the Society during the short period comprised in the first of these sub-divisions, have for the sake of continuity been included in the biographical accounts already given. The deaths and retirements during the first ten years of her Majesty's reign have therefore now to be dealt with. They bring back some names familiar to the reader from the time when that of the Society itself was first intro-duced into these pages. The same four, *Cristall, Barret, Varley,* and *Hills,* who had been true to it throughout the presidential reign of the first, were still represented in the Gallery when it opened for the spring season of 1832. But they all, as we have seen, died in this middle period of Fielding's term of office. Two other full Members

passed out of the ranks during these ten years, *Harding* for a time only, but *J. W. Wright* by his death. This group of Members (other than Harding, who reappeared) will first engage our attention, the Associates being subsequently dealt with.

The circumstances under which JOSHUA CRISTALL retired from the chair have been referred to on a former page. The Society received his resignation on the 21st of July, 1831, with an expression of its 'great regret that Mr. Cristall's intention to continue absent from London obliges him to relinquish the office of President, because it is aware that no one of its Members can be better qualified by character and talent to fill that office.' He was now about sixty-four years of age, and he lived through sixteen more. In these, alas! he had still to undergo severe trials. The term of happiness at Goodrich was brought to an end by the death of his beloved wife[1] from a lingering illness; and, after an endeavour for some time to brave out his solitude there, he returned once more to London. A glimpse of the sad period of his life, when his Herefordshire home was breaking up, is afforded by a few pathetic letters to his friends, copies of which are among Mr. Jenkins's papers. Several are to his god-daughter, Mrs. M'Ketchnie, then keeping a school in London, whose grandfather, Mr. Clayton, had been his early benefactor. In one of them, written in August 1839, two months after his wife's death, he refers to a short visit to town in 1835, and announces his intention to be there again in November or December. He speaks of the renewal of 'long past recollections of days of great interest,' and adds, ' But I am talking of time which is fast flying from me, having now commenced my seventy-first year.'[2]

The intention was apparently fulfilled, for in the following July he writes from Goodrich: ' I hope you will not take offence at my not calling upon you before I left Town. It was the same with many of my relations and friends. I was neither young enough nor strong enough to call on all who had paid me attentions; nor was I so circumstanced as to do what I would. It is the same with writing. I cannot always call up spirits to attend to those I am wishing to write to. . . . I still look forward with hope to settling in London; but

[1] In Goodrich churchyard a tombstone records the death of Elizabeth, wife of Joshua Cristall, on the 27th of June, 1839, at the age of sixty-eight. It is sixty-six in the burial register.

[2] See *supra*, i. 179, *n.* 2.

there are many obstacles, principally money. But the next difficulty is to execute works that will meet the public taste. [Then the] difficulty of disposing of the place and finding one in London that will do. I have undertaken to paint a portrait which I shall begin the following week, and that will be the profession I mean to set up when I go to Town. I have likewise a Landscape to paint. Both of these commissions will take me from home, which will be a good thing; for the melancholy with which the place is now imbued is too deep almost to bear. Otherwise the country looks beautiful and the garden charming, and now nicely taken care of.' Then he speaks of a pleasant visit from a nephew, William Cristall, of Greenwich, whose 'good and equal spirits' and fondness for natural history had been 'very useful;' and of the prospect of another from one Mr. Elliott, a very old and musical friend, fond of fishing. 'It is very delightful,' he adds, in a simple kindly way 'for persons shut up in London during the winter to come down and see nature in its best season all fresh and blooming.' Then he tells of his own pastimes: 'I am still reading Burns, who writes immediately to the heart, and is always effective. But the summer with me is not the time for reading, for a walk is more delightful. I have purchased Allan Ramsay's works, one of "the people's" edition for eightpence, but have not yet read him. I have also got the "Lay of the Last Minstrel" and the "Lady of the Lake," the one sevenpence and the other ninepence. . . .' In a subsequent letter (19 November, 1840) he recurs to his converse with the poets[1] thus: 'I was so engaged about the time I addressed you and ever since, that I had not leisure more than to peruse the beautiful little poem you sent me of Motherwell's. I am delighted with it as being elegant, natural, and descriptive of young expressions to the highest degree. It keeps up the school of Burns; and in the same impressive manner, addressing the feelings and the mind. Scotland has produced many fine examples of the natural class. You must have had great pleasure in reading Scott's "Lady of the Lake." I read it a long while ago and have it by me now (to read when time admits). When in Scotland, I traversed the banks of Lake Ketterin, rowed upon the waters, visited the lonely Isle, ascended Ben Venue, and knew all the scenery appertaining to Roderick Dhu. But now I am obliged mostly to let poetic ideas alone, for the great although perhaps dan-

[1] In another letter he refers to Thomson's *Seasons*, 'in which the English scenery and climate are so beautifully portrayed, with many grand pictures of the phenomena of nature.

gerous experiment of coming to London which I yet purpose in the spring.'

In the previous letter (9 October, 1840) he had written, ' I do not sleep on roses. I have been driven about all this beautiful summer like a vessel without a rudder, little at home, all my plans deranged.' He had been ' busy painting portraits : the profession I mean to set up when in town.' And no wonder that he cast a longing eye to the pictured ease of a London practice ; for his painter's life in the provinces was but a harassed existence like that of the country doctor. He was driven from pillar to post in his old age to take people's likenesses. ' I think I told you,' he wrote, ' I had painted a lady and child from India. After which I left home again to paint a young lady, which I finished satisfactorily, the daughter of a friend. I came home again in hopes of going on with some things for the water-colour exhibition, but am obliged to go out once more to-morrow to draw a young married lady, and her grandfather, a very old man. The worst part of the business is, I am obliged to go to the houses of the persons whose portraits I take. I suppose I may be gone a fortnight ; for the hindrances in these cases are numerous.' Then again, ' After having lost a great deal of time about a portrait, owing to the visiting propensities of the country people at the end of the summer, I came home to my work, which even here was cruelly interrupted ; and in the early part of November was called from home to paint three portraits which ought to have been done in three or four weeks at most. But they delayed me at Ross (where the parties resided) for more than six weeks. And one, who wore a low dress, put off the finishing of her picture until warmer weather. This loss of time,' he adds, writing on the 15th of January, 1841, ' has been a sad blow to me, as all the works I had proposed to do remain unfinished in cold weather and short days—besides, they took up the whole of my remaining time· in visiting and matters that I did not want to enter into. ·. . . Portrait painting on these terms,' says he, ' is not worth following.'

But the worst had yet to be told. With worries and interruptions and strength ill able to bear the winter's cold, his health broke down. On 15 January, 1841, he writes : ' I returned to Goodrich on New Year's Eve very unwell, and was obliged to go to bed ; a violent cold came on with an attack of bile and fever, which resisted strong medicines until the 6th, when I sent for a medical man from Ross.

On the 10th of the month he pronounced my fever abated, and wished me to take food ; he advised me to keep my bed on account of my cough and the coldness of the atmosphere. However, these last three days I have been up in the middle of the day, and have written a few necessary letters. I am frightened at what I have to reply to on account of my eyes, which are so very weak, and my cough so troublesome. . . . The fever was excessive. It will be a long time before I can do anything again ; so my time is lost.' Then he speaks gratefully of the attention of his two servants, and the care they took to keep him warm.

In the following March (1841) he writes from Ross, where he says : ' I have been for some time engaged in some painting concerns, and have also been confined by cold and fever again, from which I am just emerging, but must not expect a quick return to health. . . . At present my affairs are in a most complicated state, and it will be as much as I can do to get up to Town as soon as I wish, but which I trust will not be past the middle of April. . . . I shall, however, have a great deal to do to make up for lost time, and am trying to get as many works for exhibition as I can.' He had nine drawings in the gallery that year, a larger number than he had shown together since the days of his presidency. With the usual rustic figures are three studies which seem to savour of his enforced visits among the gentry of Wales. ' A Lady Drawing' is the title of two, and the third is ' A Young Lady Embroidering.' At the end of June in the same year he quitted Goodrich and settled at No. 44 Robert Street, Hampstead Road, opposite St. James's Chapel, the same street in which, at No. 1, Frederick Nash had erected his sky-parlour as an aërial studio. He writes a few sad words to his and his late wife's friend Miss Beckwith, before bidding a final farewell to the Herefordshire home : ' The garden having been nursed and embellished for eighteen years has become quite beautiful, and is now in its full effect. Everything fades in time, and my happiness has passed away with the rest. However, I try to forget the past ; and I believe every one acquainted with my poor wife must recollect her with painful interest. I am sure you must who knew her so well. . . . I shall have another set of griefs to go through in parting with the friends I have made here.'

While the gay flowers, relinquished with such regret, had been springing forth in the pretty garden on the banks of the Wye, others of an earlier cultivation, in his older home, had been withering away. When Cristall returned to the haunts of his youth, or rather of his

maturity, he found but few of his old friends in the Society left to welcome him back. But his reception was none the less cordial by those who remained, and nowhere more so than among his former companions in the Sketching Society, which was now in its fullest activity. We find him presiding once more over that body at its meeting on Friday, the 7th of January, 1842. He had been with them for a short time during his visit to town in the sad winter of 1839–40, for the following entry occurs in the records under date 17 January, 1840 : 'Mr. Cristall, seeing a minute in the book that the Society hailed his appearance, is not insensible to the circumstance that while he has been doing nothing, the members have held on, and kept as it were the ball up, so that he can come in to catch the same without deserving it.'[1]

Mrs. Finch, who knew and saw much of Cristall during these closing years of his life, gives us an agreeable sketch of his character and surroundings at this time : 'His simple establishment consisted of himself and two female servants, the eldest acting as his house-keeper.' They were the same who had nursed him in his fever at Goodrich. 'Both of them had been educated by his late wife, and in some respects were almost like his adopted children,[2] who in their time looked upon their master and mistress as little less than parents. It was a very pleasant thing when entering his hospitable doors to be able to exchange on the very threshold friendly greetings with these young women. Cristall himself was indeed,' says the same writer (viewing his character, it should be observed, from her own stand-point of earnest piety), 'a man to be sought and known ; for he combined in an extraordinary degree the buoyancy of youth with the dignity of age ; and although he lived upon and reverenced the past with all its ennobling associations, he also looked forward and with still greater interest towards the future ; for, judging from the experience of his long life which had witnessed so many ameliorations and improvements in human affairs, he believed they would continue to improve in a yet increasing ratio, as the great principles of Christianity should be better understood, and "association," which was his watchword, should take the place of nationalities and ex-clusiveness ; and it was very delightful to observe his endeavours to carry out the principle in private life, inviting as he did under his

[1] *Memoir of Uwins*, i. 200, 202.
[2] Cristall testified his feeling towards them by a bequest of all his little property.

own roof men whose position in the world threw them into a kind of rivalry with each other. These it was his wish to bring together in friendly communion, feeling that the world was amply wide enough for each man's excellence to expand in without hustlings or jealousies. His general information and intelligence, combined with his amiable and polished manners, made him the centre of a circle of admiring friends of all ages ; the young, of whose society he was extremely fond, regarding Mr. Cristall with the reverence due to a patriarch.'[1] There is, indeed, a concurrence of testimony as to the worthiness of Cristall's character, and the 'gentle and simple earnestness of his manners.'[2] ' In private life,' says a journalist of his time, ' Mr. Cristall's manners were particularly agreeable, exhibiting on all occasions a well-regulated and cultivated mind ; and as a critic, although his own productions have a peculiar and definite style, he was always ready to find talent in the works of others, and his criticisms possessed the rare merit of sincerity combined with that kindness of tone which showed that his excellent judgment was exercised to benefit others, and not for the display of individual superiority.'[3]

Any strong hope that Cristall may have entertained of success as a portrait painter in London seems to have been doomed to disappointment. Some time, apparently, after his arrival, we find him preparing ' examples ' wherewith ' to present himself to the public ' in that capacity, for one of which probationary studies his god-daughter's son was to sit. Small full-lengths ' were the class of portraits which he usually executed.'[4] But he also set to work, with what vigour remained to him, upon a large cartoon, to compete with under the Government scheme for decorating the Houses of Parliament. This he was never able to finish. In March 1845 he is again unsettled— ' harassed to death,' he writes, ' to know what to do for a house and studio—they are all so expensive. I dread giving all up, and I dread going on. It is a subject that from my friends I can get no satisfactory counsel.' By the next spring at latest he had moved to ' 11 Douro Cottages, Circus Road, St. John's Wood ;' and for two years (1846, 1847), which proved to be his last, his address stands thus in the catalogue. Here he died on the 18th of October, 1847, in his eightieth year.[5] His death is believed to have been hastened by an

[1] *Memorials of F. O. Finch*, pp. 72-75. [3] *Athenæum*, 23 Oct. 1847.

[2] C. Davey, *Literary Gazette*, 30 Oct. 1847. [4] *Men of the Reign* (1885).

According to the accepted dates, and the record of his tombstone.

accident, from the effects of which, however, he had partially recovered. He was knocked down by a cab while returning from a party at the house of Mr. Rogers,[1] and the shock is said to have been fatal, though comparatively slight at the time. He refers to his condition in a letter dated 15th January, 1846, to some unnamed brother artist, in these words : ' I am greatly obliged to you for thinking of me and for sending to me that very fine Boy . . . he is to sit to me. I expect him to be very useful in my picture. I have been very unwell since I saw you, or you would have heard from me. The blow I received from the accident has been even more injurious than the kicks and treads of the horse. I fear it will take a long time to recover from its effects . . . The difficulties of our Art,' he writes in the conclusion, ' are rendered apparent by the Cartoon competitions. Have you seen that of the Art Union ? &c.'

Mrs. Finch writes : ' I was with him a few days before his death. He greeted me with his usual urbanity, but his mind wandered, and he had no idea of his condition ; there was the same kind Christian spirit present, however, that had always characterized him, the desire of uniting man to man.'[2] He was watched over at the last by one who had known him well in his home on the Wye, and at his own express desire was buried by the side of his wife at Goodrich. The tombstone over their joint grave in that picturesque spot describes him as an ' artist devoted to the study of nature,' who ' found in it the true source of the beautiful and sublime.'[3]

Cristall exhibited from one to nine drawings in the gallery yearly between 1833 and 1847 (he sent nothing in the first year after his retirement from the chair), making a total of fifty-five in Fielding's period, and 358 from the first show in 1805. Welsh and occasionally Scotch peasant girls were his most frequent subjects in the last period, but with these were a few classic compositions. Twice again, viz. in 1833 and 1847, did he treat his former theme of ' Jupiter nursed in the Island of Crete ; ' and he had also ' Apollo tending the Flocks of

[1] *Century of Painters*, i. 512. [2] *Memorials of F. O. Finch*, pp. 72–75.

[3] The cottage, called ' Granton,' which had been occupied by Cristall, being close to the vicarage, ' was purchased by the Rev. H. C. Morgan, Vicar of Goodrich, and the studio he built was used by Mr. Morgan as a school until the present National Schools were built. About 1872 it was used as a temporary studio by the late George Sant, who painted several pictures of Goodrich and its neighbourhood. The cottage now belongs to Mrs. Jarvis, who was for many years housekeeper to the Rev. H. C. Morgan. It was left to her in recognition of her faithful services.' These facts are kindly furnished by the present Vicar, the Rev. Douglas Seaton.

Admetus' (1834), 'Cynthia with her attendant Dews and Zephyrs' (1839), 'Narcissus and Echo' (1842).

After Cristall's death his unsold works were disposed of at Christie's in a three days' sale beginning 11 April, 1848. The highest sale price for a 'Cristall' recorded by Redford is only 44l. 2s. at Mr. Allnutt's sale in 1863.

There appear to be very few prints after drawings by Cristall. In Cooke's *Picturesque Views on the Southern Coast* is one of 'Bonchurch, Isle of Wight,' with the early date 1 July, 1816; in the *Keepsake*, 1831, are 'Mima' and 'The Orphan Boy,' both engraved by C. Heath; and in the *Gallery of the Society of Painters in Water-Colours* is 'Scotch Peasants,' engraved by F. Engleheart, dated 1833.

GEORGE BARRET continued to reside in Devonshire Place, Edgware Road, until his death on the 19th of March, 1842. Little has been recorded of these last years of his life, except that they too were clouded by misfortunes. What is known of his condition at the time is chiefly derived from the printed appeal before mentioned, which was made to raise an annuity for his widow. The loss of his eldest son, whom he had educated as a surgeon, supervening upon a long illness of his own, and added to pecuniary embarrassments, is therein named as an accelerating cause of his death, which was from disease of the lungs.[1] 'As an artist,' say the memorialists, 'Mr. Barret's talents, combined with his frugal and industrious habits, ought to have produced him a handsome competency, but he was stimulated more by the love of excellence than the love of money, and though he toiled incessantly at his profession he only earned enough to supply the daily wants of himself and family.'

In the first eleven years of Fielding's presidency, the gallery was enriched by 173 more works from Barret's pencil, including twelve, in the years 1834 and 1836, executed in collaboration with Frederick Tayler. The latter were pastoral subjects, mostly Scotch, or scenes connected with shooting on the moors. The remainder belonged to the same class as before, being in their essence studies of daylight, in varied intensity of growth, fullness, or decline. Including the dozen posthumous exhibits, and those in which he had a share only, the Society had shown 473 works by Barret since the restoration in 1821, making a total, from 1805, of 571. He had never absented himself

[1] *Art Union* advertisement, June 1842, and J. J. J. MSS.

for a single season, his average contribution being about fifteen, his lowest number six (in 1813 and 1818), and his highest thirty-three (in 1825). Mr. Graves finds also five works by him at the Royal Academy, nineteen at the British Institution, and eight at Suffolk Street. He painted a few pictures in oil; but, judged by some in the loan collection at the Grosvenor Gallery in 1888, they were inferior to his water-colour drawings.

The artist's power remained unimpaired to the last. While seeking to embody his poetic feeling in a graphic representation of nature, he was wont, more constantly than before, to find its expression in words as well. Quotations in verse become more frequent in the catalogue as an accompaniment to his pictures; and in cases where no author's name is given, it may fairly be conjectured that the lines are his own. Such verbal pictures as the following are essentially those of an artist's perception:

> 'Yon amber light that gleams along the sky,
> Melting below the chasten'd crimson dye,
> Bespeaks the sober solemn twilight near.'

> '*Afternoon*. The sun has lost his rage,
> His downward orb shoots nothing now
> But animating warmth.'[1]

> '*Evening*. How changed the scene the sun late shone upon!
> But one brief hour and all its splendour's gone;
> Those gorgeous hues lit by the golden ray
> Are sobered now to one harmonious gray.
> Yet still a charm remains, at least for those
> Who, rapt in thought, in solitude repose
> Beneath the shade, and, far removed from man,
> Each change of nature unmolested scan.—MS.'

In this recourse to the pen as well as the pencil to express their sentiments, the resemblance is borne out between Barret and Finch, which is so perceptible in their graphic works.

Beyond these fugitive lines, George Barret's appearance as a writer is, however, confined to a little treatise by him on '*The Theory and Practice of Water-Colour Painting*, elucidated in a series of letters,' inscribed to a friend, the Rev. William Turner. It was published in 8vo (123 pages) by Ackermann in 1840, two years before the author's death. He proposed to write also on Oil Painting, but the intention was not fulfilled. This little volume, while giving valuable advice in

[1] These lines are from Thomson's *Summer*.

technical matters, deals with the aspects of nature under different effects, from early morn to 'moonshine night,' in a manner that vividly recalls the spirit of the author's own pictures. The following prose description of twilight is a fitting accompaniment to the above expression in verse of the same feeling: 'After the sun has for some time disappeared, twilight begins gradually to spread a vail of gray over the late glowing scene, which, after a long and sultry day in summer, soothes the mind and relieves the sight previously fatigued with the protracted glare of sunshine. At this time of the evening to repose in some sequestered spot, far removed from the turmoil of public life, and where stillness, with the uncertain appearance of all around, admits of full scope for the imagination to range with perfect freedom, is to the contemplative mind a source of infinite pleasure. The sky, too, with its streak of amber light, which glows in the west, is often opposed by horizontal and far-extended clouds of sombre gray, forming, as it were, a base for others of a more solemn hue, and of shapes so grand and well defined as to have all the effect of distant mountains with towns and castles upon some of their projecting parts against the sky. The moon's mild crescent, with her reflection in the stream, adds greatly to the interest of the scene.' [1]

The following letter, written four months before Barret's death, to his friend Mr. Hewett, a well-known dealer at Leamington, is an example of his more familiar style :

'162 Devonshire Place, Edgware Road : November 8th, 1841.

'My dear Hewett,—As you have not written to me, I will no longer follow your example, but take up my pen to enquire after the health of your Family. Knowing your sensitive mind and kind disposition, I am anxious to learn that they are now all well and hearty, and that you and Mrs. Hewett are relieved from a state of suspense which, by producing a *pain in the mind* if long continued, exceeds any that occurs to the body. I have no news to tell you as regards art, except that many of the *Acquatics* are painting in oil, which I think will interfere with the Water works, though I am of opinion that this oil in some cases will not float upon the *water*. By the bye, I was the other day speaking to a person about the Art Union, when he told me he had heard that an artist (a prize holder to some amount) finding that no one would purchase his picture *bought it himself*! and

<hr>

[1] *Theory and Practice of Water-Colour Painting,* pp. 106, 107.

of course put the money into *his own pocket*! This (if true) was a
joke that I think will make you laugh. I shall like to know your
opinion of this circumstance. At all events he fulfilled the intention
of the Institution, which is to promote art by the encouragement of
artists, and he being one followed up the principle in his own person.
Perhaps he felt an affection for the effort of his own genius, and
wished to retain it, and point it out as having been *purchased for a
large sum.* Would it be fair for him to sell it again? This is, I hope,
your high season at Leamington, and I therefore hope that you are
doing much business. For my own part, I am not in good spirits, as
this is a time that I do not expect to get much for my exertions, and
the Exhibition is a long way off. Still I am doing my best to prepare
for it. With a sincere wish for the health and happiness of you and
yours,. and with kind regards to Mrs. Hewett, your Daughter, and so
forth, I remain, as I am sure I always shall, most truly yours

'GEORGE BARRET.'

The writer did not live to see the exhibition in question, but it
contained twelve of the drawings he had prepared for it, and among
them the last which his hand produced. It had a fitting sub-
ject, 'Thoughts in a Churchyard,' and it was accompanied by the
following four lines from a poem of his own :—

'Tis dusky eve, and all is hush'd around ;
The moon sinks slowly in the fading west ;
The last gleam lingers on the sacred ground,
Where those once dear for ever take their rest.

This drawing, which is now at South Kensington, in the Ellison gift,
was studied in the burial ground attached to St. Mary's Church,
Paddington Green, on the site, it is said,[1] of the Manor House before
mentioned. In the same cemetery the painter lies interred. When he
made this drawing he was aware that his end was nigh. 'Of a
naturally mild and amiable disposition,' says the memorial above
quoted, 'he contemplated his approaching dissolution with calm and
pious serenity.'

' He left a widow, who had been a faithful and excellent wife, two
sons and a daughter, without any provision.' Their circumstances of
difficulty and distress having been reported to the Committee, a
portion of his twenty-fourth share in the Society's Fund (which share

[1] *Art Union* advertisement, June 1842.

amounted to 93*l.*) was advanced at once to relieve their immediate necessities, pending the taking of the annual accounts ; and a donation of 75*l.* was given by the Society on the 13th of June following, in aid of the subscription, before referred to, which was raised by the following friends of the deceased, to purchase an annuity for the widow : Edward Swinburne, Thomas Uwins, R.A., Joshua Cristall, F. O. Finch, James Elliot, and Henry Harrison.

'Nine years afterwards, the Society to which he had been devotedly attached, and whose exhibitions he had contributed largely to elevate by the beauty and poetic character of his works, caused a memorial tablet to be placed over Barret's grave, to mark their respect for his memory.'[1] The resolution was moved by Cattermole and seconded by Frederick Tayler on the 30th of November, 1850, and carried into effect with the grateful assent of the sons of the deceased. Mackenzie made a sketch for the slab, and Copley Fielding wrote the inscription, which runs thus : 'Sacred to the memory of George Barret: who departed this life March 19th, A.D. 1842 : in the 75th year of his age : This monument was placed over his remains : with the consent of his family : by the Society of Painters in Water Colours : in testimony of their admiration of his talents : as a landscape painter : and of their esteem for him as a member of their society : He was one of its founders : and for near forty years the productions of his genius : were among its brightest ornaments.' The stone, which, like many round it, will soon be illegible, lies flat in the grass beside a path in the eastern part of the north division of the cemetery of St. Mary's, Paddington Green. It may once have been part of a tomb ; but most of the stones were laid flat some years ago, when the old churchyard was converted into a recreation ground.

The following list of engraved works must be added to that of the preceding period : In the *Gallery of the Society of Painters in Water-Colours,* 'Evening' (engraved by W. Radclyffe), 1832.—In the *Gallery of Modern British Artists,* 2 vols. 4to, 1834, 'View near Athens.' —In the *Literary Souvenir,* 1835, 'Sunset' (W. Hill) ; 1836, 'Night' (H. Horton).—In Tillotson's *Album of Scottish Scenery,* 'Melrose Abbey' (J. McGahey).—In Tillotson's *New Waverley Album,* 'London from Highgate' and 'Bâle' (J. B. Allen).

The highest prices realized at Christie's sale-rooms for drawings by Barret have been : 420*l.* for 'Solitude' (Allnutt sale, 1863) ;

[1] J. J. J. MS.

330*l.* 15*s.* for 'Walton Bridge' (W. Leaf exors. 1875); and 383*l.* 10*s.* for 'Classical River Scene' (C. Orme exors. 1884).[1]

Barret's name has often been erroneously printed with two t's, even in many of the Society's catalogues to as late a date as 1820. He himself spelt it with one.

Barret, it may be remembered, was not only one of the sixteen exhibitors in 1805, but one of the eight original Members who had started the Society in the preceding year. The same may be said of one other who still remained in it. ROBERT HILLS the animal painter lived two years longer, and was thus the last survivor of the foundation Members. On Cristall's retirement from the presidential chair, the duties of Treasurer were transferred from Hills to Mackenzie, the former resuming his original post of Secretary, which he retained till his death. In 1833 he moved from Margaret Street to 17 Golden Square, where he died on the 14th of May, 1844, having nearly completed his seventy-fifth year. He was buried at Kensal Green.

Since the founding of the first Society, Hills had only been absent from the gallery during four years, namely from 1819 to 1822. Counting nine drawings in which other artists had a share, he exhibited 573 works there between 1805 and 1844, 117 being in the period of Fielding's presidency. In seven of these, between 1829 and 1833, the landscape was by Robson;[2] and in two, in 1838 and 1839, by Nesfield. Besides the above, he is credited by Graves with forty-four works at the Royal Academy, and two at the British Institution, between 1791 and 1824.

The subjects, now as before, were mostly farmyards with cattle, and above all, fallow deer, with a few scenes from Jersey. The last drawing of his named in the catalogue brings the series to a fitting end. It represented a group of 'Stags, showing their horns in the velvet, at various stages of their growth;' and the entry is accompanied by a note that indicates the artist's knowledge of the science of forestry.

Notwithstanding his thorough acquaintance with and fidelity to the animal life he painted, Hills's finished drawings (highly finished

[1] Redford's *Art Sales.*

[2] 'Red Deer in the Pass of Glencoe,' engraved by B. F. Gibbon and E. Webb, in the *Gallery of the Society of Painters in Water-Colours,* 1833, is after Hills and Robson.

they often were) are open to criticism for want of freedom, and a laboured handling of textures, which lack the variety and fail to suggest the mystery of nature. These defects increased in his latest period, when his eye for colour seems also to have deteriorated. The general tone of the later works is often hot, the shadows are violet, and they want the relief of a reflected glow. These remarks are not applicable to his sketches and very beautiful pencil studies from nature. For his more elaborately composed drawings, Hills was also in the habit of making small studies in colour, which he called his 'models.' A large number of these were in the possession of the late Mr. George Smith, F.S.A., of 62 Hamilton Terrace, St. John's Wood. They exhibit a freshness, and sometimes possess a silvery quality of colour, which the artist lost in his large and more elaborate drawings.

A collection of 179 sketches and drawings by Hills, the property of John Garle, Esq., F.S.A., deceased, were sold at Christie's on the 27th of April, 1874.

When Hills joined the majority, JOHN VARLEY had been dead about a year and a half. It is painful to relate the circumstances in which he was at the time of his death. Although well past sixty, he had never, notwithstanding his acknowledged position and merit as an artist, been able either by the fertility of his pencil and the constant industry with which he had so long employed it, or by gains accruing from his vocation as a teacher, to realize a competent maintenance for himself and his family. His affairs, indeed, became more embarrassed than ever, and had it not been for the action of some kind friends, death might have overtaken him while in captivity for debt. The circumstances of his demise have been related to the writer by one whose benevolence was shown on the occasion. It seems that Varley was at this time in the greatest pecuniary straits. Several writs were out against him, one of his most exacting creditors being a griping usurer who lived in Golden Square, in the painter's old neighbourhood, and was suspected of being the original of the Ralph Nickleby of 'Boz.' This man, however, had a kind clerk (the prototype, perhaps, of Newman Noggs), who took pity on the debtor, and when the sheriff's officers were after him, gave such shelter as his own poor home, somewhere in the district of Leather Lane and Hatton Garden, could afford. There he was found by our informant, Mr. William Vokins (the well-known dealer in works of art), in very cramped quarters, with

scarcely a partition to divide his sleeping apartment from that of his charitable host, yet painting away with his accustomed industry. Mr. Vokins, making himself responsible for the detaining debt, carried him off thence to his own more comfortable residence in Margaret Street, Cavendish Square.

Although the artist complained of not being well, no suspicion existed at that time of the very precarious state of his health; but his life was really in great danger. He is said to have caught a chill while making what proved to be his last sketch, in the Botanical Gardens at Chelsea,[1] and an advanced disease of the kidneys was revealed by *post-mortem* examination. His end, in fact, was very near. It is believed that an imprudence in diet was the proximate cause of his death, which occurred on the 17th of November, 1842, at his friend's house, where he had continued to paint to the very last.

It remains to describe the concluding phase of Varley's art, which had entered upon a final stage when his career was thus suddenly closed. He had long been fond of making experiments with his materials. We have seen how in 1824 he had been coquetting with varnish as a glaze to his paintings. At a much later period he tried a method of varnishing the paper first and then painting over it in water-colour, the lights being dug for through this compound. By these means he obtained great force of effect. But he failed in the skies, and therefore gave up the process. Some of his experimental pieces of this kind were in the possession of his last surviving son, Charles S. Varley; one, an unfinished example, is on linen. He did not exhibit any drawings made in this way; but, about the same time, he invented another method, which he employed with such success that for a few final years he adopted it as his exclusive manner of painting. The following account of this change in his practice is (in substance) that given to Mr. Jenkins by Varley's widow. It was his custom to sit down of an evening and rattle off a number of sketches, from which he would the next day select those he liked best and complete them in colour. The sketches were commenced with sticks of cedar charcoal, which he made by burning in the candle as he used them. He then worked out the broad masses of light and shade with Cologne earth; and upon this preparation the colours were laid. One evening while he was thus sketching, he took up some thin whity-brown paper which chanced to lie on the table,

and began to sketch upon that. Liking the tint of the paper, and always ready to try something new, he conceived the idea of laying it down upon white paper, as with an India proof print, and so mounting it to paint upon. After considerable difficulty he succeeded, and began to lay on his colour. With a stiff brush, which he poked about in all directions, he proceeded to work up the light and textures in the drawing, and scraped quite down to the white paper for the brightest points. Sometimes he would pass a wash of thin paste over the paper, which enabled him to get the lights out more readily ; and he enriched the darks with strong gum-Arabic water. He also used, presumably in a similar way, the thin white paper that druggists put up their medicines in.

It was about five years before his death that Varley adopted this new manner of painting, and the first exhibition of drawings by him on whity-brown paper created quite a sensation. He was then nearly sixty years of age. Of course the method was applicable chiefly, if not entirely, to fancy compositions ; and its adoption by our painter may be traced in the Society's catalogues by the prevalence of landscapes of a general or undefined character among his latest exhibits. After a continued course, in which 'compositions' had been gradually taking the place of subjects of the old kinds, the Welsh and other views, varied occasionally by an historic or sacred theme (as 'Andromache' in 1833, and 'The Disobedient Prophet slain,' 1838), making an average of barely half a dozen in the last ten years, he in 1841 comes out with a contingent of thirty drawings, among which 'Landscape with Bamborough Castle' is the nearest approach to anything that can be called topographic. And even this like the rest may have been, and probably was, an imaginary landscape. In 1842 he has no less than forty-one exhibits, and nearly all of them come within the same category.

This, the stars decreed, was to be the last year of his appearance as a living painter. But his new style was already so well established that it came to be identified with his name for something more than a generation among those to whom his earlier and purer style was scarcely known. A due appreciation of these had to await the time when John Varley was to take his place as an ancient master, one of the founders, and long one of the strongest supporters, of the old English school of painters in water-colours.

Including ten posthumous drawings exhibited in 1843, Varley's

works in the Society's gallery amount to a grand total of more than 700 since 1805. Thus his average in the thirty-nine years was more than eighteen, and he never missed a season. Besides this list, Graves enumerates forty-one at the Royal Academy, two at the British Institution, and four at Suffolk Street between 1798 and 1843.

To the list of Varley's early engraved works should have been added a set of six views aquatinted by F. C. and G. Lewis, a copy of which is in the print room of the British Museum.

Redford's record of sales does not show more than four sums above 50*l.* given for drawings by Varley, the highest being 105*l.* for 'Carisbrook' (16 × 28 in.) in the 'J. G. Robinson' sale, 1865.

Two of Varley's sons followed his profession, and in both cases the artistic faculty descended to a third generation. One, *Albert D. Varley*, who seems to have died in 1876 (for his remaining works were sold at Christie's on 26 January, 1877), was father of the living painter of Cairene subjects, *John Varley*. The other, *Charles Smith Varley*, died on 18 April, 1888, aged seventy-seven, and his son *Edgar John Varley* in the following September, after both had given kindly aid to the writer in compiling the above account of their ancestor.

JOHN WILLIAM WRIGHT continued to exhibit as an Associate during the first ten years of Fielding's presidency, sending in three or four drawings a year on the average. On the 14th of June, 1841, he was made a full Member, after which date his contingent is nearly doubled. On the 10th of June, 1844, he was unanimously elected Secretary in the place of Hills, who had died in the preceding month.

His contributions to the gallery from 1831 to 1847, with one posthumous work in the following year, amount to eighty. Nearly all belong to the class of illustrative studies, of a more or less conventional kind, which were very familiar in the days of the Annuals and the sentimental writing that was appropriate to that class of publications. Nearly a quarter are nominally from Shakspere;[1] either scenes which do not demand the composition of many figures, or single studies of the female characters in his dramas. No less than eight of these ladies are depicted in 1846 in separate drawings, the remaining four of that year's dozen of frames being occupied by works the names

[1] It is possible that some of the scenes from Shakspere set down to J. W. Wright may properly belong to J. M. Wright. See for example *Catalogue* 1832, Nos. 297, 351, 381, and compare 345, 346, 348, 349, 380.

whereof may be taken as types of the artist's subjects ; viz. ‘ Meditation,’ ‘ The Blue Domino,’ ‘ Yes or No,’ and ‘ There's nothing half so sweet in life as love's young dream.’ Descriptive verses, by which many of the titles are accompanied, connect these studies still more closely with the literature of their day.

Wright's contributions to the Annuals were very numerous. The following long list is probably still incomplete : In the *Keepsake* : [1] 1832, ‘ Caroline Dammerel ’ (J. C. Edwards) ; 1833, ‘ Malvolio ’ (C. Heath) ; 1845, ‘ The Love Letter ’ (J. Brain) ; 1846, ‘ Olympia ’ (W. H. Mote) ; 1847, ‘ The Lady of Liege ’ (R. Staines), ‘ Florence ’ (H. Robinson) ; 1848, ‘ Jenny Lind, in the Somnambula,’ ‘ Theresa,’ ‘ Elena and Gianni ’ (all by W. H. Mote) ; 1850, ‘ Isabel ’ (Mote), ‘ The Wild Rose ’ (B. Eyles).[2] In the *Literary Souvenir* : 1834, ‘ The Contrast ’ (P. Lightfoot) ; 1835, ‘ Diana Vernon ’ (H. Cook).[3] In Heath's *Book of Beauty* : 1833, ‘ Laura ’ (E. Scriven) and ‘ Lucy Ashton ’ (T. A. Dean), illustrations of Byron and Scott ; 1835, ‘ Ianthe ’ (H. Cooke) ; 1847, ‘ Leila ’ (Egleton), ‘ Angiolina ’ (H. Austin), ‘ Zuleika,’ and ‘ Olimpia ’ (both by Egleton), ‘ Kaled ’ (W. Hall), ‘ Medora ’ (Mote). In the *Book of Beauty and Royal Gallery* : 1848, ‘ Jane Seymour ’ (Eyles), ‘ Katherine Parr ’ (Mote), ‘ Berengaria, Queen of Richard I.’ (Eyles), ‘ Elizabeth Woodville, Queen of Edward IV.’ (Austin), ‘ Caroline, Consort of George II.’ (J. Brown), ‘ Eleanor of Provence ’ (Eyles), ‘ Matilda of Scotland ’ (Mote), ‘ Eleanor of Castille ’ (Egleton) ; 1849, ‘ Isabella of France, Queen of Edward II.’ (H. C. Austin). In Fisher's *Drawing-Room Scrap-Book* : 1849, Frontispiece, ‘ President of the Beauty-cultural Society ’ (Egleton), ‘ Valentine's Day ’ (J. Brain), ‘ The Stolen Glove ’ (H. Austin) ;[4] 1850, ‘ The offered Flower ’ (Egleton) ; 1851, ‘ The Approaching Ship ’ (Mote).

Wright also continued to send portraits to the Royal Academy, where Graves finds thirty-five works of his between 1825 and 1846.

An intimate acquaintance which he enjoyed with the late Mr. Boxall (afterwards Sir William Boxall,[5] R.A.), the portrait painter, probably led to Wright's becoming the husband of a lady who acted as

[1] The ‘ Magic Mirror ’ (E. Portbury), and ‘ Lucy and her Bird ’ (W. Finden), 1829, and ‘ The Letter ’ (C. Heath), 1835, are given to ‘ J. M. Wright ; ’ and ‘ The Orphan of Palestine ’ (Alf. T. Heath), and ‘ Remembrance ’ (L. Stocks, after Parris from a sketch by ‘ Wright ’) are ambiguously ascribed. All of these may belong to J. W. Wright.

[2] The volumes for 1851 and 1853 are wanting at the British Museum.

[3] The volume for 1837 is wanting at the British Museum.

[4] Also ‘ The Revellers ’ from a sketch by ‘ Wright.’

[5] Boxall was made A.R.A. in 1851, R.A. in 1863, and knighted in 1871.

his friend's housekeeper. In 1838 his address changes from Berners Street to Great Marlborough Street; and this change may possibly mark the date of his marriage. If that conjecture be right, he lived about ten years after the event, for his death took place on the 14th of January, 1848, from an attack of influenza, which his constitution was too weak to sustain.

Poor Wright affords one more example of an artist of acknowledged ability, said to have been both prudent and industrious, yet unable by his professional exertions to do more than support himself and his household while he lived. He left no provision for the widow and two children who survived him, beyond such share as became his due in the Members' fund of the Water-Colour Society, and the value of his remaining works, which were sold at Christie's in the following March. The Society gave to the widow a further sum of 50l. on the 14th of February, 1848. Wright is described as a most amiable man, besides being an excellent artist in his line.

The Associates who made their exits during these last ten years of Cristall's life have now to be accounted for.

When Fielding came to the chair, JOHN SELL COTMAN was still resident at Norwich, contending against adverse fortune and consequent nervous depression, his spirits sinking with the state of his finances. On one occasion at least, his melancholy took the form of evil foreboding as to his health. The story goes that Varley, on a visit to Norwich, found him in a fit of despondency, and treated it in his own characteristic fashion. On his calling at Cotman's house, the servant who opened the door informed the cheery visitor that her master was very ill and going to die. 'Die!' says Varley, 'impossible! Won't die these ten years. Let me see your mistress.' 'What's the matter?' he says on Mrs. Cotman's appearance; and to her announcement that 'Poor Cotman is given over by the doctors,' replies with confidence, 'Pooh! nonsense! They know nothing about it. His time is a long way off. Let me see him.' Introduced into the sick chamber, he rallies him thus: 'Why, Cotman, you're not such a fool as to think you're going to die! Impossible! no such thing! I tell you there are ten years for you yet to come.'[1] Of course the patient recovered; and reckoning back from the time when his death occurred,

[1] *Art Union*, January 1843.

all true believers in John Varley as a minor prophet must assign to the incident above recounted a date not later than 1832.

Cotman remained at Norwich during the first years of Fielding's presidency, sending drawings to the gallery. In 1833 he had as many as eight, the only occasion on which he exercised his full privilege as an Associate. Among the works of this time there are new elements that belong to the last phase of his career. Figures play a more important part in the compositions, and some pictures even aspire to the rank of 'history.' There is one, for example, in 1833, of ' King John and Prince Henry at Swinestead Abbey, attended by' five named earls 'after their defeat and loss at crossing the Lynn Wash.' Then we have two with the following odd titles : 'Sir Simon Spruggins, Knt., the tall fellow of the family of that ilk—*vide Lady Morley's Spruggins Family*' (1832), and ' Interior of Spruggins Hall, Manor of Dulfuddle, Bedfordshire, leading to the Picture Gallery, Arms of Spruggins, Gull, Whittingham, Bagnigge, Kiltwaddle, and Sucklethumbkin, over the Doorway—*vide Spruggins Gallery*' (1833). The book referred to under the above names was a set of lithograph caricatures published in 1829 as a satire on family pride under the form of a mock pedigree and gallery of ancestral portraits. It is conjectured that Cotman's drawings, which had nothing comic about them, were intended as the remonstrance of a devoted antiquary against such irreverent treatment of the past.

The following plates, engraved by other hands, after Cotman's works, were published during this period : In the *Gallery of the Society of Painters in Water-Colours* (1833), 'Yarmouth Roads,' engraved by A. Freebairn, 1832. The original drawing was in the possession of the late Thomas Griffiths, and afterwards in the collection of the late Dr. Percy.—In Captain Robert Elliot's *Views in the East*, 2 vols. 4to (Fisher), 1833, ' Perawa,' dated 1830, engraved by W. Le Petit from a sketch by Captain Elliot. The plate was republished by Fisher in the *Drawing-Room Scrap-Book* for 1834, and in Emma Roberts's *Hindostan*, 2 vols. 4to, 1845.—In the *Gallery of Modern British Artists*, 2 vols. 4to, 1834, ' View off the Coast of Yarmouth.' A vignette of Eton from the terrace of Windsor Castle was also engraved by Greatbatch, after Cotman, apparently as a book illus- tration.

In 1834, having accepted an appointment as drawing master at King's College in the Strand, he came to London with all his family

except the eldest son, Miles Edmund, whom he left behind for about a year to take his place as teacher in his native city, after which he too came to London ; the second son, John Joseph, being sent back to carry on the instruction at Norwich. The choice at King's College is said to have been in great measure due to the strenuous advocacy of Turner, who, when consulted as to the appointment, would by way of answer do nothing but reiterate the name of Cotman. The follow-ing letter, the original whereof was in the collection of autographs of Mr. W. V. Morten,[1] shows, however, that he also considered himself indebted to Lady Palgrave for her exertions in the matter :

'Dear Lady Palgrave,—The final arrangement is made. I am to have one guinea per annum beyond the annual sum of 100*l.* for every pupil beyond 100. The numbers amount to from 170 to 180, con-sequently an income beyond the highest sum originally fixed. As you are the first spring or mover in this delightful plan for me, you will, I hope, excuse my eagerness in laying my happiness before you. Present my most respectful compliments to Sir Thos. Palgrave. Most respectfully your devoted servant,

'J. S. COTMAN.

'Two of my sons are to be placed in the school, *one free of expense.*'

Before leaving Norwich he had had to dispose by public auction of a large collection of prints, books, pictures, and drawings, old armour, models of vessels, and objects of ornamental art, which he had accumulated. On coming to London he, after a short stay with his son John Joseph in Gerrard Street, settled himself at '42 Hunter Street, Brunswick Square,' which, along with 'King's College,' is his catalogue address in and after 1835. Here he was not entirely cut off from 'old familiar friends,' for a former comrade and admirer, James Stark of the Norwich School, was then living at Chelsea, and their intimacy was pleasantly renewed. He had also the society of some of his old pupils. In a letter dated 27 October, 1835 (printed in the Norwich Art Circle Catalogue 1888), to his son at Norwich, he gives a lively picture of his industrious household, all 'drawing mad.' Alas ! the emolument was very small, as the produce of a sale for which he made up a number of lots in May 1836 too sadly shows. But Cotman's merits were elsewhere recognized ; for in the same year

[1] Dispersed by sale at Sotheby's in May 1890.

the Institute[1] of British Architects conferred upon him an honorary membership. While engaged with his duties at King's College, Cotman was but a spasmodic exhibitor in Pall Mall East, sending in only one drawing a year until 1836, when he had seven, and being absent altogether in the following year.

When his collections had been sold at Norwich, the copper plates of his etchings had been offered for sale, together with his published works. But the former were bought in ; and in 1838 a comprehensive edition, including nearly all, except the Norman series, was published by Bohn in two large folio volumes, with the title, ' *Specimens of Architectural Remains in various Counties of England, but principally in Norfolk*, etched by John Sell Cotman, Esq., with descriptive notices by Dawson Turner, Esq., F.R.S., F.S.A., &c., and architectural observations by Thomas Rickman, Esq.' Some plates were added which had not been published before, and the collection was arranged in five parts, the last of which bears the title of *Liber Studiorum*. The contents of this part were also published separately with the same date, 1838. The set of plates so called are forty-eight in number, thirty-nine of which are soft-ground etchings of landscape subjects and studies, the remaining nine being in hard ground. Four of the latter, including the title, were in the set published in 1810–11, and five are of figures, after or in the manner of the Dutch masters. Bohn characterizes the contents of the ' Liber,' without distinction, as ' early efforts,' which Cotman had been reluctantly persuaded by artists to publish. And some at least of the soft-ground etchings seem also to have been issued many years before the date of this publication. Two of the subjects are those above mentioned[2] as having been exhibited at Norwich in 1824. And their style accords better with his works of that middle period than with those executed at the end of his life. They abound in beauty, are broadly composed, and full of dignity and grace. Whether there was originally an intention to use them, like Turner's more celebrated series of the same name, to illustrate different classes of landscape must remain a matter of conjecture ; but it would not be difficult to assign to each its distinctive letter, according to that painter's nomenclature. And, with one singular exception, each class would be represented. It is remarkable that so good an etcher, and so good a sea painter, should never, or

[1] Now the *Royal* Institute. It was founded in 1834, and the charter was granted in 1837. [2] *Supra*, i. p. 504.

'hardly ever,'[1] have etched the ocean. But he *painted* sea pieces to the last. His sole contribution to the gallery in 1838 was a very large drawing, characteristic of the mannered superficiality into which he sometimes sank in his latest style, representing a 'Lee shore, with the Wreck of the Houghton, Pictures, Books, &c., sold to the Empress Catharine of Russia, including the celebrated and gorgeous landscape of the Waggoner, by Rubens.'

He exhibited for the last time in 1839, and with four drawings made up the small total of forty-six works during his term of fifteen years, as an Associate only, the average being scarcely three a year (swollen by eight and seven in the two exceptional seasons above mentioned).

The painter's bodily strength was really declining now, and his end was not far off. The Messrs. Redgrave go so far as to assert that Cotman's 'severe nervous depression gradually terminated in mental aberration.'[2] But this was not quite so. He had, with his improved income, recovered some of his natural cheerfulness; and his letters from London show that his spirits could be high and his style jocose. Nor had the artistic faculty or the love of nature deserted him even in his last year. He then paid a final visit to Norfolk, and did some vigorous chalk sketches, now in the possession of Mr. Reeve of Norwich, which seemed to foreshadow a style resembling in its impetuous power that of the later time of David Cox.[3] These, twelve in number, were afterwards lithographed, not very successfully, by Miles Edmund Cotman, and sold for the benefit of the family. They were among the very last productions of our artist's pencil; for he died at his house in Hunter Street on the 24th of July, 1842, of 'natural decay.' St. John's Wood Cemetery is his place of burial.

Another sale of books, prints, &c., with some of his own works, took place at Christie's in May 1843. But the prices realized, especially by the latter, were inconceivably small.

A set of etchings executed by Cotman at the end of his life were brought out shortly after his death, in conjunction with some by his

[1] There is one posthumously published etching of a shore scene, in which a boat landing in the surf is introduced, but merely in the background.

[2] *Century of Painters*, ii. 378. The allegation is repeated in the South Kensington Museum Catalogue.

[3] Cox was a great admirer of Cotman's genius, and never lost an opportunity of praising his originality and knowledge of composition, light and shade. They were to have travelled together to Birmingham in August 1838, but the latter made default. See Solly's *Life of Cox*, pp. 87, 88.

son, in a thin folio volume, entitled ' *Eight Original Etchings by the
late John Sell Cotman* ; also ten etchings by M. E. Cotman. Now
first published. Norwich, Charles Muskett, Old Haymarket.' Most
of these eight are primarily figure subjects, and in their general
treatment they seem based on a study of Rembrandt, as the earlier
architectural etchings seemed based on that of Piranesi. The two sets
by father and son were afterwards published separately with the date
1846, the latter being then increased to 'eleven' plates. Mr. Reeve
of Norwich has a few lithographs and etchings by J. S. Cotman,
which are not known to have been published, and there are some also
at the British Museum.

It is only in quite recent times that complete justice has been
done to the merit and scope of John Sell Cotman's water-colour
painting. He was inadequately represented by only three drawings
at Manchester in 1857, and two in the London International Exhi-
bitiou of 1862, four out of these five being sea or river subjects.
There was again but one among the water-colours collected at the
Royal Academy in 1873. At South Kensington in 1874 he was in-
cluded among other architectural draftsmen specially represented,
and a mixed assemblage of about forty drawings and sketches was
shown there under his name. At the Grosvenor Gallery 1877–78
there was a better selected set of about fifteen. At the Manchester
Jubilee Exhibition in 1887 there were again only three. But the
wider knowledge and a higher appreciation of his art have been the
result of two really representative collections of his drawings in water-
colours and black and white, one of 197 exhibits by the Norwich Art
Circle in 1888, the other at the Burlington Fine Arts Club in the
following winter.

The Norwich Art Circle catalogue is adorned with forty small litho-
graphs and a vignette of one of the drawings exhibited there, and
three were engraved on wood in the article 'John Sell Cotman' by
Mr. Wedmore in the *Magazine of Art* for October 1888. Several at
the Burlington Club were reproduced in the *Architect.* In the
Portfolio for May 1888, p. 92, there is also a mezzotint of 'St. Mary
Redcliffe' by F. Short after Cotman. In 1871 *Nine Examples of
Pencil Drawings* and *Five Examples of Sepia Drawings* after
Cotman were lithographed in folio size by Vincent Brooks, Day &
Son, for the use of schools in connexion with the Government
Department of Science and Art. And there is a chromolithograph

by the same printers of a ' Boat on the Beach—John Sell Cotman' in Redgrave's South Kensington Water-Colours Catalogue published in 1877.

The British Museum has nine of his landscape and architectural drawings, some of them fine works in water-colours, and a striking portrait by him of John Crome, the head of which is in colours. Belonging to the South Kensington Museum there are ten drawings (five of them 'in circulation'), besides two in the Dyce Collection there.

There exist the following portraits of John Sell Cotman : Lithograph in black and red, head and shoulders nearly in profile looking to the left; from a drawing by Mrs. Dawson Turner. Taken when Cotman was a young man. Mr. Reeve has the only known impression.—Drawing in black, red and white chalk on drab paper. Profile head. By M. E. Cotman. At the British Museum.—A print lettered 'John Sell Cotman, author of Antiquities &c. J. P. Davis delt. 1818.' It is one of a privately printed collection of ' *One Hundred Etchings*, by Mrs. Dawson Turner.' The original drawing is in the possession of Reginald F. D. Palgrave, Esq., C.B. A graphic description of this portrait is given by Mr. Wedmore in 'Studies in English Art.'—Drawing in water-colours by H. B. Lowe. Figure seated, leaning on the right elbow, a copy of the work on Normandy in left hand (oval, 10½ by 9 inches). In the possession of Mr. Reeve.

The highest prices realized at sales by Cotman's water-colours, as stated by Redford, are : 105*l.* for 'Dutch Vessels—Calm, 12¼ x 18¼,' at the ' J. Heugh' sale, 1874 ; and 88*l.* 4*s.* for 'St. Michael's Mount' in ' Quilter' sale, 1875. A volume of forty landscapes was sold in the ' Mott' sale, 1885, for 215*l.* 5*s.*

The names of two more landscape draftsmen, *George Pyne* and *John Byrne*, are withdrawn from the list of Associates in the course of this first decade of the Queen's reign.

GEORGE PYNE had thirty-eight drawings in the gallery between 1827 and 1843. The subjects are old buildings, &c., chiefly in Kent ; about half a dozen views of old London Bridge ; and in and after 1837 (when and for the two following years his address is at Tavistock) there are some scenes in Devonshire.

There is not much to record of his final career. His name last appears in the catalogue in 1843 with no address, and a view of

Brentor. A little later we find it on the title-pages of two published volumes : First, *A Rudimentary and Practical Treatise on Perspective for Beginners*, 12mo, 1848 (there was a fourth edition, enlarged, in 1852, and another in 1857); and secondly, *Practical Rules on Drawing for the Operative Builder, and Young Student in Architecture*, 4to, 1854. (This is reprinted in Peter Nicholson's 'Carpenter's New Guide.' Edited by Arthur Ashpitel, 4to, 1857.)

To trace his personal history is a less grateful task. In 1836, and from 1840 to 1842 at least, he hailed from the residence of his father-in-law. But as soon as the 'Matrimonial Causes Act' came into operation, his wife obtained a release *a vinculo*, and afterwards a second husband in the solicitor who conducted her case. According to the catalogue of the South Kensington Museum (where there are three or more of his drawings), he died in 1884.

He is believed to have made a number of spurious imitations of his father-in-law's drawings, against which collectors should be on their guard.[1]

JOHN BYRNE continued to send drawings to Pall Mall East until his death, on the 11th of March, 1847. In this latter period of his life he extended his range of subjects by visiting the Continent. Redgrave says[2] that he set off 'about 1832,' and 'travelled in Italy for three years, passing that time in a careful study both of nature and the great Italian painters.' But his first foreign views were French. Except a 'Place de la Pucelle, Rouen,' in 1832, he has nothing from abroad until 1834, in which year he gives an address in Paris, and sends half a dozen subjects from that city, and Nantes, and Vernan on the Seine. The first of his Italian subjects is 'Tivoli' in 1836, and then they follow thickly for a few years from Rome and Naples, with a 'Pont du Gard' in 1838. In 1841 he falls back upon Wales for one year, in 1844 we have some views of Dartmouth, &c., in Devon, and in 1845 a small contingent from Yorkshire. A scene near Lynmouth in 1846 is his last exhibit. It completes the number ninety-six during the twenty years of his Associateship. Graves finds fifteen works by him at the Royal Academy, five at the British Institution, and twenty-three at Suffolk Street, between 1822 and 1847. Two Welsh views at Trafalgar Square in 1843 were, according to Redgrave,[2]

[1] See Dr. Percy's MS. Catalogue at the British Museum.
[2] *Dictionary of the English School.*

in oil. A drawing of 'Marius amidst the Ruins of Carthage' (1832) and 'A Roman Army overwhelmed by an Earthquake' (1834), both in our gallery, are ambitious exceptions from his usual class of subjects. John Byrne was buried at Kensal Green Cemetery.

Towards the end of the preceding year, to wit on the 3rd of October, 1847, ALEXANDER CHISHOLM, the Associate, had died, at Rothesay in the Isle of Bute. Several circumstances of his professional career place him in the same category with J. Wm. Wright ; among them, alas ! the same impecunious end. His family, a large one, were also left destitute ; as we learn from a Minute of the 30th of November recording a donation from the Society of 30l. to his eldest daughter, and from an announcement in the *Art Union* for the following year[1] that the orphans having up to the time thereof been solely dependent on her energy and industry, she was then endeavouring to raise a sum for the education of the younger children by 'the sale of a collection of her father's paintings, drawings, and engravings in 300 shares of a guinea each.' The mother had died about nine years before her husband, and the depression caused by this event is said to have told upon his art, so that his drawings during that period do not possess the vigour of his earlier time.[2]

From 1829 to 1847 he had forty works in the gallery, and besides these Mr. Graves counts up forty-one elsewhere, under the name 'A. Chisholme ;' viz. fifteen at the Royal Academy, fifteen at the British Institution, and eleven at Suffolk Street, between 1820 and 1846. His subjects at the Water-Colour Society were for the most part scenes from Shakspere and Scott, and events in English and Scottish history. A drawing of 'Shakspeare before Justice Shallow,' there in 1832, was to have been engraved in the *Gallery of the Society of Painters in Water-Colours*, but that work seems to have collapsed before the translation could be so made. 'The Twa Dogs' from Burns (1836) and 'Leonardo da Vinci expiring in the Arms of Francis the First' (1838) are also among the principal drawings which he exhibited at Pall Mall East.

Chisholm was moreover, as above stated, a designer for the Annuals. Besides his contributions to the *Forget-me-not* of 1830 and 1831, before named, he had 'The China-mender' in 1833, engraved by H. C. Shenton, a pretty composition not at all in the humorous

[1] Page 314.
[2] *Dictionary of National Biography* and *Dictionary of the English School*.

spirit of the lines by Thomas Hood which accompany it. There is, however, no want of life in his designs, and the personages are endowed with distinctive character and expression. In this respect he surpasses Uwins, whom, in works of the same kind, he somewhat resembles. He contributed eight illustrations to the Waverley Novels,[1] engraved in line (5¼ by 3¼ inches), two of which, 'Oldbuck at Elspeth's Hut,' from *The Antiquary*, and 'The Fair Maid of Perth and the Carthusian Monk' (both engraved by P. Lightfoot), are doubtless from drawings of the same subjects exhibited in 1836 and 1839 respectively. The others are: 'The Black Linn of Linklater' (T. S. Engleheart), from *Old Mortality*; 'The Regent Murray and Roland Graeme' (Lightfoot), from *The Abbot*; 'Shipwreck of Cleveland' (G. Presbury), from *The Pirate*; 'King James, Prince Charles, and Nigel' (R. Stains), from *The Fortunes of Nigel*; 'Cromwell and Lady Fauconberg' (Lightfoot), from *Woodstock*; and 'A Varangian at the Golden Gate' (Lightfoot), from *Count Robert of Paris*.

When our artist died, he was engaged in taking portraits in Scotland for a large picture of the Evangelical Alliance, in execution of a commission from Mr. Agnew of Manchester.[2] In addition to his skill as an artist, Chisholm is said to have 'had the merit of being an original thinker.'[3]

Among the figure painters of the illustrative class whose careers came to a close during the same sub-period, one more has to be mentioned, Miss LOUISA SHARPE. Her name disappears from the catalogue for one year, 1834, and then she returns as MRS. SEYFFARTH, wife of a Dresden professor of that name. Her husband, Dr. Woldemar Seyffarth, was (after her death) commissioner from the King of Saxony to the London International Exhibitions in 1851 and 1862. After her marriage she resided with her husband in Dresden, where she died, on the 28th of January, 1843, of a painful disorder. She, however, continued to share her sister Eliza's London address, and to exhibit for the most part kindred subjects to hers.

In her last season, that of 1842, she had two drawings in the gallery, making up a total number of thirty-eight during the

[1] Published or republished by Fisher & Co. with dates 1842 to 1845, and with English and French titles. Some had also been in Fisher's *Drawing-Room Scrap-Book*, which contains, by Chisholm, 'The Widow's Mite,' 1836, and 'Cromwell and the Portrait of Charles I.' 1840.
[2] *Art Union* 1847, p. 378. [3] *Almanack of the Fine Arts*, 1851, p. 105.

fourteen years of her Membership, from 1829. Her choice of
subjects shows a taste for dramatic point, and a search for anecdote of
a telling kind as well as a picturesque capability. Explanatory ex-
tracts that have to accompany her titles make quite a show in the
catalogue. It needs, for example, at least one of its quarto pages to
introduce her four exhibits in 1840. One of these is a realization of
'Will Honeycomb's Dream' described in No. 499 of the *Spectator*,
wherein, under the terms of capitulation of the town of Weinsberg,
the women thereof issue forth in procession, each bearing what she
loves best in the world, but only one saving her husband, a lively
cobbler who had won her service by 'the discipline of the strap.'
Another story depicted in the following year is that of the Lady
Kunigund, who, testing her knight's devotion by flinging a glove into
an arena of wild beasts, regained her token but estranged his love.
Several other of her themes are furnished by Addison or Steele from
the pages of the *Spectator.* In 1832 we have Brunetta avenging her-
self by dressing her negro in a petticoat of the same brocade as that
worn by her rival. In 1833 the fine lady is depicted getting into her
coach after disturbing the congregation with her 'airs and sublimities.'
And again, in 1840, there is the courtship of 'William and Betty' as
witnessed in passing by Sir Roger and his guest. Scott, Moore,
Crabbe, and Harrison Ainsworth, and divers standard tales and old
songs, furnish further incidents ; while titles such as 'The Ghost Story,'
'The Secret Discovered,' 'Constancy,' 'Inconstancy,' 'The Alarm in
the Night,' &c., evince an evolution of humour or pathos from inner
consciousness as well. Two only in 1839 are scenes of modern life in
Germany ; and one in 1838 entitled 'Gemile' is apparently from a
book by her husband, *Andronikos von Seyffarth.* As 'costume pieces'
her works formed an attraction by their high degree of finish.[1]

Miss Louisa Sharpe contributed the following subjects to the
Annuals : In the *Forget-me-not* : 1829, 'Ellen Strathallan ;' 1831,
'The False One ;' 1836, 'Juliana' (engraved by J. Goodyear).—In
the *Keepsake* : 1831, 'Juliet' (J. Edwards) ; 1832, 'Constance' (Ch.
Heath), 'Do you remember ? ' (Heath), 'The Wedding' (Ch. Rolls) ;
1833, 'The Unlooked-for Return' (Goodyear) ; 1835, 'The Widowed
Mother' (F. Bacon), 'The Gipsy Children' (J. C. Edwards) ; 1837,
as Mrs. Seyffarth, 'Lalla' (Goodyear), 'The Intercepted Letter' (E.
Portbury).—In Heath's *Book of Beauty* : 1833, 'The Orphan,' 'Gulnare,'

[1] Miss Clayton's *English Female Artists*, i. 380.

'Rebecca' (all by H. T. Ryall); 1834, 'Chylena' (H. Robinson), 'Margaret Carnegie' (Robinson), 'Flora' (Ryall); 1835, 'Edith' (Mote); 1836, 'Caroline' (Robinson); 1837, as Mrs. Seyffarth, 'Calantha' (Robinson).—In Fisher's *Drawing-Room Scrap-Book* : 1839, 'The Keepsake' (Robinson).

Another lady Member married at about the same time, and passed out of the record shortly after her change of state. The MISS SCOTT of 1833 becomes MRS. BROOKBANK in 1834. Under her new name she sends but three drawings in five years, and after 1838 it goes itself, and we lose all trace of its possessor. Her total amounts to twenty-four studies of fruit or flowers between 1823 and 1837. Her last address was still at Brighton.

WILLIAM WALKER is in the list of Associates until 1849, after which date his name is withdrawn. But the fact that he had then exhibited nothing for three years places his exit from the gallery in 1846. Throughout this period his contributions had been as often absent as present. Since his admission to the Spring Gardens gallery in 1813 he had shown sixty-two works in all at the Society. He is said to have lived till 1868.[1] In Peacock's *Polite Repository* for the years 1848 to 1852 the frontispieces bear the name 'William Walker,' probably the same artist. The subjects are : 'Assisi, Spoleto' (*sic*), 'Edinburgh,' 'Brussels,' 'Rio Janeiro,' and 'London, from Blackfriars Bridge.' Graves credits him with six landscapes at the Royal Academy between 1828 and 1834, which were probably in oils.

[1] Redgrave's *South Kensington Catalogue* (1877), p. 215.

CHAPTER III

DEATHS AND RETIREMENTS; 1848–1855

Biographies concluded — De Wint — Prout — Cattermole — Copley Fielding — Nesfield — Mackenzie — S. Jackson — Scott.

WE pass now to the third and last subdivision of the period of *Fielding's* presidency, namely, that from 1848 to 1855.

The year 1849 is the last in which the honoured name of PETER DE WINT appears in the exhibition catalogues. Under Fielding's *régime* he had continued to send a steady average of fifteen or sixteen drawings each season, all of native subjects, from various parts of England and Wales;[1] and all, we may be sure, thoroughly characteristic of the scenery of our island and its ways of life. They amount, during this period, to 279 drawings, whereof at least three-quarters of the number are of named places; the remainder being chiefly harvest and other pastoral scenes, or river and rural studies. About half of the topographic views are from the northern, and some thirty or forty from the eastern counties. In 1836 were some half-dozen subjects from North Wales, whither he went for the last time in the preceding year. In 1842 we have, it is believed for the first time, a subject from Devonshire, 'Falls of the West Lynn;' and a few studies from the West of England are thenceforth interspersed among the other views. With the eighty exhibited during the late presidency, these drawings made up a number of 359 since De Wint rejoined the Society in 1825; and with twenty-three at the Oil and Water Colour, and nineteen previously, amount to a total of 401 works exhibited by him in the Society's galleries between the years 1810 and 1849.

De Wint's personal career during this final period gives us little

[1] A single Scotch view in 1836, and one from Ireland in 1846, are not enough to imply a personal visit to either of those portions of the kingdom.

more to relate. To use his biographer's appropriate simile, it was 'uneventful as the course of a Dutch river.' The journal of his life would be chiefly a list of painted landscapes corresponding to yearly visits to customary sketching districts. Once in every two or three seasons he went to Yorkshire, his favourite county. During many of his sojourns in the country he and his wife were guests at the seats of one or other of the wealthy patrons of whom he had a goodly list. Among those who were wont to receive him thus were the Earl of Lonsdale at Lowther Castle, the Earl of Powis, the Marquis of Ailesbury, the Cleves of Oakley Park near Ludlow, the Heathcotes of Connington Castle, Mr. Cheney of Badger in Shropshire, Mr. Fawkes of Farnley, Mr. Champerknowne of Dartington in Devon, and Mr. Ellison of Sudbrooke Holme, Lincolnshire. Visits such as these were in the late summer or autumn, which season also included a long stay at Lincoln, where the Hiltons' house, close to the castle wall, afforded him good scope for studying skies. In the earlier part of the year he was fully occupied in teaching at home. He began his lessons daily at nine and ended at six, with but an hour's rest between. De Wint's teaching, though mostly confined to amateurs, was not merely that of a drawing master to young ladies. Some of his *alumni* were of very mature age. At one time he had a pupil more than seventy, and another more than eighty years old.

His greatest delight, however, to the end of his life, was in sketching out of doors. When so engaged he was personally regardless of the weather. His field sketches are often the most powerful and characteristic of his productions. They represent, without much after modification, the way in which his artist mind received its freshest impressions of nature. Properly speaking, they are not sketches, but thoughtful studies ; for the generalism is not that of the superficial 'impressionist,' but a deliberate rejection of unneeded detail. In rich depth of tone, produced with unerring certainty and simple directness of intention, they are, and while their colours remain must always be, unsurpassed.

In De Wint's manner of painting, much whereof is his own, there was no great variation between earlier and later practice. The following list of his pigments is given by Mr. Armstrong : Indian Red,[1] Purple Lake, Yellow Ochre, Gamboge, Brown Pink, Burnt Sienna, Sepia, Prussian Blue, Indigo.[1] Body colour he eschewed on principle,

[1] Specially prepared.

though he may have used it, rarely, as a convenience, in a part of a picture where a patch would not greatly offend the eye. We learn from the same authority that he habitually carried two brushes, both large ; one with a fine point, the other 'round and well worn ;' and that he saturated with water the 'old Creswick paper' upon which he drew, laying a mosaic of rich colour upon it when wet. His deepest tones were always left untouched.

De Wint's commercial dealings in relation to his art produce evinced some of the independence of his character. Until nearly the end of his career he would have nothing to do with dealers, preferring to sell for his own price direct to private purchasers. He was, it is believed, one of the first artists who adopted the now common custom of inviting patrons to an annual show day in his studio, before sending his drawings to the exhibition. In thus keeping the market in his own hands he had the same keen eye to the main chance to which Mr. Armstrong attributes his adoption of water-colours, instead of his more favourite medium, oils. Anecdotes are related of his care for the elemental pence that went to make up the well-earned pounds of his income, which read like tales about Turner ; how, for example, he was ready to quarrel about the odd shillings of his guineas, and charged an extra fee for a lesson wherein he had drawn a few cows on the margin of the pupil's sketch. The analogy holds good when he is said to have made a special reduction where the cause of charity in art teaching was concerned. It was not until about the year 1844 that he was induced to make an exception to his rule, in favour of a single dealer, Mr. Vokins. The way in which the concession was obtained, as well no doubt as its profitable result, did credit to the tact of the clever man of business. De Wint had told him, in his surly way, that he only made drawings for 'gentlemen.' 'Make me a gentleman's drawing, then,' says Vokins, 'and I will pay you a gentleman's price.' The case so put, the artist's pride remained untouched, and during his few remaining years he had many dealings with this firm.[1] The same desire to keep himself aloof from the trade element of his profession may in part account for a certain exclusiveness of habit which made De Wint generally shy of his brother artists. Though a steady contributor to the exhibitions during the many years of his Membership, and one of the Society's great leaders in art, he

[1] The Messrs. Vokins exhibited a loan collection of 155 of De Wint's drawings and sketches in their gallery in Great Portland Street, in the spring of 1884, as a centenary commemoration of the artist's birth.

never held office or took any active part in the administration of its affairs. And, reciprocally, in the sale list of his drawings, which was preserved by his widow from the year 1827, only one painter appears among his customers ; but that one is Constable, between whom and De Wint the community of artistic feeling is strongly manifested in their respective works.

'De Wint,' says Mr. Armstrong in his *Memoir*, ' was of middle height, slender rather than stout, dark in complexion, and in youth black-haired.' And he gives a photogravure from a miniature portrait representing the face as unrefined in the cast of features, which are broad, with the lips thick. Those who knew him remember an irritable roughness in his manner, which increased in his latter years, and was apt to be repellent to all but intimate friends. In analogy, however, with many of his works, a rugged exterior was but the natural covering of much depth and worthiness of character. Not only was De Wint an honourable and just man, but his tone of mind was eminently religious. ' For many years,' says his biographer, ' it was his custom to read a portion of Scripture and write out a prayer before he began his work, and this he never omitted even when travelling. In the last half of his life he devoured books of devotion.' [1] The writer adds, among his minor proclivities, that he was ' fond of chess, of gypsies, of curious locutions ; ' and that he ' loved to hear poetry read,' and ' was a good hater.' To this love of being read to, his wife, from whom he was inseparable, was wont to minister, while he worked at his easel. [2] Of the fondness for poetry, we have the evidence of a curious outburst of quotations which adorn the titles of his pictures in the catalogues of 1842 and 1843. In the preceding year he had ventured on an alliance with literature, by employing one of his forest glades (studied perhaps in the rocky Dingle at Badger) as a retreat for Jaques and the wounded stag. Before that we find nothing of the kind, except in 1836, when he quotes Thomson's *Summer* for a picture of ' Retirement,' and in 1829, when he paints ' Elijah ' from the Old Testament. But he now selects lines from Milton, Thomson, Collins, Wordsworth, Scott, or others, as well as Shakspere, to convey the motive of at least one in three of his drawings. The fine frenzy then seems to pass away, and he uses

[1] *Memoir*, pp. 39, 40.
[2] Mr. Armstrong tells us that in her maiden days she had been similarly employed by Miss Linwood, the celebrated worker of pictures in worsted. (*Memoir*, p. 12.)

verse on two further occasions only. In both it is to describe the
closing hours of day. On the last, one may, without too much
forcing of sentiment, make a double application of the well-known
exquisite lines which he borrows from the poet Gray. The drawing
was one of his beloved Lincoln, seen in the solemn stillness of eve,
when the glimmering landscape is fading on the sight. It was one of
a characteristic group of eleven works which formed his final con-
tribution to the gallery in 1849. His own sun of life was likewise
setting. His health had been failing since he was nearly carried off
by an attack of bronchitis acquired while sketching in the New
Forest in the autumn of 1843; and a fatal return of the malady
was now aggravated by a slight paralytic seizure. He died on the
30th of June, 1849, in his sixty-sixth year.

The companionship which so long had linked together the lives
of the two artists Hilton and De Wint was extended even beyond
what has been above recorded. They were comrades in death, as in
life. Both were buried in the churchyard of the Savoy, where also
lay interred Hilton's wife and mother, the latter of whom had died in
De Wint's arms. Hilton himself had breathed his last at De Wint's
house on the 30th of December, 1839. A mural monument to the
two painters was erected in the Chapel Royal of the Savoy, but it
perished in a fire which destroyed a great part of the building in
July 1864. In substitution for it, when the chapel was restored,
a beautiful font was placed there by Mrs. De Wint in memory of
her late husband and brother. A monument in Lincoln Cathedral
was also erected by her to commemorate the same undying friend-
ship.

After De Wint's death a sale took place at Christie's, in May 1850,
of works remaining in his studio. These were sold in 493 lots for
2,364*l.* 7*s.* 6*d.*, the largest price for a lot being thirty guineas. It is
difficult not to feel some regret that many fragments from his hand
were then destroyed under the idea that their existence might lead to
forgeries. The best of the drawings, however, were retained by the
artist's widow, together with a number of oil paintings which he had
executed for his own pleasure and kept in an upper room without
offering them for sale. The bulk of these are, it is understood, in the
possession of the family. Mrs. De Wint died on the 27th of Novem-
ber, 1866, aged seventy-six, leaving her daughter surviving, who a few
years before the artist's death had married Mr. Paul Tatlock, their

next-door neighbour in Upper Gower Street. Mrs. Tatlock then presented four of the oil landscapes to the South Kensington Museum, together with twelve of the water colours. Seven more of his water-colour drawings were given to the same gallery by the late Mrs. Ellison, the widow of De Wint's patron above mentioned, in a collection of fifty-one pictures presented to the nation in accordance with her husband's wishes. These, with others, given and bought, make up nearly thirty drawings there by the same artist. Besides these no fewer than thirty-three of his drawings were placed in the National Gallery under the bequest of the late Mr. John Henderson in 1880. So the nation is unusually rich in works by this distinguished artist.

The following are the highest prices recorded in Redford's *Art Sales* for De Wint's water-colours : 1,732*l*. 10*s*. for 'Southall, Notts ' [1] (12 × 36 in.) in the ' Quilter ' sale, 1875 ; 1,417*l*. 10*s*. for ' Lancaster ' at ' Lord Lonsdale ' sale, 1879 ; 1,008*l*. for the same (apparently) at the ' Sumner ' sale, 1885 ; 966*l*. for ' Christchurch ' in the ' Ellison exors. ' sale, 1874.

The following later plates have to be added to the list before given of De Wint's engraved works : In the *Gallery of the Society of Painters in Water-Colours*, 1833, ' Forest Hall Mountains ' (engraved by J. H. Kernott), dated 1832, 3⅜ × 8¾ in.—In Tillotson's *Album of Scottish Scenery*, ' Whitby ' (T. Jeavons).—In Tillotson's *New Waverley Album*, ' Kenilworth Castle.'—In the *Gallery of Modern British Artists*, 1834, ' Goodrich Castle.'

By 1832 SAMUEL PROUT had become entirely devoted to the special department which he had made his own ten years before. Henceforth in his exhibits we have no more English views or buildings (unless some there be among a half-dozen of unnamed ' interiors ') ; and ' A Shipwreck ' (1834) and ' After the Storm ' (1839)[2] are the sole representatives of the marine branch of his art. With these few exceptions to prove the rule, the drawings which he sent to the gallery at the rate of fifteen per annum during nearly the whole of Fielding's reign were all of foreign architecture. He had moreover the absolute monopoly of such subjects, or at least of his own way of treating

[1] Believed to be really ' Lincoln.' De Wint sold it to Vokins for thirty-five guineas. In the second Quilter sale, in 1889, it was knocked down for the still higher price of 1,753*l*.

[2] These, no doubt, were due to an unwilling residence at Hastings at this time.

them. Apart from the 'romance' which Ruskin finds in these, it is more than doubtful whether Prout ever painted an imaginary scene in his life. Subjects from France, Belgium, Germany, and Italy are pretty evenly distributed throughout this period, with a few from Switzerland. These were the result of many sketching tours, which he continued to make as long as his fragile health permitted him. The number of Prout's drawings exhibited at the Society's rooms from his election as Member till his death, a period of thirty-two years, was 511; making, with thirty-six as a mere 'Exhibitor' at Spring Gardens, a total of 547, not to mention previous exhibits at the Royal Academy and with the Associated Artists.

At the same time he continued to supply many designs for the engraver. The little pocket-book series for Pye went on yearly; and although the task of illustrating the 'Landscape Annual' had passed into other hands after the first two years, a similar publication, called ' *The Continental Annual* and Romantic Cabinet : edited by William Kennedy, Esq.,' was brought out for 1832 (as the first of an intended annual series), the letterpress whereof consisted of tales 'selected with a view to give effect to' the thirteen designs 'by Samuel Prout, Esq., F.S.A.,' which formed its steel-plate illustrations. The subjects are selected from the various countries in which he made his sketching tours. The *Forget-me-not* contains the following plates after Prout : 1826, 'Bridge of Sighs' (engraved by H. Le Keux); 1827, 'Sepulchral Monuments at Verona' (E. Finden), 'Dungeons of the Castle of Chillon' (H. Le Keux), 'Part of St. Mark's Church, Venice' (Freebairn); 1828, 'Rialto, Venice;' 1829, 'Vicenza;' 1830, 'Place de Jeanne d'Arc, Rouen;' 1831, 'The Japanese Palace, Dresden;' 1832, 'Mayence;' 1833, 'Nuremberg;' 1834, 'Church of St. Pierre, Caen' (interior); 1836, 'Porch of Chartres Cathedral;' 1837, 'The Doge's Palace, Venice' (the last five engraved by J. Carter); 1838, 'Church of St. Paolo, Rome.' The *Keepsake* contains : 1830, 'Venice' (Freebairn); 1831, 'Milan Cathedral,' interior (W. Wallis); 1832, ' Interior of Zwinger Palace, Dresden '.(Wallis). In Fisher's *Drawing-Room Scrap-Book*,[1] 1832–1834, are more than a dozen Indian subjects after sketches by Captain R. Elliot, R.N. ; also published in that writer's *Views in the East*, two vols. 4to, 1833. They, or some of them, were

[1] Some plates from the *Landscape Annual* are repeated in the *Scrap-Book* for 1837, 1838 and 1850.

further reproduced among sixteen views by Prout after Captain Elliot in Emma Roberts's *Hindostan*, two vols. 4to, 1845. Finden's *Illustrations of Byron*, three vols. 4to, 1833-34, contains : in vol. i. ' Piazetta, Venice ; ' vol. ii. ' Ferrara ; ' vol. iii. ' St. Mark's, Venice,' ' The Rialto, Venice,' ' Ancona,' and ' Ravenna, Dante's Tomb,' all by Prout. In the *Gallery of the Society of Painters in Water-Colours* 1833, is ' Venice ' (engraved by E. Goodall), dated 1831. In the *Gallery of British Artists*, two vols. 4to, 1834, are ' Mayence on the Rhine ' and ' Beauvais.' In William Brockedon's *Road Book from London to Naples*, imp. 8vo, 1835, are ' Pisa ' (frontispiece), ' Calais,' ' Beauvais ' (from a sketch by Mrs. Edward Austen), all engraved by Finden. These belong more to the category of landscape than to that of architecture. Prout's name occurs as a draftsman to *Landscape Illustrations to the Bible*, two vols. sq. 8vo, 1836, and Hall's *Book of Gems*, 8vo, 1836. In Rev. G. N. Wright's *Shores and Islands of the Mediterranean* (1839?) are : ' Strada S. Giovanni, Valetta,' ' Strada Reale, Corfu,'[1] ' Marina of Valetta,' ' Strada St. Ursula, Valetta.' In Tillotson's *New Waverley Album* are : ' The Abbey of St. Mary's ' and ' Coldingham ' (from a sketch by J. Skene). In Dr. Mapei's *Italy, Classical, Historical and Picturesque*, folio, 1847-59, are : ' Ferrara—The Ducal Palace ' (engraved by J. Godfrey) and ' Padua—The Market Place ' (J. Carter). Lawson's *Scotland Delineated* contains, in lithography after Prout, ' Lincluden Abbey ' (by C. T. Dolby), and ' Bothwell Castle ' (W. Gauci). Two lithotints of church interiors, ' Arundel ' and ' Boxgrove,' drawn on stone by Harding after Prout, may be found, and also one or more woodcut designs by him, in S. C. Hall's *Baronial Halls and Picturesque Edifices of England.*

Besides thus furnishing works for translation with the graver or on stone by other hands, our draftsman again became his own reproducer in '*Facsimiles of Sketches made in France and Germany*, and drawn on stone by Samuel Prout,' a large folio, published by subscription, it is believed in 1833, and dedicated to the Queen (Adelaide). The lithographs (12 x 18 in.) are fifty in number, and of architectural subjects. They are elaborate compositions, with Prout's characteristic groups and crowds of figures ; but are more strictly sketches, and drawn with more freedom and linear force than

[1] This and another, after sketches by Lieutenant H. E. Allen, are also in Fisher's *Drawing-Room Scrap-Book*, 1837, 1838.

the earlier series of 'Illustrations of the Rhine.' Some have his initials combined in a monogram, β. A series followed of '*Interiors and Exteriors,* drawn on stone by Samuel Prout. Folio, London, 1834,' and another of '*Sketches in France, Switzerland and Italy,* by Samuel Prout, F.S.A.,' published by Hodgson and Graves, 6 Pall Mall, in a large folio (1839 ?), which contains twenty-six lithographs (about 11 × 16 in.), printed by Hullmandel on stone-tinted paper heightened with white.

The remainder of Prout's published works in lithography are primarily of the educational kind. These form a contrast with the old soft-ground etchings issued for the same purpose in his early time ; being more after the model of Harding's manner of drawing on stone, which had now become popular. One of these was published in six numbers, oblong quarto, by Ackermann, under the name, '*Bits for Beginners.*—By Samuel Prout.' It contains twenty-four lithographs on white paper, of picturesque architectural studies, foreign and English, the latter of the rustic kind, nearly all with groups of figures, generally two subjects on a stone ; printed by Hullmandel and Walton. A much more important work of this time was '*Hints on Light and Shadow, Composition &c.,* as applicable to Landscape Painting.—Illustrated by Examples by Samuel Prout, F.S.A. &c.' It appears to have been first published in 1838 The edition of 1848 (large 4to, M. A. Nattali, 23 Bedford Street, Covent Garden) contains a few additional examples, making twenty-two lithographs, on stone-tinted paper, heightened with white, having from two to eight subjects on each. Printed practical remarks by the artist on the several examples, and a prefatory discourse, are offered 'as the basis of his practice, and the result of his experience.' The essential principle of composition upon which the writer most insists in his teaching is that 'the interest of the spectator can only be commanded by the unity of the whole, i.e. a unity of '*purpose* throughout the design.' He speaks with small respect of certain doctrines that have been laid down by professors, their rules of three lights, and special forms and proportions and quantities of light and shadow, considering that they prevent the exercise of eye and sense ; the great requirement being *breadth.* 'The best practice,' he says, 'is to form *one broad mass*—to keep other masses quite subordinate, and particularly to *avoid equal quantities.*' Generally, the examples are designed to show the advantages of connecting and repeating the

lights and shadows and bringing the one into the other, so that simple massing shall be obtained or preserved, and broad shadows shall be duly relieved ; together with devices for disguising the repetition of similar forms, avoiding lines that cut, and keeping minor parts of the picture duly subordinate. A few years later was published, by Tilt and Bogue in Fleet Street, ' *Prout's Microcosm*[1]—The Artistic Sketch-book of Groups of Figures, Shipping, and other Picturesque Objects. By Samuel Prout, F.S.A. &c.' Large 4to, 1841. It contains twenty-four lithographs ($13\frac{1}{4}$ x $9\frac{1}{2}$ in.) of groups &c. printed (by Hullmandel) on stone-tinted paper heightened with white. In four introductory pages, ' On the Importance of Figures,' the author repeats some of his ' Hints,' as applicable to their composition, a principal group being required for the sake of unity, and points out the several distinct uses of figures in a landscape—to identify scenes by their character, &c. ; to introduce lights, darks, and colours ; to lead the eye ; and to give scales of proportion, and distances. The examples possess the artist's merits and betray his defects, in the life and effect of the composition on the one hand, and the weak drawing of individuals on the other. This work was followed by an ' *Elementary Drawing Book* of Landscape and Buildings, by Samuel Prout, F.S.A.' Imp. 8vo, Tilt, with twenty-four lithographs of various progressive studies, from fragments to slight subjects, British and foreign. Finally we have one more educational work called ' *Sketches at Home and Abroad* :—Hints on the acquirement of Freedom of Execution and Breadth of Effect in Landscape Painting. To which are added simple Instructions on the proper uses and application of Colour. By Samuel Prout, F.S.A. &c.' M. A. Nattali, 1844. Herein are forty-eight lithographs (about $5\frac{1}{2}$ x $7\frac{1}{2}$ in.) and two vignettes on slightly tinted paper, drawn apparently with pen and chalk, and strongly shaded. Of the subjects, ten are from England and Scotland, seventeen from France, five from Italy, two from the Low Countries, and fourteen from Germany. In an introduction of sixteen pages, the author presents the views as mere architectural fragments, designed to exemplify breadth of effect and simplify composition. He insists once more on the importance of treating every work as a whole, in style, and in pervading tone of colour, as well as in light and shadow ; and of the employment of modula-

[1] The name 'Microcosm ' had, it will be remembered, been forestalled by Pyne, and by Ackermann, in other series of prints.

ting greys as the foundation of every scheme of colour. 'It has been well remarked,' he says, 'that every good artist paints in colour, but thinks in light and shadow.' He adds some slight information as to materials, and warns the sketcher against mere dexterity on the one hand and mindless copying on the other.

In 1835 Prout's address is changed from 'Brixton Place' to 'No. 2 Bedford Place, Clapham Rise.' But this removal proved to be preliminary only to a change of residence forced upon him in the autumn of the following year by a severe pulmonary attack, which banished him for some years to Hastings. It was during his residence there that he did most of his drawings on stone. Some letters to Mr. John Hewett of Leamington, a well known dealer in water-colour drawings, with whom he had continuous business relations, speak of Prout's sufferings at this time, and the privations they inflicted. 'My heart sickens,' he writes in September 1841, 'at the thought of having friends and not being able to enjoy them. When a poor creature is broken down and nearly broken up, friendship is a double comfort. I fear you have thought me neglectful, but you must make large allowance for the loss of all exertion and activity of spirit. At times I am more than half dead, and the chain of cap-tivity (the iron) enters my soul : but you may rely on my esteem, and although I cannot excuse the weakness of irresolution nor indicate neglect so like ingratitude, yet I earnestly hope that if you will not acknowledge me as an angel I shall not be thought a D ——l. . . . I hope *dearest* and *sweetest* London offered Mrs. Hewett and yourself all the happiest times and circumstances could afford. If you ask,' he adds, 'how I am—*most wretched.* Plenty of sea in which I cannot swim—this is not my element and therefore I die daily—both body and mind.' A year after (Nov. 1842) he writes : ' My health is now better, but my spirits are sunk below recovery—at best I am like a poor fish struggling in a shallow stream which runs against the —poor animal.' What early love he had for the seashore seems to have quite deserted him. ' Here I am,' he exclaims, ' drinking nauseous draughts of *the sea*, very pleasing to the eye, but at present not exactly what I wish for. It is very well, but only for a change.' In the summer, however, he was able to visit his 'sweetest London,' to attend to his business, and he had there from 1840 a *point d'appui* at 39 Torrington Square.

At the end of 1845 Prout established himself once more in his

old beloved neighbourhood at No. 5 De Crespigny Terrace, Denmark Hill, Camberwell; and now for good and all. He writes to the 'good patron of his daubings' a letter so cheery that space must here be allowed to quote it *in extenso*.

'The first Monday after the first Sunday after Christmas day.[1]

'My Dear Hewett,—You must think me a most ungrateful dog, but—and you know there is a but in every Chapter of Life, and often a sad one—at least of mine—Encore but, I have been so harassed and occupied about the things of this wicked world, that I have not had a leisure moment, certainly not a quiet one since I was favoured, honour'd and obliged by your last cheerful *memorandum*. Much pleased to learn that you find parties willing to bear my sins and abettors to encourage my wicked works. I am old, fidgetty, and hesitating—especially in accepting your—not particularized—orders. Pray tell me what kind of villany you wish me to practise—the sort of *subjects*, the *size*, and the *price*. I am sensible of your exceeding kindness, but want resolution to accept of it. Pray be explicit—I will be merciful. I will do my best for you heartily, but promises will not make, &c. You have too many of these *unhonoured* already. I want to begin for the next Exhibition—a dozen are to be made for a Gentleman and neighbour—no shop—odds and ends are fretting me. And here comes an invitation, which must be answered—I wish indeed without the pen, for I verily abhor writing letters, but as I have said my say, I need not say more than that I wish you and yours all the happiness you would wish for yourselves, now and for ever and ever, amen.

'Signed

β

'To John Hewett, Esq. his mark.
The Honorable Patron and President of Art at Leamington Spa.'

Poor Prout! With this gratitude to a friendly patron, he was working for a meagre pittance, after all. There is a memorandum in the following words at the foot of one of these letters:

'9 small 9 9 0
4 large 12 12 0
—————————
£22 1 0

July 2ᵈ, 1842. Paid S. Prout.'

[1] The postmark is 30 Dec. 1845.

And on this the writer comments: 'I could not complete more than four others, for which I should have charged four guineas each, taking a dozen ; but if the lot will suit your customers, let the small ones be one guinea each, and the four large three guineas each.'

The dimensions of these are not further specified. But Mr. Ruskin declares that the fixed price for drawings of an 'understood' size, about 10 inches by 14 or 15, was six guineas to old customers like Hewett, who sold them for from seven to ten guineas ; and that to them the artist would never raise his price a shilling, even to the end.[1] That Prout was compelled, however, at the last, to make some slight advance in the sums asked for his drawings, appears from the following painful appeal and confession, in a letter written five years later, which shows alike how scrupulous he was in his dealings and how poorly his work was paid for while he yet lived. 'For a long time,' he writes to Mr. Hewett on the 29th of October, 1850, 'I have been at the sea side, in miserable health, scarcely able to leave the sofa and incapable of the least exertion even to writing a letter. When arrangements were made for returning home, a sudden attack of fearful hemorrhage from the lungs detained me another three weeks On my return it was necessary immediately to look about for the needful, and prepare what was needful to obtain it. The second Drawing is in hand, and I thought of sending it with the Rialto. The Ducal Palace is the subject mentioned. But I am not ashamed to confess that *want of coin* obliges me to send them separately. I know my dear friend that your kindness and liberality will not raise the question about prices ; but I am a great fidget and always fearful lest they should be beyond a saleable amount, as I wish my kind patrons to benefit themselves as well as myself. On looking at the Drawing this morning, it did not appear up to the mark, and I felt half inclined to say something less than *Ten* guineas ; but it took me a fortnight, and had my best attention. I can only hope that the next Drawing will be made with better health and more energy. . . . In consequence of old age and continued indisposition the *quantity* of work will be lessened, but as family requirements will be the same I must ask kind friends to allow a small advance of prices, and what has been charged three guineas and half must be four guineas, though I hope ten guineas will answer for the size sent. I do not hesitate my dear Hewett to make the proposition to you, as it is not from

[1] *Notes on Prout and Hunt,* p. 43.

greediness of gain. Indeed it is sad to say after half a century of hard work, without the possibility of being charged with indiscretion, it still continues "*from hand to mouth.*" Messrs. —— are urgent for fresh supplies with always ready payment, but I do not intend to meet their wishes except on new terms—that is, for the two general sizes ten and four guineas.'

In 1846 he had paid his last visit to Normandy ; going on, it would seem, to Brittany also, though we find no drawings thence. On the 15th of October he wrote : 'I returned to Camberwell on Friday night a sad wreck, having met with disappointment and suffering at every stage. It has been a fearful affair, but finding my family at the sea side, their affectionate nursings have strengthened my renovating powers, and to-morrow I purpose opening shop. I should wish to defer your large drawing till my hand is *in* work, &c.' And so he struggled bravely on, employing all the little strength he had to earn his daily bread ; anxious to keep his work free from 'symptoms of old age,' and 'being ambitious,' he declared, '*even now* of making progress.' His playful way of writing never deserted him, and one cannot fail to admire the wonderful gaiety of his spirit when he was suffering continual distress from mortal disease. The following jocular letter is undated, but the ghastly anecdote it relates is almost typical of the writer's own condition at the last.

'Monday Morning.

'My dear Hewett,—By the help of my first born " *knottable darter*," the Drawings are sent off and by this time I hope " en route " for Leamington. Please to direct one of your Sleeping partners to awake, arise and blow the loud trumpet (tho' a penny one) to announce the safe arrival of S(aint) Prout's relics for the devotees of Leamington. When the Father of a friend of mine was supposed to have expired, a lighted candle was placed at his mouth to ascertain if it were so. Such had been the old gent's love of *fun* during his *life*, that he attempted to blow out the light with his *last* breath. Though wriggling with pain, I cannot resist forcing a smile, however distorted it may be ; —but, dear Hewett, ever sincerely yours,

'S. PROUT.

'J. Hewett, Esq.'

Such indomitable cheerfulness surely betokened the consciousness of a blameless life, and a mind free from the shadow of self-reproach.

'My Father's delicate health,' writes the son to Mr. Jenkins, 'had from the commencement of his professional career induced him to live quietly and retired, and of late years increasing illness obliged him to withdraw from all society, save of a few intimate and attached friends, with whom he could converse upon the Art he loved and the Bible which (we thank God for the assurance) he loved more than all. The calm course of such a life, clouded indeed by much suffering yet lit by a cheerful and ever trusting spirit, while leaving to us many valued memories, affords nothing of interest or anecdote that would enliven your ' biographical notice.

The late S. C. Hall writes as follows of Samuel Prout at this period of his life : ' No member of his profession ever lived. to be more thoroughly respected—beloved, indeed—by his brother artists ; no man ever gave more unquestionable evidence of a gentle and generous spirit, or more truly deserved the esteem in which he was universally held. His always delicate health, instead of souring his temper, made him more considerate and thoughtful of the troubles and trials of others ; ever ready to assist the young with the counsels of experience. He was a fine example of upright perseverance and indefatigable industry combined with suavity of manners, and those endearing attributes of character which invariably blend with the admiration of the artist affection for the man. During the last six or seven years of his life, I sometimes (not often, for I knew that conversation was frequently burdensome to him) found my way into his quiet studio at Camberwell, where, like a delicate exotic, requiring the most careful treatment to retain life in it, he would, to use his own expression, keep himself " warm and snug." There he might be seen at his easel throwing his rich and beautiful colouring over a sketch of some old palace of Venice or time-worn cathedral of Flanders ; and, though suffering much from pain and weakness, ever cheerful, ever thankful that he had strength sufficient to carry on his work. . . . A finer example of meekness, gentleness, and patience I never knew, nor one to whom the epithet of "a sincere Christian" in its manifold acceptations might with greater truth be applied.' [1]

Although the artist's mind was, as we have seen, unclouded to the last, it would be surprising if the drawings of his closing years had possessed all the freshness and vigour of execution that belonged to his prime (if his fragile existence could be said to have had a prime)

[1] *Retrospect of a Long Life*, ii. 211, 212.

of life. The following confession in April 1846 seems to point to a more laboured manner of evolving his later works. ' I have been for two months hard at work on a large drawing for the Exhibition, working long after midnight's ghostly hour, but all my efforts in washing in and sponging out have been ineffectual and it is now o o o &c. &c.' He had but nine small drawings in the gallery that year, an exceptionally slight contingent. ' It was rarely,' says S. C. Hall, ' that he could begin his labours before the middle of the day, when if tolerably free from pain he would continue to paint until the night was advanced.' [1]

It is not always easy, however, to assign to Prout's works the exact years of their production, for he never dated them himself ' except in the day.' ' But the magnificent certainty and ease united ' obtained by firmness of line, always ' laid with positive intention,' are only seen, Mr. Ruskin observes, in drawings of his middle time. ' Not in decrepitude,' he adds, ' but in mistaken effort, for which, to my sorrow, I was partly myself answerable,' he endeavoured in later journeys to make his sketches more accurate in detail of tracery and sculpture, and they lost in feeling what they gained in technical exactness and elaboration.' [3]

Samuel Prout died suddenly at last in a fit of apoplexy, at his house at Camberwell, on the 9th or 10th of February, 1852, at the age of sixty-eight. Three months after the painter's death, namely in May 1852, a four days' sale of the sketches left by Prout took place at Sotheby & Wilkinson's on 19 to 22 May, 1852, and produced 1,788*l*. 11*s*. 6*d*., ' a large sum,' remarks Mr. Jenkins, ' when it is remembered that very few finished drawings were among them. They were mostly in pencil.' The painter's copy of Turner's ' Liber Studiorum,' which sold for 65*l*., was the first that had been offered for public sale since the author's death, which event had occurred on the 19th of December in the preceding year.

When Prout became an ' old master ' his works realized sums that contrast forcibly with those earned by the overworked painter while he lived. The following are the highest prices (all that exceed 600*l*.) registered by Mr. Redford, with one subsequent addition.

[1] *Retrospect of a Long Life*, ii. 211, 212.

[2] Mr. Ruskin was Prout's neighbour at Denmark Hill, where a friendly intercourse was carried on between them.

[3] *Notes on Prout and Hunt*, p. 46.

Title	Collection	Price
		£ s.
'Nuremberg' (21 × 28 in.) .	J. J. Clare, 1868	1,002 15
ditto	Addington, 1886	640 10
'The Rialto' (29 × 41) .	J. Heugh, 1874	
ditto	ditto, 1878.	903 0
'Church of St. Pierre, Caen' (16 × 24) .	W. Quilter, 1875	840 0
'Würtzburg Market Place and Cathedral'		
(29 × 45) .	Austen, 1889	819 0
'Milan' (21 × 28) .	J. J. Clare, 1868	708 15
'The Doge's Palace' (28½ × 45) .	Sir G. F. Moon, 1872	609 0

A crayon sketch of Samuel Prout, by his friend Sir W. Ross, R.A., was engraved on wood for the head of Mr. Ruskin's article in the *Art Journal* on the 1st of March, 1849.

GEORGE CATTERMOLE exhibited for five years as an Associate after his second election, and was then made a Member, on the 10th of June, 1833. No longer the dry architectural draftsman employed in copying church perspectives, neat traceries, and delicate mouldings, for John Britton's 'Cathedrals,' he had now shown himself a composer of figure subjects, and a painter of historic *genre*, of great spirit and originality. The number of drawings which he sent to the gallery in the fifteen seasons when he exhibited as a full Member is no measure of his position and importance among contributors thereto during Fielding's presidency. His works were always centres of interest, and their character was unique. As a bright group of figures gives life and colour to a single landscape, so was the *tout ensemble* of landscape subjects that formed the staple of the 'old water-colour exhibition' enlivened and illumined by the living incidents of George Cattermole's creation, distributed at chosen intervals on the walls.

The architectural training of Cattermole's pencil had directed his attention to the remains of ancient structures; and his own prolific fancy, aided by historical reading, had peopled them with living attributes of the past until he seemed to dwell in a world of 'monks, cavaliers, battles, banditti, knightly halls, and awful enchanted forests,' and amid 'the pomp and circumstance of feudal times.'[1] Much of the graphic restoration was no doubt evolved from his own inventive brain, acting under a strong sense of the picturesque. But this gave to his designs a certain unity of character, which almost persuaded people that things mediæval could have possessed but one

[1] Thackeray, in Marvy's *Sketches after English Landscape Painters.*

aspect, namely, that represented by George Cattermole. Even the 'Oxford Graduate,' while falling foul of a sketchiness and want of imitative detail with which his own pre-Raphaelite taste had small sympathy, admits that ' the antiquarian feeling of Cattermole is pure, earnest, and natural ; and his imagination originally vigorous, certainly his fancy ; his grasp of momentary passion considerable, his sense of action in the human body vivid and ready.'[1] ' His long series of mediæval subjects,' says a late observant critic, ' belongs, in Art, to the same category as the creations of Scott in literature. It was with Sir Walter that his imagination " marched " most completely. The ceremonies, hospitalities, and duties of the baronial hall, the monastic guest-chamber, and the guard-room, or the wilder scenes of the chase, and freer life of the marauder's hold, furnished constant themes to his ready fancy and his facile but disciplined pencil. That pencil,' he adds, ' even in its most rapid play, was ever exact and under the control of close study and accurate knowledge. His power of indicating the play of light and gradations of relief on dresses, plate, arms, furniture, and figures, as well as the expressions and characters of faces, by a few touches, exactly of the right form and in the right place, was distinctive of the painter, and has never probably been possessed, in the same degree, by any other English artist.'[2]

Cattermole had exhibited but twenty drawings in Pall Mall East during the presidential reign of Joshua Cristall. To these he added seventy-five in Fielding's time, which was that of his maturity ; unless we count, as we may fairly do, connected subjects, three in a frame, in the last year, 1850, of his appearance, which raises the total to 101. The subjects may be roughly divided into : (1) Architectural and Landscape studies, forming not more than one-fifth of the whole ; (2) Motives from history, fiction, and poetic or ballad literature ; and (3) Fancy incidents and compositions of the artist's own devising, which make up the remaining and greater part of his exhibits. In the first category are one or two views of Haddon Hall and Naworth Castle, and a few in Derbyshire and the Scottish Lowlands. In the second, the reign of Elizabeth and the civil wars of the next century are the chief periods of English history, and Scott and Shakspere the chief authors, illustrated. It is in the third, where he allowed his fancy the greatest play, that he plunged so deep into the monastic and military life of the Middle Ages.

[1] *Modern Painters*, i. 114, 115. [2] Tom Taylor in the *Art Journal*, March 1870.

It may seem surprising, if we consider the range of his artistic inspiration, and in particular a marked affinity of his painting to the school of reaction led by Delacroix in France, and then but little known in this country, together with the high appreciation of his works abroad, to learn that George Cattermole never in his life travelled beyond the shores of Great Britain, never crossed the English, or even the Irish, Channel. Yet he was a good conversational linguist, well acquainted with the French and Spanish tongues; in the latter, at least, being entirely self-taught. No doubt, the keenness of his powers of observation, exercised as they were on works of art as well as nature, compensated in a great degree for the want of a wider field of study. It is no deduction from his claim to originality to admit that he received many a chance inspiration from whatever came in his way. He was ever on the look-out for motives and suggestions, and many of the compositions which he made the vehicle of dramatic incident had apparently their origin in some purely abstract arrangement of chiaroscuro. Of such preparatory framework there exist studies in sepia having no assignable reference to a concrete subject.

All critics concur in praise of the general artistic quality of Cattermole's painting in its pictorial and decorative aspect, the power and facility of his drawing, the richness and harmony of his colouring, his effective disposition of light and shadow and masses, and last (not least) the exceptional beauty and variety of the ' posing, draping, and grouping of his figures.'[1] His execution, in which the hand was ever the agile minister of thought and eye, is something of a counterpart in figure painting to that of Cox or De Wint in landscape. When, moreover, he essayed pure landscape himself, there was more than a mere analogy to the style of the former painter. In this department the works of Cattermole bear a marked resemblance to those of David Cox, who on divers occasions evinced a warm appreciation of his brother artist's talent. If Cattermole's paintings be conventional, it is with a conventionality of their own. If his forms be exaggerated, the exaggerations are those of the true artist, based upon ' very grand conceptions of general form,'[2] and giving marked character and individuality to his delineation. In his earlier drawings, those for example which he executed for book illustration in the first years of Fielding's reign, he adhered to the old practice of using transparent

[1] Tom Taylor, *loc. cit.* [2] Ruskin's *Modern Painters*, i. 401.

colours ; but in the mature and more masterly work of his later time he was lavish in the employment of body colour, loading his brush with pigment, and applying it to a thick absorbent paper of low tone and warm tint, prepared expressly for him by Messrs. Winsor & Newton, and known by his name.

George Cattermole's exhibited drawings formed a part only of his artistic produce. He had a peculiarity of temperament which limited his contributions to the gallery. ‘ His sensitive organization always made the necessity of considering the conditions of exhibition, in planning his work, peculiarly irksome to him. Whatever in any way hampered the free play of his imagination impaired both his inventive and executive power to a degree hardly conceivable by robuster natures.’ [1] Moreover, much of his designing during this period was done for engravers and book illustration. These facts may partly account for an apparent want of steadiness in sending drawings to the annual show. Sometimes he had from eight to thirteen, at others one or two only, and in 1841, 1847 and 1851 his name appears in the list of Members, but not in that of their works. On one of these occasions, when he was a defaulter, he aroused the virtuous indignation of steady old David Cox, who, ever solicitous for the Society's credit, expressed himself in terms of unwonted severity in a letter to his friend Roberts, of the 30th of April, 1847, which may be read at length in Mr. Solly's memoir.[2]

In the last year of his Associateship he had changed his residence from the suburbs to the centre of London, moving (in 1832–33) from Brixton Hill to 36 Gerrard Street, where he remained until, about a year before his marriage, he took up his quarters in some chambers in the Albany, which had once been Byron's, and were afterwards Bulwer Lytton's. In 1838 he was elected a Member of the Athenæum ; being already a Member of the Garrick Club. After completing, in the early part of 1839, a large drawing of ‘ The Diet of Spires,’ executed, it is believed, at the express command of the Queen, George Cattermole received the offer of a knighthood, which honour he abstained from accepting. This was one instance, among several, in which he thought fit to decline proposals the acceptance whereof might have been of advantage to him in the world. For example, he declined the offer of an engagement as instructor to the French princesses residing at Claremont, never having taken pupils at all, as he felt

[1] *Art Journal*, March 1870. [2] *Life of Cox*, pp. 148, 149.

that ' his line of art could not be taught.' He was at this time about to make the change above mentioned in his domestic state. On the 20th of August, 1839, he married Clarissa Hester, daughter of James Elderton, a Deputy Remembrancer of the Court of Exchequer. In that year he had a temporary studio at 68 Welbeck Street ; but on his marriage he and Mrs. Cattermole took up their residence at Clapham Rise, in a house that had been her aunt's, which was their home for the next twenty years. There it was that he did the main part of his work as an artist.[1] He became the father of a large family, with whom he lived on terms of great mutual affection.

What we learn of Cattermole's general proclivities and of his personal career is not out of keeping with his character as a painter. Though devoted to his art, he was also a man of literary tastes, a great reader, and at the same time fond of intellectual society of the more brilliant kind ; one of the distinguished circle that surrounded Lady Blessington and Count D'Orsay at Gore House, a great friend of Dickens, an associate of Talfourd, Lytton, and Benjamin Disraeli, of Thackeray and Jerrold, of Macready, Macaulay, and Robert Browning, now all deceased. He seems to have frequented the society of the Royal Academicians more than that of his confrères in Pall Mall East ; Maclise, Stanfield, and Landseer, being the chief artists named as his companions. Among his attainments were those of being both a good rider and a good four-horse coachman. He was also an excellent amateur actor, and on a memorable occasion gained special credit by his performance of the part of *Wellbred* in 'Every Man in his Humour,' a representation of which was given by very distinguished literary amateurs for the benefit of the ' Sanatorium ' at Ventnor in the Isle of Wight. It was played in 1845 at Miss Kelly's Theatre on 20 Sept., and again before the Prince Consort at the St. James's Theatre on 15 Nov., when Macready, who was present, gave great praise to Cattermole's acting. Nor did he disdain to exhibit on occasion the order of humour known as that of the ' low comedian.' The biographer of Dickens relates how our artist was in the habit of imitating a certain waterman or omnibus tout at Charing Cross, who rejoiced in the sobriquet of ' Sloppy,' and ' in the gruff hoarse accents of what seemed to be the remains of a deep bass voice wrapped up in wet straw,' would relate the eccentricities of an

[1] In 1844 and 1845 he had also a studio at 25 Berners Street, for working on stone, his *Portfolio*, mentioned below, being published there, by ' Messrs. Cattermole and Manser.'

II. F

imaginary friend ' Jack ' which were ' supposed to typify ' the water-man's own ‹ early and hard experience before he became a convert to temperance.' These imitations were 'a delight to Dickens,' about the time (1849) when he was beginning *David Copperfield* ; and he used playfully to adapt the dialect of Sloppy to a variety of subjects.[1] In an earlier mention of the painter, as one of Boz's companions at Twickenham in 1838, when the former was a bachelor of the Albany, the same writer describes him as one ' who had then enough and to spare of fun as well as fancy, to supply ordinary artists and humourists by the dozen.'[2] Yet there was nothing of the Bohemian about George Cattermole. Notwithstanding his keen sense of humour, he was almost prudish in his regard for the conventionalities of life. Few artists were as well dressed as he. Precise and measured in his speech, he had a horror, not merely of vulgarism and slang, but even of solecisms in language ; and he was peculiarly intolerant of any impropriety of conversation unsuited to a lady's ear. A Tory in politics, he was before all things a ' gentleman ' of the old school, even to the extent of despising some of those restrictions of the purse which ordinary people regard as prudent economy. To this latter tendency it may be in part attributed that his professional gains did not lead to affluence.

There is not much more to record of Cattermole's life beyond an indication of his chief works. Of those in the Water-Colour Society's gallery, the following appear to have attracted the most attention : 1834, 'After the Sortie.'—1835, 'Gallery in Naworth Castle.'—1836 ' Murder of the Bishop of Liége '—from *Quentin Durward.*—1837, ' Pilgrims at a Church Door.'—1838, ' The Armourer relating the Story of the Sword ' (a subject often repeated ; one version is at South Kensington).—1839, ' Sir Walter Raleigh witnessing the Execution of the Earl of Essex ' in the Tower ; ' Wanderers Entertained ' (a sub-ject repeated and engraved, with variations, under several names).— 1842, ' The Castle Chapel ' (an interior with many figures, some armed and in prayer before battle).—1843, ' Hamilton of Bothwellhaugh ' pre-paring to shoot the Regent Murray at Linlithgow (a single figure, several times repeated; two are at South Kensington); ' After the Second Battle of Newbury.'—1844, ' A Contest for the Bridge.'—1845, ' Ben-venuto Cellini defending the Castle of St. Angelo ; ' ' The Visit to the Monastery ' (of this picture Cox writes to his friend Roberts on

[1] Forster's *Life of Dickens*, ii. 393 *n*. [2] *Ibid*. i. 158.

23 April, that Cattermole's drawing of ' Holy Men coming down from a Monastery to meet Crusaders, or something of the kind . . . is worth hanging in the very first collection in the kingdom.'[1]—1846, 'The Unwelcomed Return,' representing a knight in armour in a forest of huge oaks or chestnuts. Cattermole's trees, by the way, have a strong family likeness. A subject often repeated is a scene in a refectory, overlooking an Italian lake, with monks saying grace. Over this the painter shed an air of serene repose in just harmony with the religious sentiment. It is better in the monochrome versions, the monks in the drawing of 1844 being open to the criticism that they are of an order invented by the artist, habited in various colours of the rainbow. Many of the incidents represented, of the class due mainly to his fertile imagination, evinced his keen sense of dramatic effect, with sometimes the spice of humour, the appreciation whereof is requisite to give point even to a serious narration. 'Father Thomas takes in a suspicious Note' (1843); 'Ride!' (1845); 'Conspirators' (1846); ' The Minstrel in Danger,' and ' The Silent Warning'[2] (1848); are the significant titles of some of the drawings of this class. In 1848 was a remarkable ' Scene from *Sintram*,' where Biorn, as described in De la Motte Fouqué's romance, was represented 'sitting at a huge table with many flagons and glasses before him, and suits of armour ranged on either side with closed vizors '—the armour of his ancestors, who thus in fancy were his daily boon companions. The variety of suggestion of life and gesture which the painter managed to infuse into the outer casing of the visionary roysterers was as much a stroke of artistic genius as the execution of the drawing was masterly and characteristic of his art. This subject also was repeated with entirely different grouping. In 1850, though he had no large work in the gallery, he sent a number of brilliant ones of smaller size, in which his dramatic power was well displayed. Among these were a set of designs from *Macbeth*, which, although three were on an unusually small scale, were tragic conceptions of rare quality and depth. They belong to a group of fine studies from this play, which was a favourite subject of illustration by Cattermole in his later time. One of those exhibited that year is at South Kensington, in the Ellison gift.[3]

These were the last works that George Cattermole exhibited in

[1] Solly's *Life of Cox*, p. 134.

[2] This subject with date 1837 is at South Kensington, in the Townshend bequest.

[3] A large number of the ' Macbeth ' subjects are understood to have been taken to India by their possessor.

Pall Mall East. In 1851 an announcement at the end of the cata-logue explained that the absence of his works from the gallery was caused by serious illness.[1] His malady is believed to have been gout in the stomach. It was certainly at one time apprehended that his life was in immediate danger ; for symptoms of disorder having been first felt on Christmas Day 1850, he was on the 29th of December suffering severely, and expressed a desire that certain friends and relations might be summoned to attend him. And he made the first day of the new year the occasion of his taking a serious step which bore witness to the righteous sincerity of his principles. George Cattermole was a man of much devoutness, and regular in the observances of religion ; and this mental tone inspired some of his compositions of sacred subjects. His father had been a Dissenter, of the Baptist persuasion ; but he himself had conformed to the Esta-blished Church, and he chose the time in question for a formal admis-sion to its communion through the sacrament of baptism, which was now administered to him by the Rev. Robert Bickersteth, afterwards Bishop of Ripon, who came to his sick room for the purpose.

Within the next twelve months he came to a determination to retire altogether from the Water-Colour Society. The main reason of his separating himself from that body is said to have been an intention to become a painter in oils. But, more probably, it was the sense of constraint above referred to, which he felt in working for exhibitions. The exercise of his genius was, as above stated, always cramped by the consciousness of working under imposed conditions. He abhorred the practice, considered by more matter-of-fact painters as essential to good art, of copying perpetually from models. He was wont to speak of his large drawing of 'The Diet of Spires,' now at South Kensington in the Ellison gift, as one of his most laboured and there-fore worst productions, because he was hampered by the necessity of sticking to prints and portraits, and following authorities for facts. Moreover his taste was opposed to the heavy gold frames then *de rigueur* in the gallery (before the winter exhibitions were founded). He con-sidered that his own drawings were seen to better advantage in white mounts. It is true, nevertheless, that he had been contemplating a devotion to the practice of oils. But it was really against his will that he made the endeavour. In doing so he yielded, not at all

[1] We find it only in the French edition, printed that year for the use of foreigners attracted to London by the Great Industrial Exhibition in Hyde Park.

readily, to the persuasion of friends. His brother artist John Frederick Lewis (who himself abandoned water-colour for oil) was one of these advisers ; and he was warmly seconded by Mr. Bickham Estcourt and Mr. Bryan Edward Duppa. Accustomed though he was to the copious use of body colour, his hand felt weighted by the task of dragging the more viscid medium, and he soon longed again for the freer play that he enjoyed when drawing in water-colours.

His resignation was announced on the 14th of June, 1852. A special resolution proposed by Mr. Jenkins was passed unanimously expressive of 'deep regret' at the 'loss of talent so admirable and so valuable to the interests of the Society with which they had been so long and happily connected.'[1] The desire to retain George Cattermole as a Member was evinced in a more practical form than a mere resolution of regret at his departure. The intimation was more than once conveyed to him in a pressing manner, that if he thought fit to remain in the Society he might count upon his election to the presidential chair. His mind, however, was made up ; and although he is said to have afterwards repented of the course he then took, and though often besought to return, he adhered to his determination during the sixteen years that were left of his life.

George Cattermole made no name as a painter in oils. Although in one such picture, of ' Macbeth,' he admitted that he had for once only realized his intention, his works in that medium gave him no general satisfaction ; he was fastidious and shy of showing them. As early as 1845, Cox had written prophetically : ' I very much wonder some gentlemen who are lovers of art do not beset him and procure a fine drawing, for they will never get oil paintings from him, for he is so particular about his oils going forth to the public. His water-colours are more under his command.'[2] Mr. Jenkins writes that in oil painting he ' failed to realize the finest qualities of his water-colours. The charm of his subdued colour, harmony, and freedom from gloss, which gave them the look of small frescoes, were lacking in his oils. These were superseded by a leathery brown and a highly polished surface, as though they were painted in varnish or unpleasantly over-varnished ; showing that he had not mastered the technique of the oil painter.'[3] Happily for his fame, he resumed the practice of water-colours. Withdrawn from the fashionable world and

[1] In this expression the name of Nesfield, who retired at the same time, was joined.
[2] Cox to Roberts. Solly's *Life of Cox*, pp. 133, 134. [3] MS.

society, he devoted himself unceasingly to his art, often working at
the easel from early morn to late at night. Thus it is as a painter in
water-colours that the name of George Cattermole is and will remain
celebrated, not only in his own country, but in foreign lands.

When the supreme excellence of the English aquarellists first be-
came known in France through the Paris Universal Exhibition of
1855, Cattermole's works created a sensation among foreign artists ;
and he shared with Sir Edwin Landseer the honour conferred upon
them alone among English painters of the award of *grandes médailles
d'honneur* of the first class by a jury composed of representatives of
all nations. It is said that Paul Delaroche, on seeing Cattermole's
representation of Cromwell contemplating the dead body of King
Charles, a plate whereof is in vol. ii. of the *History of the Civil
War*, declared that had he been earlier acquainted with that fine
rendering of the subject he should not have ventured upon his own
version, which is one of that eminent artist's most celebrated pic-
tures. In 1856 Cattermole was elected a Member of the Royal
Academy of Amsterdam, and of the Society of Painters in Water-
Colours at Brussels.

The subjects of his latest time included some from the New Tes-
tament, gracefully composed, and refined in religious sentiment.
Among them were some large unfinished outlines. He also left behind
him a number of powerful and suggestive sketches in charcoal, mostly
landscape. Cattermole's last years were clouded by domestic trouble.
His health and strength, weakened by confinement and anxiety
as to the future, and further depressed by the premature deaths,
at a short interval, of his youngest daughter, and of his eldest son (a
Lieutenant in H.M. Bengal Army), who died in India, at length gave
way, and he was carried off by heart disease on the 24th of July, 1868.
His grave is in Norwood Cemetery, where a memorial stone was erected
by subscription among his friends and admirers, not far from that of
his earliest patron, John Britton. The contents of Cattermole's studio
were sold at Christie's on the 9th of March, 1869.

The deceased left a family of several children. The eldest
surviving son, Leonardo Cattermole, who assisted him in some of
his later works, follows the father's profession, as a painter of equine
and cavalier subjects. To him and to the artist's widow the writer is
indebted for much valuable information. After the artist's death, her
Majesty the Queen (at the instance of the late Lord Beaconsfield)

was graciously pleased to place the name of Mrs. Cattermole on the Civil List, with a pension of 100*l.* a year.

Thanks to the munificence of possessors of Cattermole's works, the public collections are sufficiently rich in them to give an impression of his quality and genius. The Museum of South Kensington contains seventeen examples, ten in the Ellison gift, and seven in the Townshend bequest; and in the National Gallery are some fine drawings of his bequeathed by the late Mr. John Henderson. The following have been the principal gatherings of Cattermole's works in public exhibitions. There were eleven examples in the Paris Exhibition of 1855; thirty-one among the 'Art Treasures' at Manchester in 1857; and thirteen in the London International Exhibition of 1862. After the painter's death, many years elapsed without any large number of his works being seen together; but in April 1887 the Royal Water-Colour Society Art Club obtained the loan of forty, and hung them for a few days for inspection in the Gallery at Pall Mall East; and in March 1889 Messrs. J. & W. Vokins, who for many years were agents for the sale of his works, got together no less than 117 in their gallery in Great Portland Street. In the last-mentioned collection were two portraits of the artist, one in black and white chalk by B. E. Duppa (before mentioned), the property of Mrs. Cattermole, the other in oils by E. Chatfield. The following are the prices, above 400*l.*, noted by Mr. Redford,[1] as having been produced on public sale of drawings by Cattermole:—

Year of Sale	Collection	Title &c.	Price
			£ *s.*
1872	Sir F. G. Moon . .	'The Baronial Hall'[2] . . .	561 15
1874	J. Heugh . . .	'The Baron's Hall' (25½ × 34 in.) .	441 0
1875	W. Quilter . . .	'Old English Hospitality' . . .	430 10
1877	J. Knowles . . .	'Salvator Sketching, with Banditti' .	425 5

The period of Cattermole's connexion with the Water-Colour Society was that of the production of nearly all his engraved works. They are distributed in various publications, of which a list is here appended (probably not exhaustive, but as nearly so as it has been found possible to make it), in addition to the earlier designs, chiefly architectural, before mentioned: In Elliot's *Views in the East*, two vols. imp. 4to, 1833, a series of the sculptured caves of Ellora,

[1] The 'Contest for the Bridge' was bought in at 500 guineas at the sale of the late Henry Burton's collection, July 12, 1890. [2] 'Engraved by Egan.'

after sketches by Captain Elliot, three of them also published in Fisher's *Drawing-Room Scrap-Book* for 1832 and 1834 ; and seven in Emma Roberts's *Hindostan*, two vols. 4to, 1845.—In the *Gallery of the Society of Painters in Water-Colours*, 1833, 'The Bandit's Daughter,' engraved by C. G. Lewis.—In Finden's *Illustrations of the Life and Works of Lord Byron*, 1833–34, four foreign views after sketches by W. Page.—In the *Keepsake*, 1833, 'Pepita ;' 1834, 'The Two Barons ;' 1835, 'The Lady Blanche,' 'The Earl of Surrey and the Fair Geraldine ;' 1836, 'The Bride ;' 1840, 'The Tomb of the Last Heir of All ;' 1842, 'The Pearl-hilted Poignard ;' 1843, 'The Baron's Vow,'[1] 'The Brother's Revenge ;'[1] 1844, 'The Banquet,'[1] 'The Parting ;'[1] 1847, 'Rachel.'—In the *Literary Souvenir*, 1834, 'Hawking.'—In the *Calendar of Nature*, or Natural History of the Year, 12mo (Van Voorst), 1834, small woodcut vignettes, twelve of them headpieces of the months, mostly landscape. The original drawings are advertized as on sale at Colnaghi's.[2]—In the *Gallery of Modern British Artists*, 1834, 'Warwick Castle,' 'Tell's Chapel ;' scenes from 'Anne of Geierstein,' 'Quentin Durward,' 'The Hunchback of Notre Dame,' and 'Faust ;' with a melodramatic fancy called 'The Red Mask' (each about 4¾ x 6 in.).—In John Tillotson's *New Waverley Album*, 'Castle of Ashby' and 'Whitehorse Inn, Edinburgh' (from sketches by J. Skene) ; and 'Craigever Castle' (each about 3¼ x 4¼ in.).—In John Tillotson's *Album of Scottish Scenery*, 'Dunfermline,' engraved by W. K. Simmons (3¼ x 4¾ in.). —In Heath's *Picturesque Annual* for 1835, also entitled *Scott and Scotland*, by Leitch Ritchie, twenty-one plates (about 3¼ x 5½ in.). —In Thomas Roscoe's *Wanderings and Excursions in North Wales*, 8vo, 1836, 'Prince Llewellyn and the Barons,' 'Death of Llewellyn,' 'Bolingbroke's false Homage to Richard II. at Flint Castle,' 'Caernarvon Castle' (moonlight), and 'Rescue of the Countess de Burgh from Montgomery Castle.' (Possibly also a vignette of 'St. Winifred's Well' is by Cattermole.)—In the *Forget-me-not*, 1837, 'The Bridal Toilet ;' 1841, 'The King's Banner-Bearer ;' 1842, 'The Dying Knight.'—In Dickens's *Master Humphrey's Clock*, three vols. royal 8vo,

[1] These plates were re-issued in Fisher's *Drawing-Room Scrap-Book* for 1850 and 1851, the first three under the respective names of 'Old English Hospitality,' 'The Grave of Pride,' and 'The Minstrel's Song.' These are examples of many plates being made to do double duty or more.

[2] There is also an announcement of an edition of Gray's *Elegy*, post 8vo, with a design to each stanza by G. Cattermole and others.

1840-1841, many woodcuts (the rest by Hablot K. Browne).[1]—In Marvy's *Sketches after English Landscape Painters,* one coloured plate.

To the next two publications our artist was the sole draftsman. The Rev. Richard Cattermole's *The Great Civil War of Charles the First and the Parliament,* two vols. 8vo (Longmans & Co.). Volume i. 1841, has also the title, *Cattermole's Historical Annual.* It contains fifteen line engravings after George Cattermole, of historical scenes and events during the war. Volume ii., 1845, has also the title *Heath's Picturesque Annual for 1845.* It contains thirteen prints of the same class, after George Cattermole. The work was also published in New York and Paris. Some of the plates were reprinted for Fisher's *Drawing-Room Scrap-Book,* for 1847, 1849, and 1850. *Cattermole's Portfolio* of original drawings was published by Cattermole and Manser in two parts folio, each containing ten lithotints,[2] 1845. The subjects were announced as selected to display the usual characteristics of Cattermole's works in figures, architecture, and landscape, and combinations of all these together. They comprise several of his best known compositions, e.g. : 'The Monks saying Grace,' 'Old English Hospitality,' 'Hamilton of Bothwellhaugh,' &c. A few copies were issued tinted by the artist himself. *Evenings at Haddon Hall,* edited by the Baroness de Calabrella, royal 8vo (Colburn), 1846, contains twenty-four plates of various fancy subjects. The title is merely a vehicle for the collection of a series of tales written to explain a number of Cattermole's drawings supposed to be in a portfolio, turned over by a birthday party, confined to the house at Haddon by the snow. A popular edition with smaller plates was afterwards issued by Bohn.

To the following works he contributed some of the graphic illustrations. Lawson's *Scotland Delineated,* two vols. large folio (Hogarth, and afterwards Gambart), 1847-1850, contains from Cattermole's drawings eleven lithograph views, some depicting also historic events. Nine are drawn on the stone by Harding, two by Carrick. In S. C. Hall's *The Baronial Halls and Picturesque Edifices of England,* two vols. imp. 4to, are three lithotints by Harding after Cattermole. In the *Art Album* (Kent & Co.), 1861, is a coloured facsimile of 'The Days of Old' (5 × 7½ in.), representing the reading of the Bible in a

[1] The 'Maypole' Inn is entirely a fancy building designed by Cattermole. There neither is nor was, as sometimes supposed, a house like it at Chigwell.

[2] The lithotint process had been recently invented by Hullmandel.

chapel, reissued in *Beauties of Poetry and Art* (Ward, Lock & Tyler), 1865. In Redgrave's *Descriptive Catalogue of Water-Colour Paintings in South Kensington Museum*, 1877, is 'The Armourer's Tale' chromolithographed by Vincent Brooks.

Some of Cattermole's works have also been reproduced in single prints, viz. 'The Diet of Spires,' engraved by William Walker, 'Old English Hospitality,' by Egan ; and in chromolithography, 'The Dance,' and (issued by Rowney & Co.) 'Banquo,' 'Duncan,' 'Columbus in the Monastery,' and 'Almsgiving.' Some of his figure groups and compositions have also been reproduced in another way, by being dished up afresh in water-colour drawings by a nephew bearing the same surname.

The life of ANTHONY VANDYKE COPLEY FIELDING, like the lives of most of the artists with whom we are concerned, presents itself to the biographer in three aspects ; but in no case are the concurrent careers of the professed painter and the private member of society more thoroughly merged in or subordinated to relations with the body in which these two conditions were united, and of which he was so long the acknowledged head. There is little more to be related of Fielding's domestic life or of his movements outside the circle whose radius was centred in the gallery in Pall Mall East.

As in the catalogue for 1829 we find for the first time the address '41 Regency Square, Brighton,' added to that in the old artists' quarter in London, '26 Newman Street,' where his studio had been for the preceding ten years, it may be presumed that this was the date of his establishing his domestic hearth at the former place. These two concurrent addresses are repeated until 1837, when he makes a move at Brighton to '2 Lansdowne Place, Brunswick Square,' there to remain till 1847 or 1848. Then his town address becomes '56 Charlotte Street, Portland Place,' and his seaside residence is at 'Worthing, Sussex.' This was the last change.

As with his contemporaries, Cox and De Wint, Fielding's professional life was spent in sketching, painting in the studio, and giving lessons to pupils. But the last two of these occupations engrossed more of his time than of theirs ; for, sooth to say, a large class, though not nearly all, of Fielding's works, beautiful as they were, had the air rather more of models of art than guides to nature. As compared with those of the brother painters with whom his name is always

associated, the President's works were, in his own day, the most popular of all. His were eagerly purchased, while those even of David Cox were often returned from the gallery unsold.[1] His local subjects, except a few from the sketches of others, are all from Great Britain, for he never went abroad ; nor even, it is believed, crossed the Irish Channel. For the most part they divide themselves broadly into three classes. In the first and most numerous, wherein he depicted the mountain and lake scenery of the North of England, of Scotland, and of Wales, he was dependent more on the obvious character of scenes picturesque to the common eye, and lending themselves to conventional treatment under recognized rules of landscape. These, although in them his manner is not without individuality, are as a whole his least original works. Certain qualities, however, in them drew forth expressions of the warmest praise, not only from the less fastidious public, but from the 'Oxford Graduate' as well. In his criticism of the works of Fielding's best time he wrote : ' I do not know anything in art which has expressed more completely the force and feeling of nature in these particular scenes.' Entering more into analytic detail, he notes as ' very instructive ' the painter's method, akin to Turner's, of driving away the eye into the distance by a judicious treatment of the 'brown moorland foregrounds.' These were 'wet broad sweeps of the brush, sparkling, careless, and accidental as nature herself, always truthful as far as they went, implying knowledge, though not expressing it, suggesting everything, while they represented nothing. But,' he continues, ' far off into the mountain distance came the sharp edge and the delicate form ; the whole intention and execution of the picture being guided and exerted where the great impression of space and size was to be given. The spectator was compelled to go forward into the waste of hills ; there where the sun broke wide upon the moor, he must walk and wander ; he could not stumble and hesitate over the near rocks nor stop to botanize on the first inches of his path.'[2] Again, in another place, 'Copley Fielding is peculiarly graceful and affectionate in his drawing of the inferior mountains. He really has deep and genuine feeling of hill character, a far higher perception of space, elevation, incorporeal colour, and all those qualities which are the poetry of mountains, than any other of our water-colour painters.'[3] And he gives him

[1] See Hall's *Biography of Cox*, p. 155.
[2] *Modern Painters* (fifth edition), i. 185. [3] *Ibid.* p. 302.

also the first place in rendering the calm water of a lake.[1] But with all these delicate feelings and powers of realization, Fielding's art was allowed to suffer and to degenerate by too frequent repetition in the studio, and the daily habit of showing his pupils the same processes whereby he made the many pictures that supplied the demand of an ever ready market. 'He fell,' writes a later and more trenchant pen, 'into the most rigid mannerism of self-repetition, crudeness of colour, and feeble or blurred confusion of detail; and yet from isolated specimens of his work it might seem as though he might have been second only to Turner among water-colour artists.'[2]

Much of the defective realization of Fielding's work is attributed by Ruskin to his yielding too much to the fascination of the brush, to the prejudice of qualities only to be secured by hard study in black and white, and the kind of drawing for which the pencil is specially adapted. In place of these he produced effects and textures by washing and sponging and scraping, while truth of detail was nearly lost. In one department, however, his skilful management of the brush gave him a supremacy, which is eloquently recorded by the same eminent critic. 'In his down scenes and moorland showers,' Mr. Ruskin declares that 'he produced some of the most perfect and faultless passages of mist and rain cloud which art has ever seen. Wet, transparent, formless, full of motion, felt rather by their shadows on the hills than by their presence in the sky, becoming dark only through increased depth of space, most translucent when most sombre, and light only through increased buoyancy of motion, letting the blue through their interstices, and the sunlight through their chasms, with the irregular playfulness and traceless gradation of nature herself, his skies will remain, as long as their colours stand, among the most simple, unadulterated, and complete transcripts of a particular nature which art can point to. Had he painted,' concludes the writer, 'five instead of five hundred such, and gone on to other sources of beauty, he might, there can be little doubt, have been one of our greatest artists.'[3]

The second and third divisions, above referred to, of Copley Fielding's subjects display more originality than is apparent in his mountain views. They comprise respectively a large class of marine subjects and many studies of the South Downs, generally under an

[1] *Modern Painters* (fifth edition), i. 343. [2] Cassell's *Celebrities of the Century.*
[3] *Modern Painters* (fifth edition), i. 245.

effect of dewy mist. The latter and a great number of the former were based upon the study of ordinary nature, chiefly in the neighbourhood of his Sussex home. Fielding's studies of sea are of two kinds : the more characteristic of the painter, and generally the more impressive, being at the same time the more open to criticism. When he washes the white cliffs of Albion with her own blue waves his pictures are wholly delightful, while no one can deny the grandeur of his storms or fail almost to hear the rush and be carried forward by the sweep of his billows. But in the latter the violent contrasts of tone and denial of colour are apt to degenerate into mere blackness. In the same way the tender delicacy of his views of the chalk downs, with sunlight spreading through a haze, did not bear a frequent repetition. What is meant for an obscuring veil of mist is too often felt to lack the substance it is supposed to shroud. It has been said, indeed, without very great exaggeration, that Fielding painted but ' one sea, one moor, one down, one lake, one misty gleam.' [1] Certainly his variety bears but a small proportion to the quantity of his works.

Nearly all the drawings that Fielding made were exhibited in the gallery of the Society. Sometimes, indeed, as we have seen, he painted in oils, and Graves finds as many as 118 works under his name (17 at the Royal Academy, 100 at the British Institution, and 1 at Suffolk Street), between the years 1811 and 1855, presumably in that medium. But it is as a leading representative of water-colour art that he takes his place in history, and, above all, as the typical President of the ' Old Society,' when in its golden prime. The total of Copley Fielding's exhibits with the Society, reckoned according to the numbering of frames in the Catalogue, is 1,648 ; but if we count in separate subjects, several of which he was in the habit of including in one frame,[2] one hundred more must be added, making the prodigious number 1,748. With all this constant employment Fielding can have had little time left to draw for the press, and accordingly comparatively few of his designs have been engraved. He did not, as far as is known, reduce his theories to writing, or leave any published record of his processes of painting ; nor did he, like other contemporary teachers, attempt to assist the students of art by making model sketches for them on stone. His later mode of working, indeed, had

[1] *Celebrities of the Century.*

[2] This was his frequent practice up to the year 1828, but never, it is believed, after that date.

not the directness and precision requisite for the modes of printing and engraving then practised. Had any of the various kinds of photogravure been then invented, the list of his reproduced works might perhaps have been longer. The following are all the writer has met with besides the early coloured aquatints before mentioned : In the *Literary Souvenir*, 1827, 'Goodrich Castle, on the Wye,' by E. Finden after Copley Fielding ; 1835, 'Italy—The Bay of Naples,' engraved after him by C. Heath.—In Fisher's *Drawing-Room Scrap-Book*, 1832, 'The Water Palace, Mandoo,' 1833, 'Chinese Pagoda.' One or both may also be found in Captain R. Elliot's *Views in the East*, 1833, being made from his sketches, and both in Emma Roberts's *Hindostan*, 1845.—In the *Gallery of the Society of Painters in Water-Colours*, 1833, 'Southampton' (engraved by G. Cooke), 'Storm clearing off' (W. B. Cooke).—In Finden's *Illustrations of Byron*, 3 vols. 4to, 1833–34, 'Lausanne,' 'Cape Leucadia, Lover's Leap,' from sketch by Major Harriot.—In Thomas Roscoe's *Wanderings in South Wales*, 'View on the River Wye,' 'Tintern Abbey,' and 'Tenby,' from a sketch by C. Radclyffe (all engraved by W. Radclyffe).—In Tillotson's *Album of Scottish Scenery*, 'Barnard Castle' (S. Fisher), 'Branksome Tower' (W. Radclyffe).—In Tillotson's *New Waverley Album*, 'Powys Castle,' from sketch by Lady Lucy Clive, 'The Hill of Hoy,' from one by the Marchioness of Stafford, and 'Manor Glen,' and 'The Links of Eyemouth,' from sketches by J. Skene.—In Rev. G. N. Wright's *Lancashire, its History, Legends, and Manufactures*, 4to, 1842, 'Stony-hurst College,' from a sketch by J. Harwood (engraved by Thos. Jeavons).—In Lawson's *Scotland Delineated*, 1847–52, 'Dunderawe Castle,' lithographed by R. Carrick. A chromolithograph of 'Martello Tower, Sussex Coast,' $7\frac{1}{4}$ x 10 in., after Copley Fielding, was issued by Rowney & Co. It will be observed that many of the above were not studied on the spot by the artist, but merely made up by him into pictures.

It is, however, in the domestic annals, so to speak, of the old Society of Painters in Water-Colours, considered as a brotherhood of united artists, interested in each other's welfare, and combining to uphold the position of their house among the institutions of the country, that the name of Copley Fielding has to be kept in most special remembrance. Alike in the mutual relations with his colleagues, and as their representative in their joint dealings with the outer world, was he pre-eminently fitted for the offices he had to

perform, not only by his genial disposition and painstaking habits, but by his courtly manners and a more than ordinary share of social tact. Those qualities were of no small value in raising the status of the Society, whose gallery became year by year more of a fashionable resort, and the private view day one of the looked-for events of the season, it being known as the rendezvous of connoisseurs and eminent collectors, as well as of persons distinguished by rank and riches. Civilities were interchanged and maintained with other societies having similar objects, season tickets for example, being sent to every Member of the New Society, and a card to their President for the private view,[1] to which also the whole body of the Royal Academy were invited. In the former case the hospitality was returned, but in the latter even Fielding's blandiloquence did not, it seems, induce a similar courtesy.[2]

Some account of the increased consideration with which, under Fielding's leadership, the Society came to be regarded abroad as representing an important branch of the British school of painting, has been given above in an outline of its general history ; and also of the Court favour which it received at home. But further reference must here be made to the kindliness of his relations with the Members who worked with him as colleagues. Mr. Jenkins, who was Secretary during the last year of Fielding's life, preserved a few of his letters then written, which show how the President's devotion to the Society and its interests remained undimmed by the shadow of death, and how the warmth of his considerate sympathies with the Members and their private troubles was retained even to the end. The following is an example :—

'Worthing : Oct. 11, 1854.

'My dear Sir—I suppose it was from your being out of Town that Mr. Charles Turner[3] wrote a fortnight ago to ask me the same questions which he seems to have put in his note to you. I answered him and I trust satisfactorily. The Founders of the Society of Painters in Water-Colours were Messrs. Hills, Pyne, Shelly, and Wells. The latter was Professor of Drawing at Addiscombe. I never heard that he was at Christ Church. You will see by the Catalogue of the first Exhibition who were the other Artists who

[1] *Minutes*, 22 May, 1845 ; 10 June, 1850.
[2] *Minutes*, 19 March, 1850 ; 14 June, 1852.
[3] Doubtless the eminent mezzotint engraver.

joined these four gentlemen in forming the first body of the Society. We shall miss poor Bentley very much as an active Member of the Society. He was always a most excellent Member of Committee of arrangements. You will no doubt see Mr. Smith before long, who will tell you what has passed concerning applications from Mrs. Mackenzie. I fear that she, poor thing, has little notion of economizing her small resources and requires much friendly advice. I hope that she has relations who are wise enough to be able to supply this. I hope that your country excursion has been productive both of health and plenty of studies of good subjects for your future works. Much of your weather must have been as satisfactory as you could hope for. I have just come in from a country walk in which I have been much struck with the evidence of the splendid harvest we have had, in the noble collection of wheat stacks which crowd around the farms. I remember more than sixty, but never a finer season than the one just passed. How the days shorten! and the year runs on! Next month I expect to have the pleasure of meeting you at our general Annual Meeting.

'I remain, My dear Sir, Very sincerely yours,

'To Jos. J. Jenkins, Esq.' 'COPLEY FIELDING.

That golden autumn was his last. The 30th of November, 1854, was the fiftieth anniversary of the Society's birth. Exactly half a century before had the little group of ten met, as aforesaid, at the Stratford Coffee House, and dubbed themselves the 'Society of Painters in Water-Colours.' Nineteen Members of the now prosperous Society assembled on the above day of its Jubilee at their gallery in Pall Mall East. But the proceedings opened sadly, with the announcement that the President was too ill to attend the meeting. 'It will, I think,' he wrote, 'be the only time with one exception for some forty years that I shall have been absent on this occasion.' The exception was in 1842, when the cause was his wife's illness. One of the chief *agenda* being the election of officers for the ensuing year, 'it was suggested by Mr. Evans' (so runs the Minute) 'that under the circumstances it would be most agreeable to the Society and the feelings of the President to re-elect him without going through the usual form of the Ballot.' And he was 'elected accordingly by acclamation.' Fielding was much affected when he heard what had been done. But he was no longer able to perform

the active duties of his post; for the renal affection from which he suffered soon after proved fatal. The last of the letters is written from his bed, and the last thoughts it expresses are concerned for the welfare of his beloved charge. ' I hope the Society,' he writes on the 31st of January, 1855, 'will this year have at least one or two candidates whose election may prove a real accession of strength to the talents of our Society, and that the Members may not from mere kindly feeling be tempted to make an addition of doubtful merit. I trust the meeting will consider it better to fix the opening of the Exhibition for the last Monday in April, thus giving the Members the advantage of a week's long days for the completion of their works. I say this because Easter falls so opportunely this year, that if for any reason it were desirable to open the Gallery a week earlier, it might be quite possible to do so, that is the 23rd of April instead of the 30th.' Then, after giving some directions for payment of his subscription for Mackenzie's widow, he ends thus, ' I have just seen the death of a very constant visitor to our Private View announced; so you will have to scratch out the name of Henry Holland, Esq., Montagu Square; also, that of James Hall of Brewer Street, also William Brockedon. Pray excuse my bed-written scrawl. Farewell.' Barely a month more and his own name had to be removed from the list of Members; and the office of President was in abeyance when the Exhibition opened. Copley Fielding died at his house at Worthing on the 3rd of March, 1855.

When the news spread among the Members there was but one common sensation of the magnitude of the loss which the Society had sustained, and they vied with each other in expressions of regret. George Fripp, who, having served for a considerable time under the deceased President as Secretary, had a knowledge of his devotion, declared his death to be, he feared, the heaviest blow the Society had yet received, so much of its prosperity had been due for a great many years to the exertions of their late 'friend and president.' Copley Fielding's funeral, which took place at Hove near Brighton, was attended by Jenkins and Gastineau, as representing the Society; and when the Members next met, it was agreed to defer for a time the election of a new President, as a mark of respect to the memory of him they had lost.

' Mrs. Fielding did not long survive her husband: she died at Worthing on the 17th of December, 1856, in her seventy-fourth year

II. G

Their only surviving daughter, Emma, died on the 3rd of January,
1867, at Brighton. In August 1862 she presented to the Society, as
a memento of their late President, two copies of a photograph which
she had had taken for that purpose from a portrait of Copley Fielding
in her possession by the late Sir William Boxall, R.A.

Some of Fielding's water-colour[1] drawings have realized large
prices at sales since his death, the following being those noted by Mr.
Redford as having sold for more than 600*l.*

Title	Collection	Price
		£ *s.*
'South Downs, 1848'	J. C. Grundy, 1867	630 0
'The Clyde and Arran' (17 × 30 in.)	Knowles, 1877 .	651 0
'Rievaulx Abbey,' from Mr. W. H. Hutton's collection	J. Smith, 1870 .	682 10
'Vessels driving in a Storm'	Lord Bathurst, 1878	777 0
'Crowborough Hill'.	E. Bicknell, 1863 .	798 0
'Loch Awe, Ben Conachan'	Quilter, 1875. .	892 10
'Rievaulx Abbey'	ditto . .	997 10
'Mull of Galloway'	ditto . .	1,732 10

In 1889 'The Fairy Lake' brought 903*l.* A loan collection of nearly
ninety drawings by Copley Fielding was exhibited by Messrs. Vokins
in 1886.

The resignation of WILLIAM ANDREWS NESFIELD was com-
municated to a meeting at the Gallery on the 14th of June, 1852, just
twenty-nine years after the date of his election as a Member. His
name was coupled with Cattermole's in the expression of regret with
which the joint announcement was received that they had both retired.
Nesfield's contributions had for some time fallen off in numbers, if not
in quality. For ten years past he had not sent more than one or, at
most, two drawings to the annual show, and since 1850 he had not
put in an appearance at all. The reason appears to have been that
he, too, was taking to another branch of picturesque art. It was not
the fascination of oil and varnish, however, that led him astray. The
lessons of beauty which he had learned by a study of Nature in her
wildest scenes he sought to apply to her own adornment and training
where free growth had been denied. He devoted himself to landscape
gardening, and followed that art as a profession. His taste was fre-
quently appealed to in the laying-out of our public parks in London

[1] One of his oil pictures, 'Travellers in a Storm' (40 × 49 inches), was sold in 'Sharp
executors' sale for 3,150*l.* In the course of ten preceding years, three had produced about
800*l.* each, other prices being lower.

and at Kew, and largely consulted for similar purposes throughout the country. To him was entrusted the planning of the Horticultural Society's gardens at Kensington, too soon doomed to destruction. No doubt his early training at Woolwich was of service to him in these operations. But there is no doctoring of nature in his graphic works, which are fresh and suggestive of the romantic scenery in which he painted.

bited series ubjects from and South and 1846) f one of the professions. ade during Sep. 1841.' g the wash

gue. After year of his 33, the full ey' occurs, which he is contain his ere than at ll adapted one would *History of* rmerly the

artist signified his dissatisfaction with his own work by crumpling it up and throwing it towards the fire. Kindly old David, ever ready to encourage others, at once started up and saved it, declaring that it was a really fine work. He took it and damped it and got out the creases, and gave it, mounted, to his friend Mr. Roberts of Birmingham, in whose collection it was sold after his death.[1] Nesfield lived to a fine old age. He died at his residence, at 3 York Terrace, Regent's Park, on the 2nd of March, 1881, in his eighty-eighth year. His son, William Eden Nesfield, an architect, and the author of *Specimens of Mediæval Architecture, from Sketches made in France and Italy*, 4to, 1860, and 8vo, 1861-2, died on 27 March, 1888, at his residence at Brighton, aged fifty-three. The highest recorded sale price for a drawing by Nesfield is 325*l*. 10*s*. for 'The Falls of the Tummel' (24 x 39½ inches), at the 'W. Leaf's executors sale, 1875.'

The architectural draftsman, FREDERICK MACKENZIE, continued to exhibit one or more drawings annually until nearly the end of Fielding's time ; his total amounting to 88, including those at Spring Gardens. And he took an active part in the Society's affairs, having been elected Treasurer on the 30th of November, 1831 (in succession to Hills, who then resumed his old office of Secretary), and retaining that post until his death.

Some of the earlier of his contributions during this period have an interest apart from their artistic merit, and in some he worked from the sketches of others. Thus, in 1833, he sends a 'Restoration of the Roman Forum,' from a composition and measurements made by the architect James Pennethorne ; and in 1834 and 1835 he draws 'Strasbourg Cathedral' from a sketch by Wild, and 'One of the Temples of Delwarra,' from a sketch by Mrs. Colonel Hunter Blair. Mackenzie's own travels appear to have been almost, if not entirely, limited to journeyings in his own country in the service of British topography ; the only evidence (by no means conclusive) from his exhibited works that he ever crossed the Channel being the two drawings (from Rouen) in Cristall's time, and two in Fielding's ; namely, a 'Versailles' in 1839, and a 'Church of St. Denis' in 1840. In 1834 he had a view of some historic value, in connexion with these annals of 'The principal Room of the original National Gallery, formerly the residence of John Julius Angerstein, Esq., lately pulled

[1] Solly's *Life of Cox*, p. 130.

down.' Doubtless this is the elaborate study now in the South Kensington Museum, containing small representations of the pictures on the walls, which formed the nucleus of the national collection. It was bought at Christie's on the 19th of March, 1887, for 110*l.*

Mackenzie's engraved works are numerous. To those already mentioned,[1] of an earlier time, many more have now to be added. In Heath's *Picturesque Annual*, 1839 (Versailles), are, ' Palace of Versailles,' ' Gallery of Mirrors,' ' Second Gallery of Busts, &c.,' ' Theatre in the Palace of Versailles,' and ' Gallery of Battles,' 1840 (Windsor Castle), ' St. George's Chapel, Windsor, with installation of Knight of the Garter.' In the days of the Annuals, however, there was a slackening of the demand for elaborate architectural works such as those issued at an earlier time under the auspices and direction o Pugin and Britton. More popular drawing-room books with showy steel plates rapidly produced were taking their place, and the accurate pencil of the professed architectural draftsman was less in request. But there seems to have been some attempt at a revival, and the services of Mackenzie were secured in the production of a fresh series of line engravings to illustrate the architecture of the two English Universities. ' *Memorials of Oxford*, Historical and Descriptive,' by James Ingram, published at Oxford in three quarto volumes, dated 1837, contains some 100 plates by John Le Keux, after Frederick Mackenzie. ' *Memorials of Cambridge*, a Series of Views of the Colleges, Halls, and Public Buildings ; with historical and descriptive accounts by Thomas Wright, F.S.A., and the Rev. H. Longueville Jones, F.S.A.,' published in London in two vols. 8vo, 1841, 1842, contains a similar set of plates, many by the same artists. These views may be compared with his old studies of the same subjects for Ackermann's washed aquatints. In the brilliant little sepia drawings which he executed for reproduction by the graver for these later works, he is perhaps seen at his best ; for his forte lay less in harmony of colour than in thoughtful delineation and refinement of detail. Mackenzie also contributed drawings to *The Churches of London*, an octavo work

[1] *Supra*, i. 364, 371-2. The following detailed list of his contributions to the *Beauties of England and Wales* may be useful. Vol. viii. p. 640, ' West Dooway of Rochester Cathedral' (1808); vol. x. part iii. p. 634, ' Blackfriars Bridge,' ' St. Paul's' &c. (1810); part iv. p. 288, ' Covent Garden Theatre' (1810) ; p. 599, ' St. George's Church, Hanover Square ' (1810) ; vol. xi. p. 247, ' Gate of Thetford Priory, Norfolk' (1809); p. 252, ' Attleburgh Church' (1809) ; p. 272, ' Swaffham Church' (1809) ; p. 276, ' Oxburgh Hall' (1809); p. 293, ' St. Margaret's Church, Lynn' (1809); p. 315, ' Binham Priory Church,' interior (1810); p. 336, ' Blickley Hall,' by Thompson from a sketch by Mackenzie (1809).

in two volumes, published by Tilt, and .written by George Godwin, assisted by John Britton, the other drawings being by R. W. Billings. The plates, by J. Le Keux and others, are dated 1837–39. And his knowledge of architectural engineering was displayed in a work from his pen published by J. Weale in 1840, entitled, ' *Observations on the Construction of the Roof of King's College Chapel, Cambridge,* with illustrative plans, sections, and details from actual measurement, by F. Mackenzie.'

On the 15th of June, 1843, when about fifty-six, he married Mrs. Hine, a widow, daughter of Mr. John Carpenter, a farmer. The happiness which may be assumed to have been the result of this change of state was, it is greatly to be feared, tempered by disappointment in the decline of worldly prosperity during his remaining years. Notwithstanding his high professional skill, unwearied industry, and prudence in habits of life, he was unable to secure for his family even a moderate competence. This was partly owing to the uncertain state of his health, but probably as much to the change which had taken place in the condition and appliances incidental to his peculiar branch of art. After the invention of photography, the architectural draftsman's occupation was gone. In 1848, when he sent seven drawings, of Rievaulx and Byland Abbeys, to Pall Mall East, the greatest number he had ever sent there, his average of contributions to the gallery becomes rather larger than before, perhaps because there was no more work to be done for the engraver. Before his death, at sixty-seven, which occurred on the 25th of April, 1854, at his residence, 43 Stanhope Street, Hampstead Road, from valvular disease of the heart, his necessities had obliged him to forestall nearly all the benefit which his widow would have received from his share in the Society's funds, by raising money on a post-obit bond ; and when he died, she and an invalid daughter were left dependent upon charity. The Society, ever considerate of the pecuniary wants of their Members, presented a sum of 110*l.* to the bereaved family, and a subscription among admiring friends was raised to purchase an annuity. Shortly before his death there had been a proposal by the Committee that Members should present him with a folio of their drawings, which seems to have been partially carried into effect. 'There is not one of us,' wrote a Member, now living, to Mr. Jenkins, 'who did not love Mackenzie on his own account, putting aside any reference to his valuable services for twenty-one

years as Treasurer.' His remaining works were sold at Sotheby's in
March 1855

In 1848, SAMUEL JACKSON withdrew from the Society, after ex-
hibiting forty-six drawings during his twenty-six years' connexion
with it as an Associate. Snowdon, Lynmouth, the Cheddar cliffs, and
his own neighbourhood of Clifton, where he had resided since
Fielding's accession, served him still for his chief subjects; to which
were now added a few from the English Lakes; and even down to
1845 he made some use of his sketches in the West Indies for gallery
drawings. Jackson was now the senior of a little coterie of painters
of more or less distinction, residing at, and mostly natives of, Bristol
or Clifton, who may be historically associated together, as forming
something of a local provincial school. Danby had by this time gone
to live abroad, and with him two artist sons, one of whom, Thomas,
became a much respected Member of the Water-Colour Society. But
there remained James Baker Pyne, William West, John Skinner
Prout, William James Müller, and our own Members, William Evans,
H. Brittan Willis, and George [1] and Alfred Fripp. Jackson was born
four years before the first, and at least a quarter of a century before
the last of these, and might thus be called the father of the school. A
sketching club was established there in 1833, to which Jackson and
several of the above artists belonged.[2] After his trip to the West
Indies, Jackson did not extend his sketching ground again beyond the
British Isles, until he had long ceased to exhibit at Pall Mall East.
Late in life, however, he made two tours in Switzerland, one (it is
believed) in 1854, and the other, with his son, Mr. S. P. Jackson (now
a Member of our Society) in 1858. The resulting pictures are said by
Redgrave to have been some of the artist's most successful works.
He died in 1870. None of Jackson's paintings are known to have
been engraved except, perhaps, one or two lithographed views in
Bristol or the neighbourhood.

WILLIAM SCOTT, the Associate, remained a steady exhibitor of
about half a dozen drawings a year until 1850, and to the last resided
at Brighton. He continued to send studies, chiefly of rustic architec-

[1] George Fripp was Jackson's pupil

[2] Müller, Skinner Prout, Willis, Robert Tucker, T. L. Rowbotham, W. West, and
Evans, are named by Mr. Solly in his *Life of W. J. Müller* (p. 19) as having been Members
besides Jackson.

ture, and from Sussex and the adjacent counties, until 1839, in which year he had at the same time some subjects from the river Meuse. In 1840 and 1841 he adds views on the Moselle ; and then, extending his travels, he in 1842 has four drawings from the Pyrenees. Thenceforth these foreign subjects form two-fifths of his contributions. Whether he survived the period of his connexion with the Society has not been discovered. But he is reckoned among deceased artists. In the sale, at Christie's, of W. Hunt's remaining works, there was, with other portraits of Members of the Water-Colour Society, in Lot 229, one of Scott.

In the above notices are included only names with which the reader was already acquainted. There were also about half a dozen artists whose term of connexion with the Society began, as well as ended, within the limits of Fielding's presidency. These will be noticed in their due order of arrival among the new-comers.

CHAPTER IV

THE PRESIDENCY OF LEWIS, 1855–1858

General history of Society—Paris Exhibition—Count Persigny's inquiry—Pre-Raphaelitism —Drawing-master school—Copyright agitation—Premiums discontinued—Manchester Exhibition—Anniversary dinner—Exits and entrances.

WHEN the Society was left without a President by the death of Fielding on the 13th of March, 1855, a special meeting was called, at which Frederick Tayler took the chair, and a resolution was passed postponing the election of a successor in accordance with a general feeling of respect for the deceased. The vacancy was not, in fact, filled up until the anniversary meeting in the following November, when JOHN FREDERICK LEWIS was appointed successor.

The year was one of some note in the history of our water-colour school, by reason of the wider appreciation of its merits afforded by the Paris Universal Exhibition of 1855, the first of the series of such shows in which a collection of pictures was made a main feature. A display of 114 English water-colour drawings, in the 'Palais des Beaux Arts,' erected for that occasion, made quite a revelation to our continental neighbours. Let the French critic, however, speak for himself. The following was written at the time by Edmond About : ' Je puis passer sans transition de la peinture à l'huile à l'aquarelle : ces deux genres sont moins distants en Angleterre que chez nous. Plus d'un tableau anglais présente la pâleur et la grâce effacée de l'aquarelle ; plus d'une aquarelle est aussi vigoureuse qu'un tableau. L'aquarelle est, pour les Anglais, un art national. Il existe à Londres deux sociétés de peintres d'aquarelle : *Old water colour society* et *New water colour society*, qui se chargent d'exposer brillamment et de vendre chèrement les ouvrages de leurs associés. Ce genre de peinture, que nous abandonnons volontiers aux pensionnats de demoiselles, est cultivé en Angleterre par les artistes de premier ordre. Aussi nos voisins font-ils de véritables tours de force avec leurs couleurs à l'eau claire :

ils obtiennent des effets que nous n'avons pas même cherchés. Les deux peintures de M. Haag . . . ne ressemblent en rien aux petites drôleries en détrempe qui se collent dans les albums ou qui s'offrent avec un bouquet, le jour de la fête des grands parents · · · · mais à quoi bon? Les artistes qui se donnent tant de peine pour faire avec de l'eau ce qu'ils feraient aisément avec de l'huile, ressemblent à ces amants romanesques qui entrent par la cheminée quand la porte est ouverte à deux battants.' 'Oui, mais l'aquarelle est un genre national.' 'Lorsque je vois l'aquarelle viser à la couleur et prétendre aux grands effets, je crois rencontrer une jeune et jolie pensionnaire qui s'enfuit de son couvent sous des habits de mousquetaire.' 'Mais la nation anglaise est en possession depuis plusieurs siècles de . . .' 'Je crains enfin que les peintres d'aquarelles ne sacrifient leur gloire à venir à leur popularité présente. Car enfin les aquarelles, quoiqu'elles se conservent plus longtemps que les confitures, ne sauraient durer autant que les tableaux.' 'Mais nos pères ont fait de l'aquarelle; et nous, leurs descendants . . .' 'A la bonne heure! je ne discute pas les questions de patriotisme, surtout avec des Anglais.'[1]

Mr. Jenkins writes : 'At the Paris Exposition Universelle, 1855, the water-colour painters were fairly represented. The drawings by Cattermole drew forth the admiration of the French artists, who vied with each other in loudly applauding their merits. Two first-class gold medals were alone bestowed on the English artists, one of which was awarded to the romantic painter of the middle ages, George Cattermole, the other to Sir Edwin Landseer, R.A. Generally, the English school of water-colour painting produced a marked impression in Paris.'

The immediate effect, however, of these relations upon the little body of artists who had the management of affairs in Pall Mall East was not invigorating. It was unfortunate for them that they had been left at that moment without their accustomed head. The late President had been on the Associated Committee of the Fine Arts for the Paris Exhibition, and his place was supplied by Frederick Tayler, who was subsequently made a juror. The performance of his mission to Paris on this behalf gave umbrage to certain of the Members, and a 'rather fierce correspondence'[2] took place, in which printer's ink was employed, as well as the pen. The nature of the dispute will appear more definitely in the biographies which are to

[1] *Voyage à travers l'Exposition des Beaux Arts*, pp. 29-31. [2] J. J. J.

follow. Suffice it here to say that peace was restored after the election of officers in November, which put an end to the interregnum by placing John Frederick Lewis in the presidential chair.

The impression made by the English water-colours in Paris did not exhaust itself in praise or in the award of honours. On the 28th of January 1856, an application was made to the Secretary of the Society of Painters in Water-Colours by the French Ambassador, le Comte de Persigny, for particulars of information, as follows : 'Une note sur l'organisation de cette Société ; sur son règlement, la nombre de ses publications, en un mot enfin sur tout ce qui peut le mieux faire apprécier son utilité incontestée.' Such information was required to answer the questions which had been put to the Ambassador by the Minister of Public Instruction for France. In accordance with this request Mr. Jenkins was asked to draw up a report, which he did in the following words :

Particulars of the Organization of the Society of Painters in Water-Colours, 5 Pall Mall East, London.

(Furnished by order of the Society in compliance with the request of his Excellency le Comte de Persigny, Ambassador of France.)

'The Society of Painters in Water-Colours consists of 56[1] Professional Artists, separated into three classes, viz. 30 Members, 20 Associates, 6 Lady Exhibitors.

'The entire government of the Society rests with the Members, who elect, from their own class, a President, Treasurer, Secretary, and a Committee of four Members, who together form the Council.

'Vacancies in the class of Members are filled by election from the class of Associates.

'The officers of the Society are elected for one year.

'The President, Treasurer, and Secretary are eligible for re-election. The Committee are elected for two years, two of whom go out of office each year by rotation.

'The special duty of the Committee is to arrange the pictures for the Exhibition. In this duty they are not controlled by the officers or the Members of the Society.

'One day in each year is appointed for the election of Associates.

[1] This number was the limit allowed. In 1856, when this report was drawn up, there were only 49 in all, viz. 27 Members, 18 Associates, and 4 Lady Exhibitors. The full number was not reached until more than ten years after.

Applicants are required to furnish specimens of their artistic ability. The specimens must be sent to the Society one week previous to the day of election, and allowed to remain for the examination of the Members during that week.

'All Artists by profession, including resident foreigners, are eligible as Candidates.

'Candidates for the Associateship require a majority of two-thirds of the Members voting to obtain their election.

'Associates and Lady Members are not subject to expenses or liabilities of any kind.

'Elections of every kind in the Society are by Ballot.

'The Society holds an Annual Exhibition at their Gallery in Pall Mall East, of the works of Members, Associates, and Lady Exhibitors. It is open to the public from the last week in April until the end of July.

'Previous to the opening of the Exhibition to the public a day is set apart, named "The Royal View Day," for the reception of her Majesty the Queen, H.R.H. the Prince Consort, and the Royal Family.

'Another day is also set apart, named "The Private View Day," upon which the Nobility, Foreign Ambassadors, Commissioners in the Fine Arts, men of eminence in Science and in Literature, Editors of the leading journals, &c., are specially invited to view the Exhibition.

'Members are not restricted as to the number of works they may exhibit.

'Associates and Lady Exhibitors are limited to the exhibition of eight works each.

'Members, Associates, and Lady Exhibitors are required to send at least one picture each to the Annual Exhibition, or they cease to retain their position in the Society.

'The charge for admission to the Exhibition is one shilling each person. The price of the catalogue is sixpence.

'The Funds of the Society are derived solely from the payments made by the public to view their Exhibition ; and are applied :

'1. To the payment of the expenses incidental to the Exhibition, the salaries of officers, wages of servants, &c., the Committee of arrangement, and to Members for attending general and other meetings.

2. To increase the "Reserve Fund" invested in Government securities, which may be termed the Building Fund.

' 3. In the distribution of Premiums of thirty guineas each given to the Members in rotation as an inducement for them to produce works of an important character for the Exhibition. The Society has distributed nearly 5,000*l.* in Premiums.

' The number of pictures annually exhibited averages nearly 400, two-thirds of which are usually sold before the close of the Exhibition.

' All pictures sent for exhibition must be in gilt frames. No borders to the drawings of any kind are allowed.

' The Society is strictly a private Association of Artists, and have the sole control and management of their own affairs.

' The British Government renders no pecuniary aid to this or any other Art Society in London.

' This Society is encouraged by her Majesty the Queen, H.R.H. the Prince Consort, and several Branches of the Royal Family, who visit the Exhibition and purchase therefrom pictures for the Royal Collection, &c., and by the Public, with whom it has been in great favour during the last twenty years.

' The Society of Painters in Water-Colours was instituted Nov. 30th, 1804, for the cultivation and exclusive Exhibition of Paintings in Water-Colours. It was the foundation of a new and original School of Art, and has numbered among its Members the most distinguished artists who have devoted themselves wholly to painting in water-colours.

' The Society as a body does not publish Transactions, but engravings from their works are so numerous that it would be impossible to furnish a catalogue of them.

' Feb. 28, 1856.'

Copies of the Rules and Bye Laws, and of the Catalogue for 1855, were forwarded to Count Persigny with the above statement.

' There can be little doubt,' writes Mr. Jenkins, ' that the application and reply led to the formation of the Society of French Painters in Water-Colours.' That Society did not, however, hold its first exhibition until 1879.

Lewis's term of office was very short. It lasted little more than wo years, and ended in his retirement from the Society in February

1858, in order to devote himself to painting in oils. It was, however, a critical period in the history of our art, and some of the changes which marked that era were exemplified in the President's own works. The larger style of composition practised by the earlier artists was becoming less of an aim to a new generation brought up under the teaching of Ruskin and impressed by the doctrines of the pre-Raphaelite school. In its place a minutely realistic imitation of nature was now upheld as a nobler object of ambition. Of this tendency Lewis's drawings afforded a representative illustration. The Exhibition of 1856, long remembered as an epoch of art-criticism, was that of the first publication of a set of *Notes* on its pictures from the pen of the above-mentioned eloquent writer, supplementary to an annual pamphlet which he issued for five years (1855–9) on the *Principal Pictures of the Royal Academy.* Seven out of the eleven pages of these notes were devoted to laudation of the President's elaborate work in body colour, exhibited in the central place that year in the gallery at Pall Mall East, entitled, ' A Frank Encampment in the Desert.' This picture and the critique thereon will be further noticed in the separate account of Lewis's life. The excitement they produced did not, however, lead to any immediate following of the new principles within the Society. The pre-Raphaelites were still regarded there as a revolutionary clique, and it needed some years more of the fading of old traditions before the younger generation should acquire strength to break entirely with the past. In the mean time a ' drawing-master ' school continued to exert its influence, in which rules of practice, right enough when properly applied, had a tendency to become conventions, and supersede the principles which they had been meant to embody. The return to the Society in 1856 of the arch-teacher J. D. Harding, who exercised a powerful voice in its proceedings during the next half-dozen years, could not fail to strengthen this element.

The Society's relations with other bodies and with the Art world in general during this period not only comprised the correspondence with Count Persigny above referred to, but the beginning of an agitation, in which it took an early part, for the revision and reform afterwards effected in the Laws of Artistic Copyright. Working hand in hand with the Society in this endeavour were two individual reformers, to whose energy and perseverance the success of the movement was, in a great degree, due. One was the late Edwin Wilkins

Field, solicitor, the Society's legal adviser, whose active enthusiasm in the interests of water-colour art and artists was constant and untiring. Mr. Field brought the matter before a meeting of the 11th of February, 1856, and it was thereupon determined to memorialize the Royal Academy on the subject. The other moving spirit was Mr. D. Roberton Blaine, barrister, who wrote a letter, dated 12 Feb. 1856, to the late J. R. Herbert, R.A., which was printed and circulated, explaining the defective state of the Law, and proposing a memorial or petition by Societies of Artists for a select committee of inquiry with a view to legislation on the subject of Copyright in Works of Art. In accordance with the Society's resolution of the 11th of February, the following letter was drawn up and sent without delay:

'Society of Painters in Water-Colours, 5 Pall Mall, E. : February 16th, 1856.

'TO THE PRESIDENT AND COUNCIL OF THE ROYAL ACADEMY OF ARTS.

'Gentlemen,—Permit us respectfully to bring to your notice our views as to the very defective state of the Law of British Artistic Copyright. We are induced to make this communication to you in consequence of the great and increasing importance of the subject to Artists, both Painters and Engravers, as well as to the purchasers of their productions.

'We do not desire to trouble you at any length because the grievances of which we have to complain are founded on facts which have occurred and which are known in the profession It, therefore, appears sufficient for us to state that according to our experience the existing Laws of Copyright do not afford to artists sufficient protection for the copyright of their works.

'As an instance of this we believe it has been a generally received opinion amongst Artists that the exhibition of a picture does not affect the copyright in it. Such opinion is considered by legal men to be quite erroneous, on the ground that no copyright can be acquired in a picture after it has been exhibited unless it has been PREVIOUSLY ACQUIRED, and the prints from the engraving have been duly published.

'It also appears to have been a generally received opinion amongst Artists that, if a picture had or had not been exhibited, and upon its being sold the Artist reserved the copyright to himself, no other person could legally engrave it without the consent of the Artist. This

opinion is *also erroneous,* as there is nothing in such an arrangement to prevent any third party to whom the picture may be RESOLD from engraving it, and thus depriving the Artist of the reward due to his talent and industry.

'It is obvious that these and several other defects in the laws of Artistic Copyright materially endanger or diminish the profits which Artists have a just right to obtain from their works, and also render them liable to have those works laid before the public surreptitiously, as well as in a discreditable state injurious to their reputation.

'Our object in making this communication to you is that the attention of the Royal Academy may be called to the matters we have noticed, in the hope that you and the other members of that distinguished body may be induced to initiate such measures to obtain a revision of the Law of Artistic Copyright as may be deemed best for that purpose, and to consider what amendments and alterations would be the best adapted to remedy those defects in the present Law of which Artists have so much reason to complain.

'The Society of Painters in Water-Colours will be glad if they càn in any way aid this important object.

'We have the Honour to be, Gentlemen,

'Your most Obedient Humble Servants

'JOHN F. LEWIS, *President.*

'JOSH. J. JENKINS, *Member and Secretary.'*

Mr. Blaine also bestirred himself warmly therein, and induced Mr. Thomas Chambers, M.P. for Hertford (now Sir Thomas Chambers, Recorder of London), to promise to move for a Select Committee on the Copyright Acts with a view to their amendment. The matter, however, continued long under agitation, and on 8 December, 1857, a further letter was addressed by our Society to the Academy urging that body, as the head of the profession, to take the lead in endeavouring to procure a measure of reform. The Academy answered by its Secretary, John P. Knight, R.A., intimating its co-operation. The matter had not gone beyond that stage when Lewis resigned.

One important change took place during Lewis's reign, in the practice of the Society as to the appropriation of its financial profits. The annual distribution of premiums among the Members in rotation had been continued as before, the numbers given in 1855 and 1856

being four and seven respectively. After the Exhibition of 1857, however, it was resolved, on the 30th of July, that, 'it being considered desirable for the stability and future advantage of the Society that the capital of the Society be increased by every available means, no premiums be divided this season.' And on the 30th of November following, it was further resolved that the 'Rules relating to Premiums' should be suspended. These rules were never revived, and from that time the practice of giving premiums altogether ceased. The chief incentives to this economy lay in a desire to provide the Society with a more commodious exhibition room, and to free its property from incumbrances. Negotiations for renewal of their term had been pending for a year at least, and plans for an extension of the gallery had been under consideration in the spring of 1857 ; but no definite course was decided on in Lewis's time.

In the same year, 1857, which was the last of his presidency, the great Exhibition of 'Art Treasures' was held at Manchester. The advice and assistance of the Water-Colour Society had been asked by the chairman of the Executive Committee, Mr. Fairbairn, in the section of Water-Colour Art. In answer to this application a letter was written by Secretary Jenkins, suggesting the outline of an historical arrangement, and urging that the water-colour drawings should be kept distinct from any other kind of art, great dissatisfaction having been expressed at the mixture of prints and architectural drawings &c. with them at Paris in 1855. The advice appears to have been followed, and, in 'the water-colour gallery' at Manchester, 'which formed one of the most striking and attractive features of that vast collection, the progress of this art could be traced from the vapid, washed drawings of the early draftsmen, up to the solid, rich, and elaborate productions of the leading artists of the day.'[1] The President officially attended the opening in June.

The last occasion whereon Lewis met the assembly over which he presided was one of social festivity. In December 1857 the Members dined together as a body for the first time for many years, on a suggestion (it is believed) of the Secretary's, which was warmly responded to. The convivial meeting, though announced as a new departure, was, however, declared by old William Turner, then the *doyen* of the Society, who wrote approvingly from Oxford, to be also a revival of an ancient practice of the Society. The reader may

[1] J. J. J. (probably) in the *Brighton Gazette*, 17 March, 1859.

an annual rite.

The gallery catalogues during Lewis's short reign show a corre
sponding instalment of the list of changes in the yearly stock c
exhibitors. They were the following :—

Exhibition	Exit	Enter	Elected Member	Last Exhibi
1856 — —	Brandling F. Nash Richter	George H. Andrews	1878	
1857 —	Lewis	J. D. Harding Samuel Read	1857 1880	1863 1882-3

CHAPTER V

THE PRESIDENCY OF TAYLER, 1858-1870

General history of Society—Exits and entrances—Application for Government site—Gallery bought and enlarged—Revision of Laws—Winter Exhibitions founded—Frames and mounts—Fine Arts Copyright Act—London International Exhibition—Cotton Famine Fund—Addresses to Queen—Royal Academy commission—Relations with ' Institute '— Water-colour exhibitions at Dudley Gallery—Recruits therefrom—Æsthetic movement— Woodcut School—Successive Secretaries.

THE PRESIDENCY OF FREDERICK TAYLER, which began in 1858 on his election immediately after the retirement of Lewis in February, continued for the twelve following years—years of movement and change both in the Society and in the wider world of Art. With one exception, that of Henry Gastineau, it closed the grave over the group of painters who had joined in reinstating the Water-Colour Society in 1821 upon its proper and original basis, and saw the last of nearly all who had joined it in the reign of King Cristall. The deaths of David Cox in 1859 and William Hunt in 1864 were eras in the chronology of water-colour art. Intermediate in date were the departures of old Turner of Oxford, and Finch, and J. D. Harding. The following schedule continues the personal account to the time of Tayler's retirement from the chair. It must be understood, as before, that the dates in the first column are those of last and first appearance as exhibitors in the Gallery, not necessarily those of exit from, or entrance into, the Society :—

Exhibition	Exit	Enter	Elected Member	Last Exhibit
1858		Samuel T. G. Evans		
		Edward A. Goodall	1864	
		Alfred P. Newton	1879	1883-4
1859	Evars (of Bristol)			
	Stephanoff			
	Cox			
1860		Frederick Smallfield		
1861				
1862	*Turner*	*Alfred W. Hunt*	1864	
		G. W. Whittaker	1864	1876-7
		H. Brittan Willis	1863	1883-4

H 2

Exhibition	Exit	Enter	Elected Member	Last Exhibit
1862–3 1863	*Finch* *Harding*			
1863–4 1864	*William Hunt*	*George F. Boyce* *E. Burne Jones* *Eglon S. Lundgren* *Frederick Walker*	1877 1868 1865 1866	(1870)[1] 1875 1875
1864–5 1865		Frederick J. Shields *J. D. Watson*	1870	
1865–6 1866	Whichelo	*E. K. Johnson* T. R. Lamont	1876	
1866–7 1867	*J. M. Wright*	*Basil Bradley* *Thomas Danby* *Francis Powell*	1881 1870 1876	1886
1867–8 1868 1868–9 1869	*Oakley* *Burton*	*W. Holman Hunt* *George J. Pinwell*	1887 1870	1875–6
1869–70 1870	*Holland* Rosenberg Eliza Sharpe *Burne Jones*[1]			
1870–1		W. W. Deane *W. C. T. Dobson* Arthur H. Marsh	1875	1873–4

When Tayler was called upon to take office, the question was still in agitation of making some better provision for the wants of the Society than they possessed under a very limited tenure of the room at 5 Pall Mall East. This matter seemed no nearer settlement when an opportunity offered itself, which, had it been embraced in accordance with the Society's wish, might have entirely altered its nature and constitution. The new condition of things appears to have been first brought formally to the Society's notice for their consideration on the 30th of November, 1858, when a letter was read at the annual meeting from Mr. Warren, the President of the New Society of Painters in Water-Colours, in these words :—

'My dear Sir,—It seems that there is an intention on the part of Government to make the Royal Academy a grant of a site of Building for Exhibition of Art. Now, it has been hinted by influential parties to some of our Members that the Water-Colour Artists ought to participate in such grant, and we have considered the propriety of

[1] Mr. Burne Jones was re-elected as a Member on 30 Nov. 1886, and exhibited again in 888–9.

memorializing the Government. But it is thought that such Memorial would be stronger if representing Water-Colour Art *generally*, and that the two Societies should either memorialize conjointly, or, at any rate, simultaneously. Will you give this matter your consideration and kindly let me know the result ?—Yours very truly,

'Fredᵏ Tayler, Esq.' 'HENRY WARREN.

The first impression made upon the Members by this proposal is indicated in the following cautious reply :—

'My dear Sir,—I took the earliest opportunity of communicating your letter of the 23rd of August (which was forwarded to me in Scotland) to the Members of our Society on the first occasion which presented itself since you did me the favour to address me. I believe I rightly express the views of our Members when I state that they felt the subject of your communication as at present too indefinite for them to arrive at any conclusion for or against the course suggested. There can, however, be but one opinion amongst Water-Colour Painters as to the desirableness of securing for their branch of Art its just and proper recognition. But how that is to be achieved or whether this is the fitting moment probably opens a wide field of discussion. I am happy to know that the Members of the Water-Colour Society take a lively interest in the advance of the Art and give their serious consideration to all matters that can promote the honour of their profession.

'I am very truly yours,

'Henry Warren, Esq.' 'FREDᵏ TAYLER.

When, however, early in the following year, 'the Government decision became known that they had determined to parcel out the space at Burlington House amongst the representative heads of Art and of Learned and Scientific Bodies, numerous Memorials from similar Institutions were presented to the Lords of the Treasury, urging their claims to participate in the grant for a site. It was considered certain that the Royal Academy would receive a large slice, and it was thought the Water-Colour Society would also stand a fair chance if the claims of any other Art body were entertained.[1] Meetings were held in February 1859, at which the matter was more fully discussed among the Members, and, at the special instance of Evans (of Eton), who took a leading part in the Society's affairs, a committee, consisting of Tayler (the President), Jenkins (the Secretary),

[1] J. J. J. MS.

Duncan, Evans, A. Fripp, and Harding, was appointed to consider the propriety of applying to the Government for a building site. The result was a determination not only to do so, but to act independently of the 'New Society.' A memorial was, therefore, drawn up, of which the following is a copy :—

'TO THE RIGHT HONOURABLE THE LORDS OF THE TREASURY, WHITEHALL.

' *The humble Memorial of the Undersigned, being Members composing* THE SOCIETY OF PAINTERS IN WATER COLOURS *(5 Pall Mall East, S. W.).*

' Sheweth.

' 1. That Annual Exhibitions of Works of Art are essential to the existence of any National School of Painting ; that to Artists they are of the first importance, inciting them by honourable emulation ; while to lovers of Painting and the General Public they are Schools of Art, and on these grounds THE SOCIETY OF PAINTERS IN WATER COLOURS bases its claim to the attention of the Government.

' 2. In 1804 the Founders of this Society came to the following resolution : " The utility of an Exhibition in forwarding the Fine Arts arises not only from the advantage of Public criticism, but also from the opportunity it gives to the Artist of comparing his own works with those of his contemporaries in the same walk. To embrace both these points in their fullest extent is the object of the present Exhibition, which consisting of *Water Colour pictures only* must from that circumstance give to them a better arrangement, and a fairer ground of appreciation, *than when mixed with pictures in Oil.*"

' 3. The principle involved in this resolution has guided the Society to the present day ; and by it the Art of Painting in Water Colours has taken deep root in the Country, has attained to its present eminence in the great Exhibitions of Europe, and attracted marked attention from its *distinctive* NATIONAL CHARACTER. The Government of France has applied to the Society for the scheme of its constitution, and has awarded to some of its Members the highest honours ; an example which has been followed by the Academies of Holland and Belgium.

' 4. This Society was formed in consequence of the inability of the Royal Academy to foster Water Colour Art in its infancy ; and,

although the Royal Academy has numbered among its Members many of great eminence who have occasionally practised Water-Colour Painting, yet those who paint only in Water Colours are excluded from any participation in the honours of that Institution.

'5. The Society of Painters in Water Colours is therefore regarded by the Public as *supplementary* in its character to the Royal Academy, and the highest distinction attainable by those who follow this Art is the Membership of the Society.

'6. Your Memorialists are of opinion that the successful progress of Water Colour Art is mainly, if not solely, attributable to its being pursued as a *distinct School*, and to its works being exhibited apart from all other kinds of Art ; and this independence they are most anxious to maintain.

'7. The growing importance of the Art of Water Colour Painting forces upon the attention of this Society the necessity of its extension, but this object they have hitherto found to be unattainable from the limited space at their command ; now, however, that the Government is about to appropriate a site at Burlington Gardens to the wants of the Royal Academy and of learned and Scientific Bodies, they earnestly appeal to be allowed to participate in the Grant, and to erect a Gallery AT THEIR OWN COST.

'8. The Government having acknowledged the utility and convenience to the Public of congregating Societies of Art and Science, your Memorialists—believing that wherever the Royal Academy is established it becomes the *Genius loci*—the centre of all Art attraction—would humbly press their claims to participate in these advantages.

'9. Education in the Royal Academy is confined to the professional Student : Painters in Water Colours are the chief instructors of the Public.

'10. The grant now sought, if accorded, would in the opinion of your Memorialists be a *NATIONAL RECOGNITION OF THE VALUE AND USEFULNESS OF THE ART OF PAINTING IN WATER COLOURS*, and secure to it the continuance of that independence which is necessary to its future welfare and advancement.

'11. Your Memorialists therefore humbly request that they may have assigned to them, on the Burlington House Estate, a site fit for the erection of a Gallery for public exhibitions, *WHICH FROM THE NATURE AND COMPARATIVELY SMALL SIZE OF PAINTINGS IN WATER*

COLOURS NEEDS BUT A VERY moderate space, *THIS SOCIETY BEARING THE COST OF SUCH ERECTION*; and if the Government should think fit, paying also in Ground Rent or otherwise for the space so occupied.

(Signed)

'Frederick Tayler, *President.*

W. Collingwood Smith, *Treasurer.*

J. D. Harding	F. O. Finch	J. Gilbert .
William Evans	E. Duncan	H. Gastineau
Arthur Glennie	Joseph Nash	W. Turner
Alfred D. Fripp	J. Stephanoff	F. W. Topham
James Holland	Frederick Burton	Samuel Palmer
J. M. Wright	W. Hunt	George Fripp
Octavius Oakley	Thos. M. Richardson	William Callow
George Dodgson		Jos. J. Jenkins, *Secretary,*

35 Upper Charlotte Street,

'February 26, 1859.' Fitzroy Square, W.

This Memorial was duly presented on the 1st of March, and when, on the 4th, Lord Lyndhurst brought under the notice of the House of Lords the claims of the Royal Academy, and their proposed removal to Burlington House, the Water-Colour Society was named by the Prime Minister, Lord Derby, as among the various bodies whose claims were under consideration by the Government. To meet certain objections urged as to the exclusive nature of the Society's constitution, and for the further guidance of the Committee, the following resolutions were passed on the 7th of March, and printed copies of them were sent to the Government and to influential Members of the Legislature, and also to the President of the Royal Academy. '*Resolved*: 1. That the Society earnestly desire to extend their numbers and usefulness, which their limited space for Exhibition now prevents their doing.—2. That, had the Society space at its command, it would gladly open its Rooms to Exhibitors, not Members or Associates of their body.— 3. That, if it were thought desirable, and means were placed within the reach of the Society, it would also willingly establish Schools and Classes for the study and practice of Painting in Water Colours.— 4. That, in communicating with the Government and the Legislature, the Special Committee is to express the conviction of the Society that the interest of Art can only be truly promoted by the management of the affairs of this, and all other Art Societies being

left in their own individual control; and that the Society also is of opinion that the freedom of action now enjoyed by the Royal Academy, by this Society, and by other Art Societies, cannot be wisely interfered with.' The cause of the Water-Colour Society was vigorously espoused by the late Lord St. Leonards, who by arrangement with the Prime Minister brought on a discussion respecting its claim, in the House of Lords, on the 18th of March. In addition to the arguments set forth in the Memorial, as explained and amplified by the above resolutions, his Lordship urged the inability of Members of our Society to share the honours of the Royal Academy, since the latter did not admit thereto the members of any other society; but he insisted on the necessity, in the interests of water-colour art, of a separation between the two bodies, instead of, as some proposed, enlarging the scope of the Academy exhibition, so as to give adequate accommodation to water-colours there. This, he contended, would ' destroy the self-supporting independent body which ' confining itself to water-colours 'had brought that art to a perfection that had astonished the world.' Many other influential Peers and Members of the House of Commons, moved thereto chiefly by the exertions of Evans of Eton, expressed themselves warmly in favour of the claims of the Society, and promised their support in Parliament. The newspapers also took up its cause.[1] But the Members of the Government were bound to support several influential Societies, who made large demands on the available space; and, in the apportionment which eventually took place, a few only of the many applicants were so fortunate as to obtain the coveted location, our Society not being among that number. A petition from the New Society of Painters in Water-Colours was also presented, on the 18th of April, 1859, by Lord Lansdowne, and supported by Lord Monteagle; and was alike unsuccessful.

Foiled thus in their endeavour, the Society were thrown back upon their own resources. Giving up the scheme of expansion into a Water-Colour Academy, which might have been possible with a Government grant of land, and being unable to obtain a more convenient site for building, they applied a part of their accumulated capital, aided by debentures raised among their own Members, to the purchase in 1860 of the ground lease of their house in Pall Mall East,

[1] See *Times* (leader), 19 March; *Daily News*, 14 March; *Illustrated London News*, 26 March, 1859, &c.

with some adjoining property, for 11,800*l*., and in the course of 1861 considerably enlarged and improved the gallery, committee room, and approaches. The property of the Society was, by a Deed of the 25th of February, 1861, vested in trustees, the first of whom were Collingwood Smith, Tayler, Jenkins, W. Callow, and Harding. The Society's ability to incur this expenditure was increased by an opportune legacy of 500*l*. from the late Mr. Samuel Woodburn in June 1860. The New Society had also retired upon the old lines, and built for themselves a gallery at Pall Mall in 1859.

The Society was occupied in other ways at the same time in setting its house in order. Its original principles and constitution being no longer in danger of disturbance, the time was deemed a fitting one for a general revision and resettlement of the written law. The task of drawing up an amended code was entrusted to the Society's legal adviser, Mr. Field, and completed in 1860. The revised laws were finally confirmed and ordered to be printed on the 11th of February, 1861. Pre-existing codes had been ordered to be printed on 30 April, 1823, and 12 July, 1848. One of the more conspicuous results of revising the Laws was the formal classification of the lady exhibitors as Associates, to which category they had always virtually belonged. They first appear as such, without further distinction, in the Catalogue for 1861. The settlement of affairs was made the occasion of a new departure in the passing of a Rule, on the 3rd of December, 1860, that every new Member should present to the Society an example of his art, and a photographic portrait of himself, existing Members being invited to do likewise. The general meeting on the 10th of June, 1861, was one of mutual congratulation, and several resolutions were passed which testified to the feelings of contentment that prevailed among the Members. Jenkins's services, as Secretary, in connexion with the purchase were acknowledged by a testimonial of 100*l*.; and as a token of appreciation of those of Mr. Field as professional adviser, it was determined to present him with a ' Folio of Drawings ' executed by Members of the Society. The arrangement and collection of these drawings was entrusted to Messrs. Evans, Harding, and Haag, and the result was an interesting and valuable series of examples, which remained in the possession of his widow until her death in 1890, and was bequeathed by her to her son, Mr. Walter Field, its present owner, an Associate of the Society. The meeting of the 10th of February, 1862, was the first held in the new

gallery, and its capacity was satisfactorily proved by the summer Exhibition.

The possession, however, of a more commodious show room speedily gave rise to new questions for discussion, and reopened some which seemed to have been set at rest. Up to this time the Society had been in the habit of adding to its income by underletting the gallery[1] during the winter season, when it was not required for the annual exhibition. Such occupation had often rendered it necessary to hold the Members' meetings elsewhere, either at the Secretary's or some other Member's, or in a hired room.[2] The improved committee room might perhaps have obviated this necessity in future in any case; but the raising of a question of the application of the gallery when not required for the Society's exhibition led to important consequences. The result of letting the exhibition room had scarcely proved satisfactory, and the year 1862 found the Society seriously discussing the propriety of retaining the gallery in their own hands all the year round. It was urged that the staff of attendants would thus be kept together, and many other advantages would accrue. Suggestions were therefore invited as to how the new gallery could be best utilized by the Members. Harding propounded, and some others joined him in strongly advocating, a plan for the establishment of schools and for teaching water-colour drawing in classes. A second scheme originated with Gilbert, who proposed a Winter Exhibition of Sketches and Studies.[3] For this Mr. Jenkins gives the following summary of the argument: 'It was urged that exhibitions of sketches would prove to the Public highly interesting and instructive, as they would display the artistic motive from the slightest rudimentary commencement to the more elaborated sketch drawn direct from nature. Preparatory studies for pictures, in black and

[1] In 1836 William Daniell exhibited a 'panorama' there. In the winter of 1850–51 it was let to Mr. Lewis Pocock, for an exhibition of Sketches in Oil and Water Colour; and in 1854–55 it was occupied by a ' Ladies' Amateur Exhibition.'

[2] During Cristall's presidency the Society met thus at Fielding's till 1826, and then at Wild's except during Exhibition time. When Hills resumed the secretaryship these meetings took place at Walker's Hotel, Dean Street, Soho, from February 1832 to July 1835, and then up to November 1846 at the British Coffee House in Cockspur Street. From that time till the end of 1853 the gallery seems to have been so used; but afterwards private rooms mostly in the old artists' quarter about Fitzroy Square were employed, and sometimes a room at the Society of British Artists, Suffolk Street.

[3] The only previous approach to a suggestion of a second annual exhibition appears to have been a proposal made by Mackenzie in 1851 to continue the summer one, by removing the sold pictures at the end of the season, and replacing them by fresh contributions, or loans.

white, composition, and colour, would find their exponents. In the artist's sketches and studies we read his modes of thought and feeling, and note his individuality. The lover of the minute and elaborate would appear hard by the dashing and vigorous. Between these extremes all shades in the intermediate stages would find illustration. The *modus operandi* would stand out a visible truth, and thus an exhibition of sketches might after all prove one of the best of schools. The idea,' he adds, 'was taking, and soon found a ready response from the majority of the Members. The first Winter Exhibition of Sketches and Studies was inaugurated in November 1862, and has continued with unvarying success to the present time. It has been closely followed in its wake by numerous Winter Exhibitions, till they have grown to be as plentiful as blackberries.'[1] At first the 'sketch' exhibitions at the Society's gallery adhered fairly to the scope prescribed by their founders, and had a special interest of the kind above set forth. But gradually their character changed. ' It is at all times difficult,' continued Mr. Jenkins, 'and perhaps dangerous to limit an artist's freedom of expression. What one may call a sketch another considers finished. Still little by little the impression gains that the Winter Exhibitions gradually trend towards those of the summer months.'

It cannot, indeed, be denied that in the works at least of not a few exhibitors[2] there has in later times been little, if any, difference in completeness or ' finish ' between their summer and winter exhibits, except that the latter have a white margin and the former are closely framed in gold.

This fashion in framing has indeed some important bearings on the history of water-colour drawing, and on the general estimate of its position and capabilities as an art. In very early times a heavy environment of gold round the pale washed drawings which then formed the mere germ of the school, would obviously have been fatal to their effect. When, however, the art advanced to the stage at which it became the painter's aim and pride to vie with the strength of an oil picture, it was the practice to frame the richer drawings in a

[1] J. J. J. MS.

[2] The late Mr. Collingwood Smith lamented, in a letter (undated) to Mr. Jenkins that the Society had not kept its word with the public in giving them a ' genuine' Winter Exhibition. ' The critics blow upon us,' he writes, ' for assimilating our Winter and Spring Exhibitions. . . . If the Society expressed its wish to the hangers that all really genuine studies and sketches should be placed in prominent positions, and all made up or highly wrought works should be shelved, we should soon see an improved state of things.'

similar manner. In the Society's exhibition of 1823, paintings in water-colours 'were displayed in gorgeous frames, bearing out in effect against a mass of glittering gold, as powerfully as pictures in oil.'[1] And in the following year, when speaking of the small landscapes of Barret, Varley, Fielding, and Cox, Pyne writes: 'It is only of late that such cabinet productions in this material could be rendered sufficiently rich and deep in tone, to bear out against those broad and superb frames, which seemed alone fitted to the power of oil pictures of the same size; but experience has proved that water-colours, by the present improved process, have an intensity of depth, and splendour of effect, which almost raises them to rivalry with cabinet pictures.'[2] By the middle of Fielding's reign, however, these very heavy projecting frames with their French *rococo* mouldings and *coquillage*, were falling into disuse, and a lighter encasement was substituted. Within the outside border, itself less deeply enriched, a plain surface was introduced, which afterwards expanded into the broad gilt flat now in common use. This more moderate surrounding seems indicative of similarly modified views as to the true scope and limits of the art. At the same time the use of the latter species of frame for oil pictures themselves, which has of late become prevalent, accords with the fact that the modern school of oil painting, in certain of its phases, especially landscape, for which such frames are chiefly employed, is largely indebted to the example and influence of the painters in water-colours. Opinions, however, are still much divided as to the respective appropriateness of white mounts and gold for framing water-colours. Cattermole, as we have seen, preferred the white; and there are distinguished artists of the present day, who maintain that gold without a white margin is altogether unsuited to the delicacy which is, or ought to be, the peculiar characteristic of water-colour drawing. On the other hand, there are many who share the sentiments of Lewis, expressed as follows, when writing to Jenkins of a commission he had been executing in 1857. 'I shall send it framed, because I hate and detest those horrid white mounts, which in my humble opinion reduce all finished drawings to the level of sketches.' The ordinary practice accords with this theory, being to garnish the drawings with gold and serve the sketches on a white mount.

In its relations with other bodies, the Society retained under Tayler's presidentship its leading position as representative of

[1] *Somerset House Gazette*, i. 67. [2] *Ibid.* ii. 46.

English water-colour art. The agitation for a better acknowledgment of artistic copyright was taken up by the Society of Arts, and eventually brought to a successful issue in the passing on the 29th of July, 1862, of the valuable Act, 25 & 26 Vic. c. 68, 'for amending the Law relating to Copyright in works of the Fine Arts.'[1] In June 1860, our Society had given a donation of 20*l*. to the Society of Arts, in aid of the expenses of the Copyright Committee. In the same year, 1860, the collection of water-colour drawings formed by the late Richard Ellison, Esq., was presented by his widow to the South Kensington Museum, and in the Deed of gift the President of the Society of Painters in Water-Colours for the time being was named as the professional adviser for their preservation. The President had previously been consulted as to the disposition of the drawings, and had suggested the National Gallery as the proper place for their deposit.

If the old-established representative body thought it right to hold an independent position when applying to Government for a site, it was willing enough to take joint action with the 'New Society' in their dealings with H.M. Commissioners for the London International Exhibition of 1862, with a view to obtaining the superintendence of the Department of Water-Colour Art therein. The Commissioners, in April 1861, issued a set of preliminary 'decisions' announcing among other things that they would avail themselves of the following eight Art Institutions in communicating with artists who were Members of those Institutions, viz.: The Royal Academy, the Royal Scottish Academy, the Royal Hibernian Academy, the Society of Painters in Water-Colours, the Society of British Artists, the New Society of Painters in Water-Colours, the Institute of British Artists, and the Royal Institute of British Architects. On the strength of this intimation a joint letter signed by the Presidents, Tayler and Warren, of the two Water-Colour Societies, dated '5 Pall Mast East, Feb. 22, 1862,' was sent to the Commissioners, inquiring as to the proposed arrangements and suggesting that either they or some one appointed by each Society should superintend the Department of Water-Colour Art, seeing that 'the great bulk of the contributions will be made by Artists who have been Members of these Societies.' On the 1st of March, 1862, the

[1] This Act was drawn by the late Spencer Vincent, of the Chancery Bar, who, besides being a learned lawyer and accomplished in other ways, was a very excellent landscape painter in water-colours, well known to some of the leading Members of the Society. (See the introductory memoir by Mr. Whitehorne, Q.C., to the catalogue of Mr. Vincent's works exhibited at the Burlington Fine Arts Club in 1890.)

Commissioners answered by their Secretary, J. R. Sandford, that they had 'intrusted the responsible duty of hanging the pictures in the Oil and Water-Colour Galleries to Mr. Redgrave and Mr. Creswick ; ' but offering to forward a pass enabling the Presidents 'to visit the Fine Art Galleries during the progress of the arrangement, when I have no doubt that Mr. Redgrave will be glad to have the benefit of your advice and experience.' As this gave them no power of interference in the event of their opinions differing from those of Mr. Redgrave, and would have attached to them an apparent but not real responsibility, they declined the passes, and on their being sent, notwithstanding, returned them. The grounds of their joint action were further stated in their reply of the 4th of March, 1862, in the following words : ' We venture to state that the Department of Water-Colour Art is not satisfactorily dealt with. In Paris, in 1855, the Presidents were invited to superintend the arrangements of these works. They are now in the hands of those who have no practical interest in this Branch of Art, and in whom, consequently, the Water-Colour Painters fail to have confidence. We have had some experience in the anxiety and difficulty of arranging ordinary exhibitions, and we believe it to be out of the power of any two gentlemen to do justice to the claims of those Artists who will confide their works to the International Exhibition. The Water-Colour Societies were formed for the special purpose of advancing an Art peculiarly British, and it seems reasonable that those most interested in its honour should have the opportunity of placing it before the World in the most advantageous manner.' Although the Society took no part in the arrangements in Cromwell Road, it was instrumental, chiefly through the industry of its Secretary, Jenkins, in assisting Members and Associates to trace and procure the loan of their works. The collection of ' Paintings in Water-Colour and Drawings ' in the ' British Division ' numbered 625 frames ; was introduced by an able historical summary in the catalogue, from the pen of Mr. Francis T. Palgrave ; and being treated according to chronological sequence, was in itself a fair representation both of the past and of the then existing state of water-colour art. Foreign artists of distinction who came to visit the Exhibition were admitted also to the Gallery in Pall Mall during the season, by means of free passes furnished to the embassies.

The co-operation of the two Societies was not so intimate in relation to another appeal, which was addressed to them in the course

of the same year, 1862. It was the period of the great 'Cotton Famine,' when efforts were being made by all charitable persons to do something for the relief of the distressed operatives in Lancashire. Among the many devices for raising money for this purpose, a scheme was started in the November of that year, by the New Water-Colour Society in conjunction with Agnew, the picture dealer, for forming a collection and exhibition in London, Manchester, and Liverpool, of Water-Colour drawings to be presented by the Artists and sold by lottery. In this the old Society was invited to join. Being at that time engaged in preparing their first winter exhibition, they could not have contributed drawings without serious detriment thereto. Nor, indeed, did that seem to the Committee the best way of rendering assistance. So the Members got together a sum of money by individual subscriptions, to which the Society, as a body, added 50l. out of their general fund. The whole, amounting to 277l. 12s., was paid to the Lord Mayor as a subscription to the 'Lancashire Relief Fund.' Although, under these circumstances, the Society did not join in the scheme as a body, some of its Members contributed also to the bazaar.

The public duties which the Society was called upon to perform as the head of a community varied at this time, with the nature of national events, from grave to gay. The lamented death of the Prince Consort, in December 1861, had called forth an address of condolence to her Majesty on the 8th of January, 1862; and on the 15th of March following, a sum of fifty guineas was voted towards the cost of the 'Albert Testimonial.' On the 29th of April, 1863, the occasion was one of national rejoicing, when addresses of congratulation on their marriage were presented to the Prince and Princess of Wales at Marlborough House, by a deputation in Court dress, consisting of President Tayler, Treasurer Collingwood Smith, and Carl Haag. And this was followed the next year by similar felicitations on the birth of a son.

The question of changing the constitution of the Society, which had been raised in connexion with its proposed transfer to Burlington House, had, as we have seen, been set at rest for the time by the Government's refusal to grant it a site. Nor was it likely to be revived among the Members, at least after the rejection of Harding's scheme for establishing classes of tuition. And Harding himself died in 1863. The agitation for extending the scope of the two Societies had not, however, subsided in other quarters, and in some a desire seems to have existed to put pressure from the outside upon the

parent body. The Commission which sat in 1863 to 'inquire into the present state of the Royal Academy' was made the occasion of some further attempt to bring about new relations between the several existing bodies connected with Art. Interrogatories respecting the Society were sent to President Tayler, and he and Evans were subsequently examined by the Commissioners. The President however, acting on the Secretary's prudent advice, declined to give information respecting the Society's private affairs, or furnish facts which would enable the public to pry into the state of its income.

In a letter to Lord Elcho, who appears to have suggested a fusion with the Academy, Tayler pointed out that this was impracticable without a radical change in the constitution of that body; and declared that under existing circumstances the Society would not sacrifice their prosperous condition, and their independence and individuality. 'A fusion of the two Water-Colour Societies,' he added, 'would, if possible, be still more difficult. The one would not be willing to admit its great inferiority to the other, and on equal terms a fusion could not fairly take place.' A source of nominal confusion between the two 'Societies' was removed this year by the junior body once more changing its name and becoming known as the *Institute of Painters in Water-Colours*. Still, the close constitution of the two bodies remained virtually the same; the Institute following carefully in the footsteps of the Society, and opening a series of winter sketch exhibitions in 1866, according to the precedent laid down two years before in Pall Mall East.

Some slight increase, indeed, was allowed in the numbers of Members and Associates of the Society, which rose by degrees during Tayler's time from 48 exhibitors in 1855 (26 Members and 22 Associates and Ladies) to 58 in 1870 (30 Members and 28 Associates including Ladies). Meanwhile practitioners in water-colours continued to multiply outside the doors, and clamoured for further extension. A fresh attempt was therefore made, with the help of a body of non-professional artists and lovers of Art, to meet the growing demand. A new combination was formed, and an experimental exhibition opened early in 1865 at the Egyptian Hall, Piccadilly, under the management of a committee of twenty-six artists and amateurs, and with the security of 102 guarantors, the objects of which were set forth in the following preliminary notice in the

catalogue : . 'The promoters of the Exhibition, now for the first time opened, have had for their object the establishment of a gallery, which, while exclusively devoted to Drawings as distinguished from Oil Paintings, should not in its use by Exhibitors involve Membership of a Society. These two Conditions are not at present fulfilled by any London Exhibition. The Water-Colour Societies reserve their walls entirely for Members, while those Galleries which are comparatively open to all Exhibitors (such as that of the Royal Academy) afford but a limited and subordinate space to all works in other materials than Oil. The Exhibition is, therefore, not that of a new Society, nor is it intended in any way to rival existing Exhibitions· Its establishment has been called for solely by the requirements of very many Artists—requirements of which the reality is evidenced by the large number of works sent in for Exhibition. The promoters trust that the success of this their experiment may be such as to justify the hope they entertain of the Exhibition becoming annual.' The number of drawings sent in amounted to more than 1,700 ; and the 519, which were all that there was space to hang, reached a satisfactory standard of merit, and justified the promoters in making this the first of a long annual series of similar exhibitions there. An amateur element was rather largely present in the earlier shows, and some of the professional work was immature ; but many names of deserving artists, before unknown, some of which have since been greatly distinguished, were first brought before the public in the 'General Exhibition of Water-Colour Drawings.' This was the official title, but it soon became more popularly known by the name of the room at the Egyptian Hall where it was annually held. This may or may not have been the same which our Water-Colour Society had occupied in 1821 and 1822, but it was one which, from a more recent exhibition (in 1852) therein of Earl Dudley's collection of paintings by old masters, had acquired and retained the name of the 'DUDLEY GALLERY.' From this the 'general' water-colour exhibition came to be familiarly known for many years as *The Dudley*. After the first few, it became manifest that its value was not confined to the provision it made as aforesaid for the wants of outsiders ; but that it afforded an important aid to the old Society, in the endeavour to bring within its walls in Pall Mall East the *élite* of the water-colour school. The 'Dudley' became the natural feeder of that body, and served as a place of probation or rehearsal for candidates

who aspired to membership thereof. This is abundantly shown in the following schedule, containing an alphabetical list of contributors to the 'General Water-Colour Exhibitions' who, in the course of the eighteen years of their continuance, namely from 1865 to 1882, or afterwards, joined the Society of Painters in Water-Colours.

Those whose names are in italics served on the 'Dudley' Committee.

Exhibitors at Dudley Gallery	Works	Period	Elected at W.C.S.
Mrs. Allingham (Miss Helen Paterson) . .	16	1870—1878	1875
*Mrs. Angell (Miss Helen Coleman) . .	63	1865—1879	1879
*R. Beavis	4	1865, 1867	1882
Basil Bradley	3	1867	1867
E. F. Brewtnall	14	1868—1875	1875
†Sir Oswald W. Brierly	3	1865, 1868	1872
E. Buckman.	4	1872—1877	1877
John Burr	5	1866—1874	1883
*Walter Crane	42	1866—1881	1888
Thomas Danby	7	1866—1869	1867
†W. W. Deane	3	1869, 1870	1870
Walter Duncan	2	1869, 1873	1874
A. E. Emslie	7	1875—1880	1888
Walter Field	50	1865—1880	1880
H. G. Glindoni	3	1876—1879	1883
Albert Goodwin	30	1866—1877	1871
W. M. Hale.	14	1865—1871	1871
J. Jessop Hardwick	50	1865—1882	1882
J. W. Henshall	6	1878—1882	1883
S. J. Hodson	14	1866—1882	1882
A. Boyd Houghton	1	1871	1871
T. R. Lamont	2	1866	1866
Mrs. Lofthouse (Miss Mary Forster) . .	16	1873—1882	1884
‡R. W. Macbeth, A.R.A.	7	1870—1873	1871
*H. S. Marks, R.A.	43	1866—1879	1871
A. H. Marsh	6	1866—1870	1870
Herbert M. Marshall	40	1871—1882	1879
Miss Edith Martineau	46	1865—1882	1888
Miss Clara Montalba	10	1868—1879	1874
Albert Moore	5	1868	1884
*Henry Moore	70	1865—1882	1876
Miss Maud Naftel.	7	1877—1882	1887
J. W. North	11	1865—1871	1871
John Parker	29	1867—1878	1876
Miss Constance Phillott	36	1866—1882	1882
Wilmot Pilsbury	45	1866—1881	1881
G. J. Pinwell	6	1865—1869	1869
Francis Powell	6	1865—1867	1867
*E. J. Poynter, R.A.	50	1865—1879	1883
Edward Radford	11	1865—1874	1875
Cuthbert Rigby	8	1874—1877	1877
R. Thorne Waite	19	1867—1874	1876
E. A. Waterlow	21	1871—1882	1880
T. J. Watson	27	1870—1880	1880

* These three made the Institute a stepping-stone to the Society, being elected into the former in the following years, viz. : Beavis in 1867, Mrs. Angell in 1875, and Crane in 1882.

† These two had previously been elected into the 'New Society,' viz. : Brierly in 1840, and Deane in 1862. ‡ Macbeth migrated to the Institute afterwards, reaching it in 1882.

The preceding list carries us into much later times than those comprised within the term of Tayler's presidency. But some valuable Members therein named were acquired from the indicated source before the close of that period, and the six new Associates chosen in the year (1871) which followed were all known at the Dudley.

Generations of artists were again succeeding one another, and with them came successive phases of the art itself. For the most part the changes were gradual, but there were epochs of more rapid transition. The deaths of *Finch* and *Harding*, which both occurred in 1863, seem each to mark a period when old forms and practices in art were being abandoned, and new aims and principles were gaining a hold on the minds of painters. The former was almost the last of the classic landscapists, the latter had been the chief exponent of that more suggestive kind of naturalism which in its abstractions cultivated the picturesque more than the beautiful, and was now, in its turn, losing vitality, and degenerating into the 'drawing master's school.' The following year, 1864, which carried off old *William Hunt*, whose genius stood alone, brought two painters of note into the Society, who represented novel phases of modern art. These were *E. Burne Jones* and the late *Frederick Walker*. Each was a leader in his own line, and, except that both were figure painters, their forms of art had little in common.

The poetic archaism allied to decorative art, which became one of the later phases of the movement called 'Pre-Raphaelite,' but differs so widely from the realistic branch which some of the followers of that movement pursued, was little understood then by the many, nor much appreciated in Pall Mall East. When the works of Burne Jones, its strong representative, appeared in the gallery, they seemed a foreign element there, and struck a discordant note. One can indeed imagine no more diverse ways of entering into the spirit of the past than that of the new comer, and what the elder Members had been accustomed to in the works of George Cattermole. Nor had Mr. Jones's mediæval rendering of classic legends much in common with the sentimental treatment of them by the fathers of the Society, such as Shelley and Rigaud, or even with the sculpturesque classicism of Cristall. To the four summer shows of 1864 to 1867, however, Burne Jones contributed sixteen works, and his artistic rank was recognized by election as a Member in 1868. He had had no

drawing in the gallery that season, but in the following two he added ten more. Besides these, his many refined studies in pencil and monochrome of heads, draperies, and decorative composition had added much interest to the winter exhibitions. In the last year, 1870, of Tayler's presidency, an unfortunate difference arose respecting the propriety of exhibiting one of his nude figures, which had been objected to by certain of the visitors at the gallery. The painter, it is said, declined to make some slight alteration in removable chalk, and withdrew not only the picture from the walls, but himself from the Society. He adhered to his resignation, though given *locus pœnitentiæ*; and what was worse, the defection was accompanied by that of another most valuable Member, the present *Sir Frederick Burton*, who disapproved of the course which had been taken respecting the drawing in question. Burton had entered the Society in 1854, and had been made a Member in the following year, and his works, though not numerous, had been a very important source of attraction during the period of Tayler's presidency. The fact that the retirement of Burne Jones took place in the same year with the advent of *W. Holman Hunt* as an Associate, seems to mark a preference at this time for the most severely literal type of pre-Raphaelitism over the more ideal offspring of the archaic revival. The so-called 'æsthetic' school of painting, which thus lost its first foothold in the Society, afterwards found space for expansion elsewhere, and met with wide appreciation among artists and connoisseurs of art. For a time it had a home at the Dudley Gallery; and after his secession from our Society, three works by Burne Jones himself (in 1872 and 1873) were given places of honour at the Egyptian Hall. When the 'Grosvenor' Gallery was opened in New Bond Street by Sir Coutts Lindsay in 1877, æstheticism became rampant and eventually a byword. Its militant stage has now passed away, and the phrase itself is fading on the tongue while these words are being written. A reconciliation of elements formerly discordant appears in the recent return of both these artists to the Society, the name of Burne Jones having been replaced in the list of Members, and that of Sir Frederick Burton among the Honorary Members, on the 30th of November 1886.

In its contrast with the ideal branch just referred to, the art of *Frederick Walker* may be taken as in some degree representing, in its secondary stage, the opposite or realistic side of the pre-Raphaelite

movement. His motives are taken directly from what he saw around him in everyday life; though he gave to the representation a poetic colouring which, albeit based on classic study, was in its application purely his own. He was another of the representative artists of his time. Unhappily his career was prematurely closed by death in 1875. His works, though generally small and few in number, were always a leading feature in the Society's exhibitions, and he not only made a strong impression upon the art of that period, but laid the foundation of much that now exists. Our Society is entitled to the honour of having duly introduced him to the world as a painter; for his first exhibited picture had met with small favour from the hangers at Trafalgar Square, the year before his election as Associate in Pall Mall East, and it was not until he had been for four years a full Member of the Water-Colour Society that he was elected an Associate of the Royal Academy. His position as a water-colour painter will be referred to in a separate biographical notice. It is more upon his earlier work as an illustrative designer that his connexion depends with a group of draftsmen on wood who, when they became painters, several of them in water-colours, exercised a marked influence, for good or evil, upon technical practice. Of this school Frederick Walker may in some sort be regarded as a pioneer in style, and a leader of the tone of sentiment. But it would be unjust to charge him with certain mannerisms and defects which adhered thereto when its disciples took up the colour brush, and transferred their manipulation from block to paper. Their antecedents were too often recognizable in a heaviness of outline and a deficiency in the expression of space, while the more subtle relations of light and shade were too commonly neglected by them. Their manner arose in part from the exigencies of the facsimile engraver, and in part from the nature of the subjects upon which the designer's talent had originally been most exercised. He had been called upon to embody the thoughts of a new race of poets and fiction-mongers, in a style less decorative, but considered more in harmony with the 'earnest' and 'intense' school of writing that had become the fashion of the day, than the graceful and ornate designing of Gilbert and his earlier contemporaries. The rise and progress of this class of woodcut may be studied and traced in two serial publications, to each of which Frederick Walker was a leading contributor, namely, *Once a Week*, the first number whereof appeared in July 1859, and *The Cornhill Magazine*, which

came into the field about the same time.[1] The style once established was applied to the illustration of standard literature, in new and popular editions, which employed the talent of several artists who became Associates or Members of the Society during the presidency of Tayler, or immediately after its close. *J. D. Watson*, *Pinwell*, *Houghton*, and *Macbeth* were all more or less designers for the press. *The Graphic* weekly newspaper, which dates from 4 December, 1869, was started as a representative of the new school of wood illustration, in contrast with the older style then still adhered to in the *Illustrated London News*.

Before that period there had been some further changes in the tenure of the minor offices in the Society. When Jenkins resigned the Secretaryship in 1864, George Fripp resumed that post for a few months, at the end of which William Callow was appointed. Callow held it until the end of Tayler's time, and both went out of office together in 1870.

[1] The prime originator of this reaction in the manner of drawing on wood appears to have been John Everett Millais (now Sir J. E. Millais, Bart., R.A.) whose four designs in the first volume of *Once a Week* afford a strong contrast to the general style of the early embellishments of that magazine, among which were the freely handled pencillings of such established favourites as Hablot K. Browne and John Leech.

CHAPTER VI

THE PRESIDENCY OF GILBERT

The President knighted—Improved relations with the Royal Academy—Honorary Members
—New façade—Library—Assimilation of Sketch Exhibitions—The Dudley joins the
Institute—Royal title—Illustrated catalogues—R.W.S. Art Club—'Light and Water-
Colours'—Queen's Jubilee—Sequence of Officers—Exits and entrances.

THE present reign, that of SIR JOHN GILBERT, R.A., which began in
1871, has seen important changes, not only in the Society itself, which
has been signally honoured and ennobled, but in its relations with
other bodies. The new accession to the presidential chair was followed
early in the next year by a distinction conferred upon the Society in
the bestowal of the honour of knighthood upon its chief officer. The
occasion was further signalized by a visible token that one at least of
the old barriers that had stood for so many years between the Royal
Academy and the Society of Painters in Water-Colours, and had in
some respects placed the two bodies in an antagonistic position, was
now removed. Cases, only too numerous, may be cited from the
pages of the present record, in which our Society had suffered the
loss, either permanent or temporary, of valuable Members, who, being
painters in oil as well as water colours, and as such ambitious of a
place in the Academy, had, under the old rules of that body, been
forbidden to become candidates while members of another Society.
When the restriction had been removed; the Water-Colour Society
took the initiative by opening its doors, which had never wittingly been
closed to artists of merit, and admitting as an A.W.S. one who had
already become an A.R.A. W. C. T. Dobson (now R.A.) was so
elected in 1870. In 1871 the compliment was returned by making
an A.R.A. of Frederick Walker, and in the same year H. Stacy Marks
achieved the two titles A.R.A. and A.W.S. The election of our Pre-
sident, Sir John Gilbert, as an Associate of the Academy in 1872 was
the crowning event which placed the relations between that body and
the independent association on a fairer and more liberal footing. Since

that time other artists have been, and now a goodly number are, members of both bodies at once ; and, to make the reciprocity complete, the present roll of the Water-Colour Society includes the President of the Academy, who has always acknowledged the supremacy of the Society as representing Water-Colour Art. The following is a list of Members and Associates who have held or now hold rank in both bodies, arranged in the order in which they acquired the double title.

| | Elected | | | |
	A.W.S.	M.W.S.	A.R.A.	R.A.
W. C. T. Dobson	1870	—	1860	1871
Frederick Walker	1864	1866	1871	—
H. Stacy Marks	1871	—	1871	1883
Sir John Gilbert	1852	1854[1]	1872	1876
Laurence Alma-Tadema	1873	1875	1873	1879
E. J. Poynter	1883	1883	1869	1876
Frank Holl	1883	—	1878	1883
Henry Moore	1876	1880	1885	—
E. Burne Jones	—	1886[2]	1885	—
Sir Frederick Leighton	—	1888	1864	1868[3]
E. A. Waterlow	1880	—	1890	—

Another innovation took place in the next year, 1873, when, at the suggestion of the Secretary, Mr. Alfred Fripp, a fresh order of Honorary Members was created. This name had, as we have seen, been temporarily employed in 1850 to designate the lady artists who, as now, were permitted to exhibit, like the Associates, without the other privileges of full Membership. It was now the title of an entirely new class, comprising a select few representative persons, not necessarily professional artists, but distinguished in divers ways by their connexion with art ; and was conferred upon the following five persons in 1873 : *The Right Hon. William Ewart Gladstone*, M.P., then Prime Minister, under whose advice her Majesty the Queen had so recently conferred upon the President the honour of knighthood ; the late *Sir Richard Wallace*, Bart., K.C.B., who, as the possessor of a celebrated gallery of pictures, ancient and modern, may have been regarded as representing patronage and connoisseurship of Art ; *Prescott Hewett*, Esq. (now Sir Prescott Hewett, Bart.), F.R.C.S., well known as a true and influential friend of Art and artists ; *Jean Baptiste Madou*, President of the Royal Belgian Society of Painters in Water-Colours ; and *John Ruskin*, Esq., then the Slade Professor of Fine Art in the

[1] P.W.S. 1871. [2] For the second time. [3] P.R.A. 1878.

University of Oxford, whose high claims both as a critic and man of letters need not here be further declared. M. Madou died in April 1877, and the next year the number of five on the honorary list was restored by the addition of *H.R.H. the Princess Louise, Marchioness of Lorne.* In 1881 it was headed by the name of *H.R.H. the Princess of Wales*, and the recognition of Water-Colour Art beyond our shores was again supplied by the election of Professor *Adolph Menzel* of the Academy of Berlin. The last addition, made in 1886, which raises the number to eight, is that of *Sir Frederick William Burton*, R.H.A., Director of the National Gallery, who, as we have seen, had once before been a most valuable working Member of our Society. Of these Honorary Members, several, who happen to be mature as well as amateur artists, have occasionally sent drawings to the Society's exhibitions,[1] to which an interest has been added by thus showing specimens of the graphic talent of Mr. Ruskin, Sir Prescott Hewett, and H.R.H. the Princess Louise. Professor Menzel has also been an admired exhibitor.

Having enlarged and improved their show room as above mentioned, the Society now proceeded to beautify the exterior of the Gallery, and make the interior adjuncts more commodious. The result was the ornate façade, and convenient approaches within, which now exist. The architect was the late Frederick Pepys Cockerell, F.R.I.B.A., and the style, which is the middle period of the Renaissance, was not only suited to the purpose, but singularly in harmony with the graphic proclivities of the President's pencil, as may be seen in an effective cut, which he drew of it, in the *Illustrated London News* of Saturday, 24 April, 1875, the day when the private view took place of that year's summer exhibition. The sculpture in the tympanum of the arch above the doorway is by Signor Fabbrucci, a Florentine sculptor settled in London; and the tesselated pavements of the hall and landing were at the time a novel revival of ancient practice.

Being now so well and permanently housed, and being also in the way of garnishing their home with a valuable historic gallery of their 'diploma' works, the desirability of furnishing it with further records of their past life was suggested to the Members in a very

[1] Their privilege is limited to two exhibits each at a time. But the regulation has not been strictly adhered to, the Princess Louise having on one occasion sent four or five works.

practical way by their quondam Secretary, Mr. Jenkins. He not only proposed the formation of a library of works by themselves and their predecessors, but carried his project into effect by making a 'costly and interesting' collection himself and presenting it to the Society, on the occasion of the annual meeting of 30 November, 1878. Nor did his exertions end there, for he issued circulars to the Members urging them to co-operate in the scheme, which were liberally responded to in presentations of books, prints, and other works. Sir John Gilbert designed an oak bookcase, which now holds them, the central part being reserved for the Jenkins gift, with a tablet acknowledging the donation.

Meanwhile, the system of holding two exhibitions a year, one from April to June, the other from December to February, was successfully continued. Down to 1874, the winter series had not been taken into account in the numbering of the summer catalogues, the exhibition which opened in the April of that year being called the seventieth. In the next season they were recognized as taking rank with the summer shows, whereof that for 1875 is described as the eighty-fourth.[1] The latter sytem of numeration has since been continued ; though the winter exhibitions have still their separate numbering. The quantity of exhibits necessarily fluctuates from year to year, but has seldom departed widely from an average of 300 in the summer and 400 in the winter. An increase, however, in the numbers both of Members and Associates has of late years reduced the quota for individual artists. In 1880 the limit assigned to the body of ordinary Members was increased to forty ; and this has been actually exceeded in the latest years, that of the Associates also amounting to upwards of forty, and in one season (1883-4) reaching forty-five.

With this increase in its capacity for receiving within its doors the *élite* of the now vast body of painters in water-colours, the old Society, after weathering many a storm, and being exposed from its earliest days to ever increasing competition, has virtually retained its original constitution as an independent guild, confining its exhibitions to works by its own Members and Associates. The foregoing history will have shown what was the nature of the temptations it had had

[1] It must still be recollected that the present numbering begins with the exhibition of 1805, and counts in the ' Oil and Water Colour ' exhibitions from 1813 to 1820 ; whereas the original Society really broke up and was reformed in 1812, the present series of purely ' Water-Colour ' exhibitions having begun in 1821.

to resist, and the assaults it had been called upon to withstand. When the practisers of water-colour art were but few, and the art itself was still struggling to maintain its position, the inducement to artists had been strong to rely in part for their success upon established materials. Hence, the keeping up of a separate show room for water-colours apart from oils had been an early source of difficulty. Although the first society owed its very existence to this necessity, it had had to yield for a series of years to the inroads of the oil men at Spring Gardens ; and indeed, as we shall see, their influence is not extinct even at the present day. At the same time, however, the water-colour men were continually increasing in number ; and when the old Society was unable to receive them all, they formed themselves into other communities beyond its pale ; generally, however, taking a shape similar to that of the parent body, and although imitators only, yet ready enough to assume the importance of rivals. In later times the wants of the outsiders had been provided for on a more reasonable system by the general exhibition of water-colour drawings at the Dudley Gallery. Here, however, the old difficulty arose of supplying the requirements of the oil-and-water-colour men without an inharmonious union in one exhibition. It was solved, as with the multiplication of painters was now possible, in the same reasonable manner, by instituting in 1867 at a different season of the year, a 'Dudley Oil' as a complementary adjunct to the 'Dudley Water-Colour.' We have seen how in the course of the latter series of exhibitions they served as a feeder to the Society of Painters in Water-Colours. When much of the talent there shown had thus been absorbed, the old Society became exposed to a fresh form of attack, which for a time threatened to undermine the citadel. Strenuous efforts were made, chiefly by those who were interested in the success of the *Institute*, to induce the Society to sink its individuality, by joining in an amalgamation with that body, so as to form one comprehensive Water-Colour Academy. In the determination which was come to, to maintain their existing position, the Society acted in accordance with the advice of its experienced counsellor, Jenkins, who urged strong economical reasons against embarking in such a speculation, which was in fact the taking of a share in a Limited Liability Company.[1] But an amalgamation did take place outside

[1] Copies of the correspondence which passed on the subject between the representatives of the two Societies will be found in an Appendix.

the Society. Nearly all the remaining artists who were on the com-
mittee at the Dudley Gallery joined with those who then formed the
Institute, and, under the latter name, transferred to the large newly
built galleries called the Prince's Hall, in Piccadilly, and united
therein, the two water-colour exhibitions theretofore held in the
Egyptian Hall and Pall Mall (West) respectively. The old copying
of the Water-Colour Society's constitution was abandoned ; the rank
of Associate was abolished ; and the annual exhibitions, being thrown
open to all artists or amateurs of the standard of merit prescribed by
the governing body, were thenceforth conducted on the model of those
which had been commenced in 1865 at the Dudley Gallery under the
title of the 'General Exhibition of Water-Colour Drawings.' The
exhibitors in 1889 fell little short of 500, the number of drawings
being 823. The oil element was similarly accommodated under the
management of a separate society, having many members in common
with the above, called the *Institute of Painters in Oil Colours*, esta-
blished in 1883 in alliance with that for water-colours. It must be
satisfactory to members of the ancient body to observe that to the
eyes of all these new aspirants to favour in the now vast profession
of water-colour painters, the artists still upheld as the great leaders
of the school are those whose names have become identified with the
ancient glories of the Society of Painters in Water-Colours. The sight-
seer who strolls along Piccadilly should not fail to observe that side
by side with the early founders, Sandby, Cozens, Girtin, and the great
Turner, the only effigies which adorn the façade of the new temple
of art above mentioned are those of the Society's own honoured
Members, Cox, De Wint, Barret, and William Hunt.

Before the events just recorded had fully come to pass, however,
the old Society had itself received a new and honourable prefix to its
title. As a fresh proof of Court favour, it was from the 20th of July,
1881, permitted to make use of the name and style of 'THE ROYAL
SOCIETY OF PAINTERS IN WATER COLOURS.'[1] In the following
year, 1882, her Majesty was graciously pleased to sign diplomas
which entitle Members to the rank of Esquire. In that year the
Society issued an edition of the catalogue of the summer exhibition
embellished with sixty-seven facsimiles of sketches by the artists. It
was of quarto size. Since then the ordinary summer catalogue has
been published in octavo with illustrations of the same kind.

[1] The Institute and several other art societies have since been similarly ennobled.

In 1883 an association was formed in connexion with the Society under the name of *The Royal Water-Colour Society Art Club*, for the purpose of promoting social intercourse between Members and their friends by means of a series of conversaziones to be held each season in the Rooms at Pall Mall East. These have been pleasant *réunions* of lovers of Art, and the occasion of several temporary loan collections of choice examples of the works of deceased artists (mostly, but not exclusively, Members of the Society), which have proved not only of much interest in themselves, but a means of aiding a charity, any profits that may be derived from subsequent admission of the public being presented to the Artists' General Benevolent Institution. The following exhibitions have thus been held : March 1886, works by deceased Members and Associates of the Society. —31 March to 2 April, 1887, works by R. P. Bonington, George Cattermole, James Holland, F. Nash, P. De Wint, and William Hunt. —29 March to 7 April, 1888, works by G. J. Pinwell, Sam Bough, and J. W. Inchbold.—27 March, 1889, works by F. W. Topham and T. Danby.—12 February, 1890, works by deceased Water-Colour Artists. The gallery has still been lent or let from time to time, when not used by the Society, for art exhibitions unconnected with their own management. In 1878 and some subsequent years the 'Artists' and Amateurs'' conversaziones took place therein. The Photographic Society's exhibitions are annually held there, and in 1889 the walls were hung for the first time with the works of the 'Royal Society of Painter-Etchers,' which has now an established home there.

In the year 1886, certain doubts which had been entertained at a comparatively early period of the development of our water-colour school respecting the durability of works in that material, doubts which the Society in its manifesto in 1821 [1] had assumed to have been already removed, were revived after the long experience of the many intervening years. The alleged deleterious effect upon water-colours of ordinary exposure to daylight became the subject of a heated controversy which raged in the form of a paper war, chiefly in the columns of the *Times* newspaper, during the greater part of 1886 and 1887, between critics, experts, artists, and official custodians. The discussion, although conducted with a degree of acrimony much to be deplored, had at least two good results. It was made an

[1] *Supra*, vol. i. pp. 427, 428.

occasion for bringing together in the month of July 1886, by way of evidence of permanence of colour, in the Council Room of the (now Royal) Institute, a choice collection of 168 'Water-Colour Drawings by Deceased Masters of the British School,' all in a state of excellent preservation. These examples were 'almost exclusively the production of early members' of our Society.[1] The second and more important result was an elaborate scientific inquiry into the comparative stability of the various pigments formerly or now in use by water-colour painters. As the controversy had in its origin had reference chiefly to the historical collection of drawings accumulated at the South Kensington Museum, and the precautions necessary for their preservation, the matter was taken up by the Lords of the Committee of Council on Education, Science and Art Department, who in April 1886 requested Dr. W. S. Russell, F.R.S., and Captain W. De W. Abney, C.B., R.E., F.R.S., to carry out an exhaustive series of experiments on the action of light on water-colour drawings. Thereupon the Society passed a resolution urging the desirability in the interests of water-colour painters of the appointment of a water-colour painter in association with the above-named gentlemen in the task they had undertaken. Acting upon this opinion their Lordships appointed a representative committee of artists 'to consider the matter from the Art point of view, and suggest further points for investigation, or any investigation which they could themselves carry out.' Messrs. Haag and Wallis were chosen to serve on this committee on the Society's own nomination. It also comprised, on the invitation of their Lordships, Mr. Alma-Tadema, R.A., a Member, and Mr. Poynter, R.A., an Associate of the Society. Sir Frederick Leighton, P.R.A.,[2] was chairman ; the Institute was represented by its President, Sir James Linton, and Mr. Dillon ; and the British and South Kensington Museums by the curators, Messrs. Colvin and Armstrong. The first Report of the scientific inquirers, which was presented on the 30th of June, 1888, dealt with the physical effect only of light on water-colours, the chemical effect being reserved for a second Report, a further investigation being recommended into the effect on colours used with oil and other media. The Report already issued, founded upon experiments in which the several pigments were

[1] See letter from Collingwood Smith, R.W.S., in the *Times*, 14 July, 1886.

[2] By the time when the Report was issued Sir Frederick had also become a Member of our Society.

submitted to crucial tests, will serve in future as a most valuable guide to the artist in his selection of materials, and it gives a welcome assurance that, although some colours formerly too much employed may indeed be hopelessly evanescent, there still remains at his command a full gamut of permanent hues in which he may with confidence assume that his work can be rendered 'beautiful for ever.'[1]

In the Jubilee year, 1887, of Queen Victoria's reign, the Royal Society of Painters in Water-Colours celebrated the occasion by presenting to her Majesty a collection of seventy-five drawings by the hands of its Members, Honorary Members, and Associates. The collection was contained in four portfolios and presented in due form by a deputation consisting of Sir John Gilbert the President, Mr. Alfred Fripp the Secretary, and Mr. Carl Haag. In the autumn the whole set of drawings were sent by the Queen to the Bethnal Green Museum for exhibition with the other Jubilee gifts, and subsequently to Vienna with a similar object. In the same season a grand display of works by masters of the British water-colour school who had practised their art during the past fifty years was made at Manchester in the second great collection of 'art treasures' there which formed a part of the Royal Jubilee Exhibition. The lapse of thirty years since the first enabled it to illustrate the changes which had taken place in another generation, including several new phases of the art which had been developed during the presidential career of Frederick Tayler and Sir John Gilbert.

It remains to continue the account of exits and entrances of Members and Associates in the gallery at Pall Mall East, from the time when the present chief came into office. The post of Secretary has been held throughout by Alfred Fripp, who was elected with Sir John Gilbert in November 1870. Collingwood Smith continued to be Treasurer until 1879, when he retired and was succeeded by G. H. Andrews. The following schedule carries to the present time the list of changes in the body of exhibitors. The dates, as before, are

[1] Besides the correspondence in the *Times* from 11 March, 1886, to 1 October, 1887, the following contemporary articles &c. treating of this question may be consulted by the curious: In the *Nineteenth Century*, March 1886, by W. G. Rawlinson ; June 1886, by J. C. Robinson; August 1886, by Frank Dillon. — The *Athenæum*, 12 June, 1886.— *The Saturday Review*, 3 July, 1886.— *The Royal Institute of Painters in Water-Colours* (*Catalogue of Exhibition of Water-Colour Drawings by Deceased Masters*), July 1886, preface by Sir J. D. Linton, and appendix by Professor Ruskin. Professor A. H. Church's valuable work, *The Chemistry of Paints and Painting*, 8vo, 1890, contains a summary of the discussion. See also an article by the same writer on 'Light and Water-Colours' in the *Magazine of Art*, May 1888.

those of first and last exhibiting in the gallery, not those of elections and resignations or deaths.

Exhibition	Exit	Enter	First Exhibit as Member	Last Exhibit
1871		*Albert Goodwin*	1881	
		William Matthew Hale	1881	
		A. Boyd Houghton		1874–5
		Robert Walker Macbeth, [A.R.A.]		1879–80
		J. W. North	1884	
1871–2		*H. Stacy Marks*, A.R.A. [R.A.]	1884	
1872		*Oswald W. Brierly*	1880–1	
		H. Clarence Whaite	1883	
1872–3				
1873		*Laurence Alma-Tadema*, A.R.A. [R.A.]	1876–7	
		[Sir] Prescott Hewett, [Bart.] (Hon.)		
1873–4	Deane	John Ruskin (Hon.)		
1874	Burgess	Walter Duncan		
1874–5	Houghton	Clara Montalba		
1875	*Lundgren*	*Mrs. Allingham*	1890 (elect)	
	F. Walker	*Edward F. Brewtnall*	1884	
	Evans (of Eton)	Edward Radford		
1875–6	*Gastineau*			
	Pinwell			
1876		Robert Barnes		
		Henry Moore, [A.R.A.]	1880–1	
		John Parker	1882	
		R. Thorne Waite	1885	
		Otto Weber		1888
1876–7	*Whittaker*			
	Bartholomew			
1877		Edwin Buckman		
		Arthur Hopkins		
		Cuthbert Rigby		
1877–8	*Topham*			
1878		*Tom Lloyd*	1887	
		W. E. Lockhart, R.S.A.		
		Norman Tayler		
		Henry Wallis	1880–1	
1878–9	John Callow			
1879		Mrs. Angell		1884
		Herbert M. Marshall	1884	
1879–80	*Joseph Nash*	H.R.H. Princess Louise (Hon.)		
	Macbeth			
1880	Branwhite	Walter Field		
		W. Eyre Walker		
		Ernest A. Waterlow		
		Thomas J. Watson		
1880–1	*Dodgson*			
1881		Wilmot Pillsbury		
		George Du Maurier		
1881–2				
1882	*Palmer*	R. Beavis		
		Charles Gregory	1884	
		Samuel J. Hodson	1890 (elect)	
		J. Jessop Hardwick		
		Constance Phillott		
		Adolph Menzel (Hon.)		
1882–3	*Duncan*			

Exhibition	Exit	Enter	First Exhibit as Member	Last Exhibit
1883	*Jenkins*	John Burr		
		Henry G. Glindoni		
	Holl	Frank Holl, R.A.		1883
		Edward J. Poynter, R.A.	1884	
		William J. Wainwright		
1883-4	*Newton*			
	Read			
	Willis			
1884	Mrs. Angell	J. Henry Henshall		
	W. Goodall	Miss M. Forster (afterwards Mrs.		
		Lofthouse)		1885-6
		Albert Moore		
1884-5				
1885	Cox (Junior)	Charles Robertson		
		Heywood Hardy		
1885-6	Mrs. Lofthouse (*née*			
	Forster)			
1886	*Danby*	David Murray		
1886-7		Colin Bent Phillip		
1887	*W. Collingwood Smith*	Robert W. Allan		
	Miss Gillies	Miss Maud Naftel		1889-90
1887-8				
1888	Otto Weber	Walter Crane		
		Alfred Edward Elmslie		
		Miss Edith Martineau		
		Arthur Melville		
1888-9	Riviere	E. Burne Jones [returned]		
1889		G. Lawrence Bulleid		
		George Clausen		
1889-90	*F. Tayler*			
	Richardson			
	Miss Naftel			
1890		C. Napier Hemy		
1890-1	*Glennie*			

No one at all acquainted with the present state of art can fail to recognize in the above list some illustrious names. It would, however, be going far beyond the intended scope of this book to attempt an account of all these artists or their works. This must be the task of some future historian. All that the present writer can hope to accomplish is contained in the following chapters. In these he has endeavoured to complete the set of biographical notices of all Members and Associates who exhibited with the Society during the life of Copley Fielding.[1] It was necessary to draw a line somewhere, and it was considered desirable to avoid as much as possible any notice or criticism of the recent works of living artists. Besides trenching on the province of the journalist and reviewer, this would unavoidably have

[1] Three living Members, namely, Sir Frederick Burton, William Collingwood, and Charles Davidson, were actually elected while Fielding was still alive ; but, as no one of them exhibited drawings in the gallery until after that President's death, they are here treated as belonging to the subsequent period, and not included in the biographical list.

been partial and incomplete. The epoch chosen, however, necessitates a dealing with the lives of a certain number of veteran artists who are still in practice. As to these individually it has been deemed expedient to continue, if possible, each biographical account down to recent times ; for it would be manifestly unjust to curtail, by adhering to an arbitrary date, the narrative of a career the latter part of which might be even more illustrious than the first. At the same time it has not been considered needful as a rule to take notice of a living artist's works produced since the epoch 1881–2.

BOOK VIII

OLD MEMBERS WHO SURVIVED FIELDING

CHAPTER I

EXITS, 1856–1859

Biographies concluded — F. Nash—Richter—Lewis—Stephanoff.

PROVIDED in the foregoing chapters with an outline of the principal events that have affected the Society as a whole since Fielding's death, we are prepared to resume the biographical notices of individual Members. And it is proposed first to trace to their end the careers of those of the old stock who remained in the Society (or, in one case,[1] resumed membership) after that epoch. They will be dealt with in the order in which they made their final exits from the Society, and the thread of life taken up in each case at the year 1832.

FREDERICK NASH did not, as he had proposed, end his days in Robert Street, Hampstead Road, under the sky studio that he had erected. In 1835 we find him settled with his wife at 44 Montpellier Road, Brighton, which house became his home till he died.[2] He continued to be a constant and industrious exhibitor in Pall Mall East, and when his life and membership came to a common close fifteen months after Copley Fielding's, he had shown 474 works[3] in the galleries of the Society from the time of his first appearance in 1810. Of these 356 were under the presidency of Fielding. Among his later subjects are still many in which the principal motive is purely archi-

[1] Harding's.

[2] In 1834 he gives the double address of 'Robert Street' and '41 Preston Street, Brighton.' In 1835 the former is withdrawn. In 1845, 1846, 1849, 1850, professional addresses in London are added to that in 'Montpellier Road.'

[3] Counting, in a few early cases, as one a set of subjects in a single frame.

tectural,[1] and there are a few that depict scenes wherein nature has full
sway. They are pretty equally divided between home and foreign
subjects. In the former class large contributions are levied on his own
Sussex neighbourhood. Shoreham and Brighton beach, and Bramber
and Arundel, and (from 1846) the ruins of Cowdry House, all in the
same county, supply a goodly number. Windsor Castle is also a not
unfrequent subject, and there are occasional views of mediæval build-
ings of note in various parts of the country. A few drawings from
the English Lakes, chiefly in 1842 and 1855, the result of many
sketches made in 1841, are exceptional in this class of subject. His
foreign views, besides those in and about Paris, which he had already
made his own, now divide themselves mainly into two groups, those
from Normandy and those from the Rhenish provinces. Among the
former are many from the environs of Rouen and Dieppe ; and a
favourite spot seems to have been the ruined abbey of Jumièges on
the Seine, and the picturesque neighbouring town of Caudebec.
Among the latter, which begin in 1838, the towns and ruins on the
Rhine and Moselle furnish a long series, including some of the Roman
remains at Trèves. A few drawings are from the Meuse. No doubt
he sketched assiduously in these places. But the list must not always
be taken to indicate the extent of his sketching tours ; for a number
of his drawings are professedly from sketches tal en by others, and
there may be more grounded on a like foundation. For while
residing at Brighton he had many pupils among amateurs, and, like
the best teachers of his time, he made use of their own beginnings as a
step whereby to lead them up to the higher platform of art. Among
those whom the catalogue names as having supplied him with sub-
jects was Captain Edward Rooper, of the Rifle Brigade, who fell
gallantly at Inkermann. His father, the Rev. Thomas Rooper, of
Brighton, was a kind and dear friend of the painter's.

The views on the Moselle above mentioned were the produce of a
tour which Nash made with his wife in 1837. They remained there
between two and three months, stopping at all the most interesting
places from one to three days, while he made a number of sketches.
Mrs. Nash writes that he ' preferred that river very much to the Rhine,
and had it not been for ill health would have paid it a second visit
when there were steamboats running, of which there were none at

[1] He seems to have worked little now for the engravers ; but there is a print of ' York
Minster,' after F. Nash, in Tillotson's *New Waverley Album.*

that time, and no good inns.' However, 'in 1843 he' went to the
Rhine, and made a number of sketches, as he never lost a moment's
time when the weather permitted him to draw. . . . He always regretted
that he had been unable to reach Rome, as he considered there were
subjects particularly adapted to his style to be found in abundance in
that fine city.'[1]

One of his studies at Arundel nearly cost Nash his life. In 1837
the roof of his painting room there was broken through by the fall of
a stack of chimneys in a hurricane, and the painter was with difficulty
extricated from a mass of ruins which had buried him.

Nash's practice was to make three drawings of his subject, coloured
on the spot, with effects of early morning, midday, and evening re-
spectively. These he continued from day to day to the point of finish
he deemed necessary, and so on during his sojourn abroad. He was,
as we have seen, an early riser, being generally out with his portfolio
between five and six o'clock, and he worked all day. When anxious
to finish a sketch he would sit on in the rain, employing a boy to hold
his umbrella over him. In the end his health fell a sacrifice to his
professional ardour, and for several years before his death he suffered
from debility and weakness in the legs, and was forced to give up
teaching. It was one of his latest regrets that he was not strong
enough to go and see the great Paris Exhibition of 1855. Until within
a few years of his decease he had given himself up entirely to his pro-
fession, and he used to declare that he should die with a brush in his
hand. To him the prediction was in seeming verified, for in a de-
lirium which accompanied his last illness his hand moved as though
at work, and he complained of the fatigue he had undergone by paint-
ing upon his picture all night.[2] He begged that it might be taken
out of his sight lest, if he worked at it any more, it should injure his
reputation as an artist. Exhausted with the imaginary effort, he
gradually sank, and calmly expired on the 5th of December, 1856, at
his house at Brighton, in his seventy-fifth year. The immediate cause
of death was bronchitis. He was buried in the extra-mural cemetery
on the Lewes road. Mr. Jenkins concludes an account of his life in the
Art Journal for February 1857 with the following testimony to his
worth : ' A good husband, amiable and upright in all the relations of

[1] J. J. J. MSS.
[2] He had in hand a large drawing of Paris for the next year's exhibition ; but it was not
enough finished to be shown as a posthumous exhibit.

life, we are not often called upon to record the death of one who leaves a worthier name behind him.'

Nash's latest works, when his physical powers had declined, did not fairly represent his merits as an artist; nor did his later picturesque style give any idea at all of the grandeur which he infused into his earlier painting. Hence his name does not stand out in a degree of relief at all proportioned either to the number of his works or to the great talent with which he was endowed. Like Mackenzie, he survived the period when architectural drawing had no rival in photography,[1] and although he wisely cultivated his talent in a more extended field of landscape his professional profits did not, it is feared, greatly exceed what was needful for the support of his limited household. His income being also reduced when he could no more take pupils, his case affords another example of a real benefit conferred by the survival to his widow of his share in the Society's fund.

Among the contents of his studio, which were sold at Brighton after his death, was the palette of Sir Thomas Lawrence, which he had bought as a memento, and a choice copy of the *Liber Studiorum* of Turner.[2]

The drawings by HENRY RICHTER, whose Membership lasted a year or two after Fielding's presidency ended, were now almost exclusively of the popularly humorous and sentimental kind fostered by the 'loo-table' Annuals that flooded the book market in the earlier part of that period. Among the more ambitious subjects are comic scenes from Shakspere, such as Falstaff and Bardolph, Touchstone and Audrey, or Slender's introduction to Anne Page; and in 1838, the 'Fat Boy' in *Pickwick* 'discovering Mr. Tupman and the spinster Aunt in the Spider Bower.' But Gipsies, Reveries, and Ringlets, Bouquets and Billets-doux, Don Juans, Evening Prayer, *et hoc genus omne* furnish the commoner motives of his artistic industry. From 1835 to 1845 is his most prolific decade. In 1843 are two scenes 'from the novel of *The Trustee,*' which seems by the quotations to have been somewhat of the 'penny dreadful' order. 'The Parting of Romeo and Juliet' (1845) was reckoned one of the best of his later works. During the final ten years of his exhibiting, of which

[1] One can scarcely help recalling in such cases the late Charles Landseer's celebrated pun, when he declared that sun pictures were a *foe-to-graphic art.*

[2] *Brighton Gazette,* 19 March, 1857.

1856 was the last,.he sent but·one or two drawings each season ; but he was never entirely absent during Fielding's reign, and when his Membership and his life ended together, he had exhibited eighty-seven works in the galleries of the Society since his first appearance at Spring Gardens in 1813.

He had many times shifted his residence ; but from 1842 had been constant to Lisson Grove, where he died at No. 101, on the 8th of April, 1857, of pneumonia and typhoid fever, at the age of eighty-five. His mind seems to have been remarkably vigorous at this great age. He printed a pamphlet of eight pages of abstruse reasoning on *German Transcendentalism* with the date 'Dec. 1, 1855,' and at the time of his death was engaged in translating a metaphysical work by Beck, the weakness caused by a long and close application to which task is said to have hastened his end. Richter moreover played an excellent game at chess, and was very fond of mathematical science. It seems strange that with all this depth of thought his graphic works should have been, in their motives, so much the opposite of profound.

The following may be added to the memoranda of his engraved works : In the *Forget-me-not*, 1832, 'Uncle Toby and the Widow' (engraved by C. Rolls); 1833, 'Night,' allegorical figures (W. Finden) ; 1834, 'Victoria' (Rolls).—In the *Keepsake*, 1833, 'Jeanie in the Outlaw's Hut' (Rolls), 'One Peep was enough' (F. Bacon).— In Fisher's *Drawing-Room Scrap-Book*, 1833, 'The Love Letter,' 2¾ x 3⅝ in. A quarto edition of Milton's *Paradise Lost* was illustrated and some of the plates were engraved by Richter. His drawing of 'The Tight Shoe,' exhibited 1820, has also been engraved.

The year 1832 has been included in our account of the earlier time of JOHN FREDERICK LEWIS because it was the last in which he exhibited Scotch and Italian subjects, and his visit to Spain in the summer of that year marks the beginning of a distinct period of his art. His first occupation in Spain was to begin a series of small but careful studies in· water-colours from the works of the old masters in the gallery at Madrid. Thence he went to Toledo and Granada, making sketches of the Alhambra, and to Cordova and Seville. There he passed the following winter, making further studies from the Murillos in the Museum. The year 1833 was also spent in Spain with an excursion in the spring to Tangiers, a second visit in summer to Granada,

and a sojourn again in Madrid in the autumn, to finish his studies
there. The first fruits of this long visit to Spain were visible in the
same year's exhibition, to which he sent 'An Andalusian Peasant
begging at a Convent Door in Seville,' ' A Calasero in Andalusia,' and
' Mass in a Moorish Chapel in the Cathedral of Cordova.' The next
year, 1834, he was again in England, and his ten contributions to the
gallery were all illustrations of Spanish life and architecture. Eight
drawings of the same class follow in 1835. In 1836 he sent three
important drawings, all devoted to the representation of a Spanish
Bull Fight, and accompanied by descriptive notes and quotations
from ' Childe Harold.' In two the scene is laid at Seville. In the
first the slaughter begins with the brutal sacrifice of horses ; the next
is sacred to the death of the taural victim ; while the third picture
was called ' The Suburbs of a Spanish City [Granada] on the Day of
a Bull Fight,' and represented ' the immediate neighbourhood of the
amphitheatre, the rendezvous of the fighters, &c., from whence they
repair to the arena.' In 1837 are three more : ' Peasants &c. of
Granada dancing the Bolero ; ' ' Sacristy of a Cathedral ; ' and an
important composition representing ' A Spy of the Christino Army
brought before the Carlist General-in-Chief, Zumalcarregui.'[1] In
1838 he sends ' Murillo painting the Virgin in the Franciscan convent
at Seville,' from a peasant model ; and ' The Pillage of a Convent by
Guerilla Soldiers.' These two pictures were executed in Paris, where
the artist had passed the preceding winter, and with one exception
(' A Devotional Procession—Scene in Toledo,' exhibited 1841) were
the last of the series which mark the Spanish period of Lewis's art.

In this group of pictures we see the culmination of his water-
colour painting. They are rich in hue, thorough in design, and fully
regardful of the minutest detail. At the same time the suggestion of
texture is conveyed without obtrusive elaboration, their primary aim
being more the portrayal of character than objective imitation.
Lewis concurrently sent a few Spanish subjects to the Royal
Academy, that is to say four in 1835, and two in 1836 ; but they
were merely studies of single figures. He also produced two series
of lithographs from studies made in the Peninsula. The first, pub-
lished in folio in 1835, is entitled ' Sketches and Drawings of the
Alhambra, made during a residence in Granada in the years 1833–34.'
In this he was assisted by J. D. Harding, who drew some of the sub-

[1] Engraved on wood by Mason Jackson in the Art Journal, 1858, p. 41.

jects on the stone. The rest he executed himself, as well as the whole of the second work, called ' *Lewis's Sketches of Spain and Spanish Character*, made during his tour in that country in the years 1833-34.' Folio, 1836. Each work contains twenty-five lithographs. As was the case with his coadjutor in the former work, Lewis's early training as an engraver may have favoured his practice of lithography; for we find his pencil employed in translating by this means the work of another hand. A set of ' *Illustrations of Constantinople*, from original sketches made during a residence in that city in the years 1835-6' by an artist named Coke Smith, were 'arranged and drawn' on stone by J. F. Lewis, and brought out in 1838, uniformly with his own Spanish Sketches.

The following exhibited works by Lewis, including some of those mentioned above, were separately engraved on a large scale:[1] ' Highland Hospitality,' exhibited 1832 (mezzotint by Wm. Gilles), 'Interior of a Highland Cottage,' 1832 (line by C. G. Lewis); 'Spanish Mendicants,' 1833 (mezzo. C. G. Lewis); ' The Contrabandista,' 1834 (mezzo. C. Turner); 'Spanish Monks preaching for the benefit of their Convent, Seville,' 1835 (mezzo. J. G. Bromley); 'Suburbs of a Spanish City on the Day of a Bull Fight,' 1836 (etching and mezzotint). To this list of engraved works may be added the following reproductions on a smaller scale: In the *Gallery of the Society of Painters in Water-Colours*, ' The Bachelor' (engraved by J. H. Robinson), 1832.—In Finden's *Illustrations of Byron*, 3 vols. 4to, 1833-4, vol. iii., ' Madrid,' ' Seville—the Giralda,' ' Saragoza,' ' Grenada.'—In the *Forget-me-not*, 1837, 'Tajo di Ronda—Arrieros descending the Mountain'(C. Rolls).—In ' *Sporting*, edited by Nimrod,' two heads of ' Foxhounds' (in dry point by C. G. Lewis), 2 Oct. 1837.

It is not often that in tracing an artist's career one can define its successive phases so distinctly within specific periods as is possible with that of Lewis, whose last, or Eastern phase, in which he is best known to the present generation, was separated from those that had gone before by an unproductive interval of many years. There was nothing of his in the gallery in 1839. On the 8th of April, as we read in the Minutes, Evans had reported to the Committee a letter from him ' dated from Rome,' stating that through illness and other circumstances he should not be able this year to support the Exhibition. Accordingly, in the next catalogue, his address becomes

[1] See advertisements in Catalogues of Exhibition of 1835, 1836.

'Rome; or T. Griffith's, Esq. 14 Waterloo Place;' and so it remains for five successive seasons. During that time he has only two drawings at Pall Mall East, both in 1841, namely, the Spanish 'Procession' before mentioned, and a single representative[1] of his Roman period, called 'Easter Day at Rome—Pilgrims and Peasants of the Neapolitan States awaiting the Benediction of the Pope at St. Peter's.' This, however, is described as an important work, with large masses of figures, and gorgeous in colour.

Again there is a long series of years during which Lewis's name remains in the catalogue, but his Membership is virtually in abeyance. He seems indeed to have been somewhat out of mind as well as out of sight; for his address remained registered as above when he had really quitted Rome and migrated further East. Not long after writing the letter above mentioned, he had taken again to travelling. In 1840 he went to Corfu and Albania, made sketches in Janina and the Pindus, nearly died of fever in the Gulf of Corinth, but went on to Athens and Constantinople, where he met and bid a last farewell to Wilkie, who died on the voyage home. We read of him as sketching in the mosques during the following spring; and after a summer tour in Asia Minor he comes to a halt at Cairo for the winter. Next year, 1843, he makes excursions to Mount Sinai and up the Nile into Nubia, &c.[2] All this time he is set down as living at 'Rome.' It is not until 1844 that the catalogue address is changed to 'Cairo; or at F. C. Lewis's, Esq. 53 Charlotte Street, Portland Place.'[3] Still he sends no drawings to the gallery. What has he been doing all this while? it may naturally be asked. How was he spending his time? And why were the talents of so great an artist as he had proved himself to be thus hidden under a bushel?

Fortunately there exists one graphic account by an illustrious pen of John Lewis's mode of life in Egypt. Though no one could be spared from Pall Mall East to look him up, he was visited by an appreciative friend, on a *Journey from Cornhill to Grand Cairo*, in the autumn of 1844. 'Lewis and Thackeray were old friends. They had often met at Maclise's in former days;' but now 'they had not

[1] There was one other later, 'Roman Peasants at the Entrance of a Shrine,' exhibited 1854.

[2] *Art Journal*, 1858, p. 42.

[3] Probably on a first intimation of his whereabouts, for a letter from him (the purport of which is not given) is mentioned in a Minute of 8 April, 1844, as having been received from him by the Secretary, 'dated Cairo.'

seen each other for years.'[1] Eastern things were not so familiar to Englishmen then as they are now. 'There is,' wrote Thackeray, 'a fortune to be made for painters in Cairo, and materials for a whole Academy of them. I never saw such a variety of architecture, of life, of picturesqueness, of brilliant colour, and light and shade. There is a picture in every street, and at every bazaar stall. Some of these our celebrated water-colour painter, Mr. Lewis, has produced with admirable truth and exceeding minuteness and beauty ; but there is room for a hundred to follow him, &c.' It is easy to see that the same 'celebrated water-colour painter' is referred to under the initial ' J.' in the following account : ' I was engaged to dine with our old friend J., who has established himself here in the most complete Oriental fashion. You remember J., and what a dandy he was, the faultlessness of his boots and cravats, the brilliancy of his waistcoats and kid gloves ; we have seen his splendour in Regent Street, in the Tuileries, or on the Toledo. My first object in arriving here was to find out his house, which he has taken far away from the haunts of European civilization, in the Arab quarter. It is situated in a cool, shady, narrow alley ; so narrow, that it was with great difficulty—his Highness Ibrahim·Pasha happening to pass at the same moment—that my little procession . . . could range themselves along the wall, and leave room for the august cavalcade. . . . We made for J.'s quarters ; and in the first place entered a broad covered court or porch, where a swarthy, tawny attendant, dressed in blue with white turban, keeps a perpetual watch,' &c. Then the writer describes how he was admitted through a court with a camel in it, and a gazelle ' to glad J. with his dark blue eye,' and poultry and pigeons, into his ' long, queer, many-windowed, many-galleried house,' with its fountains within and without, mystery of pipe-bringing servants, and great hall of audience, its ceiling 'embroidered with arabesques,' its divans, its great bay window looking out on 'a garden about the size of Fountain Court, Temple,' ' more sumptuously furnished ' too than the houses of the ' Beys and Agas his neighbours,' in that he had imported the European luxuries of 'one deal table, value five shillings,' and 'four wooden chairs, value six shillings. When these things had been examined at leisure,' he goes on, ' J. appeared. Could it be the exquisite of the " Europe " and the " Trois Frères "? A man—in a long yellow gown with a long beard some-

[1] J. J. J. MS.

what tinged with grey, with his head shaved, and wearing on it first a white wadded cotton nightcap, second a red tarboosh—made his appearance and welcomed me cordially. I was some time, as the Americans say, before I could " realise " the *sémillant* J. of old times.[1] He shuffled off his outer slippers before he curled up on the divan beside me. He slapped his hands and languidly called " Mustapha." Mustapha came with more lights, pipes and coffee ; and then we fell to talking about London, and I gave him the last news of the comrades in that dear city. As we talked, his Oriental coolness and languor gave way to British cordiality ; he was the most amusing companion of the —— Club once more. He has adapted himself outwardly, however, to the Oriental life. When he goes abroad he rides a gray horse with red housings, and has two servants to walk beside him. He wears a very handsome, grave costume of dark blue, consisting of an embroidered jacket and gaiters and a pair of trousers, which would make a set of dresses for an English family. His beard curls nobly over his chest, his Damascus scimitar on his thigh. His red cap gives him a venerable and Bey-like appearance. There is no gewgaw or parade about him, as in some of your dandified young Agas. I should say that he is a Major-General of Engineers, or a grave officer of State. . . . His dinners were excellent,' &c. As to Lewis's inducement to an Eastern life, he says : ' It was an indulgence of laziness such as Europeans, Englishmen at least, don't know how to enjoy. Here he lives like a languid Lotus-eater—a dreamy, hazy, lazy, tobaccofied life. He was away from evening-parties, he said ; he needn't wear white kid-gloves or starched neckcloths, or read a newspaper. And even this life at Cairo was too civilized for him ; Englishmen passed through, old acquaintances would call ; the great pleasure of pleasures was life in the desert, under the tents, with still *more* nothing to do than in Cairo ; now smoking, now cantering on arabs, and no crowd to jostle you ; solemn contemplations of the stars at night, as the camels were picketed, and the fires and the pipes were lighted.'

So the years slipped away, and nothing came to the gallery in Pall Mall East. Nothing since 1841. At last the Society's patience was exhausted. On the 7th of July, 1848, it appears on the Minutes that ' the attention of the meeting was called to the fact that Mr. J. F.

[1] Lewis was equally struck with the change in his guest's appearance, as he afterwards told Jenkins. For ' Thackeray had grown from a slender into a large portly man.'

Lewis had not for some years contributed any work to the exhibitions, and had thereby rendered himself liable to Law LII. After discussion it appeared that no satisfactory reasons had been given for his non-compliance with the Law, and his name was ordered to be withdrawn from the list of Members.' But, a little later, to wit on the 30th of November, 1848, the ' Secretary read a copy of his letter to Mr. J. F. Lewis, conveying the Resolution passed July 7th, with Mr. Lewis's reply, in which he stated that he was anxious to occupy his former position, and would in future conform to the Rules, &c.' Thereupon he was re-elected a Member. Still, to the next year's exhibition he again contributed nothing but his local habitation and his name. In 1850, however, he showed, by sending a picture, called ' The Hhareem,' that the volcanic fire of his art, after its long quiescence, was bursting forth from a new crater. This picture created a sensation among visitors to the gallery. It was a revelation to many of the existence of a painter of note, with whose former works they were unacquainted, and in its aim and manipulation was a novelty to all.

Lewis did not follow up his success by sending any drawing in 1851 ; but in the spring of that year he came back again to England, this time for good, taking up his residence at first at 6 Upper Hornton Villas, Campden Hill. In 1852 he had another very highly finished work in the gallery : ' An Arab Scribe - Cairo,' writing at the dictation of a lady accompanied by a Nubian slave-girl.[1] In this interior the elaboration of detail was as marvellous as in the last, the trellis window at the back, through which figures in the street are seen, the coloured tiles on the wall, the variously embroidered and woven stuffs and accessories of fruit, cats, butterflies, &c., which were introduced, affording ample material for his minute study. Again an interval of a year ; after which he becomes once more an annual exhibitor. At the same time he settles in the house he occupied for the remainder of his life, called ' The Holme,' at Walton-on-Thames.

In 1853 a set of more than sixty small studies made by him from the old masters, chiefly abroad, including those in Spain above mentioned, were bought by the Royal Scottish Academy. These to the number of sixty-one (together with a view of the Tribune in the Uffizi at Florence) are now in the National Gallery of Scotland, and form part of a collection of such reproductions placed there for the

[1] Engraved on wood by Mason Jackson in the *Art Journal*, 1858, p. 43.

benefit of students. As a further acknowledgment of their apprecia-
tion of his high standing in art, an Honorary Membership of the
Royal Scottish Academy was conferred on him at about the same
time.

The two Eastern drawings which he had already exhibited were
enough to testify that he had not allowed his power as an artist to
decay in the languor of an Oriental life. These had shown his
mastery in dealing with the complication of modified light in an
Eastern interior. He now proved himself equally skilful and true
when depicting the fullest sunshine.[1] 'Camels and Bedouins—Desert
of the Red Sea,' 1854, and 'The Well in the Desert, Egypt,' and
'The Greeting in the Desert,' 1855—in which works he once more, by
the superb drawings of camels they contained, made manifest his
ancient supremacy as a painter of animals—sufficed to place him in a
position of perfectly unique excellence in their class of subjects, now
so common, but then almost untried by English artists. In 1854 and
1855, Lewis had also some works at the Royal Academy, the latter
of which were in oils. On the 5th of July, 1855, 140 of his sketches,
studies from nature in Spain, Belgium, Italy, Greece, the Levant, and
Egypt, were sold at Christie's.

The year last mentioned, 1855, was, it will be remembered, that in
which the Society lost its much respected President, and as a tribute
to his memory allowed the office to remain in abeyance for a few
months, during which period of interregnum the exhibition was held.
When a fresh choice had to be made at the anniversary meeting in
November, Lewis was elected to the vacant chair. Although there
does not appear to have been any question of the propriety of Lewis's
election, the meeting at which it took place was not altogether
harmonious in discussing another matter in which his interests were
concerned. Some dissatisfaction had, it seems, been felt respecting
the hanging of some of the works of our water-colour painters at the
Paris International Exhibition of that year, those of Lewis among the
number. On Fielding's death, Tayler had been appointed to take his
place in the Associated Committee of the Fine Arts constituted to

[1] Mr. Jenkins made the following note of part of a conversation with Lewis in June
1856: 'When at Cairo (he told me) he used to try experiments by putting coloured pieces of
drapery in the courtyard of his residence to see the effect of the sun upon them. The light
being so intense that he could not distinguish any difference in the grey coloured materials, the
colour could only be seen in the reflexions. The vivid light robbed the colours upon which
it immediately fell, and rendered all a sort of white. His object had been to paint intense
light.'

assist in carrying out the scheme. Out of this mission there arose some polemical correspondence, which will be further referred to in the separate biography of that artist. To Lewis's own record belongs more appropriately the following account, entertaining at least, if not particularly flattering, given by the French critic before quoted, of the works by which he was represented in Paris, and their mode of production. They were five in number, all drawings of his last period, in the group above mentioned. Of the principal one, the ' Hhareem,' M. Edmond About wrote : 'Il a fallu bien des mois pour exécuter cette grande salle à claire-voie, où le soleil pénètre à travers un grillage et vient dessiner de petits losanges sur les hommes et les animaux. M. Lewis travaillait tous les jours à cet étrange ouvrage. Après avoir esquissé la composition, qui est jolie, il passa à l'exécution, qui est médiocre, au dessin, qui est faible, au coloris, qui est criard. Lorsqu'il avait manqué un morceau, il l'enlevait proprement, remplaçait le papier par une pâte de fabrique anglaise, et recommençait la besogne. Un jour, il trouva l'aquarelle fendue en deux. Il l'envoya en Angleterre, fit recoller soigneusement les morceaux, et reprit la suite de son travail. Vous voyez,' adds the writer, by way of comment, ' que la fabrication des aquarelles anglaises est chose compliquée ; mais il y a gros à gagner dans ce métier-là.' And after citing the fact that the picture in question was sold in London for 1,000l. and the copyright for the like sum, he declares : ' Je pense qu'il est difficile de pousser plus loin le fétichisme de l'aquarelle.' [1]

The first year of Lewis's presidency, 1856, was signalized by one of his most remarkable triumphs. He exhibited a single work of large size, which occupied the central and most conspicuous place in the gallery, where it acquired additional celebrity from the exalted terms of praise it received from Mr. Ruskin, whose voice had already become to many the voice of a prophet. In a pamphlet of criticisms on the season's pictures, the author of *Modern Painters* went so far as to write : ' I have no hesitation in ranking it among the most *wonderful* pictures in the world ; nor do I believe that, since the death of Paul Veronese, anything has been painted comparable to it in its own way. . . .' [2] Its title is entered in the catalogue thus : ' A Frank Encampment in the Desert of Mount Sinai, 1842. The Convent of

[1] *Voyage à travers l'Exposition des Beaux-Arts*, 1855, p. 32.

[2] *Notes on some of the Principal Pictures exhibited in the Rooms of the Royal Academy, and the Society of Painters in Water-Colours*, No. II. 1856, second edition, page 37.

St. Catherine in the distance. The picture comprises Portraits of an English Nobleman and his suite, Mahmoud, the Dragoman, etc. etc. etc., Hussein, Scheikh of Gebel Tor, etc. etc.' The subject, not otherwise an agreeable or interesting one, was recognized by the critic last quoted as a sort of fulfilment of an independent prophecy of his own. Some months before, in his customary strain of comparison between past and present times, he had written thus : ' I do not know if there be game on Sinai, but I am always expecting to hear of some one shooting over it.' To present this contrast of ' Syria, Ancient and Modern,' was (in the critic's view) the painter's intention. So the coincidence was sufficiently striking. But it is mainly on technical grounds that Mr. Ruskin bases his high encomium. The picture was executed wholly in body colour, stippled on with the point of the brush. In the sky even, ' the whole field is wrought gradually out with touches no larger than the filaments of a feather . . . in fact,' as he calls it, ' an embroidered sky.' Every object was represented with extraordinary minuteness of detail, requiring the use of a magnifying glass for analysis with ordinary eyes. ' Yet,' adds the critic, after drawing attention to the enormous amount of work it contained, ' marvellous as this quantity of detail is, the quantity is not the chief wonder, but the *breadth*. . . . Labour thus concentrated in large purpose—detail thus united into effective mass—has not been seen till now.' [1] The President had one more drawing, a large and important one, an interior scene, called ' Hhareem Life—Constantinople,' in the gallery in the following year, 1857, full again of the most elaborate detail. This time the critic, while giving full credit to the painter for his ' conscientiousness of completion,' thought fit to administer somewhat of a corrective to the former almost unqualified praise, in the shape of a warning against his apparent devotion to ' subjects involving minuteness as a part of their expression.' [2]

The last public act performed by Lewis, as President of the Society of Painters in Water-Colours, was his attendance at the opening of the Manchester Art Treasures Exhibition in the summer of 1857. He was indeed re-elected at the November meeting, but his resignation, both as President and Member, was announced when the Society

[1] *Notes on some of the Principal Pictures exhibited in the Rooms of the Royal Academy, and the Society of Painters in Water-Colours*, No. II. 1856, second edition, page 38.

[2] *Ibid.* No. III. 1857, pp. 9, 48.

assembled for the election of Associates on the 8th of February, 1858. It appears that the motive of his retirement was a determination to abandon the practice of water-colour painting as less lucrative than oils, his success in which medium had led him to aspire to admission to the Royal Academy, whither he had continued to send oil pictures while exhibiting water-colour drawings in our gallery. In the course of his correspondence with Jenkins, who was then Secretary, he says : ' I work always from before 9 in the morning till dusk, from half-past 6 till 11 at night, always. I think that speaks for itself; and yet I swear I am 250*l.* a year poorer for the last seven years, i.e. since I left the East.' Again: 'When I wrote my first letter to you I was so ill as to be frightened. I felt that work was destroying me. And for what ?—To get by water colour art 500*l.* a year, and this too when I know that I could with less labour get my thousand ' (by painting in oil). At a special meeting (with eighteen Members present) on the 1st of March, 1858, on the circumstances of his resignation (about which there seems to have been some misconception) being explained, an expression of sincere regret was unanimously passed ' that any circumstances should have arisen to deprive the Society of his eminent talent and valuable services.'

Lewis was in his fifty-third year when he left the Society, whose walls he had adorned with ninety-seven works, since his first at Spring Gardens in 1820. His ambition was gratified by admission to the Academy as an Associate in the year 1859 that followed his secession, and by subsequent election as a Royal Academician in 1865. This final portion of his career does not belong to our history ; suffice it to say that his exhibited works in oil, henceforth confined to Eastern subjects, became familiar to all picture-seers ; that he withdrew to the list of retired Academicians in 1876, and died on the 15th of August of the same year at his house at Walton-on-Thames, at the age of seventy-one. He was buried at Frimley. His ' remaining works,' including a great many drawings and sketches in pencil and water-colours, were sold at Christie's in May 1877.

The following (from Redford's list) are the largest prices that his water-colour drawings have realized in the auction room : At Mr. W. Quilter's sale, 1875, ' School at Cairo,' 1,239*l.*, ' The Prayer of Faith,' 1,176*l.*, ' Lilium Auratum,' 1,060*l.* 10*s.* (sold again in 1889 for 1,050*l.*).—At Mr. W. Leaf's sale, 1875, ' Easter Day at Rome ' (30½ x 52 in.), 787*l.* 10*s.*—At Mr. J. Arden's sale, 1879, ' Harem of a Bey

(35½ × 53 in.), 720*l*. 10*s*.—At Mr. G. R. Burnett's sale, 1860, 'The Frank Camp,' 1856, 607*l*.

Although JAMES STEPHANOFF continued to exhibit drawings in the gallery without further intermission annually until 1859, there is little to add as to the scope or character of his art, and the information is but meagre as to his personal history during that time. His exhibits amount to a total of 225 from the date of his first appearance at Spring Gardens, composed of 30 in the 'Oil and Water Colour,' 43 under Cristall, 125 under Fielding, and 27 afterwards. To any painter who devotes himself to the making up of pictures of historic *genre* from the resources of the studio, a list of the titles of Stephanoff's drawings would furnish a valuable repertory of stock subjects. A large contingent is of scenes from Shakspere (of whose plays 'King Henry VI.' is that most frequently resorted to, though subjects are taken from a dozen others as well), and a variety from other writers, both inventors of fiction and recorders of fact. A number of drawings represent anecdotic incidents in the lives of celebrated painters, as Titian, Rubens, Vandyke, Salvator Rosa and others, in their intercourse with kings, brigands, and other persons. Some of these he, in 1843, designates as forming part of 'a series of subjects illustrative of Art.' Whether such a collection was ever made complete or issued in another form has not been discovered, and the same may be said of a series 'intended to illustrate the Customs and Manners of the Olden Time,' to which half a dozen of his drawings from 1839 to 1841 profess to belong. The latter were, as he states in the catalogue, meant for publication under the title *Reliques of the Olden Times*. Among them are : 'A Tournament, 14th Century,' 'A Baron's Hall,' 'Storming of an Ancient Fortress,' 'The Ceremony of the Doge wedding the Adriatic.' Another class of subjects of a more realistic kind, well suited to the delicate elaboration of his handiwork, consisted of collected groups of ancient sculpture and other objects of art, of which the following studies were examples. In 1833 he depicts 'The Virtuoso' surrounded by a selection of the Elgin marbles with a bust of Pericles ; and also sends a drawing of 'Roman Antiquities at the British Museum.' In 1843 he paints 'A Museum, containing a selection of some of the Antiquities brought from Xanthus, and now in the British Museum ;' and in 1845 he takes a more comprehensive historic view in ' An Assemblage

of Works of Art in Sculpture and Painting from the earliest period
to the time of Phydias.'

The archæological tastes indicated in the above choice of subjects
give to James Stephanoff a distinctive place in our list of artists, as
the range of writers from whose works he drew his more ordinary
motives gives him a higher position than that of the average designer
who worked for the Annuals. He was employed by the Society of
Antiquaries in 1829 to make a series of seventeen water-colour
drawings of St. Cuthbert's stole at Durham ; and in 1838 a drawing
of St. Peter from a thirteenth century decoration in the Islip Chapel,
Westminster Abbey, of which he also made a large lithograph. The
Society has also a delicate outline pencil drawing of his, about 1842,
of the frontal of the altar in the same chapel, and in 1839 he made
the drawing of an enamelled ouche in gold engraved in *Archæologia*,
xxix. p. 70.

Moreover, he contributed something to the graphic record of his
own times. For happily he seems to have revelled in what would be
to many the irksome task of depicting crowded assemblies. We
have seen how he took his share in representing the ceremonial of
King George's coronation. In 1833 he painted the ' Interior of the
House of Commons ' during the era of its Reform, and in 1838 ' the
Reception of her Most Gracious Majesty at Guildhall by the Lord
Mayor and the Civil Authorities on the 9th of November, 1837.
The post, however, which he had held of ' Historical Painter in
Ordinary ' to King William was not continued in the present reign.

James Stephanoff sent no drawing to the gallery in 1860 ; and a
letter was received from him on the 11th of February, 1861, stating
that in future from infirmity he should be unable to comply with the
Rule requiring him to send at least one drawing for exhibition ; but
that he desired to retain his Membership. It was, however, con-
sidered that the Membership must cease, but a provision in the Laws
relating to age and infirmity was applied to his case. From 1835 to
1843 he had resided at '6 Devonshire Street, Portland Place.'
Therefrom in 1844 the address changes to ' Derby Villa, Shepherd's
Bush,' where he remains till 1848. In 1850 this gives place to the
address ' West Hanham, near Bristol,' where his brother 1 was living.

[1] Francis Philip Stephanoff died at West Hanham on the 15th of May, 1860, at the age
of seventy-two or thereabouts. Owing to a fall when a boy, which injured his head, and to
the sad death of his wife suddenly in his arms after only a year's marriage, he had become

He died in 1874 at 6 Frederick Place, Clifton, Bristol, aged eighty-six. He married Lucy Allen, and had two sons and two daughters. The elder son died young, after showing the family taste for both painting and music.

Graves counts fifty-eight works by James Stephanoff in other galleries between 1810 and 1851, twenty at the Royal Academy, thirty-three at the British Institution, and five at Suffolk Street. He was a member of the Sketching Society. If the artificial character of most of this artist's subjects did not conduce to the study of nature's colouring, and his taste for 'purple and fine linen' was apt to bestow upon his pictures more of decorative softness than of stern realism, they formed, perhaps the more on that account, a recognizable element in the concerted harmonies of the 'old Society' gallery, and were thus looked for and accepted in the annual show.

quite incapacitated at times from following his profession. Like his brother he was not only a fine musician, but also a lover of antiquities. His wife's maiden name was Selina Roland. They had one son, who gave promise of being an artist, but died at the age of sixteen. Among other large subjects, F. P. Stephanoff painted a much admired picture of the 'Death of Cardinal Wolsey,' in 1844 ; and he was awarded a prize of 100*l.* for a cartoon in the Westminster Hall competition for Decorating the Houses of Parliament.

CHAPTER II

EXITS, 1859–1862

Biographies concluded—*Cox—Turner—Finch.*

THE period of Fielding's presidency embraces that of the most important representative drawings by DAVID COX, when his artistic strength was in full maturity and his physical energy yet unimpaired. It extends also to the time of his declining years, when his art was entering into a final stage, marked by characteristics of its own. By the beginning of the period he had fairly emerged from the subjection to 'neutral low tones and flat washes,' which in an earlier stage had assimilated his works to those of Varley and Prout ; and in some cases [1] those of this middle period are distinguished from what preceded, as well as what followed them, by a greater, sometimes even a high degree of 'finish.' 'After 1834 and 1835 especially,' says Mr. Solly, ' his exhibited works had a well-marked character of their own, very distinctive of Cox's as compared with those of any other artist.' [2] But he assigns to the painter's third and most representative manner the score of years from about 1830 to 1850. To the drawings of this period he ascribes ' a visible increase of breadth, more vigour and rapidity in the handling, more insight into the deeper meaning and mystery of nature, more movement, more sparkle and brilliancy, and more mature knowledge of effect, and of the forms and treatment of sky and clouds. There is also,' he adds, ' a more decided character in the figures introduced.' [3]

During the first half of this time Cox continued to reside in Foxley Road, Kennington Common, exhibiting an average of thirty

[1] Notably, Mr. Solly tells us, in small drawings which Cox made for ladies' albums in or about 1834. (*Life of Cox*, p. 75.)

[2] *Life of David Cox*, p. 94.

[3] *Ibid.* p. 248. Cox's figures, like Turner's, are sometimes very expressive. See some shipwreck scenes of his middle period. ' Penmaenmawr' (Sir Joseph Heron's) and 'Wreck on the North Coast' (F. Craven's), both exhibited at Manchester in 1887, are examples.

drawings a year in Pall Mall East, making sketching visits to the country in the late summer and autumn, generally in company with friends,[1] working hard at home in the winter, and still taking pupils as a matter of necessity. For even Cox's drawings as yet commanded but small prices, and many still returned unsold from the gallery. It needed unceasing industry and careful living to enable him to lay by, as he did, a little money every year. His charge for a drawing lesson is believed never to have exceeded half a guinea, whereas Varley, as we have seen, charged double that amount.

In 1832 he made one more short trip across the Channel. This produced about a score of drawings of French subjects, chiefly on the coast, about Calais, Boulogne, and Dieppe, in the gallery in that and the next two years. But he did not dive into the Continent, and never went there again ; being satisfied that his own country was for him the land of landscape, and afforded more than enough for the requirements of his pencil. Nearly forty foreign drawings may, however, be counted under his name in the Society's catalogue during the ten years from 1829 to 1838. By far the most of his subjects at this time are from North Wales ; but autumn visits to two or three favourite resorts in England group some of the others into corresponding divisions. Thus an expedition to Derbyshire with his son in 1831 to do some drawings of Haddon Hall, followed by many sojourns in after years at the ' Peacock ' at Rowsley, hard by, produced a series of views and studies in the same county, from one to six in every season from 1832 to 1840, and of these we do not lose sight entirely until after 1848. They include, especially in 1840, interiors and exteriors of Hardwick Hall,[2] and divers views of Bolsover Castle, besides his ' delightful old Haddon.' Of professedly Derbyshire subjects there are about thirty. Then come, dating from 1835 and extending to 1847, an important series of more than twenty drawings from Lancaster and the neighbouring district, mostly of the Ulverstone Sands, with market people crossing at low tide. This subject he repeated many times under various effects, thus coming into direct competition with Turner, who had already twice depicted the same scene, with a stage coach as the main incident ; to wit, in a drawing

[1] Messrs. William Roberts, Charles Birch, William Stone Ellis and Norman Wilkinson were frequent companions in these tours.

[2] A ' Hardwick Castle ; windy day ' (34 x 24 inches) was sold in Mr. Quilter's collection in 1875 for 1,008*l.* It had been bought for 150*l.* ; but Cox received only 30*l.* for it. (Redford's *Art Sales.*)

at Farnley Hall, and in one of the engraved series of *Picturesque Views
in England and Wales.* The first set of Cox's drawings of the sands
were made in 1834. One of the most celebrated was the 'Crossing
the Sands' exhibited in 1835, which was in the collection of the late
Mr. A. Levy (23 by 33 inches) and sold at Christie's to Messrs. Agnew
in 1876 for 1,732*l.* 10*s.*, the largest price, with one exception, ever given
for a drawing by Cox. A third group of drawings to be noticed
apart, which also belong more especially to this culminating period,
are those from sketches on the Wharfe, of Bolton Abbey and Park,
Barden Tower, and the neighbourhood. Of these there are about one
a year throughout this time. Some of his most lovely landscapes are
in this group. The little congregation of artists at the 'Devonshire
Arms' at Bolton Bridge during these sketching sojourns seems to
have been in some degree a foreshadowing of later days when old
David Cox was wont to preside over his historic circle of art disciples
at Bettws-y-Coed.[1] About half a dozen exhibited drawings of Powis
Castle, the seat of Lord Clive, were the result of visits there, the first,
it is believed, in 1837. To the above classes of subjects have still to
be added a considerable number from the home counties (Windsor,
the Thames, and the South Coast), some from the midlands (Kenil-
worth Castle being a favourite subject), and others from Yorkshire
and the English Lakes. He never crossed the Tweed until four years
before his death, when sent to Edinburgh to sit for his portrait. Four
views which he exhibited in 1836 were from sketches made by his
son.[2] A very few subjects still come from South Wales and his old
Herefordshire district. With these drawings of a strictly local class,
we have about half as many more which belong to the general
category of English or Welsh Landscape. 'Lane' or 'Road Scene,'
'Heath Scene,' 'Rocky Landscape,' and the like, are common titles.
A large proportion are Harvest Scenes ; and in 1837–39 the roads are
occupied four times by soldiers on the march. Groups of rustic
figures, such as gipsies, drovers, fern-cutters, and market folk, are more
often the leading figure incidents that give a special character to the
scene. We find, indeed, at the beginning of the period, two whereof
the title seems to disclaim the landscape element altogether ; namely,
'The Music Lesson' (1833) and 'The Lady of the Manor' (1834).
But these are quite exceptional. A large proportion are put forth as

[1] See Solly's *Life of Cox,* p. 130. [2] *Ibid.* p. 83.

representations of particular states of weather or times of day ; as
' showery,' ' windy,' ' midday,' ' evening,' &c.

To this period belong some engraved works. A plate of ' Calais
Pier,' engraved by W. J. Cooke, in the *Gallery of the Society of Painters
in Water-Colours* (1833), is dated 1832. And some, though not a
large proportion, of his works were used for topographic illustration
in drawing-room books. Among the many popular publications of
this kind which were issued during his residence at Kennington,
several contain plates after drawings by David Cox. Those on
' Warwickshire ' and ' Dudley Castle,' mentioned in a former chapter,
were followed, at an interval of five or six years, by two books,
published by Wrightson and Webb, Birmingham, with letterpress
by Thomas Roscoe, entitled, *Wanderings and Excursions in North
Wales* and *Wanderings and Excursions in South Wales*. Both
contain some fifty plates engraved by William Radclyffe, about half
after Cox, and others after brother members of the Water-Colour
Society. The former volume came out in 1836,[1] the latter in 1837.
Then there is *The Annual of British Landscape Scenery* (*An Autumn
Ramble by the Wye*), by Louisa Anne Twamley, in octavo (Tilt), 1839,
with twenty of the same plates, eight of which are after his drawings,
and four after his son's. Miscellaneous plates after Cox may also be
found in *The Gallery of Modern British Artists*, 2 vols. 4to (Simpkin
& Marshall), 1834, viz. : ' Fort Rouge, Calais ; ' ' Sea-Coast ' (engraved
by R. Brandard) and ' Furness Abbey ; ' and in J. Tillotson's *Beauties
of English Scenery*, small octavo, no date, viz. : ' Torquay,' ' The Tor,
Devon,' ' Hythe,' ' Dover.' Several plates in Emma Roberts's *Hin-
dostan*, 2 vols. 4to, published by Fisher in 1845, which bear the name
of Cox, were probably issued before in Elliot's *Views in the East*, in
1833, and utilized in Fisher's *Drawing-Room Scrap-Book* 1832, 1834
&c. For some years, beginning with 1840, the vignette titles to
Heath's *Book of Beauty*, representing groups of figures in an Italian
garden, and the like, engraved by E. Radclyffe, are by D. Cox.[2]
There are also vignettes engraved by E. Radclyffe after Cox on the
title-pages of the *Keepsake* 1841, 1842, 1843.[3] One of his designs is
engraved in L. Marvy's *Sketches of English Landscape Painters*.

When Cox gave up teaching, it was to be expected that he would

[1] A later edition is dated 1853.

[2] Presumably the elder. That for 1847 is by ' D. Cox junior.' Vols. 1843 to 1846 have
not been searched. They are ' wanting ' at the British Museum.

[3] That for 1846 is by ' D. Cox junior.'

also cease to compile his little treatises on practical art. One more
of the series came out, however, as late as 1845. It was now published
by Ackermann, under the same title of *Progressive Lessons* which
had already been employed (with additions to and variations of the
contents) in successive issues since 1816. It now underwent still
further alteration ; for, as the preface sets forth, 'in order to explain
the system adopted in the present improved state of the Art, it was
necessary to discard the preceding work altogether, and to produce
another entirely new.' The notes on Perspective are indeed retained,
and the rewritten letterpress embodies some of the old matter. The
pigments to be used are varied by the addition of Indian Red and
Brown Pink, and the substitution of Cobalt for Prussian Blue. But
a fresh set of graphic illustrations take the place of the earlier ones,
and accord with the changes which the art of David Cox had under-
gone in the interval. Instead of resembling as before the works of
Varley, Prout, and De Wint, they have now the freedom and mystery
of the style which the author had made for himself. A few of the
simple examples for the pencil are lithographed (by Day and Haghe).
For the rest, aquatint and hand-tinting are employed. They embrace
some of the artist's familiar subjects of this time, and several of the
plates are signed and dated 1838.

The year 1836 is to be noted in connexion with the sequence of
his works in water-colour, by reason of his having then procured a
species of paper which he afterwards used for many drawings, and
thereby gave them a specially marked character. Mr. Solly gives the
following account of his discovery and use of this paper : 'It was in
the year 1836 that Cox first met with the rough Scotch wrapping
paper which on trial turned out to be very unabsorbent of colour when
used for water-colours, producing a powerful effect. The surface is
hard and firm, the paper being made from old linen sailcloth well
bleached. Cox obtained the first few sheets by chance at Grosvenor
& Chater's, and on showing it to S. & J. Fuller their traveller
ascertained, from the Excise mark stamped upon it, 84B, that it was
manufactured at a paper mill at Dundee, North Britain. There a
ream was ordered for Cox, and it was some time before it could be
obtained. On its arrival he was rather surprised to find that it weighed
280 lbs. and cost 11s. However, his friend Mr. Roberts was willing to
share in the purchase, and after some years Cox rather regretted that
the quantity ordered had not been larger, as he was never able to

obtain the same quality of paper again. . . . Some of Cox's most powerful studies and drawings after this period were painted on the rough Scotch paper. It gave the texture he required, and suited his peculiar mode of rapid work with a large brush, charged as full as possible with very wet though rich colour. It enabled him to obtain *power* at once. The paper was very thick, not quite white, with here and there little black or brown specks. In the landscape part these specks were of no consequence, but they looked out of place in the sky. On one occasion being asked what he did to get rid of them, he replied, "Oh! I just put wings to them, and then they fly away as birds!"[1]

At about the beginning, however, of her Majesty's reign, the artistic career of David Cox was entering upon a new stage. Even he, like many of our best water-colour painters, was beset with a hankering after oil. He had occasionally painted in that medium as far back as 1812, when he did 'little oil sketches on mill-board,' and he and Havell sketched at Hastings.[2] And Mr. Solly mentions an oil picture by him with the date 1831 in Mr. Bullock's collection. But his serious devotion to the viscid medium commenced about ten years later.

Before that time a strong impression had been made upon him by the work of that admirable artist William J. Müller, whom he had had the advantage of watching at his easel, after that painter's return from the East in 1839. Müller was nearly twenty years younger than Cox; but the veteran did not hesitate to place himself under his tuition on that account, and not only received a few lessons from him in his department of art, but procured a few of his pictures to place before him as models to work by. Müller's masterful rapidity of hand already resembled what he himself had only acquired after long practice.

The desire to take to oils was one main reason of his determination, two years after, to break up once more his London establishment and retire again into the country. He also loved the quiet of a rural life; and the fact that his son, who was married, had now acquired a standing in his own profession, and was able to take a transfer of much of his teaching, set him free to indulge both inclinations. So in 1841 Cox and his wife took up their last abode at Greenfield House, Greenfield Lane, in the village of Harbourne, about two and a half

[1] *Life of Cox*, pp. 80, 81. [2] *Ibia.* p. 26.

miles from his native Birmingham. The very name seemed chosen to express the rural quiet he sought. The house had a large garden, wherein he grew his favourite foreground plants, large-leaved docks and thistles, and hollyhocks in variety. But his was no absolute retirement from the world, for Cox was of too sociable a nature to lead the life of a recluse. One of his inducements to settle here was the proximity of congenial friends to whom he had become attached. Among them were Mr. Roberts and Mr. Birch, the frequent companions in his sketching tours, whose names are also well known as those of collectors of Cox's works. The former was an able amateur artist, a pupil of De Wint's, and a friend of Cotman and other painters of the Norwich school. In this year (1841) of our artist's removal to Harbourne he had only ten drawings in the exhibition ; and although in the year after the number rose again to eighteen, he never again contributed so many, for he was busy at the same time preparing pictures for the exhibitions of oil paintings. In 1842 we read of his sketching from nature in oils at Bolton Abbey, and in the next year, when a rather serious illness had deprived him of his customary tour, taking more than ever to that medium in the studio, and beginning to prefer it to water-colours, which he eventually did.

On the 23rd of November, 1845, he lost (at the age of seventy-four) the faithful wife who had been his sympathetic helpmate from the outset of his career. Her appreciative companionship was taken from him just as he was mounting the summit of his power as an artist. Mrs. Cox and he had already been long enough in their new home to win the affections of those around them by acts of unostentatious benevolence ; and their domestic relations had been those of the closest attachment. Recently they had resumed one at least of the habits of their early married life, she having re-established her Dulwich custom of reading to him as he sat at the easel. The bereaved husband was sustained after his severe shock by the consolations of a strong religious hope, and in the following March he is again incessantly employed with his art. ' I keep on at my water-colours,' he writes, ' a little each morning while my room is getting warmed, and then work at my oil until dark. At lamplight at my water-colours again.' [1]

During the four years of his residence at Harbourne he had usually paid a visit to his son in London before the opening of the

[1] Solly's *Life of Cox*, p. 142.

exhibition, and later in the year betaken himself to one or more of his favourite haunts in Yorkshire and Derbyshire and North Wales. But a sojourn of two or three weeks in the summer of 1844 with the late Harry Johnson (Müller's pupil and travelling companion) at the Royal Oak Inn, Bettws-y-coed, gave uniformity to his annual movements for nearly all the rest of his life. He had spent a second summer at the same place in 1845, and had even contemplated the purchase of a residence there ; having suffered in the spring from a cold on the chest and craved for the sweet mountain air of Bettws. Although this scheme was never realized, it became his unvarying annual custom for the next ten years to spend some time in the summer or autumn at this beloved resort. These repeated visits to the same spot not only impressed a special character upon all his later work, but have for all recorded time associated the name of David Cox with Bettws-y-coed, and the colony of artist disciples who gathered round him there while he lived, and long retained the traditions of his presence and example after he ceased to be among them in the flesh. 'Many are the anecdotes,' wrote Mr. Jenkins [1] in an account of what proved to be the last of Cox's visits to Bettws, 'told in the village of the kind-hearted and simple-minded artist who still preserved that most attractive and rarest of all gifts of manner —a genuine and unaffected simplicity. Many are the memorials which are proudly exhibited of his frequent and long sojourns at Bettws. The landlord of "The Oak" boasts of a signboard [2] painted by his yearly visitor. The walls of the parlour are ornamented with specimens of his art, and that in a style very different from what he exhibits at the Water-Colour Gallery. A figure, life-size, having all the effect of a fresco, but probably painted in water-colour on the plaster, is a copy from memory [3] of the fresco by Redgrave exhibited at Westminster Hall, of Catherine Douglas securing the door with her bare arm. English artists,' continues the writer, 'do not, like their brethren on the Continent, form a class apart, and are not, like them, gregarious in

[1] In the *Brighton Gazette*, 23 October, 1856, under the title 'An Artist's Haunt ;' afterwards reprinted in the *Art Journal* with the heading 'Cox and his Sketching Ground.'

[2] This sign, which was painted by Cox in 1847, and retouched by him in 1849, and after his death placed, in 1861, at the request of many admirers of the artist, in the hall of what had now risen to be an 'hotel,' became in 1880 the subject of a dispute at law between the landlady's trustees in bankruptcy and the lessor, Lady Willoughby D'Eresby, to whom it was eventually awarded by the judge. It was stated that a connoisseur had offered 1,000*l.* for the picture. (*Times*, 17 September, 1880.)

[3] Mr. Solly mentions several other instances of Cox's making studies, from recollection, of pictures that struck his imagination. See *Life of Cox*, pp. 76, 77.

their habits. English artists have no such places of rural rendezvous as the French meet with in the forest of Fontainebleau, at Barbizon. Perhaps the nearest approach to these continental assemblages which Great Britain affords is at Bettws, where "The Oak" occasionally shelters at one time ten or a dozen artists. This distinction is entirely owing to David Cox. It is his pencil that first made the little village known to the world of art; it is the fame he has acquired which has induced others to visit this district, and for the many solid advantages which result from this succession of visitors the inhabitants are indebted to the friendly warm-hearted artist who enjoys the happiness of doing good to others. What Walter Scott did for the Highlands, and Wordsworth for the Lake District, Cox has done for Wales—attracting there not only the younger aspirants for artistic honours, but the admirers of wild, uncultivated, and picturesque scenery, and even the ordinary tourist, who hurries from place to place in search of that mental excitement he is incapable of feeling.'[1] 'In Cox's favourite region,' wrote Thackeray,[2] 'the very stones are christened after him; as you wind out of Capel Carig, a little turret, in which a stone seat is inserted, bulges from the walled road-side, and is known as Cox's pulpit.' 'Here it was the painter loved to sit and contemplate the varied influences of sun, and cloud, and rain, upon the mountain tops. . . . At every turn memorials of the kind and affectionate nature of the man spring up, and many are the tales told to his honour in the valleys of the Lledr and the Conway, that will not soon be forgotten.'[3] Each of his biographers gives a detailed account of life at Bettws in Cox's time, and his habits and comrades at the Royal Oak Inn. There he put up for the first half-dozen years; but from 1852, when old age was creeping over him, his quarters for the sake of quiet were a farmhouse belonging to the landlord about a hundred yards off.

All this time he was painting more and more in oils; but although he finally declared his preference for that material, it cannot be said to have superseded his water-colour drawing, for the subjects of his oil-pictures being almost always what he had previously painted in water-colours; some of the most representative drawings being so repeated many times over, the original conception might still be claimed as belonging to the purer medium. Moreover, he continued to exhibit at the Water-Colour Society drawings which made up amply in quality

[1] Obituary notice of Cox in the *Brighton Gazette*, 16 June, 1859 (by J. J. J.).
[2] In Marvy's *Sketches after English Landscape Painters*.
[3] *Brighton Gazette*, ubi supra.

for the falling off in quantity that took place on his retirement to Harbourne. The culminating point of Cox's art is nearly coincident with the last subdivision of Fielding's presidency. Throughout that time the gallery in Pall Mall East was enriched with a series of his most celebrated works. Among them the following may be mentioned as specially important and characteristic: In 1847, 'Bolton Abbey.' In Mr. H. T. Brodhurst's collection. 'This,' the artist wrote to his friend Roberts, 'the members all seem to agree is the very best drawing I have ever made, and they have used the most expressive words of praise I have ever received.'[1]—'Caer-Cennen Castle, S. Wales.' Engraved in the *Art Journal*, 1868. An oil painting of this subject in Mr. Levy's collection was sold in 1876 for 2,625*l.*—In 1848, 'The Skylark' (24 × 34 in.). This drawing, an open rural scene of light and air and sweet repose, takes its name from a songster on the wing at which a group of children are gazing. It was sold in Mr. Levy's collection in 1876 for 1,365*l.* Cox repeated it in oil in 1849.—'Peace and War' (23 × 34 in.). The scene is on the heights of Lympne, near Hythe in Kent, overlooking the plain of Romney Marsh, with soldiers marching down under the admiring gaze of rustics in charge of sheep. Powerful in the contrast of light, it recalls the work of Muller, and is said to have been suggested by a picture of his; but, as we have seen, it was not the first subject of the kind that Cox had painted. It was in Mr. Quilter's celebrated collection. An oil picture with the same name, representing troops on the march by a harvest field, the scene whereof was at Lancaster, painted by Cox in 1846, which was in Mr. Gillott's collection, fetched at Christie's the largest price ever realized by one of the artist's works, 3,601*l.* 10*s.*—In 1849, 'Beeston Castle, Cheshire' (24 × 34 in.), photographed in Mr. Solly's book, and there described among the drawings in Mr. F. Craven's collection at High Broughton, Manchester. Reckoned one of Cox's most perfect works.—'Cross Roads' (24 × 34 in.). Formerly in Mr. Levy's collection. A favourite subject of the artist's, with the incident, repeated in other of his works,[2] of a traveller being directed as to his way. On rough paper and characteristic of his later style. —'The Missing Flock' (45 × 24 in.). This large drawing is one of a group of pastoral subjects in which a multitude of sheep play the leading part, that forms at this time a notable element in Cox's *œuvre*.

[1] Solly's *Life of Cox*, p. 148.
[2] For example, 'Keep the Left Road,' 1854; and 'Asking the Way,' 1855.

This example, a wide hilly landscape with drifting cloud shadows and a perturbed flock, went to enrich the Craven collection. In 1849 we have also 'Counting the Flock,' and in 1850 'Changing the Pasture,' each of which titles was repeated for other pictures.[1] In the artist's last years there were exhibited, 'Driving the Flock' (1856), and another 'Changing the Pasture' (1858). The year 1850 is specially noteworthy for the production of one of Cox's most celebrated works, esteemed above all others for its deep and impressive pathos and a poetic feeling by which the human sympathies are powerfully moved. 'A Welsh Funeral, Bettws-y-Coed, North Wales,' the original drawing whereof was exhibited in that season in the Society's gallery, may be taken as the typical *chef-d'œuvre* of the fourth and final period of his painting, which belongs to the last decade of his life, wherein he seemed to work less with his hand than with his mind. The ceremony here represented was one which he had himself witnessed on the occasion of the death from consumption of a young woman of his favourite Welsh village. The solemn impressiveness is produced by mere suggestion, according with the fine artistic harmony of the composition and chiaroscuro, and 'the tone of colour so perfectly in keeping with the sad scene, deep, full and solemn.'[2] The church is seen in small part only, and not a face is visible, the backs of the mourners being towards the spectator, as the slow procession passes down a road into the yew-tree shade of the graveyard. The drawing, which is in Mr. Craven's collection, is photographed as the frontispiece of Mr. Solly's *Life* of the painter. Cox repeated the subject two or three times in oils. This fine drawing, strange to say, was not sold in the gallery, and, although the artist's brother Member Topham persuaded an Art Union prizeholder to buy it for 50*l.*, it proved so little to his taste that he returned it to his adviser at the same price !

The fact is that these drawings of Cox's later time, admired so much by connoisseurs, were not appreciated by the general public. Though to the observant lover of art ' evincing the hand of a master, and far more suggestive of the real scene or effect than the most laboured imitation of the minute and accurate copyist of nature's

[1] In 1870 a ' Change of Pasture,' a drawing from the collection of Mr. J. W. Brown, realized 1,207*l.* 10*s.* at Christie's. At Mr. Levy's sale there in 1876 an oil painting of ' Counting the Flock ' produced 2,415*l.* and a water-colour drawing of ' Changing Pasture ' 1,333*l.* 10*s.* Mr. Solly tells us that a drawing (possibly this) with the same title as Mr. Levy's had the date 1845. [2] J. J. J'

details,'[1] they appeared to most people 'slight and careless,' and were pronounced 'mere blots of colour.' Cox himself knew their value, and would wince a little at the criticisms passed upon them. Before this very exhibition he had written to his son, ' My drawing upon the Scotch paper is so rough I fear I shall bring down all against me, but the paper has plagued me so that I am very nervous.' And three years later, when his handling had become yet looser and the details less defined, though his feeling for 'nature in her solemn moods' was deeper than ever, he writes in a tone of quite unusual complaint, as follows, respecting the exhibition of 1853 : ' I wish now I had taken Mr. Roberts's advice and sent my drawings in without a price, as it strikes me the committee think them too rough ; they forget that they are *the work of the mind*, which I consider very far before portraits of places [views]. I also think the committee ought not to hang my principal drawings by the door, as my drawing of " Penmaen Mawr " of last year, and my drawing of " Bettws Church, with the Funeral," also hung at that end of the room. . . . I certainly have said that I will remain with them as long as I am able to paint for them ; but perhaps I may not live to send any more, and if I should be spared,[2] I think I shall not be able to contribute much. I hope to be in London on the 3rd of May, and then I will take out of the price-book the sums I have asked for my four large drawings, and if there are those of the public who appreciate mind before mechanism, they will write to me to learn how I estimate them. I may be wrong, but the world has yet to be taught. Perhaps I am made vain by some here who think my " Summit of a Mountain "[3] worth—I am almost afraid to say—100*l*., and if I could paint it in oil, I shall some day, with D.V., get that sum.'[4] During all this time the field of his fancy was more and more confined to the surroundings of his ' dear old Bettws,' while the series of his visits there was rapidly drawing to a close. Age had now crept over him, and his health was giving way. He had suffered severely from bronchitis in the spring of 1853, which was followed in the summer by a slight paralytic seizure, and his eyesight began to be affected. But his exhibited drawings in 1853 to 1856 showed no signs of failure in mental power. Among these were ' Snowdon from Capel Curig ' (1854, 1855), ' Peat Gatherers, North

[1] J. J. J. [2] He had had a recent attack of bronchitis.

[3] ' The Summit of a Mountain,' exhibited in 1853, was one of the representative drawings of this period of his art. [4] Solly's *Life of Cox*, p. 229.

Wales,' and 'Moors near Bettws-y-Coed' (1856), and other fine works.

The year 1855, in which he attained the age of seventy-two, was one of much honour done to David Cox. Friends and admirers clubbed together to present him with his portrait ; and he was induced to take a journey to Edinburgh to sit to Sir John Watson Gordon, R.A. The result was considered an excellent likeness, if a little too grave, and although, to judge by a contemporary photograph,[1] the President of the Scottish Academy seems to have been a little too much possessed with a desire to claim for his sitter a double resemblance to Lord Brougham and Sir Walter Scott. Cox himself is said to have demurred to the 'long Scotch head' that was given him.[2] The picture was presented, with much ceremony, at Harbourne, at Mr. Birch's house, Metchley Abbey, on the 19th of November ; was exhibited at the Royal Academy in 1856 ; and, after Cox's death, was placed in the public Fine Art Gallery in Birmingham, where it now is. A subscriber's plate of it was engraved by S. Ballin.

The few years which remained of Cox's earthly career belong to the period that followed the death of Fielding. More and more had his drawings become 'works of the mind,' less and less 'portraits of places.' Lingering yet in the cloudland of his Welsh hills, he wreathes the rolling mist more thickly about their slopes, as it were a parting shroud ; and then he bids them farewell. On the 22nd of September, 1856, he signed his name for the last time in the visitors' book at the 'Royal Oak,' and never, except with the mind's eye, saw his dear Bettws again. After becoming feebler in body year by year, and suffering from repeated colds, he died of bronchitis on the 7th of June, 1859.

Of the works of his last three years, his biographer writes : 'Those exhibited in 1857, 1858, and 1859, above all others, are endowed with a pathos and a power to touch the heart, and awaken the higher sympathies of man, which to kindred minds is altogether irresistible.'[3] It seems to have been generally assumed, while the veteran yet lived,

[1] This photograph is printed in Mr. Solly's *Life*, and a reproduction of it in Mr. Hall's *Biography*. A much earlier portrait, in oils, taken by Mr. William Radclyffe junior in 1830, is described in the former book (page 66). A later one, by Sir William Boxall, R.A. (*ibid.* p. 285), was painted from the life in 1856, and a subscription bust in marble was executed after Cox's death, by Mr. Peter Hollins of Birmingham. The bust was exhibited in the Society's gallery in 1862 by their special permission, and afterwards presented to the Birmingham Literary Institute.

[2] Solly's *Life of Cox*, pp. 239, 245. [3] Solly, p. 94.

that these final works were indeed his last ; for loan collections of
his drawings already began to be formed and placed on view.
One of these, organized mainly by the late Mr. Edwin Field, friend
and benefactor as he ever was of our water-colour artists, was held
by the Hampstead Conversazione Society at the end of 1858.
Another, of 169 oils and water-colours, was opened to the public in
the spring of 1859, at the then called 'German Gallery' on the west
side of New Bond Street.[1] And in May there appeared in *Punch* a
genial and eloquent critique on Cox's works in that year's exhibition,
beginning with the prophetic address to the painter : ' I feel as if you
and I were shaking hands for a long, long parting. Is it the wavy
mist of tears in my eyes, or the dimness of years in yours, that blears
those Welsh mountains and wild western moorlands, the last, I fear,
that your glorious old hand—true to the heart as ever, but now
trembling—will create for the pleasure of all that have ever looked
nature lovingly in the face ? ' and ending with the exhortation, ' Go,
my dear young friends, reverently and tenderly, and give your fare-
well and God-speed to old David Cox, for he will draw no more.' It
is recorded in the Minute-book that the death of David Cox was an-
nounced at a meeting of the 13th of June, 1859, and the then President,
Mr. Frederick Tayler, at the wish of the Members present, undertook
to proceed to Harbourne to attend his funeral, as a mark of the
Society's respect ; and further, that on the 2nd of August he reported
that he had done so, and ' related in feeling terms the affectionate
regard with which Cox's memory was honoured by his friends and
neighbours assembled on the sad occasion.' At the same meeting
20*l.* were voted in aid of a subscription, set on foot by Mr. John
Jaffray of Birmingham, for a memorial of the deceased. Those who
knew David Cox are as much united in ascribing to him an uprightness
of character and general kindliness of disposition, as they are in re-
cording his unceasing industry, and devotion, heart and soul, to Nature
and to his life's work of depicting her beauty. To young artists ever

[1] Probably Cox's works have been more assiduously brought together in loan collections
than those of any other of our painters. Besides those above mentioned during his life there was
an assemblage of eighteen choice specimens among the Manchester ' Art Treasures ' of 1857.
After his death, Leeds had its muster in 1868, and Manchester again in 1870, 1875, and at
the Jubilee Exhibition there in 1887. The Burlington Fine Arts Club exhibited fifty drawings
and sketches belonging to Mr. Henderson in 1873, and the Liverpool Art Club, no less than
fifty-seven oils, 297 water-colours, and seventy-nine sepia pencil and charcoal drawings, in
November 1875. But the most numerous collection yet made has been that at the Art
Museum at Birmingham, where more than 460 examples in oil and water colours were shown
in November 1890.

helpful and sympathetic, with children kind and genial, constant to his friends, and respected by all, he seems to have inspired in his person a kind of affection which gave an added interest to his works, and proclaimed them as the outcome of his own gentle spirit.

Cox's peculiar method of working in water-colour seems to have arisen spontaneously out of the qualities and aspects of nature which he set himself to express. The loose hold wherewith he dealt the unerring side-strokes of his eagle quill gave a feeling of motion and breeze ; while the sharp edges and full tones which bounded and enriched the 'blots' that flowed from a liquid brush, brightened the sunshine and cleared the watery air. A resemblance has been traced in his way of 'repeating broken tints loosely hatched over one another until the local colour was obtained,' to the painting of Gainsborough and Constable, he being, like them, more intent 'upon obtaining the exact tone and colour of nature than in defining form ; which is gradually developed in his pictures by the juxtaposition of lines and tints rather than by drawing.'[1] All critics, however, admit that Cox's *style*, in the higher sense of that term, was pre-eminently his own. In that singleness of mastery he may indeed be classed with the greatest. His pictures, wrote Mr. Jenkins, 'are valued and admired for the same reasons that induce us to appreciate the works of Turner—their perfect originality. . . . Like Turner he gives his own free view of nature ; unbiassed by the thoughts of others, faithful to his own perceptions, distinct and original.'[2] The late eminent critic of contemporary art, Tom Taylor, made the following comparison between Turner and David Cox, the latter of whom he regarded as 'the best example since Gainsborough of a mind that impressed itself upon every scene it assumed to reproduce.' In 'his singular mastery over air and space . . . he seems to me often to excel Turner . . . when dependent on cloudy or vaporous effects, in which Turner's elaborate cloud-marking often tends to give the sky undue solidity, rivalling, and sometimes surpassing, that of the earth and what stands upon it. For unmistakable love of and sympathy with his subject, for delight in his work, and the power of giving delight, there is no artist, not even Turner, to whom I should, without great unwillingness, cede pre-eminence over David Cox. In delicacy of manipulation, in variety of invention, in range of experiences, and in sweep of knowledge, Turner is, no doubt, his superior ; but not in the loyalty of his service to nature, nor in his

[1] *Century of Painters*, ii. 484. [2] *Brighton Gazette*, 23 October, 1856.

intense power of realising her aspects, with a rapidity and simplicity of means that astonish, but in which lies the certainty of thorough understanding and the finest imaginative power.'[1]

When David Cox settled at Harbourne he gave up the wearisome toil of teaching, though he did take a pupil or two at intervals as an exceptional favour. In 1850, having been asked to make such an exception, he wrote to his son, ' I could not refuse my old friend . . . else I am quite frightened to give a lesson now, and I sincerely wish it was over.'[2] But he was always ready to lend a helping hand to s udents ; and when he did teach, 'none ever communicated every a'om of what a pupil wanted to know, with such a winning simplicity.'[3] His practice in giving lessons had been that of other leading artists of his time, to teach by example as well as precept ; and in this way he would readily impart instruction in his later days. One whom he assisted in this way gratuitously at Bettws has noted his method of work when he one day took up the brush expressly to show his friends how he sketched. 'The process was simple in the extreme. He worked with a large swan-quill brush, and *slopped* his colours with water (he used the old-fashioned *hard* cake colours, but of extra size, in the usual japanned tin sketching-box). He was jealous of wearing his brush ; and if any colour was obstinate from having been baked in the sun, he rubbed it with his finger. His tints were very fluid but not watery, and he explained that by working with a full brush, the colours never dried *dark*, as they would do if the brush were half dry. I noticed that tints which looked very dark dried quite light. His system was constant *repetition of touches* till the effect was produced, being very careful that the preceding touches *were dry.* He seldom washed his tints after laying on, as he liked to see each touch defined, not softened off ; he said it gave spirit and character to the sketch. "But mind," he said, "I am only showing you how I *sketch.* These are three sketches I have just done for you. They are not *drawings.* I have done the same thing for other people, and they have sold them afterwards as my drawings." '[4] Although no man was ever more assiduous in his study in the presence of nature, he was equally careful to cultivate the memory. Even when sketching out of doors ' he had the habit sometimes, when impressed with a rapid passage of light, movement of clouds, or other effect, of turning round

[1] *Handbook to the Pictures of the International Exhibition of 1862,* p. 109.
[2] Solly's *Life of Cox,* p. 221. [3] *Ibid.* p. 32. [4] *Ibid.* p. 174.

with his *back* to the scene, and making a rapid memorandum, with chalk and colours, of the *effect* as it existed in his *mind*, as he said that the *impression* was more fresh, powerful, and vivid thus than if he had continued to gaze on the scene, which would have become weakened by looking.'[1] To obtain an effect rapidly he frequently adopted the plan of tinting on a chalk or charcoal sketch ; and often in this manner, but also with oil and water colours or in sepia, he worked a great deal by lamplight[2] in the winter evenings, declaring that a picture begun under these conditions was 'always broader in effect and more brilliant, and often better and more pure in the colour of the tints,' and that 'what he did by lamplight in general turned out better by daylight than what he did by daylight.'[3] Coloured effects, made at these times on the rough paper, to help him in his future pictures, he called his 'cartoons.'[4] The pigments used by Cox in his water-colour practice were few and simple ; and he depended more on their combinations and contrasts than on their individual brightness. It has been admitted that, in his second manner at least, he made sometimes a sparing use of body colour for touches of light ; but Mr. Jenkins preserved a scrap of documentary evidence as to the practice in this respect of his later time. A discussion having arisen among the artists assembled one evening at the 'Royal Oak' at Bettws on the merits of *body* or *opaque white* in water-colour painting, his great authority was cited in its favour and also against it. Some were sure that the veteran landscape painter used it ; others were equally certain that he did not. Cox was staying at Bettws at the time, and for quiet was sleeping at the Inn Farm close by. It was suggested that a note to the painter asking the question would probably determine the dispute as far as he was concerned. This was agreed to. Mr. Cobbett sent round a few lines by a Mr. Hoyle. 'Be kind enough to ask Mr. Cox for me if he advocates the use of white *or not* in water-colour drawings.' The note was quickly returned, with the following words written at the foot : '*I do not use it.—David Cox.*'[5]

After Cox's death the circle of appreciation of his works widened, and their commercial value rapidly increased. What had been sold by him for tens now fetched their thousands of guineas in the market.

[1] Solly's *Life of Cox*, p. 313.

[2] A letter recommending this practice to his son, and describing his whole process with the colours he used, is set out in Mr. Solly's *Life of Cox*, p. 119.

[3] Solly's *Life of Cox*, pp. 118, 219. [4] Hall's *Biography of Cox*, p. 134.

[5] The original writing is among Mr. Jenkins's notes and memoranda.

One after another, collections of his works were brought to the hammer, and the prices of his water-colours rose until in 1875 they reached, or appeared to reach,[1] their culminating point on the dispersion of that of the late Mr. William Quilter. The following are those named in Mr. Redford's valuable list of sale prices as having brought more than 1,000*l.* at Christie's : ' The Hayfield' (33 × 22 inches), sold in the . Society's gallery for 50*l.*, and bought by Quilter for 500*l.*, went in the sale of his collection (1875) for 2,950*l.*—'The Vale of Clwyd' (21 × 27), which was knocked down at 1,627*l.* 10*s.* on the same occasion, produced 2,415*l.* in the sale by his executors in 1889.—' Ulverston Sands' (23 × 33), sold in Mr. Levy's collection for 1,732*l.* 10*s.* in 1876. —' Rain cloud, Curig Cenin' (24 × 29½), in Mr. Timmins's for 1,575*l.*, in 1873.—' Green Lanes' (25 × 30), in Quilter's for 1,470*l.* in 1875, but only 892*l.* in 1889.—' The Skylark' (24 × 34), in Mr. Levy's, for 1,365*l.* in 1876.—' Changing Pasture' (23 × 33½), in the same, for 1,333*l.* 10*s.*—' The Change of Pasture,' in Mr. J. W. Brown's, for 1,207*l.* 10*s.* in 1870.—' Rocky Pass, Capel Curig' (23½ × 34), in Mr. J. Heugh's, for 1,050*l.* in 1874.—' Hardwick Castle, Windy Day' (24 × 34), in Mr. Quilter's for 1,000*l.* in 1875. His oil paintings have sold for yet larger sums. An equal number, culminating in Mr. Gillott's ' Peace and War,' knocked down as aforesaid for 3,601*l.* 10*s.*, are named in the same list at prices of more than 2,000*l.* Descriptive catalogues of drawings by Cox in many collections will be found in Mr. Solly's *Life*, together with priced lists of important sales.

Some of Cox's works have been engraved since his death. But there is no style of reproduction which has done full justice to the water-colour drawings of his mature and most original manner. Twelve line engravings by the late Edward Radclyffe were issued in 1862–3 by the Art Union of London ; and the same engraver began a series in etching and mezzotint, intended to form a parallel to Turner's celebrated prints, and to be called the *Cox Liber Studiorum*. But he only lived to finish three, which were published in 1876 for the

[1] Unfortunately, the high prices in that memorable sale cannot always be taken to indicate the true state of the market at the time. After the collector's death, a second ' Quilter sale' took place at Christie's on the 18th of May, 1889, by order of his executors, whereat a considerable number of drawings by Cox and others, which were believed to have been sold, and had been recorded as sold, to persons in whose names they had been bid for in 1875, reappeared and were again apparently sold, possibly to real buyers, at much lower prices. One drawing, however, of David Cox's was knocked down for a higher sum than before.

Liverpool Art Club. Messrs. Redgrave, writing ten years before, state that Cox himself had prepared 'one hundred fine drawings in sepia, lately belonging to Mr. Quilter, of Norwood,' for publication in rivalry of Turner's *Liber*.[1]

On Fielding's accession WILLIAM TURNER increased his yearly number of exhibits to about eleven, and he maintained that average throughout that President's reign. He also extended his range of subjects within, but never beyond, the boundaries of Great Britain. Besides many drawings made from material in his own county of Oxford, he had, from 1839, a large number of mountain views in the northern highlands of Scotland, especially in the Isle of Skye; and from 1841, a fair contingent from the English Lakes, chiefly Keswick and Ullswater. Bamborough Castle, and other picturesque sites in Northumberland, North and South Wales, and Devon and Cornwall, all in turn afforded work for his pencil; and in various parts of England he found the extensive prospects which were his most characteristic kind of landscapes. Among these were views over the Severn Valley, and from the Malvern Hills, wide stretches of Salisbury Plain with Stonehenge, and on the Downs of Sussex, Hampshire, and the Isle of Wight. He sought to give interest to his views of the latter class by the introduction of shepherds with their flocks; and peopled many of his Scotch scenes with Highland drovers. But he made little use now of the devices of composition to impart a charm to his landscapes; trusting rather to fidelity of detail and calculated gradations of perspective to give them an air of truth. Many of his paintings are, as before, studies of atmospheric conditions at various times and seasons. 'Sunrise' and 'sunset,' 'moonlight' and 'twilight,' 'autumn' and 'winter,' 'after rain,' 'storm clearing off,' are among the constant descriptive additions to the titles of his works. And he marks the rigidly topographic aim of his art by the peculiar care with which he enters in the catalogue, as if he were laying down a map, the name of every village included in his English prospects, and every hill-top in his highland views. President Fielding was rather tedious in this kind of identification, but Turner of Oxford surpassed him in that particular. Like his greater namesake, he is given also to adding copies of verses, but with better reason, for there was less in the paintings themselves to touch the poetic chord. Nor

[1] *Century of Painters*, ii. 483.

are they in his case original or varied. A quatrain descriptive of sunlight alternating with shadow to the landscape does duty time after time ; again and again the same blest shepherd on the turf reclines ; and some lines by Mrs. Hemans are repeatedly pressed into the service to describe a favourite subject on the river Cherwell near Woodstock, 'where the white water-lilies grow abundantly.' Although in his later practice Turner diverged thus widely from that of his old preceptor Varley, his manner of painting retained to the last an old-fashioned air, which contrasted still more with the modern styles that surrounded his works in the gallery, and seemed to mark the latter as representatives of a bygone age.

There are but few facts to add of the personal life of William Turner. He was married, but had no family. His time seems to have been occupied in making the sketching tours required for his landscapes, some of which are described as 'painted on the spot,' in finishing the rest in the studio, and in attending to the requirements of his numerous pupils at Oxford, both in and out of the University. In a letter to Mr. Jenkins on the 8th of March, 1855, he excuses himself from attending a meeting after Fielding's death on the plea of age and weakness. ' I have,' he writes, ' been in London only once since 1851, and then remained a few hours only. I trust,' he adds, ' that the Society will continue to go on prosperously, both collectively and individually.' He continued to exhibit drawings at Pall Mall East for eight years after Fielding's death, but in diminished numbers, his average then being reduced to six ; and he died on the 7th of August, 1862, in his seventy-third year, at Oxford, where he had resided, in the same house, No. 16 St. John's Street, since 1833. He was buried at Shipton-on-Cherwell, near Woodstock. The sketches, sketch-books, drawings, and oil pictures &c. in his studio were sold at Christie's on the 9th of March, 1863, those by his own hand being comprised in some two to three hundred lots. In the fifty-five years from the date of his admission as an Associate in 1808 to that of his death, he never missed one as a contributor to the exhibition ; his total number of works so shown being 455. The fact that but few of the drawings were hung on the screens is evidence that few were of very small size. Graves enumerates thirty-eight works in other galleries. The highest price for a drawing of W. Turner's noted by Redford is only 31*l.* 10*s.* for ' Kingley Bottom ' (10 x 11 in.), at the ' A. Levy ' sale, 1876.

When last particularly mentioned, FRANCIS OLIVER FINCH was exhibiting a few drawings annually, and taking pupils to raise an income, on which he might marry the lady of his choice. The long-wished-for event took place in the spring of 1837. He then moved from 82 Great Titchfield Street, where he had resided with his mother for fifteen years, to 51 Upper Charlotte Street, Fitzroy Square. The mother followed her son's example in both particulars. She herself married again, and with her new husband, Dr. William Thomson, settled in one half of this larger house, while the young Finches made a nest in the other. Mrs. Finch in the 'Memorials' of her husband gives a pleasant account of their quiet social ways in the old artists' quarter, with Cristall, Uwins, Samuel Palmer, and others, of whom George Richmond, R.A., is perhaps the only survivor; their quartet parties at Bone's the enamellist in Percy Street, hard by, and *soirées* at neighbour Bartholomew's the flower painter; their little monthly meetings of brethren of the brush to compare sketches and talk of art and science; and their other evenings at home *tête-à-tête* (for they had no children), when they alternately read aloud, and where they made a home for many cats. But the greatest enjoyment of his life, she tells us, was painting, and its greatest trial teaching. He grudged the time of which the one occupation deprived the other. 'The only drawback' to the delights of his studio was a certain 'want of confidence in his powers, which often depressed him much;' and this was increased by want of time to devote to his drawings. For he was usually slow in execution, except when fitfully inspired. Then, for a time, every touch appeared to tell.

Finch's contributions to the gallery during the sixteen years [1] of his residence in Charlotte Street accord with the even tenour of his life there. He has a steady average of between four and five drawings. They are, with scarcely an exception, landscape compositions; in three instances only illustrating passages from the poets, namely, a scene from the 'Castle of Indolence' in 1843, one from 'Comus' in 1844, and an 'Ideal Landscape from Keats' "Ode to the Nightingale"' in 1852. Finch, being a poet with the pencil as well as the pen, did not, like certain less inspired painters, encumber the catalogue with long quotations of descriptive verse.

[1] Calvert notes that Finch 'attained to his great powers, not at once, but with slow and natural growth,' his best period being 'the last fifteen or twenty years of his practice;' which embrace most of this stage of his career. (*Memorials*, p. 344.)

In the summer of the year last named, he went abroad for the first and only time, on a visit with his wife to some friends in Paris ; the trip being partly undertaken to recruit his spirits, which had been depressed by sorrow at the recent death of his eldest aunt, and anxiety at his mother's failing health, as well as the serious illness of his step-father. He took the opportunity of making a little copy of one of the Claudes in the Louvre, where he spent some time almost every morning.

On the death of Mrs. Thomson in 1853, the Finches made another move, to 2 Argyle Square, Euston Road (then called the ' New Road '), where their society was more limited. Here Finch devoted himself more assiduously to labours connected with his Church, the place of worship being on the opposite side of the square, where he took an earnest part in debates and discussions as a champion of its faith. These exercises were not disconnected with his art ; for he held the doctrine of his prophet that Beauty (with the perception whereof man alone among all living creatures has been endowed) is the outward and visible sign of the spiritual graces of Goodness and Truth. Thus, with him, the handling of the brush was in itself a kind of religious observance. Among his literary ' Remains ' there is an address to the ' Society of Junior Members ' of his congregation, in which he warmly supports the view that the aim and end of art is to awaken in the mind sensations of sublimity and beauty ; and he joins with his old master Varley in an expression of contempt for ' pictures which appeal only to the bodily eye, and exhaust their meaning *there*, claiming its mere recognition of a resemblance of certain natural objects presented to it.' [1] With all this earnest piety Finch was no ascetic, nor did his sentiment preclude a keen sense of humour. At the late Sir Henry Cole's chambers in the Adelphi in his bachelor days, about the year 1830, his singing of Horace Smith's ' Loves of the Pigs,' ' with a humorous pathos and hesitating sort of accompaniment on the piano,' was said by his host to have been ' a triumph of comic genius.' [2]

His social qualities are thus attractively set forth by his old friend and brother Member, the late Samuel Palmer : ' Those who were intimate with Mr. Finch will find it difficult to name a man more evenly and usefully accomplished. Besides modern languages and scientific acquirements he had large general knowledge. His conver-

[1] *Memorials of Finch*, pp. 235, 236. [2] *Ibid.* pp. 35, 36.

sation was never obtrusive, and never flagged; it was solemn, playful, or instructive, always at the right time and in the right place. An eminent friend, a sagacious observer of men, said that he never thought a friendly dinner party complete unless Finch were at the table ; " it was like forgetting the bread." ' [1]

A thoughtful summary and appreciative estimate of the qualities of Finch's art and his position as a painter, from the pen of his friend Edward Calvert, is appended to Mrs. Finch's *Memorials* of her husband. It contains the following comparison between him and two of his brother artists, the first of whom he resembled so much in style as to be sometimes called an imitator of his works. ' In chaste truthfulness of colour and grandeur and repose of style, he seems to rank with Barret and David Cox, although more varied than the one, less free and large with the pencil than the other. These three men, successors of Girtin in his healthy view of nature, were unable to exceed his delicacy of sight and readiness of representation, yet appear to have surpassed him in appliance of the means of art to a raised imitation. Barret and Finch have highly ethical tendencies. Neither is content unless some defined kind of human life be represented or implied. With the latter, this is so unmistakable as to win for him a name among the painters of poetic landscape.' Of Cox he remarks that ' with an ideal less defined,' he is so like Finch ' in simplicity of character as well as in noble colouring, that one cannot help associating old David Cox and Francis Finch as " brothers in Art." Both masters in the poesy of landscape, they differed in motive and expression. One a mountain giant sounding forth wild music from his home among the rocks ; the other a. herald of civilization to the valleys and the hills. Both grand in utterance, Justice would link their names together for enduring honour.' [2] Barret and Cox, indeed, with the great Turner, were the leaders of landscape in his day in whom Finch most delighted ; with Claude and the two Poussins among the ancients. Of his own affections, ' one of the most marked,' says the same friendly critic, ' is the attachment to that which is equable in things, whether in climate, the state of the elements, or the doings and manners of men. . . . An old Saturnian quietude pervades all that he thinks and does. Repugnant to him is turbulence of every kind, even when of nature's producing, as in steep waterfall, or in storm of wind or rain. . . . Dear to his tastes are the garden

[1] *Memorials of Finch*, p. 354.　　　　[2] *Ibid.* pp. 342, 343.

and the grove, sacred places, bowers votive to peace and to friend-
ship, seats and walks, where what is noble in converse with men and
with gods may be safe from disturbançe.'[1]

No account of Francis Finch can approach completeness without
some tribute to his memory as a painter in words as well as with the
brush. Appended to his widow's memoir of him are some literary
remains in prose and verse, all of which amply justify their publica-
tion. The former consist of a few essays and discourses, chiefly
theological, but one or two, as in an instance above referred to, bearing
on the nature of the fine arts. They are written in an easy style, and
the arguments clearly set forth. In the latter the works of pen and
pencil have a closer connexion. To use the words of his brother
Member, Carl Haag, Finch's 'pictures are all painted poetry,' and, as
his widow wrote, 'his pictures being brief poems, his brief poems are
pictures.' The verses consist of ten sonnets, to most of which this
description may be literally applied, and a longer piece entitled 'An
Artist's Dream.' Here the dreamer is supposed, under the guidance
of a friendly genius, to be led forth from a grove of outer darkness
through deep recesses of a mountain, where various forms of art are
cultivated. Therein he learns that none can hope to reach the bright
city of palaces upon its summit, without a purification of the soul
from selfish influences, such as love of fame and praise of men. The
poem is replete with imagery, and contains passages of great beauty.
Of the sonnets, the following is a specimen —:

> Night holds her silent vigil, and on high
> Spreads out her glittering stars, like shining eyes,
> To watch the slumbering earth. Calm splendours rise
> Before my thoughts, of distant Araby
> And deserts vast, where patient camels ply
> Their night march, and the lonely stillness lies
> O'erarched with solemn brightness ; nor denies
> Imagination to reveal that sky
> Where the fixed pole-star at the zenith shines
> O'er waste of northern ice. The summer's breath
> Recalls my shuddering fancy, and combines
> Night with the garden's sweetness, like a wreath
> Wound in her ebon locks : so let her reign
> With sleep's consoling quiet—I refrain !

The artist's biography has still to be concluded. Finch remained
a steady, though small, exhibitor, and was never once an absentee.

[1] *Memorials of Finch*, pp. 345, 346, 349.

He survived Copley Fielding seven years, the last of which were saddened by many troubles. In 1857 his health had begun to fail, and on the 13th of May he was afflicted by a stroke which produced partial deafness. In the following year he became more extensively paralyzed. Meeting about the same time with more family bereavements, in the death of his remaining aunt (then residing with the Finches), of his wife's father and her godmother (long also an inmate of their house), and of his 'old friend and stepfather,' Dr. Thomson, and the domestic circle being thus reduced, he moved to a smaller house in the neighbourhood, 38 Manchester Street, at Michaelmas, 1860. A year after, 10 October, 1861, he quite lost the use of his limbs; although a partial recovery enabled him afterwards during two hours in the day to make small copies in pencil [1] of some old studies. In the Minutes of the anniversary meeting on the 30th of November we find recorded, as read, a letter from Mrs. Finch 'informing the Society that her husband had been suffering from a severe stroke of paralysis, and that he feared that he would never recover the use of his hand sufficiently to contribute to the exhibition in future.' Nevertheless, he had as many as twenty drawings in the gallery in 1862, by much the largest contingent he had ever sent. Some at least must have been earlier works. He was able to be moved in the following May to the house of a cousin of his wife's at Holloway (6 Highfield Villas), where he could watch the sunsets and enjoy a purer air than that of St. Pancras. And there he died peacefully on the 27th of August, 1862. He was buried in Highgate Cemetery.

It is a pleasure to record that the close of Finch's life was not, as in the case of too many of his contemporaries, embittered by the fear of want or by straitened circumstances. But this was not owing to any exceptional success in making a profit by his profession. During the forty-two years from his election as an Associate in 1822 to 1863, he exhibited 234 drawings in the gallery, making an average of between five and six a year. This limited production was at least equal to the demand, for his drawings were in the nature of 'caviare to the general.' Charming as they sometimes are, no higher price is recorded of them in the 'Art Sales' than 37*l.* 16*s.* for a 'composition' sold in the year of his death. But they are generally of small size. Shortly

[1] The 'small black and white studies which he was in the habit of making as overtures to more elaborate works,' says his friend Calvert, 'might serve as a school of composition.' (*Memorials*, p. 345.)

before his death, he and his wife made to the Society the liberal offer contained in the following letter, written by her on their joint behalf:

'6 Highfield Villas, Holloway, N. June 31st, 1862.

' *To the Committee of the Water-Colour Society (Old).*

' Gentlemen,—If a few of Mr. Finch's framed drawings should be found acceptable to the Society, nothing will give us greater pleasure than to make arrangements for reserving them for this purpose. With myself the desire has been so strong for some time past that in the coming time there should be some little focus, as it were, for the gathering together a few specimens of my husband's peculiar style, that I feel I would almost make any sacrifice rather than have them scattered. Circumstances have lately arisen, however, that have put us more at ease on the subject of our pecuniary resources, and having reduced our expenditure very considerably by giving up housekeeping, we shall be enabled to reserve the drawings in question without feeling the loss in any degree that we care about, and in order to save the Society any future expense Mr. Finch prefers to make them over at once as a gift, only wishing or stipulating as to retainment of their possession for our joint lives. Allow me to remain, Gentlemen, yours obediently, ELIZA FINCH.'

A list of twelve drawings accompanied the letter. The Society considered themselves compelled by want of space at their disposal to limit their acceptance to one drawing as one of the collection of single specimens which it was proposed to gather together of the works of all the Members. No engraved works after F. O. Finch have come to the writer's knowledge.

CHAPTER III

EXITS 1863 – 1865

Biographies concluded—*Harding—Hunt—Whichelo*.

NEARLY all the facts which go to make up the biography of JAMES DUFFIELD HARDING relate to the professional career to which his life was wholly and earnestly devoted. In the year 1832 he removed from 12 North Crescent, Bedford Square, to a larger and more modern house, one of a few then recently erected as the nucleus of Gordon Square. Here he was still residing when the first term of his Mem ship came to an untimely end by his resignation on the 30th of November, 1846. During these fifteen years his show of drawings did not make an average of quite three in a season, though he had fairly established himself as a leader in the more modern development of his art. His time was mainly employed in other ways than in the working up of pictures for exhibition. This was the period of his greatest activity in producing graphic works for the press. He was at the same time labouring assiduously in the calling to which his heart was always the most responsive—that not merely of a teacher, but a teacher of teachers. Thus the aspects under which his life work has to be regarded are threefold, as he combined the three vocations of painter, draftsman for the press, and last, not least, professor of Art, both as to theory and practice.

Whether Harding would have obtained a higher position among artists had he confined himself to painting only, may be left open as matter for discussion. If so, it would have been as a painter in oils rather than in water-colours. His practice in the latter medium is open to criticism on account of a copious use of opaque pigment in the laying on of lights, which he defended on principle, and would therefore have adhered to. It was no doubt well adapted to the dexterous rapidity of his handling, but it imposed restrictions on his art, being, when partially used, inconsistent with unity of effect, and

II. N

incapable, without infinite labour and minute manipulation, of the delicate gradation to be obtained under the old and purer system of transparent colour on white paper. His tints are gay and harmonious nevertheless, without much regard for the exact local colours of objects. It is not known that he ever worked for the theatres, like Stanfield and Roberts ; but his painting belongs to the same school, and he would have made a most effective scenic artist. In his pictures the deft handling of the brush seems to betray a consciousness that his more fitting material is oil, which makes the reason he gave for withdrawing from the Society in 1846 no great matter of surprise. It was 'in consequence of a desire to offer himself as a candidate at the Royal Academy.' As, after making unsuccessful efforts for the next ten years to obtain admission to that body, he eventually returned to the Water-Colour Society, he may, notwithstanding this temporary desertion, be classed here as one whose Membership was not finally concluded until long after the epoch of Fielding's death.

Up to 1846 the drawings he had sent to the gallery showed the same variety as before, the foreign outnumbering the home subjects. A large and important work of his, powerful in colour and effect, and of great beauty, was a marked feature in the exhibition of 1845. It represented the range of snow mountains seen from Berne, in the light of ' Morning as it sometimes wakes among the Alps,' and was accompanied in the catalogue by a long verbal description of a stormy sunrise in September 1844, and the gorgeous sight that followed, as beheld by the artist on the spot.[1] His one exhibit in 1844 had also been a view of the high Alps, in the range seen from the road between Como and Lecco. Harding, it need scarcely be added, travelled much abroad, collecting subjects and pencil sketches. He is said to have been on the Rhine and the Moselle and in Venice in 1834, again on the Rhine in 1837, and in Normandy in 1842 ; but no subjects from the French province are comprised among his works of this period at Pall Mall East.

Harding's engraved works, under which term are included those reproduced by lithography, are very numerous. Many of great excellence are contained in his educational publications. Notice of these being for the present reserved, the list begun in the previous

[1] The author of *Modern Painters* (i. 100) refers to this ' grand sunrise ' as exceptional among the artist's works, in the interest of the sky, and as displaying a power not even then ully developed. Ruskin and Harding were at Venice together in 1845.

account of the painter is here continued ; the prints from his original designs, and those for which he was only the draftsman upon stone, being, as before, separately dealt with. In the first category we have a large number of plates in which his drawings are interpreted by line engravers, including some of the best who flourished in the time of Turner, and became distinguished in his service and under his guidance. These will be taken, as far as may be, in order of date. First, we find our artist assisting his old master, P. F. Robinson, the architect, with a ' View of Woburn Abbey,' engraved by W. Radclyffe in the *New Vitruvius Britannicus*, imp. folio ; issued in parts beginning 1831.[1] *' Richmond and its surrounding Scenery*, engraved by and under the direction of W. B. Cooke, with descriptive letterpress by Mrs. Hofland,' 4to, 1832, contains twenty-four plates ($4 \times 6\frac{1}{2}$ in.) dated 1831–32, seventeen of which are after J. D. Harding. They do no justice to his spirited style. Of the remainder, six are after the late George Barnard, who, it is believed, was one of his pupils. The ' Byron's Dream,' engraved by J. T. Willmore in *The Keepsake* for 1832, has been mentioned before. The three octavo volumes of *The Landscape Annual* for 1832, 1833, and 1834, the second title of which was in the first two ' The Tourist in Italy,' and in the third ' The Tourist in France,' the letterpress in all being by Thomas Roscoe, contain twenty-four plates in each, together with a frontispiece and title vignette, whereof the designs are all by J. D. Harding. In these plates, which are executed by the best engravers, the characteristic qualities of his treatment of landscape are faithfully rendered. The original work was published by Jennings and Chaplin, 62 Cheapside. Later impressions of the three sets of plates were published in one volume by A. H. Baily & Co., 83 Cornhill, with the title, ' Seventy-five Views of Italy and France,' and the date 1834. And there was another reissue of the plates, together with Prout's, in 3 vols., 1849–50, as ' Thomas Roscoe's Continental Tourist,' with French descriptions added, by A. Sasson. Plates after Harding are also distributed among the following works :—In *Gallery of the Society of Painters in Water-Colours*, 1833, ' Italy,' engraved by E. Goodall.—In Finden's *Illustrations of Byron*, 3 vols. 4to, 1833–34 twenty-one of the plates, including three vignettes, chiefly after

[1] Some of the landscape embellishments to the following works by P. F. Robinson are drawn on stone by J. D. Harding : *Rural Architecture*,—*Designs for Ornamental Villas*, —*Designs for Lodges and Park Entrances*.

sketches by others.—In John Tillotson's *Album of Scottish Scenery*, small 4to, published by Allman (1834?), one out of twenty-six plates, viz. : 'Doune Castle' (engraved by E. Finden).—In *Landscape Illustrations of the Bible*, descriptions by T. H. Horne, 2 vols. 1836, some plates after Harding's drawings.—In G. N. Wright's *Landscape Historical Illustrations of Scotland and the Waverley Novels*, 2 vols. 8vo, 1836-8, some plates attributed to Harding.—In Thomas Roscoe's *Wanderings in South Wales* (1837 ?), the title-vignette of 'St. Govan's Head.'—In Fisher's *Drawing-Room Scrap-Book* for 1837, 'Church at Polignac;' 1838, 'Hurdwar' (from a sketch by Captain R. Elliot, R.N.). These were probably reissues.—In *The Keepsake*, 1839, 'The Battle Field ;' 1840, 'The Indian Maid' (both engraved by Willmore).—In Heath's *Picturesque Annual* for 1840, royal 8vo, which volume is devoted to 'Windsor Castle,' ten full-page plates and title-vignette, all after drawings by J. D. Harding.— In Finden's *Ports, Harbours, Watering-Places, and Coast Scenery of Great Britain*, 4to, 1838, fifteen out of fifty steel plates.—In Dr. Camillo Mapei's *Italy, Classical, Historical, and Picturesque*, 4to, 1859, two out of sixty-three plates, namely, ' Vicenza ' and ' Benevento.'

The above are all from metal plates. The impressions from drawings on stone, mostly by the artist's own hand, exemplify still better the characteristics and quality of his style and draftsmanship. Besides those which illustrate his treatises on Art, the more important are comprised in the following publications: Harding's *Sketches at Home and Abroad*, folio, 1836. Fifty lithographs, containing fifty-nine landscape sketches. On grey or warm stone-tinted paper, heightened with white. This series is noteworthy as being a first application of the process called 'lithotint,' whereby a graduation of tones executed with a brush can be reproduced. It 'created some-what of a sensation in the art world, and gave a great impetus to art illustration by this method. It was soon followed by similar publications from drawings by Stanfield, Roberts, Nash, and others.' [1] The work was dedicated to King Louis Philippe, who sent the artist a diamond ring and an autograph letter. It is said that his Majesty desired also to confer upon him the decoration of the Legion of Honour, but finding that this would involve a breach of etiquette, ordered a Sèvres breakfast service as a further gift instead, which, however, got damaged by an accident to one of the principal pieces.[2]

[1] *Portfolio*, February 1880 [2] *Ibid*.

In course of time the work becoming scarce, a selection of twenty-four of the prints was autotyped, and reproductions on a smaller scale (10½ by 7 in.) published by Chapman & Hall, 4to, 1874. —Harding's *Portfolio*, published by Tilt, 1837, printed by Hull-mandel, contains twenty-four original lithographs, drawn by Harding on the stone (about 5 by 7 in.), without letterpress. Some copies are tinted in colours, which is not always an improvement, particularly as the white has in some cases become discoloured. The subjects are English, German, Italian, and French.—*The Park and the Forest*. Imp. folio (McLean), 1841. Twenty-six large original lithographs drawn by Harding on the stone ; without letterpress. Printed by Hullmandel. This series was issued by the artist professedly as a work on foliage, not (as he tells us in a prospectus) to portray botanical varieties or celebrated trees, but to depict the marked features that give, or combine to give, a peculiar charm to landscape. It was not, on the other hand, intended merely for technical instruction in drawing. This had been given in his treatise 'On the Use of the Lead Pencil.' It was an attempt (and no better has ever been made) 'to illustrate the picturesque beauty of trees themselves, alone and in combination,' and 'afford ideas to the planter and the landscape gardener, as well as to the artist.'—Our artist's last set of original lithographs was published a few years before his death, and was in the nature of a summary of his life's work, being appropriately called *Picturesque Selections*, subjects, as he describes them, 'selected from a large collection of out-of-door studies, rather for their picturesque than for their imposing character.' It is a large folio, published by Kent & Co. (1861 ?), containing thirty lithographs, some with two, three or four subjects on the stone. Some are dated 1859 and 1860. They were printed by Lemercier of Paris, and Hanhart & Co. of London, and professed to embody all the then improved appliances of lithography. The artist considered that in them he approached more nearly than he had yet done to 'the freedom and force, in short the individuality, of an original drawing in black and white chalk upon tinted paper.' The drawings in this work, as in the cases of the 'Sketches at Home and Abroad' and the 'Park and Forest,' were to be effaced from the stones after a thousand impressions had been taken.

In the following publications, Harding worked more in association with others : *Recollections of India*, by the Hon. Charles Stewart

Hardinge, in two parts, royal folio (McLean), 1847. Twenty-two out of the twenty-seven lithographs are landscapes drawn on the stone by J. D. Harding, from sketches made by the author in British India, the Punjab, and Kashmir, in 1845–46, some being scenes during the Sikh war. The figure groups were partly arranged by H. Warren. The prints are on tinted paper, and heightened with white.— S. C. Hall's *The Baronial Halls and Picturesque Edifices of England*, 2 vols. imp. 4to (1848 ?). The seventy-two lithotint illustrations herein were produced under Harding's superintendence, and many drawn by himself on the stone ; thirteen of the latter being also from his original designs. Dates from 1843 to 1847 are on the stones. There are also many cuts, some of which are probably his. Prout, Cattermole and Holland are among the other contributors.— J. P. Lawson's *Scotland Delineated*, 2 vols. folio. Published in parts, first by Hogarth, afterwards by Gambart, 1847 to 1852. Many large lithographs, seven of which are from Harding's drawings. Of these, four were also put on the stone by him ; and he further lithographed thirty-two after Leitch, Cattermole, Roberts, Stanfield, J. Nash, and Creswick.—To the list of drawings on stone, by Harding, after the designs of other artists, have to be added some in J. F. Lewis's *Sketches and Drawings of the Alhambra*, imp. folio, (1835 ?) 1838.

The long series of published works in which Harding appears not only as a practical artist, but as a teacher of art, have yet to be mentioned. To deal with them fairly, and indeed to form a just estimate of the whole produce of his pencil, it is necessary to have some acquaintance with the theories that governed and regulated, and in some respects limited, his practice. The outlines and tendency of both may be gathered from two treatises written as text-books in two successive grades of instruction. The first, originally published in 1834,[1] is entitled *Elementary Art, or the Use of the Lead Pencil*, and, as its name implies, is devoted not only to an explanation of the best methods of representing natural objects by line and shadow, but to an advocacy of the implement above named as applicable to that purpose. Therein he holds up to just ridicule some of the crude and laboured 'styles' of pencilling which it had hitherto been the

[1] The third edition (royal 8vo) was published in 1846, the fourth (4to) in 1854. In these the second title was enlarged into *The Use of the Chalk and the Lead Pencil*, and ther were divers emendations and new illustrations.

habit of drawing masters to teach ; and inaugurates a better method, based on observation of nature, but having due regard to the powers and limits of the material, a method which has since been generally adopted by landscape draftsmen when sketching in black and white. The work contains many beautiful and characteristic examples of Harding's own handiwork, chiefly drawings on stone of sylvan sub- jects. The author's main theme throughout is the representation of foliage. The germ, indeed, of the ' Elementary Art' is said to have been an observation that occurred to him during his early sketching in Greenwich Park, that the theory of tree-drawing should be based on the laws of tree-growth.[1] His subsequent thoughts on the subject he now reduced to systematic form. In a later volume [2] devoted exclusively to this branch of the subject, he again sums up his theory somewhat in this fashion. Seeing that the endless ramifications and aspects of leaves, in a tree, are beyond human power, both of vision and imitation, all that the artist can do is to convey an impression of the essential qualities which distinguish them from other classes of objects. His task must be to impart ' ideas of their height, their rotundity, their intricacy, the transparency and flexibility of the foliage, the opacity and hardness of the stems and branches, and the suppleness of the spray . . . that some branches project, that others recede ; that some trees are young and pliant, others old and rigid.' Ruskin, who was a pupil of Harding's,[3] admitted him to be ' un- questionably the greatest master of foliage in Europe,'[4] but disparaged his practice as ' originally based on the assumption that nothing is to be delicately drawn, and that the method is only good which insures specious incompletion.' ' His execution,' he adds, ' which in its way no one can at all equal, is yet sternly limited in its reach.'[5] He declares him over-fond of brilliant execution, ' fonder of seeing something tolerably like a tree produced with few touches, than something very like a tree produced with many ; '[6] a kind of criticism which might, however, be applied to the whole practice of suggestive generalization which we understand by the term ' sketching,' a term fairly descriptive of the best of Harding's drawings in pencil or chalk.

In the *Principles and Practice of Art*, royal quarto, 1845, Harding

[1] *Portfolio*, February 1880. [2] *Lessons on Trees*, mentioned below.

[3] ' When the first volume of *Modern Painters* by an Oxford Graduate appeared in 1848, many of his old pupils recognised, in an amplified and elaborated form, some of his lessons in chapters " on skies," " on water," " on mountains," &c.' (*Portfolio*, February 1880.)

[4] *Modern Painters* (fifth edition), i. 382. [5] *Ibid.* iv. 79. [6] *Ibid.* i. 397-9.

ascends to higher ground, treating, under the first head, of the philosophical theory of Beauty, and under the second, of pictorial devices more than the imitation of objects. The writer continues to advocate the kind of imitation that is mental rather than mechanical, subjective rather than objective, and upholds his principles of art as deducible from truths existing in nature ; contending that in Form and Composition, at least, wherein the feelings and the judgment are equally concerned, the latter should hold the former in control. Harding's theory of Beauty, like Hogarth's, is based on Variety, which he regards as a primary characteristic of Nature. 'Perfect Beauty,' he affirms, ' is constituted of infinite Variety.' His choice of forms and grouping of objects, therefore, has constant reference to this essential quality. In the practical application of his theory, however, he pursues an entirely different course from that of Hogarth. Whereas the latter employed it to trace and modulate the gradations of a curve, the former appeals to it in marshalling contrasted objects and regulating the proportion of opposing forms and masses.[1] It is less with him a guide to ' the Beautiful,' the smooth and polished symmetry of Edmund Burke, than a means of insuring 'the Picturesque.' Composition, while conducive throughout to this view of perfection in the general design, he further employs for the practical purpose of avoiding some of the defects which are necessarily inherent in graphic art. Principally he uses it to overcome the consciousness of a flat surface and of the boundary of a picture ; pointing out the arrangements of lines and objects most conducive to ideas of space. The volume contains useful hints for the management of light and shadow, mainly with the same object ; chapters on colour and drawing from nature, and an appendix on materials, wherein he strongly advocates opaque white for the lights, and gives a list of thirty-three pigments found by him to be ' permanent' after four years' exposure to light and rough usage.[2] The book is profusely illustrated with

[1] Harding goes so far as to denounce in set terms the 'repetition of forms,' which he says had been ' urged as a special nostrum for good composition,' calling it ' a fallacy ' which ' a breath should be sufficient to dispel.' He is constrained, however, to admit that ' repetition of *lines* and *forms* of the same kinds of objects . . . may sometimes (rarely) be useful ' to give an idea of ' repose.' Many of Harding's works would have been the better for a little of this ' repose ;' which with a wider theoretic view would in itself have added more of the variety that he worshipped.

[2] Harding also exerted himself to secure to artists a supply of the best materials by lending the sanction of his name to specially prepared pencils, and by the invention of a well-known kind of drawing paper, admirably adapted to the reception of even washes of colour.

original examples executed by the author himself in various styles of engraving and lithography. A posthumous edition edited by William Walker (a pupil of Harding's) was published by Kent & Co. in 1876 with some additional plates prepared by the author.

Other educational works were more in. the nature of drawing ·books of technical instruction, illustrated by examples. Harding, indeed, though most fertile of models for imitation, was wont to condemn the old plan of setting a student down to copy ' copies ' in an unintelligent way. This he likened to the equally antiquated school practice of learning lessons by rote, instead of reading and understanding what one reads. The object of his own teaching was to make the pupil think of the thing depicted, and descry the artist's meaning and intention, in place of resting content with his graphic results. The course of instruction in which Harding endeavoured, under this system, to embody the grammar of art, is comprised in the three publications next named :—*Lessons on Art* (second edition, revised, royal quarto, 1849 ; another, royal octavo, 1854). Here the author takes up the study from the very beginning, and, by means of a series of progressive examples, leads the pupil from simple forms to complex combinations, explaining the reason of every step. The book contains a series of 140 verbal lessons in drawing with the lead pencil, with lithographed examples and woodcuts, and blank spaces to copy on.—*Lessons on Trees*, royal quarto (Bogue), 1852. Contains sixty-three lessons on thirty stones, mostly signed and dated ' J. D. H. 1850,' with letterpress instructions. They are ' progressively arranged from the elements to the complete pictorial combinations.'—*Guide and Companion* to Lessons on Art, imp. 8vo, 1854. This was supplementary to the ' Lessons,' but meant more for teachers, to enable them to appreciate the scope and purpose of the system, and examine their pupils as to the intent of every line and touch of the pencil. Thus the ' Lessons ' were to teach *how*, the ' Guide ' to explain *why*. These books are confined to pencil drawing, being in fact an amplification of the ' Elementary Art.' In the earlier work he had, as we have seen, exposed the inartistic aims of the old teachers, whose pupils learnt to pride themselves on smoothness of touch and softness of effect, or on a ' bold ' handling without regard to facts of nature. In these later volumes he not only shows the real power of the material, but defines the limits within which it can be fitly applied to the delineation of natural facts. For example, he holds

that local colour should rarely, and only in very marked instances, be indicated by pencil shading, the brush being the proper implement for this purpose. Harding's disapproval of direct copying was further applied to the mere imitation of natural objects. He recommended the delineation of general (geometrical) forms, as a matter distinct from shadows and from details of texture, and for such practice devised a set of cubic sections which, put together in various ways, were capable of being combined in an endless variety of solid structures, bearing a general resemblance to buildings and other objects. He had these 'models,' as he called them, manufactured and sold, and afterwards published a small illustrated handbook setting forth their advantages, entitled *Drawing Models and their Uses*, foolscap 8vo (Winsor & Newton), 1854. In the 'Guide and Companion' he further carries the student, with their help, to the application of his pencil to shading and shadow, and the indication thereby of the different textures of surfaces.

Besides these treatises, in which precept and example were combined, Harding brought out very many sets of lithographs containing the latter alone. The list that follows comprises all that have come to the writer's knowledge, but its completeness is not vouched for : *The Lithographic Drawing Book* for the year 1832 (six numbers). *Ditto*, 1834.—*Hullmandel's Lithographic Drawing Book* for 1835 (this contains twenty-four numbered prints on white paper, the subjects embracing English and foreign landscapes, architecture, marine, &c. They are effective and in a matured style. Mostly signed 'J. D. H. 1834'). The above were all published by Ackermann & Co.—*J. D. Harding's Lithographic Drawing Book* for 1837 (Charles Tilt), imp. 4to. Six numbers. Contains twenty-four numbered prints of home and foreign picturesque subjects, on stone-tinted paper without white. Some are signed 'J. D. H. 1837.'—*Harding's Early Drawing Book*, oblong imp. 4to (Charles Tilt). Contains twenty-four lithographed landscape studies, signed 'J. D. H. 1838.' *The Lithographic Drawing Book for* 1838. Six numbers. (According to Ackermann's advertisement in 1840 there were two such series, one in imp. 4to at 3s. a number, the other at 1s. 6d. a number ; complete at a guinea and half a guinea respectively.)—*Harding's Drawing Book for the Year* 1841. 'Studies in Sepia, partly original and partly selected.' Imp. oblong 4to (Tilt & Bogue), 1841. Contains twenty-four subjects, some reproduced before, mostly English views. In a

mixed manner of lithography and lithotint, heightened with white. The imitation of sepia drawing is not nearly so well given as it was by the old aquatint process in Prout's and Cox's early examples.—*J. D. Harding's Lithographic Drawing Book for the Year* 1847, imp. oblong 8vo (David Bogue, late Tilt & Bogue). Contains twenty-four numbered prints on white paper. Some signed ' J. D.. H. 1846.'—*The Early Drawing Book*, by J. D. H. ' New edition '(Bogue). Imp. oblong 8vo. Contains twenty-four lithographs of studies and bits, chiefly of rustic and picturesque architecture, dated 1854, 1855. The author explains in a prefatory address, that the work is ' supplemental to " Lessons on Art" and "The Guide and Companion," and intended to supply examples for the application of principles and methods learnt from those works.'—*J. D. Harding's Drawing Book*, 4to (Winsor & Newton). Contains forty lithographs (published in eight numbers), dated 1863. They form a progressive series, the latest being elaborate drawings, much shaded. Some have perspective and guiding lines added, and of some there are separate outlines. These numerous books, says Ottley, gained for their author ' the highest eulogium from foreign artists of eminence, and a hearty, almost reverential, welcome among every artistic association he chanced to visit abroad. In the schools of Paris especially, which he often visited, he had always an enthusiastic reception from professors and students.' [1]

It was not only by the employment of his pen and pencil thus, as well as by his own personal tuition, that Harding laboured with all his might to place the education of students in art upon a sound basis. He had endeavoured to organize a system of training teachers long before the Government measures were adopted for that purpose in connexion with schools of design, and had nearly matured a scheme which was frustrated by the death in 1850 of Sir Robert Peel, whose approval had been gained ; as an earlier plan with a similar object, which he had hoped to set on foot at Rugby, had had to be abandoned on that of Dr. Arnold in 1842.[2] And again, at a later period, he brought forward, as already related, a proposal at the Water-Colour Society, to employ their vacant gallery in the winter months as a place of instruction. But this proposal was defeated by the amendment which resulted in the establishment of the Winter Exhibition of Studies and Sketches.

The ' Principles and Practice of Art ' was published about a year

, [1] Supplement to Bryan's *Dict. of Painters and Engravers.* [2] *Portfolio,* Feb. 1880.

before Harding sent in his resignation of Membership of our Society. This was not, however, his final adieu. In the year after Fielding's death, namely on the 30th of July, 1856, he was restored to his former position ; and he remained a Member until it was his turn to depart this life also. In the mean time he had been making ineffectual attempts to obtain admission to the Royal Academy. From the year 1843 his name reappears in the Academy Catalogues after a long absence, and from that date until 1858 he had generally from one to four works in the exhibition at Trafalgar Square. Generally they were views in Switzerland or Italy. In 1846 a view of Verona is accompanied by three stanzas from the pen of Mrs. V. Bartholomew. The single exhibit in 1848 appears to have been the same grand view of the high Alps that had been the subject of his last contribution to our Society in 1846. As a rule his works in oil, though they were brilliant and effective, do not seem to have met with much favour from the hanging committee. One of his best, in 1850, was placed in the Architecture Room.[1] He was, however, honoured by a commission from her Majesty the Queen to paint a picture of the Crystal Palace of 1851, which was exhibited in the following year. A view of the reconstructed edifice at Sydenham followed in 1854. In 1855 his works at the Paris Exhibition received honourable mention, he being the only English landscape painter not in the Royal Academy who was thus distinguished.[2] After returning to the Society he had but one more picture at the Academy, a view of Fribourg in Switzerland, in 1858. Switzerland had latterly become a more constant sketching ground ; and he was there in 1850, 1853, and 1856.

He was then residing at 3 Abercorn Place, St. John's Wood, which was his address from 1848 to 1860. Then he removed to 15 Lonsdale Terrace, Barnes, where he died on the 4th of December, 1863, in his sixty-seventh year, after two months' illness. He had that year been in Switzerland. At his funeral, in the West London Cemetery, New Brompton, the Society was represented by several of its Members. During his second Membership, Harding exhibited thirty-five works, ten of which were in the first winter exhibition in 1862–63. They were British and foreign views of the same class as before, and make up the total of his exhibits at the Society, including his three years as an outsider at Spring Gardens, to 116. Graves counts up his exhibits at the Academy as thirty-five, at the British

[1] *Art Journal*, 1 June, 1850. [2] Ottley, *Dictionary of Modern and Living Painters.*

Institution eight, and Suffolk Street seventeen ; making an addition of sixty, mostly oil pictures.

The sale of his remaining works, numbering more than 400, with some drawings by other artists, produced 4,000*l.* at Christie's in May 1864. The highest price for a work of his own was forty guineas for 'On the Wharfe.' The following prices above 200*l.* have been obtained for Harding's water-colour drawings in public sales.[1]

· Price	Title &c.	Collection	Year of Sale
£ s.			
399 0	'Grand Canal, Venice' (engraved) .	Sir G. F. Moon . .	1872
320 5	'Venice' (30 × 42 inches) . . .	W. Leaf . . .	1875
294 0	'Berncastle'	G. Bicknell . .	1863
275 5	'Marseilles' (21¾ × 34¾ inches) . .	Knowles . . .	1877
215 0	'Wisp on Simplon'	S. Rücker . . .	1852
210 0	'Lake Como'	Rücker executors .	1876

To the list of Harding's writings must be added a paper ' On some ancient Greek Vases found near Corinth,' in the *Journal of the Society of Arts* supplemental volume, 1852.

WILLIAM HUNT lived through Copley Fielding's time, and in the twenty-five drawings which he sent on an average each summer to the gallery for the first score of these years, the various phases of his mature art were fully exemplified. These range themselves within a few simple divisions ; for his scope was not wide, the quality of his greatness being in a manner dependent on the narrowness of its field. How well he accomplished what he undertook cannot be duly estimated without bearing in mind how much there was that he never attempted. The drawings of William Hunt (*paintings* they should be called, for colour is of their essence) were rarely more than ' studies '—studies, that is to say, *from* nature, or of external objects, natural and artificial, mostly the former ; not studies *for* pictures, nor experiments in composition or combination, or contrast, or proportions of form or mass, or even of colour. Rarely, and to a very limited extent, did anything of the nature of the ideal enter into their con_ ception. When settled in his domain, the subjects over which he ruled supreme were almost limited to single figures and heads and still life ; including under the latter term, fruit, flowers, dead birds, nests, and a few interiors. But in all these classes it was rustic life

[1] Redford's *Art Sales.*

and rural nature only, in their uncultured state, which he sought to depict. In each branch it was the same. His interiors were of the stable, the kitchen, and the blacksmith's shop. His figures were Hastings mariners, or peasant boys and girls, with now and then a mendicant friar. His flowers, if not his fruit, grew in a village garden, or were gathered from the hedgerow or the coppice. This he could no more help, as Thackeray said of his own satirical vein, than one can help being 'irascible, or red-haired, or six-feet high.'[1] Hunt was not insensible to his want of power to depict genteel life, nor wholly without regret that it should be so. His correspondence with an intimate friend contains the following lament : ' I do not wish it to be known what I had to do for Mr. R——, but have no other objection to tell *you*, only that I am ashamed to say that I broke down ; it was to make a drawing of Mrs. R ——. I think I could have made a nice drawing of her if she had been one of my tramp girls. I think her very beautiful.' ' I wish,' he says in another letter, ' I could get a very beautiful face to paint from, so that I might, by taking a long time, try if I could not, although I broke down with Mrs. R——, still do something that way. It is a different thing having a lady to sit, to a model that you pay, and can have at your command at any time.' The only approach to added sentiment of a serious kind in his figure drawings occurs in a few to which he gave conventional names, such as ' Devotion,' ' Prayer,' ' Piety,' &c. Of these it may at least be said that they are unaffected and earnest in feeling, and afford a wholesome contrast to the ' Book of Beauty' type of drawings then in vogue with similar names. But they are less true because less spontaneous than the rest of his works, and are chargeable with over-finish in the execution. Mr. Ruskin, than whose no study of this great painter has been longer and deeper or more loving, places in the first and highest class of his figure subjects, his ' drawings of rural life in its vivacity and purity, without the slightest endeavour at idealization, and still less with any wish either to caricature or deplore its imperfections. All the drawings belonging to this class' he declares to be ' virtually faultless, and most of them very beautiful.'[2]

In depicting such subjects, this absolute adherence to unadorned and undistorted fact arose, in no degree, from want of discrimination of character, or dullness in the sense of humour. It was rather owing to the presence of these qualities in more than usual subtlety and

[1] Lecture on *Humour and Charity*. [2] *Notes on Prout and Hunt*, p. 85.

strength. He had a keen appreciation of the ludicrous, and as his principal biographer [1] tells us, although sensitively mindful of his personal deformity, which 'frequently made him reserved and not easily accessible to strangers,' yet at times, ' when his health was at its best and his spirits were' good, there were few more boisterous, gay, and frolicsome men than little ' Billy ' Hunt. He loved and was beloved by children, assisted at their games, was 'great in charades,' and ac-companied their songs by performing on the bones. He had. a pecu-liarly comic power of twisting the nasal organ, which he employed not only to amuse, but sometimes in self-defence. ' When walking on the parade at Hastings,' says the writer above quoted, ' the small boys laughed at him because he was deformed,[2] and probably because his hair was long. " I turned round upon them," said he, after such an event, " and shook my nose at them, and they were afraid." '[3] Finch declared to Samuel Palmer that Hunt used persistently to vote for electing as a Member a certain Associate (long since deceased) who was of a quarrelsome habit, mainly for the sake of the ' fun ' he would import into the meetings of the Society. Jenkins notes, under date of February 1856, how Evans of Eton told him that ' old Hunt,' as he was then, had just been chuckling over one of the candidate's drawings exhibited that day, and seemed to enjoy it more from its excessive badness, than the better class of works. It was the figure of a child, and he had ' found great humour in the legs, which he declared were drawn upside down, and struck him as " so funny." '

This unforced sense of the ridiculous was utilized largely in the class of work which gained him the widest popularity. At what precise date is uncertain, but it must have been near the end of Cristall's or the beginning of Fielding's reign, when Hunt had the good fortune to meet with a model at Hastings who served him for many of his best known and most characteristic works for years to come. He was a healthy-looking boy, a typical rustic in figure and face ; and withal a remarkably clever lad, being a capital mimic, who could assume a variety of expressions, and retain them long enough for the artist to fix them on his paper for all time. He was just the character for Hunt's pencil, and fed his lively zest for ' fun.' The youth was accordingly captured and brought to London, where the painter

[1] Mr. F. G. Stephens in *Fraser's Magazine*, October 1865, p. 531.

[2] His deformity consisted in weak legs, not properly attended to in childhood, so that his knees and toes turned in, and he could only shuffle along.

[3] *Fraser's Magazine, ibid.*

kept him in his house to draw from. Many and varied are the cha-
racters in which this lad was made to figure, and many and varied his
depicted occupations, as shown on the walls of the gallery in Pall
Mall East, for a long series of years, during which ' Hunt's boys ' were
always a stock feature of the old Water-Colour Exhibition. At one
time he would be a sturdy young cricketer, handling his bat with
nervous grasp and knitted brow, lips compressed, watchful and eager
of eye, the whole body braced up for a hard hit. At another, he
would be fast asleep in placid unconsciousness. In one picture you
might see him burning his mouth with hot porridge ; in another red
to the finger-tips with winter's cold. Here he is intent on catching
with his hand a ' bluebottle' on the wall ; there he dodges a wasp
with his knife and fork. Two of the most popular impersonations
were, it is believed, exhibited in 1834 under the names ' The Com-
mencement ' and ' The Conclusion,' but are better known as ' The
Attack ' and ' The Defeat.' These Mr. Jenkins describes in the follow-
ing words : ' In the " Attack " he is seen with an immense pie before
him. He has commenced a determined onslaught on the crust. Just
note how he holds the knife and fork ; how the hands are turned in
and the knife forced down to the very bottom of the dish. Sturdy in
hand, as vigorous as his appetite. His eye glistens, and his whole
face beams with healthy animal life. And he eats with hearty relish
as much as he can get, and is bent on making a holiday feast. In the
" Defeat " the same boy, the same table ; but the pie has vanished.
The young lout has eaten it all. The dish is empty, the knife and
fork drop from his listless hands, his head droops, his eyes are closing,
in a few minutes he will be asleep, dreaming, perchance, of mountains
of pies and endless treats.' [1] A few savoured more highly of carica-
ture. One in particular of ' a young shaver,' or, as it was also pun-
ningly called when exhibited in 1841, ' giving himself (h)airs,' would,
with others in which lather was a main element, have brought him a
small fortune in these days of saponiferous advertizing. The humour
of these boy-pictures was not, it may be admitted, of the most refined
order. Mr. Ruskin says they ' are usually very clever, and apt to
be popular,' but condemns them as ' on the whole dishonourable to the
artist.' [2] And the purists in art call them vulgar. But they are not

[1] J. J. J. MS.
[2] *Notes on Prout and Hunt*, p. 86. This must be taken in connexion with the writer's dictum
that ' there is no place for humour in true painting ' (*Ibid.* p. 89). Thackeray, on the other
hand, somewhere wrote : ' If I were the Duke of Devonshire, I would have a couple of Hunt's

necessarily so, though their subjects may be, and ordinary people liked them so much. Hunt's humour, no doubt, belongs to the class of low comedy ; but a low comedian may be free from vulgarity, as, for example, was the late Robert Keeley, to whose humour that of William Hunt bears no small resemblance. There is in all these boys the same apparent unconsciousness of the presence of a spectator that was characteristic of the style of that excellent actor. It was this purely native expression that Hunt detected and was able to represent. Its absence in persons of a higher class disqualified them for his models, the facial expression of well-bred folk being too much under their own control. So, too, when Hunt chose to be pathetic, his pathos was simple and unaffected as that of Keeley, and Robson too, when in a serious mood. In course of time it was but natural that Hunt should be deprived of his clever boy model with the flexible face. Being a strong, healthy lad, he in a few years outgrew his master's requirements. With his waning adolescence, the series of portraits came to an end. ' What a pity ! ' sighed Hunt. ' He ought never to have grown.' But the grateful painter did not forget him in after years, and left him a small legacy.

There were other figure subjects among Hunt's studies, less liable than his ' boys ' to the above kind of criticism. Several were of negroes, generally young, whose dark skins afforded good material for his wonderful blendings of colour. These had nothing of the modern comic ' nigger ' element about them, though he may have given them on occasion such popular names as ' Massa Sambo ' (1836), ' Jim Crow ' (1837),[1] or his sister, ' Miss Jemima ' (1839). There was, indeed, no touch of the ' Elegant Pastoral ' in his village maidens, and the actual grace which exists among them is absent from his portraiture. ' It is to be sorrowfully confessed,' says Ruskin, ' that the good old peach and apple painter was curiously insensible to this brighter human beauty.'[2] But they are none the less true for all that. The nice observation of character shown in such studies as ' The Shy Sitter,' now in Mr. Orrock's collection, it would be difficult to surpass. Some of

in every room in all my houses ; if I had the blue devils (and even their Graces are, I suppose, occasionally so troubled) I would but cast my eyes upon these grand, good-humoured pictures, and defy care.'

[1] One Rice, a comic singer, with a blackened face, was at this time very popular in London, the burden of his song ' Jump Jim Crow ' being in every mouth. This was some years before the original ' Ethiopian Serenaders ' at the St. James's Theatre brought bands of coloured minstrels into fashion.

[2] *Notes on Prout and Hunt,* p. 13.

his figure subjects were possibly chosen for the sake of the accessories. Now and then he gave us a Capuchin monk, whose grey beard and the coarseness of whose serge dress could not fail to be an attraction to the painter. And to a late period he continued to exhibit at intervals examples of plain interiors and of the candlelight effects which had first brought him into notice. Gradually the proportion of life studies became smaller, those of still life more numerous, until the latter superseded the former entirely.

In 1845 Hunt moved from the neighbourhood wherein he had resided for more than twenty years—the last three at 55 Burton Street, Burton Crescent, the preceding ones at 6 Marchmont Street, Brunswick Square—to No. 62 Stanhope Street, Hampstead Road. The studio in Marchmont Street seems to have been an untidy place with a flight of ladder steps by which to climb into it, and a dirty floor, full of holes. James Holland related to Mr. Jenkins how the dealer Roberts (nicknamed 'Spectacles'), who had a keen eye to business, once paid Hunt a visit there, and glancing round at the dirt, scraps of paper, drawings, and sketches, remarked that it was 'no use working in such a sty as that,' and advised him as a friend to 'have a clear out, and sell the whole, muck and all, in a lot.' 'But who would be the buyer?' said Hunt. 'I will,' replied the dealer, flourishing a handful of new bank-notes, amounting in value to 200*l.* The bargain was struck. Hunt took the notes; and Roberts, after having the drawings 'shaved, pared, clipped, and mounted,' made a good thing of the transaction; while the artist found that he had been too precipitate in the matter. Among the drawings which thus changed hands was a study for which Holland's little daughter (who afterwards died) had sat as the model. Her father told how, to the child's disgust, the painter had stripped off her nice frock, put on her 'a nasty red petticoat,' and thrust into her hand a large lump of yellow soap, calling the subject 'Saturday Night.' What a pictorial prize for some artistic soap-boiler of the present day!

In 1851 the number of his exhibits drops suddenly from twenty-one to eleven, all of which are flower and fruit pieces. After that date they greatly outnumber the other classes of subjects in his annual average of about eight works. This year (1851) is the first in which he gives a country address in the catalogue, namely, 'Park-gate, Bramley, near Basingstoke, Hants.' This for a series of years he adds to that in 'Stanhope Street, Hampstead Road.' Probably a

resort in summer to his Hampshire home had become a substitute
for his annual sojourn at Hastings. However that may be, he was
now looked upon almost exclusively as a painter of fruit and flowers,
and in this capacity won a place in popular estimation as high as he
had previously enjoyed as a humorous delineator of rustic life.
Those who had been most tickled with the fun of his boy-pictures,
declared that his fruit made the mouth water. It was with a different
kind of admiration that the connoisseurs regarded his works. To
them, no matter what the subject, it was as a consummate painter
and colourist that he stood unrivalled among water-colour draftsmen ;
as one moreover who, deriving his power from observation of nature
alone, had been 'enabled to set forth at once the wonderful simplicity
and the divine mystery that exist in common things. No painter in
his time,' wrote a just critic in the month of the artist's death, ' has
been endowed with so marvellous an insight into the subtleties of
colour ; and, although he was not a designer, and his pictures were
always painted directly, and almost slavishly, from the objects before
him, his perception of truth was so fine, and his colour so full and
resplendent, that under his treatment the most commonplace people
and things were invested with an interest utterly new to us, which we
should perhaps have been too proud to discover for ourselves, but
which he, in his humility, had brought to light. We were but faintly
beginning to appreciate and understand his genius, when he was
taken from us—one of the greatest artists of the century.' [1]

A representative set of eleven of Hunt's water-colours were in
the Paris Universal Exhibition of 1855, where they are said to have
been highly appreciated ; and from 1856 he added to his name the
honorary title of ' Member of the Royal Academy of Amsterdam.'

In a previous section of this memoir some of the technical
characteristics of Hunt's earlier manner have been described.[2] In
the course of what he called the ' fudging out' of his art, he had
gradually changed his method of painting, and more especially his
selection of materials. Beginning with an exceptional and sparing
use of opaque white, he increased it by degrees, combining and
mixing it more or less freely with the transparent pigment, until in
his latest flower and fruit pieces there is little else but body colour,
and what had hitherto been regarded as distinctive of water-colour
painting was discarded altogether. 'His later' drawings, writes

[1] *The Reader*, 27 February, 1864. [2] Vol. i. p. 470.

Ruskin, depended 'for their highest attainments on the flexibility of a pigment which yielded to the slightest touch and the softest motion of a hand' always more sensitive than firm.'[1] Hunt's handling was peculiar, but no other method would seem capable of reaching the essential qualities of his work. Ruskin aptly describes it as a 'broken execution by defined touches,' touches which, however minute, 'are always frank and clear, to a degree which may seem not only imperfect, but even harsh and offensive, to eyes trained in more tender or more formal schools.' These 'became indeed in process of years a manner in which the painter somewhat too freely indulged, or prided himself; but it had its origin and authority in the care with which he followed the varieties of colour in the shadow, no less than in the lights, of even the smallest objects.'[2] It was, in fact, a method of painting opposed to that which had long prevailed in the water-colour school, of transparent washes of colour over colour, or the blending of tints in each ; and it marked a new departure in practice. The course finally adopted by William Hunt to 'render with absolute purity all accidents of local colour and all differences of hue between direct and reflected light' was that which found favour with the new pre-Raphaelite school, of which the critic quoted was then the leading apostle, namely, to 'attain the required effect' not by 'pigments mixed on the palette, but only interlaced touches of pure tints upon the paper.'[3] When in the last decade of his life, the artist was employed by Mr. Ruskin to make a series of small studies of natural objects as types of work to be given to country schools of art. Six of them were exhibited in the gallery between the years 1856 and 1861. Some of these, in particular one of 'Mushrooms—Study of Rose-Grey' (1860), were exquisite. But the generous donor ultimately gave up the project, finding, as he tells us, that 'no kindness or care could altogether enable' the artist 'to work rightly under the direc-tion of another mind.'[4] The old man used to pause in the task, which he was trying his very best to accomplish, and cry out, 'How difficult it is to paint this oyster-shell!' After painting some 'Pilchards—study of gold' in 1860, one of the most striking of the series, he wrote, however, 'If you want studies of colour, fish is the sort of thing to look at.'

Hunt himself described his method as 'pure colour over pure

[1] *Notes on Prout and Hunt*, p. 9.
[2] *Ibid.* p. 18.
[3] *Ibia.* p. 18
[4] *Ibid.* p. 84.

colour;' and of body-white he said, 'I always glaze it over with pure colour.' On one occasion, however, he was heard to exclaim, 'There is colour upon that light, but I cannot afford it.' Again, 'It is astonishing the number of colours you can work into flesh.' But for so 'working in' these many hues he repudiates the employment of opaque pigment in the following criticism of one of Lewis's later water-colours. 'I think it much inferior to his former work. It is most painfully made out. It is painted in body colour, which will never do for flesh.'[1] That there was no spark of jealousy in such criticism on one distinguished like himself for the same minuteness of detail, may be inferred from the modest candour evinced in the following extract from a letter to the same correspondent dated 24 April, 1862 :—'I think I have learned much from seeing Birket Foster's and some other drawings, and intend to try to take advantage of the knowledge as soon as I get into the country, for I think it never too late to try to do better.' Hunt at any rate was true to water-colour. Late in life he wrote (with more shrewdness than grammar) to his friend Brown :—'The Water-colour men are taking to oil; that will be all the better for those who stick to Water. I am fearful Cox will never get the same qualities in oil that he gets in water, and which quality was a great charm in his works.' .

What has been related above of William Hunt has been chiefly connected with his work as an artist; for all his life long he was devoted to the practice and improvement of his art, and beyond and beside his technical knowledge and keen observation of what he saw, he was not a man of much intellectual culture, having received but a poor general education. His love of flowers was not that of the botanist or the horticulturist, nor in his view of human nature was he either philosopher or poet. To the end of his life he retained a taste engendered no doubt during his early residence in the parish of St. Giles, a simple delight in theatrical entertainments. 'It was very striking,' writes Mr. Stephens, 'to see the white-haired, eager-looking old man absorbed in the glitter and show of the stage.' To take him to the play was to give him a great treat. 'There he would sit, his hands upon his stick-top, bent forward with strength of interest in the performance, his eyes bright as those of a child, his mouth restless with emotion.' And, strange to say, what charmed him most were

[1] In a letter to Philip Brown, Esq. The picture was probably 'The Hhareem,' exhibited in 1850

productions 'of the melodramatic and "spectacle" order; a sensa-
tional piece was his delight, fireworks fascinated him, blue and red
fire had charms at the age of three score and ten years.'[1]

Like most of his brother painters, Hunt gave lessons to pupils
during some part of his career.[2] But there can have been little of the
conventional drawing master about him. He had indeed an aversion
to the recognized system of teaching. 'I cannot tell,' he wrote in an
outspoken friendly letter, 'what to recommend you to do. I should
say paint your pictures from nature ; and, if you did that, there are
some of the members, Mr. Harding in particular is, strong against
that, and says if that is Art he knows nothing about art. Perhaps he
cannot paint from nature, at all events only in his mannered way. I
like some of the Preraphaelites' work which looks like the thing they
represent, not as if they had been taught in a conventional manner
like Harding and lots of his school.' He has been known to say, on
looking at a picture, 'I like that because it is not like a drawing
master's drawing.' We have seen how little he was able to lay down
rules or propound doctrines, and what was his advice to one young
student. One more example may be cited of the kind old man's
readiness to assist another, as well as to acknowledge talent whenever
he saw it. It is in the following account given by Miss Clayton :—
Miss Anna Maria Fitz-James, a fruit painter (a pupil of Valentine
Bartholomew), 'with a view of obtaining pupils, exhibited a small
painting at a shop in Camden Town. Shortly afterwards, on entering
the shop, she was informed that this work was sold. An old gentle-
man had been so much struck by the little drawing that he was
anxious to see the painter. The name of this old gentleman was
William Hunt, and of his kindly, flattering invitation the young
aspirant was only too glad to avail herself. . . . From that time until
his death Miss Fitz-James found William Hunt the best, the kindest
of friends, although two years elapsed from the beginning of their
acquaintance before he would take her as his pupil. Having discon-
tinued teaching so many years, he feared to offend those whom he
had refused. One morning in July 1863, when Miss Fitz-James
went to him, he was painting one of his most lovely pictures—one
composed of white grapes, two peaches, and some holly. He told his
young visitor of the difficulty he had met with in procuring the holly,

[1] *Fraser's Magazine*, October 1865, p. 528.
[2] Mr. John Sherrin, R.W.I., was a pupil of Hunt's.

having obtained it from a stranger, in whose garden he saw it at Hampstead Heath, when being driven out in the little pony carriage belonging to a friend, who used to call and take him out for drives. It was the only time Miss Fitz-James ever found her dear old master low-spirited ; it was just after his accident, and that morning he had heard of the death of his old friend and brother artist, William Mulready.[1] He was just four years the senior of William Hunt. Seven months later, the mourner himself was laid to rest.'[2]

This brings us to the last stage of our narrative, and refers to an event to be described in fuller detail. On the 23rd of May, 1863 Hunt had written to his 'friend Brown :' 'I am glad to say I can still amuse myself by making drawings. Of course you will be in Town before long to see the Exhibitions. I fear I shall not be able to see them. If you or your son Charles are in Town before I leave, which will not be yet awhile, perhaps you would help my nephew get me up the steps and stairs of the Royal Academy. I should much like to go there.' While at Bramley in the following summer, he met with a serious accident by a fall on the staircase, owing to the breaking of a rope which he had used instead of a rail wherewith to haul himself up to his bedroom. It gave way as he was descending the stairs, and (to use his own expression) he 'tumbled down to the first landing all of a heap.' This mishap occurred on the 14th of · July, and it was unluckily followed soon after by a second of the same kind ;[3] in an attempt to seat himself, he appears to have mistaken the position of his chair. 'Of course,' he writes on the 3rd of August, 'I fell to the ground all my weight, and hurt the opposite side to that which was hurt before, and now I am quite unable to walk at all.' On the 13th of October, however, he writes again to the same friend :—'I am tolerable myself—except that I am very feeble. How I do wish that I were 30 years younger ! How I would paint out of doors ! I suppose it is that I must not sit out of doors that makes me think I never saw the country looking half so beautiful as it does at present. . . . One sees so much more might be done when we are about being obliged to leave it off altogether. . . . You must fag away and do better and better.' In November he is in London again; for he writes on the 21st :—' You will of course be in Town when all the

[1] He died on the 7th. [2] *English Female Artists*, ii. 274, 275.
[3] These were not his first misadventures of the sort. On 17 May, 1861, he writes with 'a sprained hand, having tumbled out of a cab a fortnight back.'

Exhibitions are open. I get to see very few drawings, but did manage
to see the Winter Exhibition, by sending a chair with wheels to the
Gallery on Saturday and going there on the Sunday—so had a good
view of the pictures by myself—no one to get in the way.' Thus all
his thoughts and interests were absorbed in his art still ; and he con-
tinued to busy himself in the welfare of the Society. The last acts of
his life had relation to the selecting of candidates for admission as its
Associates. The place of meeting for that purpose, on Saturday, the
6th of February, 1864, was at Suffolk Street. Thither he sent his
invalid chair ; and after spending the morning at his easel, he was
carried up to the room where the probationary drawings were on view.
Next day he wrote to the Secretary :—' Will you have the kindness to
give my vote for Watson, Walker, Lundgren, and Solomon ? The
drawings by Shields and Johnson are very good, do you not think
so ? If you elect more than four,[1] I should give my vote to Johnson.'
This was the last note that poor Hunt was destined to write. The
effort to attend the election had proved to be more than his enfeebled
frame could bear. Soon after returning home he had been taken ill.
A paralytic attack supervened ; and, at the gallery, on the Monday
morning, shortly after his communication had been received, a further
message arrived that Mr. Hunt was speechless. He died on the
following Wednesday (Ash-Wednesday), the 10th of February, 1864.
His grave was made in Highgate Cemetery, where his funeral was
attended by many artists, including a representative group from the
Water-Colour Society.

In the summer exhibition of that year, a marble bust of the
deceased, by the late Alexander Munro, the property of Madame
Bodichon, was placed in the centre of the gallery. This bust was in
the summer of 1889 presented by her to the Society, and it now
occupies a recess on the staircase. There are two portraits of Hunt,
painted by himself, the property of Mr. Sutton Palmer and Mr. Osler
respectively. In the *Illustrated London News* of 20 February, 1864,
there is a woodcut of him, a half length, seated, the face nearly in
profile.

William Hunt was married,[2] and had one child only, a daughter,
who became Mrs. Robinson, and several grandchildren. He seems

[1] There were only two vacancies, which were supplied by Walker and Lundgren, both
deceased. Watson and Johnson have since become Members ; and Shields is an Associate.
[2] It is stated in *Century of Painters*, ii. 505, that he ' never married.'

to have survived his wife, for her sister, Miss Holloway, kept house for him for many years up to his death. A nephew, William Hunt, attended upon him a good deal in his helpless bodily condition. Among these and other relations he was able to divide a personal estate valued at about 20,000*l.*

The number of Hunt's drawings in the Society's summer Exhibitions, from 1824, when he was made an Associate, to 1864, the year of his death, was 742; whereof 507 belong to the twenty-three years of Fielding's presidency. To these must be added the nine works sent to Spring Gardens, and forty studies and sketches in the first three winter Exhibitions ; making a total of 791 works of all kinds. A sale of remaining works took place at Christie's in May 1864, mostly sketches and slight studies of figures, beach scenes at Hastings, &c. ; scarcely any of flowers or fruit. The latter class of subjects had had too ready a sale to need recourse to the auction room. They had lately, to his own regret, occupied him entirely. On October 25th, 1863, he had written :—' I was in hopes of trying my hand at figures, but have so many persons' promises to do fruit and flowers for them, that I can get no time to do anything else.' Thus he was not one of those who, as his father had prophesied he would be, are unable to make a living out of the painter's trade. Even during his lifetime the market value of his works rose so as to justify him in considerably raising his prices in his later years. ' Les petites études de M. Hunt,' says our French critic, amazed, in 1855, ' qui frisent de près la caricature, se vendent plus cher que les tableaux de M. Ingres et de M. Delacroix.' [1] In September 1858 Hunt writes :— ' I have now thirty-five guineas for the same size that I used to have twenty-five, perhaps somewhat more finished. On the 8th of March, 1862, he writes :—' Friend Brown—I am still painting fruit. You will be glad to hear a drawing of mine of a bird's nest was sold at Christie's yesterday for 117*l.*, size 11 by 10 inches.' One of his best known works, called ' Too hot !' representing a boy cooling his porridge, which he repeated more than once, was sold before he died for 300 guineas. The same, or a replica, realized no less than 750 at Quilter's sale in 1875. That price was also reached on the same occasion by ' The Eavesdropper ' (29 × 21 in.), which had been sold two years before for 520. In 1872 ' Spring Gathering ' (12⅜ × 16½ in.) brought 590 guineas at

[1] About's *Voyage à travers l'Exposition des Beaux-Arts*, p. 32.

Gillott's sale, and in 1868 an oval study called 'Supplication' was sold for 50s. Two flower and fruit pieces have also reached the price of 500 guineas each, viz. :—' Roses in a Jar and Mossy Bank ' (9 x 11½ in.), in a sale by R. Wade's executors in 1872 ; and ' Summer Flowers and Early Fruit ' (15¼ x 19¾), in that of J. Heugh, 1874 ; thus justifying Hunt in his estimate of this branch of art, which he declared to be ' most difficult, and not to be thought so slightly of as some of the artists do.' The most important collections made of Hunt's works have been those of Mr. Wade, the artist's old doctor, who used to reside in Dean Street, Soho ; and that now in the possession of Mr. James Orrock, of the Royal Institute of Painters in Water-Colours. He was well represented by thirty-seven works at the Manchester Jubilee Exhibition.

JOHN WHICHELO remained an Associate until his death, ten years after that of Copley Fielding ; and, during the forty-three years of his connexion with the Society, sent an average of between three and four drawings to the summer exhibitions, besides having some fifty 'sketches and studies' in the first four of the winter shows. These (including eleven posthumous exhibits in 1865–66) make up a total of about 200 works at Pall Mall East. Whichelo established a claim to the title of naval as well as marine painter on the strength of four drawings of historic scenes, two of which were of events in his own time, namely, ' The Bombardment of St. Jean d'Acre,' exhibited in 1841, and ' The British Fleet, under Sir Charles Napier, entering the Baltic,' exhibited in 1854. The others were of older stories, ' The Glorious Battle of the Nile,' exhibited 1844, and ' H.M.S. Victory in the Battle of Trafalgar firing her first broadside,' exhibited 1851.[1] The choice, in two of these, of the moment when a magazine explodes or a ship is in flames, as well as a sketch, exhibited in 1864–65, of the ' Burning of Drury Lane Theatre,' seems to indicate a taste for fiery effects. Coast and coasting, however, among merchant craft and fishing smacks in the Channel and on Dutch rivers, make up the bulk of his maritime contributions ; with occasional studies of H.M. ships at Portsmouth or in the Medway. Whichelo, as has been said, aspired to be a landscapist as well, painting elaborate tree subjects with small figures, in which the foliage, though rather stiff and mannered, was not ill

[1] There was also a sketch of the 'Storming of Algiers' in the Winter Exhibition of 1864–65

executed. Some are views near Norwood (the then rural district now centred in the Crystal Palace), where he was a resident in 1833; others from the New Forest. One visit at least to Yorkshire [1] seems to have produced a few inland sketches; but more are from Surrey and Hants. There is no evidence of further acquaintance with British scenery, unless we include that of Jersey, whence he has five subjects in 1854, one of which is a man-of-war coming to the relief of a mail steamer in distress off the Corbière rocks. But he penetrated the Continent somewhat further than the Low Countries. From 1835 we find a few views on the Rhine, and in and after 1846 some from Switzerland; one or two on the coast of Sicily being, probably, from sketches by other hands. In 1836 and 1844 there are three works (seemingly drawings) at the Royal Academy by 'J. Whichelo,' the subjects and addresses leaving no doubt that they were by our Associate. And in 1849 'John Whichelo' had two sea pieces at the British Institution. [2]

Early in this period our artist took up more central quarters than Brixton or Norwood, where he had previously resided. From 1834 to 1837 his address was 238 Regent Street; and from 1838 to 1846 he had chambers at 26 Charles Street, Haymarket, opposite the site of the present 'Junior United Service' Club. Then he retired again to a suburb, making his home at Hammersmith (at Ravenscourt Park till 1856, and then at Shaftesbury Lodge, Shaftesbury Road) from 1847 to the date of his death, September 1865. He is described, by a friend who knew him in Charles Street, as a gentlemanlike man, and tall in stature.

His works are not very often met with. There is no example in the South Kensington collection. There was a sale at Christie's of his remaining drawings in April 1866.

[1] Ravens Gill, Bewerley Hall, Yorkshire—A Study from Nature, 1857,' was exhibited in 1858. And there is a 'Kirkstall Abbey' in 1862.

[2] See Graves's *Dictionary of Artists*.

CHAPTER IV ·

EXITS, 1866–1889

Biographies concluded—*Masey Wright—Eliza Sharpe—Gastineau—*
Evans (of Eton)—*F. Tayler.*

JOHN MASEY WRIGHT was entering his fifty-fifth year when Fielding's
term began. He continued to exhibit drawings of the same class as
before throughout that period, and for ten or twelve years after its
close; rarely more than one or two in the season; though in two
exceptional years, 1833 and 1843, he had a round dozen at a time.
Shakspere's plays are to the last his main source of inspiration;
Milton supplies a few subjects (from *L'Allegro* and *Comus*); and
some are from *Don Quixote, Burns's Poems,* the *Vicar of Wake-
field,* &c. Now and then there are fancy scenes, and sometimes a
sacred subject is illustrated. From 1832 to 1854 were sixty-nine
contributions,[1] and after that but eleven in the summer exhibitions,
making with the previous thirty-one a total of 111 drawings since
1824. The last of these was in 1864; but a score of 'sketches and
studies' were in the first five of the winter shows, between 1862 and
1867, the last year's being posthumous exhibits. Graves credits him
with thirty-six in other galleries between 1808 and 1836. In his many
figures he was wont to please more by simple gracefulness of con-
ception than strong marking of characters; and, latterly, the pale
delicacy of his colour and rather conventional elegance of his drawing
were little in accord with the taste for vivid realism which had begun
to prevail. The presence of his modest offerings was somewhat
of an anachronism. They were little heeded by the many, and
when he passed away were scarcely missed.

The highest price mentioned by Redford for one of J. M.
Wright's drawings is only 28*l.* 7*s.* for the 'Procession of the Flitch of
Bacon" (8¼ × 24 in.) at the 'Agnew and Sons' sale in 1881. In
the worldly sense, he had not been, latterly at least, a successful

[1] It is possible that a few more may have been set down, by a misprint, to J. W. Wright.
See *supra,* p. 31, *n.* 1.

artist. The frequent changes of residence which we find on looking
through the yearly catalogues—(he gives no less than twelvé different
addresses during the term of his Membership)—are not a sign of
prosperity. And theré is more direct evidence on the Society's
Minutes, that his profession had not been a source of wealth to him.
On 12 February, 1849, there is an entry of ' 20*l.* voted to Mr. J. M.
Wright on the application of Mr. Mackenzie, who stated that he
was suffering from pecuniary embarrassment. On 11 June, 1860,
' Wright, J. M.—Member—had, voted to him as a gift, 20*l.*' And again,
on 31 July, 1861, 'Application from Mr. Wright soliciting assistance,
and 10*l.* voted in aid of his immediate wants.' In the mean time,
mainly, it is believed, at the instance of Samuel Palmer, his necessities
had been partially relieved by the grant of a life annuity of 50*l.* by
the Royal Academy. This was in May 1858. What his condition
was at that time was feelingly described by an honoured Member of
the Society, now living, in a letter to a friend which was forwarded to
the Council in support of the application, in the following words :—

It has long been with me a source of grief to know that my old
friend Mr. Wright has been compelled to work so hard and with such
small pecuniary result at his advanced age, eighty-four.[1] He not only
has to maintain himself, but a son crippled some years ago by being
run over by a cab, and also blind of one eye and nearly so the other ;
arid an unmarried daughter too claims his help. During an intimate
acquaintance with him for about fifteen years, I have had frequent
occasions to admire his character, and to respect and esteem him the
more, the longer I have known him. I assure you his equanimity
under trials, his disinterested generosity in poverty, his cheerful and
uncomplaining and ever amiable temper of mind, have endeared him
to everyone capable of appreciating that which is best and noblest in
human nature.' Wright was a recipient of the annuity for eight
years, and died on the 13th of May, 1866, in his eighty-ninth year.

The following later engraved works have to be added to the list
already given : in the *Gallery of the Society of Painters in Water-
Colours,* ' Scene from *Twelfth Night*' (engraved by F. Bacon), 1832.—
In the *Gallery of Modern British Artists,* 1834, ' Romeo and Juliet,'
' Don Quixote and Samson Carrasco,' ' Village Glee-singers.'—In the
Forget-me-not, 1843, ' The Birthright ' (J. Skelton).[2]

[1] He seems not to have been really more than eighty. See *supra,* vol. i. p. 536, *n.* 2.

[2] This is merely inscribed ' Painted by Wright,' and may possibly be by J. W. Wright.
See also *supra,* p. 32, *n.* 1, for others in the *Keepsake* of similarly doubtful attribution.

During Fielding's presidency, which was her most prolific period, Miss ELIZA SHARPE had forty-five drawings in the gallery ; but the term of her lady-membership extended to a much later time. In 1834, the year of her sister's marriage, both their names are absent from the Catalogue. They are restored in the following season, when Miss Sharpe exhibits two drawings contrasting in sentiment ; one called ' The Phrenologist,' which was bought by the King of Prussia,[1] the other 'The Dying Sister.' Both of these are in the following list of plates contributed by her to the Annuals of this period :—In the Keepsake, 1833, 'Flora' (engraved by T. Engleheart); 1834, 'The Widowed Bride' (J. C. Edwards); 1835, 'The Love Quarrel' (F. Heath) ; 1840, 'The Somnambulist' (R. Staines).—In Heath's Book of Beauty, 1833, 'Belinda' (H. Robinson).—In the Forget-me-not, 1836, 'The Dying Sister' (H. Robinson), 1838, 'The Phrenologist' (C. Rolls). The subjects of her exhibited drawings continued to be of the class that found favour with the patrons and publishers of these drawing-room books. The following is a representative selection of their titles :—The fancy subjects include :—' The Sleep Walker' 1836, 'Curiosity' 1841, 'Prayer' 1849, 'The Little Dunce' 1843, 'St. Valentine's Morning' 1846, 'A Dame's School—the Bible Lesson' 1855, 'The Soldier's Widow opening for the first time the Wardrobe of her late Husband' 1853, 'A Bride taking leave of her widowed Sister' 1867, 'The New Mamma' 1865, &c. Among authors illustrated are Maria Edgeworth (scene from 'Madame de Fleury' 1837), Dickens ('Little Nell, showing the old church' 1844), Scott ('Lucy Ashton' 1853), Wordsworth ('Bessie Bell and Mary Grey' 1868), Moore ('Rich and rare were the gems she wore' 1850), Mrs. Hemans and other poets ; with Shakspere (' Portia and Nerissa' 1833, and the statue scene in 'Winter's Tale' 1852), and Musæus ('The Widowed Lady Richildi consulting the Magic Mirror,' 1854). About half a dozen are from Holy Scripture both in the Old and the New Testament, as 'Ruth and Naomi' 1836 and 1856, and 'Christ raising the Widow's Son' 1839. Her after exhibits were fewer and less important, and number only sixteen in the summer and nineteen in the winter shows, to the first eight of which she sent sketches and studies. With these her contributions to the gallery do not exceed eighty-four in the forty-two years of her connexion with the Society,

[1] The original sketch, with a record of the purchase, was in the Winter Exhibition of 1864-65.

During their joint lifetime Mrs. Seyffarth and Miss Eliza Sharpe had generally a common address, but neither was long constant to one place of residence ; the most permanent abode of the latter being at 8 ' Bark ' or ' Park ' Place, Bayswater, from 1846 to 1854. Her name last appears in the Catalogue in 1870, with, for a third year, the address 34 Oakley Crescent, Chelsea. But she lived a few years longer, dying on the 11th of June, 1874, at the house at Burnham Beeches of her nephew Mr. C. W. Sharpe, engraver,[1] having then attained the age of seventy-eight. Her personal activity was maintained to the last. ' Up to the age of seventy-seven,' writes Miss Clayton,[2] ' she could walk, dance, and skip like a young girl, and sweep a grand eighteenth century curtsy with inimitable grace. Six months before her death, she had her name put on a tombstone at Willesden, with a suitable inscription, the date only being left vacant. . . . Through her own industry and talent, she was enabled to leave a modest little fortune.'

HENRY GASTINEAU was a steady supporter of the exhibitions throughout the Copley-Fielding age, with a yearly average number of twenty-three drawings (rising once to thirty-five, and never sinking below sixteen), which, if not sensationally attractive, or varied with gay colour, were sound, well-considered landscapes, that helped to maintain at its high level the staple quality of the gallery's contents. Though little called upon now to make views for books of engravings, he still confined himself almost entirely to the class of drawings adapted to that purpose. Most of his subjects are taken from the British Isles ; many from Cornwall and Devon, and North and South Wales ; not a few from Yorkshire and other northern counties, and a fair contingent from Scotland ; while the coast of Kent and other home localities contribute a small quota. After 1838 we have a number of subjects from the North and East of Ireland, the rock-bound coast of Antrim being a favourite sketching ground. These are intermingled with occasional scenes from Switzerland and the Italian Lakes, and in 1844-5 there are one or two from Waterloo and Brussels, the few other foreign views being possibly from pupils' sketches. For teaching continued to be a main part of Gastineau's professional work.

[1] Clayton's *English Female Artists*, i. 382. Redgrave says in his *Dictionary* (2nd edit.) that she died in Chelsea. [2] *Ubi supra.*

To the list of his engraved works have to be added :[1] In Havell s *Noblemen's and Gentlemen's Seats*, 'Fonthill' (sketched by T. Higham), a coloured aquatint, 1833.—In Finden's *Illustrations of Byron*, 3 vols. 4to, 1833-4, vol. i., 'Bellagio, Lake of Como,' and 'The Simplon Village.'—In Lawson's *Scotland Delineated*, 1847-52, 'St. Andrew's,' lithographed by R. Carrick.

There is little more to relate of his even personal career. Happily it does not furnish another text for lamentation over hardships like those which beset the course of so many of his brother artists. He lived a quiet family life in his settled residence at Camberwell, devoted to his profession, and taking his due share in conducting the affairs of the Society and performing its social observances. When Fielding died, Gastineau was one of its deputed representatives at the funeral. Soon after, he is busying himself about making up the Committee, though hampered at the time with studio work. 'When yesterday I received your letter,' he writes to Jenkins on the 13th of April, 'I was in a state of desperation, having just sponged out best part of my principal picture. How I shall recover myself I know not, but shall be happy that Topham and Oakley should join us. I intend to be at the Gallery on Monday at three o'clock, and then (if not too late) will be ready to do anything in my power to seek after another Committee man. Our beginning this year seems to be unfortunate, but I hope we shall get out of our difficulties, and that all will end well.' On the 15th of November, 1857, in answer to a suggestion of the President's that the members should dine together, he writes : 'It has long been my opinion that the Water-Colour Society has been very negligent in not seeking some more definite opportunities of association as a means of producing that *social union* which may tend to its general welfare.'

This veteran artist lived on, through the reigns of that President and the next (Lewis and Tayler), the long term of Fielding's tenure of the chair having filled scarcely more than two-thirds of the allotted span of his own connexion with the Society. When he died, on the 17th of January, 1876, aged eighty-six, he was the oldest surviving member of the Society, having been an exhibitor there for fifty-eight consecutive years ; that is to say, in every summer show from 1818 to 1875, and in all the winter ones to 1875-6, except the penultimate

[1] Two earlier plates in Britton's *Cathedral Antiquities* (*Wells*), 1824, should have been mentioned before.

one in 1874-5. His drawings in the former series amount to 1,082, and his 'studies and sketches' in the latter to about 200, making in all nearly 1,300 exhibits. To the last they were of the class above described ; and with him the old school of picturesque topography may be said to have expired.

Henry Gastineau died at Camberwell, and was accompanied to his grave in Norwood Cemetery by a representative band of his brother Members. He had survived his wife fifteen years. He left several children, one of whom, Miss Maria Gastineau,[1] followed her father's profession. His remaining works were sold at Christie's on 19 May, 1876. The highest price for a 'Gastineau' in Redford's list is 127*l.* 1*s.* for 'Mill near Ambleside' in 'G. Bicknell' sale, 1863.

During the first ten years of his Membership, WILLIAM EVANS *of Eton* exhibited about 100 drawings in annual groups of from five to fifteen. After that his average declined, and at the time of Fielding's death he was becoming intermittent in his consignments to the gallery. From 1832 to 1834 he had not more than 130 drawings there. In the earliest of these years his subjects from Windsor and the Thames are varied by some from the Isle of Wight and the counties of Hants and Dorset, and others from Scotland. The latter begin in 1833, and are mostly from the Isle of Arran. In 1834, about half a dozen of his drawings are of Clovelly in Devonshire. In 1836 and 1837 we have evidence of a visit to the West of Ireland in a number of subjects from the counties of Galway and Mayo. Then follow some from Ulverston, Whitby, and elsewhere in the north of England ; in 1840 a 'Lismore Castle, county of Waterford,' painted for the Queen ; and then and after, a few of the Lakes of Killarney are intermingled with home views in various places. In 1845, on the advent of his namesake from Bristol, the distinguishing words ' of Eton ' were added to his patronymic, and this cognomen is given him in the catalogue to the last, even long after the death of his brother painter. The date 1847 is noteworthy as that of the beginning of a fresh series of Scotch subjects, which not only were his most characteristic ones for many years after, but indicate some of his habits of life at that period of his career. Evans was from this time an almost constant guest of the Duke of Athole's during

[1] Her sad death, on 27 September, 1890, at Llantysilio, near Llangollen, where she was sketching, was caused by exhaustion in the attempt to scale a Welsh mountain to witness a brilliant sunset.

II. P

the vacation, and quite in his element among the Highland scenes and Highland sports on the Duke's estate. But his drawings were not as numerous as of yore ; and it may be surmised that when he donned the kilt, the pencil was often laid aside in favour of other congenial pursuits. During six years after Fielding's death he had but four drawings in the gallery, all subjects from his favourite resort. But soon after, they cease, and, returning to some of his former classes of subjects, he becomes a more constant exhibitor, though generally a small one. Late in life he entered upon an entirely new sketching ground. In 1867, when in his sixty-ninth year, he exhibited the first of a series of views on the Riviera, chiefly about San Remo, and these form nearly his whole contribution to the gallery till 1872, when and in 1873 he fell back on his Scotch subjects, ending in 1874 and 1875 with sketches of the Burnham Beeches. These were his last exhibits. He had also twenty or more in the winter exhibitions from 1862 to 1874. From first to last his works at the Society number about 240.

Evans just lived to enter his eightieth year. His strength had failed very gradually, 'fading away from week to week,' until he died on the 31st of December, 1877, where he had so long resided and was so much beloved, and where he had so amply justified the appellation by which he was known, of ' Evans of Eton.' Although he did not hold office, Evans's whole artist life was passed in promoting, by every means in his power, the welfare of the Water-Colour Society, for which he never ceased to labour until his last hour. In 1859 he is making strenuous exertions to press its claims to a site at Burlington House, and in communication on the subject with Lord St. Leonards and many other influential members of the Legislature. In 1861 he took an active part in the arrangements for and collection of the folio of drawings presented to the late Edwin Field in acknowledgment of his services as the Society's professional adviser ; his own contribution to which, ' Eton from Romney Island,' was the sole work he exhibited in 1863. The subject was well chosen, not only as characteristic of the painter, but because donor and donee had tastes in common in their equal love both of the scenery of the Thames and of the stream itself. One phase of Evans's devotion thereto is worthy of special record. He was a prominent member of a society called the *Psychrolutes* (from the Greek ψυχρολούτης, a bather in cold water), the qualification for membership whereof was

the daily practice of bathing out-of-doors from November to March. It was presided over by the late Vice-Chancellor, Sir Launcelot Shadwell, and among its leaders were the brothers Selwyn, more especially George Augustus, the first Bishop of New Zealand, and afterwards Bishop of Lichfield. Before his consecration to the colonial see in 1841 Selwyn held a curacy at Windsor, and resided at Eton, as tutor to the sons of Lord Powys. At this time he and Evans were much together, leading an amphibious life, and spending a great part of their leisure time both on and in the water. The Society had its professors and leaders in special feats of swimming and diving, who rejoiced in appropriate titles of classic derivation. It had its ceremonials and red-letter observances, the season ending with a presidential address on the river-bank, to which the assembled psychrolutes were required to listen in a humid state before any application of the towel was permitted. As an instance of the respect entertained by the brethren for Father Thames and the sanctity of his silver stream, it is related that one of a fishing party in a punt, who happened to be smoking, was seriously enjoined by his psychrolutic comrades to abstain from fouling the sacred river by expectoration, and to use the boat, if needful, as a spittoon. An official almanack and diary of the Society's proceedings is still preserved by the artist's son, Mr. Samuel T. Evans, himself an Associate of the Royal Society of Painters in Water-Colours.

The following engravings have been made after drawings by William Evans of Eton : In the *Gallery of the Society of Painters in Water-Colours,* 'Fisherman's Hut,' interior (engraved by C. Fox), 1833.—In Tillotson's *New Waverley Album,* 'Round Tower, Windsor,' —Separate plates, 'Celebration of the Fourth of June at Eton' (engraved by C. G. Lewis), published 1 May, 1837 ; [1] 'The School Yard, Eton College—The Morning of the Montem of 1841,' and 'The Playing Fields, Eton College—The Evening of the Montem of 1841,' subscription plates [2] of two drawings made for J. H. Smyth Pigott, Esq., and exhibited in 1844.

The last of the old Members who survived Fielding was FREDERICK TAYLER, a name afterwards conspicuous in the Society's records. He was, as the reader may recollect, admitted Associate in the last year of Cristall's presidency, namely, on the 14th of February, 1831 ; and

[1] Announced in Catalogue for 1837. [2] *Ibid.* 1847.

three years later, on the 9th of June, 1834, he became a full Member. He was Vice-President when Fielding died, and filled the Presidential chair from February 1858, when it was vacated by Lewis, until June 1871, when he himself retired. He continued, however, to send drawings to the gallery as an ordinary Member until his death on the 20th of June, 1889. He was then by much the oldest Member of the Society, having long survived the contemporaries of his youth.

Tayler contributed some 500 drawings and sketches to the exhibitions in Pall Mall East, whereof nearly half (220) were shown (at the rate of two to fifteen per annum) during Fielding's presidency. This includes a dozen, between 1834 and 1836, painted in conjunction with George Barret;[1] and one in 1860, 'The Favourites,' in which the landscape is by T. M. Richardson. His works, though similar in character and artistic features, arrange themselves in the following general classes :—(1) Sporting scenes both of past and present times. The former include stag-hunts of the early eighteenth century, and hawking parties of prior date, when gay costumes of ladies were among the picturesque accompaniments of horn and hound. In these the horse is generally an essential element. The latter are for the most part incidents on the moors, and of deerstalking in the Scotch Highlands.—(2) Pastoral scenes, with rustic figures of gleaners and the like, also mostly from Scotland.—(3) Other illustrations of past times, involving the picturesque grouping of figures and animals, some being suggested by scenes in the *Waverley Novels.*

It has been already stated that Tayler's first exhibited work (at the Royal Academy) was in oil, and that in his early days he painted a little in that medium. Yet at the time when he was President of our Society, the oil method either was or had become 'strange to him.' For Mr. Frith, R.A., relates that Tayler, 'being ambitious to try his hand in oil colours,' went to that painter ' for some friendly lessons in a part of the art with which he was unfamiliar. Though hampered by a strange method,' continues the same writer, ' he succeeded in producing a charming study, which was immediately bought by Mr. Jacob Bell; and if the great demand for his water-colour drawings would have allowed him time for different practice in oil, I have no doubt that my old friend . . . would have rivalled his own excellence in water-colours.'[2] It is, however, almost entirely by his work in the

[1] One of these, ' The Gleaners' (20 x 25 inches), exhibited in 1834, was sold at Christie's in Mrs. Sara Austen's sale, 10 April, 1889, for 110*l.* 5*s.*

[2] Frith's *Autobiography,* i. 192.

latter medium that his name is and will remain known in the history of art. Few painters, indeed, have been more successful than he in showing the capabilities of the material in rapid and suggestive sketches. Mr. Ruskin selected the works of Frederick Tayler as his illustration of powerful *sketching*, the best of its kind, to contrast with highly finished *drawing*, like that of John Frederick Lewis. 'Few drawings of the present day,' he writes, in the first volume of *Modern Painters*, 'involve greater sensations of power. Every dash tells, and the quantity of effect obtained is enormous, in proportion to the apparent means. But,' he adds, 'the effect obtained is not complete. Brilliant, beautiful, and right, as a sketch, the work is still far from perfection as a drawing.' In another chapter he links the name of Tayler to that of Cox himself in praise of 'the purity and felicity' of some of their 'careless, melting, water-colour skies,' produced with the facility afforded by the material in 'one accidental dash of the brush, on a piece of wet or damp paper,' an effect that would require 'the labour of a day in oils.' True, the latter reference to the artist's work is made, like the former, by way of comparison ; its object, this time, being to enhance the merit of greater completeness in similar passages produced by the hand of Turner.[1]

Not a few of Frederick Tayler's drawings have been reproduced by various processes of printing. Among his engraved works are 'Weighing the Deer,' 'Crossing the Tay,' &c. In 1844-5 were published by McLean under the title, *Frederick Tayler's Portfolio*, a series of twenty-four or twenty-six original and characteristic designs executed by him in lithotint, a process which his facility in handling the brush enabled him to employ with peculiarly good effect.[2] Before the great revival of the practice of etching with acid which has recently threatened to supersede all other kinds of engraving on metal, Tayler was one of the little society of artists called 'The Etching Club,' which kept alive the practice of that art in England when it was well-nigh extinct among us. He contributed his quota of small plates, delicately executed, to the following publications by the Society :— *The Deserted Village—Etched Thoughts—Milton's L'Allegro—Songs of Shakespeare* (2 parts), and some promiscuous subjects called *Etchings by the Etching Club*. He also with other artists furnished designs on wood to the following works :— *The Good-natured Bear—Chevy Chase*, and *Robin Hood* (in Felix Summerley's Collection)—*Thomson's Seasons—*

[1] See *Modern Painters*, i. 34, 253. [2] *Cattermole's Portfolio* followed a year after.

Goldsmith's Poems—The Traveller, &c.—Bloomfield's Farmer's Boy, and *Sir Roger de Coverley* (published by Longmans & Co.),—*Old English Ballads* (Ward & Lock, 1864); and, in his old age, made a series of *Studies in Animal Painting*, for a book with that title (published by Cassell & Co. in 1884 in English and French).

Mr. Redford notes the following six drawings of Frederick Tayler's as having been purchased (or bought in) at public sales for more than 350*l.* :—'Return from Hawking' (20½ by 28½ in.), 465*l.* 3*s.*, N. N., 1864 (bought in) ; 'The Greeting,' 388*l.* 10*s.*, J. L. Clare, 1868 ; 'Gillie and Hounds,' 372*l.* 15*s.*, J. Rucker's Exors., 1876 ; 'H.M. Buckhounds' (21 by 30 in.), 367*l.* 10*s.*, C. Suthers, 1876 ; 'Sheep Shearing' (20½ by 28½ in.), 363*l.* 6*s.*, N. N., 1864 (bought in); 'Sheep Shearing' (20 by 28 in.), 357*l.*, A. H. Campbell, 1867. Her Majesty the Queen and the late Prince Consort purchased several of Tayler's works, which are now in the royal collection. There are also examples at South Kensington, four being in the Ellison gift.

At the time of the Paris Exhibition of 1855, Frederick Tayler received the cross of the Legion of Honour of France, and a gold medal in recognition of his merit as an artist. Besides these honours, he was decorated with the cross as Knight of the Belgian Order of Leopold, and received the first gold medal from Bavaria in 1859, and the Austrian medal from Vienna in 1873. He was also a Member of the Pennsylvanian Academy, the Royal Cambrian Academy, and the Société des Aquarellistes of Belgium ; and one of the Vice-Presidents of the Society for the Promotion of the Fine Arts. The Athenæum and Garrick Clubs also included his name in their lists of members. From 1874 to 1881 he was one of the Committee of the ' Black and White' exhibition at the Dudley Gallery.

Tayler was a frequent guest in Scotland at the houses of the aristocracy, and had many opportunities of gratifying a keenness for sport which gave zest to his delineations. In 1856, at Inverary Castle, he painted the portraits of the Marquis of Lorne and his sister, Lady Edith Campbell, afterwards Countess Percy, galloping through the heather on their ponies. Of this portrait the Duke of Argyll wrote to him that it was ' like a sunbeam on the wall.' In his early time he was much engaged in teaching, and had many aristocratic pupils.

In 1837 he married, at his brother's parish church of Stoke Newington, Jane, daughter of Edward Parratt, Esq., and grand-

daughter of Edward Parratt, for upwards of thirty years Clerk of the Journals of the House of Lords. There are five surviving children of the marriage, two sons and three daughters, to more than one of whom a practical taste for art has been transmitted. His second son, Mr. Norman Tayler, gained the first medal for drawing from the life when a student at the Royal Academy, and in 1878 was elected an Associate of the Water-Colour Society. Frederick Tayler resided in London, wherein the catalogues assign to him a variety of addresses. In his later life he unfortunately incurred some pecuniary losses which deprived him of much of the well-earned profits of an industrious life.

No biography of Tayler would be complete without some account of his official life as President of the Water-Colour Society for thirteen consecutive years. But his course of action during that period is so identified with those of his brethren as a body that it is needless to add much here to the general sketch already given of the proceedings of the Society. Although the period referred to is marked by several occasions on which important questions came under discussion, and the Society asserted itself with vigour in its corporate capacity, there seem to have been few in which the President took a decidedly leading part, beyond that which devolved upon him as the representative of the majority of his constituents. Amiable and generous in his nature, he was not one who loved to thrust himself into the forefront as an advocate. Thus he was for the most part content to hold the reins when the team was composed of steeds that required no urging.

He had had a foretaste of official life, which did not, however, foreshadow the equanimity of his subsequent reign. When Fielding died, Tayler found himself somewhat in the position of one who 'hath greatness thrust upon him.' Happening, as the senior member of the committee of management, to be Vice-President for the year, and it being determined, out of respect to Fielding's memory, that no permanent successor to his office should be immediately appointed, it was resolved (at a meeting at Secretary Jenkins's house on 13 March, 1855, Tayler in the chair), on the suggestion of Evans of Eton, that the then present chairman should discharge the duties of President in the interval. Tayler was consequently appointed as aforesaid to take the place of Copley Fielding in the Associated Committee of the Fine Arts for the Paris Universal Exhibition, which was to be

held in the ensuing season. He accordingly hastened to the French capital, but only to find the hanging of the pictures nearly completed. Arriving so late, he had in fact no voice in the hanging. But he had nevertheless to bear the brunt of a somewhat merciless attack on the subject of its alleged unfairness, particularly in the places given to the works of Lewis. The matter was warmly discussed by the malcontents, and even went so far as the printing of polemical tracts on both sides. Serenity was restored on the election of Lewis as President; but the anxiety and vexation of spirit under the sense of unjust imputations which he had endured were enough to prostrate poor Tayler for the time with a serious illness. All, however, was forgiven and forgotten; and on Lewis's withdrawal from the Society in February 1858, Tayler was elected President by the unanimous voice of his brother Members; he himself, to make the mutual accord more palpable, giving his own modest vote to Evans, who in the above controversy had been his most fiery opponent. Thenceforward, though burning questions arose from time to time among the Members, the President maintained throughout an impartial position, his retirement, owing apparently to a mistrust of his own strength, and much against the Society's wish, drawing from the meeting at which it was announced a special expression of gratitude and esteem. He continued to be regarded with respect and affection by all who knew him, until the day of his death, which event happened on the 20th of June, 1889, at the age of eighty-seven, at his then residence, No. 63 Gascony Avenue, West Hampstead. The Society was represented beside his grave in Hampstead Cemetery by a large deputation; and there were present also several leading Members of the Royal Academy. His engravings, etchings, and illustrated books were sold at Christie's on the 27th of January, and his remaining drawings and sketches on the 17th of February, 1890.

BOOK IX :

ACCESSIONS UNDER FIELDING

CHAPTER I

NEW ASSOCIATES ; 1832–1837

Biographies—*F. Stone—G. Chambers—C. Bentley—J. Nash—V. Bartholomew—J. Holland—A. Glennie—Lake Price.*

THE careers of all the Members and Associates who entered the Society before the end of 1831 having been traced as far as may be to their close, an account has now to be rendered of the artists who joined it between that date and Fielding's death in 1855. These it will be expedient to deal with in the order of their admission as Associates, dividing the period as before into three parts by the dates of the Queen's accession (1837) and the death of Cristall (1847). The first subdivision of six years comprises the *débuts* of the several artists whose names are at the head of this chapter.

Out of eight candidates who presented themselves in 1832, none were chosen ; and it was not until the 11th of February, 1833, that a fresh exhibitor was admitted. He was a figure man, FRANK STONE by name, better known as a painter in oils, who afterwards became an Associate of the Royal Academy, and whose son Marcus Stone is now a full Academician. The successful candidate came from Manchester, where his father was a cotton-spinner, and he himself, born on the 22nd of August, 1800, had followed that business till he was twenty-four years of age, when he abandoned an occupation that seemed to be leading him to wealth, in order to fulfil his desire to become a painter.[1] The sacrifice, indeed, was less than it had appeared to be ; for the business did not continue to prosper, and the share

[1] He is said to have ' received no education in art, never having studied under any master, or even having had a drawing lesson at school.'—H. Walker's *Our Living Painters* (1859).

which he still retained therein proved inadequate to his support, so that throughout his life he remained hampered by narrowness of means. While still in Manchester he had begun to practise in oils, and painted portraits in that material ; but it is believed that when he came to London, which was not until 1831, it was with the intention of devoting himself to water-colour art.

His first lodging in town consisted of a back parlour and a bedroom in Newman Street, and some of his earliest work consisted in making pencil drawings for Charles Heath at 5*l.* each, to be engraved by him in the *Book of Beauty* ; for that speculator declined to pay twice the amount for a water-colour head, remarking that the former would answer his purpose quite as well. But Stone found a purchaser for his ten-guinea drawings in the cunning dealer before mentioned under the name of 'Spectacles' Roberts, who, it is said, agreed to take, at that price, all the water-colour drawings he could paint during a term of three years. Roberts 'went into Holywell Street and purchased a large lot of all kinds of silks and satins, boots, and petticoats, costume, &c., which he sent to Stone's, also a large bookcase-looking piece of furniture which was converted into a wardrobe to keep them in, and F. Stone had the properties transferred to Berners Street,'[1] where he set up a fresh and probably a better studio. Many drawings so made passed through Roberts into the hands of Mr. Bernal. The connexion with this dealer seems not, however, to have been wholly advantageous to the artist. It is said that Robson treated it as an impediment to his election, and further that his vulgar patron's offensive behaviour was one cause of Stone's afterwards taking to oils as a means of escape from his thraldom.[2]

Frank Stone exhibited twenty-three drawings in the Society's gallery (generally one a year, and never more than three) in the fourteen years from 1833 to 1846. During the last four of these he was a full Member, to which rank he was raised on the 13th of June, 1842. He was another of the artists whose subjects belonged to the ephemeral literature of the drawing-room, and adapted themselves to the fashion of the day. 'The Reverie,' 'Lady and Duenna,' 'O dear! what can the Matter be?' 'The Selected Flower,' 'The Treacherous Shot,' are titles culled almost at random, which sufficiently indicate their general nature. His first exhibit, named 'The Massacre of Glencoe,' and four scenes from Shakspere and Scott in 1835–37,

[1] J. J. J. MS. *ex relatione* James Holland. [2] *Ibid.*

may be regarded as exceptional ventures. Beginning as above mentioned, Stone continued his employment also in drawing for the Annuals. Among his contributions to them and to similar publications are plates named as follows :—In Heath's *Book of Beauty*, 1833, 'Donna Julia,' 'Madeline,' 'Thérèse,' 'Geraldine ;' 1834, 'Bianca Venuzzi,' 'Catherine Seymour,' 'Matilde,' 'Lucy,' 'Alice ;' 1835, 'The Pink Domino ;' 1837, 'The Countess.'—In Finden's *Illustrations of Byron*, 3 vols. 4to, 1833–34, vol. i., 'Miss Chaworth,' 'Maid of Saragoza,' 'Ali Pasha,' 'Maid of Athens,' 'Ada.'—In the *Forget-me-Not*, 1834, 'The Mother's Picture ;' 1836, 'The Confession.'—In the *Literary Souvenir*, 1835, 'La Pensée.'—In the *Amulet*, 1836, 'My Mother's Warning.'—In Fisher's *Drawing-Room Scrap-Book*, 1836, 'The Lily of the Valley' (probably a reissue).—In the *Keepsake*, 1842, 'Lady Jemima.'—In the *Book of Gems*, 'The Coquette.' He is named as a draftsman of plates in Finden's *Gallery of the Graces*, 4to, 1837, and in Heath's *Gallery of British Engravings*. He also contributed to the publications of the *Etching Club*, and drew on wood for several works, notably an edition of Thomson's *Seasons*, illustrated by the same group of artists.

At this time he was beginning again to paint in oil and send works to the Royal Academy, the earliest of which we find in 1837, when he exhibited two portraits. In 1838 he has 'A Study' there, and in 1839 four portraits. In 1840, with one more portrait, he sends his first subject picture in oils, a 'Scene from *A Legend of Montrose*.' In 1841 he received a premium of fifty guineas from the British Institution. It was in the first year of his full Membership of the Water-Colour Society that he exhibited in Trafalgar Square (in 1843) the picture by which he is perhaps most generally remembered, a love scene called 'The Last Appeal,' well known by a popular engraving. Others of the same class followed year by year, of which several have been engraved, with the titles 'The Course of True Love,' 'The Impending Mate,' 'Mated,' &c,

That Frank Stone, coming to London at a comparatively late period of life, without the advantages of wealth, station, introductions, or any special educational acquirements, and having made no high mark in his profession, should have stepped at once as he did into a circle of the *élite* in the literary and artistic world, says much for his innate abilities, and the natural good taste and courteous bearing that were in keeping with his tall and handsome person. Mingling in the higher

ranks of his own calling, he was the associate also of Thackeray and Dickens, the poets Campbell and Rogers, and many others of their class. In 1845, having then been some years married, he moved from Berners Street to Tavistock House, Tavistock Square, which was his home until 1851. The house then became the residence of Charles Dickens.[1]

One common attraction which drew author and artist together was the taste and talent they both had for play-acting. When in the before-mentioned amateur performance of Ben Jonson's *Every Man in his Humour*, Dickens took the leading part both as actor and manager, Stone supported him in both capacities, coming effectually to his aid in the character of ' Downright ' to his friend's ' Captain Bobadil.' Stanfield had originally been cast for the part, but was too busy with the scenery to undertake it. It was then offered to Cattermole; but finally fell to the lot of Stone, who played it, writes Dickens, in a ' very sober ' suit, ' chiefly brown and grey,' which was a contrast to the ' very bright ' costumes of nearly all the other characters.[2] We get a more graphic glimpse of our artist, when off the stage, in one of the letters of ' Boz ' in 1847. In that year they were comrades in a troupe of amateur players, who made a theatrical tour in the North. On this occasion Dickens conceived the idea of further aiding the charity for whose benefit they acted, by writing an account of the company and their doings, as from the pen of Mrs. Gamp, supposed to be a spectator of their performances. The *jeu d'esprit* was to be illustrated by Stone and others, and some of the woodcuts were actually engraved ; but it was never finished. Dickens's biographer, John Forster, however, has given to the world some portions of the incomplete manuscript, among which is the following sketch of our artist's personal appearance at this time. It is part of the immortal Sairey's account of her conversation with the wig-maker to the company. ' " There," he says, alluding to a fine-looking, portly gentleman, with a face like a aimiable full moon, and a short, mild gent, with a pleasant smile, "is two more of our artists, Mrs. G., well beknowed at the Royal Academy, as sure as stones is stones, and eggs is eggs." ' [3] It need scarcely be added that the former was Frank Stone, the latter Augustus Egg.

It was not till 1851 that Stone became an A.R.A. ; and he had

[1] F. Stone painted an oil sketch of one of Mr. Dickens's sons, who was afterwards drowned at sea. See Forster's *Life of Dickens*, ii. 339 *n*.

[2] *Letters of Dickens*, i. 134, 148. [3] Forster's *Life of Dickens*, ii. 353.

already severed his connexion with the Water-Colour Society. On the 17th of June, 1846, doubtless with a view to seeking admission to the Academy as an oil painter, he gave in his resignation at our Society. He at the same time asked permission, which was unanimously accorded, to place a premium picture of his in the next exhibition at Pall Mall East; but his name does not appear in the catalogue for 1847.

In the summer of that year he was staying with Dickens at Broadstairs, as we read in a letter from his host under date the 2nd of September. ' Stone is still here,' he writes, ' and I lamed his foot by walking him 17 miles the day before yesterday.'[1] The terms of playful companionship which existed in the same circle of friends may be further illustrated by an amusing anecdote. Stone was fond of riding, rather proud of his horsemanship, and somewhat noted among his associates for marvellous tales of his leaps in the hunting field. Forster, when about to meet him one day at dinner at their common friend George Cattermole's, took upon himself to play him a trick. He bribed his host's little daughter, with the promise of a new shilling, to drop herself under the table when she came in to dessert, listen for Stone's voice, and when he began a narrative, to come up suddenly and cry, ' Old Stone, don't humbug us with your rubbish!' The scheme was successful, Forster adroitly leading the victim on to recount one of his adventures, and the child popping out at the right moment; but adding, much to Forster's discomfiture, ' and now where's the new shilling?'

In November 1848 the genial artist is found assisting in the illustrations of one of Dickens's Christmas books, ' The Haunted Man,' his design of ' Milly on the Chair ' being pronounced 'CHARMING ' by the author.[2] The two friends continued their comradeship on the amateur stage also. The Merry Wives of Windsor, with Stone as ' Page,' was among the comedies they acted; and in 1851 he played ' the Duke of Middlesex ' in the representation of Bulwer's comedy, Not so bad as we seem, at Devonshire House,[3] and was complimented thus by Dickens in a letter to the author during the rehearsals :—' The Duke comes out the best man in the play. I am happy to report to you that

[1] Forster's Life of Dickens, ii. 355. [2] Letters of Dickens, i. 199-203.
[3] The play was written and acted for the benefit of the proposed ' Guild of Literature and Art,' of which Dickens was an enthusiastic promoter. The third performance was at the Hanover Square Rooms on the 3rd of June, 1851. It was afterwards acted at the Haymarket Theatre by professional players.

Stone does the honourable manly side of that pride inexpressibly better than I should have supposed possible in him. . . . He is *not* a jest upon the order of Dukes, but a great tribute to them.'[1] Another successful part of his was 'Mr. Nightingale' in Dickens's farce, *Mr. Nightingale's Diary*. Dickens was also desirous that he should play as his substitute the 'title rôle' in '*Uncle John*,' in his own native town of Manchester, in August 1857. This he had agreed to do, but the project was abandoned in deference to the 'men of business,' who declined the risk of a change, as Dickens's name had become identified with the character.[2] On one occasion his inventive friend had devised a new part expressly for Stone; and the conception of its appropriateness gives him the credit of some considerable degree of dry humour. 'I have got,' he writes, 'a capital part for you in the farce, not a difficult one to learn, as you never say anything but "Yes" and "No." You are called in the *dramatis personæ* an able-bodied British seaman, and you are never seen by mortal eye to do anything (except inopportunely producing a mop) but stand about the deck of the boat in everybody's way, with your hair immensely touzled, one brace on, your hands in your pockets, and the bottoms of your trousers tucked up. Yet you are inextricably connected with the plot, and are the man whom everybody is inquiring after. I think it is a very whimsical idea and extremely droll. It made me laugh heartily when I jotted it all down yesterday.'[3] This, however, affords but the 'fabric of a vision' of what Stone might have transformed himself into, had the idea been carried into effect, which was not destined to be.

Among our artist's works at the Academy after he had left our Society were: 'The Gardener's Daughter,' and some subjects among the fisher folk of Boulogne. There again he is found associating with Dickens, who took for him the house on the St. Omer road which he inhabited with his family in 1853.[4] Six years later he had to engage for him a residence for a longer term. Frank Stone died on Friday, the 18th of November, 1859, and was buried in Highgate Cemetery. The event is thus referred to by Dickens in a letter written the next day: 'You will be grieved to hear of poor Stone. On Sunday he was not well. On Monday went to Dr. Todd, who told him he had aneurism of the heart. On Tuesday went to Dr. Walsh, who told him he hadn't. On Wednesday I met him in a cab in the Square[5] here,

[1] *Letters of Dickens*, iii. 126, 127. [2] *Ibid*. ii. 24–27. [3] *Ibid*. iii. 180, 181.
[4] Forster's *Life of Dickens*, iii. 83, 84. [5] Tavistock Square.

and he got out to talk to me. I walked about with him a little while at a snail's pace, cheering him up ; but when I came home, I told them I thought him much changed, and in danger. Yesterday at 2 o'clock he died of a spasm of the heart. I am going up to Highgate to look for a grave for him.'[1] His widow outlived him thirty years, and died on the 2nd of January, 1890.

The catalogues show forty-two works by F. Stone at the Royal Academy, twenty-four at the British, and ten at the Suffolk Street Gallery ; making a total of seventy-six,[2] besides our twenty-three water-colour drawings. In 1875, the ' Last Appeal ' and ' The Admonition,' both in water-colours, were sold at Christie's for 147*l.* and 99*l.* 15*s.* respectively.[3]

For seven consecutive seasons in the earlier half of Fielding's reign, the gallery contained from four to eight drawings by one of the most eminent of our marine painters, GEORGE CHAMBERS. He was elected an Associate on the 10th of February, 1834, and a full Member on the 8th of June, 1835 ; and had exhibited forty-one works there when his short career was terminated by death at the early age of thirty-seven, before the full merit of his paintings had come to be generally appreciated. Until about two years before he joined the Society, Chambers had practised almost exclusively in oils ; but he proved himself also a master of the more subtle medium, which he employed with great elegance and freshness· of effect. His short life is of touching interest ; for the years through which he had ascended, by toilsome steps, to his present position, had been mostly expended in overcoming the obstacles of his birth ; and now the enjoyment of a brief period of increasing success was marred by the consciousness of a decline in physical strength.

Chambers was born in 1803, of the poorest parents, and began life under the most untoward circumstances. He was second son in the large family of a common mariner at Whitby, who ' occupied a humble tenement in a court leading to the old Methodist chapel, in the very heart of the community of sailors and fishermen whose houses, crowded and jumbled together, stretch up the East Cliff,' under the Abbey ruins, a ' district of squalor and dirt.'[4] The father being unable to pay for the schooling of two boys at once, though

[1] Forster's *Life of Dickens*, iii. **227** *n.* [2] Graves's *Dictionary of Artists*.
[3] Redford's *Art Sales*. [4] J. J. J.

the fee was but a penny a week, George took turn and turn about with his elder brother John for some time at that rate, and, provided with this amount of education, was launched on the world at the tender age of eight. His first service was on board the coal sloops in the harbour, where he was employed to hold open the sacks while they were being filled, for which he received two shillings a week, and was allowed to take home to his mother the sweepings of coal dust from the deck. At ten he was sent to sea in the *Enterprise*, a 'Humber keel,' owned by his uncle and worked by him and a single shipmate. On board this small craft he was, during the next two years, made familiar with much hardship and privation. At twelve he was apprenticed for seven years to one Captain Storr, of the transport brig *Equity*, belonging to his father's employers, Messrs. Chapman. Such a life would in any case have been hard and rough ; but in his it was peculiarly trying. For his master was an unfeeling man, given to drink ; and, when in his cups, would amuse himself with cruel jokes, of which his poor apprentice was made the victim. Little Chambers was active and willing, and could climb like a cat. But he was singularly small in stature. It was said that on board the *Enterprise* he made his bed in a sea-boot ; a dormitory scarcely more commodious than that of the famous parent of many children in the nursery legend. When he joined the *Equity*, the captain had no small trouble to find a suit of slops small enough for him, in Ratcliff Highway. It was Storr's pleasure to wager bottles of wine with his comrades that he had a cabin boy who could creep into a cat hole, or coil himself in the binnacle, feats which young Chambers had duly to perform. He suffered yet more, however, from inconsiderate neglect. His clothes being stolen, he was left through a severe winter without bed or bedding, which so injured his health that cramps and rheumatism affected him sorely for the rest of his life.

But in these voyages, while sowing the seeds of disease, he at the same time laid the foundation of his artistic fame. When in foreign ports, it was his delight to go into the churches and look at the pictures they contained, and so he acquired some taste in art. Meanwhile a love of drawing began to display itself. He sketched portraits of the ships he met with, and copied the captain's rude drafts of the headlands they passed. The sailors of the crew, with whom he had become popular, encouraged him with gifts of paper and pencils. Moreover, he found other work for the brush, which he

performed in a manner so attractive, that it led to a recognition of his talent, and at length gave him liberty to employ it as he desired. He used to paint the ship and its stores and buckets; and some of such ornamentation happening to catch the eye of one Captain Braithwaite, of the *Sovereign* of Whitby, when that vessel and the *Equity* were both at St. Petersburg, young Chambers was borrowed to decorate the former. He proved so competent, and gave such satisfaction, that Braithwaite interested himself in his behalf, and, getting Storr to swear to him, over a bottle at the London Docks, that he would set the artist free, obtained his manumission. Storr, indeed, endeavoured to evade the promise, but Messrs. Chapman, the shipowners, were induced to cancel the seaman's indentures when two years of the seven were still unexpired.

Free from servitude, Chambers had still his living to seek. He worked his way in a trader to his native Whitby, and there engaged himself for three years as house and ship painter at from five shillings to six and sixpence a week, in a business carried on by a widow named Irvin. Here he surpassed his fellow-apprentices, and brought new custom by his clever lettering and marking of the Greenland whale boats. Mr. Jenkins relates the following anecdote, told him by the late Mr. A. Clint in October 1857. Clint 'took lodgings in a house, when he was staying at Whitby, in which there was an imitation marble mantelpiece painted by Chambers. His landlady informed him that she sent for the house painter, with whom little Chambers was employed, to have the mantelpiece grained, stating that she wanted it done in the best way possible. The man said he would send some one who could do it better than any one in Whitby, and sent Chambers to do the work. When he presented himself, the lady expressed her surprise to the master that he should send a mere boy, as she wanted it done by a first-rate workman. ' Let him alone,' said the master, ' and see it when it is finished. He will do it better than any *man* that I know of.' And to the surprise of every one the sailor boy did it to admiration. Mrs. Irvin had a foreman, John Younghusband by name, who was probably the 'master' referred to. This cleverness brought an offer to Chambers of double wages from a trade rival. But, declining to leave an indulgent mistress, he more profitably employed the spare time she allowed him, in making copies on millboard of sketches furnished by captains of scenes in the whale fishery. For these his prices began

with a few shillings, but soon rose to a guinea. He had patrons, too, of the opposite sex, and was employed in painting pails for the old women, and designing valentines for the young.

At the same time he did what little he could to obtain some teaching in art. It is told how he got a librarian's shop-boy to lend him a drawing book for the night ; and how he once sat up all night to earn an extra shilling to give to Mr. Bird, a landscape painter, to show him how to copy in colours a picture of ' Jacob and Rachel.' Bird, however, who was not a mere brother of the brush,[1] did more than this. He gave him some commissions, and recommended him to others. At this time, his biographer tells us, his best efforts were little oil paintings of vessels at sea, not painted to look ' fine,' but actually sailing, and their crews engaged in performing some nautical operation, such as reefing, tacking, &c. He painted on the panel of his humble home a picture of the *Equity*, and a panoramic view, which are possibly still to be seen.[2] He also worked earnestly from nature ; but one of his attempts nearly cost him his life. In order to make a drawing of Whitby from the sea, he pulled off with two com- panions in an old coble. He had scarcely finished his sketch when a violent storm arose, and the three were only able by almost super- human efforts to keep the craft afloat until they reached the harbour. Chambers had pulled so hard that he had to be placed under medical care, and it took him five weeks to regain his strength and recover the use of his hands. The ill wind nevertheless blew him some good ; for his medical attendant, Mr. Allan, who was a clever artist, lent him sketches and prints to copy, besides giving him introductions. And moreover, as we shall see, his own sketch of the town was of great use to him afterwards.

[1] Watkins, who relates the anecdote (*Life of Chambers* [1841], p. 15), calls him a geologist and local antiquary. Probably he was the John Bird, mentioned by Redgrave (*Dictionary of the English School*) as a self-taught man, who drew views for Angus's ' Seats,' and the ' History of Cleveland ' (1808), and died at Whitby, 5 Feb. 1829, aged 61.

[2] Mr. Jenkins adds the following in a memorandum, dated 9 August, 1865 :—' In 1865, in company with Dodgson, I made a sketching excursion in the neighbourhood of Whitby, and then searched out the "Wesleyan Court" in which Chambers lived with his parents. It is to be found in the quarter occupied by sailors and fishermen, the poorest and most squalid part of Whitby, under the East Cliff. Mr. Wetherall, a resident and friend of Dodgson's, told me that at some time or other Chambers had painted a picture on a panel over the chimney-piece of the house in which his father lived. The subject was a fleet of North Country vessels in a calm off Flamborough Head. This picture was cut out and sold ; and is now in the possession of a Mr. Corner. Mr. Wetherall took me to the house of a Mr. Redman in Whitby, who had several scraps by Chambers and two of his early pictures.— J. J. J.'

Chambers was but nineteen when, his term of service at Whitby having expired, he found himself again thrown upon his resources. He had literally nothing but his talent to rely on for support. What little savings he had made had been exhausted in the funeral of his mother, who had died but shortly before. Meeting with no encouragement from his relations to pursue a career of art, his sailor father being of opinion that painting only spoiled good canvas, he resolved to shake the Whitby dust from his feet, and try his fortune in a larger world. Putting himself on board a new ship, the *Valley-field*, Captain Gray, he earned a couple of pounds and his passage to London to make a start in the great (and on that small) capital. Even there he had to encounter the opposition of a relative, a married sister, who tried to dissuade him from his intent, but did not refuse to afford him board and lodging. His prospect seemed dark enough ; but, bent on his chosen career, he refused an offer of 30s. a week as a journeyman house painter, and set to work resolutely to paint shipping. Fortune favoured the brave, and by a lucky chance he gained a staunch friend, who recognized his talent, took him by the hand, kept a generous eye on him for the rest of his life, and virtually adopted him as a son.

The name of this kind benefactor, which deserves to be recorded beside those of patrons of art more noble in rank, was Christopher Crawford, landlord of the 'Waterman's Arms,' 22 Wapping Wall, near St. James's Stairs. This was a house of call for Whitby sailors, and thither, eight years before, little Chambers had been brought by Captain Storr, of the *Equity*, with the bundle of miniature slops above mentioned. The place was frequented by three classes of visitors, owners, captains, and common seamen, each having its appropriate parlour ; while the landlord, 'an honest, hearty, blunt and bluff John Bull,' was 'ever to be found seated in his great arm-chair in the bar, smoking cigars, and surrounded by parrots and other exotic things, presented to him by sailors from some far foreign land.' Crawford's antecedents, however, implied education, and were consistent with the taste for art which he certainly displayed. He had been on the stage, as a comedian, at Whitby ; and sailed to Greenland as a ship's doctor.

It happened at that time that a view of Whitby was wanted as an appropriate decoration of the owner's room at the 'Waterman's Arms,'

and Huggins[1] the marine painter had been applied to for the pur-
pose. But, as he would have had to pay a visit to Yorkshire and
required his travelling expenses, there was a demur about the price.
While the landlord, in his big chair in the bar, was meditating on this
matter, the same subject was talked of in the sailors' room, hard by ;
and Crawford overheard one of the crew of the vessel in which our
hero had worked his way to London declare himself—'blowed' (at the
least)—if his comrade, little Chambers, wasn't the right man to do the
job. Crawford thereupon sought out this 'little Chambers,' and recog-
nizing a portrait of the brig *Equity* that the painter still had by him,
was reminded of the sailor lad's visit to Wapping in 1815, which
Chambers had not forgotten. He found the young artist diffident of
his power to execute such a commission ; but liked his modest way,
and proceeded to tempt him with the novelty (to him) of a prepared
canvas. Chambers evinced his delight by beginning to design upon
it at once ; and, the first step taken, went on with and completed the
work. A difficulty arose as to the particular vessels to be introduced
into the picture, there being danger of offence to owners whose ships
might be omitted. But this was overcome by limiting the set to
those in which Crawford himself had sailed. When the picture was
finished, Chambers's patron took him with it to Mr. Chapman, the
shipowner who in former years had so considerately cancelled the
sailor lad's indentures ; and he, pleased, no doubt, that the young
man's liberty had been so well employed, gave him a commission for
another picture, with his own ship, the *Phœnix*, put in, 'returning
home with full cargo.'[2]

The view of Whitby for Crawford was a great success, and brought
further employment to the artist in taking portraits of vessels. But
his desire was to paint pictures rather than portraits ; and he longed
to go to nature again, if only to obtain suitable backgrounds to his
shipping. Through the interest of the friends last mentioned, he was
enabled to gratify these aspirations in coasting voyages to Yorkshire
and Northumberland, and to the Isle of Wight, during which he made
numerous sketches. Among other acts of generosity, Crawford is
related to have bought and presented to Chambers a ten-guinea pic-

[1] William Huggins, afterwards appointed Marine Painter to King William IV.; born 1781,
died 1845. (Redgrave, *Dictionary of the English School.*)

[2] This picture, says Chambers's biographer, Watkins, was engraved by Messrs. Fisher,
ostensibly for the painter's benefit, but he only received a few copies as his share of the
profit.

ture by Whitcombe,[1] which had taken our artist's fancy. The above
cruises gave Chambers the means, some time after, of testifying his
gratitude to Crawford, by decorating the walls of his enlarged parlour
(probably the captains' room) with a long coast view from Whitby to
the Tees, introducing the vessels of various owners who frequented the
house. This proved a considerable attraction to visitors.

It was moreover by that means a source of further advantage to
Chambers. A gentleman, who called one day about some foreign
shells which were on sale, chanced to see it ; and being struck with its
picturesque truth, made inquiries respecting the painter. This was
Mr. Horner, projector and proprietor of the Colosseum[2] in the
Regent's Park, who was engaged in superintending the execution by
E. T. Parris, and his assistants, of the huge panorama of London from
the top of St. Paul's, which was long its chief attraction. Here,
thought Crawford, was a fresh chance for his *protégé*. So he dragged
him off to the Regent's Park, in spite of his shyness, and his protests
that such work was out of his line, and presented him as a candidate
for a place among the staff of Parris's assistants. Horner, who was a
native of Hull, received them as brother Yorkshiremen, but, with the
prudence of his race, demanded further samples of the young man's
work. A picture on hand of Bridlington Quay was enough to show
that Chambers could paint houses as well as ships, and his further
capabilities for the particular task required were proved the next
morning in a wonderfully elaborate bird's-eye view which he sketched
from Crawford's garret window four storeys high. On being intro-
duced into the building where the painters were at work, suspended in
boxes that swung in the vast rotunda, ' little Chambers ' at once gave
evidence that this perilous position had no terrors for a sailor lad like
him. His answer to Horner's inquiry, whether his head would stand
it, was to seize a slack rope and mount at once to the roof, hand over
hand, with the agility of a monkey.[3] So he was taken upon trial.

[1] Thomas Whitcombe, an excellent and effective painter of sea fights &c. Born about
1760. Living soon after 1824. (Redgrave, *Dictionary of the English School.*)

[2] For many years a conspicuous object, on the site now occupied by the row of houses
called Cambridge Gate ; not far from the old Diorama designed by Pugin.

[3] His readiness to go aloft is illustrated in an anecdote reported by his friend Sidney
Cooper, R.A. The incident seems to have occurred at the ' Waterman's Arms,' where, a
chimney catching fire, Chambers without a word climbed the stack with a mat, which he
placed on the chimney-pot, and then sat upon. Thereupon the smoke poured forth into
the bar, and a sea-captain firing his carbine up the flue to dislodge the soot, dislodged our
artist also. (See *My Life*, by T. S. Cooper, R.A., i. 223.)

After the first day's work, Horner called him up. 'I want a word with you, sailor,' says he. 'I have only to tell you this—that you have done in a most masterly way more work in a day than a fine German artist that came here with a livery servant spoiled in a week.'[1] Needless to say, Chambers made good the first impression. He worked so well and so fast that he superseded the rest of the assistants, and he and Parris finished the painting between them. The former was naturally employed on the river and shipping ; but he did other parts as well, for which, however, the latter is alleged to have assumed the credit. It is said that our artist was engaged on this panorama for seven years.[2] But this can hardly be the case if, as it is also stated, the term during which Parris was so occupied was no more than from 1825 to 1829.[3] Unfortunately, after all, he was doomed to be deprived of the anticipated profit of all this hard work. Horner's affairs becoming involved, poor Chambers had to suffer the loss of a great part of his wages. Dejected by this disaster, he sorrowfully returned to his former quarters in the East of London, with the prospect of being cast back upon his old practice of ship portraiture.[4]

Chambers had apparently by this time taken to himself a wife, though it is not quite clear whether this event had preceded his engagement at the Colosseum. She was a lively young woman, with whose grandmother his sister had lodged, and had a liking for the arts, and a respect for the artist which had gradually warmed into a passion that was mutual. Their attachment had been somewhat of a trial to good Christopher Crawford, who thought Chambers too young to marry, and wished to send him to Italy. But the lover beginning to pine, he made the best of the matter, let him have his way, stood sponsor to his first child, and was as much his friend after as before ; proving his goodwill by getting berths for the artist's father and his younger brother William. Unhappily the after life of George Chambers was much embittered by his wife's frivolities.

The experience which Chambers had acquired at the Colosseum now turned his thoughts to the stage ; and he earnestly desired to try his hand on a scene. A friend from Whitby named Dodd, who was

[1] Watkins's *Life of Chambers*, p. 31. [2] *Penny Cyclopædia*, Supplement, vol. i.
[3] Bryan's *Dictionary of Painters* (Graves's edition).
[4] In each of the Royal Academy Catalogues for 1828 and 1829 is named a work by George Chambers, viz.: ' Sketch on the River Medway,' and ' Off Ryde, Isle of Wight ; ' and the successive addresses given are ' 44 Cleveland Street, Fitzroy Square,' and ' 11 Wapping Walk, Shadwell.'

both a portrait painter and an actor in London, introduced him to Farrell, the manager of the Pavilion Theatre, who received him into the scene room, and, as he had no knowledge of distemper, and little of technical perspective, gave him a few lessons to start with. Amid some ill-natured ridicule from the older hands, he managed, by perseverance, to master the material; and his success with ' a view on the Liffey' was rewarded by an engagement at two guineas a week, which amount was soon doubled. His scenes at this theatre proved very popular, and were no less admired by artists than by the public. A ' Panorama of Views on the Rhine,' a representation of ' The Glorious First of June,' and a drop scene of ' Greenwich Hospital,' are specially recorded. They were ' like pictures, and possessed equal attraction with new plays.' Notwithstanding his close duties at the theatre, which often extended through the night, Chambers contrived to find time to paint some cabinet pictures; and, although he is said to have been unsuccessful at the Royal Academy,[1] he was more fortunate outside the walls. For two small works of his, in the window of a framer named Smart, in Greek Street, Soho, caught the eye of Admiral Capel, who, struck with their nautical exactness, not only gave the painter a commission, but also some valuable introductions; so that he was able in time to leave the theatre, and set up as a marine painter at No 37 Alfred Street, Bedford Square. His scenes at the Pavilion Theatre were long preserved by an excellent artist who succeeded him, William Leighton Leitch, whose admiration restrained him from painting them out.

The tide of Chambers's fortune seemed now to have fairly turned. Among the patrons whom he had acquired through Admiral Capel's introductions were Colonel Long, and Admirals Munday and Lord Mark Kerr, the latter of whom in particular took every opportunity to advance his interest. Thus Chambers came to be fully employed by the first naval commanders of the day. He was still a young man (only twenty-seven in 1830, when William IV. came to the throne), and as diffident and bashful as ever. So he was quite taken aback when his noble friend in the navy came to him one day with the news that the sailor King had commanded his presence at Court. He scarcely knew what to do, and is said to have procured a Court suit for the purpose. When Queen Adelaide offered him accommoda-

[1] Watkins relates that he once showed his vexation, by leaving a rejected picture uncalled for at Someiset House till some time after the Exhibition had closed.

tion in Windsor Castle, he in his simplicity answered that he thought
he should be 'more coomfortable at the "Red Cow."' The frankness,
however, with which he was received by their Majesties soon put him
at his ease, and when he thought the Queen stood too close to his
pictures to judge of their effect, he did not scruple to tell her to 'coom
backarder.' Several commissions were given him for pictures from
his sketches; and when the artist got home he declared that 'the
King was a jolly good fellow, and the Queen a nice little woman.'
For the former he painted 'The Opening of London Bridge' and 'The
Hydra Frigate on the Coast of Spain;' for the latter, a 'View of
Dover,' and another of 'Greenwich;' the prices being thirty guineas.
Sir Herbert Taylor, the King's private secretary, also gave two
commissions.

It happened more than once in Chambers's career that some
apparent stroke of good or ill fortune had a sequel of an opposite
kind. And it was so on this occasion. On his return journey from
Windsor he caught a severe cold, and his rheumatic pains returned,
aggravated by mental excitement, which deprived him of all power
to begin the royal commissions for six months. During this illness,
however, he once more gained a friend and patron in his medical
attendant. This time it was Dr. Roupell, who afterwards became
possessed of some of Chambers's best works. When the patient was
convalescent, he and Mr. Carpenter, the before-mentioned dealer in
Bond Street, with whom the artist had had kindly relations, took him
to their houses in the country to recruit his strength; and when his
commissions were fully executed, he was ordered to his native town
for change of air. There he spent some time with his relations.
'He had left Whitby,' writes Mr. Jenkins, 'a poor wanderer, to seek
his fortune in the way he loved best. He now returned in all humility
to the humble home of his parents, though broken in health, a man
of distinction, to be pointed at in the streets by wondering sailors
and fishermen as little Chambers who had won the favour of the
King.'

While at Whitby, Chambers kindly gave a helping hand to some
local artist brethren, and took them out sketching. But he was not
always honoured as a prophet in his own country. For his biographer
Watkins (whose acquaintance with him began at this time) relates
that the two, when visiting Staithes on an excursion of this kind, were
mobbed and pelted by the uncouth inhabitants.

Chambers made good use, notwithstanding, of the sketch he then took, for he writes to his companion soon after, from London : 'I keep on improving prices for my pictures every day. I am just painting a view of Staithes[1] from the sketch I made with you ; it is a beautiful subject. I could have sold it to a dozen different gentlemen. There is always something good in these barbarous places, where they have not manners to allow you to sketch.'[2]

The 'favour of the King' did not extend beyond the giving of commissions. For the post of Marine Painter to the Crown was bestowed in 1834 upon Huggins, whose work, Redgrave tells us, was esteemed by King William IV. 'rather for its correctness than its art.'

Mrs. Chambers joined her husband at Whitby, and the two were in the South again in the spring of 1833. In the following autumn he writes that he has still been 'running about' to recover his health. 'My time has been spent in the delightful county of Sussex, at Tunbridge Wells, Lewes, Brighton, Shoreham, &c. I have had a most delightful little residence about one mile from Brambletye House.' On their return to town Chambers and his wife took up their residence in a small house, No. 6 Park Village West, Albany Street. This brings us to the time when he became an Associate of our Society. He refers to that event, in one of the letters above quoted, in the following words :—'I have also to tell you more good news. I was last week elected a member of the old Water-Colour Society, which is almost as good as being a Royal Academician. I was unanimously elected, although I do not know a single member. There were a great number of candidates, who have been trying for years past to become members.'[3] This election as Associate was followed the next year by election as Member.

The forty-one drawings which Chambers exhibited at Pall Mall East belong to the last seven years of his short life. They are mostly of subjects which combine shipping or boats, and studies of wave or water, with scenery of the coast or river below the bridges. About half a dozen, in 1837, 1839 and 1840, are Dutch, the result of two trips to Holland which he made with pupils. For at this time he did a little teaching, his usual fee being three guineas for a couple of lessons. Two drawings only were of historic subjects, being represen-

[1] There is such a view among his exhibits at the Water-Colour Society in 1834, misprinted Starths' in the Catalogue.
[2] *Life of Chambers*, p. 76. [3] *Ibid.* pp. 76, 77.

tations of the battle of Trafalgar at critical moments, first the *Victory* breaking the line, and secondly her situation when Nelson died. These were exhibited in 1837 and 1838. Except one in 1840 of a 'Greenlandman bearing up to leave the Ice—full Ship,' the rest were English scenes within the limits of his native sketching ground. Thus Chambers, as a water-colour artist, belongs to a somewhat different class from the same Chambers the marine painter, who was contemporaneously employed to decorate the painted hall at Greenwich Hospital with records of naval history. For that gallery he, in 1836, painted 'The Bombardment of Algiers by Lord Exmouth,' and received for it 200 guineas. One of his pupils[1] told Mr. Jenkins that when he received the commission he made many beautiful studies, varying the arrangement for the general effect ; but would not begin the picture itself for some time, 'for,' said he, 'I am to have a large sum for it, and I must study it well, and not slash it off merely to get the money.' He also went down to Portsmouth to study the men-of-war. 'The Taking of Portobello in 1739,' another of his pictures at Greenwich, was presented by the Under Governor, Edward Hawke Locker. He also copied on commission (for 100 guineas) from the same institution, West's picture of 'The Battle of La Hogue,' in the Duke of Westminster's collection.

In July 1837 Chambers paid another visit to Whitby, in health much improved since the last. 'He looked,' says Watkins, 'a jolly, chubby, sailor boy again.' On his return he moved to 7 Percy Street, Rathbone Place. In the following season he writes: 'I have been very unlucky this year with exhibitions—altogether badly placed, and none sold. It will not do without getting more to nature. I wish I were living on the sea coast for a year or two.' The means of gratifying some of this thirst for nature were given him by another accomplished pupil now living, Mr. J. Chisholm Gooden-Chisholm, who has kindly furnished the writer with the following interesting note of his recollections of the time :—'Chambers and I were much about together on the river, on several yachting excursions, in which he accompanied me. We had very rough weather, so I doubt that very much came of them to him ;[2] but when it was impossible to use

colour, his scrap-book was always in his hand, and any accident in the arrangement of a vessel's sails and notes of colour of clouds were at once recorded. Failing any particular object, he would be studying black and white in a little jet mirror, probably come from his early days at Whitby. This occupation would seem always to afford him great contentment.' The same informant was his companion in one of the Dutch trips. 'I was in Holland with him fifty-one years ago' (i.e. in 1838), 'and our life there was to be in a boat sketching all the mornings and afternoons, and then at Amsterdam into the boat to sketch the great schuyts that were taking people away to the villages on the Zuyder Zee after their work of the day was over in the city.' These sketches were the foundation of a drawing exhibited in 1840 of 'German Reapers leaving Amsterdam for the different Towns in Waterland—Evening.' A subject of a similar kind, 'Dutch Passage-Boat crossing the Maas,' was among his drawings in Pall Mall East in 1839; and a painting thereof, which, after being rejected at the Academy,[1] was sent to Manchester, where it gained a twenty-guinea prize, and Chambers received the Heywood Silver Medal.

Of the season of 1839, he himself writes :—' I have nothing in the Academy this year, but have been very successful in the Water-Colour Gallery. My drawing, a Broadstairs anchor-boat going off, is hung as the centre drawing, and has been very highly spoken of. Mr. Harding bought it before the private view, which is a great honour; but in spite of all, I do not find the encouragement that I strove for. Artists are all alike for that. There is no selling a picture but through dealers.' The purchase by the Queen Dowager of one of his drawings exhibited in 1840, 'Dover Pilot-Lugger returning to the Harbour,' was, however, a pleasant reminder of the Court favour he had enjoyed at the beginning of the last reign. On her present Majesty's accession, his friends at Whitby endeavoured, by means of a memorial, to obtain him the post of 'Marine Painter to the Queen.' But when he died that honour had not been conferred upon him.

His health was now failing rapidly. Though he expressed a wish to go to Stockton or Shields, as he declared it impossible to study

[1] The only pictures of Chambers's which obtained admission at the Royal Academy appear to have been the two above mentioned in 1828 and 1829, and one in 1838 of 'Dutch Vessels going out of Harbour, Rotterdam in the distance.' Graves indeed counts up fourteen under the name 'George Chambers,' but he evidently includes father and son under that their common name. For the remaining eleven were hung in the years 1850-1861, that is, from about ten to twenty after our artist's death.

marine in London, he was, in fact, too ill for sketching of any kind. Being obliged to desist from work, he was once more threatened with poverty; when his old benefactor, Christopher Crawford, came again to his relief, and sent him off for a cruise in the *Dart* packet, Captain Airth, to the Mediterranean, and Madeira, where he remained ten days. He was able to sketch on deck, and made some studies on the island, for a large picture, which he did not live to paint; for he only returned to die (as it was found, of heart disease), at Brighton, on the 29th of October, 1840, aged thirty-seven. The faithful Crawford followed, as chief mourner, to his grave at St. James's Chapel, Pentonville. The sale, in February 1841, of his remaining works did not realize much for the family. But a contribution of 50*l*. was voted on the 8th of that month by the Society in aid of a subscription (of which T. Sidney Cooper, R.A.,[1] was Treasurer) to assist his widow and three orphans under twelve years of age, besides what they received in respect of his share as a Member. Among the many evidences that the great Turner, with all his thrifty ways, was not wanting in kindly charity to brother artists, is the fact that he gave 10*l*. to this fund; and he further testified his appreciation of Chambers by attending the sale for the purpose of giving it help. Stanfield, R.A., is said to have put the last touches to a painting left unfinished by our artist.[2]

'Chambers,' says his biographer Watkins, 'was a born gentleman, as well as a genius; his love of the fine arts had refined him. . . . His voice was mellow, and his smile sweet.' Mr. Chisholm calls him 'a lovable little fellow, entirely unaffected by the success which reached him.' His tastes were very domestic, but he was sociable withal. He talked with visitors while he was at work in the daytime, and loved· to chat with friends round his fireside in the evening. He read little, and said he would rather make a sketch than write a letter. But he was fond of music, and played well on the flute. He and a few brother artists used to hold small sketching meetings at each other's houses, after which, when at home, Chambers 'would adjourn to his kitchen and sit over hunks of bread and cheese and glasses of beer

[1] Sidney Cooper, who first met Chambers at Carpenter the dealer's, became sincerely attached to him. 'His early death,' he writes, 'was a very great loss to art, for, had he lived, I feel convinced that he would have become one of the greatest marine painters of his time, or, indeed, of any time. . . . His painting of rough water was truly excellent, and to all water he gave a liquid transparency that I have never seen equalled . . . his ships were all in motion.'— *My Life*, by T. Sidney Cooper, R.A. (1890), i. 221, 222.

[2] *Dictionary of National Biography.*

till eleven o'clock. When no sketching night was on, I suspect,'
writes Mr. Chisholm, 'that a glass of gin and water, and a pipe,
perhaps in a public-house in the neighbourhood, sufficed him. He
was a perfectly sober man, but this was the sort of life pursued by
most of the artists, aye, and the rising ones, of the time.' Though,
as Watkins declares, Chambers keenly felt the necessity of 'painting
for the pot,' he had to pass his mornings in London in doing little
paintings or drawings for this purpose, and 'the disposal of these at
shops,' writes Mr. Chisholm, 'would afford their producer his quantum
of out-of-door exercise.' 'He painted in his drawing-room; but,
excepting the picture on the easel, there were no marks of its being
a painting room. His colours and brushes were kept in a mahogany
case, designed by himself, and having the appearance of a piece of
drawing-room furniture.' [1] Chambers's way of speaking was apt, as
might be expected, to be homely and colloquial. A not uncommon
interjectional phrase of his was—' Blow me !' Always on the look-
out for subjects for his pencil, he one day, finding nothing that
interested him, was seen to pull up suddenly before a formal row of
leafless trees, with the exclamation, 'Blow me ! I *must* do *something*,'
and proceed to make a careful study of the bare branches.[2] 'It was
distinctive of him more than of any other artist that I have worked
with,' continues Mr. Chisholm, 'that on any impressive effect in sea
or cloudland presenting itself, his plain little face would light up, and
his hand become tremulous, and for the time he was raised. These
would be the rare intervals when the poverty and discomfort of his
life would be lost to him. He had ample of the miseries.'

The engravings after George Chambers's works are not numerous.
He himself produced but one (unfinished) etching, 'Hay Barges in
a Breeze.' In the *Gallery of Modern British Artists*, 2 vols. 4to, 1834,
are two plates in line after paintings by him, viz.:—' Burlington Quay,
Yorkshire,' engraved by J. C. Bentley; and 'North Foreland.' In
the spring of 1839, he writes of having been 'at Liverpool since
Christmas to take a view of it to publish,' and that he expects 'to
have a large lithograph finished in about a week or two' of 'Stranded
Shipping.' [3] A picture of his, possibly this, is said to have been
engraved by 'Carter, of Liverpool.' And there is a lithograph by
Gauci after a study by him of 'Scheveling Beach.' The highest

[1] Watkins's *Life of Chambers*, p. 82. [2] J. J. J. *ex relatione* A. Clint.
[3] Watkins's *Life of Chambers*, pp. 143, 144.

sale price recorded by Redford for one of **Chambers's water-colours**
is 215*l.* 5*s.* for 'Merchantmen signalling for Pilot, 1835,' at the '**Birch**'
sale, 1878. Nothing had previously reached one-half that amount.

Another able painter of sea and shore subjects, as well as general
landscape, was elected an Associate on the same day, 10 February,
1834, as George Chambers. His name was CHARLES BENTLEY. He
did not possess the seaman's knowledge which gave special character
to that artist's painting; but the number of his works, and of the
annual seasons during which they adorned the gallery, made him a
more conspicuous contributor to its attractions. He practised almost
exclusively in the water medium, and was a typical representative of
its modern application to the class of subjects which he mostly
selected. Using body colour without stint, he gave his drawings
much spirit, with varied effects, and imparted to his scenes the
suggestion of movement and life.

There is little to record of Bentley's personal history; but that
little is all to his credit. He was born in 1805 or 1806 in Tottenham
Court Road, London, where his father was ' a carpenter and builder,'
who ' employed ' several men. Having shown from his earliest days
a taste for drawing, ' he went,' writes his mother,[1] ' to Mr. Fielding to
colour prints, and then was 'prenticed to him ' to learn aquatint
engraving. Doubtless the master so named was one of Copley
Fielding's brothers, all of whom practised in that branch of chalco-
graphic art; but which of the three is uncertain. Mrs. Bentley adds,
however, that ' while he was 'prenticed he went to Paris to do a work
Mr. F. had there.' And there exists a set of coloured aquatints published
in Paris as illustrations of a folio entitled, *Excursion sur les Côtes et
dans les Ports de Normandie,*[2] some of which are engraved by Newton
and Thales Fielding; so one of these may have been Bentley's master.

The name of Bentley occurs as engraver on some good plates in
the line manner, though he is said to have relied mainly on his talent
for drawing from the time of completing his term of pupilage. He is
not found among exhibitors either at the Academy or elsewhere before
he joined our Society. By that time, however, his merit as a designer
had been displayed in some of the illustrated publications of the day,
and he continued to be employed in this way during the period when

[1] In December 1855, when she was in her eighty-eighth year. J. J. J. MSS.
[2] Some of these views are after drawings by Bonington.

he was still an Associate, in which rank he remained until the 12th of January, 1843, when he was elected a full Member. The following plates from his drawings are in the Annuals, and works of the same class :—In the *Literary Souvenir* for 1833, ' A Shipwreck off the Isle of Wight,' remarkable for a fine and original effect of sky, with a halo round the sun ; 1834, ' St. Michael's Mount ;' 1835, ' Venice ' (all engraved by J. Thomas).—In the *Gallery of Modern British Artists*,[1] 2 vols. 4to, 1834 :—' Pont Gwryd, with Snowdon in the distance ' (engraved by the artist), and ' Scarborough Castle.' Throughout this work the artist's name is printed ' J. C. Bentley.'—In the *Keepsake* for 1839, ' The Shipwreck,' a group of two figures, apparently Don Juan and Haidee ; 1841, ' Morning ' a view of a ferry. (Both by J. T. Willmore.) The painter's name is printed ' J. Bentley.'—In the *Forget-me-not* for 1842, ' Fort Rouge, Calais ' (T. Thomas).—In Fisher's *Drawing-Room Scrap-Book* for 1837, 1838, 1840, 1841, eleven views in the Mediterranean and in India, after sketches by Lieut. H. E. Allen, R.E., Sir Grenville T. Temple, Bart., and G. F. White, Esq. These had probably been published elsewhere, according to common practice in these compilations.—Among the *Illustrations to the Waverley Novels*,[2] collected and issued, or reissued, by the same publisher, ' The Pass of Aberfoil—" Stand ! " ' from *Rob Roy* (J. Redaway), with date, 1842.—In Tillotson's *Beauties of English Scenery*, ' Hull,' ' Falmouth,' and ' St. Mary's Church, Minster ' (H. Wallis) ; and in Tillotson's *Album of Scottish Scenery*, the ' Bridge of Bracklin ' (engraved by W. B. Cooke after ' J. Bentley ').

Graves finds eleven works of his at the British and three at the Suffolk Street Gallery. The drawings he is best known by are, however, what he exhibited in the Society's Gallery. The titles of these, as entered in the catalogues, mark out his sketching area as nearly confined to the seas within sight of the British and Irish coasts, or of Normandy and the Channel Islands. He rarely penetrates so far inland as to lose touch with the sea or get free of the salt savour of maritime scenery. Three times only does his range extend as far as Holland ; for four views of Venice, and one on the Rhine, are not enough to imply personal travel thither. The latter belong, more

[1] Several of the plates after other artists in this collection are also engraved by Bentley, among them a ' Rievaulx Abbey ' by Turner, and ' Burlington Quay ' by Chambers, in the latter of which the painter and his translator are in unusual sympathy.

[2] One of these, of ' Hamish Bean and his Mother,' from ' The Highland Widow,' after Topham, is engraved by ' J. C. Bentley.'

likely, to the category of three, in 1841 and 1849, from the Black Sea, which are professedly after sketches on the spot by another hand, that of 'Coke Smyth, Esq.' With these exceptions, and two illustrative designs in 1838 representing fancy scenes from 'The Red Rover' and 'Tom Cringle's Log,' Bentley's named subjects are all from his native shores. To find them we must make almost the entire round of the English and Welsh coasts, taking an occasional run up the Thames ; and must visit all the four provinces of Ireland for those of twenty-eight which form the contingent of the sister kingdom. In and after 1848 there are generally also one or two drawings from the Firth of Forth. Including all the above, his total number of exhibits from 1834 to 1854 was 197, made up from an average of nearly six during the nine years of his Associateship, and thirteen for the eleven when he was a Member.

Apart from his acknowledged artistic talent Bentley had come to be regarded personally in the Society as a most valuable Member, when he was snatched away in the prime of life, and in the midst of his career, by an attack of cholera, which carried him off after a few hours' illness on the 4th of September, 1854. Dying as he did, it is to be feared that he must be reckoned as one more able artist who made but a small pittance by his profession. Redgrave tells us that he was 'in the hands of picture dealers, uncertain in his transactions, and always poor.' He left a widow, and a very aged mother (then living at Boston in Lincolnshire), who was stated to have been more or less dependent on his support. For many years, up to his death, he resided at 11 Mornington Place, Hampstead Road.

His remaining works were sold at Christie's on the 16th of April, 1855. The highest price for a 'Bentley' recorded by Redford is 98*l*. 14*s*. for 'Boats returning to Harbour,' in 'Fred. Somers' sale, 1867. —Four of his drawings have been imitated in chromo-lithography by Rowney & Co., viz. 'llfracombe' 10 x 14¾ in., 'Old Pier Head, Coast of Normandy' 9½ × 14¾ in., 'Off Port Madoc' 10 x 15 in., 'Scarborough Castle' 8¼ x 11.

The third Associate, elected with Chambers and Bentley, was JOSEPH NASH. He was not far removed from them in age, being about five years younger than the first, and two than the second of the group. But he long survived them both, exhibiting drawings throughout Fielding's term of office, and as long again after his death. Nash is commonly regarded as an architectural painter and draftsman,

in which department his works are numerous, and widely known through the medium of the press, particularly by lithographic prints. But he aimed at subject drawing also, and has even been set down as, primarily, an historical painter.[1] Considerably more than twenty per cent. of the drawings which he sent to our gallery make distinct claim to a place in that category, being illustrations of Shakspere's plays and Scott's novels, *Don Quixote* and other standard fictions, or scenes and incidents of past times and historic tradition. When he depicted an ancient building, moreover, he usually peopled it with men, women, and children, costumed and occupied as in the days of its prime. Thus he ventured to tread the ground already occupied by George Cattermole, whereon, in his own line, that painter held undisputed sway. In several respects there was much in common between the two artists. In others they differed widely ; and, for the most part, the resemblance was only superficial. In manner of painting they agreed in the lavish use of body colour, which practice Nash was one of the earliest to adopt ; and, drawing in a sketchy way, they were equally regardless of textural detail. Masters of picturesque composition, they aimed alike at making the artistic arrangement of the design a main source of its attraction. Hence the works of both were admirably adapted to engraving. But, partly from a difference of handling, and of proclivities as to line and form, and more still from diversity in general sentiment, the drawings of the two are so obviously distinct, that they seem scarcely to belong to the same school. Each illustrated the time of the civil wars of the seventeenth century ; but Cattermole also lived more in the Middle Ages, Nash more in that of the Tudors. As a subject-painter, the former displayed dramatic power and luxuriant fancy to which the latter could make no pretension ; with Nash, the disposal and grouping of the figures, and their utility in setting off gay costume and effecting a pretty play of light and colour, were apt to be more important considerations than the expression of individual character. Thus their proper functions were those which they performed as accessories to his architectural drawings, where the nobles who disport themselves, and the cavaliers who flaunt in stately mansions and quaint Elizabethan halls, administer merely to the sentiment of the building portrayed.

Joseph Nash was the eldest son of a clergyman of the Church of England, the Rev. Okey Nash, who kept the Manor House School,

[1] See Graves's *Dictionary of Artists*.

II.

North End, Croydon, and was sometime Vicar of Throwley in Kent.
He was born at Great Marlow in 1808, and educated at his father's
school, where he showed his bent by covering his lesson books with
sketches. In 1829 he became a pupil of Augustus Pugin's, and he
was one of the group of young men who went with him to Paris, as
before mentioned, to make drawings for his *Paris and its Environs*
(2 vols. 4to, 1830). Joseph Nash, Benjamin Ferrey, and Talbot Bury
were the principal contributors of the drawings engraved in that work.[1]
He began in this early part of his career to draw upon stone, his first
lithographic work being also done in conjunction with Pugin, whose
Views Illustrative of the Examples of Gothic Architecture, 1830, are
lithographed by J. Nash, from sketches taken under Pugin's direction.
It was chiefly, however, as a painter of *genre* that he made his first
independent efforts to obtain distinction as an artist.

At the time when he joined the Society, Nash furnished the
drawings of some of the pretty steel plates that adorned the Annuals
and their allied publications ; and there are one or two of later date.
The following prints are from his designs :—In the *Keepsake* for 1834,
'The Merchant and his Daughter' (evidently meant for Shylock and
Jessica), engraved by C. Rolls ; 1848, 'The Crevice in the Tower,'
engraved by Frederick A. Heath.—In the *Gallery of Modern British
Artists*, 2 vols. 4to, 1834, 'Scene from *Kenilworth*, Wayland, Amy
Robsart, and Janet '—' Roland Græme's first Interview with Catherine
Seyton, from *The Abbot*'—and ' Christopher Sly and the Hostess.'—In
the *Forget-me-not* for 1839, 'Alice Lee,'[2] engraved by L. Stocks.

During the first four years (1834–37) of his Associateship, more
than three-fifths (sixteen out of thirty-seven) of his drawings belong
to this illustrative class. But with these he exhibited eleven archi-
tectural subjects, the majority of which he transferred to stone, to
make up a set of twenty-five lithographs, published by McLean of
the Haymarket in folio, in 1838, with the title *Architecture of the
Middle Ages*. Except two (at Arundel and Oxford) the examples in
this collection are all foreign, and for the most part ecclesiastical,
buildings. But they nearly all belong to the latest or flamboyant
period of the Gothic style, and its mixture with that of the Renaissance.

[1] There is at the South Kensington Museum a collection of etchings of Paris, by J. Nash,
small folio, without title, date or text (*Universal Catalogue of Books on Art*. Supplement,
1875.)

[2] The plate is inscribed ' F. Nash.' But the table of contents attributes the drawing to
' J. Nash.'

In a few prefatory words, the artist shows a partiality for the archi-
tecture of that transitional time, which declared itself more plainly
afterwards in his choice of subjects for illustration. The present
selection was avowedly made with an eye to the picturesque chiefly ;
and the series not only satisfies the taste by its artistic quality, but
exemplifies in perfection the ' new style of lithography' as employed
by a first-rate executant. For, in his own class of subjects, Joseph
Nash's drawing on stone is on a par with that of J. D. Harding,
which it resembles both in manner of handling and the character of
its interpretation of nature. It was, however, by delineations of civil
architecture that Joseph Nash achieved his greatest success and his
widest celebrity. The four series of coloured lithographs entitled
The Mansions of England in the Olden Time, correctly described as
' depicting the most characteristic features of the domestic archi-
tecture of the Tudor Age, and also illustrating the costumes, habits,
and recreations of our ancestors,' takesi ts rank among books of
history. While Nash was engaged on this large undertaking, his
exhibited drawings were naturally almost confined to subjects of the
class that he was so collecting. Thus for some ten years from 1839,
when the ' Mansions' began to be published, he sent scarcely half
a dozen pure figure-pieces to the gallery.

On the 13th of June, 1842, he was elected a full Member. In
1846 his sole exhibit is a view, painted for the Honourable Society of
Lincoln's Inn, of the ceremony of opening the new Hall by the Queen
in November 1845. In 1847 he falls back upon his foreign sketches,
and announces on the cover of the catalogue the intended completion
of his great work early in 1848. A letterpress description followed
in octavo in 1849, the lithographs having been printed in folio size by
Hullmandel.[1] While the ' Mansions' were in progress, Nash found
time to employ his crayon in transferring to stone Sir David Wilkie's
Oriental Sketches, published in two folio volumes in 1846 ; the first of
the two series which they comprise being dated 1840 and 1841. As
a sort of culmination to his own architectural series, he brought out
a large folio set of twenty-five *Views of the Exterior and Interior of
Windsor Castle*. They were coloured lithographs of original drawings
which he exhibited at M'Lean the publisher's in May 1847. The

[1] A second edition was published in 1869, in royal 4to, re-edited by J. Corbet-Anderson,
in which the drawings are re-lithographed on a smaller scale by Samuel Stanesby. Another
edition is dated 1872.

volume is dated 1848, and there is an edition dated 1852. In J. P. Lawson's *Scotland Delineated*, a series of large views lithographed by J. D. Harding and others, and published by Hogarth in 2 vols. folio, 1847–1854, two, ' Moray House, Canongate,' and ' Glasgow Cathedral —Interior,' are by Harding after Nash. The great Hyde Park Exhibition of 1851 afforded excellent opportunities for Nash's pencil. His two drawings the next year were views inside it, and he contributed to the collection of *Comprehensive Pictures of the Great Exhibition of* 1851, painted for H.R.H. Prince Albert, and reproduced in two volumes folio, published in 1854 by Dickinson, with that, title. To complete the list of his engraved works, there may be mentioned seven woodcuts in Edward M'Dermot's *The Merrie Days of England*, 4to, 1858–9, for which designs by Nash were copied on to the block by J. F. Skill ; and others contributed to the illustrations of *Old English Ballads*, 4to, 1864.

Nash's drawings in the gallery continued to be of the same class until the end, varying only within the limits above indicated, but showing a decline of power in his later time. In 1856 he sends ten drawings, all from Oxford. In 1859, for a change, his nine are all designs from his favourite authors, Shakspere, Scott, and Cervantes. He does not seem to have sketched any more abroad, and was content to be represented at Paris in 1855 by one view of Abbeville only, with five of his drawings of old English mansions, which sufficed to gain him honourable mention. The number of his later exhibits varied much from year to year between one and fifteen, but until 1875 his name had never been absent from the summer, and but once from the winter, exhibition. He was then getting old, his health was broken, and, except two posthumous drawings, and four sketches in 1879–80, there was nothing more of his work seen in the gallery.

He died at Hereford Road, Bayswater, on the 19th of December, 1878, in his seventy-first year, after much suffering ; having been longer connected with the Society than any then remaining Member except Frederick Tayler. In the very year of his death he had been granted a Civil Service pension of 100*l.* a year, which he was not destined to enjoy. Joseph Nash married a lady of some property who resided at Croydon, and he left a son and a daughter, the former of whom followed his father's profession, though in a different branch, being known as a draftsman on wood and a painter of marine subjects. He

is a Member of the Royal Institute and one of the artistic staff of the *Graphic* journal.

Though a valued Member of the Society, Nash was not always in perfect harmony with his brethren therein. Two printed pamphlets exist in which he expresses in decided terms his disapproval of certain of their proceedings. They are addressed to two successive Presidents, John Frederick Lewis and Frederick Tayler. In the first, written in April or May 1857, his complaint is against the hanging committee, on their having, as he contends, acted unjustly in skying nine or ten of his drawings in that year's exhibition. The second, which was distributed among the Members in April 1862, is, though it does not name him, 'an attack on J. D. Harding for having made some unfavourable observations on the drawings presented by Mr. Nash's son, who was a candidate in 1861, and again in 1862 ;' on the ground of his alleged pre-Raphaelitism. It is stated that in the latter part of the summer of 1854, Joseph Nash was a sufferer from an attack of brain fever.[1]

There was on the 19th of December, 1854, a sale at Southgate & Barrett's, 22 Fleet Street, of what is described in the catalogue as a 'Selection from Joseph Nash's finished drawings and sketches together with the ancient furniture, armour, and tapestry, engravings, &c., from the artist's studio.' The catalogue had a pretty lithographed title, on drab paper heightened with white, of a Renaissance doorway as a frame, and a group of studio 'properties' in front :—a good example of Nash's pencil. But the works sold were said to be of small importance.

The name of Joseph Nash was, as we have seen, on the roll of the Society for forty-five years ; for nine as an Associate, and thirty-six as a Member. He contributed 186 works to forty-two summer, and 80 works to thirteen winter, exhibitions : making a total of 266 drawings and sketches, 47 as Associate and 219 as Member. Graves also finds fourteen works of his, three at the Royal Academy and eleven at the British Institution. The highest recorded price for a water-colour drawing by J. Nash in a public sale is 50*l.* 18*s.* for 'Queen Elizabeth' in the 'A. Grant' sale, 1868.

With the notable exception of William Hunt, in one only of the phases of his art, the painting of flowers and fruit had hitherto been

[1] J. J. J. MS.

left to the Lady Members. At the election of Associates on the 9th
of February, 1835, however, admission was given to two of the sterner
sex whose spurs at least had been won by success in that line of
practice. One of them, VALENTINE BARTHOLOMEW, was in the
main an artist of·this class, in which branch of art he held a
distinguished position, being appointed in 1836 'Flower Painter to
their R.H.'s the Duchess of Kent and the Princess Victoria,' the latter
part of which title was superseded when the Queen ascended the
throne in the following year, and Bartholomew became 'Flower
Painter in Ordinary to her Majesty,' retaining that office till his
death. Bartholomew's art was very different in kind from that of
William Hunt, with his birds' nests and hedgerow handfuls of wild
plants. His models were reared in the conservatory, and his studio
was supplied with orchids and rare exotics.[1] 'Largeness of style'
and 'careful execution' are the qualities for which his works were
esteemed, and his painting was altogether of the elegant order.

Born on the 18th of January, 1799, he was in the prime of life
when he became an Associate, in which rank he remained until his
death forty-five years after, at the age of eighty. He first saw the
daylight, such as it was, in Red Lion Street, Clerkenwell, where his
father lived for more than sixty years, 'much esteemed for the part
he took in parochial affairs.'[2] The son was so far brought up for an
artist that, when sixteen years old, he had some professional instruc-
tion given him with that view. But his teacher died soon after, and
thenceforward Bartholomew relied on his natural taste and his own
industry, and taught himself to paint by constant practice from
nature.

So he grew up to man's estate, and in 1821 was so fortunate as to
become known to Charles Hullmandel, the lithographer, for whom he
not only executed a published work on flowers and other subjects, but
after a time undertook the management of the business in Great
Marlborough Street, where all the early printed lithographs were
issued from the press. There the young artist resided for the next
five years in a refined family circle, which included not only the

[1] Some at the Water-Colour Society in 1843 and 1846 were 'from the collection of
Sigismund Rucker, Esq., West Hill, Wandsworth;' and one at the Royal Academy in 1848
was 'reared by John Allnutt, Esq., of Clapham.'

[2] *Portraits of Men of Eminence*, photographed by Ernest Edwards, vol. iv. p. 89
(Bennett, 1866). A likeness of the artist is in this collection, together with a memoir whence
some of the following facts are taken.

lithographer Charles, but his father Nicholas Hullmandel, eminent as a professor of the pianoforte, and sister, Miss Eveline Charlotte Adelaide Hullmandel, a good musician too, who won the heart of Valentine, and became Mrs. Bartholomew in 1827. Although for a time, while occupied with the above duties, his art had been in abeyance, his professional prospects had gained by the contact into which he was brought with the many artists of the day who resorted to Hullmandel's establishment for the means of multiplying their works. So that when on his marriage he gave up his part in the lithographic business and made a real start as a painter, he was to some extent known in the profession, and able to form a connexion as a teacher as well as a practitioner of the art. Moreover he had not entirely neglected the brush, for he is found exhibiting at the Royal Academy in 1826, ' A Group of Flowers from Nature.' From 1829 to 1838 he had at least one drawing at Somerset House every year, nearly always of flowers ; and in 1836, when he became Court painter, he had also two views there of Eton and Windsor contemporaneously with two of Windsor at the Water-Colour Society. After election as Associate in Pall Mall East in 1835 he was less regular in exhibiting at Trafalgar Square, but sent an occasional drawing there till 1854, making up a total of twenty at the Academy from his first in 1826. Leaving Great Marlborough Street, he and his spouse took up their quarters at 16 Foley Place. There he lived while ascending the path of his professional success, and there he was residing when he joined our Society, and when he received his Court appointments. There, too, he became bereft of her who during the twelve years of her married life had been his much loved companion. Mrs. Bartholomew died on the 1st of January, 1839.

The Mrs. Anne Charlotte Bartholomew whose name is, for several reasons, more inseparably associated with his, was a second wife. Her union with him, which took place in 1840, seems to have been singularly well assorted. The lady, some twelve months, at most, younger than he, was herself in the third year of her widowhood. Her former husband was Walter Turnbull, a composer of popular melodies ; and she was daughter of Arnall Fayermann, of Loddon, in the county of Norfolk, niece of Admiral Fayermann, and grand-niece of John Thomas, Bishop of Rochester. Mrs. Turnbull was a woman of parts, and elegantly accomplished in literature and art. When still a spinster she had published a farce entitled *It's only my*

Aunt, which was afterwards successful on the stage ; and, just before her marriage with Bartholomew, had solaced her bereavement by producing a volume of poems called the *Songs of Azrael,* which was followed five years after by *The Ring, or the Farmer's Daughter,* a domestic drama in two acts. She also painted miniatures, some of which were exhibited at the Royal Academy ; and, finally, under her new husband's inspiration, became a flower painter to boot. Miss Clayton[1] pays a high tribute, doubtless deserved, to her active benevolence, as well as to her various accomplishments. She was never, indeed, as that writer asserts, a Member of the Society of Water-Colour Painters, though her name does appear in the catalogues in her capacity of poet ; for her admiring spouse was much in the habit of adding to the interest of his drawings by making long quotations from her verses.[2] Thus there was far more of mutual admiration than of rivalry in their artistic intercourse. At mid-summer 1842, the Bartholomews removed from Foley Place to 23 Charlotte Street, Portland Place. Their sociable life there, with friends of kindred tastes round about them, Mr. and Mrs. Finch among the number, is pleasantly referred to in the biography of the latter artist much quoted above, and appears to have been a very happy one. The earthly union of this attached couple lasted more than twenty years, when it ended in the death of the wife, whose health had often failed her, on the 18th of August, 1862. The husband continued to reside in the same house for sixteen more years, and, on the 21st of March, 1879, he also departed this life. All that we thus learn of Bartholomew's career, pictures it as one of placid content, well befitting the tender amenities of the kind of art he practised.

A very few of his exhibited drawings are of landscape subjects. They are confined to the two views of Windsor in his second year, 1836, before mentioned, and sixteen old sketches shown in 1871–76, nearly all in the winter exhibitions. Some of the latter are of York-shire Abbeys (one dated 1832), and two ('Luxembourg, original Sketch from Nature,' exhibited 1870–71 ; and 'Heidelberg, 1855,' exhibited 1873–74) indicate at least one of the trips abroad which he is known to have taken for the purpose of sketching. In 1838 he is reported to have been on the Moselle in company with J. D. Harding,[3]

[1] *English Female Artists*, i. 399. [2] See *Catalogues* 1841, 1843, 1846-48.
[3] J. J. J. *ex relatione* Mrs. F. Nash.

who is said to have been indebted to Bartholomew for his introduction to Hullmandel.

Bartholomew had 169 drawings and sketches in all in the gallery, 115 in the summer and 54 in the winter exhibitions. Two or three years before his death he ceased to exhibit. Graves finds twenty-seven of his works at Suffolk Street, besides the twenty at the Academy, between 1826 and 1856. He was not raised to the rank of full Member of our Society.

It was not as a painter of flowers that JAMES HOLLAND was chosen an Associate on the same day, 9 February, 1835, with Valentine Bartholomew. Floral study, with which he had begun his career in Art, had been with him introductory only to a more extended range of subjects. One flower piece alone is named among his contributions to the Gallery, and, curiously enough, it is numbered as the very last of all his summer exhibits. But it was sketched thirty years before, during the term of his early Associateship, and called a ' Study of Roses in my Garden at Blackheath, 1839.' This first application of his talent had been due to the accidents of his birth. He came into the world in September 1800, at Burslem in Staffordshire, where his father was engaged in the pottery works. Thomas Holland, his grandfather, was noted as the first manufacturer of the 'shining black ' ware. On this ware little James Holland's grandmother painted flowers, while he sat and watched her, learning thus to do the like. But he went to nature for his models ; and two specimens of his drawing, 'Flowers ' and a ' Red Linnet,' got him employment in this way for seven years under James Devonport, of Longport.

Coming to London in 1819, to set up as a flower painter in watercolours, he is said to have had but a small beginning, and to have sold his first dozen drawings for the sum of ten shillings,[1] after which the dealer's price was raised to five shillings apiece. But he persevered, and got some pupils, and taught himself landscape, by making many sketches on the banks of the Thames near Greenwich. His earliest flower groups at the Royal Academy appeared in the year 1824.[2] Doubtless he was known among the rising artists of the time ; for he was a man of many acquaintances, and his disposition

[1] Ottley's *Dictionary of Recent and Living Painters*, 1876.
[2] Graves gives 1815 as the date of his first exhibiting ; apparently assigning to him a ' Design for a military depôt,' by one ' J. Holland ' of ' St. Pancras.'

by no means reserved. The number and character of the anecdotes which Mr. Jenkins has noted down as culled from his conversation show him to have been long and well acquainted with the habits and ways of his professional brethren. There is at the South Kensington Museum a water-colour portrait, dated 1828, of James Holland seated at his easel, by the hand of William Hunt, who was ten years his senior, and already a Member of the Water-Colour Society. About 1830 Holland is said to have visited France, and made some architectural sketches there.[1] A 'View of London from Blackheath,' at the Royal Academy in 1833, is mentioned as a work by him of considerable pretension. In the *Gallery of Modern British Artists*, 2 vols. 4to, 1834, is one of the earliest of his engraved works, a view of 'Greenwich Hospital,' which shows that he had already become an accomplished landscape designer.

Holland was a worker in oil as much as in water colour, and when he used the latter was apt to thicken it lavishly with opaque pigment. His best known works therein belong to a later period, when, after an absence of many years, he became a full Member of the Society, and his mode of painting was more in vogue than when he was first elected an Associate. At that time, he seems to have been hesitating as to the branch which he should chiefly adopt. A letter to his friend and admiring patron, the late Mr. Edward Magrath,[2] of Upper Terrace, Hampstead, bearing date 24 April, 1837, seems to have been written in this indeterminate frame of mind. ' Pray believe me,' he says, ' when I assure you it is more a want of confidence in my own powers that has hitherto kept me from sending to the R.A., than any want of faith in their disposition to do justice to any talented artist. I will henceforth devote myself to painting, and look forward with hope to do something worthy notice.' He was then exhibiting pictures at the British Institution and the Suffolk Street Gallery, as well as drawings in Pall Mall East.

The result of this competition was that, after retaining the Associateship for eight years, he sent in his resignation on the 30th of November, 1842 ; and although he again sought admission, it was not until fourteen years had elapsed. During this first period of his connexion with the Society, he exhibited thirty-seven drawings in North Italy and Switzerland and Portugal, the remaining few being sketched within easy reach of his place of residence, No. 3 Union

[1] Redgrave's *Dictionary*. [2] For many years Secretary of the Athenæum Club.

Place, Blackheath. His first visit to Venice was in the year of his election (1835), and for the next two years that city and the journey thither supplied the subjects of his exhibited drawings. Of the 'Tombs of the Scaligers, Verona,' in 1837, he writes, in the letter above quoted:—'Mr. Burke's drawing is very much admired, and would (if people are to be believed) find twenty purchasers.'[1] In 1837 he was sent to Portugal by the proprietor of the *Landscape Annual*, and the resulting pictures were engraved in the volume for 1839, with letterpress by W. H. Harrison, entitled *The Tourist in Portugal*. The four volumes of that periodical, since Harding had contributed the drawings for 1834, had been devoted to Spain and Morocco, as re- presented by the pencil of David Roberts. The drawings sent by Holland to the Gallery in 1838 (one) and 1839 (five), were all from Portugal,[2] and in the remaining three years, 1840-42, there were some from each of the sources above mentioned.

In the year after leaving our Society he became a Member of the Society of British Artists, remaining so until 1848. In 1845 he sketched at Rotterdam; in 1850 in Normandy and North Wales; in 1851 at Geneva, thus accumulating varied material, some of which he worked into pictures. Among the most successful subjects were still those from his old neighbourhood; Greenwich Hospital being always a favoured one. A picture thereof, painted for Mr. Hollier, was pre- sented to the institution by that gentleman's widow; and a smaller one went to the Paris Exhibition of 1855, where the painter was honourably mentioned by the jury.

Holland returned to the Society in the year when Lewis became President, being re-elected Associate on the 11th of February, 1856, and was made a Member the next year—namely, on the 8th of June, 1857, on the death of Richter. He was thenceforth a constant ex- hibitor, sending an average of four or five drawings annually to the summer exhibition, and many more to the winter ones, from their commencement in 1862-63; his contributions to the former being of a high quality of beauty, and his slight but singularly effective sketches, often little more than memoranda,[3] forming a characteristic feature of the latter collections. He now asserted his true pre-eminence as an original and poetic artist. He, whose taste for colour had in the

[1] The same subject was afterwards painted for Mr. Hollier.

[2] He had also a picture of Lisbon at the Royal Academy in 1839.

[3] Holland once wrote that 'parting with a sketch was like parting with a tooth; once sold, it cannot be replaced.' (Valpy's *Memoir of Samuel Palmer*, p. 76.)

undeveloped stage of his art subsisted on a merely vegetable diet, now spread his wings to sport in Venetian sunbeams. Among the subjects during the time of his Membership, those from Venice were the most frequent and characteristic, and displayed his greatest power in the assortment of rich and radiant hues. The gem of the Adriatic inspired him with the poetry of the palette, and he revelled in dreams of moonlight, or the vesper hour, or the glory of midday sunshine. Some of his delicate harmonies rival even the pencil of Turner. In not a few of his works the effects of colour are obtained or aided by figure groups in gay costume. Among the Venice views were also a sprinkling of his Portuguese subjects, with some from Genoa and Verona, a few views in the Tyrol (in and after 1858), and two at Rotterdam (in 1857 and 1862). The winter 'sketches and studies' are more varied, comprising also some from North Wales (about Bettws, &c.), and Lynmouth, and one or two from Rouen. In 1866 he recurs to his favourite Greenwich in a drawing called 'The Anniversary of the Battle of Trafalgar in the old days, when Greenwich Pensioners drank ale and smoked to celebrate great victories.'

With the 37 in Fielding's time and 65 afterwards, Holland had 102 drawings in the summer shows, together with 93 exhibits (containing nearly double that number of distinct subjects) among the winter sketches and studies. There were 14 of the latter on the Gallery walls when he died on the 12th of February, 1870, in Osnaburgh Street, Regent's Park, where he had resided throughout the second term of his connexion with the Society. Graves finds 32 works by J. Holland at the Royal Academy, 91 at the British Institution, and 108 at Suffolk Street; making 231 between 1851 and 1867.

Besides the engraved works above mentioned, there are the following :—In the *Forget-me-not*, 1842, 'Venice' (engraved by J. Carter).—In S. C. Hall's *Baronial Halls, &c., of England*, vol. i., a lithotint of 'Charlton House, Kent.'—In Marvy's *Sketches after English Landscape Painters*, a sea piece, with sun on the horizon, coloured. And there exists a fine print on a larger scale of one of his views of Venice.

His remaining works were sold at Christie's on 26 May, 1870. The following are the prices exceeding 200*l.* noted by Redford for which water-colour drawings by James Holland have been sold at auctions since his death :—' Roses,' 288*l.* 5*s.*, at the Quilter sale, 1875. ·

'Rotterdam' (24 × 31 in.), 280*l.*, T. Shaw sale, 1880.—'The Rialto,' 258*l.* 6*s.*, Heritage sale, 1874.

No Associate was added in 1836, but on the 13th of February, 1837, two were elected. One was ARTHUR GLENNIE, a landscape painter. The six views, five in Rome and one at Licenza, which he sent to that year's exhibition, were typical of the class of subjects which he almost exclusively adhered to during a long career of more than half a century as Associate and Member. He was born on the 5th of February, 1803, at Dulwich Grove, Surrey. His father was William Glennie, LL.D., and his mother's maiden name was Mary Gardiner. He was one of a family of thirteen (twelve brothers and one sister), and the only member thereof who followed the profession of an artist. Nor did he himself betray his love of art by any early indication, until, being put to school at Dulwich Grove aforesaid, he there learnt drawing with the other boys, as a part of the educational course, from the school teacher, our own Samuel Prout, who used to spend a great portion of one day in the week there and to take the boys out to sketch in fine weather. But he began life in a mercantile business, and it was only when ill health gave time and occasion to follow art instead as an amusement that the talent he displayed was held, under Prout's advice, to justify his taking thereto as a profession. With this sound foundation of knowledge he, later in life, derived much benefit from the remarks and advice of that excellent artist, William Havell.

He was thus about thirty-four years of age when he joined the Society. In 1837 and 1838 his eleven subjects are from Rome and the neighbourhood. In 1839, four out of the five are from Sandwich in Kent. In 1840 the address changes to 'Keston, Bromley, Kent.' Next year he is at 'Penzance,' and it may have been at this period that he was engaged in teaching, chiefly at Sidmouth in Devonshire, for about two years. From 1842 to 1854 he is at '90 Park Street, Grosvenor Square.' From the first, however, he had (with the above exceptions) exhibited foreign subjects, and in 1846 we have 'Rome' as his second address. But it was not until 1855, the year of Fielding's death, that he made his head-quarters in the Eternal City, which continued to be his home for the rest of his life.[1] He was only an Asso-

[1] From 1855 to 1870 he was at 43 Vicolo de' Greci, in which house the Associate Henry Riviere had for many years a lodging also. From 1871 his address was at 17 Piazza Margana.

ciate in Fielding's time, but on the 14th of June, 1858, received his full Membership, having exhibited a total of 68 drawings in annual numbers varying from one to six during the twenty-two years when he held the lower rank.

In 1865 he married Anne Sophia Parker, daughter of the late Rev. E. G. Parker, formerly Chaplain at Bahia under the Foreign Office for twenty years, and afterwards Chaplain to her Majesty's Forces. There was no issue of the marriage.

With few exceptions his subjects were foreign, and chiefly confined to Italy. Most are from Rome, and the Campagna, and the surrounding territory of Central Italy, some extending to towns in Umbria and Tuscany, and on a few occasions northward to the Riviera. A considerable number of his drawings, beginning with the year 1844, are from Fiume on the borders of Croatia, and Pola in Istria.[1] To this district he appears to have been attracted by the residence of a brother-in-law during his life, and, after the death of that relative in 1860, by duties devolving on himself as his executor. In August 1866 the painter was sojourning with his wife at Sorrento, and after that year there are many subjects thence and from the Bay of Naples. Mrs. Glennie accompanied him also to Istria, which profitable sketching ground he revisited 'many times for the purposes of his art.' On the 28th of January, 1868, he writes to his friend Jenkins, on returning to Rome after seven months' absence, that his wife and he having found Fiume too hot in the summer had sought 'cooler quarters in the Croatian Mountains,' where they had enjoyed ' a delightful climate, in the midst of pine forests.' The result was apparent in several subjects in the winter exhibition of 1867–68. It is remarkable that there are no studies of Venice among the Italian subjects exhibited by Glennie. A view 'in the Slotspladsen, Copenhagen—done on the spot' (exhibited 1863), one 'in the Baltic' (1881–2), and one 'from the Calvary, Botzen' (1882–3), are solitary exceptions among the foreign views, in that they show some travel in the north of Europe. The names of about a score of home subjects lie scattered among the above in the pages of the catalogues from 1837 to 1881, including the four early Kentish drawings before mentioned, a few sketches at old Gilbert White's Selborne in Hampshire (in and after 1865), and others in the Home Counties, together with three that have Scotch

[1] A. Glennie's 'Drawings of Pola in Istria' are described by C. C. Nelson in a 'Sessional Paper' of the Royal Institute of British Architects, printed in 1851.

names, which do not necessarily imply a personal acquaintance with North Britain.

Arthur Glennie died at his house in Rome on the 23rd of January, 1890, aged eighty-seven, being then the oldest exhibitor in the Society. His widow died on the following 30th of July, aged fifty-eight. The Rome he painted had undergone vast changes in his later days, and that some of his views in the Forum had already become antiquated he recognized by adding the words 'as formerly' to some of the drawings of his last decade. At the time of his death he had exhibited an aggregate of 252 drawings in the summer exhibitions, and 134 frames of 'sketches and studies' in the winter shows, which began in 1862–63 ; making a total of 386 exhibits, as Associate or Member, since 1837. To this, if separate sketches, several in a frame, be counted singly, must be added about forty, which brings the total to considerably above four hundred. A gathering of seventeen works by the deceased Member was also made in the winter exhibition of 1890–91. Landscapes, inspired by the above scenes, careful in topography, distinguished by tender harmonies of colour generally warm in tone, and conveying the impression of a broad glow of Italian sunshine, form the staple of Glennie's pleasing art. His practice was almost exclusively confined to water-colours, and his atmospheric effects appear to be due to the employment of the transparent pigments that characterize the British school of water-colour painting in its native purity. He used Newman's dry colours, and his drawings were generally worked up as much as possible on the spot. Although his subjects are of topographic interest it is not known that any works of Glennie's have been engraved, otherwise than in six very slight memoranda in the illustrated catalogues between 1883 and 1886.

W. LAKE PRICE, who was elected an Associate with Glennie on the 13th of February, 1837, is, happily, still within the category of living artists, though the short term of his connexion with the Society came to an end many years ago. Primarily a draftsman of architectural subjects, he, like his fellow-student, Joseph Nash, established a claim to be called a subject-painter as well, by virtue not only of the figure incidents that enliven his views of buildings, but of compositions in which they take the chief place. His exhibits in our gallery amount to no more than forty-two. They extend from the year

1837 to 1852; but not quite consecutively; for in 1840 and 1842 he sent nothing, and the omission, which was in contravention of Law XXXIV., being repeated in 1846, his name was removed in the following year, to be restored, however, on an expression of regret, for the remaining five years of his appearance in Pall Mall East. Previously to 1840, most of his architectural studies are of interiors of the old English mansions, Knole, Haddon, and Hardwick. To these are added a few historic and dramatic scenes, as 'Charles the Fifth at the Court of Francis the First,' 'Scene at Loch Leven,' with Mary Queen of Scots signing her abdication, 'Othello relating his Adventures,' and fancy subjects entitled 'The Farewell,' 'The Doomed,' 'Discovery,' 'The Confession,' 'The Baron's Return,' &c. During most of the period of his Associateship, our artist had a studio address at 46 Warren Street, Fitzroy Square, but in 1839 and 1840 he hailed from Rome, and in the following two years from Venice, whence, from 1841, nearly all his subjects were taken. To this extent only do the facts of Lake Price's career form an integral part of the Society's annals; but an acquaintance with many of its earlier Members strengthens his connexion with its history. In his drawings may, moreover, be traced the influence of the old school of broad composition and harmonious colour. Among the painters of yore for whom he retains a special reverence is Richard Parkes Bonington,[1] for whose figure work in water-colours he has an unbounded admiration, as well as for his unsurpassed power as a draftsman on the lithographic stone.

These dozen years of contributing to our gallery form only a small portion of the artistic career of Lake Price. He was born in 1810. His father was Mr. W. F. Price, son of Dr. Price, chaplain to King George IV. His mother, C. M. J. Price, was daughter of William Lake, son of Sir James Lake, Baronet. His family being in easy circumstances, and he himself not being compelled to work for a living, his pursuit of art has always been in unrestrained accordance with his own inclination. He has studied and painted what took his fancy, and has not been under the necessity, like most of his artistic brethren,

[1] Bonington's short earthly career terminated in 1828, and, like Girtin's, at the early age of twenty-seven. But he, also, lived long enough to earn undying fame. Though claimed both by the English and French school, he was not a member of any society of artists. In all its affinities, however, his art was of the kind that owed so much of its development to the Society of Painters in Water-Colours, and his concurrent share therein should be duly taken into account. In water-colours none ever handled pencil with more brilliant touch, and his mastery in landscape composition was supreme.

of eking out an income by giving lessons to amateurs. At first he was designed for an architect, a choice partly to be attributed to the fact that an uncle, J. W. Hiort, was Chief Examiner of H.M. Board of Works. He was, therefore, put through a professional course of education, and learnt the practical part of the business with a large firm that built Kemp Town, Brighton. Then he was articled to Augustus Pugin, in whose pupil-room he was the contemporary of Charles J. Mathews, Welby Pugin, Benjamin Ferrey, our own Joseph Nash, and others now no more. Here, however, his strictly architectural education came to an end ; for on proceeding to take some lessons from De Wint in water-colour sketching, the charms of Nature proved too strong to resist, and he abandoned architecture for water-colour art. The knowledge he had acquired under Pugin, nevertheless, gave a direction to his subsequent practice. His art has been pursued in various parts of Europe ; wherein he has travelled much for many years, having been very frequently in Italy and Sicily, Malta, Spain, Portugal, France, Holland, Belgium, Germany (Saxony, Bavaria), Switzerland, and the Tyrol ; and being conversant with the French, Italian, Spanish, and German languages. He married Julia Ann Lake (daughter of E. W. Lake, Esq.), and survives her, having had issue two sons and two daughters.

Lake Price has painted a little also in oils, and exhibited a few pictures at the Royal Academy. He has practised etching too ; but the works by which he is the most widely known are lithographs by his own hand. The following list of publications comprises also designs of his engraved or reproduced by other processes :—*Interiors and Exteriors of Venice*, folio, M'Lean, 1843, lithographs.—In S. C. Hall's *Baronial Halls &c. of England*, vol. i. 1843, 'Hardwick,' in lithotint.—In *The Keepsake*, 1845, 'Lord Byron's Room,' Venice (engraved by J. T. Willmore, A.R.A.) ; 1846, 'Cortile Salviati,' Venice (Robert Wallis), 'Sala de Gran Senata,' Venice (John Le Keux) ; 1847, 'The Baptistery, St. Mark's, Venice' (E. Radclyffe), 'Exterior Gallery, round the Ducal Palace, Venice' (R. Wallis), 'Titian's Studio,' Venice (John Le Keux), all line engravings.—' *Tauromachia*,' letterpress by Richard Ford, folio, Hogarth 1852, lithographs, depicting the Bull Fights of Spain.—Among thirty *Illustrations of Childe Harold*, drawn on commission of the Art Union of London, 4to, 1855, 'Bull Fight, Seville' (canto 1, stanza 76) ; 'Bridge of Sighs, Venice' (canto 4, stanza 1). Lake Price is also an accomplished

photographer, and the author of a *Manual of Photographic Manipula-tion*, treating of the practice of the art in its various applications to Nature,' Churchill & Sons, post 8vo, 1858. There is also a second edition. In 1857 he executed at Windsor Castle large portraits of their R.H.'s the Prince Consort and Princess Royal ; and at Osborne, of Princes Leopold and Arthur, and of the Grand Duke Constantine of Russia surrounded by his staff on the deck of the frigate *Svetland*, with the crew at quarters. Full-length portraits of their R.H.'s the Prince of Wales and the Duke of Edinburgh, also taken by him at Windsor Castle, engraved by R. J. Lane, A.R.A., were published by Mitchell of Bond Street in 1858. Also in 1858, *Interiors of Osborne*, Isle of Wight, published by Dickinsons of Bond Street. Various Roman subjects by him were published by Messrs. Fores of Piccadilly. Divers figure compositions, arranged after the manner of *tableaux vivants*, and photographed, by him, were published by Graves & Co. of Pall Mall. Twelve portraits of Royal Academicians (12 x 10 inches) three-quarter length, were published by Lloyd Brothers of Grace-church Street, 1859. These comprise Frith, Maclise, Phillip, Cope, Ansdell, Elmore, Stanfield and Roberst ; and there was one of Catter-mole. In 1859 he was commissioned by the Art Union of London to take three photographic views of Rome on a large scale (18 x 14 in.), as prizes to be distributed to the subscribers. They represent ' The Forum,' ' The Temple of Saturn,' and ' St. Peter's.' He was also at one time offered a handsome commission by Colnaghi for a photo-graph, eighteen inches high, from Raphael's ' Transfiguration,' but was unable to obtain the requisite consent of Cardinal Antonelli. Two chromolithographs, ' The Spanish Contrabandista,' from life at Granada, and ' Goat Herd of the Campagna,' from life at Rome, by Lake Price, were published by Rowney & Co. of Oxford Street, in 1886.

Independently of his services to art, the gratitude of his country is due to Mr. Lake Price as one of a small band of patriot spirits who were in some sort pioneers of the Volunteer movement of 1859. Moved by the celebrated threat of the French colonels to invade England, he and a few others associated themselves together, at a time when the scheme was regarded by the public as visionary, to promote the formation of a citizen army. For that purpose, fixing their head-quarters in an entresol over a bootmaker's at No. 455 Strand, they proceeded to establish correspondents all over England.

As representatives of this union, Lake Price and J. E. Millais, R.A. (now Sir John Millais, Bart.), waited by invitation on The Hon. Francis Charteris (afterwards Lord Elcho and now the Earl of Wemyss) to explain the views of their association ; and it need not be said to what willing ears their appeal was addressed. More than that : Lake Price designed the first grey uniform seen in England. It was made by his tailor, drawn, in three views, on his person ; engraved and published by Ackermann in Regent Street. Mr. Price, having lived for a series of years at Ramsgate, is now resident at Blackheath ; and contemplating the reproduction of some of his earlier works which are out of print, by a process of photogravure.

CHAPTER II

NEW ASSOCIATES ; 1838-1847

Biographies—*W. Callow—G. A. Fripp—O. Oakley—S. Palmer—T. M. Richardson—W. C. Smith—A. D. Fripp—D. Morison—W. Evans* (of Bristol)—*G. Harrison—S. Rayner—Miss M. Harrison—G. F. Rosenberg.*

THE second or central sub-period into which the presidency of Copley Fielding is herein divided introduces us to some of the veteran Members who are still working in the Society's support. Out of thirteen painters who became Associates during the ten years from 1838 to 1847, four remain[1] to this day contributors to the annual exhibitions. The first of these is WILLIAM CALLOW, the only Associate elected in 1838. He was so admitted on the 12th of February, and he acquired full rank ten years after, namely, on the 12th of June, 1848. His connexion with the Society has been longer than that of any other living Member. In 1861 he was appointed one of the Society's trustees, from which office he retired in 1878 ; and from 1865 to 1870 he held the post of Secretary. He is a landscape, marine, and architectural painter, chiefly the latter, and has been a most industrious exhibitor. During the eleven years of his Associateship, he sent annually his full complement of eight drawings, making a total of eighty-eight. As Member, from 1849 to 1881, the year in which the Society received the ' Royal ' title, he had a total of 547 in the summer exhibitions, and 231 in the winter shows, making 778 exhibits, or (together with the previous 88) a grand total of 866. And if distinct subjects within a frame of sketches be counted separately, about a hundred more must be added, to give the number exhibited at Pall Mall East up to that epoch only. William Callow's drawings embrace a wide range of subjects, chiefly foreign. These are taken from various parts of France, from Calais to the Pyrenees, and from Havre to Marseilles and the Riviera. Holland and Belgium, the

[1] W. Callow, G. and A. Fripp, and Maria Harrison.

Meuse, the Rhine, and the Moselle, and various principal towns in Central Germany (the range extending in 1852[1] northward to Hanover, and eastward to Leipzig and Dresden), Switzerland, with the Tyrol and divers northern towns of Italy including Venice, and an extension on some occasions to Rome and Naples, are comprised within the broad area of his sketching ground. Home views are also numerous, though less so. They are taken from many different counties in all parts of England, with a few in South Wales as far west as the Wye, and a small contingent is from Southern Scotland (from 1844), extending from Jedburgh and Edinburgh to Glasgow and Inverness (in 1850). Such home views are more common in the winter exhibitions, which began in 1862-3. They also include marine subjects and atmospheric effects at rise and set of sun.

William Callow, the elder son of Robert Callow, Esq., was born at Greenwich on the 28th of July, 1812. He was one of a family of four ; of whom his only brother, John Callow, was also, in his turn, an Associate of our Society. Indications of William's love of art were shown at the earliest possible period, in attempts to draw everything he met with. To become a painter was, from the first, his one ambition ; so he was allowed to begin his art education at the age of eleven years, by being placed with the Fielding family (in London) as an articled pupil. He remained with them till he was sixteen, and then went to Paris to continue his studies. Some half-dozen years of practice and observation in the French capital having brought his power to maturity, he, in 1835, established himself there as a teacher of his art. The young man's talent for tuition was soon recognized, and rewarded by patronage of the highest rank. His pupils included many of the French nobility. The earliest were the Duc de Nemours, and the Princesse Clémentine of Orleans. Later, he gave instruction to the Prince de Joinville. At the same time he began to extend his acquaintance with nature and collect subjects for his pencil by making a series of sketching tours on foot. In 1835 he went down the Seine to Havre ; in 1836 to the South of France and the Pyrenees ; in 1838 to Switzerland ; and to Italy in 1840. During Callow's residence in Paris he had also some practice in aquatint engraving, with knowledge acquired probably from the Fieldings, and there exist some early prints so executed by him, illustrating various methods of deep-sea fishing.

[1] Subjects exhibited in 1853 and 1854.

By this time he had become an Associate of our Water-Colour Society, having been unanimously elected on the strength of his specimen drawings of landscape and marine subjects sent from Paris ; for he was otherwise unknown at that time as an artist in his native country. The impression made of his skill on the first appearance of his works in England may be inferred from the fact of his being engaged to illustrate the volume for 1839 of Heath's *Picturesque Annual*, the plates in which are a set of eight views with a title-vignette, representing the palaces and gardens of Versailles and the Trianons, all from the pencil of William Callow.[1]

He continued to reside in Paris and to teach the members of the family of King Louis Philippe until 1841, when he returned to live once more in England, pitching his tent at first in the old artist quarter, at 41 Charlotte Street, Portland Place. Here again he combined with the practice of his art employment as a private teacher, in which he persevered for more than forty subsequent years. On the 2nd of July, 1846, he married Miss Harriett Anne Smart, niece of Sir George Smart, the eminent musical professor. In 1856 he added a country address, 'Great Missenden, Bucks,' to that in London, which latter, after several changes, was finally dropped in 1876 ; but he went on taking pupils.

Though settled now in England, his travels abroad were more frequent and extended than they had been when he lived in France. One of these many continental trips was marked by the following gratifying series of incidents. In 1863, while at Coburg, he had the honour of receiving a command from the Queen, who was staying at Rosenau, to bring his sketches for inspection, and her Majesty was graciously pleased to direct his attention to many places of interest in the neighbourhood, and on his return to England to give him a commission to make two drawings from the sketches she had seen. The Crown Prince and Princess of Germany also invited him to Berlin, where he remained some days sketching with the Princess at Potsdam, who presented him with a valuable breakfast service in Berlin china. He was also summoned to attend the Emperor William the First, and further honoured with a commission from that monarch for two drawings of Berlin and Potsdam. Before

[1] There is also a plate after W. Callow, engraved by J. C. Varrall, of 'The Boulevard du Temple,' in *The Keepsake* for 1849 ; and several of his drawings have been imitated in chromolithography by Rowney & Co.

returning to England on that occasion, he extended his tour to Stettin on the Baltic.

Although Callow's works are chiefly in water-colours, he has between 1846 and 1881 painted small pictures in oils, and exhibited them at the Royal Academy, and in provincial gatherings. He has sent pictures, both in oils and water-colours, to the principal towns in England, Scotland, and Ireland, and to Paris, Berlin, Adelaide, Melbourne, Boston, and Philadelphia ; and has at various times received the following medals from foreign bodies :—*Gold* : Paris, 1840 ; *Silver* : Cambrai, 1836, 1838 ; Boulogne, 1837 ; Rouen, 1840 ; *Bronze* : Rouen, 1839 ; Philadelphia, 1876 ; Adelaide, 1887. He is a Fellow of the Royal Geographical Society ; and was a member of the 'Graphic,' until the very recent dissolution of that society. Callow continued to take pupils until 1883. In that year he had the misfortune to lose his first wife, who died without issue. In 1884 he married a second, Louisa Mary, daughter of Mr. Jefferay, of Buckinghamshire.

Callow's style of painting, formed during his long residence in Paris, is naturally based on the French school of that period ; for, notwithstanding his boyish training under the Fieldings, he was virtually unacquainted with the works of the water-colour painters in England previously to his coming to reside here in 1841. He brought with him a 'dashing' method of execution, which, being of foreign birth, possessed an air of originality. Though so many of his drawings represent buildings, he does not belong to the severer class of architectural draftsmen which included Pugin and Mackenzie ; nor quite to that of Prout and Joseph Nash, who cultivated the pictorial element more than they did as a main attraction. In Callow's views that element is the leading motive. He rarely, if ever, attempts the elaborate representation of a great cathedral, for example, with all its minute details of ornament. Street scenes, with old overhanging houses, and the traffic at their base, are his commoner and more characteristic subjects, and picturesque buildings usually form an important feature in those which partake more of the nature of general landscape. He is very skilful in the effective disposition of light and shade and masses, the colour being dealt with in artistic fashion to afford harmonious contrasts, rather than registered with local exactness.

After the election of Callow in 1838, no more Associates were

admitted for three years, when, on the 8th of February, 1841, the
doors were again opened for the reception of one who has long held
a distinguished place among the Society's Members, and whose name
is representative of a type of landscape art most refined in character,
and withal essentially and purely British. GEORGE ARTHUR FRIPP
came from Bristol, where he was born in 1813. His father was a
clergyman, the Rev. S. C. Fripp, and his paternal grandfather a
merchant of that town, from whom the family taste for art may have
in part descended ; for he took a delight in collecting Dutch pictures,
when he found opportunities of purchasing them at a moderate price.
The Fripps have an ancestry far back in the county of Dorset. The
student of heredity has, however, more tangible ground whereon to
theorize, in the fact that his grandfather on the mother's side was
Nicholas Pocock, the marine painter, whose name occurs on an early
page of this history, as one of the actual founders of the old Water-
Colour Society. The proclivity for art is extant in others of the
family, notably in George Fripp's brother Alfred, now also a leading
Member of the Society.

George Fripp received his art education in his native town, where
in his youth there dwelt a notable group of good landscape painters.
The Bristol school, indeed, has furnished from time to time so many
contingents to the main body of artists in London, that the traces of
local origin have been absorbed in the process, and somewhat unduly
lost sight of.[1] There he had some lessons in oils from James Baker
Pyne ; his master in water-colours being Samuel Jackson, father of
the Bristol school, and Associate of our own Society. Fripp's first
practice was as an oil painter, and he pursued it for four or five years
in his native town. But the first development of his power as an
artist in water-colours was in companionship with his distinguished
friend and fellow-townsman William J. Müller, with whom he spent
seven months abroad in a sketching tour to Italy in 1834. In 1838
he exhibited a picture of 'Tivoli' at the Royal Academy. In 1841
he came to try his fortune in London, and sending up as a venture
some probationary drawings to the Society of Painters in Water-
Colours, was, to his own modest surprise, at once elected an Associate
on the 8th of February in that year.

His career was now established as a water-colour painter, though
he for some years painted a few pictures in oils also. Three of these

[1] See *supra*, p. 87.

were shown at the Royal Academy, namely :—in 1843, 'In the Via Mala—Pass of the Splügen, Switzerland ;' 1844, 'Durham, from the South ;' and 1848, 'Mont Blanc, from near Cormayeur, Val d'Aosta.' The last, a very large painting, was purchased and presented to the Corporation of Liverpool by Mr. James Robinson, solicitor, of that town. This work is said to have elicited a tribute of praise from the lips of Turner, to the painter's intense gratification ; for there is no more devoted admirer than he of the genius of that great master. On the 9th of June, 1845, Fripp was elected a Member of the Water-Colour Society. He had, during the five seasons of his Associateship, exhibited thirty-seven drawings in the gallery ; beginning in 1841 with views from the neighbourhood of Bristol, with three foreign subjects :—'Heidelberg,' 'Splügen,' and 'Tivoli.' In 1842 he sent two castles in South Wales ('Tenby' and 'Caerphilly'), and three views of Durham, together with four Thames subjects, the first of a long and characteristic series ; and in 1844 the first of many Yorkshire views, namely, 'Richmond Castle' and 'Bolton Abbey.' All told their story of careful study in the face of nature. In 1846 he married Miss Mary Percival ; and they made their first residence at 3 Lidlington Place, near the Hampstead Road, he having previously shared with his brother Alfred (who had become an Associate in 1844) the successive addresses, '92 Albany Street' and '17 Golden Square.' In 1848 he succeeded J. William Wright as the Society's Secretary.

Not being limited now in the number of exhibits, he, for the first dozen years of his Membership, sent an average of about seventeen works to the annual show, amounting to 158 more in Fielding's time. That he was steadily winning his way to public favour and the estimation of connoisseurs, we have evidence in a letter from David Cox given in Mr. Solly's Life of that artist. 'G. Fripp,' he writes in 1850, 'has some very carefully finished landscapes, which are very good and are much liked.' Reference to the catalogue informs us that a large proportion of his drawings that year were studies on the Dorset coast, about Swanage and Lulworth. The next year, 1851, is a marked one in the list of his annual exhibits, as the first in which he included in his *répertoire* scenes from the Scotch Highlands.

He retained the post of Secretary until the 13th of February, 1854, when, finding the extra work too burdensome, he sent in his

resignation owing to domestic arrangements,[1] and was succeeded by
the late Mr. Jenkins. The fact was, that at this period, and for many
years, the claims of a large and increasing family demanded an en-
tire devotion to professional work. He now found it expedient to
employ some of his time in teaching. It is apparently in the last
year of his secretaryship that he writes thus to Mr. Jenkins, on a
Wednesday, from 66 Albany Street :—' The last few days a sudden
rush has been made at me by pupils, so as to make it worth my while
to work at them from morning till night ; but on looking over my
memorandums, I find that I have rather more leisure till Saturday,
when I run down to Southend.' Many of his exhibited drawings
from 1852 to 1859 are from this neighbourhood, at Leigh, Hadley
Castle, &c., in the south of Essex. Mr. and Mrs. Fripp now (1853–
54) moved to 56 Camden Square, which remained their residence for
ten years.

Our artist had continued to make journeys to Perthshire and
Argyllshire, and his broad yet highly wrought delineations of mountain
and moorland scenery in that part of North Britain had come to be
as much an annually expected feature of the exhibition as his quiet
studies on the Thames. The *spécialité* he had so acquired was
honourably recognized in a command which he received from her
Majesty the Queen to visit Balmoral for the purpose of making
sketches of the royal residence and the neighbourhood thereof in
1860, a series of drawings from which were added to the royal
collection. Thus the range of his Scotch subjects was extended to
Aberdeenshire. Subsequently, he has penetrated further north and
west, and illustrated much of the grand scenery of Ross-shire and
the Isle of Skye. His sketching there and elsewhere has often been
accomplished during visits to admiring friends and patrons, at whose
houses his genial society could not fail to render him ever a welcome
guest.

In 1864, when Jenkins resigned the secretaryship, the Society
thankfully accepted George Fripp's offer to undertake the duties of
that office until the annual election of officers in November ; and he
accordingly resumed it for that short interval, retaining it further until
Callow's election in 1865. Since then his services to the Society
have consisted chiefly in his valued contributions to the gallery. In

[1] Ottley, in the supplement to Bryan, alleges that it was ' on account of ill health ;' but
this is a mistake.

the same year he removed to 36 Carlton Hill, St. John's Wood, where he erected a studio, and remained for another ten years ; after which he established his household for a while (1875–1876) by the sea at Lancing in Sussex, retaining a small studio at Hampstead. Then he dwelt for a series of years at 13 College Terrace, Belsize Park, previously to removing to his present quarters in Fairfax Road. He was elected in 1872 or 1873 a Member of the Belgian Society of Painters in Water-Colours, but resigned his membership in 1888, by reason of his inability to contribute regularly to the exhibitions. In the latter year he had the misfortune to lose his wife. Nearly all his remaining family had by that time been established in the world ; several of his children having, moreover, shown a taste for art, especially a son, Mr. Charles Fripp, whose spirited battle pieces are the result of experience in the field in several African campaigns as artist correspondent of the *Graphic* newspaper.

Up to the time, in 1882, when the Society received the title of 'Royal,' George Fripp had exhibited 455 drawings (and sketches) in its gallery, 402 in the summer and 53 in the winter exhibitions. He has been more constant to the former, having missed but two within the period named, whereas in the latter he exhibited nothing for the five successive seasons from 1869–70 to 1874–5. The cause may probably exist in the habit of his mind, which does not content itself with incomplete work or fragmentary delineations of nature, his own 'sketches and studies' being rather pictures in various stages of progress, than works of art fulfilling their whole purpose as suggestive representations of nature.

The works of George Fripp may be generally classified under a few distinct heads. It is hard to say which is the most characteristic group. Setting apart foreign scenery, chiefly of Switzerland and the North of Italy, for the most part the result of early tours abroad, the rest are characteristically British. None more so than the long series of river scenes, mostly on the silver Thames. With these may be grouped a large number of rustic and agricultural subjects, such as farm buildings, windmills, and harvest scenes. Of ruined castles and abbeys in South Wales, Yorkshire, South Kent, and Sussex, there are an appreciable number. Mountain scenery, chiefly in Scotland, but also in North Wales and Yorkshire, forms a principal class ; and finally, some careful portraits of cliffs and rocky coasts are entitled to a category by themselves. These last include the Dorset views

above mentioned, studies on the Cornish coast about Tintagel, exhibited in and after 1867, and a series of views in Sark, the result of two sketching sojourns in 1871 and 1872. The artist's water-colour drawings, particularly of his middle and later time, are characterized by refined delicacy and tenderness of aërial effect, by truth of colour, and by the learned breadth and scrupulous balance of their composition. There is a restful purity in his river scenes. His delineation of mountains conveys a feeling of solidity and surface which seems to add to their vastness, and his rock studies are true to the geological formation. Like his fellow-student Müller, he is some-what short-sighted. He paints transparently and with few colours, soaking them well into the paper. His early drawings, which partake of the characteristics of the Bristol school, are distinguishable from more recent works by a greater darkness in the shadows. The later are softer in their gradations, and in them the warm colour is more generally diffused. A plate of ' Kilchurn Castle ' engraved by Wallis in S. C. Hall's series *The Queen's Gallery* in the *Art Journal* for February 1868, is the only engraving after a work of George Fripp's that has come to the writer's knowledge.[1]

One new Associate only, OCTAVIUS OAKLEY, was admitted at the annual election on the 4th of February, 1842. He became a Member two years after, and remained one until his death in 1867. Oakley's clean, smooth, and highly finished drawings of rustic figures were familiar for many years to frequenters of the Gallery, more especially those of the class which had earned for him the sobriquet of 'Gipsy Oakley.'

As his baptismal name indicates, he was one of a large family. His father was a wool merchant of London, much respected and, in 1800 when his eighth child was born, wealthy also. The boy received a good general education at the school of the Rev. Dr. Nicholas, at Ealing, and as he was intended for the medical profes-sion, it was proposed to apprentice him to Aston Key, the surgeon. But this design was frustrated by his father's misfortunes. On the opening of the foreign ports, after the peace of 1815, the value of

[1] This print, from a drawing at Osborne, is made the text of a dissertation by Mr. P. G. Hamerton in his *Life of Turner* (pp. 76-7) on the justifiable limits of artistic exaggeration in dealing with a topographic subject. He cites it as an example of legitimate treatment adopted to accentuate the local character ; and contrasts it with Turner's distortions of fact, which transfer the same scene to the regions of fancy.

wool suddenly fell, and Mr. Oakley having a very large quantity in stock, was in consequence a serious loser. The event had an influence on the son's career. His medical studies being commenced under less favourable conditions than those above mentioned, a distaste for the profession, which he had evinced from the first, was so obviously strengthened, that the father was induced to alter his plans for the son's future, and young Oakley was sent to a cloth manufacturer's near Leeds, to gain a practical knowledge of that branch of industry, with a view of his engaging in the wool trade. In both these schemes, however, the boy's natural bent was studiously ignored. It was the old story, so often repeated in these pages. He had shown the artistic faculty from an early age, being never so happy as when employed with his pencil. But the practical father considered this a waste of time, and to escape punishment the young artist would take refuge in the privacy of his bedroom, and save up candle ends, that he might draw when others were, and he ought to have been, in bed and asleep. On one occasion an elder sister ventured upon an expostulation, which was afterwards regarded by the family as prophetic. 'Who knows,' said she, 'but some day he may be glad to earn his bread by his pencil?' And so it turned out. But for the present her brother Octavius was packed off to the north country.

Being of somewhat elegant appearance, and comparatively slight in physique, the 'fine London chap' met at first with small consideration from the brawny Yorkshire lads among whom he was thrown, and he had to show his pluck in a pugilistic encounter with the village bully before he was able to gain their respect. In the want of sympathetic companionship, however, his love of art was a double solace to him, and in time it proved a means of securing the friendship and the interest also of those about him; for he used to make pencil likenesses of his acquaintance, and eventually, acting on the advice of a young lawyer in whom he found the most congenial spirit among them, he began to turn his talent to account, by receiving payment for his portraits. As sitters became more numerous, practice developed his talent, and in fulfilment of the prophecy he at length bade adieu to the wool business, and set up as a professional artist. How he acquired his skill in water-colours, tradition does not say; but he painted portraits in that medium, which were greatly reputed for their individuality. His early patrons doubtless afforded ample

material for the delineation of character, much of his first profes-
sioual limning being employed on the shrewd features of Yorkshire
farmers. He used to relate in after times how one of his sitters, on
being shown his half-length likeness, expressed his dissatisfaction at
the curtailment of his manly figure by exclaiming 'Eh! mon, but I
want t' whole carcase.'

It was, however, by a more aristocratic class of sitters that Oakley
was destined to be chiefly employed as a portrait painter. The talent
and taste displayed in his early productions gained him the support
of several noblemen and persons of influence ; and when he took up
his residence at Derby, about the year 1825, he was invited to stay
at Chatsworth, where he painted the Duke of Devonshire and many
of his distinguished guests. This led to his spending much of his
time at the different country seats in Derbyshire. The Earl of
Shrewsbury, one of his patrons, thought so highly of his talent that
he offered to give him introductions at some of the foreign courts if
he cared to go abroad. But Oakley preferred to live quietly at home
with his young wife (he had by that time become a married man),
and pursue his placid art among rural surroundings ; for, successful
as he was, portrait painting in high life was not the branch of art
most congenial to his taste. He had a love of nature which inclined
him to prefer pure landscape and rustic figures of children of the
soil. Moreover, he had already conceived his fancy for gipsies, and
was making a *spécialité* of the study of their picturesque life. He
was now well known amongst them, and they would often pitch their
tents purposely near to his house.

During his residence at Derby he began to exhibit at the Royal
Academy, and had seventeen portraits there between 1826 and 1832.
Among these are (in 1829) Lord Melbourne and the Hon. Mr. and
Mrs. Lamb, and (in 1831) the Duke of Rutland. He also painted
Prince George and Princess Augusta of Cambridge, and divers
persons eminent in the literary and scientific world ; among the
latter Audubon the naturalist and Spurzheim the phrenologist.

The premature death of his wife led to the breaking up of his
home at Derby. Being then unsettled, he came to London, and
sought for a time the companionship there of his brother artists.
In 1836 he settled in a pleasant villa at Leamington, in the Holly
Walk, and there took up again the position of a fashionable portrait
painter. He also continued to study his gipsy figures from life, his

wandering acquaintance following him into Warwickshire. They were not immaculate neighbours, but he rarely suffered from their predatory habits. In or about 1841 he was induced by several of his artist friends, among whom Cattermole, Stone and Charles Landseer are named as influential with him, to remove to London, where, as we have seen, he was elected Associate by the Water-Colour Society n the following February. He was made a full Member on the 10th of June, 1844. While sending rustic studies to Pall Mall East, he at the same time resumed the exhibition of portraits at the Royal Academy. He had thirteen there between 1842 and 1860.[1] Among them (in 1844) was a likeness of Lord Auckland ; and the last (in 1860), of ' Mrs. Octavius Oakley,' indicates that the painter had married a second time.

From 1842 to 1848 he lived at 3 Bentinck Street, Manchester Square ; from 1849 to 1861 at 30 Somerset Street, Portman Square ; and from 1862 to the time of his death, at 7 Chepstow Villas, Bayswater. That event occurred at the last-named residence, on the 1st of March, 1867, when he was in his sixty-seventh year. The second Mrs. Oakley survived her husband. One of his daughters married Mr. Naftel, a Member of the Society. To another, Mrs. Mark A. Bourdin, the writer is indebted for many of the facts above narrated.

Oakley's exhibits at the Water-Colour Society number in the whole 210, from 1842 to 1867, those of the last year being posthumous. No exhibition, either in summer or winter, during that period was without from two to sixteen of his works. The rustic figures were not confined to gipsies, but these had frequent companions in gleaners and fisher-boys ; and on his coming to reside in London, the Italian organ and image boys supplied him with models as well suited to his pencil as had been the Bohemians of the rural districts. He also painted landscape subjects and fragments, of picturesque character and detail. Many both of these and of the figure subjects were studied in the Channel Islands, Guernsey and Sark. None of his works went to Paris in 1855; but ten were among the Manchester Treasures in 1857, and three in the London International Exhibition of 1862. His remaining works were sold at Christie's on the 11th and 12th of March, 1869, in two hundred lots, with forty-two by other artists.

[1] He had also, according to Graves, one drawing at Suffolk Street.

Three Associates were elected on the 13th of February, 1843, SAMUEL PALMER held for many years an exceptional position in the Society. At a period when landscape art, though practised usually with an eye to picturesque beauty, had again become essentially realistic, he alone sought after and cultivated the ideal ; and latterly it seemed to be his sole province to keep alive the embers of poetic fire, when in danger of extinction. Thus his history connects itself more closely with that of the artists of an earlier generation with whose names and careers the reader is already familiar, than with the present or future part of this narrative.

Samuel Palmer's place of entry upon the stage of life was scarcely what one would choose for a poet's birth. Surrey Square, St. Mary's, Newington, where he first saw the light, on the 27th of January, 1805, is near the Bricklayers' Arms tavern in the Old Kent Road, and close to the site of the present goods station of the South-Eastern Railway. His parents are described as ' old-fashioned and simple-minded people,' but happily they had none of the prejudices against an artist's career which have hindered the early professional training of so many of our painters. He was, indeed, in a great degree, self-taught ; but in his case circumstances conspired to foster the æsthetic germ that was born within him, and favour the current of a vein of poetry which tinctured all his art. Of his remoter ancestors we learn that a great-great-grandfather and namesake was ' collated to the living of Wiley in Wiltshire in 1728 ; that the next in descent was also a clergyman ; and that a grandfather was author of several works, one of which contains a portrait of our artist's mother as " Lavinia " by Stothard, and another, the *Guide to Domestic Happiness*, has its niche among the *British Classics.*' In Palmer's own belief, his early ' spoiling of much paper with pencils, crayons, and water-colours,' in attempts to depict ecclesiastical structures, arose from ' a passionate love for the traditions and monuments of the Church,' inherited from his clerical forbears. But they were naturally laid to the account of a love of art, and when the boy entered his teens it was thought right that he should attempt painting as a profession. Shortly before that time he had lost an affectionate mother, to whom the influences of a home ˈtraining had doubtless been largely due. ' If my life-dream must be told,' he wrote in his declining years, ' it begins with good parents, who, thinking me too fragile for school, gave me at home the groundwork of education,

sound Latin, so far as it went, with the rudiments of Greek ; and my father, having notions of his own, thought that a little English might not be superfluous.'[1] By little and little, he made him learn much of the Bible by heart ; and took pleasant ways of storing his mind. ' He carried in his waistcoat pocket,' adds the son, ' little manuscript books with vellum covers, transcribing in them the essence of whatever he had lately read, so that in our many walks together, there was always some topic of interest when the route was weary or unattractive.' Other, and earlier, impressions were derived from the domestic attendant of his infancy, than whom there never was more ' mete nurse for a poetic child ; ' a woman of singular intelligence, who ' with little education else, was deeply read in her Bible and *Paradise Lost.'* He told the following anecdote to illustrate her influence on his mind : ' When less than four years old, as I was standing with her, watching the shadows on the wall from branches of elm behind which the moon had risen, she transferred and fixed the fleeting image in my memory by repeating the couplet :—

> Vain man, the vision of a moment made,
> Dream of a dream, and shadow of a shade.

I never forgot those shadows, and am often trying to paint them.' Tonson's *Milton*, her gift, ' a venerable brass-clamped copy of the minor poems,'[2] lived in his pocket for twenty years, and was his treasured companion till death.

It was, however, with scarcely any other art-teaching than his own that he ventured on his professional career by sending two pictures, necessarily in oil, to the British Institution, when just completing his fourteenth year. Both were ' compositions ' : one a ' Bridge-scene,' the other, ' Landscape.' One (we are not told which) he was so fortunate as to sell ; and the news of the event was brought him on his birthday in 1819, together with ' an invitation to visit the purchaser ' (whose name has not transpired), and receive from him ' further encouragement.' He had three pictures at the Academy in the same year, viz. ' Cottage Scene, Banks of the Thames, Battersea,' ' Landscape with Ruins,' and ' A Study ; ' and then for a series of seasons was represented at one or the other gallery by one or more works from

[1] This and the accompanying extracts are from an autobiographical letter written by him to Mr. F. G. Stephens on 1 November, 1871, and published in the *Portfolio*, vol. iii. pp. 163, 164.

[2] *Times*, 20 December, 1888. .

year to year. He tells us, however, that he considered his time to
have been 'misused' until he obtained an introduction to Linnell,
who took an interest in his improvement, and gave him as a friend
some technical instruction in oils. Linnell recommended him to study
the figure ; and he accordingly sat among the students at the British
Museum who draw there from the antique. But he made small
progress in anatomy. 'Sedulous efforts,' he says, 'to render the
marbles exactly, even to their granulation, led me too much aside
from the study of organisation and structure.' He consoled himself
afterwards with a dictum of Mulready's, that, 'no one had done much
who had not begun with niggling.'

At least as deep a debt of gratitude to Linnell was that which
Palmer acknowledged for an introduction to William Blake. For
that 'great man' he conceived the most profound reverence, the
'memory of hours in familiar converse with whom' he cherished to
his dying day. 'The acquaintance commenced,' says Gilchrist, 'when
Blake was about midway in the task of engraving his Job.'[1] Palmer
may then have been eighteen or nineteen, and Blake about sixty-six
or sixty-seven. This is Palmer's account of his first reception. 'He
fixed his grey eyes upon me and said, " Do you work with fear and
trembling ? " " Yes, indeed," was the reply. " Then," said he, " you'll
do ! " ' It was between 1825 and 1827, the year in which Blake died,
that the two would walk up together to North End, Hampstead, to
visit Linnell when he lived at Collins's Farm. Blake was then in
Fountain Court, Strand, and called for Palmer on the way, the latter,
according to the Academy Catalogues, hailing from 10 Broad Street,
Bloomsbury.

It must have been at about the time of Blake's death, and when
under the full inspiration of the poet-painter's mind, that Samuel
Palmer, just come to man's estate, went for his health, which was
fragile, to live at the village of Shoreham, on the Darent, in Kent,
about five miles north of Sevenoaks. There he remained for seven
years. The character of his art was in a great degree formed by the
influence of the rural surroundings amid which he then pursued his
studies. Though Shoreham is now accessible as a station on a branch
of the London, Chatham and Dover Railway, it is still a country
place ; but in Palmer's time it had yet more left of its primitive
character. 'It was,' he wrote to Mr. Jenkins in 1879, in the playful

[1] *Life of Blake*, i. 297.

style which was his wont, 'a genuine village with the appurtenances thereto belonging. The shoemaker, in advance of his age (such virtue is in the smell of leather); the wise woman still resorted to; the "*Extollager* who went by the stars of the heaven," a strange gentleman whose sketching-stool, unseen before in those parts, was mistaken for a celestial instrument;—the rumbling water-mill, and haunted mansion house, where one of the rooms declined to be boarded; the hospitable vicarage, with its delightful sentiment and learned traditions; the "crazy old church clock;" and the "bewildered chimes" of Wordsworth.' Readers of the life of Francis Finch[1] will have recognized in the above description a local name therein mentioned as having been applied to a set of enthusiasts, of whom that poetic artist was one. Palmer, too, joined in their night wanderings, and in their reading of Chaucer, Jonson, Shakspere, Spenser, and Milton. Among his intimates at this time were one John Giles (a cousin), George Richmond (the veteran R.A.), Edward Calvert, and Henry Walter, some of them brethren in this union of choice spirits. Palmer in these days was also led by the harmony of sweet sounds. He sang and played on the violin. But he gave up music and musical society in later years, and devoted himself solely to the sister art. Though he worked also in oils, many of his compositions, at this period, were in sepia and ivory black; nearly all being pastoral or scriptural subjects and archaic in character. They 'express,' writes Mr. F. G. Stephens,[2] 'that exquisite idyllic feeling which is manifest in later productions, with, as might be expected when the youth of the draftsman is considered, less of the solemnity, if not less of the grave suavity, of the work of a riper time of his life. They give us glimpses of Arcadia, as it appeared to the fancy of the inventor.'

In 1835 he came to London again and settled at 4 Grove Street Lisson Grove, and in 1836 visited North Wales, where he made some elaborate studies of waterfalls and sketches of other subjects.[3] In 1837 he married his friend Linnell's eldest daughter. Palmer, in one of his letters to Jenkins (dated 30 April, 1879), informs him, with many appended notes of admiration, that when Mrs. Palmer was 'a little girl about nine years old,' she was considered by John Varley, who was then possessed with his craze of 'Zodiacal Physiognomy,' to be

[1] *Vide supra*, vol. i. pp. 519, 520. [2] *Portfolio*, iii. 164.
[3] Some of these were shown many years after in the Winter Exhibitions of 1864-5, 1866-7, and 1871-2.

'so perfect an example of Scorpio!11!! that he got' her father 'to
make a sketch of her, an etching from which' he believed to be
contained in the painter-astrologer's extraordinary book bearing that
title. The forecast was not one of the prophet's happiest hits.
Being found, in her womanhood, in no way to justify such a classifica-
tion, Miss Linnell was chosen as our painter's congenial companion
for life. She was also a keen and accomplished student of art. As
he and his friend Richmond had married at about the same time, they
determined to form *une partie carrée*, and travel together through
France and Italy for their joint wedding-trip. The Palmers remained
in Italy for two years, during which the husband made many sketches
from nature in water-colours, and imbibed the classic spirit of the
country, while the wife copied from Raphael and Michael Angelo.
The return to London and its fogs, after their residence in the sunny
south, is believed to have laid the seeds of an asthma from which he
suffered much in later years.

His painting had now settled more into a conventional style, but
was not less careful than before. He practised more in water-colours,
and after his election as an Associate of the Society in 1843, ceased
to exhibit oil pictures at the Royal Academy. During the twelve
years of his Associateship, the termination of which coincided with
that of Fielding's presidency, he had sixty-seven drawings at Pall
Mall East. The earliest are directly due to his sketching from nature,
being named views for the most part in Italy. But these soon give
place to motives of the more general kind, mostly derived from the
study and aspects of bucolic life in England. Some give evidence of
sketching westward, as 'King Arthur's Castle, Tintagel' (1849), and
'Scenery of West Somerset' (1852). But most were doubtless based
on the aspects of the home counties, and many still inspired by his
loved village in Kent. His biographer[1] tells us that he sketched at
Guildford in 1844, and at Margate in 1849. According to the same
authority the centre of this period is marked by a transition in the
character of his painting, the colour at this time being comparatively
faint as a rule, but delicate and pleasing, and the drawing careful, and
the artist's style assuming its later individuality about the year 1850.
A few selected titles and subjects between 1843 and 1854 will
sufficiently indicate the range and tendencies of his art at that time.

[1] See *Samuel Palmer: A Memoir by A. H. Palmer*. Published by the Fine Art Society,
1882.

In 1843 we have, variously, 'The Colosseum and Alban Mount,' 'Harlech Castle, Twilight,' 'Rustic Scene near Thatcham,' 'Evening, the Ruins of a Walled City;' in 1844, 'Jacob wrestling with the Angel,' 'The Guardian of the Shores,' 'Twilight after Rain,' 'Mountain Pastures,' 'The Silver City—Morning on the Jura Mountains;' in 1845, 'Evening in Italy—The Deserted Villa,' 'Saturday Evening— The Labourer's Reward.' Many of the above have illustrative verses. From 1846 rural scenes greatly preponderate, such names as 'The Listening Gleaner,' 'The Skirts of the Village,' 'Sylvan Quiet,' 'The Breezy Heath,' 'Haste and Patience,' and 'Fast Travelling,' having more than ordinary significance. Among these, interspersed, are a few illustrations of more ambitious themes from *Télémaque*, *The Pilgrim's Progress*, *The Faëry Queen*, and *Robinson Crusoe*. In the latter subjects he was able to turn to good account his foreign reminiscences, and in 1846 he therefrom contributed four drawings on the wood to the illustration of an edition of Dickens's *Pictures from Italy*.

Within this period changes were taking place in his domestic condition. In 1848 Mr. and Mrs. Palmer, with one son six years old— now their sole child, for they had lost an only daughter in the previous year—removed to Kensington, where they resided for the first two years or so at 1A Victoria Road, and then, for about a dozen, at 6 Douro Place, Marlborough Place, close by. Another son was born in 1853. At this time, besides practising his art, Palmer did a little teaching, both in schools and in private lessons ; and, as a substitute for some of the rural objects of study which had played so strong a part in his own art-training, he used to cherish in his garden a natural growth of weeds to inspire his pupils with a love of the picturesque.

While at Kensington he 'became acquainted with eminent and excellent neighbours.' Among these may be reckoned two, to whom he was indebted for aid and experienced advice in early efforts to master the art of etching, if not for his first introduction to its charms. These were the late T. O. Barlow, R.A., the well-known engraver, and C. W. Cope, R.A., an artist whose skill on canvas was more than equalled in his work on copper. Ten out of Palmer's thirteen plates are said to have been executed while he lived at Kensington. The width of appreciation of what may be called with peculiar truth his 'painter-etchings' belongs to a later age, but the year 1853 is a noteworthy date in his career, as that of his election as a Member of the Etching Club.

In the next year, 1854, on the 12th of June, he was elected a full Member of the Water-Colour Society. Inspection of the Catalogue does not show in his case, as in that of many new Members, a sudden influx of drawings awaiting the privilege of unlimited admission to the gallery. For his produce was regulated rather by the inspiration his mind received than by the desire to meet or to create a popular demand. His annual contribution of from two to eight works maintained its average of more than five for some years, but never rose, and latterly was much reduced. The quality of his drawings made up, indeed, for their paucity of number. In the first two years he sent three notable illustrations of *Comus*. In 1856 he did a little more drawing on wood, furnishing nine illustrations of ' The Distant Hills ' to W. Adams's *Sacred Allegories*, and three cuts for a book of poetry for children. In 1857 he sketched in Cornwall, and in 1858 and 1860 in Devon. Some of the studies which he sent to the winter exhibitions between 1864 and 1867 were from Clovelly and Tintagel, and many of the sunset effects which he reproduced were witnessed by him from the Atlantic cliffs of that romantic coast. His biographer relates that, when on his sketching tours, he travelled much on foot, with simple *impedimenta*, associating freely with the peasant folk, and sometimes walking, as in his student days, throughout the night.

In 1861 poor Palmer had to endure a painful bereavement in the loss of his elder son, who was then about nineteen and a young man of high promise, to whom he was devotedly attached. They had been companions on the Cornish tour. He died and was buried at Abinger, whither he had been taken for change of air. This event, together with a consciousness of his own impaired health, seems to have determined Palmer to return no more to London. After a year in Reigate, he settled for the rest of his life at Furze Hill House, Mead Vale, Redhill ; in the district which, it may be recollected, was chosen also by his father-in-law, Linnell, for a rural retreat in declining years. There he led a retired life, indulging his literary tastes, and applying his poetic fancy to natural scenes, of which he had sufficient memoranda. Before leaving London he had already begun to be careful of his health, as appears from his friendly and unreserved correspondence with Jenkins, to whom, when he also had been, as he often was, a great invalid, Palmer wrote in the following characteristic style, by way of condolence, on the 21st of January 1860 :—' Affliction while it lasts will ever *be* affliction, and there are

many trials which at the time scarcely admit comfort of any kind, but it is not the smallest of the "great uses of adversity" that it enables us to sympathize with each other; for those who have not suffered, though they *may* be good-natured, are yet *hard*, and sitting here in the midst of a universe of mystery, I am conscious of really knowing of being equally certain of two things; one that the world is round, the other that our moral being can never be perfected but through *suffering*. As, however, self-preservation is said to be the first law of nature, might we not do well to get out of the exhausted air of London altogether? Our friend Hunt would not at his age be the man he is if he had stuck to Stanhope Street; and perhaps you and I should hardly know each other after a couple of years' residence at Reigate or Brighton. I will not say with the poet, whose name is synonymous with elegance, " Oh, for a lodge in some vast wilderness! " but perhaps you will join me in saying, " Oh, for a lodge in a nice little garden with a nice large Studio! " Surely the sight and smell of sunshine and new-mown hay are more congenial with our pursuits than those of smoke and sewers.' At Redhill he had his wish, and the little garden was considered all the nicer for a corner carefully preserved in native wildness. After Palmer's retirement into the country, however, his failing health became more an object of solicitude to him, and some of his later letters are those of a confirmed valetudinarian. But there was no falling off in the quality of his art. Although his exhibits at the Society during the last sixteen years of his life were but one or two at most in each summer season, his most important works were among them, evolved and elaborated in the studio at Furze Hill.

Some of his fresh undertakings were a return to an early love. Acting on a suggestion, and in performance of a commission from the late Mr. L. R. Valpy, he turned once more to the old Milton volume, which had not directly furnished him with themes since 1856, and began in 1864 a series of drawings in illustration of *Il Penseroso* and *L'Allegro*. Five or six of these appeared in the gallery in the years 1869 to 1881, and were among the works which excited most admiration for their imaginative feeling and brilliancy of colour. The possessor wrote, in a letter to the *Athenæum*, dated 2 October, 1877, that in drawing them ' It was with a view to obtain a representation or rendering of Milton's ripe and expansive thought and sympathies rather than to secure special designs or illustrations.' While these drawings were in progress, and while he was under the same kind of

Inspiration, Palmer in 1872 resumed, with even greater ardour than before, his work upon copper. So great became his enthusiasm for the art of etching that he was 'always willing,' it was said,[1] 'to exchange the brush for the needle.' 'So curiously attractive,' he once wrote, 'is the teasing, temper-trying, yet fascinating copper. Colours and brushes pitched out of window; plates, *Liber Studiorum* size, got out of the dear little etching cupboard where they have long reposed, great needles sharpened three-cornerwise, like bayonets;—oh, the joy!' In the composition of these later etchings, he would revert in fancy to the old days of his youthful residence at Shoreham. Referring to those times he wrote to Mr. Jenkins on 28 July, 1879 (in a letter already quoted): 'When I was first introduced to dear Mr. Blake, he expressed a hope that I worked "with fear and trembling." Could he see me over an etching, he would behold a fruition of his desire copious as the apple-blossoms of that village, where I lost, as some would say, seven years in musing over many strings; and of which this "Bellman" is in some way a "cropping-up" (geologically speaking), though I had no room for the clear trout river which ran through it, not unfamed in song.' The etching particularly referred to is an illustration of the lines in *Il Penseroso*:

> And the bellman's drowsy charm
> To bless the doors from nightly harm,

which is the subject of one of the Valpy series of drawings. Another was suggested by the same poem, and called 'The Lonely Tower.' It was published by the Etching Club, and the plate destroyed. The last of his etchings was called 'Early Morning—Opening the Fold,' published by the Fine Art Society shortly before his death. In his etching operations he was now assisted by his remaining son, Mr. A. H. Palmer (afterwards his biographer), who, having obtained some instruction from Goulding, the eminent printer, made use of a private press to turn out excellent proofs of his father's work.[2] In these last years, too, the artist resumed a literary work, which had been interrupted at Kensington by professional avocations, that of translating the *Eclogues* of Virgil into English verse. This was to be illustrated with etchings, for which the drawings were nearly complete, when the design of publication was frustrated by the author's death. Thus

[1] *Times*, 13 January, 1883.
[2] A set of Palmer's etchings, with some in special states, was presented by Mr. Jenkins to the Society. Many of the impressions were selected by the artist himself for the purpose.

his days drew quietly towards their close. He rarely left his retreat at Redhill, save to make an annual visit to his friend J. C. Hook, R.A. (a brother Member of the Etching Club), at Witley, in Surrey, and Churt, near Farnham. And so age crept on, and Samuel Palmer, happy to the last, and much beloved, died on the 24th of May, 1881, and was laid to rest at Reigate.

During the forty years of his connexion with the Society, Palmer did not exhibit more than 176 drawings and sketches in its gallery, 142 being in the summer and only 34 in the winter collections, in ten out of 20 of the latter of which he was altogether unrepresented. In his later works the composition became more careful, and the colour more intense and glowing. Like Turner, he 'painted his impressions' and sought more to suggest the light of heaven than the varied hues of earthly objects. An effect of great brilliancy is produced in these drawings by subtle manipulation without the use of opaque pigment.[1] When his position was assured by Membership, their titles had come to indicate more distinctly than before the subjective character of his treatment of landscape, the special sentiment or poetic aspect of the scene being more to him than the local association. They do not serve as a guide-book description of the view, by giving compass-bearings, and telling off the hill-tops in sight, as was the practice of Fielding and others. These are but 'Distant Mountains' to his eye. The Italian scenes are 'Memories' and 'Day-dreams,' and Rome becomes 'The Golden City.' Once, indeed, he condescends to paint what would formerly have been called a 'gentleman's seat,' but with him it is 'An ancient manor house beneath the western slopes of lovely Albion.' In the first two years of his Membership, 1855 and 1856, he had exhibited three illustrations of *Comus*, which afterwards came to be placed in the Milton series collected by Mr. Valpy. Of his subsequently exhibited drawings the following are the best known and most generally esteemed :—In 1859, 'The Comet of 1858, as seen from the skirts of Dartmoor.' In 1860, 'The Ballad,' representing a girl reciting to a

[1] The editor of the second edition of the *Century of Painters* (p. 411) informs us, however, that Palmer prepared the cardboard on which he painted by 'a slight wash of Chinese white, with perhaps a little cadmium to obtain a warm ivory tint.' But it is added that 'he took infinite pains in the preparation of his pigments, and would use several palettes in order that he might not be tempted to mix those colours together which did not properly assort, or whose juxtaposition might lead to serious consequences. It is therefore probable that his pictures . . . will stand well.'

companion, with an autumn landscape and the sun setting behind hills ; 'The Abbey,' with another sunset sky ; and 'Mountain Pastures,' with moonrise over the sea.—In 1869, 'Pompeian Memories, in which, as Mr. Stephens writes, he gave 'the ruins once again to the livid splendours of the sun, with harsh-looking wastes about them, and the surrounding plain in ridges that culminate in the peaks of the mountains which are swept by thunder-clouds as these take their course to the fiery horizon.'[1]—In 1871, 'The Fall of Empire.'—In 1873, 'A Golden City,' the glorified Rome above referred to.—In 1877, 'Tityrus restored to his Patrimony,' under another gorgeous setting of the sun.

To these have to be added the following that belong to the 'Milton series :'—In 1868, 'From *Il Penseroso*,' otherwise called 'The Lonely Tower,' and 'A Towered City ; from *L'Allegro*.'—In 1869, 'Morning.'—In 1870, 'The Curfew.'—In 1877, 'The Waters Murmuring.'—In 1881, 'The Prospect,' and 'The Eastern Gate.' The Milton drawings, collected by Mr. Valpy, ten in number, included these seven and another called 'The Bellman,' all from *L'Allegro* or *Il Penseroso* ; and the two *Comus* subjects exhibited in 1856 were etched by the artist's son, Mr. A. H. Palmer, for a new edition of the poet's works. The originals formed an important part of a representative collection of drawings, paintings, and etchings by the artist exhibited at the Fine Arts Society in 1881, shortly after his death ; which were the subject of an amply descriptive notice with critical remarks from the pen of Mr. F. G. Stephens prefixed to the Catalogue. Subsequently, after the owner's death, the series of ten were sold, in May, 1888, at Christie's, and realized prices varying from 94*l.* 10*s.* each (for the *Comus* drawings), to 173*l.* 5*s.* each for two of the later series, viz.: 'Towered Cities,' and 'The Eastern Gate,' exhibited in 1868 and 1881 respectively.

The following had been the highest prices obtained for Palmer's water-colour drawings in previous sales :—In 1875 (J. Mitchell sale), 'Emily and Valancourt, '105*/* – 1883 (G. Gurney sale), 'The Traveller,' 120*l.* 15*s.* ; 'Lycidas,' exhibited 1873, 131*l.* 5*s.* ; 'Glorious Sunset,' engraved, 131*l.* 5*s.* ; 'Tityrus restored to his Patrimony,' exhibited 1877, 168*l.* Four of the most celebrated of his oil paintings were sold in 1881 (Giles sale) for sums varying from 89*l.* 5*s.* to 162*l.* 15*s.*[2]

Mr. Stephens, whose special study of Palmer's works is apparent

[1] *Portfolio*, iii. 166. [2] Redford's *Art Sales*.

in several critiques,[1] finds traces in his technique of an influence derived through Linnell, Mulready, and John Varley, and still further backwards, through Cozens and Claude, to an original source in Adam Elzheimer. He observes in his works a change of motives and expression coincident in time with his abandonment of oil for watercolour; and comparing painting with poetry, recognizes in the later practice an alliance with the writings of Tennyson, and in the former a resemblance to Keats. Among characteristic devices of composition, he notices a favourite practice, ' much affected in later life, according to which he placed the central light of his design in the rear of, and partly obscured by, a mass of trees, rocks, ruins, or what not, and thence projected large shadows into the middle of his foregrounds ;' and ' a peculiar mode of representing the full-orbed sun, by means of rays of golden light issuing from the luminary, and thus depicting the result of prolonged sun gazing on the retina, rather than the actual aspect of the luminary itself.'[2] Prefixed to the *Memoir* of Samuel Palmer, by his son A. H. Palmer, above quoted, from which most of the above facts are derived, is a photo-printed portrait of the painter, as an old man seated at a table, his face resting on his left hand. A woodcut likeness also accompanies the obituary notice of him in the *Illustrated London News.*

Another of the Associates elected on the 13th of February, 1843, was THOMAS MILES RICHARDSON. He came of an artistic family. From the date of his election to 1847, his name is entered in the Catalogue as 'T. M. Richardson, Jun.,' to distinguish him from his father, who was also a landscape painter in water-colours of much ability, at Newcastle-on-Tyne. The elder Richardson was founder of the Newcastle Society of Painters in Water-Colours, established in 1831, and five of his children have been or are practitioners in Art. Besides the subject of this notice, the eldest son George,[3] who died many years ago, was an artist. The names of two others are in the list of Members, past and present, of what is now the Royal Institute of Painters in Water-Colours, viz., Edward Richardson, deceased, and John Richardson, now living. A younger brother of the brush, Charles Richardson, completes the group. Our own Member, T. M.

[1] *Ubi supra*, and in the *Athenæum*, 4 June and 5 November, 1881.

[2] *Notes of Drawings &c. at the Fine Art Society*, 1881, pp. 10, 15, 18, 19.

[3] ' Mr. G. Richardson ' was Secretary of the Newcastle Water-Colour Society. See *Library of the Fine Arts*, i. 255 (April 1831).

Richardson, was born in 1813, and originally practised at Newcastle. He did not come to London until some years after he had joined our Society. In his early time he did a little in oils, and there were, between the years 1832 and 1848, while he still lived with his father at 53 Blackett Street, Newcastle, six of his works at the Royal Academy, three at the British Institution, and five at Suffolk Street.[1] He was unanimously elected a member of our Society on 9 June, 1851. The history of his life is almost written in the account of his exhibited drawings, nearly all of which are local views, British and foreign, which imply many seasons of sketching both at home and abroad. He was married, at Frankfort, to Miss Mary Green, in 1845 ; and the graphic taste of the family has been carried into a third generation in the persons of two daughters who also practise art. After a year's address at 6 Stanhope Place, he was at Radnor Place, Hyde Park, from 1847, until in 1856 he settled himself in the residence, No. 12 Porchester Terrace, Bayswater, which became his home for life.

The statistical record of Richardson's works shown at Pall Mall East deals in large figures. Never from the time of joining the Society till his death was he unrepresented in the gallery in any one season, summer or winter. The total, 688, separately numbered exhibits, is made up of 429 in the former, and 259 in the latter series of shows. This includes the one drawing in 1860, 'The Favourites,' which was the joint work of himself and Frederick Tayler, but does not include above 140 of the winter 'sketches and studies,' which were placed in the same frames with others. So that the number of separate subjects exceeds 800. The very large majority are either Scotch or Italian views. The former begin in 1846 with a 'Moor scene in Lanarkshire—Rain passing away.' In 1847 he showed us the Bass Rock and took us to Arran. We are among the Perthshire Highlands in 1848, and his range extends to the counties of Inverness, Argyll, and Aberdeen in 1849, 1850, and 1851 respectively. After this there was not a year without a Scottish subject. The home views are not, however, exclusively from North Britain. As early as 1843 or 1844 there are subjects from Northumberland, Durham, Yorkshire, the English Lake District, and North Wales. And these were continued at intervals until late times. From 1852 there were occasional subjects from Hastings or St. Leonards, and from 1861 a few from the Isle of Wight. Among foreign subjects those from Italy

[1] Graves.

occupy a similar position to that of the Scottish among home scenes. They begin with views on the Lake of Como in the year of his election, 1843. These are continued from 1849 to 1852, and after that there was scarcely a year without its contingent from the sunny peninsula. In 1852 they extend southwards, and thereafter a large proportion are from Naples, Salerno, and Calabria. In 1850 are two Italian figures; in 1853 we have an 'Italian composition,' and in 1856 a 'composition' of Sicilian scenery. But with these exceptions, the views, at least in the summer exhibitions, are all of real places. Among the winter 'sketches,' Italian subjects do not begin until 1872-3, after which they appear almost yearly. Besides these, the views from abroad comprise many from Switzerland (from 1844), a few from the Rhine or Moselle (from 1843), one from Nice (in 1869), and the department of 'Hautes Alpes' (in 1870). Latterly to the winter exhibitions he was in the habit of sending frames containing a collection of some half-dozen little pictures of his familiar subjects, grouped under a general title, as 'Highland Lochs,' 'Border Castles and Towers,' 'Italian Lakes,' or 'Scenes in Switzerland.' During his last few years, although still an unfailing contributor to the gallery, he was in feeble health and a frequent sufferer; and his life came to its end on the 5th of January, 1890.

The works of T. M. Richardson are specially characterized by clever drawing and workmanlike skill in manipulation of material. They are rendered attractive by bright contrasts of colour, and a deftness of handling which is particularly apparent in his sketches. As might be expected from so prolific a painter, there is much similarity of treatment in his many landscapes. In his finished drawings the pictorial arrangement conforms to a settled system of construction, the effect being commonly enhanced by the introduction of telling groups of figures and animals in the foreground. In depicting extensive moorland and other scenes, he not unfrequently extends the field of vision laterally by the use of paper of widely oblong proportions.

Not many of Richardson's works have been engraved. The two following prints are from his drawings :—In Lawson's *Scotland Delineated*, 1847-52, 'Donolly Castle,' lithographed by Dickinson.— In S. C. Hall's 'The Queen's Collection' in the *Art Journal*, an 'Italian Landscape.' He is understood to have made one etching only, 'many, many years ago,' as he said in his last year; and there is a

portrait of F. O. Finch prefixed to the Memoir of the life of **that** artist, engraved by Alfred Roffe, from a photograph by T. M. Richardson.[1]

Redford's list shows no fewer than eight drawings by Richardson which have realized more than 200*l.* in public sales, between the years 1862 and 1881, the highest prices being 315*l.* for 'Como,' in 1876· (Wyatt sale); 310*l.* for 'Sorrento,' and 283*l.* 10*s.* for 'City of Chiuse,' in 1878 (Birch sale); and 252*l.* for 'Como' in 1862 (Charles Layton sale). His remaining drawings and sketches were sold at Christie's on 16, 17, and 18 June, 1890, in more than 600 lots.

WILLIAM COLLINGWOOD SMITH, the third Associate elected on the 13th of February, 1843, was another skilful and prolific artist in landscape, whose works were plentiful in the gallery for five and forty years. Untiring in devotion to his art, and exercising wide influence as a teacher both of professional students and amateurs, he may be taken to have exhibited in his style of painting a type of the ordinary practice of water-colour sketchers in the middle period of the present century. He, moreover, conferred much benefit on the Society by the active and zealous interest which he long displayed in its welfare, and the management of its affairs.

He was born in 1815 at Greenwich, where his father held for many years a post of trust under the Admiralty. Mr. W. Smith, being himself fond of drawing as an amateur, as well as a very good musician, had no scruples in dedicating his son to an artistic profession. Although originally intended for the line of life from which he never deviated, Collingwood Smith was, however, in a great degree self-taught; except that he received some occasional instruction from J. D. Harding. By the age of sixteen or seventeen he was already beginning to practise as an artist on his own account. His first appearance as an exhibitor was at the Royal Academy in 1836, with an oil painting of the north aisle of Westminster Abbey; and he continued to send works thither, and to the British Institution and the Society of British Artists, until he joined the Water-Colour Society. It was, however, during the early part of his career only that he painted a few pictures in oil. He afterwards became exclusively a water-colour painter.

Probably by reason of the surroundings of his youth, Collingwood

[1] See *Memorials*, p. 330, *n.*

Smith's earliest subjects were nearly all marine. A large proportion of the drawings which he exhibited as an Associate and for the first few years of his Membership belong to that category. Some even aspire to historic rank as battle-pieces of the old school. For we have, in 1846, 'The French ship " Le Vengeur" sinking' on the glorious 1st of June; in 1849, 'Admiral Collingwood breaking the Line at Trafalgar ;' and, in 1851, an 'Attack by English Gun Brigs under the Earl of Dundonald during the Spanish War.' Otherwise, they are chiefly landscape with water, or landscape with architecture. The subjects are varied in locality, including views in many parts of Great Britain, and numerous foreign scenes, for the most part in Italy. Some of the most important were taken from the Italian lakes, and others from Venice, Geneva, and Rome. The production of these works involved much travelling, in Scotland, Wales, France, Switzerland, Belgium and Germany, but especially in Italy.

He always resided, however, in or near London. In 1847 he married Louisa, daughter of the late W. Daniel Triquet, by whom he had one son, William Harding Smith, who follows his father's profession.[1] At first they lived at Camberwell, and, during the last thirty years of our artist's life, at Wyndham Lodge, 13 Brixton Hill. He generally had also a studio in some more central part of London. Before February 1860 it was in Chester Square, and after that date at 15 Cockspur Street, Charing Cross, in one that had been occupied by F. R. Lee, R.A. He was elected a full Member on the 11th of June, 1849, and in the next year's exhibition had no less than thirty-two drawings. They embraced subjects throughout the length and breadth of the land, but were still confined to Great Britain. We do not find foreign subjects until 1852, when he has twenty-three drawings, including seven from Normandy and one on the Lake of Thun. From that date views in Switzerland mingle more with the home subjects, until in 1857 those of the Italian lakes begin.

Though Collingwood Smith did not abuse, as some artists have, the privilege of loading the Catalogue with descriptive quotations, he could not resist the occasional temptation to send now and then a few illustrative lines from Byron or Rogers, not always unfamiliar to the ordinary reader, to accompany these Swiss or Italian views. A letter to Mr. Jenkins, to which internal evidence gives the date 1861 (in addition to '29 April'), contains an amusing reference to the

[1] He has kindly furnished the writer with some of the facts of this biography.

practice. It also affords a pleasant example of the lively and genial
style of our artist's writing and discourse. 'I have been pulled over
the coals,' he says, 'for putting a quotation from Byron's *Chillon*
to a scene in Italy, and being badly off in Poesy, as Longfellow,
Barry Cornwall, and Byron's effusions will not *fit* my drawing, I
have tried a stanza of my own—and if it won't do—the cold mutton
and hard beer which have formed my supper are alone to blame.
The doggerel is enclosed, and if you think it will pass muster for
Milton or Rogers, please order its insertion instead of those which
now exist to " No. 91—Lago d'Orta," and if it will not pass, expunge
all quotation, if it does not disarrange the catalogue, for of these
topographical matters I am very ignorant.

> By the bright Lake of Orta have I stood
> And looked on spire and palace, strand and wood.
> While, from her azure floor, St. Giulio's Isle,
> And farther, farther off, full many a mile
> More distant, e'en than piercing eye could stray,
> Hill, rock and glacier rose : all seemed to smile
> In the gay sunshine of the noontide ray.

'Mrs. Smith asks me to add—

> Asses, baskets, broken bottles,
> Lazy monks with naked throttles,
> Fountains, pines, and dogs, and pitchers,
> Women ! those sad, sad bewitchers
> All 'drawed out' and done 'from natur'
> On a large-sized sheet of paper—

but don't.' Neither effusion was inserted, for the seven lines to
'Lago d'Orta—from the Sacro Monte'—beginning 'I saw their
thousand years of snow,' stand unaltered in the published catalogue.[1]

Collingwood Smith began to teach at an early period in his
career, and at one time had the largest *clientèle* of pupils in London,
among families of the nobility and gentry. He instructed not a few
of the most distinguished amateurs, including the late Mr. Gambier
Parry, and many well-known officers in the military and naval
services. Nor was his tuition confined to amateurs. In later times
he could boast that the following Members and Associates of his
own Society had been among his pupils : Samuel Read, William
Collingwood, Wm. Matthew Hale, and W. Eyre Walker ; and also
J. W. Whymper, of the Royal Institute.

[1] Is in fact No. 99.

His own water-colour drawings are 'marked by breadth of effect, firmness of drawing, and precision of touch, if they sometimes lack qualities of colour and intricacy of form of a more subtle kind.' [1] His handling was free and sketchy in early years. But the works of his later period are painted with much more finish, tone, and atmospheric effect. Latterly, he used little or no body colour, but painted with transparent pigment over a neutral groundwork of chiaroscuro, thus reverting in system to the practice of the early draftsmen, with the advantages of improved materials and modern experience in their use and capabilities. Rapidity of execution was one of the chief characteristics of his work, especially in sketching, when he would seize at once upon the chief points of light, shade, and colour, and commit them quickly to paper. His field kit was of the simplest ; stool, board, colour-box and brushes, being all that he took about with him, or required.

His art being to him alike his profession and recreation, his life affords nothing more to relate except what is connected therewith. His zeal in the interests of the Society has already been referred to. He was elected Treasurer on the 11th of June, 1854, after the death of Mackenzie, and retained that office until 1879, when he retired. He was also one of the Society's trustees from 1861 till his death, which event happened on the 15th of March, 1887, at his residence at Brixton Hill, he having then attained the age of seventy-one.

During the forty-five years of his connexion with the Society he exhibited 681 drawings in the summer exhibitions and 369 frames of 'sketches and studies' in the winter—making a total of 1,050, or, counting the separate small subjects when grouped together in one frame, about 2,000 in all. Many large drawings of Collingwood Smith's were engraved on wood for the *Illustrated London News*, chiefly views among the Italian and Swiss lakes and mountains. His last work was a view of 'Windsor from Datchet,' contributed to the collection of drawings done for the Queen on the occasion of the Jubilee of her Majesty's reign. His remaining works were sold at Christie's on the 3rd and 5th of March, 1888. The sale comprised 355 lots of drawings and sketches by him, and a collection of 67 water-colour drawings by other artists—422 lots in all. According to Redford, the highest prices for his drawings in the sale registers are 102*l.* 18*s.* for the 'Bay of

[1] *Times*, March 21, 1887.

Uri,' in Mrs. Morrison's sale, 1884; and 94*l.* 10*s.* for 'Constantinople
and the Golden Horn,' in the 'Fuller' sale, 1870.

Collingwood Smith received diplomas from various International
Exhibitions. He took no special share in societies unconnected with
his own, but was always ready to promote social gatherings of his
brother artists. He was a Member of the 'Graphic' Society, and a
supporter of the 'Artists and Amateurs' Society while it held its
conversaziones in the gallery at Pall Mall East. On the secession of
that body to the Prince's Hall in Piccadilly, he brought forward a
scheme for a new association, which took shape under his assiduous
guidance as the 'Royal Water-Colour Society Art Club,' more par-
ticularly described in the foregoing general account of the Society.
Collingwood Smith was its Treasurer and an active manager of its
meetings until his death. When in 1857 an annual dinner of the
Water-Colour Society had been proposed, he wrote to the Secretary,
Jenkins : 'I have been for eight years trying to bring about a meet-
ing of this kind, and am glad to find that the arguments of others
have at last (after a space of fifty-three years) determined to carry this
matter out.' He goes on in the same letter (14 November, 1857) to
add : 'My nervous affliction, which generally attacks me before the
30th instant, is giving me its usual warnings.' This must not be
supposed to indicate an infirm state of health, bodily or mental. He
was, indeed, remarkable for the energy and activity of mind which he
displayed up to the very hour of his death. It merely refers to his
anxious solicitude to discharge satisfactorily the duties of his office of
Treasurer. In another letter he contends that Dante's *Inferno* is
'deficient' in not having 'depicted the miseries of a poor wretch
casting up his accounts for the annual meeting.' Ever conscien-
tious in the performance of his duties, he was also a man of generous
impulse and of strong religious feeling.

Two Associates were elected on the 12th of February, 1844, one
of whom was ALFRED DOWNING FRIPP, younger brother of George
A. Fripp. Promotion to the rank of Member followed almost as
quickly as it had in his case. It took place two years after, on the
8th of June, 1846, when the candidate was 'duly elected upon the
first ballot.' He also, after an interval, held the office of Secretary,
which he undertook on Callow's retirement in 1870 and still holds.
He was born at Bristol in 1822, and, like his brother, there fell within

the artistic influence of William J. Müller, to whom he was indebted for his first knowledge of art. He joined George Fripp in London, where the latter was, as we have seen, received into the Society in 1841. Alfred, then only eighteen, employed some of the time until he also was ripe for election, in study at the British Museum and the Royal Academy, and, in 1843 or 1844, laid the foundation of his acquaintance with nature and human nature during a thrice-repeated tour through the West of Ireland with his fellow-artists, F. W. Topham, Mark Anthony, and Frederick Goodall, R.A. When he was elected an Associate, old Secretary Hills expressed to him the pleasure he had had in voting for the two grandsons of his dearest friend, Nicholas Pocock, which he felt would probably be his last acts in the Society ; as, indeed, they were. Hills's name appears again only at the next meeting. Later in the same year J. W. Wright assumed the office of Secretary, and Alfred Fripp became tenant of Hills's vacant rooms in Golden Square. With the above training and practice our artist became qualified to take his place as a figure painter of rustic life, and his deftly painted Irish groups, which had great spirit and character, were a welcome novelty in the Society's gallery. One of ' Irish Reapers meeting their Friends after harvesting in England,' and testifying their joy in an airy dance, was an attractive feature in the exhibition of 1846, during which the artist was elected a Member. Other themes were of a more sentimental nature, and Moore's Melodies were naturally drawn upon for one or two of the motives. With these products of the Emerald Isle were mingled studies of Welsh peasantry, and in 1848 and 1849 a few from the Scotch Highlands.

In 1850, after the death of his first wife, he went to Rome, where he was elected a Member of the British Academy of Arts in 1851. Among his intimate acquaintances there were Frederick Leighton, E. J. Poynter, George Aitchison, G. H. Mason, Penry Williams, Arthur Glennie, and Carl Haag—all names distinguished in the modern history of English art. Italian subjects in that and the following years tell of journeying further south to Naples, Capri, and the Abruzzi, and in 1854 there are several subjects from Venice. The leading motive in all these pictures was generally a figure or group of figures ; but carefully studied landscape was often added, and in a few cases forms the entire subject, as, for instance, in his ' Pompeii— the City of the Dead,' a very large drawing, which had a central place

in the gallery in 1853.[1] Italy had wholly superseded Ireland as the source of his inspiration, for from 1852 to 1858 every subject without exception is from the former country. During the six years in which these drawings were executed, Alfred Fripp continued to reside in Rome. After exhibiting an average of nine or ten drawings since he became a Member, he had only one in 1857, a temporary falling off due to an illness which had confined him to bed for the whole of the previous winter. On his return to England, Italian subjects become again the exception instead of the rule, and he reverts to Welsh and English scenes and incidents of life. In 1862 we have a tendency to seaside subjects, and 'A Dorsetshire Shepherd Boy' indicates an acquaintance with that county, which afterwards ripened during a residence at Blandford from 1865 to 1869, and in constant summer sojourns at Swanage.

Alfred Fripp married again in 1861, and has two sons and two daughters, the latter both married. Upon his election as Secretary he removed from Dorsetshire to London, taking up his residence in Hampstead, being attracted thither by the near neighbourhood of his first and best friend, Edwin W. Field, the Society's solicitor.

In his painting Alfred Fripp eschews the use of body colour. The drawings of the Italian period possess a richness and force of colour ; which is more subdued, though not less harmonious, in his later works, under increased refinement and more elaborate finish, and a successful endeavour to present the delicate greys of mist-laden atmosphere on our native shore. More owing doubtless to the constant calls upon his time in his official capacity and to the pains bestowed on his work than to any relaxation of industry, his productions have been less numerous than in the earlier days. During the ten years preceding the epoch of 1881, his yearly average was little more than three, including the winter exhibition, to which he was but an occasional contributor. At that era his total of exhibits was 122 ; ninety in the summer, and thirty-two in the winter shows. But happily this is not his final record. One of his works, 'The Irish Mother' (exhibited in 1846, and repeated in oils at the British Institution in 1848), was engraved for the artist by the late Francis Holl, R.A. Another, 'Young England,' was well reproduced in chromo-lithography, and published by the Art Union of London as a prize ; the stone being destroyed after 500 impressions had been

[1] It was at the Manchester Jubilee Exhibition, 1887.

taken. One picture by Alfred Fripp, called 'Sad Memories,' with lines from Moore's Melodies, was at the Royal Academy in 1848; and Graves notes two at the British Gallery, and five at Suffolk Street, between 1842 and that year.

It is not merely by the works of his pencil, and the punctual performance of his duties as Secretary, that Mr. Fripp's exertions have been of service both to the Society and to the profession. To him was mainly due the introduction into the former of the seceding members of the 'New Water-Colour' (Topham, Duncan, Dodgson, Jenkins, and Davidson) in 1848 and some following years; the foundation of the new class of Honorary Members in 1873; and the erection of the new entrance-hall with façade and staircase by his friend Cockerell in 1875. In 1872 and for six successive summers he filled with acknowledged credit the responsible office of representative of the London exhibitors with the Arts Committee of the Corporation of Liverpool to arrange their annual Autumn Exhibition; he was officially present at the opening of the noble Art Gallery given to that city by Sir Andrew Barclay Walker; and he has, at the President's request, represented him on the following important occasions :—In 1878 as a member of the committee [1] to arrange the water-colours at the Paris Universal Exhibition ;—in 1884, as one of the hanging committee [2] of a representative Exhibition of Works by Members and Associates of the Society, made at the instance of the Corporation of Liverpool, on the occasion of the adding of a new wing to the Walker Art Gallery, presented by the same munificent donor ; —in 1887, on a similar duty at the Manchester Jubilee Exhibition.

The other Associate elected on the 12th of February, 1844, DOUGLAS MORISON, fills but a small space in the history of the Society. He never became a Member, and exhibited only fifteen works on the walls in the three years following his election. His drawings were of architectural subjects, except two views in Scotland, 'Falls of the Dulnain' and 'Taynault Bridge,' in 1846, which are the last works of his named in the catalogues. He is said to have died young in that or the following year.[3] The date of his birth has not been ascertained, but its place was Tottenham, where his

[1] In association with E. A. Goodall for the Society, and Louis Haghe and J. D. Linton or the Institute.
[2] In conjunction with F. Powell, W. Collingwood, E. A. Goodall, and E. F. Brewtnall.
[3] Redgrave's *Dictionary*.

father was a medical practitioner. The name Douglas Morison indicates a Scottish origin ; but our artist himself was far from being a true child of the mist, as the following incident will show. He was a friendly pupil and frequent companion of Frederick Tayler's, and being on a visit with him at the Highland home of Cluny M'Pherson, a keen deerstalker, was anxious to see something of that sport. Having no idea, however, of the fatigue of a long day's journey over the hills, with no bodily sustenance beyond the biscuit and small flask of whisky which sufficed for his wiry host, he was completely prostrated on his return. So great, indeed, was the shock to his delicate system that, in Tayler's belief, he never entirely recovered from it.[1] Morison had been for a short time a Member of the New Water-Colour Society before he joined the Old. He was elected by the former in 1836, but resigned in 1838 ; he had eight Scotch views there in 1837. Graves also finds six works by him at the Royal Academy between 1836 and 1841.

That Morison's art was acceptable in high ranks of society is indicated not only by the subjects of his water-colour drawings, but in two published volumes of lithographs by his hand. The first, printed by Hullmandel, and published by Graves in 1842, in imperial folio, contains twenty-five *Views in Haddon Hall*, with a title-vignette. These are dedicated to the Duke of Rutland. The drawings (on stone) are dated 1841 and 1842. This work was followed by *Views of the Ducal Palaces and Hunting Seats of Saxe Coburg and Gotha*, published in large folio by Hogarth in 1846, and printed by Hullmandel and Walton. The latter was brought out by subscription under royal patronage. Sketches for it were made by the artist on the spot, the late Prince Consort suggesting the subjects and supplying materials from his library for the letterpress. The dates 1843, 1844, and 1845 are under some of the lithographs, which are twenty in number besides the title, and are on tinted paper heightened with white, after the practice of Harding and Joseph Nash. These prints vary in merit, but show little originality. Some of the tree drawing is curiously mannered in the leafage ; and the figure groups are let in to the landscape in conventional fashion. The earlier series display an unfortunate anachronism, by representing the building in its modern state of picturesque dilapidation, and peopling it with residents of its palmy days. Of the six works exhibited by Morison

[1] J. J. J. MS.

in 1844, five represent royal interiors, four in Buckingham Palace, and one in Windsor Castle, the remaining drawing being of Chatsworth. Of his seven in 1845, five are of Furness Abbey in Lancashire, and two at least are subjects from Derbyshire.

The 10th of February, 1845, added three more Associates to the list, none of whom attained to the rank of Member. One was a second WILLIAM EVANS, known by way of distinction from his Eton namesake as ' Evans of Bristol,' which city was presumably his birthplace, at this time so prolific a feeder of the landscape school ; or otherwise, more familiarly as ' Welsh Evans,' from the range of his earlier subjects. He was born in 1809.[1] His father, who was ' the prompter at the Brunswick Theatre,' was ' killed by the fall of that building, which suddenly gave way and buried a number of persons in the ruins.'[2] Nothing further is recorded of his early life. But a familiarity with North Wales scenery, shown in the drawings he sent to the gallery in the first five years of his Associateship, which are exclusively from that section of the Principality, is said to have been the result of a residence there for many years.[3]

His premature death, which occurred after a long illness, at the age of forty-nine, seems attributable to the life of endurance to which he was there exposed. Mr. Jenkins writes as follows :—' To study the snow effects on the mountains he put up at a wretched little farm called Tin-i-kie[4] near Bettws-y-Coed. When I was in Wales I went to this farm and was shown the hovel of a room in which Evans slept. It was full of holes and open cracks ; swarming with rats, which are said to have continually disturbed him by coursing over his bed in the night. No wonder he set up a chest complaint, from cold and exposure in such a place, which terminated his life.' Except, however, in 1848, when he hails from Harlech, his catalogue addresses are all in London.

In 1850, among Welsh subjects, there are two views at Greenwich ; and the next year his single exhibit is ' Ash Church, Kent.' Then he takes new ground altogether, and with few exceptions his later drawings represent scenes in Italy. Tivoli is the site of some, others are on the lakes, two as far south as Sorrento and Capri,

[1] Messrs. Clement and Hutton, in *Artists of the Nineteenth Century*, give the dates of birth and death erroneously as 1811 and 1859. See advertisement of his death in the *Times,* 18 December, 1858. [2] J. J. J. *ex relatione* T. Danby.
[3] Redgrave. [4] *Sic.* Otherwise perhaps Tyn-y-caicu.

Florence and Genoa supply one each, and there is a view of Heidel-·
berg *en route* in 1857.[1] In 1858 we have a drawing of 'Wastwater
Lake' in Cumberland, which gives colour to a statement by
Mr. Jenkins that Evans accompanied J. B. Pyne to assist him in the
production of his work of 'The Lake Scenery.' There is no
acknowledgment in the book of such aid having been rendered.
Evans's drawings are gay and rich in decorative colour, and agree-
able to the eye without very close suggestion of familiar aspects of
nature. His manner of painting involves much use of the texture
of the paper, and devices of soaking, pumping, and taking out lights
by means of bread, scratches and abrasion. This gave a uniformity
to Evans's works, which savour of mannerism. Some are large in
size ; but he was not a very prolific artist, his contributions to the
gallery numbering no more than forty-five, including two posthumous
exhibits in 1859. Two, 'The little Hypocrite' in 1850, and 'Sabine
Peasant Woman' in 1856, are exceptional, as figure subjects.

Mr. Jenkins writes further :—'I knew him very well, meeting him
often at the house of some musical friends. He played the guitar
well, and halted from time to time between following painting or
music as a profession. He occasionally taught both, now painting,
now the guitar, as disappointment followed the one or the other.'
He died on the 18th of December, 1858, at his residence, 143 Mary-
lebone Road. It is presumed that he was unmarried, as an applica-
tion respecting the drawings he left unexhibited came from a brother.
Twelve of his works were shown at the Royal Water-Colour Society
Art Club on the 30th of March, 1888, nine from the collection of
Dr. Jackman, and three from that of Mr. W. Harding Smith.

The connexion of GEORGE HENRY HARRISON, who was elected
on the same 10th of February, 1845, with our Society, was of even
shorter duration than that of Evans. He died within two years
of his admission, and twenty-two works from his hand, seven of
which were exhibited by permission after his death, were all that
adorned the walls of the gallery. Though he did not live to middle
age, he had already acquired a reputation among his brother artists
for taste and skill so great that ' on his election into the Old Water-
Colour Society, he was congratulated by all as a rising man—certain

[1] Redgrave says that he wintered successively in Genoa, Rome, and Naples. He was in
Rome in 1854. (J. J. J. MSS.)

to become an ornament to his profession.'[1] The class of subjects most characteristic of his fancy were such as Watteau might have selected, involving the combination of figure groups gaily attired and harmoniously disposed both in colour and form with luxuriant foliage. Among his first year's exhibits were 'Sir Roger de Coverley with the Gipsies,' 'A Quiet Afternoon in Kensington Gardens,' 'A Fête at St. Cloud in 1745,' 'Beatrice in the Garden,' and others which afforded scope for such treatment. He also exhibited, according to Graves, fourteen works at the Royal Academy, two at the British Gallery, and eleven at Suffolk Street, between 1840 and 1846.

George Harrison was born in March 1816, at Liverpool, where his parents then resided. His father, originally in the enjoyment of a good income arising from property in land, had the misfortune to incur considerable losses in business—speculations which rendered him incapable of supporting his family of twelve children, whose education fell chiefly to his wife's care, although he himself lived till 1861. It is probable that the father was a man of elegant tastes, and he may have been the 'Mr. Harrison, a merchant' of Liverpool, mentioned in 1809 in the curious little book by William Carey as being possessed of a drawing of 'Melrose Abbey' by 'young Fielding.'[2] It was, however, through the mother that the love of art was more obviously transmitted.

About the year 1830, when the family losses occurred, Mrs. Harrison, who had already cultivated a talent for painting, found an opening in London, where she took part in the formation of the 'New Society of Painters in Water-Colours' in 1831, and became celebrated as a painter of growing flowers, and of fruit and birds' nests, exhibiting works of this class for some forty years in the gallery of that institution, until her death on the 25th of November, 1875, at the age of eighty-seven. Miss Clayton in 'English Female Artists'[3] gives some interesting details of Mrs. Harrison's life and her early precocity in art. Her maiden name was Mary Rossiter, and her father was a hat-maker of Stockport. Care of an invalid mother and sister had left her little time for painting, but, during a honey-moon visit to Paris in the eventful year 1814, she had obtained per-mission to copy pictures in the Louvre, 'being, it is believed, the first English lady who had ever painted there.' Her son George, about

[1] *Art Union*, February 1847.
[2] In the passage before quoted, vol. i. p. 260, *n*. 2. [3] Vol. i. pp. 411-13.

fourteen years of age, came to London at the same time as his mother, with some intention, it is said, of becoming an engraver, but finding some sale for his landscapes among dealers, devoted himself to drawing only. Like his mother, he had already made some acquaintance with nature, during rambles amidst the scenery of Denbighshire.

He was a young man of great energy, and applied himself stead-fastly to the task of his artistic education. He obtained employment in making anatomical drawings and illustrations, and studied anatomy at the Hunterian school then existing in Windmill Street. His only supplement to his self-teaching, besides what he may have learnt from his mother, was due to an acquaintance which he was so for-tunate as to make with John Constable, R.A., who kindly criticized his sketches, explained to him the principles of composition, and exhorted him to persevere in the unremitting study of nature. Beginning, as above noted, to exhibit at the Royal Academy in 1840, and at the Water-Colour Society in 1845, he also gave lessons both in London and Paris, where the family went to reside, and in the neighbourhood whereof most of the exhibited subjects of 1846 and 1847 were studied. The palaces and gardens of St. Cloud and Fontainebleau, peopled as in the days of Henri Quatre or Louis Quinze, were scenes well suited to his special proclivity. In his teaching he remembered Constable's advice, and impressed it on his own pupils by making what is believed to have been the first attempt to lead amateurs to sketch landscape in out-of-door classes, 'an idea,' writes Mr. Jenkins, 'that might be more generally adopted with advantage to pupils.' His plan was to meet on Saturdays during the summer months at a given rendezvous within easy reach of town, and return thither in the evening together. Many pleasant afternoons were so spent, and fellow-artists with their friends would join the party.[1] An advertisement, in the *Art Union* for June 1843, of the coming meetings, runs as follows :—

' *Rendezvous of Mr. Geo. Harrison's Sketching Class for the Ensuing Month.*—On June 3—Putney Bridge ; on June 10—Lewisham Church Yard ;— on June 17—Vale of Health, Hampstead ; on June 24— Dulwich College. At 3 P.M.—punctuality is indispensable. Further particulars may be obtained of Mr. Geo. Harrison, 6 Bowling Green Street, Kennington.' Most of these resorts, alas ! have lost their rural charms in proportion to their greater accessibility.

[1] He formed similar classes in Paris. —*Dictionary of National Biography*.

Our artist was forced by the state of his health to travel abroad, and his short life was terminated on the 20th of October, 1846, by an 'aneurism of the aorta, after long and severe suffering.' He was buried at Kensal Green. 'He will long be regretted,' adds the writer of the obituary notice in the last-mentioned periodical, 'by his friends and relations, as a kind-hearted and amiable man, energetic, and devoted to his profession.'

The art talent of the family did not become extinct on the death of George Harrison. It had also descended upon a brother and two sisters who survived him, and who followed the same profession. The first, William Frederick Harrison, who was the eldest son, painted coast scenery, and exhibited at the Royal Academy, the Dudley Gallery, and elsewhere. He died of the same disease as his brother, on the 3rd of December, 1880. Both the sisters are living. One, Maria Harrison, who paints flowers, was, as we shall soon see, admitted into the Water-Colour Society in her brother's place. The other, Harriet Harrison, also a painter of flowers, is an Honorary Member of the Society of Lady Artists. Another brother is Mr. Robert Harrison, Secretary and Librarian of the London Library.

There is a lithotint by George Harrison of 'Hinchinbrook House, Huntingdonshire,' in vol. 1 of S. C. Hall's *Baronial Halls &c. of England*; and he made for the *Illustrated London News* some drawings of festivities at Buckingham Palace.

The third Associate elected on the 10th of February, 1845, was a draftsman of architectural subjects, by name SAMUEL RAYNER. He exhibited twenty-nine drawings in the gallery in the six years 1845 to 1850. Among them were about nine of abbeys and picturesque buildings in Scotland and the north of England, besides six of Haddon Hall, four in the Midlands (at Kenilworth and Lichfield), one of Salisbury, and two of Knole ; and four foreign subjects, two from Caen and one of Heidelberg. His studies were cleverly handled and agreeable in colour, but obviously based upon the manner of George Cattermole, whose works they sometimes resemble so closely that they may be easily mistaken for his. Rayner was not, however, a direct pupil of that artist. He also did some work for the engravers. In Britton's *Cathedral Antiquities*, there are two plates after his drawings in the illustrations of *Wells* (1824), and in the *Exeter* (1826) three more, besides one drawn by Cotman after a sketch

by S. Rayner. In S. C. Hall's *Baronial Halls &c. of England*, vol. I,
is one lithotint (of ' Retainers' Gallery, Knole') after S. Rayner. He
left the Society in disgrace, after a judgment given on the 6th of
February, 1851, in the Court of Queen's Bench in a case involving a
serious charge of fraud.[1] At a meeting of the Society held on the
10th of February, 1851, for the election of candidates, after the ' atten-
tion of the Society ' had been ' called to his case,' it was unanimously
resolved ' that Mr. Rayner's name be erased from the list of Associates.'
 The date of Rayner's birth has not been ascertained, but he
cannot have been a very young man at the time of his election.
Probably he is the same artist to whom, under the name ' Samuel A.
Rayner,' Graves attributes twenty works at the Royal Academy, four
at the British Institution, and nineteen at Suffolk Street between
1821 and 1872. There was a drawing by S. Rayner at the Dudley
Gallery in 1865 and another in 1871. We shall again meet with his
surname among the lady exhibitors. No less than five daughters of
the ex-Associate followed his profession, and one joined our Society.
' Mrs. Rayner also,' Miss Clayton tells us, ' was distinguished in early
life for her beautiful engravings on black marble, though she has
ceased to create artist work in later years.' [2]

 No further changes took place in the personnel of the Society in
1845 or 1846 beyond what have been mentioned. In the February
of the latter year seven candidates presented themselves, but none
were elected as Associates ; and the only election in February 1847
was that, on the 8th, of MISS MARIA HARRISON, sister of the late
Associate, George Harrison, as a Lady Member. Her parentage has
been already stated. To add that her mother instructed her in the
art of flower painting is to say no more than might be anticipated.
But her training went beyond the narrow practice of the department
to which her professional work has since been confined. She and her
sister were sent, when in London, into Kensington Gardens to draw
from nature ; and when the family went to Paris she took lessons in
chalk drawing,[3] and acquired a general knowledge which enabled her
to give lessons in schools on her return to England. Her contributions

[1] According to the *Times* report, *Roe* v. *Manser* was an action on a promissory note for
2,000*l.* purporting to be drawn by defendant in favour of his daughter, Mrs. Rayner, and
endorsed by the husband, Samuel Rayner, to the plaintiff ; the defendant pleading that the
note was forged. [2] *English Female Artists*, i. 383.
 [3] Miss Clayton says from a ' M. Millais.' (*English Female Artists*, ii. 280.)

to the gallery, which have been constant since her election down to the current year, have all been flower or fruit pieces. In 1881 she had exhibited nearly 300 drawings and sketches in the gallery, and they now amount to more than 400. Since 1862 she has resided at Hampstead.

On the 14th of June, 1847, a new precedent was set in the summer election of an Associate. The addition so made was one more to the strength of the department of fruit, flowers, and still life, already represented by Bartholomew and Miss Harrison, and with exceptional power by William Hunt. WILLIAM F. ROSENBERG, the new Associate, had, it is true, no opportunity of making his *début* in the gallery until the following year ; but in virtue of the date of his election, it will be convenient to deal with him in the present chapter. His works were not, however, confined to the above category. His name of ' Rosenberg ' curiously foreshadowed a change that subsequently took place in his line of art. Beginning with flowers, he ended with mountains. Never more than an Associate, he was from 1848 to 1870 a constant exhibitor, his works numbering 228 in all, whereof 150 were in the summer gatherings. These figures include twenty posthumous exhibits, and number as one each above half a dozen frames, including from two to six separate studies or sketches. To the end of Fielding's time he was constant to a modest range of subjects, which included fruit, dead game and fish, and a few views near Bath. One or two studies of buildings in Wales and Shropshire occur in 1855. In the following year a ' Scene in Glencoe ' leads the way to loftier aspirations, and between 1857 and 1860 we have views in Switzerland as well as the Scotch Highlands. In and after 1861 mountain views in Norway became his common and most characteristic subjects, though with these were associated drawings of the class in which he had first appeared. His treatment of mountain scenery was more remarkable for careful accuracy of detail than for largeness of feeling or pictorial composition. The date of his birth is not recorded. His patronymic implies foreign ancestry, but he himself is believed to have been a native of Bath, where his family resided, and he lived and died, his address in the catalogue changing once, in 1864, from 6 New King Street to 3 Brunswick Place, where he died on the 17th of September, 1869, after a short illness, leaving a widow. He was much engaged in tuition in his native city, which

employment added about 500*l.* a year to his income, a great portion of it being in colleges and schools of the best class. An octavo handbook published in 1853, *The Guide to Flower Painting in Water-Colours*, with illustrations, was the work of his pen. That he interested himself in the promotion of art in his own neighbourhood is shown by letters written in 1854, 1856, and 1863, in which he asks Mr. Jenkins for the loan of drawings to exhibit at the 'Bath Fine Art Society,' which he defines as a 'Graphic Society on a large scale.' That he was of a modest and amiable disposition is apparent in another of 17 April, 1858, wherein he asks, without a trace of irritation, and in a manner strongly contrasting with that of some other similar requests received by the Secretary, whether a drawing of his not hung by the committee had been rejected for want of merit; saying, 'I value the criticisms of brother artists of note *very much* more than any others.' The works remaining at his death were sold at Christie's on the 12th and 14th of February, 1870. They comprised more than 300 drawings and sketches.

Charles Rosenberg, a brother, it is believed, of George F. Rosenberg's, and also a water-colour artist, was the author of *A Critical Guide to the Exhibition of the Royal Academy, 1847* (4to, 1847); and a *Guide to the Exhibition of the Royal Academy and Institution for the Free Exhibition of Modern Art, 1848* (4to, 1848). A sister, Frances Rosenberg, also painted flowers. She married Mr. Harris, a jeweller in Queen Square, Bath.

CHAPTER III

NEW ASSOCIATES; 1848-1849

Biographies—*G. H. Dodson*—*E. Duncan*—*F. W. Topham*—*D. Cox* (junior)—*J. J. Jenkins* —*C. Branwhite*—*Mrs. H. Criddle*—*J. Callow.*

FOR some years the flow of new blood into the body of the Society had somewhat slackened, and the death of Cristall in the previous autumn had deprived it of the last of its original Members, when, in 1848, it received an accession of strength from an unexpected quarter. It has already been related that dissensions arose in the 'New Society' and caused an exodus of some of its best Members. Three of these[1] presented themselves as candidates, and were unanimously elected Associates of the Old Society on the 14th of February.

GEORGE HAYDOCK DODGSON, the first in alphabetical order, was an artist of very sterling quality, whose landscapes possessed in a high degree the charm of beauty. He was a native of Liverpool, where he first saw the light on the 16th of August, 1811. He used to declare, jocosely, that he was 'born in a ditch,' referring to the quarter named 'The Castle Ditch,' where his parents, who belonged to the middle class, resided. From his youth he had looked forward to becoming, some day, an artist, and the desire was doubtless increased on his taking a series of lessons from a local drawing master, Mr. Hunt, father of one of the most distinguished living Members of our Society, Alfred W. Hunt. He was, however, originally intended for a civil engineer, and with that view was, on leaving school in 1827, apprenticed to the celebrated George Stephenson, the pioneer of railway locomotion; and with him he remained until 1835. His practice, when employed on his master's work, had in more than one way an influence on his future career in

[1] Dodgson, Duncan, and Topham. Jenkins and J. Callow, also seceders, were elected in the succeeding two years. Riviere also came thence; but his retirement was rather later.

art, when he determined, as he eventually did, to give up engineering and take to painting as a profession. It chanced that he and three companions were set to prepare plans for the line which now runs between Pickering and Whitby. They had to be ready for delivery without fail by a certain 30th of November,[1] in order to fulfil the legal requirements. To complete these drawings in time the young men were obliged to work night and day; and they sat up without taking off their clothes for a whole fortnight, keeping themselves continuously awake by the aid of opium and strong black coffee. It is believed that an affection of the nerves from which he suffered much in after times was in a great measure due to this severe strain upon them. He, moreover, met with an accident which at least contributed to impair his health throughout life. He had a serious fall in a gymnasium in Liverpool, and thereby broke a blood-vessel. The strength thus shaken and overtaxed was never entirely regained. Not only did he suffer greatly in old age from tic-douloureux, but his hand was always affected with a nervous tremor, which, although apparently under more control when he painted, had doubtless an effect in the peculiarity of his touch. But the exertion which ruined his health gave him at the same time the means of supporting himself in life; for the money he earned thereby was enough to start him in the profession for which he was best qualified. So he determined to devote himself to art, as he did not now feel strong enough to pursue his first calling. After spending some months of sketching in Wales, Cumberland, and Richmond in Yorkshire, he settled in London in 1836, between which year and 1839, when he married, he made sketches in Westminster Abbey, St. Paul's, and other public buildings.

One of his first ventures was connected with the very undertaking which had so injured his health. He furnished a set of pretty sketches which were engraved on steel and wood for a thin royal octavo volume, published in 1836, with the title, ' *Illustrations of the Scenery on the Line of the Whitby and Pickering Railway*, with descriptions by H. Belcher.' We shall see that, late in life, he revisited this district and drew from it the subjects of many of his most characteristic studies. Between 1835 and 1841 Dodgson had nine works in the Suffolk Street and one in the British Gallery. In

[1] The Act for the Whitby and Pickering Railway received the royal assent in May 1833.

his earlier days he was employed upon architectural subjects, for the execution of which his training (like that of old Paul Sandby) as an engineer's draftsman, together with a very refined eye for colour, eminently qualified him. There exist some beautiful drawings of St. Paul's Cathedral and Greenwich Hospital, in which the tender harmonies of grey in the stonework are treated by him with consummate delicacy ; and he painted a most elaborate view of St. Paul's from the south end of Blackfriars Bridge, now in the Walker Art Gallery, Liverpool. A large group of Wren's principal buildings composed by the late C. R. Cockerell, R.A., which was exhibited at the Royal Academy in 1838, and engraved, was chiefly coloured by Dodgson.[1]

It was in 1842 that he joined the New Water-Colour Society, by which time he had become more addicted to pure landscape. He was elected a full Member thereof in 1844, and resigned in 1847. Between the date of his marriage and 1846 his time seems to have been occupied in drawing on wood and stone, and making small water-colour drawings for exhibition. After this he made some larger ones, as 'A Village Fair,' and two others exhibited in 1847 called 'Sweet Summer Time' and 'Going to the Chase.' Altogether he had forty-five drawings in the gallery of the New Society from 1842 to 1847. Other designs for engraving were made by him at this time. Among them were those for seven of the plates at the head of the *Cambridge Almanack*, between the years 1840 and 1847 ; and many drawings for woodcuts in the *Illustrated London News* and other publications. A vignette to *Old English Ballads*, published by Ward & Lock, small 4to, 1846, though unsigned, has the apparent marks of his style. 'Summer Time' has been chromo-lithographed (9¼ x 11¼ in.) by G. Rowney & Co.

His reception into the Old Society on the 14th of February, 1848, was followed four years afterwards by his election as a Member, on the 14th of June, 1852. The architectural drawings in which he had shown such exceptional quality supplied a very small part of the matter which rendered his works attractive at the Water-Colour Society. If we except divers views of Richmond Castle and Whitby Abbey exhibited in and after the years 1862 and 1863, and two or three drawings sent late in life to the winter shows, most of which partook largely of the nature of landscape, and some dim interiors

[1] Burlington Fine Arts Club Catalogue, *Exhibition of Drawings of Architectural Subjects,* 1884, No. 47.

II.

treated more for their effects of chiaroscuro than for their ornamental
detail or proportions, the only adequate representative of his power
in this respect was a remarkable view of 'Ludgate Hill' exhibited in
1870-71. From 1848, when he joined the Society, to about 1860, his
catalogued works are for the most part of general subjects of the
landscape class. These are roughly divisible into two equally
characteristic classes, corresponding to the moods of his mind, as
alternately swayed towards *l'allegro* and *il pensieroso*. In the first
we have garden scenes, with gay figures and green umbrageous foliage
in warmest sunshine. Of summer days, that here enjoy an undisputed
reign, the artist seems to have made a special study ; for, accom-
panying his works, the catalogue abounds in such titles as : 'Summer
Time,' or 'Summer Shade,' or 'Summer Morning, Noon, Evening,
and Night,' as the case may be. More specific names are : 'Sunshine
Holiday,' or 'Sunny Hours,' 'A Music Party,' or 'A Fête Champêtre,'
'A Village Fair,' or 'Going to the Chase.' Views of the far-famed
terrace at Haddon, interspersed throughout the whole period of his
Membership, belong to the same category. Of the graver class the
subjects are mostly evening or twilight scenes, or strong effects of
artificial light. Such are : 'The Vesper Bell,' 'Interior—Evening,' and
'Preaching in the Crypt,' or 'Gipsies—Twilight,' 'The Beacon,' and
'The Village Smithy.' To these may be added the somewhat
depressing theme 'A London Fog' (1851), and later on (1863) a
poetic rendering of the subject of Hood's weird lines, 'The Haunted
House.' A few, allied to the gayer scenes, some of which afforded
scope also to the latter kind of pictorial treatment, were : 'A Christmas
Morning' (1848) ; 'Return from a Christmas Party' (1851), and
'Christmas Revels at Haddon—Bringing in the Yule Log' (1860).

After this period, although general motives of all the above kinds,
together with occasional studies of atmospheric effects, as 'A Showery
Day,' 'A Storm in the Hills' (1863), 'Grey-hooded Even' (1871),
and 'The Harvest Moon' (1880), continue to the end, his drawings,
if not topographical in the drier sense, become more definite as to
places whence the artist derived immediate inspiration. These can
be classed according to their several districts, thus :—Some sparkling
views on the Thames begin in 1860, come thickly in 1861 and 1862,
and afterwards at intervals. Studies of woodland scenery among the
fine beech trees in Knole Park become from 1863 a most charac-
teristic group of his works, particularly in the winter exhibitions.

Whitby with its neighbourhood, the scene of his early illustrations, is reverted to in 1863, and becomes, from 1866, a nearly constant sketching ground. Beginning with views of the old Abbey in 1863, 1866, and 1867, he at the same time showed, in the winter exhibition of 1865-6, the first of a series of charming studies, of great force and graceful composition, made among the leafy Yorkshire becks of the district at Larpool, and here and after 1872 the moorland dale of Goathland. Very distinct in feeling from these, but from the same district, are a number of coast studies on Whitby scaur, beginning with the winter exhibition of 1867–8, and becoming from that time his most noteworthy works. In these he showed a unique power of dealing with blinding effects of storm-driven spray, as well as a keen appreciation of the depth and richness of colour in the dark cliffs of this rough bit of coast. In the last half-dozen years of his life, a period beginning with 1875, he supplemented these maritime views with a further set from the picturesque seaboard of the Gower district of Glamorganshire. In these the mind is once more in the *allegro* mood, revelling in the bright hues of noonday sunshine on a southern shore.

Thus the works of Dodgson, though much varied in scope, and sometimes rising to the importance of pictures with human interest and motive, and though always animated by a spirit that is truly artistic, and always complete in pictorial arrangement, were yet limited in range, in so far as they never, or rarely, extended to a distant horizon, or embraced a width of landscape such as those of Fielding and Cox, and other of his contemporaries. But Dodgson never crossed the borders of England ; and moreover the delicate handling demanded by a far perspective may have been beyond his physical power. His skill in landscape composition and breadth of chiaroscuro are evinced in a number of charcoal studies, one or more of which he sent to the winter exhibitions.

His manipulation in water-colour was peculiar ; arising probably in some degree from the unsteadiness of his hand. He used powerful colours, including vermilion and emerald green, spotting them separately upon the paper, whereon he sometimes worked when it was in a very wet state, and in some marvellous way produced a richness of broken tints without losing purity.

After his death, which event, arising from congestion of the lungs, occurred on the 4th of June, 1880, his memory as an artist

was specially honoured by the Society in the exhibition of the following winter, when a representative loan collection of his works, to the number of fifty-two, was gathered together and shown upon screens in the centre of the room. His remaining works were sold at Christie's on 25 March, 1881. The highest price recorded for a work of his in a public sale is 145*l.* for a 'Fête Champêtre' sold by E. Duncan's executors in 1883.

Dodgson resided near the Regent's Park during the greater part of his time, from 1850 for ten years at 18 Mornington Road, and from 1860 for about twenty at 1 St. Mark's Crescent, Gloucester Road after which he moved, shortly before his death, to 28 Clifton Hill, St. John's Wood, where he died. He left surviving, a widow, two daughters, and a son, who is also a professional artist.

EDWARD DUNCAN, chiefly celebrated as a marine painter, was another of the seceders from the younger Society, and elected unanimously on the 14th of February, 1848. For thirty-four years, during which he never missed an exhibition, his works were conspicuous on the walls at Pall Mall East. They number in all 225 separate exhibits, 172 in the summer and 53 in the winter shows, to which may be added about a dozen sketches shown with others in a frame. In the above are included twenty-three posthumous exhibits in the winter of 1882-83.

Duncan was born in Frederick Street, Hampstead Road, London, on the 20th of October, 1803. 'From childhood,' writes Jenkins, 'he seems to have had a pencil constantly in his hand. I have seen drawings executed by him at the early age of eleven years, which foreshadow his precision and careful work of later years. At first the boy seemed destined to become an architect, and Charles Wild,' the Member of our Society, 'was consulted by his parents' on the subject of his profession. 'But in the end he was bound to one of the Havells to become an engraver.'[1] According to Duncan's own statement to Mr. Jenkins, it was Robert Havell, the aquatint engraver, who lived in the house in Newman Street which became known afterwards as Leigh's Academy of Art, and has been conducted since Leigh's death by Mr. Heatherley. There were two Robert Havells, father and son, under both of whom Duncan served as an apprentice. In their house above mentioned there hung for many years the

' J. J. J. MS.

picture called 'Walnut Gathering,' referred to early in these pages [1] as an important work by their distinguished relative, William Havell, one of the first Members of our Society and leaders of the British school of landscape. This and others of that artist's works Duncan had frequent opportunities of seeing and occasionally of copying. These produced a strong impression on his mind, which took deeper root as his years increased. His first practice, however, on his own account, was as an engraver, like his master, in the aquatint style. In that capacity he was employed in the representation of stage coach incidents for Fores of Piccadilly, the publisher of sporting prints, and in various kinds of work, some of which had little or nothing of an artistic character. Yet it was in the course of this miscellaneous occupation that he acquired the knowledge which finally determined the line of art wherein he made his name. First and foremost, he derived the acquaintance with shipping and nautical matters that he afterwards displayed as a marine painter, which was full and accurate, not at all from a 'life on the ocean wave,' like that of Chambers. There was really nothing of the sailor about Duncan. The 'rolling deep' was never his home.' What he knew of these matters he mostly [2] picked up ashore in the society of sea-captains and the like, into which he was thrown as engraver of the sea-pieces of William Huggins, before mentioned as marine painter to King William the Fourth. Many of his pictures are said to have been aquatinted by Edward Duncan. His connexion with Huggins was of yet more enduring character, for in the course of time he led the daughter of that painter to the hymeneal altar.

There was yet another example of Duncan's power of retaining and turning to account his casual information. In these days, when he undertook whatever work might come to his hand, he was a good deal engaged in drawing, for the purposes of illustration, the fat cattle exhibited at agricultural shows. Therefrom he gained a knowledge of such stock and their recognized points of merit, which might have enabled him to pass muster as a breeder of sheep and oxen, and actually furnished him with the means of excelling, as he also did, as a painter of bucolic scenes. For some years he continued to exercise his profession as an engraver, 'halting between the necessity of living, and inclination to devote his time to painting.' [3] The yearning at

[1] *Supra*, vol. i. p. 296.
[2] About 1840 he made a little voyage to the Zuyder Zee in a Dutch schuit from Billingsgate wharf. [3] J J. J.

length was too strong to resist, and he yielded thereto after having duly qualified himself for the higher pursuit by careful and earnest study of nature.

He began to exhibit his pictures in the London galleries in 1830. Graves finds, from that year to 1879, seven at the Royal Academy, thirteen at the British Institution, and twelve at Suffolk Street. Although he earned a fair success at the New Society of Painters in Water-Colours, where he was chosen as a Member in 1834, and exhibited an average of about thirteen drawings a year there from 1835 to 1847, he was still greatly dependent upon his engraved work.[1] In 1847 he retired from the New Society, and in the following year, as we have seen, joined the parent body. This was followed by election as Member on the 11th of June, 1849.

Most of the drawings exhibited by Duncan, particularly the larger ones, represented subjects or incidents associated with the sea. His line of art differed essentially from that of the old marine painters who made portraits of men-of-war and depicted naval engagements, or even those who confined themselves to the merchant service, and whose big East Indiamen in full sail walked the waters life-like in their water-colour drawings. In his long list of contributions to the gallery only three or four views are to be found (in 1855 to 1857) at Portsmouth and Spithead, painted just after the close of the naval war with Russia, when portraits of her Majesty's ships were in special demand, that seem to connect themselves with the old school. Three small historical sketches in the winter show of 1864-5 of royal 'progresses' by Henry VIII., Charles II., and Queen Victoria respectively, are also quite exceptional.[2] It was with vessels of the commercial class that Duncan concerned himself most, and landsman as he was, his marine painting has generally more reference to the land than to the sea. He did not depict the waves with the same obvious love of the clear blue depths of ocean or the glitter of the salt spray with which they are represented by some of our living artists. Like the lady passenger on a coasting voyage described by

[1] To this period belong the following prints: 'Off the Foreland. The Schooner Ellen Gillman,' lithographed by E. Duncan after Huggins, 1840. 'Florence, or the Sutherland Family,' engraved by H. Rolls in the *Forget-me-not*, 1841. There are also at the British Museum, 'Partridge Shooting' and 'Pheasant Shooting' (both $6\frac{3}{4}$ x $10\frac{1}{4}$ inches), drawn and elaborately aquatinted by E. Duncan; and a small etching by him of a boat converted into a house.

[2] He, however, painted in oils, for Lord Dufferin, a large picture of the capture of the French ship *Guillaume Tell*, over which he spent six months.

Thomas Hood, he seems more at his ease in the shallower water, where the ship with its living freight has some chance of 'going ashore.' Yet he revels in rough and breezy weather, and his most successful works are representations of wrecks and lifeboat manoeuvres, and rescues with the rocket line. It is not the mere interest in navigation that gives zest to his work, but rather the sense of danger that excites, and gives a human interest to the scene. Seafaring pursuits conducted near the coast, and industrial occupations upon the shore itself, were among the most favourite subjects of his pencil. Oyster dredging, crab catchers, shrimpers, and the like, afforded such material ; but the most characteristic are those which involved the introduction of many figures similarly employed, as in gathering maritime produce, such as mussels, seaweed, or fragments of wreckage. The landing of fish, cattle, or sheep, are subjects of the same class, which he treated with success. The localities where Duncan found scenes and objects of this kind were exclusively on the British coasts, those which belong more to the sea being studied about the mouth of the Thames and in the Downs, northward along the east coast of Suffolk,[1] and sometimes, but more rarely, as far as, and even across, the Scottish border. The Bristol Channel supplied more studies of trading craft ; and for the shore subjects the neighbourhood of Swansea was his constant, and latterly quite his most favoured resort. In 1854 and 1855, and not unfrequently afterwards, he had a series of effective drawings of the picturesque Vraick, or seaweed harvest on the coast of Guernsey, and other of the Channel Islands were laid under contribution for wrecking subjects and scenes in troubled waters.

A contrast to the above are a large number of inland scenes, which he painted with equally characteristic care and skill. Most of the agricultural subjects relate to the tending or pasture of sheep. Besides these he painted many views of quiet Thames scenery, beginning about the year 1861, in some of which he introduced figures engaged in rush-cutting and other industries. With these exceptions, merely local landscape formed but a small part of his œuvre ; but interspersed among the exhibitions were views in North as well as South Wales, and in the Home Counties, and elsewhere in widely scattered spots in England, with a few in Scotland about the Edinburgh district, and even as far as Ross-shire and the Isle of

[1] Several from Yarmouth and Lowestoft are in 1851.

Skye.[1] In winter 1866–67 there was a series at Stratford-on-Avon of subjects connected with the life of Shakspere.

Even after joining the Water-Colour Society, Duncan did not for some years at least sever his connexion with the press. Many drawings of his were engraved on wood in the *Illustrated London News*, which had been started in 1843. For example, in 1850 (27 July), is 'Lowestoft Regatta,' and (17 August) 'Sniggling for Eels ;' and among the sketches sold as remainders after his death · there were : 'Transept of the Exhibition of 1851, looking South,' 'On Christmas Eve,' 'A Christmas Dinner,' and 'The Fleet in the Solent, 1854,' all reproduced in that journal.[2] In many cases he was fortunate in having the co-operation of the engraver Linton, who had a special knack of translating his work. In 1853 a treatise on *Modern Husbandry*, written by his friend George H. Andrews, was published by Ingram, Cooke & Co. with illustrations by Duncan. The following are also works for which he is stated [3] to have drawn on wood : *Favourite Modern Ballads*, *Favourite English Poems*, *Rhymes and Roundelayes*, *Poetry and Pictures from Thomas Moore*, *The Soldier's Dream*, *Lays of the Holy Land*, and Bohn's edition of Southey's *Life of Nelson*. His picture of 'The Lifeboat' was engraved and published by the *Art Union*. There have also been reproductions of his works in colour. He is among the artists of whose drawings there are facsimiles in ' the *Art Album*,' 4to, 1861 ; and sixteen of his sketches in water-colour have been chromo-lithographed by G. Rowney & Co. To the same class belong his illustrations to the following 4to volumes of ' Vere Foster's Water-Colour Drawing-Books,' viz.: *British Landscape and Coast Scenery* (eight facsimiles), *Marine Painting* (*Advanced*) (eight facsimiles) ; and *Simple Lessons in Marine Painting*.

Though Duncan, writes Jenkins, 'produced a greater number of drawings than most men, they all bear evidence of the artist's conscious care.' The 'strict drawing, tasteful arrangement, and careful finish,' which rendered his works so popular, were the outcome of a mind that was singularly well ordered. Though his life was unusually busy, he was never known to be in a hurry. Thus he found ample time and leisure to do his best in everything. There are no signs of haste in the composition of his drawings, all the

[1] In Winter Exhibition, 1868–9, &c.
[2] Also a sketch in pen and ink, ' Il Penseroso,' for the *Art Union*.
[3] In Bohn's edition of Chatto's *Treatise on Wood Engraving*, 1861.

details whereof are thoroughly worked out.[1] 'I do not like,' he once wrote to Jenkins, 'the scene-painting style of . . . and . . ., and I hope that will be the general feeling, as that style of art is not likely to improve the character of the Society if we have too much of it on the walls.'

The further events of Duncan's life are mainly connected with his professional work, so far at least as it directed his movements and determined his places of resort from year to year. A series of his letters, preserved by Mr. Jenkins, for whom, alike in their general tone and in particular expressions, they bear evidence of warm respect as well as long and intimate friendship, fill in some of the domestic details of his career, and harmonize with other evidence of the affection with which he was regarded by his family and an attached circle of acquaintance. They tell us of home events both grave and gay, his daughters' marriages and a son's bereavement; of annual Christmas gatherings at his house, of pleasant suppers of the 'Chalcographic Society;'[2] and, from 1855, of his sketching ashore

[1] J. J. J. MSS.

[2] The 'Chalcographic,' which numbered among its members several artists well known in our Society, in or after Fielding's time, originated, as the name implies, in a different though allied branch of the artist profession. Its birth was nearly coeval with that of the first Water-Colour Society. It is believed to have been founded in commemoration of the result of an action at law, which was considered beneficial to the interests of engravers. Delatre v. Copley, tried before Lord Kenyon in the Court of King's Bench on 2 July, 1801, had for its subject a claim by the plaintiff to the payment of a sum (800l.) agreed upon for making a copy of Bartolozzi's engraving of defendant's picture of the 'Death of Chatham,' now in the National Gallery. The task had been three years in hand, and part payment made; but Copley refused the balance (580l.) on the ground that the copy was a bad one, particularly in the likenesses. It was considered to a great extent a professional contest of rights between painters and engravers. Bartolozzi, Nagle, Landseer and Smith were among the witnesses for the plaintiff; while West, P.R.A., Beechey, Bourgeois, Opie and Hoppner gave evidence for the defendant. The Attorney-General was on the one side, and Erskine on the other; and the verdict was for the plaintiff. (See Williams's *Life of Lawrence*, i. 210-213. The writer, however, states on p. 333 that Sir John Leicester was the originator of the 'Chalcographic Society' in 1810.) It was apparently as a league for the defence of professional rights that the founders were first united; but, whatever steps they may have taken with that object in early times, the society had, by the end of Duncan's day, become no more than a sociable club, comprising members whose connexion with graphic was, like his, at least as strong as with chalcographic art. The following account of the society is given in Buss's *Almanack of the Fine Arts*, 1852, pp. 154, 155: 'The object of this association is to hold a series of friendly meetings amongst the Professors in the art of Engraving. It has existed for nearly 50 years, and has numbered on its list all the most distinguished members of the English School of Engravers during that period. By means of these friendly meetings, which are held in succession at the residences of the different members, an intercourse is kept up amongst the engravers in various styles of art— any technical improvement is canvassed as to its utility, proofs of plates in progress are exhibited, and criticism courted; meritorious works by continental engravers examined, and choice states of etchings, or of plates by the ancient engravers, are brought to contribute to

and afloat near the Mumbles and on the coast of Gower, whither he
is always trying to induce his artist friends to come and join him
and share in contemplation of the beauties of nature around him.
They tell of him at Hastings in August 1858, not sketching, but
making 'pot-boilers.' He has been there a fortnight with Whitaker,
and is about to accompany Leitch to Penygwrhyd. In the following
summer he and Mr. Gooden (now Mr. Gooden-Chisholm) took a
memorable trip up the Thames in Andrews's boat. There they made
many sketches themselves, and encountered Dodgson, George Fripp,
Edwin Field, and others, similarly employed. From May to mid-
July 1861 he is in Scotland. In 1865, apparently for the only time
in his life, he went abroad, and spent a few weeks in Italy, visiting
Venice, Rome, and Naples; but there is no trace of this journey in
the subjects of his exhibited works. In August he is at Port Madoc
with Topham and Field, and writes that he is changing his London
quarters. This was only the second removal since he had become an
Associate, when he lived in Mornington Place. The first was in
1858–59 to 10 Oakley Villas, Adelaide Road, and his new and last
residence was at 18 Upper Park Road, Haverstock Hill. All these
were on or near the road to Hampstead.

His letters from this time continue to describe him as frequenting
his accustomed summer haunts, the Mumbles in particular, and en-
joying his social surroundings when at home. The Christmas party
of 1871 includes George Cruikshank the caricaturist in its circle of
old friends. In 1874 he had the satisfaction to see his son Walter
admitted an Associate of the Society. The next year he is up the

the interest of the evening. An interchange of ideas such as must result from these meetings
cannot fail to add to the knowledge of the members, and to assist them in their laborious and
refined studies upon copper or steel; besides the pleasure which is always felt at meeting
with, and numbering amongst one's friends, a man of talent in any branch of Art. By its
rules visitors are admissible to the meetings. Nothing is allowed to be placed on the supper
table but bread and cheese and salad, with ale or porter, consequently the members become
great connoisseurs in Parmesan, Gruyère, Stilton, Cheshire, Cream, Neufchatel, Shabzigo, (sic)
choice cheeses, and lobster salads. Burton ale, Guinness's stout, and other favourite com-
pounds of malt and hops, keep close to the law, only construing it in its most liberal sense.
The meetings are held on the first Friday of every month. Amongst its present members are
the names of T. S. Agar, J. H. Robinson, S. Cousins, E. Goodall, F. Bacon, W. Finden,
G. R. Ward, E. Duncan, &c. &c.' To the names of the above engravers may be added those
of William Holl and T. O. Barlow, R.A. In later times the suppers were less strictly
limited. Nor were the members solely confined to professional artists. Mr. John Paget,
lately police magistrate, who is an excellent amateur draftsman, was a member, and the
most genial of hosts. It is only very recently that these festive meetings have become things
of the past. Both this society and the 'Graphic' have (alas!) expired while this history has
been in course of compilation.

Thames, 'steamed by Jackson to Oxford, and to do sketching on the way.' But we have references now (which was not so before) to his state of health, and the inroads of time on his constitution ; and these become more frequent as the years advance. In 1875 he begins to complain of rheumatism. On the 16th of September, 1881, he writes from 4 Southend Villas, Mumbles : 'The weather here is glorious, but I have not been sketching from nature. I find I am not up to the mark for such work. Rheumatism, and very shaky legs, bunions and foggy eyesight, take all the sketching pluck out of one ; and Nature, who is no flatterer, tells me that I am now only an old Hulk and must be very quiet and content at my moorings, and feel thankful that my timbers are in fair condition and may last for some time yet if I am careful. So I have not been killing myself with hard work or with caricaturing Nature, but have been looking at and enjoying the beautiful and ever changing effects that I have seen daily from my window. I hope to retain the impressions for my winter work.' In less than a fortnight, however (28 September, 1881), he writes from ' Mr. Morgan's, Pitt Farm, Oxwich, Gower,' that he is ' able to work out of doors and get some sketching in Penrice Park, a very beautiful spot. . . . I am up at seven while here, this morning at 6.30, and I feel better for such early rising.' At home in October after two months of what he calls ' holidays,' he is off to Leicester to stay with his friends the Pagets, and on 3 November is ' back to London fog.' On 29 January, 1882, ' the foggy weather has quite upset me. I have felt very queer all this last week.' The subsequent letters are from one of his sons, reporting fluctuations in his state, through February and March. But in April there comes a deadly wind from the east. On the 9th a ' Chalcographic' meeting at Mr. Paget's is put off on account of Duncan's illness, and on the evening of the 11th, ' cheerful and resigned,' he breathes his last.

Though ' poor Duncan,' wrote one of his associates to Mr. Jenkins, immediately after our artist's death, ' lived to a very advanced age,' he ' *enjoyed* his life up to within a short period of his death ; for his two great enjoyments were the practice of his art and the society of his friends, and I am not aware that these have scarcely suffered any interruption during his long life . . . he was such an amiable man, so genial, kind and hospitable.' Jenkins himself wrote of his friend in the following warm terms of admiration : ' Mr. Duncan in himself eminently represented one of the finest types of English character.

Blest with great talents, a happy disposition, and a vigorous constitu-
tion, he worked hard because he loved his work and his art for its
own sake. Scrupulously upright, genial, hospitable, and very generous,
he drew around him an attached circle of devoted friends who have
rarely had to deplore the loss of a more estimable or valued life.'
To this tribute of praise may be added the testimony of Mr. Andrews,
who wrote at the time of his own election into the Society in 1856,
to Mr. Jenkins (then Secretary), as follows : ' It is to Mr. Duncan
that I owe everything, for he has over twenty years treated me with
undeviating kindness and given me most freely every information
that he could to enable me to progress in art. Without that valuable
help I never could have done anything in it. The great advantage
of an acquaintance with artists I owe to the same source, for I never
in my life had, nor have I ever required, any other introduction than
the simple statement that I was a " friend of Duncan's," that seemed
always a full and sufficient reason that I was to be treated with
respect and consideration.'

It is pleasant to be able to add that in his later years he made a
handsome income by the disposal of his works, although the sums he
received for them were greatly surpassed by what they have realized
in public sales. A drawing exhibited at the New Society's, entitled
' The Last Man from the Wreck,' for which he charged 160 guineas,[1]
was bought for 504*l.* at the ' Parker ' sale at Christie's in 1875 ; and
the ' Lifeboat going out' (20 × 39 inches) realized 483*l.* at the
' Brooks ' sale in 1879.[2] Two separate sales, each of Duncan's
' remaining works,' took place at Christie's after his death. The *first*,
on the 9th, 10th, and 12th of March, 1883, comprised 496 water-
colour drawings, thirteen oil pictures, eighty pencil, pen and sepia
studies and sketches, and forty albums of scraps, &c., all from the
artist's hand ; and with these were sold eighty-three works by other
artists which he had collected. The *second*, on the 11th, 12th, and
13th of March, 1885, comprised 280 water-colour drawings and
sketches, twenty-four oil pictures, ninety-one pencil, pen and sepia
studies and sketches, and eighty-six albums of scraps &c. by Duncan ;
with 145 works by other hands. Two of Duncan's sons are artists,
one of them, as before mentioned, an Associate of the Royal Water-
Colour Society.

There was a third seceder from the ' New Water-Colour,' who

[1] J. J. J. MSS. [2] Redford's *Art Sales.*

found a home in the 'Old Society' on St. Valentine's Day, 1848; a popular and attractive painter of figure subjects and studies, whose art was of a gayer sort than that which has just been described. FRANCIS WILLIAM TOPHAM was for thirty years a contributor to the gallery; his most noteworthy drawings being those which portrayed in bright hues a certain type of beauty common to Spain and to the West of Ireland. He was himself a Yorkshireman, born at Leeds on the 15th of April, 1808. Like his comrade Duncan, he began professional life as an engraver. But his training was of a more mechanical kind. Articled to an uncle, who was a writing engraver, his 'prentice hand was exercised in carving names and monograms for cards and billheads, and on spoons and coffin plates; and it was quite a treat to him to have to execute a few extra flourishes for the business card or invoice form of a Chinaman or a tea dealer, with perhaps the insignia of his trade. When Topham had acquired due proficiency in this kind of work, he came to London, about the year 1830, and made a step in advance by engraving coats-of-arms. If a precedent were needed for this, there was a good old one in the early heraldic employment of William Hogarth. Then he obtained an engagement with Messrs. Fenner & Sears, who had recently erected a large building to carry on an extensive business as engravers and publishers. Here he undertook to execute, under the direction of a professional line engraver,[1] a landscape plate of a view in the South Seas. But the task proved somewhat beyond his strength. Fortunately for him, however, another engraver, Tombleson by name, 'whose ready mode of doing his work found more favour with the establishment,' was substituted as his director while the plate was in progress, and not only finished it for him, but gave young Topham some friendly aid in his endeavours to become an artist. Shortly afterwards he made what was perhaps his first professional design. It was for a label required by Messrs. Kirby & Co., the great pin manufacturers, which was entrusted to his employer's firm to be executed, and was duly engraved. Thence he advanced to more artistic work, and after a time did plates for the pocket-books which, as we have seen, used to afford scope for artistic talent of no mean order.[2]

[1] Believed to have been T. Engleheart, eldest son of Francis Engleheart, who engraved after Wilkie and Smirke.

[2] See account of Pye's plates after Havell and Prout, *supra*, vol. i. pp. 296, 297, 481.

At this time he also became acquainted with one Henry Beckwith,[1] an engraver, who worked for the same house, and happened to be employed on a plate from a subject by 'Hancock.' This led to Topham's obtaining a picture from that painter which he undertook to engrave for Alaric Watts, the editor of the *Literary Souvenir*. After working day and night on the plate, he was, however, unable to agree with that gentleman as to terms, and sold the plate to the rival editor, S. C. Hall, for some of whose publications he was afterwards occasionally employed to design as well as to engrave. Further and more permanent results accrued from an application to Virtue the publisher, who gave him a drawing by Bartlett to translate on copper, and continued to employ him in similar work until he left off engraving entirely. It was while he was thus pursuing the laborious profession of a line engraver, that he entered upon matrimonial life. He married a sister of his friend Beckwith.

No complete list can be given of the plates which he engraved. Some are after the landscapes of T. Allom, as well as Bartlett's. Three of his own illustrations to the Waverley Novels, hereinafter mentioned, are among them, as well as two plates, included in Fisher's *Drawing-Room Scrap-Book*, called 'The Robber's Deathbed,' dated 1843, and 'The Shipwreck,' a vignette dated 1850; of which the former at least is from his own design. In Tattersall's *Lakes of England* there are fourteen illustrations etched by him. Topham's connexion with chalcographic art did not cease with his exchange of the burin for the brush. He supplied designs for the Annuals and other book illustrations, and he drew on the wood for divers publications. The following is an imperfect list of his engraved works not already referred to:—In S. C. Hall's *Book of Gems* (about 1838), frontispiece.—In Fearnside & Harral's *History of London*, some of the illustrations.—In Fisher's *Drawing-Room Scrap-Book*, 1839, 'Prince Charles Edward bidding adieu to his Friends;' 1841, 'The Lady's Sorrow;' 1843, 'The Robber's Deathbed,' engraved by him. Among the illustrations of the *Waverley Novels*, published by Fisher, there are: To *Peveril of the Peak*, 'Holm-Peel Castle, Fenella and Julian Peveril;'[2]—*Red Gauntlet*, 'Prince Charles Edward taking leave of his Adherents;'—*The Betrothed*, 'He is gone for ever;'—*The*

[1] There is a small 8vo volume called *The Angler's Souvenir*, by P. Fisher (a pseudonym of W. A. Chatto), published in 1835, which contains vignette plates and woodcut borders by 'Beckwith' and Topham.

[2] Also engraved by Topham.

Highland Widow, ' Hamish Bean and his Mother ; '—*The Talisman*, ' Sir Kenneth and the Baron of Gilsland ; '[1]—*Anne of Geierstein*, ' Anne of Geierstein and Arthur Philipson ; '—*Count Robert of Paris*, ' Bertha at the Camp of the Crusaders ; '[1].—*The Surgeon's Daughter*, ' Zilia de Monçada and her Father.' The above are line engravings. He also drew on wood for Mrs. S. C. Hall's *Midsummer Eve* ; T. Moore's *Melodies and Poems* ; Burns's *Poems* ; Dickens's *A Child's History of England*, frontispiece ; *The Book of Ballads* and the *Illustrated London News*.

Thus before he ceased to engrave he had also taken to original drawing. His education as a painter appears to have been picked up for himself, partly by study from nature, and partly at the Artists' Society in Clipstone Street, which he is understood to have joined shortly after the events above recorded. The following account of this ' Academy,' as it was called, is taken from a draft, found among Mr. Jenkins's papers, written by him for the information of Mr. N. Neal Solly, for his *Life of Müller* :—' About the year 1823-4 a few artists, with Mr. S. P. Knight as their chief, banded themselves together into a little society for the systematic study of veritable rustic figures from the life. The idea was novel in its leading feature, that of pressing into their service models drawn from the wandering tribes of sturdy beggars, ballad singers, gipsies, pifferari, Italian boys, street musicians, and tramps of every caste, worn, travel-stained, and often picturesque in rags, who throng our public ways. It was an attempt to return to the Dutch-like truth in its severest realism, as a corrective and antidote to the artificial and conventional manner which the painters generally had fallen into of dressing up their figures representing humble life. This society commenced with the modest number of eight or nine members, who met in a rough room down a stable-yard in Gray's Inn Lane. Each in turn had to catch his model from the streets and arrange the figure for a given number of nights, and many were the amusing tales told of the trials and difficulties experienced, and the tact required to make these vagabond wayfarers comprehend the novelty of the situation, for which they were offered to be well paid for " sitting still and doing nothing " for a couple of hours on three evenings of the week. The plan of study, however, prospered and soon became popular ; applications for admission outgrew the means of accommodation, till eventually the

[1] These are also engraved by Topham.

members removed to spacious rooms in Clipstone Street,[1] Fitzroy Square, further enlarged their numbers, added costumes, collected books, and introduced lectures on anatomy and cognate subjects applicable to the fine arts. With the termination of the lease of these premises, the society made a third remove to rooms built for them in Langham Chambers, which they now occupy. . . . In addition to the ordinary routine of study, the members once a week held an evening meeting for sketching an improvised composition. A subject was named, often a single word, as " Summer," " Winter," " Snow," &c., as the theme upon which to build a composition. At the end of two hours, the individual studies were collected together, and nothing could be more interesting than to compare the remarkable variety and different mode of treatment which the same word suggested to the minds of the different sketchers.' It, in short, included another of the sketching societies that date from the time of Girtin.

To return to the life of Topham : According to Graves, he began to exhibit his works in 1832, and between that year and 1858 had seven at the Royal Academy, three at the British and three at the Suffolk Street Gallery. In 1842 he was elected an Associate, and in 1843 a Member of the New Society of Painters in Water-Colours. It was apparently in 1844[2] that he went to Ireland, as before mentioned, with Alfred Fripp,[3] and there entered upon the field of art which he made more especially his own. He retired from the New Society in 1847, having exhibited thirty-eight drawings in its gallery during the six years of his connexion with it. The two exhibits of his first year in Pall Mall East were a Welsh view near Capel Curig, and an Irish subject of the conventional sort from the popular ballad of ' Rory o' More.' His election as Member followed in four months after his admission there as an Associate, namely, on the 12th of June, 1848, in the place of J. W. Wright, deceased. Topham was not a prolific exhibitor, but his share in making the gallery attractive was more than proportionate to the number of his works. From 1848 to 1877 he had always one at least but never more than five drawings in the summer exhibition, the total amounting to no more than eighty ; and in the winter ones, from the first in 1862–63, to that of 1877–78, which

[1] ' The Artists' Society,' at 29 Clipstone Street, Fitzroy Square, was, according to the heading of its printed notice form of ' List for providing Models,' established in 1830, ' for the Study of Historic, Poetic, and Rustic Figures.'

[2] A folio of his Galway sketches, exhibited at the Graphic Society, 13 February, 1878, was dated 1844, and his Irish subjects at the New Society begin in 1845. [3] *Supra*, p. 291.

followed his death, he had but thirty-nine, having been absent four times. For the first half-dozen years his subjects were confined to the United Kingdom, Welsh and (from 1850) Scotch figures being painted, as well as Irish. ' Highland Smugglers leaving the Hills with their Whiskey' (1851) and 'The Morning of the Pattern—a Holy-day in the West of Ireland' (1852) are among the more ambitious titles. After this the range was widened by journeying abroad.

One drawing, in 1851, of a special subject demands notice of a phase of his life in England before following him to Spain. It was an illustration of Dickens's story of *Barnaby Rudge*, where children flock round the half-witted hero, while he and his mother pass through her native village, as she had herself done when a child. Another from the *Old Curiosity Shop* followed in 1856; and the two together point to a fellow-feeling with the author. This, as in the case of Frank Stone and Cattermole, exhibited itself also in their kindred taste for the drama. Topham had already shown himself possessed of histrionic power by acting in the two pieces mentioned below, which had been got up by a party of ' Artist Amateurs,' and per-formed at the St. James's Theatre on 13 May, 1850, for the benefit of the ' Artists' General Benevolent Institution,' under the patronage of the Queen and Prince Albert. The committee of management included Dodgson, Duncan, Topham, and E. A. Goodall; and Topham played the parts of *Martin Heywood*, in Douglas Jerrold's ' The Rent Day,' and *Stephen Harrowby* in ' The Poor Gentleman.' The amateur performance of Sir E. B. Lytton's comedy, '·Not so bad as We seem,' which took place in the following year, has been referred to in connexion with Frank Stone, who acted *The Duke of Middlesex*. For *Mr. Goodenough Easy*, John Leech had been originally proposed by Dickens, the stage manager, but he eventually gave the part to Topham, who he ' thought would do it admirably.'[1] That the im-personation was a brilliant success *va sans dire*. In the same year Topham became one of Dickens's company of 'splendid strollers.'[2]

In the winter of 1852–53, leaving his wife and family in England, Topham went to Spain to study the class of subjects which proved so congenial to his artistic taste. That his life there was not one of comfort or of admiration of his surroundings, otherwise than in their picturesque aspects, is apparent in the letters which he wrote home to his friend Jenkins. He was hampered, both in the production of his

[1] *Letters of Charles Dickens*, iii. 123. [2] *Ibid.* i. 241.

works, and by difficulties in sending them home. Those intended for
the exhibition of 1853 appear to have been too late. He writes of
delays in shipment and at sea ; and he had but one drawing there
that year, called 'Wild Flowers,' the first of his Spanish series being
in 1854. His troubles began with unruly conduct among his models.
On 25 March (?), 1853, he writes from Seville that they had 'suddenly
disappeared.' On the 1st of April they had 'suddenly reappeared,'
but 'too late.' Then he describes a bull fight, in terms of disgust
enough to allay any fear of his desiring to depict its brutality.
From the same letter we learn that he was proposing to draw some
of his subjects on wood for the *Illustrated London News*. Thence he
proceeded on his tour, and in the summer was at Madrid. The
account of his impressions of Spain in general and its capital in
particular, in a letter of the 23rd of July, 1853, in the same series,
must be given in his own words, italics and all. 'I am now in
Madrid, which *glorious* city every Spaniard will recommend you to
visit once before you *expire*, and which every Englishman *who knows*
its *glories* will advise you to avoid and steer clear of *if you* wish to
live. "There is but *one Madrid*," *says* the Spaniard. "So much the
better," says the Englishman. The Spaniard will tell you that
whenever it is mentioned the world is silent with awe, that there is
but one stage from Madrid to *paradise*, where there is a window for
admiring angels to look down on it. In my opinion it is the most
ugly, unsocial, *unhealthy*, beastly, stinking place I was ever in, except
Lisbon. . . . It's only redeeming point, the Museo, . . . is certainly
glorious. I will pass over its thousand marvels and merely tell you
that we know nothing of Velasquez in England. *He* is marvellous
beyond expression. . . . Since leaving Seville I have visited Cordova,
Granada, Toledo, and other places of interest, and everywhere I have
regretted my inability to paint architecture. Such glorious combi-
nations of landscape and architecture I don't think are to be found in
any other country.' Then he regrets the wanton destruction of anti-
quarian and artistic remains ; and waxes enthusiastic on Granada, its
beauties and its climate. But Seville he considers the best sketching
ground. He had 'purchased a good many articles of dress, &c.,'
for studio use at home ; and was now about to start for Segovia.

The following extract is from an undated letter to his friend
Davidson, now a Member of the Society.[1] It doubtless belongs to a

<hr>

[1] Elected Associate, 12 February, 1855 ; Member, 12 June, 1858.

later period of the same tour, and is written from Cuenca, of which picturesque town there is a tinted pen-and-ink sketch, about $11\frac{1}{2} \times 8$ inches, at the back, representing houses clinging to the two vertical sides of a ravine, with no foreground, introduced 'to convince' his correspondent that the place whence he wrote was 'hardly a back-ground for a figure subject:' 'I wrote to you I think from Cordova, and I have since been to Granada, Madrid, Segovia, Toledo, &c. . . . Edward Goodall [1] is here, and his feeling is like mine, although his models do not make promises and disappoint him. I think, however, he is not satisfied with Spanish subjects altogether, but I expect it will be otherwise as he goes further south. I make some excuse for him because he, like myself, is half starved, and you will readily imagine that an Englishman with an empty stomach and only nastiness to live upon cannot be in the best possible temper. I think our landlord begins to fear that he won't get his money ; for he does not perceive that we make much here. He recommended our sending for the printer that we might have some bills and cards to distribute, that our first visit might be better known, and that so we might have a better chance. Since they discovered that we sometimes pay the people to have their likenesses taken, they—"the landlord and his lovely family"—think we are insane. We leave this place very soon for Valencia, and then we finish our sketching in Spain, and make the best of our way to old England.'

In 1854 or 1855 he took up his quarters at 1 Bloomfield Villas, Tufnell Park West, having previously lived at 32 Fortess Terrace, Kentish Town. After this, Spanish subjects were most looked for as representing his talent, such titles as 'Fortune Telling—Andalusia,' 'A Gipsy Festival near Granada' (1854), 'The Andalusian Letter-writer,' 'The Posada' (1855), 'Spanish Gossip' (1859), &c., sufficiently indicating their nature. He had domestic afflictions to endure in the winter of 1856-57—his wife's illness and a child's death ; but the following November he joins the first annual dinner of the Society, and in May 1858 he is the host at a 'Chalcographic' supper, whereat Jenkins is to be 'presented to the brethren.' In August 1860 he revisits Ireland, with a brother artist, Baxter, and his own son, Frank W. W. Topham.[2] He found most of his old Galway friends

[1] Now also a Member. The sketch of Cuenca was by his hand.

[2] Now a Member of the Royal Institute of Painters in Water-Colours, and also an accomplished painter in oils.

dead or gone to America, but was recognized and received a warm welcome at Claddagh. The next year some of the products of this fresh visit appeared in his two exhibited drawings, 'The Angels' Whisper,' from the lines of Samuel Lover, and 'Irish Peasants at the Holy Well.' In 1861 he is sojourning in North Wales, his address being 'Dinas, near Llanrwst;' and thence comes a subject of 'Peat Gatherers' for the next exhibition. In July 1862 he is again in Ireland, and writes from 'Eglinton Hotel, Salt Hill, Galway:' 'I regret that it will not be possible to meet our Chalcographic friends on Friday. It would, indeed, be a treat if I could get away from wretched Galway for such an evening—but alas! I am hard at work, having established (for a short time) a capital studio in Galway, and returning home to dinner daily, I get a little fresh air.' At this time and for fourteen years, he hails from 'Warwick House, 86 Adelaide Road, N.W.' Within this period a few Italian subjects occur, almost the only foreign ones not brought from Spain.[1] They begin in 1864 with 'Italian Peasants' and 'The Fountain at Capri.' 'A Venetian Well,' 1870, and a few winter 'sketches and studies,' also at Venice, are nearly all the rest.

Towards the close of the period his life was again shadowed by domestic calamities, and the deep black edge to his letter paper tells of successive bereavements. On the 5th of November, 1873, he writes, after his wife's death, that he has 'taken a house at Reigate for the winter months, on account of his daughter's weak health, and speaks at the same time of the dangerous illness of a grandchild. Next year it was his own turn to be on the sick list. On 29 December he complains of 'bronchial irritation and cough,' and has 'been shut up here with cold for nearly two months.' He had moved shortly before into new quarters in Arkwright Road, Hampstead, where his house was christened 'Dinas,' the name of that he had occupied near Llanrwst. He was not destined to reside there long. In the winter of 1876-77 he set off for another, and what proved a fatal, visit to Spain. He appears to have been taken ill at Madrid, but ventured upon an excursion thence to Cordova, in company with two friends, Mr. Joshua Mann and Mr. Rutter (an amateur artist). The long journey, and a fast, it is said, of seventeen hours with only two biscuits among the three, were too much for his strength to

[1] 'Village Musicians, Brittany,' 1857, and 'On the Beach near Boulogne,' 1866, are other exceptions.

endure, and when he got to Cordova it was quite exhausted. Unable to rally, he died there on the 31st of March, 1877.[1]

In the next summer and winter exhibitions there were six drawings and sketches by his hand, but none were the produce of this last abortive tour. For the meeting of the Graphic Society on the 13th of February, 1878, a collection was made of works by Topham, including three portfolios of sketches: from Galway of 1844, from Scotland of 1850, and from Spain of 1853. A number of his drawings were also brought together at the conversazione of the Royal Water-Colour Society Art Club on the 27th of March, 1889, in conjunction with a gathering of works by his brother member the late Thomas Danby. Four of his drawings are at South Kensington; three in the Ellison gift, and one in the William Smith bequest.

Topham's best works are remarkable for power and depth of colour, the shadows being rich and transparent. Latterly, however, he was much addicted to body colour. Jenkins, on being asked with reference to the exhibition of the artist's works at the 'Graphic,' how his friend succeeded in obtaining such force of colour without blackness, wrote the following answer:—'If Topham were alive and the question put to him I suspect he would say that he didn't know, or possibly he might say, " I keep painting in and out until my eye is satisfied;" much in the same way that Will Hunt said, " I grub it out somehow or other." Topham was essentially a colourist, and the sense of colour seems to me a gift which no procedure can explain or any particular pigments express in other hands. What the mind recognizes will come out. Topham's shadows are "rich and transparent" because he saw light in shadow, &c. . . . Topham's mode of working was altogether without system. I have often painted in the same room with him. He put on colour and took off colour, rubbed and scrubbed, sponged out, repainted, washed, plastered and spluttered his drawings about in a sort of frenzied way in the effort to produce something lurking in his mind, but which he could not readily realize. Every drawing seemed something like an experiment.'

That his drawings were highly appreciated in his lifetime is indicated by the following list of prices (above 300*l.*), realized in art sales, as noted in Mr. Redford's valuable work.

[1] He was interred in the little Protestant cemetery inclosed and arranged by the late Duncan Shaw, British Consul at Cordova, a friend to all English artists, who himself lies buried there.

Year of Sale	Collection	Title &c.	Price
1865	Knowles . .	'The Gipsy Toilet' (30½ × 20½ in.) two pictures	£ s. 498 15 each
1867	A. H. Campbell .	'The Passing Train' (22 × 33) . .	315 0
1873	Murrietta . .	'The Picador, Seville' (20½ × 30½) .	378 0
1874	McLean . .	'Preparing for the Bull Fight' (27 × 41)	341 5 bought in
1875	W. Quilter . .	'Little Nelly in the Churchyard'. .	325 10
1876	C. Suthers, Assª. .	'Dressing for the Fair' (22 × 39) . .	378 0

In this year (1848) a second ballot for Associates was taken, at the meeting of the 12th of June, after the election of Topham and W. Callow as Members. The choice fell upon DAVID COX, *Junior*, only son of the great painter of the same name. He has been mentioned [1] in connexion with his father's career in the biographical account of the latter given above. He was the child born in 1809, when his newly married parents were living near Dulwich, and the husband was humbly striving to obtain a place in the ranks of his profession. He accompanied them to Hereford, and was in part educated at the Grammar School there. The father often took the son with him on his sketching tours, and at the age of seventeen he determined to be an artist too. He exhibited a ' Cottage at Hereford ' at the Royal Academy in 1827, and between that year and 1830 had three works there and one at Suffolk Street.[2] A few plates bearing the name of ' D. Cox, Junior,' have been mentioned in association with his father's engraved works.[3]

Now, and for many years past, Cox junior had become himself a married man and a recognized artist ; insomuch that, since his father's retirement to Harbourne in 1841, he had succeeded to the goodwill of whatever was transferable in that artist's London business of teaching. He resided at this time at Streatham Place, Brixton Hill, and his home remained in the same neighbourhood for the rest of his life. In 1841 he was elected an Associate, and in 1845 a Member of the New Society, but he resigned his Membership thereof in 1846, after exhibiting eighty-six drawings in its gallery, and, as we have seen, he was admitted to join his father at Pall Mall East two years after Though never more than an Associate, he contributed a larger number

[1] *Supra*, vol. i. p. 336. [2] Graves's *Dictionary*.
[3] *Supra*, vol. i. p. 154, *n*. 2. The four in *An Autumn Ramble on the Wye*, viz. 'Tintern Abbey ' (interior), ' Monmouth,' ' Ross,' and ' The Wye Bridge at Builth ' (all engraved by W. Radclyffe), were, in common with the other plates in that book, reissues of some contained in *Wanderings and Excursions in South Wales*.

of drawings to our gallery than many artists who have acquired the
privileges of Membership. For during the thirty-eight years of his
connexion with the Society he never missed an exhibition, generally
sending his full quota of 8 to the summer one, and in the winter,
where the number was not thus limited, an average of about 14.
His total of separate exhibits stands as high as 587, 268 being in the
former, and 319 in the latter season. In this enumeration are in-
cluded 6 posthumous exhibits, but where several sketches are in a
frame they are reckoned as one only. His subjects are all of the
landscape class and, with few exceptions, views of named spots, his
usual sketching ground being nearly conterminous with his father's,
and the treatment and manner of painting obviously founded on that
artist's practice. It need scarcely be added that the fire of original
genius which had illumined the master's works did not burn so
brightly over the pupil's, and that of the light it had shed very much
was lost in the reflexion. The drawings of the younger Cox were,
however, as a rule harmonious in colour, and, being for the most part
unobtrusive, their number was not felt to weigh too heavily in the
general balance of the walls. Views in North Wales form the largest
class, and there are some also in Scotland, not a few among the
Cumberland lakes from 1861, others in the Midlands, and many in
the home counties of Kent, Sussex, and Surrey. In the winters of
1865–6 and 1877–8 are groups of sketches from Devon, the former
about Tiverton and the Exe, the latter round Dartmoor. Exceptions
to these and to the rest, which are confined to Great Britain, are two
separate groups of foreign views, the first exhibited between the years
1853 and 1857, from Grenoble and the Isere, and the second from
Switzerland, in the winter show of 1869–70, and the summer one of
1870.

After his father's death in 1859, he moved to 2 New Park Road,
Brixton Hill. In the catalogue for 1860 his name is entered (with
that address) simply as 'David Cox.' But a year after he reverts to
his old description as 'David Cox, junior.' There could indeed be
only one *David Cox*, and the son honoured his father's memory by
modestly abstaining from the use of the well-known name without
the qualifying addition. There still remains some need for the exer-
cise of caution by collectors, on account of the superficial resemblance
of manner which exists among the works of the two Coxes. More-
over, when the son was called at length to rest with his ancestors, he

too had attained so venerable an age that he was himself -entitled to be spoken of as 'old' David Cox. He died in his seventy-seventh year, on the 6th of December, 1885, at Chester House, Streatham Hill, where he had resided since 1876. His remaining works, comprising upwards of 400 finished drawings and sketches, were sold at Christie's on the 14th and 15th of April, 1886.

The 12th day of February, 1849, is entitled to be marked with a red letter in the calendar of this history, for the reason that among the three candidates then elected was JOSEPH JOHN JENKINS, without whose initiative and preliminary labours the task of compiling it would not have been undertaken. He was another of the band of artists who in 1847 had renounced their short allegiance to the rival society in Pall Mall, and now rejoined his former comrades, Dodgson, Duncan, and Topham, in their more congenial home of Pall Mall East. His election as Member followed a year after, on the 10th of June, 1850.

Jenkins was primarily a figure painter, but many of his subjects and studies were combined with landscape, and some belong to the latter category alone. In early life, however, he pursued the profession of engraving, for which he was educated by his father, who was a pupil of William Holl (the elder), and practised that branch of art with skill and success.[1] The son was born in 1811. Among his papers there is a letter, dated 19 February, 1875, from one who claims renewal of acquaintance as a playmate of his childhood, wherein a faint glimpse is given of his early home. 'I recall,' says the writer, 'your father showing me . . . a plate upon which he was at work, "The Greenwich Pensioner," cooling his tea in a saucer with his breath, and a proof of its companion, the old dame "Threading the Needle;' and his giving me my first lesson in etching. I can likewise see you unrolling a drawing, most neatly and carefully executed, of a foot from plaster.' A writer in the *Athenæum* (21 March, 1885) mentions a picture with the above title, 'The Greenwich Pensioner,' in the gallery of the Society of British Artists in 1829, as our artist's 'first exhibited drawing,' and that it was followed by 'The Hareem Queen' in 1832. Mr. Graves, however, assigns the year 1825 (when the artist was only fourteen) as the date of his first appearance in

[1] A print called 'Happy Times,' whereof 111 impressions were sold at Christie's among J. J. Jenkins's 'remainders,' is believed to have been engraved by the father.

public, and finds under his name between that date and 1849 thirteen works at Suffolk Street, one at the Royal Academy, and two at the British Institution.

Thus he used the pencil contemporaneously with the graver, and there are line engravings of which he seems to have been both designer and executor on the metal.[1] Among the works which he engraved are portraits, including those of Lord William Russell, Allan Cunningham, (Sir) Joseph Paxton, and others; a 'Susanna and the Elders,' by Francesco Mola, and 'The Greenwich Pensioner and the Chelsea Pensioner,' by M. W. Sharp.[2] The class of subjects in which his talent was shown as a rising painter was that which found ready acceptance in the Annuals, wherein the following plates from his designs may be found :—In the *Keepsake*, 1835, 'My Aunt Mansfield' (engraved by C. Heath).—1838, 'Zuleikha' (T. Stodart), 'Theresa' (H. Cook), 'Angelica' (W. H. Mote).—In the *Forget-me-not*, 1838, 'Rosanna' (H. Rolls); 1840, 'Alice' (H. Rolls).—In Heath's *Book of Beauty*, 1838, 'Rhoda' (Hall).—In Fisher's *Drawing-Room Scrap-Book*, 1838, 'The Devotee' (J. Jenkins), a vignette; 1839, 'The Flower Garden' (P. Lightfoot), 'The Ancient Prude' (J. Brain), 'A Society of Antiquaries' (T. A. Dean), the incident represented being a child discovered hiding in a box of curiosities; 'The Poet's Grave' (J. Cochran); 1840, 'Kate is crazed' (J. Thomson); 1850, 'The Mask' (W. H. Mote); 1851, 'Highland Flowers' (W. Hewett). The designs for these prints were mostly, if not all, of an earlier date than his election as an Associate of the New Water-Colour Society, which event occurred in 1842, and was followed by his election as a Member thereof in 1843. During the six years of his connexion therewith, he exhibited fifty-seven drawings in its gallery in Pall Mall.

While working at his art he also in his earlier time gave lessons to pupils in figure drawing. He further took advantage of the period of his life when his health was less precarious than it latterly became, to lay in a stock of impressions by sketching sojourns, both in this country and abroad. An undated letter of his (conjectured to have been written about 1840) to an old friend and brother artist, the late H. Pidgeon, proposes a 'sketching business' in Wales with Dodgson, and in a postscript he adds: 'My companion for Scotland cannot go, and I hate wandering alone.' For we shall see that he

[1] For example, 'The Devotee,' mentioned below.
[2] See Puttick and Simpson's sale catalogue, 2 July, 1885, Lots 88, 126, 128, &c.

was of an eminently sociable disposition. Another letter, also undated, to the same friend, gives a full and particular account of a journey to Belgium, with critical encomiums on the famous pictures by Van Eyck and Memling at Ghent and Bruges, and those of Rubens at Antwerp; together with graphic descriptions, which, although of stock sights now familiar to every tourist, have a pleasant *naïveté* about them, that seems to appertain to a first trip abroad. As a painter of contemporary life, this visit to Belgium was not very profitable to him. He was far from being taken with the aspect of the people. ' I selected Belgium,' he writes, ' because I was led to believe that I should meet with very picturesque figures and fall upon new subjects. In this I have been most completely disappointed. The people are neither "picturesque" nor "agreeable." ' But he tried there to realize the past, and nearly succeeded at the Hospital of St. John in Bruges, where the sœurs de la charité, who in the same vaulted room and the same costume of old were tending the sick or dying ' as they might have done in the time of Memling himself,' seemed to him ' to have just glided from the old frames to visit the scenes of bygone days, and flit about like ghosts of the past.' But at the Béguinage in Ghent he says of the 400 or 500 nuns assembled for vespers : ' I stood at the door and longed to see a beautiful woman— a beautiful nun.' But no, ' nothing but age and ugliness passed me there, and the poetry of the thing vanished with the sight.' There was in fact no sentimental prettiness about it, and it formed but sorry material for the *Book of Beauty* or the *Drawing-Room Scrap-Book*; so we find among his pictures no motives derived from the Flemish tour. It was far otherwise with a visit which he made to Lower Brittany in 1846,[1] where the habits and picturesque costume of the peasantry afforded the very models he required. There he resided for some time, and thence he derived the scenes and subjects of many of his most successful works.

In 1847 he seceded, with the group of companions above mentioned, from the New Society. In the following year it was reported that he had formed an intention of giving up water-colour painting and taking to oils.[2] However that may be, he offered himself as a candidate at the old Society of Painters in Water-Colours, and was elected, as above mentioned, Associate in 1849, and Member

[1] *Athenæum*, 21 March, 1885. A French passport was granted to him at Boulogne, for the interior, on the 25th of August, 1846. [2] *Art Union*, 1848, p. 131.

in 1850. He had not long been invested with a vote in the Society's affairs when he began to show his zeal in its interests, and to make his influence felt. To him is said to have been due the printing in that year of a French edition of the catalogue for the benefit of the many foreigners who came to England in 1851 to see the Great Exhibition in Hyde Park.[1]

It was also at or before this time that he conceived the idea of writing a history of water-colour art in England, embodying therein an account of his own Society, though embracing a much wider scope. The first public intimation of this design came in the form of an advertisement in the *Times* newspaper of 20 February, 1852, in the following words :—' Preparing for Publication. *A History of the English School of Painting in Water-Colours*, with Examples illustrative of its Progress, and Biographical Notices of the most eminent Professors of the Art. By Jos. J. Jenkins, Member of the Society of Painters in Water Colours. Mr. Jenkins respectfully solicits information respecting the early Professors of the Art,—5 Newman Street.' The intending author did not, however, trust for information to what might come to hand in answer only to this appeal. He set about his task systematically, and for the purpose of collecting facts had a paper printed for circulation among *cognoscenti*, directing their attention to useful points of inquiry. These were arranged under the two heads :—1st, *The History of the Material*; 2ndly, *Personal History of the most Eminent Artists in Water-Colour*. The inquiries thus set on foot were pursued, as the reader is aware, until almost the last year of his life, but the task remained unfinished at his death. For he was only able to work at it as time and opportunity served, and as the state of his fragile health permitted. It happened, moreover, that as the time became absorbed by his ordinary avocations, the means of obtaining information were more commonly available through the special channel which they afforded him. Contemporary facts which he was enabled to register clustered naturally round his own standpoint ; and thus the materials he left were more fitted for constructing a history of the 'Old Water-Colour Society' than one of the wider scope originally announced. Early in the course of his inquiries, he sought for such information as was to be found in the

[1] *Athenæum*, 21 March, 1885. The practice of publishing such catalogues is there stated to have ' obtained for some time.'

archives of the Society, and on applying to the Secretary, George
Fripp, in April 1853, he found that at the death of that gentleman's
predecessor in office, J. W. Wright, they were in a state of some
confusion. 'All the Society's papers,' wrote Mr. Fripp, 'came to me
loose at the bottom of a cab.' They had, however, been placed, and
carefully preserved by him, in a large trunk which Jenkins obtained
leave ' to look at and rummage.' It is not surprising, after evidence
such as this of industrious interest in the affairs of the Society, and
a systematic habit of working, that J. J. Jenkins was unanimously
chosen as Secretary when the next vacancy occurred, namely, on
the 13th of February, 1854.

He had not been Secretary much more than a year when Fielding,
the President, died, and a season of some temporary discord followed
as above mentioned, which gave ample occasion to prove his value in
an official capacity. It is not necessary here to refer in detail to the
controversies which took place over Tayler's mission to Paris at the
time of the Exhibition of 1855, to the resignation of President
Lewis three years afterwards, to the agitation for a site at Burlington
House in 1859, or to other vexed questions that arose or were
debated during Jenkins's term of office, both within the Society and
with respect to its external relations. But it is impossible to read
the letters which passed between Members and the private correspon-
dence with successive presidents, preserved among Mr. Jenkins's
papers now in the Society's possession, without perceiving how he
was universally trusted, how his opinion was valued and respected,
how calm was his own judgment, and how his tact and good temper
fitted him to be the peacemaker who was to reconcile discordant
elements. 'Certainly,' wrote Samuel Palmer [1] after his friend's
retirement from office, ' Mr. J. Jenkins's vigilance in everything
which affected the interests of the Society, and the sound wisdom
which on every occasion he brought to bear upon them, left nothing
to be desired, and will long be remembered by us.' As a testimonial
of the esteem in which he was held by his brother Members, they
presented him with a gift of 100*l.* on the 10th of June, 1861. A
vast deal of work, which he cheerfully undertook, was thrown upon
him that did not strictly belong to the duties of his office. For
example, when the London International Exhibition of 1862 was in
course of preparation, he became engaged in a burdensome corre-

[1] MS. letter to Mr. Henry B. Jenkins, the artist's brother.

spondence as a medium of communication between the Commissioners and the Members of the Society, who were making up lists of their chief works, and indicating where they were to be found. He also wrote occasional articles on art subjects in the *Brighton Gazette*, and other periodicals.

He resigned his post of Secretary in 1864, probably on the ground of failing health. One of his later acts had been the institution in the previous year, of press private views of the Society's exhibitions, a great boon to critics, and an example which was followed by the Royal Academy and other societies.[1] The benefits conferred on the Society by Joseph Jenkins did not end with his term of office. In his later years he busied himself in the foundation of a permanent library and museum at the Society's house, to preserve examples of the work of deceased Members, and records of the history of their art. For this purpose he not only made a gift of books himself in 1878, but induced other Members to present examples of their engraved and other works to the collection. In 1884, having been unable through illness to send anything to the gallery for two successive seasons, and being conscious that age and infirmity had at length incapacitated him from further work, he generously resigned his Membership to make room for some younger man. But the vacancy would soon have occurred without his taking that step. He died the next year on the 9th of March, 1885, at 67 Hamilton Terrace, St. John's Wood, where he had resided since 1874.

By his will, of which his brother Member, Edward A. Goodall, was made executor, he was found to have left to the Society a sum of 1,000*l.*, and a further addition to its art treasures in nine drawings by living Members. He also bequeathed 500*l.* to the Artists' Benevolent Institution. Notwithstanding his weak health, from which he had been a sufferer for many years, he had survived all his relations, and was thus able to confer upon his professional brethren an inheritance which might otherwise have been bestowed on his own family. He had never married, and, after the successive deaths of his mother and only brother, his life would have been solitary had it not been for the sociable disposition which drew around him a circle of attached friends with whom he was in frequent communion. He kept up a friendly correspondence by letter with several brother artists at home and abroad;[2] and we have seen how he was the expected guest of

[1] See *Athenæum*, 21 March, 1885. [2] See account of Henry Riviere, *infra*.

Duncan at his Christmas dinners ; who, with Topham, was also among the boon companions that met periodically at the social suppers of the Chalcographic Society. He was, moreover, for some time a member of the 'Graphic.' There are memoranda of his goodwill to others in divers small benefactions, such as a gift to Topham in 1868 of a Spanish mantle for his studio wardrobe ; and one to the Artists' Society at Langham Chambers, of two 'properties' in the shape of an old leather chair and an earthenware pitcher, for which the Secretary, Charles Cattermole,[1] returns thanks on the 26th of September, 1874.

On the 3rd of June, 1875, he was elected a Fellow of the Society of Antiquaries. From 1859 to 1873 he resided at 35 Upper Charlotte Street, Fitzroy Square ; previously to which his address had been 5 Newman Street from at least the date of his joining the Society ; and at an earlier time at 8 Caroline Street, Bedford Square. As a contributor to the gallery he was not largely productive, never exceeding eight in the summer or nine in the winter exhibitions ; and at both he was occasionally unrepresented. Thus the total number of his exhibits is only 271 for the thirty-six years of his connexion with the Society. Of these 152 were in the summer and 119 in the winter shows. To the latter figure the inclusion of a few frames of three or four subjects apiece may entitle him to an addition of eleven more. The earliest years, from 1849 to 1851, comprise most of his subjects from Brittany, notably a drawing among his first batch called 'Going against the Stream,' which was the fellow to one of 'Going with the Stream,' and formed with it a very popular pair. They depict a boat with two Breton figures emblematic of the 'course of true love,' the latter illustrating the exception required to prove the oft-quoted rule. These two drawings were engraved, in probably the most successful prints from the artist's designs. To some of these Brittany subjects there are such titles as : 'The Rival's Wedding' (1849), 'A Gossip over the Wedding Dress' (1851), 'The Roadside Cross' (1862), 'After Vespers' (1863), &c., which sufficiently indicate their nature. After these dates they occur from time to time only. Between 1850 and 1856 there are occasional subjects from Boulogne ; and others on the coast of France, chiefly near Calais, are found from 1875 to 1878. Studies on the Thames begin in 1863, and continue to the last, coming more thickly between 1866

[1] R.W.I., son of Rev. Richard Cattermole.

and 1869. In the winter of 1865–66 there are a group of studies from the district about Whitby; and scattered among his works are views in North Wales, at Haddon, and Warwick, in the counties of Surrey, Sussex, Kent, and on the coast of Norfolk. It was in the later years, and chiefly in the winter exhibitions, that these landscape subjects became more common. The earlier works belonged more to the figure and *genre* school. Their motives, as before intimated, inclined to the sentimental or to the infantine and mildly humorous class. A few titles will be enough to define their scope; such as: 'Thoughts of Home' (1852); 'Evangeline at Prayer' (1854); 'The Return, in Sight of Home' (1856), &c., among the more serious; and of the lighter class, 'After a Romp' (1849); 'Waking Up' (1851); 'Take Me Up' and 'Put Me Down' (1855); 'Come along' (1856); 'Now then' (1858); 'Donne Moi' (1860); &c. &c.

Several other of the exhibited drawings were engraved as separate plates; for example, 'The English Side of the Channel,' and 'The French Side of the Channel,' and 'Sleeping Companions' (all exhibited in 1853): 'Hopes' and 'Fears' (1855), both engraved by William Holl. His engraved works further include a drawing entitled 'Love,' the property of the Queen; and a complete list should include the ticket of the 'Guild of Literature and Art' which he designed for Charles Dickens. And there may be more. A sale of his books and prints took place at Puttick and Simpson's on the 2nd of July, 1885, and his remaining works and collection of drawings were sold by Christie & Co. on the 1st of March, 1886. The highest registered prices of Jenkins's drawings at public sales are the following :—'N'ayez pas Peur' and 'Donnez Moi,' 84*l.* each ('G. J. Rogers' sale, 1867); and 'New-Comer,' 78*l.* 15*s.* ('G. Gurney' sale, 1888).[1]

CHARLES BRANWHITE, another of the Associates elected on the 12th of February, 1849, was a Bristol man by birth and by residence throughout his career. He was of an artistic family, his father having been a very clever miniature painter there, who also painted some portraits in oil, and had great power in reading the characters of his sitters. An elder brother, Nathan, who died young, was also a portrait painter, and an engraver[2] as well. Charles was born in 1817 or 1818. Having received some instruction in art from his father,

[1] Redford's *Art Sales.* [2] Redgrave's *Dictionary*, second edition.

he began his own practice as a sculptor, and at about the age of twenty obtained silver medals for figures in bas-relief from the Society of Arts.[1] It was not until some years after that he took to painting, as a landscape artist, working chiefly in oils. Between 1845 and 1859, Graves finds thirty-six works of his in the London exhibitions ; nine at the Royal Academy, twenty-five at the British Institution, and two at Suffolk Street. And he also exhibited with success in provincial galleries.[2] But his name as an artist is best known by the works which he contributed for thirty years to the Old Water-Colour Society, as an Associate ; for he never became a full Member. He sketched well in water-colours, having a very rapid and popular style of execution. But he was so lavish in the use of body colour, that many of his drawings may be regarded as works in distemper. His most characteristic subjects are winter scenes with ice, often under a sunset effect ; and green foliage by river beds. The resources of his native land sufficed him for the *locale* of both ; the ' Bath Canal ' affording his ideal of a ' Frosty Evening,'[3] and the East Lynn, at Lynmouth, for many a leafy retreat at the summer's noon. Wales, as well as Devon and Somerset, supplied him with scenes, and sometimes he sketched on the Thames. There are also subjects of a later time from Switzerland ; but he seldom ventured upon extensive landscapes. His works, though mostly in the nature of ' studies,' are composed with pictorial effect. Branwhite contributed eighteen drawings to the gallery in Fielding's time (1849–1854) ; and remained a steady exhibitor until his own death, which occurred on the 15th of February, 1880, at the age of sixty-two, at his residence, Bramford House, Westfield Park, Bristol. His place of interment is Arno's Vale Cemetery, Bristol.

Only missing one exhibition, that of the winter of 1873–74, he had in all 266 drawings in the gallery, 143 in summer and 123 in winter shows, in the course of his Associateship of thirty-two years. The remaining works in the deceased's studio were sold at Christie's on the 15th of April, 1882 ; the water-colour drawings in 156 lots, and the ' pictures ' in four. Among the latter was his last oil painting, ' The Head of Nant Frangon ' (46 × 73 in.). The highest price recorded by Redford for a drawing by Branwhite is 185*l*. 18*s*. for a ' Rocky Landscape,' in the sale of — Moore's collection at Christie's in 1866.

[1] Clement and Hutton's *Artists of the Nineteenth Century.* [2] *Ibid.*
[3] In the Exhibition of 1851.

MRS. H. CRIDDLE, elected a Lady Member on the same 12th of February, 1849, was a constant contributor to all the Society's exhibitions for more than thirty years. She was one of the group of artists of her sex who had higher aspirations than to delineate flowers, fruit, and birds' nests. Like the Misses Sharpe, she painted subject pictures, chiefly in illustration of the poets. There were 139 exhibits under her name, sixty-three in the thirty-two summer shows from 1849 to 1880, and seventy-six in the winter ones from 1862-3 to 1879-80. They comprise many subjects from Shakspere, with some from Spenser and Milton, Thomson, Crabbe, and writers of her own day, as Dickens, Tennyson, Longfellow, and George Eliot. The themes of not a few are to be found in old and popular ballads and tales ; and the rest are mostly original or fancy subjects, the tendency throughout being generally towards motives of a sentimental kind. One or two scenes are from the New Testament. The following particulars of her life are chiefly derived from the account in Miss Clayton's *English Female Artists*, vol. 2, published in 1876, revised and added to by personal friends of the deceased artist.

Mrs. Criddle was a Welshwoman by birth. Her maiden name was Mary Ann Alabaster, and her life began in the year of our first exhibition, 1805. She was born at the Chapel House, Holywell, in Flintshire. She appears to have derived a love of drawing from her father, a man of inventive ingenuity, who used to make caricatures to amuse his children of an evening. But her anxious desire to take lessons in art remained ungratified until she had grown to be a woman. For her father died when she was but thirteen, and she was then recalled from Miss Masters's school at Colchester, where she had been encouraged to read, but never taught to draw, only to find herself again forbidden by her mother from indulging in so vain a pursuit. But the thirst for art was strong within her, and many a time would she steal from her bed in the early morn to try her untutored hand at painting in oil. At length her will prevailed and, at the age of nineteen, she was allowed to attend the studio of Hayter, with a view of devoting herself to an artist's career. Working there assiduously from 1824 to the autumn of 1826, she received in the latter year the silver palette of the Society of Arts for a chalk study from the antique. This was followed by further rewards: the large silver medal in 1827 for an oil copy from West ; the gold Isis medal in 1828 for an oil portrait of her sister ; and the large gold medal in

1832 (which had not been awarded for ten years) for an original
picture, 'The Visit to an Astrologer.' Her appearance at the
London exhibitions began under her maiden name in 1830, and
continued after her marriage with Mr. Harry Criddle of Kennington,
in 1836. Mr. Graves counts up fifty-two works exhibited by her
between the first date and 1848: eleven at the Royal Academy,
twenty-five at the British Institution, and sixteen at Suffolk Street.
Her first exhibited picture (at the British Gallery) was bought by the
Marquis of Stafford, afterwards first Duke of Sutherland. So far
her practice had been confined, or nearly so, to oils. It was not until
1846 (when she was forty-one years old) that, finding that medium
injurious to her health, which had never been strong, she took
some lessons in water-colours from Miss Sarah Setchel, of the 'New'
Society;[1] and three years afterwards she was, as we have seen, received
into the 'Old.'

In 1847 she had sent a large cartoon to the competitive exhibi-
tion in Westminster Hall for the decoration of the new Houses of
Parliament. Its subject was taken from the 'Epithalamium' of
Spenser; as was also that of the last drawing she exhibited in our
gallery in 1880. In 1852, about three years after her admission
into the Society, Mrs. Criddle was obliged to lay aside her pencil for
a time, owing to an affection of the eyes, produced by an attempt to
practise miniature painting. At first it rendered her partially blind,
and she did not entirely recover her sight for several seasons. Her
husband died in 1857, leaving her with one son, born in 1844, who
afterwards emigrated to North America. He was remarkable for his
strong musical taste. She had also adopted and educated three sons
of a deceased brother, two of whom being good linguists obtained
consulships in the Far East.[2]

Having previously resided in London, she now retired into the
country, and in 1861 settled in the village of Addlestone, near
Chertsey, where she was much respected by a cultivated circle of

[1] The powerful group entitled 'The Momentous Question,' exhibited there in 1842,
which had suddenly established Miss Setchel in high repute as an artist, must then have been
fresh in the memory of the town.

[2] Charles Alabaster, the eldest, took orders, married, and finally settled in New Zealand,
where he died. Henry became the trusted adviser and friend of the young King of Siam.
He married the younger daughter of the late James Fahey, Member, and for many years
Secretary, of the 'New Water-Colour Society,' and died a few years since, leaving three
sons. He wrote a little work on the Buddhist faith. The remaining nephew, Challoner, is
in the consular service in China.

friends, and died at the age of seventy-five on the 28th of December, 1880, having shortly before resigned the 'Associateship' of the Society of Painters in Water-Colours, which had long since been adopted as the equivalent title to 'Lady-Membership.'

The only works of hers known to have been engraved are four pictures of 'The Seasons,' painted in 1854, the originals of which were sold to the Baroness Burdett-Coutts; and some illustrations to *The Children's Garden*, a little book written by her friends and neighbours, the Misses Catlow (authors of several other well-known works on natural history).

A summer election, on the 11th of June, 1849, brought into the Old Society one more seceder from the rival body in Pall Mall, in the person of JOHN CALLOW, the brother before mentioned of William Callow, the Member now living. He was ten years his junior, having been born on the 19th of July, 1822. The younger brother was indebted to the elder for his artistic education. He joined him in Paris in 1835, at the age of thirteen, and, residing with him there, became his pupil. After William Callow's departure thence, early in 1841, he continued to reside in Paris till 1843, during which time he was occupied in teaching in addition to painting and engraving.

He was elected to the New Water-Colour Society in 1845, in which year he had eight drawings there. These were followed by ten in each of the following two years, and he left that Society in 1848. All the above were of marine subjects. Beginning with 1850, he exhibited drawings at our own gallery until 1878, the year of his death, 191 works in the summer shows during that period, and 154 in the winter ones from 1862-3 to 1878-9 (the last set of eleven being posthumous), making a total of 345 exhibits, which number may be swollen to 431 if we count all the small sketches which in the winter were often put together, several in a frame. The subjects are generally sea and coast scenes, with native shipping, on the British coast all round England and Wales, and in the Bristol and British Channels, including the Channel Islands and coast of Normandy. There are also some inland views in North Wales, the first being in 1861; and a few Scotch views on the Forth and Clyde in 1862 and 1863, and at the English Lakes in and after 1864. These are mostly in the earlier winter exhibitions, to which he also sent marine sketches and studies for pictures, and (in 1872-74) a few studies in Knole

Park. Besides his water-colour works, he painted a few pictures in oils, from about 1852 to 1859, some of which were exhibited at the Royal Academy, and the British Institution, and (together with water-colour drawings) at numerous provincial galleries in England, Scotland, and Ireland.

The brothers Callow resided together again in London, first at 20 Charlotte Street, Portland Place, and then (from 1860) at 3 Osnaburgh Terrace, Regent's Park, until John Callow's marriage, on the 15th of February, 1864, to Rebecca Searle, after which he settled at New Cross. In addition to private tuition of amateurs, he was largely employed as a drawing-master in colleges and schools. In 1855 he was elected professor at the Royal Military College, Addiscombe, which post he held for six years till 1861, when he received compensation in consequence of changes made in the establishment. After this he was appointed, on the 19th of August, 1861, a master of landscape drawing to the Royal Military Academy, Woolwich (at a salary of 250*l.*), his colleague being the late Aaron Penley, of the New Society. Here he remained for three years and a half, when he was placed on the retired list with a pension. In 1875 he was chosen professor at Queen's College, London, which appointment he held till the time of his death. That event occurred on the 25th of April, 1878, at his residence, Hellington House, 35 Lewisham High Road, New Cross. He left one son surviving.

At the sale by ' Callow's executors,' on 24 June, 1878, a drawing by our artist, of ' Scarboro' from the Sea,' brought 57*l.* 15*s.*; and in April, 1879, 214 of his drawings were sold by auction.[1] John Callow contributed some examples in sepia and in water-colours to Vere Foster's *Drawing Copy-Book*, oblong 4to, 1871 ; and thirty sketches of his of the same class have been chromo-lithographed by G. Rowney & Co. under the titles *Callow's Easy Lessons* (12), and *Leaves from Callow's Water-Colour Sketch-Book* (18).

[1] Redford's *Art Sales.*

CHAPTER IV

NEW ASSOCIATES, 1850-1854

Biographies—*C. Haag—P. J. Naftel—Miss N. Rayner—J. Burgess—J. Bostock—Sir J. Gilbert, R.A.—H. P. Riviere—Miss M. Gillies—W. Goodall—S. P. Jackson—H. Brandling.*

THE 11th of February, 1850, brought into the Society two new Associates and one more Lady Member. The first two are well known and admired among living artists, and one of them is further distinguished as having introduced new and striking features into the technical development of English water-colour art.

CARL HAAG, though naturalized now in England, is of German parentage, and was a successful artist in his own country before he settled in this. He was born at Erlangen in Bavaria, the eldest son of his parents. His father, though not an artist by profession, was a skilful amateur, who not only made drawings himself in red chalk, but had his own views on art-training. He desired to encourage original observation ; and so, when he saw his son, who had ever a pencil in his hand, adorning the walls and furniture of the house with sketches of natural objects, he steadfastly refused the boy's repeated requests for drawing lessons, though there were competent masters to be had in the country town where the family resided. He promised, indeed, to have him taught when older ; but said he had better begin by finding out what he could for himself. Through life he appears to have followed the principle thus early instilled into his mind. The parent, however, did not live to fulfil the promise he had made. He died when young Carl was but eight years old, leaving the boy's mother to carry out his plans of education. She had already aided her son's early progress by giving him a colour-box and brushes. At the age of about fourteen, his bent being evidently settled, he was accordingly sent to Nürnberg. There, for about two years, he received instruction at the Polytechnic School for drawing, where he was put through a comprehensive course in all the

departments considered necessary to the education of an artist. Thus qualified for election into the Nürnberg Academy, he became a student thereat in 1836, and there passed through the antique and life schools, and became the leading scholar. There he experienced much kindness and attention from the eminent director, Albert Reindel, with whom he was a favourite. In 1844, when Haag left Nürnberg for Munich to enter upon the higher grade of professional study provided in that city, Reindel offered to procure him a state scholarship or stipendium for a term of two or three years, to aid him in his studies there, should the student think fit to apply for it. But Haag had an ambition to make his own way without assistance. He left the matter open for a short time, and then, feeling confident that he could maintain himself independently, abstained from making such application.

At Munich he did not strictly adhere to the Academy course, but studied, from his own points of view, the works of Cornelius, Kaulbach, and Carl Rottman, forming or modifying his own taste by such observation. The fact was that he had, without seeking it, already acquired credit for originality, which enabled him to take up an independent position as a professional artist. It had happened in this wise. When a student at Nürnberg, he used to keep an album wherein to preserve memoranda of friends and acquaintance. There he not only noted their birthdays and collected their autographs, but drew their likenesses with his own hand. His manner of executing these portraits was to begin with a pencil sketch, which he made more complete by degrees, and after finishing with great care in the same material, began to tint with water-colours. Touching upon this from time to time, he went on adding tints, until the drawing finally assumed the aspect of a finished miniature in colour. When the later stages of the process had acquired this importance, he gradually took to working up the portraits more and more in colour, until the elaborate pencil-drawing which had served as a foundation came to be discontinued. In short, this gradual development of his art was not dissimilar to that, which had taken place in the practice of our earlier water-colour draftsmen and brought into existence the English school. Now, unknown to Haag, the fame of this portrait album had preceded him to Munich, and the repute which it conferred upon him led to his being employed, on his arrival thither, to paint little effigies of the same kind. He proved very successful in securing likenesses, ·

which he attributes in a great degree to a power of working from memory. Possessed of a gift of mentally recalling with distinctness the image of his sitter, he would compare with his sketch this vision of the mind's eye, and only when the two appeared to coincide would he trust himself to continue the drawing in the absence of the original. His practice, thus carefully pursued, grew apace, and he was soon able to earn his living by these little water-colour portraits, the heads in which were of about the size of half-a-crown. He was largely patronized by the nobility and high aristocracy, and among his sitters were the Duke and Duchess Maximilian of Bavaria, parents of the present Empress of Austria. But this employment did not satisfy his desire, or fulfil his aims in art. True, he made designs also for book illustrations;[1] and practised in oils, though his predilection was always for water-colours. After about two years at Munich, finding that he was becoming overburdened with commissions for portraits, he determined to quit that city and see the world. His proficiency in art was then assured, and honours would doubtless have awaited him had he either remained where he was or returned to Nürnberg. But he preferred to travel.

It was in the autumn of 1846 that Carl Haag left Munich with the intention of going to Paris. On the way, however, he turned aside into Belgium to visit some of his artist friends in that country—Wappers at Antwerp, and Gallait and others at Brussels. While staying in the latter city, he encountered a lady whom he had known in Germany, la Comtesse de Lallaing,[2] and she beset him with a request to paint her portrait. He could not well refuse; and while engaged in the task other commissions were forced upon him, so that in the end he was persuaded to stay in Brussels for five months and through the winter, and the journey to Paris did not take place. But instead, in the spring of 1847, he came to England. One of his chief inducements to visit this country was the opportunity so afforded of acquainting himself with the native school of water-colour painting. How purely local it had hitherto been may be inferred from the fact that, although its fame had reached his ears and excited his curiosity, he had never up to that time seen a single example. The British *aquarelles* were talked of abroad by travellers, but not

[1] They are contained in various works published at Leipzig, and would not be easy to trace.

[2] Her ancestors were patrons of Rubens, and in their family the great painter held the office of page.

exported to the Continent. On his arrival in London in April he went
to the water-colour exhibitions, passing from picture to picture with
ever renewed delight, and especially struck with the perception that
English art was not dependent on 'old master' traditions, but
altogether self-made. He was thereupon fired with an ambition to
be himself one of this band of originals, and accordingly resolved to
take up his residence in London, and endeavour to join the school.

True to this resolve, and to the principle of independence that he
had shown on former occasions, he set to work to discover for himself
the secrets of water-colour art ; beginning, with scientific method, by
making an investigation as to the nature of its materials. At that
time the question of permanence of colours had begun to be seriously
agitated. So, before attempting to paint pictures, he procured, from
most of the artist's colourmen, samples of all the pigments they sup-
plied, and, with the valuable aid of his friend, Mr. (now Sir) Frederick
Abel, submitted them to every variety of test, the result being the
selection of mineral colours for exclusive use. To these alone
he has since adhered in his practice. With them he began to draw
from nature, availing himself of such subjects as the metropolis
afforded. In the summer of 1847 he made many sketches and
studies at the Tower of London and in Westminster Abbey, and a
panorama six feet long from the top of the Monument. At the same
time he was occupied in puzzling out a technique, and settling for
himself his method of working. He had convinced himself that 'in
the elements of water-colour painting there was both a purity and a
power capable of still further development . . . an almost illimitable
field for further discovery and improvement.'[1] Pure *aquarelle*, he
saw, was in its nature opposed to the *gouache* system practised abroad.
Opaque white he had rejected from the first, not as being in itself
unpermanent, but because he distrusted its combination with other
pigments. Using the paper alone for his white lights, he 'took them
out' much after the manner employed as aforesaid (if not invented)
by Turner. He abstained from mixing his colours, applying them
separately in a pure state, in successive superincumbent washes,
stippling with the point of the brush, where needed, afterwards.

Our aspirant was not, however, so wholly taken up with his new
pursuit as to abandon the project of travel which was to enlarge his

[1] Biographical account by M. Phipps-Jackson, prefixed to *Catalogue of Exhibition of
C. Haag's Works* at Goupil's, 1885, p. 6.

mind with a wider view of the world. The winter of 1847–48 was spent at Rome, where he made studies of all kinds of subjects, using for this purpose oils, which he considered best suited for rapid sketching. Returning to London in the spring of 1848, he continued his experimental practice of water-colours, endeavouring now, by more direct comparison, to obtain a power in this material which should equal that of the oil medium. His course was to sketch his subject first in oils, and from the sketch so made to paint his picture in water-colours. At about the same time he took a step which bore witness to his keenness and pleasure in the pursuit of art even in its more elementary stages. In 1848 he entered himself as a student at the Royal Academy, and sat down among a squad of English lads to draw with them from the antique. He had done something of the same kind in his native country. Perspective drawing having always had a strong fascination for him, he had chosen to go through his student's course a second time, after he had become a learned proficient, for the mere enjoyment of observing how a fresh professor of the science would deal with a subject that was familiar to himself. And it was with a similar feeling, and because he held that practice in drawing could never be wasted upon an artist, that he attended the classes of the late John Prescott Knight. To the surprise of George Jones, the keeper, it was casually discovered one day that the young German was as much a master of the subject as the professor himself; and it was with a sense of roguish complacency that our artist received a recommendation from Jones to go *up* to the life school, for which he had shown himself 'fully qualified.' As, however, he did not view that sanctuary from the lower level thus implied, he abstained from availing himself of the privilege.

Carl Haag was so employed in securing for himself, as it were, a second course of art education, when an event occurred which threatened to close abruptly his professional prospect, but had in the end a strongly beneficial influence on his career. On the 8th of December, 1848, a friend had been spending the evening with him at his lodgings in Shaftesbury Terrace, Pimlico, and the two had been amusing themselves by endeavouring to blow out a candle with blank charges from a new pistol just received by the former as a present. When his friend had gone, the powder-flask by some unknown means, perhaps a spark from a cigar, exploded in Haag's right hand, as he held it lightly, and was probably playing with the spring. Stunned

at first, he was aroused by the landlady ; and two young men who lodged in the house and were fortunately at home, one of them being a medical student, came to his assistance, put him to bed, and instead of going to the opera, for which they were dressed, went off and fetched the best surgeon they knew, Prescott Hewett, of St. George's Hospital.[1] He found the poor artist's hand ' torn asunder between the first and middle fingers down to the wrist, the thumb being wrenched from the joint, and remaining attached by the sinews only.'[2] It did not seem possible that the hand could be saved. But this eminent surgeon bound it up and treated it with such skill that in about two months' time Haag was able once more to wield his brush. The period of confinement had been an anxious and weary time to him, but he had employed it in meditation, and it served the purpose of a wholesome fallow in the course of cultivation of his art, and promoted a fresh luxuriance of the subsequent growth. For the first five weeks as he lay in bed, he had continued to paint in fancy, not only composing new designs, but considering the technical processes of his art. The result of all this thinking was that when he again began to paint in water-colours he adopted a new system, contrasting in some respects with his earlier practice, and enabling him more completely to achieve the end he desired.

The change was of the following nature. Whereas, in the first practice, the required tone had been obtained by the addition of layers of thin colour, it is arrived at in the second by the removal of superfluous pigment purposely laid on in extra strength. While the effect produced by the former, with the stippling essential to its completeness, found an analogy in the work of Dürer, the latter had in its result more of the richness and transparency of Rubens. The first efforts of his restored hand were gratefully devoted to the painting of two pictures for the kindly surgeon, whose skill had made this possible, and who had attended him as a friend. The friendship, so commenced, was followed by further benefactions on the part of Sir Prescott Hewett,[3] whose interest and taste in art, and benevolence to artists, are well known ; and it has been cemented by many years of intimacy and mutual regard. He introduced him to Colonel Pennant, afterwards Lord Penrhyn, who was his first patron in England.

[1] Among the sources of relief at that critical time, remembered with gratitude by the artist, was the power of conversing freely in a common language (French), with which both were familiar.

[2] *Portfolio*, June 1878. [3] The baronetcy is of later date.

That gentleman gave him commissions to paint in water-colours fac-similes of some of the oil sketches he had made in Rome. On these being shown to Uwins, our ex-Member, for his opinion, he advised Haag to seek admission into the Water-Colour Society, for which, as he had now become a resident in England, he conceived that he might be eligible. The Secretary, George Fripp, was consulted on the subject, and the result was the artist's election as an Associate on his first application.

That year, 1850, he sent six drawings of Roman subjects, both figure groups and architectural studies. Two of them, 'The Fish-market at Rome' and 'A Group of Pilgrims in sight of St. Peter's, Rome,' were painted for Lord Penrhyn. In the autumn he went to Nürnberg, and remained there painting all the winter, returning to England in the spring of 1851, when his chief drawing at the gallery was an important view of the 'Schoene Brunnen' at Nürnberg, which he had painted on the spot. Still for a few years Carl Haag was partially occupied in painting portraits. These, as the reader knows, were not admissible into the Society's exhibitions. But he sent some to the Royal Academy. In the years from 1849 to 1855 he had eight exhibits there,[1] of which all but the first (called 'The Return from the Vineyard') were portraits. Now, however, he did not confine himself within the limits of the miniatures which had gained him such repute in Germany. He succeeded in an attempt, which it is believed was quite a novel one, to paint heads and half-lengths of life size in water-colours. His power in this department was made manifest in a drawing exhibited at our gallery in 1852, entitled 'A Lady in the Costume of Coblentz.' Portraits which he so painted are not readily distinguishable from works in oil.

In this same year, 1852, after spending the autumn in Rome, being desirous of obtaining subjects of a novel character for exhibition, he went into the Tyrol, seeking untrodden paths, and came by chance upon a hunting castle of the late Prince of Leiningen (our Queen's half-brother) and the Duke of Saxe-Coburg and Gotha, in the valley of the Inner-Riss. There he was found sketching by the Prince, who, on seeing his portfolio, declared that the contents reminded him of works in *aquarelles* which he had seen in England. The justice of the comparison was easily explained. Hospitable entertainment followed, and our artist was detained in the neighbour-

[1] Graves finds ten in all, the last in 1880

hood until the Duke of Coburg's arrival enabled him to complete a commission for a large water-colour picture, introducing portraits of the two illustrious sportsmen returning from a chamois hunt. The Prince also promised an introduction which would enable the artist to submit his sketches to the Queen. Returning to England in the spring of 1853, our artist found that this promise had not been forgotten. Not only had he the gratification of being elected, on the 13th of June, a full Member of our Society, but there awaited him an invitation to Balmoral, whither he went in the autumn. In the meantime the picture that he had painted for the Prince in the Tyrol, which had become the property of her Majesty, was shown at the Society's gallery. Another important drawing of the same year, 1853, was: 'Marino Faliero and the Spy.' In Scotland, Haag accompanied a royal shooting party from Balmoral to the summit of Loch-na-gar, and made sketches thereof which were afterwards elaborated into two large drawings exhibited in 1854 in Pall Mall East. They were entitled respectively, ' Morning in the Highlands— The Royal Family ascending Loch-na-gar,' and ' Evening at Balmoral Castle—The Stags brought Home,'[1] and were painted by command, the one of Prince Albert, the other of the Queen. From the manner in which these commissions were confided to him the artist had for a time to bear the weight of a twofold responsibility of a delicate kind. For they were given separately under pledges of secrecy on his part, it being the simultaneous design of each of the royal couple to present the work so bespoken as a Christmas gift to the other. The following winter Carl Haag spent at Windsor, engaged in completing these pictures. The latter was, in fact, presented to the Queen that Christmas, the former to the Prince Consort on the 26th of August, 1854. Both, together with the Tyrolese drawing, were lent by her Majesty, in January 1890, to the exhibition at the Grosvenor Gallery of ' Works of Art illustrative of and connected with Sport.' Their richness of colour did not perceptibly suffer from the proximity of oil paintings among which they were placed.

In 1854 a series of titles, specified below, which have been conferred upon Carl Haag, began with his appointment as Court-painter (*Hofmaler*) to the reigning Duke of Saxe-Coburg and Gotha. In the autumn of that year he resumed his travels, seeking yet newer

[1] There is a large wood engraving of this, filling two pages of the *Graphic*, 6 December, 1890.

subjects, and visited Dalmatia and Montenegro, where, among other works, he painted a portrait of Prince Danielo of Montenegro. The winter of 1854-55 was passed in Venice. In the exhibition of 1855 he had the unusually large number of thirteen drawings, among which were figure studies from the above localities, a view of the ' Ruins of Salona, in Dalmatia, with a party of Morlachs listening to a Bard singing the history of the destruction of that city ; ' another of the ' Ruins of the Palace of Diocletian, Spalatro ; ' and a drawing of the ' Prince of Wales and Prince Alfred returning from Salmon Spearing ' (the property of Prince Albert). On the 3rd of March, 1856, he writes from Rome, where he is working to make up for time lost by an accident, which also incapacitates him from serving on the year's committee. In the next three exhibitions we find little but studies of Italian and Tyrolese figures.

After another winter in Munich, he was in England for some months in 1858, only to set forth in the autumn upon a tour of greater extent and duration. He then began a long sojourn in the East ; spending that season in Cairo, and the following winter also in Egypt, in company with Frederick Goodall, R.A.[1] He was delighted with the new ground on which he had entered. A letter to Secretary Jenkins, in the spring, apologizes for his not sending a single drawing to the gallery for exhibition in 1859, on the plea of want of time under ' the hard work in sketching and collecting the most valuable materials one meets with here at every step. . . . Tell those,' he adds, ' that are in search of new ground of subjects for their pencil that there is but one Cairo, and artists ought to see it. Goodall and I have spent a most delightful winter here. The weather was ever fine. The most grand and picturesque subjects crowded upon us. We met with no difficulties whatever, but made most valuable acquaintances, and many a good friend among the here residing Europeans.' They had just returned from a week's sketching at the Pyramids, and were preparing for another sketching trip in the desert towards Suez. ' After that,' he says, ' I shall start for Jerusalem, where I intend staying over Easter. My way will be through the short dessert. The coming somer and autumn will find me travelling about in Syria and among the Greek Islands. We winter in Cairo again. The result of these journeys will, I hope, enable me to send home much new stuff from these old places. If God preserves my life and health,

[1] Then A. R. A.

I shall come home to old England in the spring of 1860, when I hope to meet you in best health and have many a pipe together looking over the new Portefoglios.' One sees from this letter not only how he had come to regard this country as his home, but how nearly by that time he had mastered the English tongue ; and it affords some suggestion of the lively geniality of his humour. The scheme of travel was executed nearly in accordance with this programme. The latter part of April 1859 found him in Jerusalem at the Easter festivals, and sketching the Holy Places. In the summer he travelled in Samaria and Galilee, and in the autumn went to Palmyra. Thence he returned to Egypt for the second winter. In the course of these peregrinations he had lost no opportunity of studying Eastern life, more particularly that of the various desert tribes. For this latter purpose he sojourned long among the Bedaween Arabs, learning their manners and habits of living, as well as noting their appearance and costume. The result was that, on his return to England early in 1860, he had a store of material and memories, which enabled him to assume what was then quite a unique position as an illustrator of the East. His four drawings that year constitute an epoch in his career as being the first of the series of subjects of this class, for which he has since then been chiefly celebrated. They were all notified as 'painted on the spot,' and were entered under the following titles :— ' Ruins of the Temple of the Sun, Palmyra (the Ancient Tadmor in the Wilderness) ; ' 'Preparing for an Encampment at Palmyra ; ' ' The Cave beneath the Holy Rock, Mosque of Omar, Jerusalem ; ' and ' The Jews wailing at the Temple Wall.' The last two were painted by command of her Majesty. The first was a work of special importance.

In this year Haag gave further and loyal proof of his adoption of the home of water-colour painting as his country, by joining the Volunteer movement which had arisen in his absence, and enrolling himself in the Artists' Corps, in which he served for the next seven years. He has been heard to relate, with comic gusto (for he is an excellent *raconteur*), how, on a winter's morning when engaged in cleaning his rifle, he heard what seemed to his martially disposed ear, attuned by thoughts of French invasion, to be a cry of ' War's broke out.' On his presenting himself, weapon in hand, at the window, to the amusement of some passers-by, it, however, resolved itself into the more familiar complaint, ' We're all froze out.' In the course of the next five or six years he exhibited divers views in the East, including the

Acropólis of Athens (1861), two of the Gates of Jerusalem[1] (1861, 1864), and several of Baálbek, or Palmyra (1862, 1863, 1865). Haag was again summoned to Balmoral in 1863—the Prince Consort having died in December 1861—and a picture, exhibited in 1865, of one of the last happy scenes in her Majesty's married life, 'Fording Poll Taibh in Glen Tilt,' was the result. Well assured in his high position, and pos-sessed of ample material to work upon, our artist now led a more settled life. He resided at 16 New Burlington Street when in London, and he further provided himself with a studio on the Rhine, both for his own sketching and to serve as the summer resort of his now aged mother. For this purpose he, in 1864, bought and furnished an old tower at Oberwesel. But his bachelor life, comfortable as it was, was soon to be superseded by a better; for in 1866 he led to the hymeneal altar the only daughter of General Büttner,[2] Commandant of Lüneburg, in Hanover. The issue of the marriage has been three sons and one daughter. On marrying, he bought his present house in Lynd-hurst Road, Hampstead, and gave it the name of 'Ida Villa,' after Mrs. Haag's baptismal prænomen. There he built a very handsome studio,[3] in the Egyptian style of architecture, a notable example of the luxurious artist-habitations which in the present day contrast so nobly with the straitened surroundings of the struggling draftsmen who founded the now Royal Society of Painters in Water-Colours.

One more visit to Egypt took place in 1873, when Haag was entertained by the Khedive on an introduction by the Prince of Wales. In the same year a large dramatic drawing entitled 'Danger in the Desert,' which was exhibited here in 1871, gained an Art Medal at Vienna. It was exhibited in Paris in 1878, and has been etched by L. Flameng in the *Portfolio* of June 1878. Other of the most striking of the later works have been 'The Swooping Terror of the Desert' (1873), representing an eagle threatening an attack on a travelling group; and the 'Sphynx of Geezeh and Pyramid of Cheops' (1880). Works of so elaborate a nature cannot, of necessity, be very numerous. From his first appearance in 1850 to 1881 Haag ex-hibited 130 drawings in the summer show and 144 sketches and

[1] A third, the 'Golden' Gate, was not shown.

[2] General Büttner, of whom our artist painted a life-size portrait in water-colours, which was exhibited at the Royal Academy, served under three English Kings of Hanover, and was present at the Battle of Waterloo.

[3] A description of it by M. Phipps-Jackson, illustrated with cuts, is in the *Art Journal* for March 1883, under the title 'Cairo in London.'

studies (including six in frames with others) in the winter ; making a total so far of 274 subjects. In 1876 a loan collection of eighty-eight of his paintings, studies, and sketches, illustrating his career, was exhibited at the German Athenæum in Mortimer Street ; and another assemblage of his works was made at Messrs. Goupil's in New Bond Street in 1885.´ Besides the office of *Hofmaler* above mentioned to have been conferred upon him by the Duke of Coburg, Carl Haag has received from time to time the following foreign titles and distinctions in recognition of his talent as a painter :—Honorary Member of the Société Royale Belge des Aquarellistes, at Brussels, 1864 ; Royal Bavarian Cross of Merit, 1872 ; Officer of the Order of the Medjidié, 1874 ; Knight of the Legion of Honour, France, 1878 ; Knight-Commander of the Saxe Ernestine House Order, 1887. He was also elected an Honorary Member of the Royal Society of British Artists in 1882. A recent notice of Haag's life and works from the able pen of Mr. Frederick Wedmore, with a self-drawn portrait of the· artist, and six cuts from his pictures and sketches, is contained in the· *Magazine of Art* for December 1889.

The second Associate elected on the 11th of February, 1850, was PAUL JACOB NAFTEL, now also a well-known living Member of the Society. He was raised to the full rank of membership on the 13th of June, 1859. Naftel was a native of the Channel Islands, and at the time of his election resided in Guernsey, where he was largely employed in tuition, not only as drawing-master at the college there, but as a private teacher of amateurs. He did not take up his residence in England until the latter part of the year 1870, after which, for the next thirteen years, he lived at 4 St. Stephen's Square, Westbourne Park.[1] On settling here he again became very successful as a teacher of landscape drawing in water-colours, from which department of the art he has never swerved. The educational practice which he left behind him in Guernsey was taken up by a son of our late Member, Joseph Nash. Naftel had, as before mentioned, married a daughter of Octavius Oakley. Mrs. Naftel is herself an accomplished artist, and the talent thus shown on both sides was transmitted to an only daughter, the late Maud Naftel, whose premature death within three years of her election as an Associate is now mourned by the Society.

> [1] He thence moved to his present residence and studio at 76 Elm Park Road, Fulham Road, Chelsea, in 1883-84.

· Our artist's life having been devoted to his profession, in which he has ever been an assiduous worker, its noteworthy incidents are mainly the travels and changes implied in the varied localities from which his exhibited landscapes have been taken. Of these an inspec. tion of the catalogues gives the following statistics. From the time when he joined the Society in 1850 to the epoch of 1881 he had exhibited in the gallery 520 drawings or frames of studies, or nearly 550 separate works or sketches, 298 of which were in the summer shows. And he has since then continued to be a prolific contributor. As during the first twenty years of this period Naftel still resided in Guernsey, a large proportion of his earlier drawings were of scenes in the Channel Islands. These were his recognized *spécialité*. Among the familiar features of the ' Old Water-Colour ' exhibitions were, for many years, his pretty little reminders of the bright contrasts of colour afforded by the gay vegetation that sparkles on these granitic rocks, and crowns the sea-cliffs which rise pink and grey above clear blue waves ; as well as his graceful studies of the tangled water-lanes and embowered stone-built springs that are characteristic of the locality. These drawings were further remarkable for an extremely lavish use of body colour, less prevalent in the painter's later practice. That their artist quality is not dependent, however, on colour alone, is made manifest in a series of effective woodcuts from his designs, which adorn the late Professor Ansted and Dr. Latham's elaborate book on *The Channel Islands*, 8vo, 1862. The remainder of his land- scapes are from studies made in various districts of the United King- dom ; and abroad, for the most part, in Italy. In the home category we have a considerable number from Scotland, beginning in 1859 with views of Loch Lomond and in the Perthshire Highlands. In 1866 are some from the Isle of Skye ; a few from Arran occur between 1875 and 1877 ; and Ross-shire affords more in 1879. North Wales gives us one in 1850, but very few more until 1875, after which they become more numerous thence, particularly in the winter show of 1875-6. Between 1872 and 1875, and afterwards, there are drawings from one spot only (Penllergare) in South Wales. Between 1858 and 1864 there are about half a dozen Irish subjects, from the counties of Wicklow and Kerry, and again in 1878 a group from Killarney and Glengariff. Of the English counties, York- shire furnishes its contingent from the Wharfe, the Greta, and the Tees, in 1867, 1868' and later years ; Cumberland, some views of

Borrowdale, chiefly in 1872 ; North Devon and Somerset, a few in 1853 and 1854; and one or two other counties a drawing or two each, including a set from Madingley near Cambridge in 1864-5, where the Prince of Wales resided when at the University. Views at Windsor and Eton, and on the Thames, were exhibited in 1857, 1858, 1863-4, 1869, and 1877. The foreign subjects begin as early as 1851 with three from Switzerland, being scenes on the Grimsel route. The first Italian views are in 1860, and the six years that follow, being chiefly from the Bays of Salerno and Naples, and including nine or ten drawings of the ruins at Pæstum. In 1861, 1862, and 1865, there are some from North Italy, of Venice and the Lago Maggiore, &c. Thence, and on the St. Gothard Pass, are also some views in 1877, with one at Bordighera. There are, moreover, three outlying subjects from Spain (one of Cadiz and two of Seville) in 1871, and three from the Pyrenees in 1881. His drawings of later date do not come within the scope of this history.

The Lady Member elected on the 11th of February, 1850, was Miss NANCY RAYNER, eldest of the five artist daughters of the then Associate, Samuel Rayner, who directed her studies in art from an early age, when her talent showed a strong power of development. She is said also to have ' owed much to the advice and friendship of Cattermole, Oakley, David Cox, Samuel Prout, Frank Stone, and more especially David Roberts.'[1] Picturesque and rustic figures, and careful studies of interiors, were what she mostly painted. Her works are not numerous, owing to the shortness of her mortal career, which was terminated in 1855 at the age of twenty-eight by a slow decline. In the six years of her connexion with the Society, from 1850 to 1855, she exhibited only thirteen drawings. Among her four in 1852 were two interiors of Knole. After that she had but one a year, the last of which was quaintly called 'An Equestrian Portrait of an Officer in her Majesty's Service, taken at St. Martin's-le-Grand.' She is said to have been ' unusually successful in securing fame and high patronage as soon as her works were brought before the public.'[2] On the 30th of November, 1855, at her mother's solicitation, a sum of 20l. was voted by the Society, by way of help to her surviving sisters.

One Associate only was elected on the 10th of February, 1851,

[1] *English Female Artists*, i. 383. [2] *Ibid.*

out of sixteen candidates. This was JOHN BURGESS, an artist of original taste, known almost exclusively to the public by his skilful and picturesque treatment of architectural subjects. His fame has scarcely been commensurate with his merit, owing to a temperament that restrained him from pushing himself even into the rank to which he was fairly entitled. He is said to have owed his election mainly to a strong advocacy of his claims by George Cattermole, who ex. tolled the ' fine spirit ' of his drawing, and regarded his entry into the Society as an infusion of new blood whereof he thought it was then in need. During the twenty-four years of his exhibiting in Pall Mall East, he remained an Associate only ; but throughout that time con. tributed steadily to the gallery, his works there amounting in all to 258. With few exceptions they represent foreign buildings and street scenes, mostly in France, from Normandy and Brittany, and other districts north of the Loire, extending (chiefly in 1858) into Burgundy on the east. Belgium (1852 &c.), Holland (1857), Westphalia (1859 to 1861), and Nuremberg (*passim*) supply further subjects. They are generally of Gothic architecture, to which a few studies of Roman remains at Trèves and Arles form exceptions. In his later time, and more commonly in the winter exhibitions, there are to be found a few landscape sketches, chiefly from the neighbourhood of Leaming. ton, where he lived. It is said, indeed, that he much disliked to be called an architectural artist, feeling conscious of his power in land. scape, and considering that his best work lay in that department. A series of unexhibited pencil drawings in Derbyshire and South Wales, as well as in Warwickshire, many now dispersed, are probably the best evidence in support of his opinion.[1]

Burgess was about thirty-seven years of age at the time of his election, and had been established for about ten years as a successful teacher of drawing at Leamington ; having taken up the practice there of one Mrs. Dighton (widow of Dennis Dighton, military painter) on the purchase of her goodwill. He came, by both parents, of a remarkably artistic stock. On the father's side he is reported to have belonged to a fifth generation of painters ;[2] of four of these we have further details. His great-grandfather, a portrait painter of

[1] At the British Museum are two bold landscape sketches by Burgess in sepia and indigo.

[2] See ' The Late John Burgess, Esq., of the Society of Painters in Water-Colours.' A sketch by Rosario Aspa. Reprinted from the *Leamington Spa Courier*, February 1877. From this pamphlet most of the facts of this notice are derived.

merit both in oils and crayons,[1] had three sons who followed art, namely, Thomas Burgess, an artist of promise, who died young ; H. W. Burgess,[2] landscape painter to King William IV., author of a set of large lithographic ' *Views of the General Character and Appearance of Trees*, Foreign and Indigenous, as connected with Picturesque Scenery,' published in 1827 ; and *John Cart Burgess*, who painted flowers, is said also to have published works on art, and was our Associate's father.[3] On the mother's side the roll is scarcely less full of artists' names. She herself was a silver medallist for sculpture at the Royal Academy, and one of four children of Anker Smith, the engraver and A.R.A., who followed the arts. Her three brothers referred to were Edwin D. Smith (a miniature painter) ; Herbert L. Smith (historical and portrait painter, who died in 1870) ; and Frederick Smith (sculptor, a pupil of Chantrey's, who died young).

It is to be inferred from these surroundings that any proclivity which he may have shown for artistic pursuits would have been duly encouraged. But his earliest *penchant* was for the sea, and this he was allowed to indulge, in a Channel cruise. Landing, however, in the course of it, on the Isle of Wight, he discovered the superior attraction of the pencil, and subsequent sketching on the Thames with his uncle, the Court landscapist, confirmed him in the choice of his professional career. Then he went abroad and made sketches, of a large size, in Normandy. But he was at that time intended for a figure painter ; so, after a sojourn in Paris in 1833, he travelled to Italy, *viâ* Turin, to complete his education in art. There he remained from 1834 to 1837, making many miscellaneous sketches, and no doubt maturing his taste in a congenial atmosphere. But he had not the faculty of systematic application required for the higher study of the figure ; although many of his life sketches, and the groups that animate his street scenes, denote his power in this line, which included considerable grasp of character. His real inclination was for landscape ; and here also he had full liberty to follow his bent. Being in

[1] A portrait by him of a ' Dr. Yonge ' was exhibited among the ' Old Masters ' at the Royal Academy in January 1877. See a letter from ' A Granddaughter of the Artist,' in the *Times* of 17 January, 1877, naming several members of the family who followed his profession.

[2] J. B. Burgess, R.A., the well-known living painter of Spanish subjects, is his son.

[3] The son's name is given in the letter in the *Times* above referred to as ' J. C. Burgess.' But the Water-Colour Society Catalogue describes him simply as ' John Burgess, junior.'

easy circumstances, he enjoyed life in Florence and Rome, proceeding thence to Naples. And when he returned to England in the year of her Majesty's accession, he brought back a portfolio of sketches of merit enough to justify his courtier uncle in submitting them for the young Queen's inspection. Her Majesty graciously selected a subject from his portfolio, and commanded a drawing thereof for the royal album. It is noted by his biographer as characteristic of the artist's modesty, that the sum he asked for the finished work being con-sidered to be very much less than its value, he was paid twice the amount as a better approximation to a fair price. He continued his study of nature by sketching in Devon and collecting 'street bits in Surrey,' and views on the Thames, and so maturing his art, until, in 1840, he settled in Leamington, and bought the teaching business there. It secured him a steady income, and, in 1842, he married Miss Vaughan of Llanelly. 'Wellington House, Leamington,' remained his home during the whole time of his connexion with the Society, which ended with his life on the 11th of June, 1874.

Burgess's coloured drawings are admired for the clearness and range of their greys. 'Sunny and cheerful effects are the rule, while a play of colour pervades every work, most agreeable to the eye, and satisfactory to the judgment.'[1] It was, however, in his use of the lead pencil that his strength and originality as an artist were most apparent. He was an extremely able sketcher, and his archi-tectural drawings made on the spot take rank with those of Prout and Edridge, being indeed favourably compared with the former in respect of the better drawing of his figures, as well as the more im-pulsive quality of his suggestion of nature. Like Prout he preferred to sketch standing, not only because it gave him more facility of escape from a crowd of lookers-on, but because one's ordinary view of nature is observed from the eye-level so obtained. He chiefly drew on tinted paper, with French pencils of two powers of tone, putting in the high lights with opaque white. He used his pencil in the manner of a brush, to produce both flat and graduated tints, and got special effects by the ways in which he fashioned the point and applied the implement. For example, he had a device of indenting the paper with the uncut end of the pencil before laying on the black lead. 'It should be remembered,' says his biographer,

[1] Sketch of his Life, by R. Aspa, p. 8.

'that Burgess's powers can only be judged by the studies he made from nature, or the finished works he produced from them ; as, for instance, those shown at the exhibitions of the Society to which he belonged.' This he affirms by way of warning to collectors who may have offered to them as 'drawings by Burgess' some of the numerous bits which the artist knocked off for his pupils' edification, to illustrate, it may be, defects as well as principles. These, it is contended, ought not to have been preserved.

In personal character Burgess was the reverse of conventional. A rugged exterior concealed the goodness of his heart. He was a warm friend to those he esteemed, but a strong hater of humbugs. An honest pride forbade him to pass himself off as a better man than he was, but inclined him at the same time to be dissatisfied with less than due appreciation. Thus he was chary of parting with his works to those who could not understand their quality, and would habitually show his worst drawings to strangers. He would raise his price to one who tried to lower it, and make the rate of his charges inversely proportional to the good judgment of the buyer.; while an independent spirit kept him aloof from dealers. Mr. Aspa, in the obituary memoir above quoted, relates a number of anecdotes illustrating these traits of character. When asked where his best drawings were to be found for the Manchester 'Art Treasures' Exhibition in 1857, Burgess wrote to Jenkins : 'I cannot look back with any particular pleasure on any of the works I have sold. I believe my best drawings are in my own possession.' The only two there exhibited, ' Roodloft under Repair ' and ' Cathedral of Chartres,' were accordingly contributed by the artist himself. He had two works at the Royal Academy in 1860 and 1861. His remaining works were sold at Christie's on the 3rd of February, 1876.

In the three years 1852 to 1854 the name JOHN BOSTOCK, of 7 Campden Hill Villas, Kensington, appears as that of an Associate exhibitor, attached to four drawings only. The Minute-book records that he was elected on the 9th of June, 1851, and that his name was withdrawn from the list of Associates in the catalogue for 1855, as he had not sent any drawing for that year's Exhibition. In answer to a letter of inquiry from him, dated 27 March, 1856, he was informed that he must be proposed again, according to rule, if he wished to become once more an exhibitor. It does not appear

whether he again became a candidate, and there is, indeed, no further trace of his career. The titles of his four drawings are—in the 1st year, 'Going to Market,' and 'The Lonely One,' with desponding verses by T. K. Hervey in elucidation of the sentiment; in the 2nd, 'The Inseparables;' and in the 3rd, 'A Gathering for the Birthday.' These are subjects which, a few years earlier at least, would have raised a strong suspicion of alliance with the Annuals; and on a search among volumes of that class, the same name is found under the following prints :—In Heath's *Book of Beauty* : 1835, 'The Lady Elizabeth Leveson Gower' (engraved by H. T. Ryall); 1837, 'Juliet' (W. Eagleton), and 'Ila' (H. Austen); 1838, 'Marguerite' (H. Robinson); 1839, 'Miss Ellen Home Purvis' (G. Stodart); 1840, 'The Lady Gardner' (W. H. Mote), 'The Hon. Mrs. William Ashley' (H. Robinson), and 'The Lady Williams Bulkeley' (H. Robinson).—In the *Keepsake* : 1836, 'Camilla' (J. Thomson);[1] 'Fashion's Idol' (H. Ryall);[1] 1840, 'Florine' (W. H. Mote).—In Fisher's *Drawing-Room Scrap-Book* : 1841, 'Katherine Airlie' (H. Cook); 1849, 'Frances Diana Manners Sutton' (H. Robinson).

At the election on the 9th of February, 1852, there were nine candidates, of whom two were accepted as Associates and one as a Lady Exhibitor. The name of the first was already distinguished, and destined to be more so. It was JOHN GILBERT, now Sir John Gilbert, R.A., and President of the Royal Society of Painters in Water-Colours. Sir John was, it need scarcely be said, a born artist. As has been the case with so many of the eminent men whose careers are here registered, his bent was not only pronounced in boyhood, but it proved strong enough to override the plans which his parents had endeavoured to form for his course through life. He was born in 1817, at Blackheath, where his father resided, a gentleman of good family in Derbyshire, of limited income, captain of the Royal East London Militia, who upon the disbanding of that regiment found it necessary to turn his attention to business as a land and estate agent. The pursuit of Art being thought to be out of the question, it was looked upon as fortunate when a friendly neighbour, a Mr. Dickson, who held a large farm at Kidbrook, close by, offered to take the lad into his office in the City, where he too carried on the business

[1] To these the draftsman's name is given as 'W. Bostock.' Graves attributes fifty-nine exhibited works, specially portraits, to 'James Bestock,' between 1826 and 1869.

of an estate agent. There the young Gilbert remained for about two years.

The office of the firm of Dickson & Bell was in Charlotte Row, the name then given to a few houses which lay between the Poultry and the east end of Bucklersbury, a locality now much altered by the formation of Queen Victoria Street; and it happened that the room in which the pupil was placed had a window nearly opposite to the side door of the Mansion House that not only commanded a prospect of the crowded and continuous flow of traffic through the main artery of the City, but afforded on occasions a view of the pomp and circumstance that cluster about the dwelling of the great Lord Mayor. It is easy for anyone acquainted with the proclivities evinced in much of the artist's after-work to understand the fascination exercised by such a moving and motley scene, and how his attention came to be absorbed by what was going on in the street outside. There was not much work doing in the office, so he was for ever making sketches of passing objects, and, however little he may have learnt of mensuration or land surveying, he at least was storing his mind and his portfolio with a mass of useful memoranda, comprising, among other things, graphic notes of costumes and liveries of City companies complete to the last buckle, and the many florid trappings that so enhance the dignity of the Corporation of London. When circumstances permitted, he would, moreover, betake himself to Woolwich Common to watch and sketch the Royal Horse Artillery at their manœuvres, and of these and other troops he made a vast number of studies, until he had drawings of most of the uniforms of the British Army. The way in which the young man employed his time was duly reported to his parents, and, on his hoard of clever sketches being brought under serious consideration at home, it became abundantly evident in what direction lay his natural bent. He was then, mainly on his mother's intercession, allowed to pursue it, and, wisely, in his own way. He took a few lessons, chiefly in colour, from George Lance, the late able painter of still life; but, with this exception, had no teacher but himself and his own observation of nature and art.

His first exhibited work was a water-colour drawing at the Society of British Artists in Suffolk Street, in 1836, of 'The Arrest of Lord Hastings at the Council Board in the Tower by the Protector, Richard Duke of Gloucester.' The next year, 1837, he had an oil picture

there of 'The Coronation of Inez de Castro,' the first he had exhibited in that medium, a venture the year before at the Academy having been rejected there. In 1838, however, he had a ' Portrait of a Gentle. man' in the first exhibition held in Trafalgar Square, and between 1840 and 1851 ten subject-pieces there, either in water-colour or oil, all of historic incidents or illustrations of Shakspere or 'Don Quixote,' except one from Scott's ' Monastery.'[1] He also exhibited, according to Graves's list, as many as forty pictures at the British Institution, where, it will be recollected, neither water-colours nor portraits were admitted.

Before, however, John Gilbert had done much of this work with the brush, the special aptitude of his talent in another way had been discovered and acknowledged, and turned to most profitable account, not only by himself, but by his employers, to the great advantage of British art, and literature as well. Some of his pen-and-ink drawings coming to the hand of Mr. John Sheepshanks, the munificent donor of pictures to the nation, that gentleman showed them to Mulready, who advised that the artist should seek employment in drawing on wood for book illustration. Duncan also, who had much experience in such matters, on being asked whether he thought that the young man might hope to make his bread and cheese by such an occupation, declared that many a publisher would be delighted to avail himself of such talent. Gilbert was then entering upon his majority. He began in 1838 by illustrating a child's book of Nursery Rhymes; and soon devoted himself mainly to wood drawing, in which his success as an illustrator was quite without a precedent. The main story of his life henceforward until the time of his election into our Society would be comprised in or indicated by a list of the engravings designed by him for this purpose. It is impossible, however, to furnish a complete catalogue even of the works he has so adorned. ' I have illustrated,' he writes, ' nearly every British Poet, illustrated newspapers, cheap weekly publications, books of all kinds, too numerous to name.' The names of the books so enriched, wholly or in part, by Sir John Gilbert occupy nearly six pages of the British Museum Library folio catalogue, and are comprised in little short of 150 separate entries. He made a distinct mark as the originator of a new and improved style in such embellishments. ' His influence,'

[1] Two of these, a scene from *Don Quixote*, representing Sancho ' entering the gates of sleep ' (1849), and ' Touchstone and the Shepherd ' from *As You Like It* (1850), are wrongly attributed in the catalogues to J. (i.e. Josiah) Gilbert of Ongar; and *per contra*, three portraits by the latter, in 1847 and 1849, are unduly credited to J. Gilbert of Blackheath.

says a writer in the journal that derived chief benefit therefrom,
'developed an eminently daring, suggestive, picturesque, and playful
style of wood engraving, quite novel in the history of the art, which
commends itself by its admirable appropriateness to the nature of
the material and the methods of printing.'[1] It was to the enterprise
of the late Herbert Ingram that the foundation was due of the
newspaper from which the above words are taken, and with it that of
pictorial journalism in general. But the early success of the move-
ment whereof the *Illustrated London News* was the pioneer was to
an appreciable extent derived from the aptitude displayed by the
proprietor's friend John Gilbert, long employed as its leading artist,
whose style of drawing, singularly well fitted to the purpose in hand,
became, and remained for many years, the model for this kind of
illustrative work. Since that time, with the development of photo-
graphy, and its applications, and the introduction of divers mechanical
and other methods of aiding or superseding the craftsman's labour,
not to mention new theories of graphic delineation, the art of the
wood engraver has passed into new phases. But at the period in
question there were no such effective means of conveying to the eye
a vivid impression of the scenes of passing events of note, as those
afforded by our artist's free pencilling, cut as it was in facsimile upon
the block. The class of subjects, moreover, which he had hitherto
chiefly studied, the moving crowds, and incidents of London life and
ceremonial, were precisely calculated to serve his turn as a delineator
of the public events of the day. This had been his 'drawing from
the life,' his preparation for the painting of 'history.' He had neither
time nor inclination now to employ 'models' in the ordinary sense,
or build up his subjects by slow degrees in the studio. What he
sketched he presented as it passed before his eye, visual or mental.
The power he had thus acquired of rapid and decisive drawing, and
readiness of design that guided his hand, were extraordinary. He
has been known to put an elaborate working drawing on the block
while the publisher's messenger was waiting. Some of his large
two-page cuts for the newspaper were executed thus. He would first
sketch the whole design in ink upon the plain surface of the compound
block, made up as it necessarily was of a number of smaller ones
clamped together. This he would then cover with white, the ink
marks just showing through as a guide. Then he would begin the

[1] *Illustrated London News*, 16 March, 1872.

engraver's drawing upon the top left-hand elemental block, which, when covered with the necessary lines, would be screwed off and sent to the engraver. So with a second, and a third, and all the rest, until the design was complete. It might thus happen that the first detached portion would be under the engraver's hand before the last was out of the draftsman's. When the imagination had to be called into play, as generally in book illustration, the power of visualizing was no less remarkable. 'Sir John Gilbert,' said a late critic, 'has the faculty of thinking out his subject at the end of his pencil. He extemporizes on paper as a musician does on the piano; a theme given, he can reduce it to form; a narrative read, he at once knows how best a picture can be made. His fertility of pictorial invention is inexhaustible.' [1]

Gilbert's contributions to the *Illustrated London News* begin with its first number, published on 14 May, 1842, and extend until the time when he left off that kind of work. Among the 'cheap weekly publications' for which he drew on wood in his early time, the most important was the *London Journal* (first issued in 1845), a penny periodical of small 4to size, part of which was devoted to more or less sensational fiction. But its importance was derived from the very effective woodcuts on the upper half of the first page of each number, representing some scene of the story in course of issue. These were not only telling and vigorous in the delineation, and rendered attractive to the ordinary eye by forcible contrasts of black and white (and what engravers call 'colour'), but they displayed to the more cultivated taste a degree of refinement and artistic feeling hitherto unknown in illustrations of their class. When Mr. Jenkins was forming the nucleus of a collection of Members' works for preservation in the Society's Library, one of the present Associates [2] wrote to him in March, 1879:—'The works of Sir John Gilbert alone are so multitudinous and admirable that they would form an important part of the collection. Many of his best designs might be culled from the numbers of the *London Journal* and of *Reynolds's Miscellany*, which made me look for their weekly appearance when I was a boy, as eagerly as the public do now for a Millais at the Academy.' Nearly all the book illustrations have also been drawn on wood, and many were executed before the date of his joining the Water-Colour

[1] J. B. Atkinson's *English Artists of the Present Day*.
[2] Mr. Shields, himself distinguished as a draftsman on wood.

Society. He also drew upon stone a series of *Chronological Pictures of English History*, containing some hundreds of scenes and portraits, grouped together, a folio page for each reign or period, published in 1842-3 by Roake & Varty (afterwards Varty alone), of 31 Strand.[1] He has also produced a considerable number of etchings, including four or six for Carleton's *Traits and Stories of the Irish Peasantry*.

Though elected a Member, with the late Samuel Palmer, on the 12th of June, 1854, Sir John had only exhibited as an Associate when President Fielding died in March 1855. During his three years in the junior rank, he had exhibited ten drawings, most of which were typical in subject of those in the long series that have followed. Especially so were two studies in the first year, of a ' Standard Bearer ' and ' A Trumpeter,' which were eminently characteristic of his proclivities. Similar subjects have been repeated by him from time to time with evident gusto. The first two years' exhibits also included scenes from some of Shakspere's historical plays (Richard II. and III.), and the third, a drawing of ' Hudibras in the Stocks.' After becoming a Member he remained a constant exhibitor, his drawings, many of them large in size, being chiefly illustrative of historic incidents, generally English, and often as represented by our great dramatist, whose plays have afforded him an inexhaustible mine of motives. Other standard poets and writers of fiction, none more often than Cervantes, have supplied many of the subjects. With these have been some representations of modern life and fancy scenes from bygone times. While working thus with the brush, he in no degree relaxed his industry in drawing for the engraver. The list of books containing his designs becomes fuller and fuller with the increasing years. Most noteworthy of all was the elaborate *Illustrated Shakespeare*, edited by Howard Staunton, and published by Routledge in monthly numbers, beginning in December 1856. This work was steadily pursued, one play every month, and, after being three years in hand, was issued complete in three handsome volumes with its hundreds of wood engravings. Illustrations of the ' Songs and Sonnets ' followed, and editions of various poets and standard writers, mostly published by the above-named firm. They comprise the poetical works of Milton, Pope, Goldsmith, Cowper, Burns, Scott, Campbell, Wordsworth, Longfellow, and others of minor note. Illus-

[1] Five out of the thirty-eight lithographs are by Waterhouse Hawkins, the rest by Gilbert.

trations to the *Book of Job*, the *Pilgrim's Progress*, the *Proverbs of Solomon* (by historical parallels), Fox's *Book of Martyrs*, the *Swiss Family Robinson*, and many other books of various kinds, with collec_tions of Ballads, and Fairy and Nursery Tales, were poured forth continuously from his prolific pencil for a long series of years, while he was at the same time painting both in oil and water colour. Coloured facsimiles of his pictures have also been published on a large scale as supplements to the *Illustrated London News,* and on a smaller scale in *The Art Album,* 1861 (afterwards reissued in 'Beauties of Poetry and Art,' 1865).

When Gilbert handles the brush, at least in his water-colour drawing, it is in a manner distinctly founded on his practice when working for the press, the surfaces being habitually modelled by means of lines such as those which he would make with pen or pencil to guide the engraver. Even shading and shadow seem primarily con_ceived in line. These peculiarities give a marked character, and for some purposes a strongly expressive quality, to his work. Gilbert's firm and robust style of illustration, while it was the very opposite to the laboured sweetness of the Annuals, had at the same time nothing in common with what at the period of his rising became known as the school of the pre-Raphaelites. His painting is not minutely realistic. To the sense of form which governed it, mediæval dryness and angularity are altogether repellent. His pencilling leads the eye by .way of flowing lines, of well-rounded curvature, that give a richness to their contrasts, and a fullness to the forms they inclose. These qualities belong to the Renaissance, and harmonize with Classic taste rather than Gothic, and that of the Roman more than the Greek. .What influence he has derived from the 'old masters' seems due to the Flemish school, and more particularly Rubens, to whose works, albeit the application of their art is very different, those of Gilbert bear a strong resemblance, both in form and composition, and to a considerable degree in colour. There is a *soupçon* also of a Spanish element in his use of black, caught peradventure in the Netherlands, that gives local character to his many scenes from 'Don Quixote' and 'Gil Blas.' As a colourist he is striking and powerful, fond of ˙rich and full contrasts, with a partiality for scarlet, whether in soldier's -tunic· or cardinal's robe, and for the fine harmonies of black and yellow that occur in gold lace and state trappings of British royalty. The keynote seems to have been struck during his early studies near

the Mansion House and on Woolwich Common ; and some of Sir John's most effective pictures in later times have still been illustrative of scenes of military and state pageantry not unfamiliar to dwellers within the sound of Bow bells.

Painter, on a moderate scale, of ' history,' in all senses of the word, Sir John would be entitled, by virtue of a large group of his works to take primary rank as a military painter also. He has not indeed depicted the wars of his time, though on an occasion he portrayed the supplemental scene to one such tragedy, in a picture exhibited in 1856 at Pall Mall East of ' Her Majesty the Queen inspecting the Wounded Coldstream Guards at Buckingham Palace,' after the close of the Crimean campaign. When, however, he gives a rein to his fancy, he is commonly carried to the battle fields of old ; and there he plunges into the thick of the fray. It is in subjects of this kind that he most exhibits the individuality of his genius. Like Cattermole, he imbues himself with an ideal spirit of the past, which gives a marked unity to the representation. There are, nevertheless, essential differences between the two painters, not only in sentiment, but in the artistic treatment of their subjects. Gilbert's force lies more in the play of line, Cattermole's more in picturesque grouping. Gilbert's crowds do not possess the suavity and repose, the ' temperance even in the whirlwind of passion,' that ' give smoothness ' to the well-balanced composition of Cattermole. But the heavy troops and big Flemish war-horses that he moves in masses over the rolling ground have a sway in their combined movement which his predecessor never attempted. And when they charge, it is with a rush that carries all on earth before it, and seems to sweep along with it the wreaths of cannon smoke and the very clouds of heaven. In many of Gilbert's fancy subjects, wherein he delineates soldiers on the march and the like, a wild forest landscape is a main part of the motive. Here, again, the influence of Rubens is apparent, though the application is thoroughly British, and suggestive of the ruggedness of England in the olden time.

With such constant devotion to his art, the events of Sir John Gilbert's life have not been greatly varied. For more than fifty years he has been continually at work, with few holidays, spent in travelling about England and Scotland, France, Belgium, and Holland. But the benefits that he has conferred upon the Society are not confined to his contributions to the gallery walls. They began before he

occupied the presidential chair. It was, as before mentioned, owing to his suggestion and advocacy in the year 1862, that the attractions of that gallery have been nearly doubled by the establishment of a second annual exhibition. The circumstances have been already referred to. The reader will recollect that up to that time the Society had been in the habit of under-letting their room in the winter time, when it had been used by dealers and others for various art exhibitions. This appeared to many of the Members, and to Gilbert among them, to be objectionable in some respects, and the question of retaining the gallery in the Society's hands during the ensuing winter came on for discussion in the month of July. At a general meeting held on the 21st, J. D.. Harding explained the views which he and some other Members entertained in reference to the future application of the gallery when not required for the purpose of the exhibition, viz. by holding classes for instruction in water-colour painting, instead of letting the premises as hitherto. A letter was also read from Gilbert, bringing forward an alternative scheme in the following terms :— ' I would venture to propose for consideration the advisability of get- ting up a second annual exhibition *ourselves*, a Winter Exhibition of SKETCHES—not finished drawings, but sketches, first ideas of pictures, in chalk, pencil or colours, not close framed, but mounted and framed in light narrow gilt mouldings, of course for sale.' This, the writer contended, would not only be more profitable than letting it to some one who would perhaps use it for the very same purpose, but would enable the Society to retain the control of its own house. At an adjourned meeting held on the 28th of July, to discuss these propositions, that of Gilbert was after a lengthy debate so far adopted that, on his own proposal, seconded by Mr. (now Sir Frederick) Burton, it was resolved, ' That an Exhibition of *Sketches* shall be held in the Winter of this present year, 1862.' Messrs. Gilbert, Holland, and Burton were appointed to serve on a committee for that purpose in conjunction with the officers of the Society ; and it was arranged that the exhibition should open on the 1st of December and close at the end of February. The result of the experiment and the subsequent expansion of the winter exhibitions have been duly set forth in the general history of the Society. Gilbert's own contributions to the earlier of these new exhibitions were, as might be expected, strictly ' sketches ' of the kind he had described as above ; in no case could the advantage of showing such preliminary studies be better exemplified.

It remains to speak of the later honours with which our artist's career has been rewarded ; beginning with his election as President of this Society on the retirement of Frederick Tayler in June 1871. The occasion of his appointment was that selected by her Majesty the Queen to confer a distinction upon the Society, which had not hitherto been enjoyed by any associated body of British artists except the Royal Academy, by raising its President to the dignity of knighthood. As some misapprehension occurred at the time as to the nature of the transaction, it may be well to reprint here the material part of a letter which Mr. Jenkins, as Secretary, wrote to the *Times* of the 22nd of August, 1871, explaining the circumstances, in correction of an error, which, however, turned out to be prophetic. Our artist had been already, but prematurely, styled in the newspapers a member of the Royal Academy. Thereupon Mr. Jenkins wrote :—' Mr. Gilbert, on whom the honour of knighthood is to be conferred, is the President of the Society of Painters in Water-Colours, and it is generally understood that the dignity is offered to the President of this distinguished body of artists as a public recognition of an art which in its modern form of expression is peculiarly British, and which the Society of Painters in Water-Colours, as the representative institution from its foundation in 1804, has done so much to foster and elevate.' The knighthood of Sir John Gilbert was thus offered and accepted in August 1871 ; but it was not actually conferred until the 14th of March, 1872. In the mean time, namely, on the 29th of January, 1872, Gilbert was elected, almost unanimously, an Associate of the Royal Academy, although he had painted little in oils since he joined our Society. The news came to cheer him in illness, for he was at the time confined to the house for seven weeks, a sufferer from acute rheumatism.

The presidency of Sir John Gilbert has, as the reader knows, been signalized by important events and changes in the Society, which, although he has ever been duly alive to its interests, belong more properly to its corporate history than to his individual memoir. Amidst the duties of office and his own more serious work, he finds time for the playful employment of his pencil in various minor ways in the Society's service. Thus, when the new building in Pall Mall East, designed by the late Frederick Pepys Cockerell, was opened, its ornate entrance had an appropriate record in a large wood drawing by him, published in the *Illustrated London News* of 24th April, 1875. And in the year 1882, when, after conferring the name of ' Royal ' upon

the old Water-Colour Society, the Queen was graciously pleased to signify her readiness to grant diplomas to the Members, the never-failing pencil of Sir John Gilbert furnished at once an appropriate design. His graceful handiwork may be recognized in the decorated covers of the modern illustrated catalogues,[1] and on the cards of meetings of the Society's Art Club. These are small and casual sprinklings of his talent; but he is understood to be preparing a much wider benefaction. Some six or seven years ago, although he has since continued to paint as before, Sir John determined not to part with any more pictures. He has thus accumulated a very large collection of his works, both in oil and water colour, and of these he proposes to make a munificent gift to the nation.

Sir John Gilbert's works exhibited at the Water-Colour Society show an average of between three and four drawings in the summer, and rather more in the winter. In the year 1881 he had made up a total of 112 in the former and 98 in the latter, or 210 exhibits, containing some 230 separate subjects at least. Besides these there are 74 counted up by Mr. Graves, from the catalogues of other galleries, to wit:—31 at the Royal Academy, 40 at the British Institution, and 13 at Suffolk Street. And happily, his graphic power is still in full productive energy. Sir John Gilbert is an Honorary Member of the Royal Society of British Artists, and of the Royal Scottish Society of Painters in Water-Colours; Honorary President of the Liverpool Society of Painters in Water-Colours; Honorary Member of the Societies of Artists and Painters in Water-Colours of Belgium; and Chevalier of the Legion of Honour of France; and has been awarded medals in gold and in bronze by Sydney, Australia, and a gold medal by Austria.

The second Associate elected on the 9th of February, 1852, was HENRY PARSONS RIVIERE, who, although he never rose to the rank of Member, was a constant contributor to the gallery for nearly forty years. He was born on the 16th of August, 1811, and was one of a family of artists. His father was a drawing master, and so also was his brother, the late William Riviere, formerly head of the drawing school at Cheltenham College, and afterwards a private teacher at Oxford, who died in 1876. Briton Riviere, R.A., is William's son. They were connected with the allied art of music (in which Henry Riviere was also proficient),

[1] There was a quarto one in 1880, besides the octavo one since used.

in the person of his sister, the wife of the composer Sir Henry Bishop, but better known by her own talent as a singer, under the name of Madame Anna Bishop.

Henry Riviere appears to have been regularly educated as an artist, attending the schools of the Royal Academy as a student. He probably owed much of his skill in water-colours to practice among kindred spirits at the less formal academy in Clipstone Street. In a letter to his friend Jenkins, written in December 1867, he waxes sentimental over the changes that had come over that old artist quarter. The latter was still in Upper Charlotte Street, Fitzroy Square, when Riviere then wrote from Rome :—' So you are alone in your glory ; all the Boys having left the Clipstone Street neighbourhood must make it somewhat melancholy; changes come over us,' &c. &c. Just then a fire had nearly burnt down the 'favoured spot.' But there was enough of artist life in the old precincts when Riviere sent thence to Suffolk Street his first exhibited pictures in 1832. They were, ' An Interior,' and ' The Triumph of Silenus,' after Rubens. Two years after, in 1834, he was elected a Member of the New Society of Painters in Water-Colours. There he exhibited his drawings during the next sixteen years, at the end of which he followed the example set three years before by his friends Duncan, Dodgson, Jenkins, and Topham, and retired from that body, rejoining them after the lapse of two more within the walls of the Old Society. His drawings exhibited in our gallery for the first dozen years after his election were commonly devoted to the illustration of Irish life and humour of the popular kind. ' A Bit of Blarney,' ' A little Botheration,' ' Sleep Thee, my Darling,' ' Don't say Nay, charming Judy Callaghan,' and the like, were the sort of subjects, until in 1865 his address at 9 Russell Place, Fitzroy Square, is suddenly dropped, and the titles of his drawings indicate a visit to Rome.

He had made a rather sudden change in his plans of life, giving up a considerable practice in teaching, which he had enjoyed in London, and settling himself as a painter in the ' Eternal City,' where he continued to reside till near the end of his days. When he had settled in Rome the subjects of his drawings were, with scarcely an exception, views within and without the walls of that city ; most commonly of the Forum and the surrounding ruins, with groups of figures characteristic of the place, and sometimes a separate study or subject of human motive, of a pathetic or humorous kind.

Riviere was an intimate friend of Jenkins's, and a good corre_ spondent. During his residence in Rome he wrote him frequent letters; reporting the progress of his own works; retailing the artist gossip of the Café Greco, descanting, sometimes with warmth, on current questions of art and politics (being in the one department a strong anti-pre-Raphaelite, and a fervid Tory in the other), com_ menting on the affairs of the Society and the profession in general in an outspoken way; and manifesting a special interest in his own circle of friends, including more particularly the little group of secessionists above mentioned, with whom he had a natural fellow_ feeling. These letters, now in the Society's possession, are numerous between 1865 and 1869. In some of the later ones he shows some degree of bitterness in reference to his non-election as a full Member. In October 1866 he has 'been at work upon the ruins of Rome and nearly completed two large drawings (41 x 21). The Roman Forum is one, the Coliseum the other.' He has also commenced one or two figure subjects, 'to gratify his taste.' His only exhibit in 1867 was of the latter class, 'The Dying Brigand,' priced at 150 guineas. In 1868, the 'Coliseum' appears alone, at 125 guineas. Meanwhile he writes, on 29 March 1867 :—' Hundreds have been to my studio to see my Forum.' In May he has sent it off to Fuller's, and has to paint a repetition. 'A picture of this size,' he adds in a characteristic strain, 'is no joke to paint out of doors or on the spot, with a few stones thrown occasionally at your head; for the savage nature of the old Romans still remains with the present generation, but the nobler qualities and grand inspirations have long died away,' &c. &c. The picture in question does not seem to have been exhibited at Pall Mall East. In the year 1869 he was doing so well in Rome that he felt himself 'in a position to do without the Society,' though he evinced some soreness at having, as he said, worked there for more than sixteen years without 'due advantage' therefrom, referring apparently to the fact that he was still an Associate only. In that year he was fitting up in his studio an elaborate screen adorned with gold-work, for the showing and sale of his drawings, priced at 600*l.*

During his residence in Rome, he paid occasional visits to London, where he had retained an address, which in 1870 changes from 17 Kilburn Priory to St. John's Wood Road. In 1871 his Roman address becomes 68 Via Sistina, in place of 43 Vicolo di Greci. But in 1884 the latter is dropped, on a final return to his

native country. He continued to reside at 26 St. John's Wood Road until his death there on the 9th of May, 1888.

Riviere's drawings in the summer exhibitions of the Society from 1852 to 1888 amount in number to 172, and his winter 'sketches and studies' from 1862–3 to 1888–9 (the nine in which last year were hung after his death) to 121, making a total of 293 exhibits. He had also, according to Graves, six works at the Royal Academy, seven at the British Institution, and fifteen at Suffolk Street between 1832 and 1873.

MISS MARGARET GILLIES, the lady elected on the same day, 9 February, 1852, with the President, was an illustrator of a very different type from his. She was then already of a 'certain age,' having been in practice as a miniature painter for twenty years, and her birth having occurred more than fifteen months before that of the Society of Painters in Water-Colours, namely, on the 7th of August, 1803. She was a younger daughter of William Gillies, and, on his side, of Scotch descent; her mother being of a Gloucestershire family. The father was from Brechin in Forfarshire, but at the time of her birth was settled in London, where he had acquired some wealth as a merchant. Only a little of Margaret's early life was spent at home. When but three years old, she was taken to Lisbon with her mother, whose waning health required a warmer climate. In five more years the parent's illness had a fatal end, and the children were sent to Brechin under the care of a governess. Family troubles did not fall singly on the bereaved father, who suffered a reverse of fortune also, which induced him to accept a brother's offer of a home and education for his motherless offspring. This proved, however, much to their advantage ; for Mr. Gillies's Scotch relations were of no small intellectual distinction. One of his brothers, John Gillies, LL.D., was a scholar and an historian ;[1] and the uncle, who, having no family of his own, benevolently adopted his brother William's children, was Lord Gillies, an Edinburgh judge, who moved in the highly cultivated literary society of the Scottish capital, which has long been famed in history. Miss Margaret had, indeed, a year's schooling at Doncaster, and paid occasional visits to her father in London. With these

[1] He translated Aristotle's *Ethics, Politics* and *Rhetoric*, and the *Orations* of Isocrates, wrote a *View of the Reign of Frederick II. of Prussia*, and a *History of the World from Alexander the Great*, and succeeded Dr. Robertson as Historiographer Royal of Scotland.

exceptions she resided and grew up at the judge's house in Edinburgh. At the *réunions* there she often met such men as Walter Scott, Jeffrey, and Lord Eldon. But amidst the charms of literary society, a passion for art, which she had acquired without any regular training, grew up within her, and proved too strong to resist. When still under age, she resolved to make art her profession, and so was allowed to travel south again and try her fortune in London with the pencil, in company with an elder sister, who had in a like manner devoted herself to the pen. The father had taken another wife, and a third and still older sister had also married and gone to India, when the two Misses Gillies thus set forth on their joint career. For fifty years they pursued their path through life side by side, never separating until death did them part in 1870, when the elder was summoned to another world.

Margaret Gillies had, it is said, exhibited her *penchant* for drawing at a very early age ; for we are told that when she was a child at Lisbon, little pictures of the exiles' adventures used to come from abroad for the amusement of her sister and a younger brother at home.[1] At a later period the direction of her talent showed itself in a faculty for seizing likenesses ; and her first efforts were to maintain herself by making portraits. She accordingly procured some instruction in miniature painting from Frederick Cruickshank.[2] Doubtless she was favoured by good introductions to patronage, and she does not seem to have lacked sitters, even at the beginning. We read indeed that ' when she undertook her first miniature she had to take a lesson in the art before each sitting in order to enable her to achieve the task,' and ' thus had to get her training as she went along, learning and working at one and the same time.'[3]

Her first appearance in the exhibitions was at Somerset House in 1832, where she had a ' Portrait of a Lady,' and one of ' Mr. Robert Maule Gillies,' in the Antique-Academy room. From that time until 1861 she was a steady annual exhibitor at the Royal Academy of from two to seven works, making an aggregate of 101. Among the persons portrayed are the following, of more or less distinction :—Rev. W. J. Fox, afterwards the anti-corn-law lecturer (1833); Dr. Southwood Smith (1835); John Finlaison, the Government actuary (1837);

[1] *English Female Artists*, ii. 90.
[2] *Ibid.* 91. Probably the F. Cruickshank, painter of portraits, by whom Graves finds 166 works exhibited between 1822 and 1860, 149 of them at the Royal Academy.
[3] *Times*, 26 July, 1887.

the 'Rajah Ram Roy' (1838); Miss Helen Faucit as *Julie de Mortemar*, and Macready as the *Cardinal Richelieu*, in Bulwer's play (1839); the poet Wordsworth (1840); J. G. Lough, the sculptor, and the Hon. Richard Denman (1841); Charles Dickens (1844); R. H. Horne, the poet, and William and Mary Howitt (1846); Judge Crampton (1847); Edwin Chadwick (1848); Mrs. Marsh, author of 'Emilia Wyndham,' &c. (1851); Dr. Sutherland [1] (1852); and Mrs. William Gladstone (1854). Not a few are portraits of children, generally in family groups. The occasion of painting Wordsworth's likeness [2] was one of special gratification to the artist. She was employed to do so by Moon, the publisher; and the performance of the commission involved a visit of several weeks to the poet at his home at Lake Rydal, which she remembered to the last as one of the most interesting events of her life. She was not content, however, to be a mere taker of likenesses. As early as 1838, among her quota of drawings at the last 'Exhibition' at Somerset House, was one of 'The Captive Daughter of Zion,' which was at least an approach to a subject picture. But for a time she relapses entirely into miniature portrait taking. About a dozen years later, she seems to have resolved on a more serious attempt to tread the higher walk of art.

In 1847 she was living with her sister near London, and her home is pleasantly referred to in Mary Howitt's *Autobiography* (published in 1889). The writer tells us of an 'annual hay-making at Hillside, High-gate,' on the 31st of July, to which she took Hans Christian Andersen, the Danish author, 'thus introducing him to an English home, full of poetry and art, of sincerity and affection. The ladies of Hillside, the Misses Mary and Margaret Gillies—the one an embodiment of peace and an admirable writer, but whose talent, like the violet, kept in the shade; the other, the warm-hearted painter—made him cordially welcome.' [3] Five-and-thirty years after, the sister having died in the mean time, Mrs. Howitt writes to Margaret Gillies, 'You are so tenderly connected with old, old times that seem to belong to another life, that I have for you a peculiar affection,' and refers again to the 'life at Hillside, and the wild single daffodils in the field opposite, all of your planting. They did not get double and spoil themselves like other daffodils.' [4]

[1] This, being hung in the East Room, must have been an oil picture.

[2] This portrait has crossed the Atlantic, having been bought by a literary society at Boston, U.S.

[3] Vol. ii. pp. 30, 31. [4] Vol. ii. pp. 311, 312.

In 1851 she went to Paris and became a pupil of both Henri and Ary Scheffer.. She had painted a few subjects[1] as well as portraits in oils, but found a field for her more imaginative efforts the next year on the walls of the Water-Colour Society. Her first exhibits there in 1852 were two in number, entitled, 'Jéanie Deans's Visit to Effie in Prison,' and 'The Absent Thought.' These were typical of the nature of the works, which were to follow during a long series of years, whereby her talent was best known and most favourably esteemed. Miss Gillies's art was essentially feminine; dealing almost exclusively with maiden's sentiment and woman's sorrow. Shakspere and Scott won her graphic alliance chiefly by the woes of their heroines. Trials, such as those of Imogen and Rosalind and Jeanie Deans, are what she most aspired to delineate. Once she pictured a scene from Spenser; and it was 'Una with the Red Cross Knight.' More often she found verses to her purpose in the later poets' writings; and her earlier subjects more especially are accompanied by quotations from Shelley and Keats, and Wordsworth, and Moore, Tennyson, Browning, Longfellow, and Alaric Watts. Old songs too, and ballads, mostly from beyond the Tweed, with 'Robin Gray' at their head, afforded kindred motives of a sentimental character, and Dickens lent another in his 'Little Nell.' A general elegance of treatment as well as the leaning towards a special type of features suggest the influence of her teacher, Ary Scheffer, whose example she also followed in the purity and pathos of her motives. Besides subjects from the poets, and other fancy compositions, there were a considerable number of figure studies made during repeated travels abroad. Italian figures from Florence begin in 1862, and a few years afterwards there are some from Normandy and from Toulouse; in 1870–71 groups from Venice and Verona, in 1874–75 and the following winter studies from Brittany, and in 1877–78 two from Rome and Albano. From 1860 or earlier there are moreover Scotch peasants, and in 1865–66 Irish also.

Another bright glimpse of our artist during one of these visits to Rome is also afforded by the pen of her old acquaintance, Mary Howitt. 'In the spring of 1877,' she says, 'we had the joy of welcoming our faithful friend, Miss Margaret Gillies, whose affectionate nature luxuriated in a sojourn at Rome.' And thence under date

[1] One, of ' King Alfred when a Child listening to his Mother's Recital of the Heroic Deeds of the Saxons,' was hung at the Royal Academy in 1848.

25 March in that year she had written : 'Yesterday in the afternoon I went out to try to find people who would take tickets for Madame Ristori's reading for the benefit of the "Gould Memorial School." I had not at all a successful crusade.　None were inclined to put their hands in their pockets, excepting dear Margaret Gillies, on whom I called, and after that went no further.　She was just finishing her picture, and was worried at the last, and wanted to go to good Mr. Glennie to borrow a sketch of distant scenery in the neighbourhood of Rome, the bad weather not permitting her to go out sketching for herself.　When her things were all put aside and left for their Sunday rest, we took a little carriage and drove to the Glennies', down into the very centre of Rome ; and had such a cordial reception, such a nice call ; tea made for us, and dear Margaret given the pick of his rich portfolios for a bit of Latin or Volscian mountain, blue and dreamy in its sunny distance.'[1]

Miss Gillies contributed to our gallery from 1852 till 1887, continuously, until the last six years, her total being 254 works, 115 in the summer, and 139 in the winter exhibitions.　Graves records two of her works at the British Institution and eight at Suffolk Street. She also exhibited with the Society of Female (now called ' of Lady') Artists.　The earlier addresses in the Academy catalogue show frequent changes of residence, but in 1863 the sisters removed from 6 Southampton Street, Fitzroy Square, where they had been for at least ten years, to 25 Church Row, Hampstead, in which quiet retreat their home remained during the last years of their respective lives. Margaret Gillies survived her sister for seventeen years, and died on the 20th of July, 1887, at Crockham Hill near Westerham, in Kent, of pleurisy, after a few days' illness, when nearly eighty-four.　In her time she had lived much in London society and been intimate with the leaders of literature here.　And within a week or two of her death ' the venerable Miss Gillies, a pleasant-looking lady in grey satin, was among the guests to view the album offered to the Queen on the occasion of the Jubilee, and was herself a contributor.'[2]

Many of Margaret Gillies's works are said to have been engraved both in this country and the United States.[3]　The following are all that have come to the writer's knowledge :—' The Past and the Future,' exhibited at the Water-Colour Society in 1855 (engraved by Francis

[1] *Mary Howitt: an Autobiography*, ii. 262, 263.　　[2] *The World*, 27 July, 1887.
[3] *English Female Artists*, ii. 92.

Holl); of the size of the drawing, twenty by sixteen inches._—In the *Keepsake*, 1856, 'Subject from Auld Robin Gray,' apparently that exhibited in the Water-Colour Society in 1854, to illustrate a French version of the ballad (engraved by Frederick A. Heath); 1857, 'The Lady Violet' (engraved by Alfred T. Heath).

No new Associates were elected in the summer of 1852; but two more were added on the 14th of February, 1853, one only of whom, S. P. Jackson, now survives. The other bore a surname illustrious in modern English art history, and partook of the talent so widely dis‑tributed in his family. WALTER GOODALL was the youngest son of Edward Goodall, the eminent landscape line-engraver, whose appre‑ciative and masterly skill with the burin secured from early death so many of Turner's finest compositions. He was thus the brother of Frederick Goodall, R.A., and of Edward A. Goodall, now and for the last quarter of a century another worthy Member of this Society. Walter was born on the 6th of November, 1830. With his artistic surroundings, it cannot be doubted that his natural instinct was duly encouraged at home. Part, however, of his training was certainly acquired by association with other art students at the well-known 'academy' in Clipstone Street, where he was wont to work from the life. And he also studied at the Government School of Design at Somerset House, and at the Royal Academy. He did not practise in oils. His first exhibited works appear to have been three drawings at the Royal Academy in 1852, the year before his election by the Water-Colour Society. Two of them were portraits of young ladies, the third was a 'study from nature.' After that date his exhibits in London were confined to our gallery, though many of his works went to the Royal Manchester Institution.[1] He was made a full Member of the Water-Colour Society on 10 June, 1861.

Walter Goodall was a refined and graceful draftsman and colour‑ist; his works, which were of the figure class, recommending them‑selves rather by good taste and sweetness of expression, than by strength of character. The subjects were for the most part studies of peasant life, somewhat idealized; often of children, with some familiar incident, as of the poultry yard or the dairy, or by the sea‑side, to connect and give a name to the group. Sometimes a local association was suggested by the title, that indicated travel, or a

[1] *Dictionary of National Biography.*

sojourn at some particular spot, at home or abroad ; as ' Sea-anemone gathering, North Devon' (1859), 'The Dutch Shrimpers' (1860), or 'A Brittany Interior' (1864). In 1867 and 1868 the titles, ' La Mère,' ' La Prière,' and ' Chantez-chantez toujours,' speak of a further visit to France ; and in the intervening winter exhibition there were three studies in the Pyrenees. These lead the way to more distant wandering.

The winter of 1868–69 was spent in Rome. We have pleasant glimpses of him there in Riviere's letters. On the 2nd of December the latter tells of his arrival, and writes that he has seen to his wants, ' Tell his father and Edward so at the Chalcographic.' Glennie too is going to call on him. Then on the 25th of January : ' Our friend Goodall really enjoys Rome ; he will soon be on his way to Paris to give lessons to F . . ., and then makes his way on to England in time for the Gallery. He is very much liked among us—feels the time pass gloriously—will work *all* day long, and pleasant companions at night.' Again, on 9 February, 1869 : ' Walter Goodall has done about 300*l*. in drawings and commissions. Mr. Field, the lawyer, has been of use in recommending a Mr. R . . . to him, and I sent a collector up to him, who also bought a small work from him.' Some of the results of his visit to Rome were seen in the figure studies and groups that he exhibited in the following three years ; and in 1872 there is a ' Venetian Fruit Boat,' the first of several which he painted. Goodall was not, however, a prolific contributor. He never exhibited more than five drawings at a time in the gallery. From his election in 1853 to his last appearance in 1884 he had but 154 works hung, 87 in the summer, and 67 in the winter exhibitions.

For some years before poor Goodall ceased to paint, he had, it is painful to say, become a confirmed invalid. About fourteen years before his death he was afflicted by a paralytic seizure, whereby, although for a time it did not prevent him from using the brush, he was finally rendered altogether helpless. In 1887 his name was placed by the Society on an honorary retired list ; and he died at the age of fifty-nine on the 14th of May, 1889, at the village of Clapham, about a mile from Bedford, leaving a widow and three children surviving. He was buried in Highgate Cemetery. For twelve years from 1865 Goodall had a studio at 6 Wells Street, Oxford Street ; but for a considerable time before his death he had resided in the country. The highest sale price recorded by Redford for one of his

drawings is 108*l.* at the 'A. Grant' sale, 1863, for 'The Harvest Home.' He did some woodcut illustrations to *Rhymes and Roundelayes*, and *Ministering Children.*

SAMUEL PHILLIPS JACKSON, also elected Associate on the 14th of February, 1853, had altogether no more than eleven drawings in the gallery in Fielding's time; but he has been a con_ stant contributor of landscapes ever since. He is son of the former Associate, Samuel Jackson, of whom a biographical account has already been given; and was born in 1830. His works, the great majority whereof have been of coast scenery in England intermixed in later years with inland scenes from Wales and on the Thames, have been very numerous; although for the first twenty-four years, during which he remained an Associate, they were limited by law to eight a year, in the summer exhibitions.

S. P. Jackson received his early instruction in art from his father in Bristol; but he also studied figure drawing a good deal at the life school there. He has devoted himself, however, entirely to land_ scape of the classes above mentioned. His first exhibited work in London was painted when he was about twenty. It was a large picture, four feet long, called, 'An Indiaman ashore on the Welsh Coast,' and was hung on the line at the British Institution in 1850 or 1851. Another of the same size followed next year, and was not only favoured in like manner, but bought by Mr. Bicknell of Herne Hill, the well-known collector. A third, equally large, in 1852, was chosen by the late George Lance for a member of his family as an Art Union prize. These successes were followed up by the exhibition in good positions of his works at the same gallery in Pall Mall, until he had had nine[1] pictures in all, hung there. At the Royal Academy also he has had, between 1852 and 1880, with intervals of from four to eight years,[2] an aggregate of fifteen works exhibited. About half of these were drawings. After joining our Society he ultimately gave up oil painting, as he found a readier sale for his water-colours.

S. P. Jackson continued to reside at Clifton until 1870, when he removed his home to Streatley-on-Thames, near Reading; a few years before which date, Thames subjects had begun to appear among his works at the gallery, particularly in the winter 'sketches and

[1] Graves's *Dictionary of Artists.*
[2] There was nothing in 1854-58, 1860, 1863-68, and 1872-79.

studies.' Out of our artist's Bristol origin there had arisen some close friendships, notably with the late Francis Danby, A.R.A., who resided there for many years ;[1] and with Charles Branwhite, late Associate of this Society. His removal eastward brought him more in contact with contemporaries here, and among deceased Members of the Society with whom he was in most intimate alliance were Jenkins and Duncan, with whom he enjoyed many a pleasant and profitable trip on the river. He made a shorter move in 1876 to 1 River Terrace, Henley-on-Thames, where he remained until quite recently, when he returned to his native Clifton. It was in the same year, 1876, that he became a full Member of the Society.

Of Jackson's coast studies, most have been in Cornwall, with some in Devon, and a few in the Channel Islands. They extend also to South and North Wales ; and, in 1863 more especially, there is a contingent from Yorkshire. A few earlier drawings (1857 and 1858) are from the Lakes in Cumberland. Some of the Thames views are taken in winter. Among the more important drawings, in their several classes may be mentioned :—' The Spartiate, Sheer Hulk, at Hamoaze, Plymouth,' one of his first year's exhibits (1853) ; ' Sty Head Tarn—Early Morning' (1858) ; ' A Summer Day on the Coast' (1855) ; ' A Dead Calm, far at Sea' (1858) ; ' Dartmouth Harbour' (1858) ; ' Whitby Pier in a Gale' (1863) ; ' St. Ives' Pier' (1864) ; ' The Thames from Streatley Bridge' (1868). Thus his *répertoire* has been confined to England and Wales. There is a single exception, however, in a ' Lake of Thun—Evening' in 1859, the solitary mark of a tour in Switzerland, made with his father in the previous year. When the Society acquired its ' Royal' rank, i.e. on the close of the exhibition of 1881, he had already, although but five years a full Member, had 237 drawings in the summer, and 260 exhibits in the winter shows. In the latter series, moreover, particularly during the earlier years, there had been many ' sketches and studies,' often four in a frame, which if counted separately would add some fifty or more to the number of distinct works. And, happily, this does not nearly close the record.

Jackson's drawings are remarkable for clean handling and sober harmonies of colour, in which the moist vapours of our west country are suggested by the use of well-concocted greys, which won the expressed approval of Copley Fielding when our artist made his

[1] He died at Exmouth, 9 February, 1861.

début in the gallery. Several of his works have been successfully reproduced in chromo-lithography.

Respecting HENRY BRANDLING, who was elected an Associate on the 13th of June, 1853, and exhibited eight drawings in 1854–56, six of which were views in Nuremberg, the remaining two, both in 1854, being 'Crypt of Glasgow Cathedral' and 'Durham Cathedral— Installation of Bishop Neville, 1441,' respectively, the scantest information is all that can be given. Neither date of birth nor death is recorded, and literally nothing has been gathered, either of his antecedents, or of his subsequent career after his name was struck out by the Committee from the catalogue list of Associates for 1837 because he had sent in no drawing for exhibition that year. In Graves's list one 'H. Brandling' is named as an exhibitor of portraits at the Royal Academy, viz. two works in 1847–8; also 'H. C. Brandling' as doing the like in 1850. Whether these or either be identical with our evanescent Associate, it is hard to say. When he came to the Society his address was 34 Fitzroy Square, and when he left it 28 Maddox Street.

BOOK X

CHAPTER I

DEATHS; 1855–1881

Biographies—*W. W. Deane—F. Walker—G. J. Pinwell—A. B. Houghton—
E. S. Lundgren—J. W. Whittaker.*

AN account has now been rendered of all Members and Associates of the Society who exhibited their works in its galleries before the epoch of the death of President Fielding in 1855. Among that number it will have been seen that there are a few of the veteran exhibitors at Pall Mall East at the present day. These having been so included with their former contemporaries, it is not proposed to deal further with the lives or works of living men. But to complete the roll of the deceased, it becomes necessary to add, by way of supplement, some notice of those who made their entrance as well as their exit at more recent dates. To this task the remainder of the present volume will be devoted.

It is painfully remarkable how many of the subjects of the following notices were destined to die at a comparatively early age. During nearly eight years after Copley Fielding's death no loss among these younger Members has to be recorded; but one death occurred early in 1873. WILLIAM WOOD DEANE, an excellent painter of architectural subjects, which he treated in a picturesque manner and with a refined eye for colour, was an Associate from the 13th of June, 1870, to the day of his too early death. He was another of the artists who have been promoted from the ranks of the Institute to those of the Society. He was born on the 22nd of

March, 1825, in Liverpool Road, Islington, the third son of John
Wood Deane, who was a cashier in the Bank of England, after
having been at sea in the merchant service, and was also a devoted
amateur of water-colour drawing.[1] His maternal grandfather, whose
name was Glasse, was Mayor of Barnstaple, in North Devon. As an
elder brother, Dennis, had been made a painter, William was trained
as an architect, after having previously received a general education
at the Islington proprietary school, under the mastership of Dr.
Jackson (afterwards Bishop of Lincoln and of London). He 'was
articled to Mr. Herbert Williams, architect, on September 7, 1842.
On the 13th of January, 1844, he was admitted a student of the
Royal Institute of British Architects, and ' he ' obtained prizes there in
1844 and 1845. After serving his articles, he assisted Mr. Mocatta,
and received some premiums in competition.'[2] This was in 1846.
He had begun to exhibit designs at the Royal Academy in 1844.
'About this time he took up with private theatricals, and played at
Miss Kelly's theatre, which he subsequently decorated.'[3] In 1848
he was elected an Associate of the Royal Institute, of British
Architects. Going abroad in 1850 with his brother Dennis, he spent
that and the next year in continental travel, mostly in Italy. After
his return to England in the spring of 1852, his professional work
was chiefly confined to making designs for others, colouring their
perspective drawings, and giving lessons to young architects. He
also drew a little on wood for the illustrated journals ; and sometimes
painted in oil. He can scarcely be said to have practised as an
architect, though there exist in London two buildings at least, designed
wholly or partially by him ; namely, Langham Chambers (at the
north end of Regent Street, since altered), which he built in con-
junction with the late Alfred Bailey during a short partnership
between them at 13 Great James Street, Bedford Row ; and Messrs.
Dickinson's shop front, No. 114 New Bond Street. That his inventive
power, no less than his taste, entitled him to success in the profession
which he had to abandon for lack of patrons, was the opinion of
appreciative friends. But it was as a water-colour painter that he
attained to distinction. Dr. Percy in his MS. catalogue[4] states that
he ' was a pupil of Cox.'

[1] There is a coloured etching, published 1 June, 1805, of the ' Surrender of the Cape of
Good Hope by the Dutch in February 1803,' from a sketch made by him on the occasion.
[2] *The Builder*, 25 January, 1873. [3] *Dictionary of National Biography*, xiv. 260.
[4] At the British Museum.

He ' virtually relinquished practical architecture in 1856 ; ' but did not entirely devote himself to painting until after his mother's death in September 1859, when he received a small accession of means, and took up his quarters at 17 Maitland Park Terrace, Haverstock Hill, in 1860. During the intervening summers he had sketched in Normandy in 1856, Belgium in 1857, and at Whitby in 1859. In 1860 he also remained in this country, sketching in Cumberland. He was elected an Associate of the New Society in 1862, and a Member thereof in the autumn of 1867, when it had come to be called the ' Institute ; ' and he exhibited nearly 100 drawings and sketches in its gallery in Pall Mall, from 1863 to 1870. His group of drawings each summer was generally confined to a special district of the Continent where he had made his last sketches. Beginning in 1863 with the picturesque streets of Vitré in Brittany, he selected buildings in Rouen (with two at Le Puy) for 1864 ; and Trèves and the Moselle, with Rheims, sufficed for 1865. In 1867, after he had been travelling in Spain with Topham in the preceding year, his views were solely Spanish, from Grenada and Seville, some of them enlivened with many figures. From 1867 to 1870 the rest are nearly all Italian, from Venice chiefly, with two at Assisi, and some on the Riviera. Among the 'sketches and studies' were a few of more general landscape, one or two being (quite as exceptions) from North Wales. At Pall Mall East, from 1871 to 1873–4, were exhibited 58 of his works, 17 in the summer show, and 41 in the winter, the last 16 appearing after his death. About two-thirds of the whole were Italian subjects, and two-thirds of these from Venice ; France contributing about 8, including some fine studies of the cathedral of Chartres ; and the home drawings, only 7 in number, being of buildings, either in Kent (Chiddingstone, Hever) or on the Scottish border (Jedburgh, Melrose, Stirling), with one London view, taken from the National Gallery in Trafalgar Square. During the whole period of his connexion with our Society, poor Deane was a sufferer from an affection of the liver, which finally caused his death, that event occurring on the 18th of January, 1873. He left a widow, sister of the architect George Aitchison, A.R.A. The memoir by his brother-in-law in the *Dictionary of National Biography* is the authority for many of the dates and facts above given. To those who knew him well, our artist's memory was endeared by his sterling depth of character, while a wider circle of acquaintance regretted the

lost charm of his brilliant conversation. There is a woodcut portrait of him in the *Graphic* of 15 February, 1873.

The drawings of Deane are specially admired for their power of suggesting the different qualities of atmosphere peculiar to the several countries where he painted, and for the purity and harmony of their colouring, as well as a breadth of treatment which is at the same time comprehensive of facts and judiciously reticent of detail. His Venice views have an affinity to those of James Holland (and of the great Turner), particularly in a recognition of the value of pure white. But the lavish use of opaque colour sometimes produced in his works a tendency towards 'chalkiness.'

Graves finds twenty-three works of his at the Royal Academy, four at the British Institution, and thirteen at Suffolk Street—between 1844 and 1872. The highest sale price recorded by Redford for one of Deane's drawings is 105*l.* for 'Horse Fair, Seville' (26 x 35 in.) in the 'Sibett' sale, 1884.

FREDERICK WALKER was born in Marylebone, on the 24th of May, 1840, under circumstances not adverse to his cultivation of art as a profession. His father was a designer of jewellery, and had also a taste for painting, which descended from a former generation, our artist's grandfather having, as an amateur, made some creditable family portraits. His mother, also, fostered his desire to become a painter, when, after he had been through his course of general education at the North Collegiate School, Camden Town, and at the age of sixteen had, by way of experiment, been put, like Sir John Gilbert, for eighteen months with an architect and surveyor (one Mr. Baker), the direction of his bent was clearly pronounced. From early years he had been always sketching, when at school had ever a pencil in his hand, and before he was set to count up acres, roods and perches, had been busy at the British Museum copying the Greek statues. When emancipated from the former less congenial task, he returned to the latter practice with fresh gusto, working in Great Russell Street in the daytime, and at Leigh's life school in Newman Street in the evening. In March 1858 he was admitted as a student at the Royal Academy. He did not advance there beyond the antique school, his further studies 'from the life' being made from what he saw around him in the outer world, where he was ever observant, and making mental sketches when not actually plying the

pencil. That may be said perhaps of all true artists; but with him it had a special significance. His fancy designs, made without models before him to copy from, have been cited [1] as singularly apt illustrations of the value of cultivating the memory as an aid to art. A large number of these, many of which are in existence, he executed at the sketching club at Langham Chambers. They are mostly done in grey with a brush, over unobtrusive but exquisite outlines in pencil; and, although the hand of genius is perceptible in all, they show between the first and the last a progressive advance in power. While the young man was still working at the Academy, he was not unmindful that he had his living to make. He accordingly at the same time entered upon an engagement for three years with T. W. Whymper, the wood engraver, to attend his *atelier* on three days in the week and draw on the block under his instruction. Thus he learnt the technical requirements of this species of engraving, and the manner of delineation then in vogue. A newer style of wood drawing developed itself when he took to original designing.

His first essay in making illustrations for the press, which was the beginning of his career as an artist, is thus graphically described by the late Tom Taylor. 'In November 1859 a nervous, timid, boyish aspirant for employment as a draftsman on wood, called on the editor of *Once a Week*, with specimens of his work. They were examined, approved, and a commission was given him to illustrate a story called "Peasant Proprietorship," which appeared, with the nervous young artist's illustration, in the number for February 18, 1860. This shy, sensitive, feverish draftsman was Frederick Walker, then a youth of nineteen.'[2] By the end of 1860 he had contributed twenty-four designs to the above periodical. In the following spring he came under the notice of Thackeray, who was then editing the *Cornhill Magazine*, and about to publish in its pages his story of 'Philip.' That writer employed his own pencil for the illustration of his earlier works, as for example in *Vanity Fair*, but he latterly sought the aid of professional artists. Still, for a time he remained, to a certain extent, his own designer, merely seeking a skilled hand to put his sketches into a form adapted for publication. This task Walker was invited to perform for him, and accomplished

[1] By Frederick Smallfield, A.R.W.S., in an inaugural lecture at Bedford College, 12 October, 1887.
[2] *Preface to the Catalogue of the Exhibition of Works of the late F. Walker, A.R.A.,* 1876.

entirely to the author's satisfaction. On his first introduction, Thackeray handed the young artist a pen, and requested him, as a test of skill, to make a rapid sketch of the satirist's own broad back. It was, fortunately, a kind of art for which Walker possessed a natural aptitude. His happy talent for hitting off personal character was often exercised in little pen-and-ink drawings sent to his friends,[1] so he was easily able to stand the trial. The sketch made on that occasion was exhibited among Walker's works after his death. In the May number for 1861, Walker's first cut for 'Philip' appeared in the *Cornhill*, and he continued to illustrate that story until the end in August 1862. How long Thackeray himself had a share in the designing is uncertain. For some time the cuts are unsigned ; but afterwards they are marked with the initials 'F. W.' This may indicate that Walker had by that time had the entire task intrusted to him. It is said that on the author's happening to fall ill, the modest young draftsman timidly suggested that he thought he could furnish a design himself, and, thereupon proving his capacity on a subject given, was from that time left to do the whole work. While Thackeray lay sick, he would place the artist by his bedside and relate the story to him orally, so that he might picture to himself the scene.

Meanwhile he continued to work for *Once a Week*, whereto, when he contributed his last design in 1863, he had furnished seventy-four illustrations in the three years of his connexion with that publication. His employment on the *Cornhill Magazine* lasted longer. The story of 'Philip' had come to an end in August 1862. After that he illustrated stories by Miss Thackeray, including 'Elizabeth' and 'The Village on the Cliff,' and again accompanied with his pencil the issue of her father's last and unfinished novel, 'Denis Duval.'

In these illustrative designs there may be traced a gradual change of method as well as growth of power. Beginning in the traditional manner which he had learnt from the engravers, he formed by degrees a style of his own, based partly on the wood-drawing of Adolf Menzel (whose book on Frederick the Great's Generals was much studied by Walker) and partly on a new practice introduced into that art by Millais and the pre-Raphaelites, but far surpassing the productions of the latter in breadth and grace, as well as freedom of hand. Walker also made designs on wood for *Good Words, Sunday at Home,* and other

[1] Mr. Marks possesses one containing excellent caricature likenesses of the Academicians Calderon, Marks, Yeames and Leslie, of Storey, A.R.A., and the late Mr. Wynfield.

magazines. While working thus for the engravers, he was teaching himself to paint in water-colours, and in oils also. His first exhibited work was in the latter material, and won deserved praise from the critics in spite of the lofty place which was assigned to it on the Academy walls in 1863. It was a pathetic subject, called 'TheLost Path,' and represented a woman in a snowstorm, clasping a child to her bosom.

He was more readily appreciated by the Society of Painters in Water-Colours, who elected him an Associate on the 8th of February, 1864, on the strength of three drawings out of the four wherewith he made a triumphant *début* at the ensuing exhibition in Pàll Mall East. Two of them were designs originally made for wood drawing ; one having served as an illustration of 'Philip' in the *Cornhill* in 1862 ; and a second, called 'Refreshment,' representing a group of children at dinner in a field, having appeared in the same year in *Good Words*. The third, called 'Garden Scene,' was in fact a subject from Miss Brontë's 'Jane Eyre.' The remaining drawing, which was the largest, represented under the name 'Spring' a girl and boy gathering primroses in a copse. In these he amply proved that, besides being a refined master of human expression, he had (subject to a lavish use of opaque pigment) already acquired consummate skill in his craft as a water-colour painter. The first-mentioned exquisite drawing, of 'Philip in Church,' afterwards gained a second-class medal at the Paris International Exhibition in 1867. It was the only medal awarded to an Englishman for a work in that medium.

By the 30th of November, 1866, on which day he was elected a full Member, he had only added two more drawings to the summer exhibitions and three 'sketches and studies' to the winter ones ; for his temper was of too fastidious an order to let work flow quickly from his studio. All, or nearly all, were subjects which the artist had treated on wood blocks ; and during the next four years some of the most attractive of his drawings were still inspired by the tales of Miss Thackeray. Of these were, one in 1867 from 'The Village on the Cliff,' two subjects in 1868 (i.e. 'The Fates' and 'The Chaplain's Daughter') from her 'Jack the Giant Killer ;' and, best of all, 'Let us drink to the health of the absent,' a sketch for illustration of the first-named story, exhibited in the winter of 1870-1. 'The Escape,' shown in 1872 (four figures in a boat at sea), had also been put on wood in *Once a Week* in 1861. Beautiful as these were, it is to the remaining subjects, which do not owe even so much of their sentiment

to the inspiration of others, that one must look in order to form a just estimate of his creative originality. For the most part, however the latter connect themselves with his work in oils, which medium he now began more assiduously to cultivate. He had sent nothing to the Academy since 'The Lost Path' had been skied. But in 1866 he exhibited at Gambart's gallery in King Street, St. James's, a picture called 'The Wayfarers,' representing a blind man led by a boy along a wet country road. In the next year, 1867, when he first exhibited in our gallery, he also sent a second venture to the Academy. It was a remarkable picture, representing a group of naked boys disporting themselves on a river bank,[1] and called 'Bathers.' Though again unfavourably hung he persevered, and continued to send there one picture every year, which always attracted the general as well as the critical eye. These were all works now well known, and need no minute description here. In 1868 there was the 'Vagrants,' recently placed in the National Gallery. In 1869 'The Old Gate;' in 1870 'The Plough.' Walker's high claim to graphic honours, long established as it had been through his water-colour drawings, was now recognized by the Academy; and advantage was taken of the same relaxation of rules which had empowered it to grant the Associateship to Sir John Gilbert, when knighted in 1871 as President of the Society of Painters in Water-Colours, to confer the same distinction upon Frederick Walker.

In his first year as an A.R.A. (1871) he exhibited at the Academy a study which, in its depth of tragic expression, stood alone among his works. It represented a female prisoner 'At the Bar.'[2] In 1872 his pathetic picture of almshouses,[3] called 'Harbour of Refuge,' was at Burlington House. A scarcely satisfactory work of his last year, called 'The Right of Way,' representing a child alarmed by a sheep, completed the number of eight pictures, which were all that appeared at the Royal Academy. Several of these subjects, repeated in water-colours, were at the Society's gallery, viz. :—'Wayfarers' (in 1870); 'The Harbour of Refuge' (1873-4); and 'The Old Gate' (1875); besides a pen-and-ink sketch of 'The Vagrants' (in 1870-1). Other of his most characteristic original designs exist in water-colours only;

[1] The landscape was studied between Cookham and Marlowe. (G. D. Leslie's *Our River.*)

[2] A *replica* was at the Dudley Gallery Oil Exhibition in 1872. The original failed to satisfy its author, and after it had been exhibited he painted out the head.

[3] The buildings are a study of Jesus Hospital, Bray. (G. D. Leslie's *Our River.*)

for example, 'The Street, Cookham,' with a girl driving a flock of geese (exhibited 1866–7); and 'The Village' (1873).

It was in the portrayal of ordinary humble life in the world around him that his special *forte* lay. In such scenes as those last referred to, of which 'The Harbour of Refuge' may be taken as a type, wherein there is generally a tinge of sadness, he was the most original, and showed most the bias of his mind. That in the representation they had to conform to his own ideal, is but the inseparable result of his being an artist of poetic perception. The graceful refinement which he was wont to infuse into pictures of peasant life did not conflict with reality, and his simple pathos was, at the same time, as distinct from the stern sadness of Jean François Millet,[1] or the massive solemnity of Jules Breton, as it was opposed to the Arcadian prettiness of the last century, or the forced sentiment of this, that had recently worn itself out in the pages of the Annuals. While observant of domestic and rural surroundings, Walker's eye for beauty, like that of Flaxman, was guided and sustained by a classic feeling, derived from his early study of Greek art. The influence of the Elgin marbles, of which to the last he had casts in his studio, is to be traced, not only in his rendering of the figures of the boy bathers, but in other everyday scenes wherein he was not directly painting the nude. But the charm of his work lay chiefly in form and expression. Though agreeable hues in delicate gradations are frequently to be found in his drawings, he does not take the highest rank as a colourist. The flesh tints are not very pure, and the general tone too often tends to a coppery brown that interferes with the true rendering of natural light. Mr. Ruskin denounced his skies as of 'the colour of buff plaster,' admitting, at the same time, that 'in their chosen key,' his 'harmonies of amber colour and purple' were 'full of exquisite beauty.' His way of painting in water-colours the same writer aptly describes as 'a semi-miniature fresco, quarter wash manner of his own—exquisitely clever, and reaching under such clever management, delightfullest results here and there, but which betrays his genius into perpetual experiment instead of achievement, and his life into woful vacillation between the good, old, quiet room of the Water-Colour Society and your labyrinthine magnificence at Burlington House.'[2]

The subjects of his exhibited works do not give much indication

[1] Walker and Millet died in the same year.
[2] Letter to H. Stacy Marks, A.R.A., printed in the *Times*, 20 January, 1876.

of travel abroad, or of study in the face of Nature in her wilder
haunts at home. 'A Gondola' in 1868–9 is all that tells of conti-
nental touring; but we learn from another source that he was in
Venice in 1870.[1] It is on record, too, that he visited the Paris Uni-
versal Exhibition in 1867.[2] And he spent the winter of 1873–4 in
Algiers; but this was in search of health, not of new subjects for his
pencil. 'A Moss-bank near Torquay' (1865–6) is all which nomi-
nally comes from the English West Country, though the background
of 'The Plough' is said to have been studied in Somerset; and from
North Britain the only definite titles are a 'Stream in Inverness-
shire' (1868), with a girl bringing linen to wash, and 'A Lady in a
Garden, Perthshire' (1869–70).

But Walker was not, in the distinctive and higher sense of the
word, a 'landscape' painter. 'Red-roofed or grey remnants of old
English villages and manor-house,'[3] cottage and suburban gardens
full of lilies, and fields or coverts teeming with sweet blossoms of
spring, he indeed loved and studied, and set down with much detail,
but in a fragmentary fashion. The scenery of Cookham[4] on the
Thames afforded the most fitting *locale* for his homely incidents. For,
as Constable said of himself, he 'preferred a modest subject which he
might ennoble, to a grand subject with the risk of debasing it.' It was
not the rolling mists and mountain grandeur that attracted him to
the Highlands, but the pursuit of grilse and salmon. For, unaddicted
though he was to robuster forms of sport, he was 'passionately fond of
fishing.' And 'when away from home for a holiday,' he 'seems
rarely to have touched a pencil.' Mr. Hodgson, R.A., in a recent
interesting sketch of the artist,[5] relates as an exceptional case that
when at 'Corryhoylie,' the house of the late Mr. Ansdell, R.A., on the
bank of the Spean, where Walker used to stay and fish, he was
induced to make up for the loss of a bank-note (under some forgotten
circumstances) by setting to work and producing 'an exquisite draw-
ing representing old Green' (the fisherman) 'on a rock by the side of
the Spean, with a salmon just caught.' Possibly it was the drawing

[1] A slight sketch by him of the house in which he then lodged was lent by Mr. Birket
Foster to the Exhibition of his works in 1876. [2] Ruskin.

[3] *Art and Letters*, November 1881, p. 46.

[4] His mother took a cottage at Cookham, 'halfway up the main street on the right hand
as you go up from river to railway,' and a consumptive brother passed much time there.
(G. D. Leslie's *Our River*.)

[5] 'An Artist's Holidays,' in the *Magazine of Art*, September 1889, pp. 388–9.

called 'Fisherman and Boy,'[1] exhibited in 1867. There exists an
amusing caricature in pen and ink, which he made in answer to an
invitation in September 1873 to leave the easel shrine of his devotion
and 'come to the North,' allured by visions of huge fish, one of 26
pounds caught by his friend Mr. Watts being introduced to him by
a kilted gillie, and others swimming around ready to be hooked. He
calls it 'The Temptation of St. Anthony Walker.'[2] His admiration
for the finny tribe was manifest in one of his latest drawings, reckoned
by some as among his choicest gems, which depicted, with extraordi-
nary minuteness of detail, a 'Fishmonger's Shop' (1872-3). He
repeated the same subject in 1873, on a smaller scale but with broader
chiaroscuro, in a drawing unexhibited in his lifetime.[3] In other of his
drawings, which, being on a small scale, were mostly hung on the
screens, he seems to have been actuated by a desire to emulate, in
closeness of observation, the later and more imitative work of Hunt,
notably in a 'Study of Mushrooms and Fungi' (1868-9), which, save
in colour, almost equals that exemplar. Mr. Ruskin, indeed, went so
far as to say, 'It entirely beats my dear old William Hunt in the sim-
plicity of execution, and rivals him in the subtlest truth.'[4]

It is sad, indeed, to have to record the premature close of a life
the work of which seemed not yet half done. Poor Walker in-
herited a tendency to pulmonary disease, which developed itself at
the time when he ought to have been in his prime. In the winter of
1872-3 the climate of Algiers had been tried, as above stated; but
what benefit he had gained therefrom was lost on his return in the
cold winds of March. One careful drawing (before mentioned) of a
red brick bridge and groups of country people, called 'The Village,'
represented him in the gallery in the summer show of 1873, and the
'Harbour of Refuge' in the following winter exhibition. But for
1874 he sent nothing; and on the 23rd of July he writes from
Folkestone to S. P. Jackson, who had offered him help as to
lodgings :—'I fear I must give up the notion of being at the Thames
side this season, for since I wrote to Leslie on the subject I have had
a letter from my Doctor, who thinks I ought for this season to avoid
the Thames as "lowering" and "relaxing," compared with certain spots

[1] In the catalogue of the Walker Exhibition, 1876, this drawing is described as a scene
in 'Corriechoille, Glen Spean.'
[2] Engraved on wood in *Art and Letters*, November 1881, p. 50.
[3] Exhibited No. 9 in the Walker Exhibition, 1876.
[4] Letter to H. S. Marks, *Times*, 20 January, 1876.

I have mentioned to him as being good from an artistic point of view—·
and as there is some chance of my going to Scotland a little later
perhaps it is better for me to give up the notion.'[1] He had but one
study in the winter exhibition of 1874–5. It was called 'The Rain-
bow ;' and that evanescent glory was a too fit emblem of his fleeting
course. A deeper meaning, too, than was intended attaches itself to
one of the sketches which he left unfinished in his portfolio. It was
a study for a picture to be called ' The Unknown Land,'[2] and repre-
sented a band of explorers springing ashore from a ship's boat in the
bright glow of the rising sun. In the fading light of the painter's
earthly life, it seems to typify that ' bourne from which no traveller
returns.' He went once more to Scotland to fish, but died while on
the excursion, after a few days' illness, at St. Fillan's, Perthshire, on
the 4th or 5th of June, 1875. He was buried beside his mother and
brother, at his favourite sketching resort, Cookham-on-the-Thames ;
and a memorial tablet, with a profile portrait carved by H. H. Arm-
stead, R.A., has since been placed in the church there by the painter's
friends and admirers. He died unmarried.

His remaining works were sold at Christie's on 17 July, 1875. In
January 1876 a singularly complete representative collection of
Frederick Walker's works was formed and shown at Deschamps'
Gallery, 168 New Bond Street, in aid of a ' Walker Memorial Fund,'
the first object of which was the erection of the tablet above
mentioned. The catalogue of this collection, with a biographical
preface from the pen of the late Tom Taylor, and a schedule of all
Walker's exhibited paintings and drawings, forms a valuable guide to
this artist's works. Fifteen of his most noted drawings have been lent
to the Winter Exhibition of the Royal Academy which opened on
the 5th of January, 1891.

The following high prices were realized at Christie's by the sale of
Walker's water-colour drawings in 1886 :—' The Lilies ; Lady watering
Flowers' (12 by 16 in.), 1,365*l.* ; 'Street, Cookham ; Geese and Figures'
(9¾ by 13¾ in.), 903*l.* ; ' Stothall Garden ; Lady seated with Dog '
(18 by 22 in.), 567*l.*[3]

When he had fairly taken up the brush, Walker discontinued his
regular practice of drawing on wood. But there are a few examples
of later date. When John Leech died in October 1864, the pro-

[1] From an autograph letter in the collection of Mr. W. V. Morten, now dispersed.
[2] It was engraved on wood in *Art and Letters*, Nov. 1881, p. 49. [3] Redford.

prietors of ' Punch ' were sorely at a loss for a successor. Except a headpiece by Tenniel, the Almanack for that year had been wholly embellished with Leech's designs; and for 1865 new hands, more or less unused to the kind of work, were pressed into the service. Among these were Millais and Frederick Walker, the latter con_tributing a half-page cut entitled ' New Bathing Company (Limited)__ Specimens of Costume to be worn by the Shareholders.' It represents a party of ladies and gentlemen partially immersed in the sea, and is more distinguished by graceful fancy than by comicality of humour. Another design, ' Captain Jinks of the " Selfish "[1] and his Friends enjoying themselves on the River,' evidently derived much of its force from the artist's love of the quiet Thames, which resented the ruthless disturbance of its silver fish and placid surface by steam launches. Once also he drew a large cartoon (85 by 51 inches), exhibited in the ' Black and White ' Dudley in 1872, for a theatrical poster of a dramatized version of the late Wilkie Collins's ' Woman in White.' And for a series of years he designed invitation cards for the ' Moray Minstrels.' But these were sportive effusions, like the pen-and-ink caricatures in letters to his friends. He also etched a few plates, one or two being translations of the ' Wayfarers.'

It remains to indicate some points of his character as recorded by those who knew him. Mr. Hodgson, R.A.,[2] describes him as a man with ' strange whims and weaknesses . . . contradictory, capricious, and to some not altogether lovable.' He was, he says, ' blown about by every wind, childishly elated at one moment, depressed almost to despair at the next. . . . His mind was not very cultivated; he was inarticulate, and his conversation gave no idea of his powers. His intellect, I should opine, was rather of a slow and lethargic cast. Never did artist groan as he did in the throes of production. It was painful to see him; he would sit for hours over a piece of paper, biting his nails, of which there was very little left on either hand; his brows would knit, and the muscles of his jaw, which was square and prominent, would twitch convulsively like one in pain; and at the end all that could be discerned were a few faint pencil-scratches, the dim outline of a female figure perhaps, but beautiful as a dream—full of grace, loveliness, and vitality. A few scratches would indicate a background, a background which seemed a revelation, so completely

[1] Said to be a careful study from life. (G. D. Leslie's *Our River*.)
[2] 'An Artist's Holidays,' *Magazine of Art*, September 1889, pp. 388, 389.

was it the appropriate setting to the figure.' Thus sensitive in temperament, not over industrious, but ever fastidious as to his own work, he was at the same time steadfast in his endeavours to realize the conceptions he formed. 'Nothing is more remarkable in Walker,' says an appreciative writer, ' than his firm and lasting attachment to motives which had taken strong hold of his imagination. He had but little invention, in the ordinary sense of the word, neither had he the faculty of rapidly conveying his impressions through the medium of the language of art. . . . His ideas were not renewed, but merely developed. He seems never to have approached a subject in his youth without having discovered something in it which was beyond his power then to express, but he rarely laid it aside, until by incessant effort and oft-repeated experiment he had satisfied his ideal.'[1] Some further traits of character are noted in Mr. Leslie's *Our River*, among other things his fondness for cats and his influence over them. The black kitten that trims the floating cradle in Millais's flood was from one that belonged to Walker.

There is a remarkable similarity in the work and in the artistic career, and also in the general incidents of life, between GEORGE JOHN PINWELL and Frederick Walker. The former was the younger by little more than two years and a half, and the survivor by three months only. The two were partially educated at the same school of art. Each began his professional employment as a draftsman on wood, and in some cases they illustrated the same books. This kind of practice led in both cases to water-colour painting, and when they were in our Society, first as Associates and then as Members, their mode of painting had a close resemblance, their sentiment was almost the same, and their subjects were often nearly allied. Each died in harness, cut off in the flower of his age by a fatal malady, after a vain attempt to arrest it by passing a winter in Africa. The analogy was made even more complete after death, for, as had been the case with Walker's, an exhibition of Pinwell's works was held in the same gallery (Deschamps') in Bond Street in February 1876, with a similarly complete catalogue, and a preface which furnishes the fullest *résumé* we have of the artist's biography. What it is needful here to note are rather the points where the lives and works of the two men differ, than where they agree. Had it not been that all the above

[1] *Art and Letters*, October 1881.

were coincidences of fact only, and not of time, it might almost have been a question which artist was the originator of their common style. But, as in every case Walker led the way, and Pinwell followed, in their correlative course, it is the former who must be regarded as the master, and the latter mainly as an apt and sympathetic disciple.

Pinwell was born in London on the 26th of December, 1842. The circumstances of his early life are said to have made it a struggle against adverse surroundings. From the date of his earliest recollections he was trying to draw ; but he had almost arrived at man's estate before his inadequate professional training began. He studied, it is said, in a Government local school of Art, presumably before he entered the academy in Newman Street in 1862, by which time that establishment had come under the management of Mr. Heatherley, after Leigh's death. A short course there was all the teaching our artist had in the way of preparation for practice ; for the next year he began his work on wood, designing for the gravers of his first and most constant employers, the brothers Dalziel, in illustration of an edition of *Goldsmith's Works*, completed in 1864. He also drew sometimes in companionship with Walker and others, for the periodicals *Once a Week*, *Good Words*, *The Sunday Magazine*, and *London Society*, and helped to illustrate *A Round of Days*, Dalziel's *Arabian Nights* (10 designs), and *Wayside Posies*, poems of Jean Ingelow and Dora Greenwell, and Robert Buchanan's *Ballads of the Affections*. When the ' Dudley ' was founded, he obtained therein an opening for exhibition of his essays in water-colour ; and he then began, like Walker, by developing in colours what he had already drawn for the press in black and white. The subject he chose for his first exhibit at the Egyptian Hall in 1865 was the incident adopted by Goldsmith in the *Vicar of Wakefield*, from the author's own travels, of the wandering youth earning his humble board and lodging with a merry tune. After that, he had three drawings there in 1866, one being from the same author's metrical sketch ' The Double Transformation ; ' and one in 1869. Thus brought into favourable notice, he sought election at the Water-Colour Society, and was at once chosen an Associate on the 3rd of April, 1869. He made his mark on his first appearance in the summer exhibition at Pall Mall East, in that year, with two memorable renderings of the poet Browning's narration of the story of the ' Pied Piper of Hamelin ; ' one of these depicting the weird minstrel charming away the plague of rats from the town ; the other

his vengeful alluring of its children to their doom. A third drawing,
called ' A Seat in St. James's Park,' and four studies in the next
winter show, were of the class that, being more of the ' Walker ' type,
showed proportionately less of Pinwell's originality.

Whether he sought inspiration from the poet's page, or trusted to
his own imagining, the follower was wont to venture much further than
his leader into fancy's realm. The next year, 1870, he gave full scope
to his inventive power in a composition of many figures, called the
' Elixir of Love,' [1] which was full of beauteous tenderness and refine-
ment. He attained full rank in the Society in the same year, and first
exhibited as a Member in the summer of 1871, doing himself less
justice, however, in a study of girls and turkeys, called ' Away from
Town.' He was more himself in 1872 in a large and conspicuous
work, the subject taken from the old historic legend of 'Gilbert à
Beckett's Troth ; the Saracen Maiden entering London at Sundown,'
and calling his name through the country. ' The Great Lady,' [2] again
his single contribution, in the summer of 1873, was another of his best
works. Meanwhile he had sent a larger contingent of ' sketches and
studies ' to the winter exhibition ; among them a few of special sub-
ject or meaning, such as ' Time and his Wife,' an old couple making
hay among graves, suggested by a simile of Dickens's, and ' The Earl
o' Quarterdeck ' from a quaint Scotch ballad. These were both in
1871-2.

In 1874 and 1874-5 three scenes of African street life bore
witness that he had been at Tangier. But they betrayed at the same
time a failure of power ; and, after relapsing, in the summer exhi-
bition, into more common themes, he sent no more himself to the
gallery, although 33 posthumous ' sketches and studies ' were placed
there under his name in the following winter. He had died in the
interim, on the 8th of September, 1875, at his residence in Adelaïde
Road, Haverstock Hill. Pinwell had been an indefatigable worker
while health lasted, but long and severe illness and the expense of
travelling reduced his slender resources and hard-earned savings, and
after his death a body of his professional friends, with their usual
kindly charity to their brethren, combined to raise a fund for the
benefit of his widow. His total number of exhibits in the gallery
(from 1869 to 1875-6) was 59 (12 in summer and 47 in winter).

[1] It was sold at Christie's in 1871 for 273*l.*
[2] Sold at Christie's in 1876, and again in 1879, for 152*l.* 5*s.*

Cut off thus prematurely, his career must be regarded as one of much hope and promise unfulfilled. Some work he bequeathed of most refined loveliness, but weakened by great imperfections. It may be a question, how far his defects of workmanship were due to ill health, and how far to insufficient training; and to what extent they might have been remediable, with time, and strength, and further practice and observation. Although many of his scenes are in the open air, he was even less of a landscape painter than Frederick Walker. He seemed to have but little sense either of chiaroscuro or aërial perspective. In his paintings definition of detail is introduced capriciously, without due regard to the relative distance of objects from the eye; and this produces a patchy effect. There is sometimes a want of keeping between the figure and the background; as if the one had been painted in the subdued light of the studio, and the other under the roofless sky. Though his pictures contain passages of refined grace, as well as dramatic pathos, the beautiful was administered in fragments, and did not govern the entirety. One cannot withhold admiration for what he was; but it is tempered with sadness when one speculates on what he might have become. He made some attempts to paint in oils, and left many unfinished studies for a picture in that medium, which he did not live to execute. He was an Honorary Member of the Belgian Society of Painters in Water-Colours. Pinwell had many friends. He is described as generous, kind-hearted, honest, and upright, though sometimes rough in his manner.

Before the above-mentioned exhibition of his works in Bond Street, they had been shown in Manchester (in September 1875); and those which had remained in his possession were sold at Christie's on the 16th of March, 1876. Eighteen of his drawings, the property of Mr. Edward Dalziel, some of which had been exhibited in our gallery, were sold at Christie's on the 19th of June, 1886.

Yet a third figure painter, who had even more recently joined the Society, and whose name is associated with the same school of wood drawing, was carried off prematurely by death in the fatal year 1875. This was ARTHUR BOYD HOUGHTON, who died at the age of thirty-nine, four years older than Walker, and six than Pinwell. He, like the last, had taken to art rather late in life, and entered into its practice before he had thoroughly mastered its processes.

He was born in 1836, the fourth son of the late Captain M. Houghton, of his Majesty's Indian Navy, on whose return invalided from India he began to practise painting, but in a somewhat desultory fashion. He first tried oils, and sent to an ephemeral exhibition, a kind of *salon de refusés* which was held for a season or two at the Portland Gallery in Regent Street, certain ' quaintly conceived drolleries, and most daintily touched scenes of street and London life.'[1] He exhibited some pictures, too, at the Royal Academy, the first being ' A Fisher,' and ' Here i' the Sands,' in 1861. He then tried his hand at drawing on the block, and was employed by the Brothers Dalziel upon their *Illustrated Arabian Nights' Entertainments*, published in parts by Ward, Lock & Tyler, and completed in 1865. To the ' upwards of 200 cuts ' therein he contributed the designs for ninety-three.

As an original designer and draftsman on wood, both his merits and defects may be gauged by this series of illustrations. The work itself when compared with the *Thousand and One Nights*, edited by Lane, and embellished by the woodcut designs of Bewick's pupil, William Harvey, shows in a striking manner the complete revolution which had taken place in this country in the style of its xylographic art. Sooth to say, Houghton's woodcut drawing in the ' Arabian Nights ' has about it a strong savour of the amateur. If Pinwell's works suffer from insufficient training, still more do those of Houghton. In his case, however, it is probable that defective workmanship was in a measure due to defective vision. For the artist possessed but one eye, having had the misfortune to lose the other early in life ; and this must have deprived him to a great extent of the power of measuring spaces. Unfortunately, in his endeavours to compress a scene within the boundaries of the block, he was apt to set himself hard tasks of foreshortening and grouping, in the attempt to grapple with which he sometimes evolved proportions and combinations that were not far removed from the grotesque. Moreover, he shared with others of his school their apparent blindness to the charms of chiaroscuro, substituting for artistic breadth a meaningless and often confused series of sharp contrasts. Taking, however, these defects and blemishes as prescribed conditions of his art, there is recognizable in his works a certain strength and originality of conception, which might under more favourable circumstances have placed him in a position of considerable rank as

[1] *Concordia*, 4 December, 1875.

an artist. He was possessed of inventive and dramatic power of no mean order; though it was of an eccentric and somewhat sensational kind, and his comic humour had a leaning towards caricature.

Besides the wood drawing above mentioned, he worked for a time on the *Graphic* newspaper, which, as we have seen, began its career at the end of 1869, and in its earliest volumes formed a contrast with the *Illustrated London News*, representing what had then become the 'advanced' school of wood drawing and engraving. A series of articles entitled 'Graphic America' in the new journal were illustrated by Houghton. He was also engaged as a 'cartoon artist' by the proprietors of *Fun.* In the *Poetical Works of Lord Byron*, published by Warne & Co. in 1868, in the series called 'Popular Poets,' fools. cap 8vo, are four full-page cuts by Dalziel, drawn by Houghton. He was able to do more justice to his talents when he took up the brush. Where his brethren of the block most commonly failed, Houghton was at his strongest. For he was a rich and powerful colourist; and it was this quality that was most to be commended in the works he exhibited at Pall Mall East. They were very few in number, no more than eleven in all (six in the summer, and five in the winter shows), and these were spasmodically sent. Three were from his Arabian Night illustrations. One in the year of his election, 1871, 'Hiawatha and Minnehaha,' was from Longfellow's poem. The most original was a procession of women and children and aged men leaving a mediæval city, presumably about to suffer a siege. It was called by the somewhat perplexing title 'Useless Mouths;' and exhibited in 1872. It measured $27\frac{3}{4} \times 18\frac{3}{4}$ inches, and was sold at Christie's in 1874 for 157*l.* 10*s.*, again in 1876 for 120*l.* 15*s.*,[1] and again on 15 March, 1890, for 138*l.* 12*s.* Graves enumerates his paintings exhibited elsewhere as seventeen in all, ten at the Royal Academy, four at the British Institution, and three at Suffolk Street. These were probably all oil paintings. One of the most noteworthy was 'John the Baptist rebuking Herod,' in 1872, his latest at the R.A.; for one which he painted later, called 'A Visit to an Assyrian Studio,' was rejected at Burlington House. He took most of his inspiration from the East, and his figures thence were full of Oriental character accompanied by appropriate incidents.

Houghton was 'early married, and early a widower,' and his

[1] Redford's *Art Sales.*

bereaved cóndition, added to failing health, is thought to have en-
gendered a certain restlessness, which is reflected in his work.[1] He
died on the 22nd of November, 1875, at 162 King Henry's Road,
South Hampstead, and was buried in the Paddington Cemetery,
Willesden Lane. He had not passed out of the rank of Associate.
His remaining works were sold at Christie's on 17 March, 1876.

There died, before the close of this fatal year 1875, yet another
Member, a figure painter also, but one whose work had little in com-
mon with that of the trio last noticed. His admission affords an
example, of which there are several, of the liberal spirit, so charac-
teristic of the English nation, that made the Society ever ready to
welcome talent for its own sake, whether native or foreign. EGRON
SILLIF LUNDGREN was a Swede, born at Stockholm on the 18th of
December, 1815. But he received his technical education in the
studio of Leon Cogniet, in Paris, where he remained for four years.
Little is recorded of his early practice as an artist, nor is it exactly
known what induced him to take to water-colour painting in prefer-
ence to oils. He appears to have done so before he came to England,
where he rarely used and did not exhibit in the latter material.
When a young man in his native country he illustrated a series of
Swedish Popular Tales. But he did not remain settled at home,
although possessed of property in Sweden.

He had a taste for travel. After making acquaintance with Paris,
as aforesaid, he went to Italy in 1841 and remained there for eight
years. He was in Rome during the memorable siege by the French
in 1849, and served as one of Garibaldi's volunteers. In the same
year he first visited Spain, where he spent about ten more. It seems
to have been in the winter of 1852–53, when the late John Philip,
afterwards R.A., was beginning to paint the subjects for which he
became so celebrated, and when, as before related, our Member
F. W. Topham was laying a similar foundation for future success,
that Lundgren made a pleasant acquaintance with both artists during
a sojourn at Seville. Long after, when revisiting that city in 1868,
he referred to this companionship in words of sweet remembrance.
' I find the place very much the same, and am continually reminded
of the jolly days I had here with Philip, Topham, Ansdell, &c.'
And later still, in December 1870, when collecting his memoranda of

[1] *Concordia*, 4 December, 1875.

the same jovial time, he declares that the occupation has 'made his autumn sunny.'

These painters appreciated his talent, and, when they came to England in the following season, introduced him to the London art circle. Topham indeed had already prepared the way. He writes to Duncan, in a letter from Seville, of the 1st of April, 1853 : 'A friend of mine, Mr. Lundgren (by the bye, I hope a candidate for future membership at our Gallery) is making a drawing on wood ;' and this with a block of his own he proposes, with the aid of Dodgson's good offices, to send to the *Illustrated London News.* Lundgren came to London in the summer or autumn of 1853 with Topham, who at once presented him to his friends in the Water-Colour Society. And the relations with Philip naturally led to what became a lifelong friendship with the late Thomas Oldham Barlow, R.A., the admirable engraver of most of that painter's works. To Mr. Barlow our artist was indebted for most kindly and valuable help and advice in his affairs. Lundgren's susceptible heart seems to have been deeply impressed by his hospitable welcome to this country. ' From the first and ever afterwards,' wrote his brother to Mr. Jenkins after our painter's death, 'he was attached to England sincerely and truly. Not only that he was, naturally, struck with admiration for the grandeur of England, but there he met with a kind reception and found his best friends. Consequently, his companions both in his wanderings and in his studies of art were Englishmen. Most of his letters and artistic works went to England.'

How his talent was employed during the next four years has not been ascertained. His name does not appear in the catalogues of the London exhibitions. But it is not unlikely that he may have obtained work here in the wood drawing on which we found him trying his hand at Seville. Certainly at a later date he was in the habit of exercising his fancy by composing sketches from memory, or of his own invention ; and it was conjectured by his brother, from the many drawings which he left, apparently first outlines for book illustrations, that he was engaged when in England in designing for the press. At any rate he acquired repute enough for facility in sketching to secure him the privilege of accompanying the staff of Lord Clyde in the campaign of Oudh, immediately following the relief of the garrison of Lucknow in November 1857. In that and the next year he made a series of military and other sketches in India, including portraits of

distinguished persons. The greater part of these drawings were
made for the Queen. A collection of 271 of them was purchased by
Mr. Sam Mendel, of Manley Hall, Manchester, and resold at Christie's
on the 16th of April, 1875, to Mr. Edward Hermon, M.P., for 3,050
guineas. The artist, writing soon after the latter date from Sweden,
whither he had then returned (alas! to die soon after), says to his
friend Barlow : 'It has interested me very much to see that the sale at
Christie's turned out so well—far beyond my expectation. I am also
glad that the collection, such as it is, may be kept together, because
of course it increases the interest tenfold. It would really give me
pleasure to get an opportunity to look over these papers again, as
they would recall to my mind many remarkable incidents, and I can
well fancy the interest they may have to many old Indians, I mean
such as have seen Indian service, and made the acquaintance with
the Bengal sunshine. Not a few of these sketches were made under
very trying circumstances, and at a few moments' notice without
much hesitation ; and perhaps not a little of their interest is derived
from the fact of their being the immediate transcripts of the moment.
But I fear it will be apparent how the damp weather, during the wet
season, spotted the paper I had to use nevertheless, as Winsor and
Newton had no agents in the jungles, and where there may be had
more Tigers and Vipers than painting materials.'

On his return to England, Lundgren was honoured with further
commissions from the Queen, one among them being for a picture
of the marriage of the Princess Royal, which took place on the
25th of January, 1858. He also made for her Majesty a series of
drawings of scenes at the Princess's Theatre during the late Charles
Kean's Shakspere revivals. In September 1859 he writes to his
friend Barlow, from Balmoral, where he is a guest at Court, in high
delight at the kindness and marked distinction he receives : 'This
week I have seen her Majesty every day, always most charmingly
gracious. . . . By the Queen's desire I was taken the other day to a
beautiful waterfall, &c. I have a kind of painting room. The other
morning the Queen and the Princess Alice came there by themselves.
. . . The other day I was up among the high mountains with the
Royal party about ten miles on horseback ;—very good and beautiful
scenery.' Yet the 'country here about,' 'exceedingly beautiful' as it is,
is 'not congenial to my own feelings. It is peculiarly melancholy.'
Perhaps he was a little home-sick. For, a short time after he had

concluded his visit to her Majesty, he set out for Stockholm, and writes ere long : ' I have enjoyed the journey exceedingly. . . . My pleasure of seeing Stockholm again surpasses what I expected. I am now travelling in the interior with my brother.' In July he again writes from Christiania, Norway.

In November 1861 he is at Cairo. Here again we find him with English associates, Mr. Frank Dillon of the Institute, and Mr. George P. Boyce, now a Member of our Society. These three artists hired a house in Gizeh on the river bank, and there they lived for a time in Oriental fashion. His letters describe the native hospitality they received from a young Egyptian, Iscander Bey, son of the late Soloman Pasha, visits to the Boulay Museum and the Sphinx's head, and an English picnic at the Pyramid of Cheops. Then he records his impressions : Egypt is even more picturesque than he expected ; at Gizeh, ' the neighbourhood is of extraordinary beauty—a strange grandeur with sycamores and lovely waters and most glorious sunsets and twilights, impossible to paint, but tuning [?] the imagination to the melody of Genesis of Moses and the Patriarchs.' Lundgren outstayed his English friends at Cairo. It appears to be in February 1862 that he writes to Barlow : ' Boyce is gone. He takes with him an interesting number of costumes and curiosities. As for myself, I have scarcely bought anything, although opportunities present themselves every day. Instead, I have unexpectedly received a Swedish thing which rather astonished me, but at the same time gave me assurance that I am not forgotten by my influential friends. The King has named me a member of an Order of Knighthood,[1] a kind of Legion of Honour, with a star and a green ribbon for the button-hole. " What do you think of that, Master Brook ? " Of course I have not the slightest use of it, in England ; but it is certainly a distinction at home and on the Continent. In many cases as good as a letter of introduction, as it at all events means that you are personally known by the King, and appreciated. To me especially who travel so much it may be a very useful thing, as I by that through the different ambassadors and consuls with great facility may get access to many places and persons whose acquaintance may be of value to me. Besides, I feel very grateful for this public mark of the King's kind disposition towards me, and his endeavour to facilitate my progress.' We trace him back to London by the summer of

[1] He was created a Knight of the Order of Gustavus Vasa.

1862, where, from the address 'Auburn Lodge, Victoria Road, Kensington,' which was Barlow's place of residence, he sends two pictures to the Royal Academy, results of his visit to the East. They were his first exhibited works, at least in England ; their titles, ' A Jew and a Mussulman playing Chess,' and ' Interior of a Mosque at the Tomb of the Kalifs, Cairo.'

In October he is in Spain again. It is ten years since his first visit, and he meets a new generation of English painters there. On the 30th he writes from Madrid : 'We have been staying two days at Toledo and enjoying the picturesque city amazingly, sketching fast. We had the pleasure to meet there two English artists, Messrs. Long and Burgess ; and, the day before we left, with S. Read.'[1] He has been at Segovia as well as Toledo, and ' had the opportunity to make a number of outdoor sketches, useful bits for backgrounds.' On the 21st of June, 1863, still, or again, at Madrid, he writes : ' In the morning I am in the Picture Gallery, and have made some sketches already. I am going to the Bull fight with the Austrian Secretary of Legation, with whom and Madrazo I dined last evening at the Swedish Minister's. To-morrow I intend to take my ticket for Bayonne.'

In the December of that year Lundgren attained the age of fifty ; yet, although he had led so long an artist's life, his name had scarcely come before the public through the usual channel of the exhibition room. Long before, as we have seen, had Topham set a mark upon it as suitable for the Society ; and now, urged by the advice of several friends, he presented himself as a candidate, with three finished watercolour drawings and a folio of sketches. His election as an Associate followed at once, on the 8th of February, 1864. ' Choristers at Seville,' and ' Egyptian Donkey and Boy,' the only works he showed that year in the gallery, were not only indicative of the countries where he had chiefly studied, but exemplified the nature of much that was to follow. A charming artist and most graceful draftsman, and moreover a rich and refined colourist, it is to be regretted that his talents were seldom or never employed to depict subjects deriving importance from dramatic interest, or human expression of a high order. Fascinating and artistic as they were, they come more within the category of studies, or even of sketches, than that of complete pictures. This apparent want of ambition was possibly due in some

[1] Edwin Long, R.A.; John Bagnold Burgess, R.A.; and the late Samuel Read, M.R.W.S.

degree to the fact that Lundgren's works of the above kind were favourites with the dealers, and, being much in demand, they occupied his time almost entirely. As might be expected under these circum-stances, he was a more prolific exhibitor in the winter than in the summer shows at Pall Mall East. On the 12th of June, 1865, he was elected a full Member. In the course of his twelve years' connexion with the Society he had ninety-three exhibits in the gallery (thirty-five in the summer, and fifty-eight in winter), without counting some twenty or thirty separate sketches included in frames with others.

During the whole of this period his catalogue address was '13 Upper Phillimore Gardens, Kensington,' the house of his friend, Mr. Frank Dillon, where he had a studio when in England. But his travels were not yet ended, and the last years of his life were spent in his native country. In 1865 he paid a visit to Italy, where he was again with his old friend Dillon and Mr. F. W. W. Topham,[1] at Ravenna, in May, outstaying them there to finish 'certain things which I have begun.' Returning to Bologna and Florence, where he meets Duncan, he is at Siena in June, full of admiration for its cathedral 'of black and white marble, sparkling with gold and frescoes, mosaics, and exquisite doorways, quite bewildering in its richness,' and the library thereof with Raphael frescoes, 'more like a jewel casket than any-thing else.' He speaks of his copying some of these frescoes, and adds : 'I think I am the only foreigner in Siena, which is a small and quiet town, 20,000 inhabitants, quite a place for study and for student's life.' His solitude was enlivened, however, by the news which here reached him of his election as a Member of the Water-Colour Society. 'As you may imagine,' he writes, 'I rejoice very much, and cannot tell how surprised I am that this distinction should fall upon me so soon.' The results of this trip were apparent in the next three exhibitions. In 1865-6 he had 'The Church of St. Vitale, at Ravenna, with the mosaics from the sixth century;' in 1866 another drawing of St. Vitale, and 'Dominican Friars showing to a Traveller the Fresco said to be painted by Raffaelle in the Library at Siena;' and in 1866-7, 'Dante and Giotto—Sketch for Fresco,' 'Michael Angelo and Lorenzo de' Medici,' and 'The Old Baptistery at Ravenna.' These, however, are quite exceptional as subjects, among his customary studies and groups of Arab girls, Spanisn gipsies, and the like.

[1] Son of the late F. W. Topham, of our Society.

After this he went to look after his property, apparently with the intention of making Sweden once more his home. Dating from 'Hastinge near Stockholm, 14 July, 1867,' he says : ' I write this from my own place where I have been staying. . . . The next day I sent for my horses and carriage, and we drove out at once to my country cottage, where I found everything better than I had expected. The situation is very pretty indeed, the garden sloping down to a good-sized lake, with varied and hilly scenery all around, full of fish they say. The fields I have let, so that I am quite free from all trouble about that, and can dispose of the houses according to my own pleasure. In the principal building I have nine rooms and kitchen besides ; in the other house four rooms and kitchen, and a third house contains a large very light room which would suit me as a painting room. My own rooms are very neatly furnished, with old carved genuine furniture, old gilt ornaments, plenty of chairs and tables, all my books, and all my English gilt frames hung up.' Sojournings in the South had, however, so far quelled the ' hardy Norseman ' in him, that he shrank from the winter's cold there, which he had ' not tried for many years,' and he went once more to Seville at the end of 1867. ' I have been fortunate enough,' he writes thence on 10 January, 1868, ' to get a tolerably good studio,' and ' now I am very busy, and plenty of visits from gipsies and others all day long, so that I have already begun several things.' Among these models were some who had sat to Philip in the old days, one of them ' Antonia,' looking ' as handsome as ever.'

He must have returned to England very early in the year, and paid a visit to Derbyshire in the early spring, for on the 1st of February and 5th of March he dates from Matlock. But he is settled in Sweden again in the autumn of 1869, and sharing a house at Stockholm (4 Oxtorget) with one of his brothers, Mildhog Lundgren, who writes in the month of September of two sudden and alarming attacks of illness with which Egron had been affected. From their effects, however, he appeared to recover, and he proceeded to occupy and amuse himself ' during the dark November days with the task of collecting the memoranda which he had made during his travels. These he eventually published in the Swedish language. After his death a copy of this work was presented by his brother, Mildhog, to Mr. Jenkins, for the Society's library, and the donor at the same time gave, in a letter to him dated 7 November, 1878, the following account

of its origin and the circumstances of its publication and reception in Sweden : ' During his long stay abroad, Egron proved himself to be gifted with an extraordinary talent for writing letters, and for making up sketches with the pen. He had the view of the things not as a commercial traveller but as a gifted artist with keen perceptive and poetic eyes, and consequently penned down his impressions picturesquely and in vivid colours. His style was improved ever more in course of time, and proved to have all the merits of an excellent one ; it was easy, pure, elegant, charming, pleasing, humorous. His writings in MS. attracted the attention of the public, so much that Egron some years before his death was considered to have acquired a kind of Mastership in our literature. The public, the editors, his friends, all were calling for the publishing of his manuscripts, and Egron was persuaded to remodel his collected letters and bring them, ·as well as a portion of pen-sketches made abroad, to the form of a work fit for the press. So the work now presented to you was published. It is entitled " *Notes by a Painter*," extracts from journals and letters, and forms three parts, Italy—Spain, India, and " Leisure hours abroad." [1] The Swedish Academy, or the supreme authority here in Belles Lettres, was pleased after the publication of the work to adjudge its medal in gold to Egron as an acknowledgment of his talent as an author, and did it with these words—" having read his work, a large and thankful circle of readers were convinced of the fact that Mr. Lundgren handled the pen in a manner quite as charming as that in which he handled the pencil, and every one who had looked at the masterly productions of the latter had in doing so refreshed his recollection of the same vigorous hand and the same fair, glowing tone of colour that was apparent at the handling of the former." ' Besides writing this work, he contributed to divers 'Christmas books, periodicals, and magazines.' It will be justly inferred from what has gone before that Egron Lundgren was not only an intelligent and well-informed writer, but an excellent linguist. It is to be regretted that, with the exception of such portions of his letters to friends as are here quoted, his published writings should be confined to his native tongue. But his brother points out that the author's Swedish being ' very peculiar,' a good translator of them must be very familiar with both languages, and fears that no competent person

[1] *Utdrag ur Dagböcker och Bref:—Italien och Spanien*, 1873-1874 ; *Indien*, 1874 ; *Lediga Stunder Främmande Land*, 1879.

could be found to undertake the task of turning his works into English.

We have seen how on his former return to Sweden, Lundgren had been honoured with a knighthood. On his final residence there he received further marks of Court favour in his own country similar to those which had been bestowed upon him in this. In 1871 he says : ' I am now staying out in the country at one of the King's summer palaces where there is a large park and particularly fine scenery. I have there with great kindness been noticed by the new King, and even at several times been invited to his table.' And on the 25th of November, 1873, ' I made a portrait of the youngest of the Royal Princes (a boy of eight). The day before yesterday I left it as finished at the Palace, and was very graciously received by the Queen.' This and subsequent letters are written from ' 5 Hercules Gatan, Stockholm.' In December 1874 he feels that his health is declining. ' I am not so well as I would like to be, and that makes me look at everything in a more gloomy mood than is useful even to the healthy. But it cannot go on for ever in this world. Years are coming on with weakness and its associates. It is then fortunate if we have sunny memories to turn back to ; and as to me, it would be most unfair to complain of not having many such, and I am therefore continually trying to adorn the present with the past.' In this contented frame of mind he lives for one short year more. In December 1875, when at Oxtorget, Stockholm, with his brother Mildhog, he was seized again with apoplexy, and died on the 16th, in the sixtieth year of his age. He had left written instructions, requesting his ' dear friend, Thos. O. Barlow,' to notify his decease ' to the Secretary of the Society of Painters in Water-Colours, as well as to the others of my English friends. As I reckon a great number of them,' he had added, ' it may be best to insert an advertisement in the *Times*.' That was done on 23 December, 1875. To what has been recorded above, it need scarcely be added that Lundgren was not only an accomplished but a most amiable man, and a delightful companion. His memory has been cherished by the circle, now fast disappearing, of those who knew him.

Among the later works he exhibited were a few studies of Swedish peasants (in 1869–70, 1870, and 1870–1), but the rest were still from Spain, Italy, and the East. There are two plates etched by him, one of ' a Spanish water-vendor,' the other, ' a boy holding a bird's cage

in his hand.' After Lundgren's death, an exhibition of his works extant in Sweden was held in 1876, to which were added some of those executed for Queen Victoria. These had not before been lent by her Majesty for public exhibition. An interesting likeness of this artist, engraved on wood from a photograph taken in Stockholm in 1874, appeared in the *Illustrated London News* of 8 January, 1876.

In the year 1876 a melancholy accident deprived the Society of a Member who for fifteen years had been an unfailing contributor of landscapes, which, if limited in the range of their subjects, were faithful renderings of native scenery, reflecting the beauty of Nature in her wilder aspects. Rough moorland tracts of ground in North Wales were depicted by JAMES W. WHITTAKER with a suggestive strength which few could surpass. With rare exceptions, his sketching-ground lay in the district round about ' Snowdon and the Glyders,' which was the title of one of his first year's exhibits, and Capel Curig, Bettws-y-Coed, the Dollwydellan valley, the Pass of Nant Frangon, and such well-known haunts of artists. In this neighbourhood he lived and died. He was, however, a ' Manchester man.' He began his professional life as an engraver, but having a taste for drawing, gave up engraving as soon as he was able to sell his sketches. Then he took a small cottage on the mountain-side on the road from Bettws-y-Coed to Llanrwst (Ffrith Cottage by name) at a rental of 10*l.* a year, and worked very hard at making drawings of Welsh scenery. For these, some dealer in Manchester gave him trifling sums of from 2*l.* to 4*l.* each. It was when on a visit to North Wales that Topham made his acquaintance, and thought so well of his drawings that he advised him to become a candidate at the Society of Painters in Water-Colours. At his first trial he failed, but he succeeded on a second attempt, and was elected an Associate on the 10th of February, 1862. Full Membership followed on the 13th of June, 1864. For some years he was very successful in the sale of his works ; but latterly they declined in merit, from a failure, it is believed, of physical energy.

His death occurred on the 13th of September, 1876, by drowning in a stream near Bettws-y-Coed, where he had resided for twenty years. The lamentable circumstances were described by his brother artist, Mr. Edwin A. Pettit, who was there at the time, in the following words :—' On Wednesday evening last he returned to the fatal spot—a most dangerous one, about a hundred yards above the Miner's

Bridge on the Llugwy—to collect his painting traps, where he had left them during the afternoon. In collecting them, no doubt he slipped, and fell a distance of between 20 feet and 30 feet on to a shelving rock, scattering the contents of his coat pockets, where with difficulty they were collected on Friday morning. The body having been washed down the stream, was recovered on Thursday evening below the Miner's Bridge ; and on Saturday, at the coroner's inquest, from indisputable evidence, the jury returned a verdict of " Accidental death." [1] He was a widower with a family of four children (the youngest a boy of twelve or thirteen at the time of the father's death), who happily were not left destitute of resources.

Whittaker had 191 exhibits in the gallery between 1862 and 1876, 70 in the summer, and 94 in the winter shows, including 14 sketches placed there in 1876-77 after his death. To these above 30 may be added for small sketches more than one in a frame, and not separately numbered. The only exceptions to the North Wales subjects are four views on the Northumberland coast, and one on that of Fife (in 1868, 1869-70, and 1870) ; and two in Piedmont (a ' Farmhouse,' 1864-5, and ' Lago d'Orta from the Monte Sacro,' 1866), with a ' Sketch in Switzerland ' (1876-7). These latter may or may not indicate foreign travel. In 1870-71 he had three works at the Royal Academy. Redford's list records the sale of one drawing at 157$l.$ 10$s.$, namely, a ' Sunset on the Glydders ' (25$\frac{1}{4}$ × 38$\frac{1}{4}$ in.), in the Halford sale, 1868, the only example that had exceeded 100$l.$

[1] *Times*, 15 September, 1876.

CHAPTER II

DEATHS SINCE 1881

Biographies—*S. Read—A. P. Newton—H. B. Willis—T. Danby—Mrs. Angell—Mrs. Lofthouse (née* Forster)*—F. Holl, R.A.—O. Weber—Miss M. Naftel*—List of present Members and Associates.

THE Members and Associates whose lives and works have been above considered had all passed away before the ennobilization of the Society in 1881. In the decade which was then beginning (the first of the 'Royal Society of Painters in Water-Colours'), four Members and five Associates, who had entered it since the death of Fielding, joined the great majority; and three of the Associates both began and ended their terms of connexion therewith during the period named. Some notice of these nine artists will complete the record of the deceased.

When the late SAMUEL READ was made an Associate on the 9th of February, 1857, no painter o purely architectural subjects had been elected to supply the place of Frederick Mackenzie, who died nearly three years before. Except Joseph Nash and John Burgess (and to some extent William Callow and James Holland), there was no one now left in the Society who specially cultivated that depart‑ ment; and the void seems to have been somewhat felt. Of the above-named, Burgess alone depicted the same particular class of objects as the new-comer. But the position of Burgess was more dependent on the quality of his style than on the nature of his sub‑ ject. Thus the name of Read came to be more familiarly associated with the stock delineation of 'architectural antiquities,' such as had in the old time given work to the plate engravers and been fostered by the enterprise of speculators like Ackermann and Britton. Here, as in other departments of graphic art, the methods of reproduction in vogue at the time had their usual bearings and influence on the work and hand of the draftsman. As the successive labours of Pugin, Wild, Mackenzie, F. Nash, Prout and J. Nash were connected

with the arts of aquatint and line engraving, and with soft etching and lithography, so were those of Samuel Read connected with that of engraving on wood. He was another of the practised draftsmen on the block, so many of whom in his time swelled the ranks of the Water-Colour Society.

Read was born in 1815 or 1816, at Needham Market near Ipswich, and was first intended for a lawyer, and accordingly placed in the office of Mr. Sparrow the Town-clerk there; but was thence removed to that of an architect in the same town of Ipswich, whom he served as an assistant. The latter position accorded more with his taste, which had early shown itself in the usual love for sketch-book and pencil; but neither calling satisfied his strengthening desire to be an artist *per se*. So when about five-and-twenty years of age (in 1841 to wit), he came to London and learnt wood drawing under the same engraver, Whymper, who was to teach Frederick Walker some fifteen to twenty years thereafter. In 1844 he began to contribute designs to the *Illustrated London News*, for which journal he continued to draw for the rest of his life subjects not exclusively architectural, but embracing also marine and general landscape, together with certain imaginative compositions for Christmas numbers, such as 'The Haunted House'(suggested by Hood's description). A series of large views by him of English cathedrals was published therein, and a number of small studies of picturesque architectural fragments, entitled, 'Leaves from a Sketch-book,' some of which were also brought out separately in a volume.

In 1843 Read exhibited for a short time at the Royal Academy, sending to the architectural room a drawing of the 'Vestibule of the Painted Hall,' at Greenwich, where he then appears to have resided. From that date he sent architectural drawings at the rate of one a year to the Academy, until 1857,[1] when he was received into our Society. His two drawings exhibited that year, one of Milan Cathedral, the other of the doorway of Roslyn Chapel, indicate the width of area from which come the subjects of his water-colour drawings. But he had travelled yet further. He was the father of the race of artist correspondents who have of late years played so important a part in preserving the great graphic record which now exists of this age, for the information of posterity. He is credited with the dis-

[1] He had three more drawings there in 1860, 1861, and 1872, making 18; and also, according to Graves, 13 at Suffolk Street.

tinction of having been 'the first Special Artist ever sent abroad to furnish sketches for any illustrated newspaper. Just before the out. break of the Crimean War in 1853, he went out to Constantinople and the Black Sea for the performance of that service.' [1]

No trace, however, of this martial experience is visible in his water-colour drawings. For the most part they represent Gothic buildings, chiefly abroad, the result evidently of much industrious travel. For the first five or six years his subjects are chiefly from Belgium, a large proportion being studies in the interiors of the churches at Antwerp, with a few from Nuremberg, Westphalia, and North Italy, and a small home contingent from Haddon and Roslyn. In the autumn of 1862 he was seen, as related, by Lundgren at Toledo, and after that date subjects thence and from other places in Spain are added to the list. A few from Normandy and the north of France appear occasionally, and an increasing number from Scotland. But he is no longer content with the border abbeys, and some views in the old town of Edinburgh between 1873 and 1876. He enters upon the wider field of landscape. Some sketches in 1865–66 had told of a visit to the Isle of Skye, and from 1872–73 a large proportion of his works are coast views, nearly all in the extreme north of Scotland, with a few from Antrim in 1874–75, and on the English seaboard. To these cliff studies of his later time he did not bring the more comprehensive scope of vision required by the largeness and infinitude of nature's handiwork. It is too much with the builder's eye that he erects these vast sea walls ; and the new departure did not raise the position he had acquired as an architectural painter. He is best remembered still by his foreign church interiors.

He was not raised to the full rank of Member until the 13th of May, 1880. When he joined our Society, Read's address was at ' 15 New Cavendish Street, Portland Place.' Therefrom in 1861 it changes to ' 55 Argyll Road, Kensington,' where it remains till 1874, when he went to live at ' Parkside, Bromley.' In thus taking up his final residence in Kent, he was undeterred by the remembrance of a narrow escape with his life which he had had a few years before, in the terrible railway accident which occurred at Staplehurst, in the same county, in June 1865. He was returning home from a continental sketching trip in the ill-fated mail train, part of which, including his carriage, was rolled off the embankment into a river. Read was only

[1] *Illustrated London News*, 19 May, 1883, p. 4S8.

rescued after he had lain for some time pressed down immovably with his head under water. Happily he had sustained no serious injury, and in a short time was even able to render some assistance to others. It was the accident which is further memorable by the fact that Charles Dickens was a passenger in the train. His activity in aiding the wounded is recorded in his Life by Forster.

Read was married to a daughter of the late Dr. Carruthers, proprietor and editor of the *Inverness Courier*. His wife and a son and daughter survived him. There is a woodcut portrait of him at the head of the obituary notice in the *Illustrated London News*, from which most of the above facts of his life are taken. He died at Sidmouth, South Devon, on the 6th of May, 1883, aged sixty-seven. Including eight in the gallery in the following winter, there were 210 exhibits in his name between 1857 and 1884, and until the year of his death he had never failed to send something to every exhibition in our gallery. Mr. Redford notes the following as the highest prices realized by S. Read's drawings at public sales :—315*l.* for 'Interior, St. Stephen's, Vienna' (52 x 30 in.), at 'W. Leaf' sale, 1875 ; 199*l.* 10*s.* for 'Church of Bron, Bourg,' and 132*l.* 6*s.* for 'Toledo Cathedral,' in the artist's executors' sale, 1884.

The works of another artist, a landscape painter in the stricter sense of the term, were shown in the gallery year by year during almost identically the same period as Read's. ALFRED PIZZEY NEWTON was elected an Associate on the 1st of March, 1858, a year after Read, and survived him only four months, dying on the 9th of September, 1883. He, too, remained long an Associate, for he was not raised to the rank of Member until the 24th of March, 1879. His exhibits at Pall Mall East during the twenty-six years (including the sketch exhibition next after his death) amount to 247, of which 100 were in the winter shows. With few exceptions they represented scenes in the Scotch Highlands, most commonly under sombre effects of morning or evening twilight, sometimes of moonshine, or of the sun's gleams penetrating through mist or rain. His greater strength was shown in his early works, exhibited then and shortly after he joined the Society. One, called 'Declining Day, View in Argyllshire,' attracted much admiration on his first appearance in the gallery, and two years after, in 1860, he had a powerful drawing there, a winter scene in the Pass of Glencoe, called 'Mountain Gloom.' His

exhibited works may be traced a little further back to three or four
at the Royal Academy in 1855, 1856, and 1857,[1] all of them views
in the Western Highlands. And he had already enjoyed Court patron_
age, having been selected by the Queen to paint a picture for a
wedding gift to the Princess Royal on her marriage in January 1858.
He also made some sketches for her Majesty in the neighbourhood
of Inverlochy Castle, which was the royal residence during a visit to
that part of Scotland.

Little or nothing further has been recorded of Newton's earlier
life, except that, being fifty-three years of age when he died, his birth_
day must have been in 1830 or the latter end of 1829; or of his
parentage other than that ' he was of Italian descent on the maternal
side, but was a native of Essex.'[2] The southern type of feature may
be recognized in his portrait, from a photograph, engraved in the
Illustrated London News at the head of a short obituary notice.

The exceptions to the Scotch subjects which form the mass of
this artist's works are, first, a few from the South of Europe, which
begin in, and belong mostly to, the years 1861 and 1863, when he
exhibited some from Mentone, Lago Maggiore, and Venice. In the
latter year there was one from Rome, and a moonlit ' Coliseum '
appeared in 1866. Then there is a small group of English subjects,
chiefly from the county of his birth, about Southend at the mouth of
the Thames. Four or five of these were in the winter show of 1869 -
70. Others are on the coast of Cheshire and in the mouth of the
river Mersey ; where there was also a local attraction for him, his wife,
whom he espoused in the year 1864, being daughter of a gentleman
residing at Rock Ferry, the late Mr. Edward Wylie. In the last year
of our painter's life, there was a more notable new departure in his
choice of subjects. In the preceding autumn he had accomplished
a long-projected journey to Athens, whence he brought home a
number of drawings which, with two or three on the way (at Capri,
Gibraltar, &c.), he sent to the gallery in 1883. It was too late, how-
ever, for these to become a characteristic portion of his *œuvre*. The
artist's health had been failing for some time, and he did not live till
the opening of the winter exhibition. He died at the house that had
been his father-in-law's (14 Rock Park, Rock Ferry) ; leaving a

[1] Graves finds another at Suffolk Street in 1855-9.

[2] *Illustrated London News.* Here and in Graves's Dictionary the second name is spelt
' Pizzi ' which seems to point to an Italian derivation, but the artist signed his name as it is
above given.

widow and five children to mourn his loss. Throughout the period of his connexion with the Society, his address was at 44 Maddox Street, Regent Street. His remaining works, including most of the Greek views, and a few essays in oil, were sold at Christie's on the 29th of April, 1884. Among the drawings 'Inverlochy Castle' was sold for 162*l.* 15*s.* and 'The Mountain Pass' and 'Left by the Tide—Isle of Arran from Bute' for 157*l.* each.

Newton's drawings are distinguished rather by general effects of light, mist, and shadow broadly indicated, than by any searching study of the varied lines and texture of mountain surface. But he seems to have been an industrious worker ; and an incident of his earlier study indicates a resolute devotion to his art. It is said that the sketch of his picture 'Mountain Gloom' above mentioned was made on the spot, in Glencoe, in so hard a frost that he had to use pure whisky as a vehicle instead of water.

Since the death of Robert Hills, the place which he had occupied in the Society as a delineator of animal life had never been fully supplied. They were different orders of *mammalia* that Lewis had selected for study. He, after mastering the *carnivora*, had taken to painting the *primates*. Tayler devoted his talent to horses and dogs ; and even Duncan, master as he was of agricultural subjects, was not primarily a cattle-painter. Thus the election on the 10th of February, 1862, of HENRY BRITTAN WILLIS, who had already acquired a name and standing in that department, filled a place which had long been practically vacant in our company of artists. He had, according to Graves, exhibited pictures or drawings of cattle at other galleries since 1844 (the very year of Hills's death), 27 to wit at the Royal Academy, 18 at the British Institution, and 14 in Suffolk Street ; 59 in all. He had, moreover, published two series of prints, viz. : *Studies of Cattle and Rustic Figures*, oblong 4to, 1849 ; and *Studies from the Portfolios of Various Artists*, folio, 1850.

His father was a landscape and figure painter of local repute at Bristol, where our artist was born in 1810. What training he had in the principles of art, he received at home ; and he bettered this in- struction by persevering study of nature, having much inborn taste, and an eye for the picturesque. Meeting, however, with small profes- sional success in his native city, he emigrated to the United States ;[1]

<hr/>

[1] *Our Living Painters*, by H. Walker.

but returning thence, a year after, by reason of ill health, he set up his studio in London in 1843, and by dint of steadfast industry 'established his position. · 'An unfinished Study,' exhibited in 1865–6, 'done at Clipstone Street Life School,' shows him to have been a student there ; and of a continuance of the same connexion with brother students at the ' Langham Chambers Sketching Club,' in 1856 there was evidence in a repetition from memory, which he sent to the gallery in 1880, of a drawing made there.[1] It is said that he owed his introduction to the Society to the discriminating interest of Carl Haag,[2] whose discernment was justified by Willis's speedy exaltation to full rank. He was elected Member on the 8th of June, 1863. After 1862 he seems to have confined himself to the Gallery in Pall Mall East. There he was a prolific contributor, and never missed an exhibition. His numbered works amount to 364 in all, 118 in the summer, and 246 in the winter gatherings, during the twenty-two years of his appearance on the walls and screens. Although his draw. ings were so numerous, they were wrought with much care and minuteness, and were generally sparkling and attractive. He appears to have been short-sighted, wearing spectacles, as represented in a likeness given of him in the *Illustrated London News*.

Brittan Willis was not, after all, exclusively a painter of cattle. His most characteristic works are those in which he would set his groups of kine in landscapes of more or less specific locality. Latterly, indeed, his drawings generally belonged more to the category ' Land. scape ' than ' Cattle,' and often entirely to the former. Thus an ac- count of his works involves a note of the districts in which he sketched not only as affecting the breeds of his oxen, but in respect of the scenery amidst which they fed. Except a sketch at Antwerp and three on the Rhine,[3] all in the winter exhibition of 1865–6, and one at Killarney in 1881–2, there was nothing in our gallery from which to infer that Willis was ever out of Great Britain. The greater part of his backgrounds or separate views are either from North Wales, mostly about Port Madoc, but extending southward by Barmouth to Dolgelly and sometimes northward as far as Llandudno ; or in the Western Highlands of Scotland from Oban to Ben Nevis. But he sketched

[1] It illustrated the given word ' Deserted ' by a representation of horses left to starve on the heights of Balaclava, the original of which had gone to Sydney.

[2] *Illustrated London News*, 2 Feb. 1884.

[3] Some pencil drawings sold after his death represent scenes from the Moselle and Heidel- berg, besides some of Killarney.

in English counties as well ; especially in Sussex, from Arundel to Pevensey, and (after 1876) at Midhurst. Other home counties furnish a few subjects, and there are some from the west country, mostly North Somerset, or the mouth of the Torridge in North Devon. Many of Willis's landscapes are effects of sunset or early morning ; and some are harvest scenes. To the winter exhibitions he sent numerous slight sketches and studies both of cattle and of 'effects ;' and a few of rustic figures. He had the grievous misfortune to lose nearly all his memoranda of this kind in the great fire of 1874 at the Pantechnicon, where they were stored.

Our artist was honoured with a commission from the Queen to paint a drawing of ' Highland Cattle,' which was exhibited in the Gallery in 1866. The following are the prices quoted by Redford over 300*l.* of his water-colour drawings at sales by auction during his life. In 1870 at G. Rennie's sale, ' Early Morning—Snowdon Range' was bought in for 320*l.* 5*s.* ; in 1879, at McIlraith's, ' Ben Cruachan and Loch Etive,' sold for 383*l.* 5*s.* His remaining works, including some oil studies and pictures, were sold at Christie's on the 16th of May, 1884, after his death ; when some of the landscape studies brought 72 guineas, and an oil painting of ' Horses and Cattle in the Essex Marshes' 262*l.* 10*s.*

During the whole period of his connexion with the Society, Willis resided at Kensington ; till 1864 at 24 Victoria Road, thenceforward till 1870 at No. 6, and then No. 12, Palace Gardens Terrace. It was at the latter house that he died on the 17th of January, 1884, after a few days' illness, leaving a widow behind him. He had many friends, and among other amiable qualities is remembered for the kindness which he showed to young painters.

In 1886 the Society suffered the loss of a painter of marked originality, whose landscapes had lent a charm to nearly every exhibition for twenty years, and infused an element of repose which could not fail to be felt in the general aspect of the Gallery. THOMAS DANBY was a son of the well-known Irish artist, Francis Danby, A.R.A., and was born, it is believed (but at what precise date is not known), at Bristol, where his father resided for a series of years in the first quarter of the century. He had an elder brother, James Francis, born there in 1816, when the father was about three-and-twenty ; and it may be taken that the ages of James and Thomas were not widely

different. Both the sons were brought up to their father's profession, and became well known also as landscape painters, being for some thirty years contemporary exhibitors in oil in the London galleries. It is necessary to distinguish the one from the other. The father's pictures, several of which are in the national collections, are for the most part of a sensational sort, either glowing representations of sun. set, or compositions that recall the theatrical dreaming of John Martin. There exist pictures, however, by the elder Danby, which show that he viewed the more ordinary aspects of nature with poetic spirit in a milder mood. It was a susceptibility of the quieter kind that descended upon Thomas Danby, his brother James taking more kindly to the sunsets of blood and fire. While the latter revelled in the redness of the western sky at eve, the former had a keener relish for the summer morn, with its fresh air and sparkling light.

An educational influence, besides the hereditary, helped to lead the taste and form the style of Thomas Danby. His parent left England in 1829, partly impelled, it is said, by a rupture which had taken place between him and the Royal Academy, and for the next eleven years resided on the Continent. Thus our young artist became acquainted with the treasures of the Louvre, where he studied to such present advantage, that when only thirteen years of age he was able to earn a livelihood by making copies of the celebrated pictures there. But the future benefit was greater. For while so employed he became deeply impressed by the works of Claude, the image whereof attended him ever after in his study of the aërial effects of nature. Much of his father's self-banishment abroad was spent in Switzerland. Hence it may be that from early times we find among our artist's works subjects from that country as also from the Italian lakes. Others which appear at intervals later in his career were the result of more recent trips to these localities.

The family came back to England in 1841, when the father began again to exhibit at the Royal Academy, and his sons soon after made their *débuts* there, James in 1842, and Thomas in 1843. The one kept up the paternal reputation for fiery sunsets after their father's death in 1861, having become a Member of the Society of British Artists, where, and at the British Institution, many of his works were exhibited until he himself died in 1875, an oil painter to the last. But the other, after sending a picture or two to the Academy annually, for about

twenty years, besides many to the British Institution,[1] found at length his true vocation as a painter in water-colours, through the opportunity afforded by the 'general exhibition' at the Dudley Gallery. There, at the second annual gathering, in 1866, he showed two large and impressive drawings, both of them simple treatments of Gwynant Lake in North Wales, but broad in composition and mellow in tone, which proved at once his power over the material, and were honourably hung, attracting much attention. Danby had already been very near election as an Associate of the Royal Academy, missing that honour by, it is said, one vote only. But, encouraged by his new success, he offered himself as a candidate at our Society, and in 1867, on his first application, was elected unanimously ; a concurrence of good opinion which had been very rare. His election as a full Member followed in the summer of 1870. While an Associate only, he had continued to send a yearly drawing or two to the Dudley Gallery, but ceased to do so after the latter date. He had had seven works in all there in the five years. In our Society he had 233 (94 in the summer, 139 in the winter shows) between 1867 and 1886 (the 8 in the last year being exhibited after his death).

Admirable artist as he was, and an unwearied student of nature, Danby's range of subjects was not wide. Nearly all, except the occasional foreign views above mentioned, were taken from a few limited areas in Wales. His most frequent haunts for sketching lay in the county of Merioneth, where minor hills and broken ground on the borders of lakes seemed more in accord with the bent of his poetic feeling than the larger forms of mountain scenery. For he concerned himself less with the portraiture of hill-tops, or the task of unfolding to the eye a stretch of familiar country, than with the play of light and the mystery of shadow over rugged tracts, often in contrast with the sheen of placid water, and the softened forms of earth and sky as mirrored in its still reflections. In his later time he varied these subjects with some from Scotland, a large proportion between 1880 and 1882 being from St. Fillan's and Loch Earn in Perthshire ; still content, it would seem, with the approach to hills, rather than seeking mountain scenery in all its grandeur. After a year or two more of drawings from North Wales, at Llanberis and Dolwyddelan, in 1882 and 1883, he broke comparatively new ground with a series of studies in South

[1] Graves finds 30 by T. Danby at the Royal Academy, 42 at the British Institution, and 1 at Suffolk Street, making 73 in all.

Wales, at Llanstephan, Laugharne, Swansea Bay, and the coast of Gower. There are a very few outlying subjects, such as two at Arundel in 1875-6, and two at Pevensey in 1885-6. But these are exceptional. Many of the most characteristic of his drawings are un-connected by name with any locality ; having titles such as ' The Way over the Stream,' ' Happy Land,' ' Shepherd's Land,' ' Up in the Hills,' ' The Cloud,' ' Spring-Time,' ' A Summer Morning,' ' Evening,' ' A Fisherman's Nook,' ' Loneliness,' and others, which indicate an aim very far remote from that of the landscape topographer. ' For his life long,' writes a brother artist who knew him well, ' he was always trying to render the feeling of a beautiful view given to the inner heart rather than the facts reflected on the eye.' Danby's colouring was tender, mellow, and harmonious, and his chiaroscuro broad and subtle. In his choice of pigments, writes the friend just quoted, ' he was devoted to *real* ultramarine, yellow ochre, and the earths of the quietest and most permanent character, and never used indigo &c.' His drawings are not easily mistaken for work by other hands. His style is his own, and in no degree based on his father's. One older artist, perhaps, his works may sometimes suggest, namely, the late Paul Falconer Poole, R.A., whose feeling for ideal landscape was of a similar poetic kind. An influence derived from this painter is likely enough to have been shed on our artist's work. For Poole was his intimate and attached friend, and had bestowed upon him a more than fatherly kindness when he was enduring the family troubles of his early career. They appear, from the Royal Academy catalogue, to have been living together at Squire's Mount, Hampstead, in 1843.

Thomas Danby was twice married, first to a wife some twenty years older, and secondly to one about twenty-five years younger, than himself. The former was daughter of Mr. Williams, landlord of the inn at Capel Curig where he always stayed ; the latter, by whom he had a family of two girls and a boy, was Miss Muir, a teacher of music, sister of Miss Emily Muir, a singer of some celebrity. Danby resided at or near Hampstead during the whole of his professional career in London, from 1855 to 1868 at Glydder House, Haverstock Hill, and from the latter date till his death at 44 (afterwards 11) Park Road, Haverstock Hill. He was often present, as a guest, in the cheery social circle, now broken up by successive deaths, that used to meet periodically round the festive board of the old Chalcographic Society. When he died, on the 25th of March, 1886, after a pul-

monary illness of many weeks, which ended in dropsy, his loss to the Society was that of one of its foremost landscape painters, and one of the few remaining links with the old poetic school in that branch of water-colour art.

Danby's remaining works were sold at Christie's on the 17th and 18th of June, 1886. Besides about 200 water-colour drawings and sketches, there were included in the sale a nearly equal number of oil pictures and studies painted before the artist abandoned the latter for the former material. Many of these studies, painted direct from nature some thirty years before, and left untouched and unsought for since, were of fine and masterly quality.

A short account remains to be given of the five Associates who have died since the year 1881, all at an early age. Three of them were ladies, two of whose deaths occurred after marriage.

Mrs. HELEN CORDELIA ANGELL was a flower, fruit, and bird painter of very distinguished talent. Her maiden name was Coleman, and her father was a physician at Horsham in Sussex. There she was born in January 1847, the fifth daughter in a large family. She obtained her first instruction in art from a brother, William S. Coleman, an artist known in two separate branches of painting, first, that of small landscapes in water-colours, much after the manner of Birket Foster ; secondly that of figure designs on ceramic ware. The former were familiar to visitors at the Dudley Gallery during its earlier exhibitions, the latter to connoisseurs of Minton's china. He is said to have discovered his sister's bent for flower painting when she was a girl of twelve, and to have encouraged the assiduity whereby she, in the course of three years' study, acquired ' that kind of local reputation which heralds a brilliant future.'[1] In her early practice she gave skilful assistance to her brother in his ceramic decoration.[2] But her name was first brought before the public on the opening of the Dudley Gallery, whereof William Coleman was, from the beginning, a member of the committee of management. To the first of its exhibitions, that of 1865, she contributed eight studies, whereof six were of wild flowers and wild fruit, and two of birds (a sparrow and a kingfisher).

Already her work had attracted the attention of old William Hunt, who died a year before her *début*, and had won from him a declaration that in her he saw his only successor. And he proved to

[1] Clayton's *English Female Artists*, ii. 262. [2] *South Kensington Museum Catalogue.*

some extent a true prophet ; albeit, she did not tread exactly in his footsteps. In her earlier studies she aimed more at minute finish than at a later period, when she had formed her style ; but there was in her best work a gem-like brilliancy in the management of colour which has been favourably compared even with the above-named consummate master.1 After the first few years, as her manner became larger and more elegant, models from the greenhouse and the parterre .were laid beside the hazel-nuts and hedge-roses ; and regularly year by year the bright and delicate flower-groups by Miss Helen Coleman came to be reckoned upon as among the increasing attractions of the February show at the Egyptian Hall.

In 1875 she became the wife of Mr. Thomas William Angell, Postmaster of the South-Western District of London, and from that date exhibited in her married name. In the same year she was invited to become a lady member of the Water-Colour Institute, and she contributed for some seasons to exhibitions thereof, besides sending at the same time her full annual quota of drawings to the ' Dudley.' But. in 1878 she resigned her membership of the Institute, and early in 1879 was elected an Associate of the Society of Painters in Water-Colours. Including three farewell bouquets in 1879, she exhibited sixty-three works in all at the Dudley Gallery.

However true it may have been that the mantle of William Hunt had fallen on the shoulders of the young artist whom he named as its future wearer, it was more as the legitimate successor of the veteran Valentine Bartholomew that Mrs. Angell assumed her position in the gallery at Pall Mall East. That painter died in the same year, 1879, and his office of Flower Painter in Ordinary to her Majesty was then conferred upon Mrs. Angell.[2] Between 1879 and 1884 there were fifty-seven of her works in our gallery, thirty-three in the summer, and twenty-four in the winter exhibitions, four in the former being shown after her death. That much-lamented event took place on the 8th of March, 1884, at the age of thirty-seven, at her place of residence, No. 55 Holland Road, Kensington. She had been failing in health for some time previously. That the rare quality of Mrs. Angell's work was becoming more and more widely appreciated when her career came thus prematurely to an end, may be inferred from the increasing demand for her drawings, and the high prices they obtained.

1 *Times*, 12 March, 1884.
2 Her name appears with this addition in the catalogue for 1879, but not afterwards.

The short term of another lady artist's connexion with the
Society was even more curtailed than that of Mrs. Angell. The art
of MRS. MARY LOFTHOUSE was of a quality too delicate and refined
to attract the attention it deserved during the two years only wherein
her landscapes were accorded a place in the gallery. But they
afforded fair ground for anticipation that had she lived longer they
would have become a much more important feature in the annual
gatherings. Mrs. Lofthouse, born in 1853, was the only daughter of
Mr. T. B. W. Forster, of Holt, Trowbridge, near Chippenham in
Wiltshire. Her father's name appears in the Royal Academy cata-
logues as that of an exhibitor of landscapes from 1859, between which
year and 1875, Graves tells us, he had thirteen works there, and seven
at Suffolk Street. So there was hereditary tendency enough to
account for Miss Mary Forster's taking to the brush, and continuing
the succession by exhibiting two pictures at Burlington House in the
following year, 1876. They were both of French subjects, ' Dauphiny
Cottages, Evening,' and 'Château de St. Laurent, Isère.' And she
had afterwards two more there, a Welsh scene in 1878, and a view of
' Christchurch, Hants,' in 1880. But her chief exhibiting before she
joined our Society had been at what had proved its nursery in the
case of so many young artists, the Dudley Gallery. Thither from
1873, when she was twenty years of age, she sent drawings to all the
exhibitions except two (in 1874 and 1876) until the last of the
'General Exhibitions' in 1882, after which she joined as a member
the 'Dudley Gallery Art Society,' which continued the annual
gatherings of drawings in the same rooms, to the first of which in 1883
she contributed three. These make up a number of nineteen which
she showed at the Egyptian Hall.

Elected early in 1884 an Associate of the Royal Society of Painters
in Water-Colours, she sent to its three succeeding exhibitions (1884,
1884-5, 1885) an aggregate of sixteen works. The first two seasons'
contingents were still under her maiden name. Before the third she
had assumed that of her husband, S. H. S. Lofthouse, Esq., barrister,
of Elm Bank, Lower Halliford, Walton-on-Thames. It is painful to
record that her death occurred but a few months after her marriage,
namely, on the 2nd of May, 1885, while the summer exhibition of that
year was on view. In the following winter show, a collection of
twenty-six frames of studies and sketches placed in the gallery bore
evidence not only to the thoroughness of her work from nature, but

to her taste and variety of observation. A large proportion of her drawings were studies in Normandy, on the Seine. Others are from Pembroke, Bradford-on-Avon, Norwich, Richmond in Yorkshire, and Christchurch in Hants. Often they contain buildings, and the scenes are commonly treated under tender gradations of atmosphere.

In the general art obituary for 1888 an important place is deservedly given to the late FRANK HOLL, R.A., who died on the 31st of July, aged forty-two. A representative collection of his works in oil was formed at the Royal Academy in the following winter, and justice has been done by the press to his great merits as a painter, in that material, of subject pictures and of portraits. But it is almost forgotten, if it was ever much known, that he painted in water-colours also, and that his proficiency therein had been acknowledged by election as an Associate of our Society in 1883. To that year's exhibition he sent one drawing entitled, 'Leaving Home.' With that single exception, however, he contributed nothing to the gallery, though his name remained as an ornamental item in the list of Associates until the date of his death. Doubtless the increasing demand for portraits absorbed his whole time in the later years. It need scarcely be said that the old rule, so stringently enforced in former days, which enjoined upon Associates and Members the duty of sending at least one work annually to the exhibition, is now no longer adhered to. Frank Holl was of a companionable turn, and had many friends in the Society. For a short time he was a member of the 'Chalcographic,' whose roll contained the name of one at least of the deceased engravers of his family, his uncle, William Holl, if not that also of his father, Francis Holl, A.R.A.

Another of the deceased Associates, who for twelve of these later years was among the regular contributors, was OTTO WEBER, a German artist of some repute, chiefly known as a skilful painter of cattle pieces in oils. He was son of a merchant of Berlin, Herr Wilhelm Weber, and born in that city on the 17th of October, 1832. His art education began there under Professor Steffeck, and is believed to have been continued under Krüger, whom he resembled in feeling and style, as well as in handling and technique. He afterwards settled in Paris, where his pictures of animal life created quite a *furore*, and were all bought up at high prices by Messrs. Goupil & Co. He appears even to have been claimed as of the French school, in

virtue of an alleged [1] pupilage under T. Couture, at whose studio he was at least a frequent visitor; for there was a picture by him at the Luxembourg of hounds in a forest receiving ' La curée de chevreuil.' In 1870, however, when the Franco-German war broke out, he was obliged to leave Paris, where he had been so well established. He first betook himself to Rome, and stayed there for two years; but finding Italian subjects unsuited to his taste and style, he in 1872 came to London, where he lived for the rest of his days. Here he set up a studio in Greville Road, St. John's Wood, with stable arrangements for the reception of live animals as models. He exhibited pictures at the Royal Academy from the year 1874 till his death, continuing to do so after his election into our Society in 1876. He was also a Royal Hibernian Academician. His water-colour drawings at Pall Mall East, which number forty-two in the summer and forty in the winter exhibitions from that year to 1888, belong, however, as much to the landscape as to the animal class. When not to the latter alone, they might more often be called ' landscape with (or without) cattle,' than ' cattle in a landscape.' The sites of his views are chiefly English, with some in the Scotch Highlands in 1876-7. In 1877-8 there are half a dozen from abroad, three Italian, and the like number from North-Western France. The English ground comprises Kent, Sussex, Windsor, and the Thames, and in and after 1884-5, Central Devon and West Cornwall. His name appears for the last time in the catalogue of the winter exhibition of 1888-9, but without exhibits, and he died not long after it had opened, namely, on the 23rd of December, 1888. His last address was ' 32 Great Ormond Street, Queen Square.' On the 20th of May, 1889, his remaining works, comprising more than sixty studies and finished paintings, were sold at Christie's by his representatives.

Another melancholy death of an accomplished young artist, which is of recent occurrence, has still to be added to the record; that, namely, of MISS MAUD NAFTEL, before mentioned as the only daughter of the Member of that name. She was a painter of charming flower pieces, which for the short period of three years during which they had a place in the gallery were a pleasing and valued feature of the exhibitions. She was elected in 1887, and had shown but sixteen drawings there when her career was cut short by a painful

[1] See the official catalogue of the Musée National du Luxembourg, 1872. Weber is there erroneously stated to have died in 1871.

illness, which terminated in her premature death on the 18th of February, 1890, at her parents' residence. Previously to joining the Society, Miss Naftel had been a contributor to the general water-colour exhibitions at the Dudley Gallery, where she had eight drawings between 1877 and 1882. She also became a subscribing member of the supplementary 'Dudley Gallery Art Society,' to which she sent two drawings in 1883, and another in 1885. Most of these were landscape studies; but a few were of flowers, and her works at Pall Mall East were, with the following exception, of the latter class. That she could infuse both character and picturesque grace into a landscape is shown even in the slight reproduction, in the illustrated catalogue for 1889, of her drawing of an English hop-garden in its despoiled condition, 'when hops are housed and gardens bare.' A posthumous work was in the Lady Artists' Exhibition in the spring of 1890, entitled, 'Unwillingly to School.'

The rest of the Members and Associates who joined the Society after the last exhibition (that of 1854) to which Fielding contributed are still working for our advantage. Among them are artists of no less distinction than many whose careers have been traced in the foregoing pages, together with others of still hopeful promise. The writer's design has, however, been limited to the compilation of a record of the past, and, as already intimated, he refrains from the invidious task of comparing the talents of living men, and assigning to them an order of merit in their profession. It may well be left to younger hands to complete, in the light of future events, the accounts of lives not yet ended, and to deal in their entirety with the main body of existing Members, whose Associateship does not reach so far back as the 'good old days of Copley Fielding.' In such a task, indeed, there can be no real finality, so long as the Society lives and renews its strength from time to time with worthy accessions. Happily the tide of prosperity of the 'Old Water-Colour Society' (as its friends of long standing still love to call it, notwithstanding its more illustrious modern title) has not yet ceased to flow. Long indeed may it continue to prosper, and confer on future ages benefits such as those it has wrought in the time past, to the cause of pure and gentle Art, based on loving and thoughtful observation of Nature; and long may it add more and more to the already immeasurable delight that it has afforded to many successive generations of

admiring followers of both. The existing condition of the Royal Society of Painters in Water-Colours may now be left to be its own witness' in the list which follows of its present Members and Associates,[1] and in the array of works available to the public twice a year for contemplation in the pleasant and familiar gallery at 5A Pall Mall East.

MEMBERS.

(Names in italics are those of Members of Council.)

Elected	Members	Elected Associate
1845	George A. Fripp	1841
1846	*Alfred D. Fripp (Secretary)*	1844
1848	William Callow	1838
1853	*Carl Haag (Deputy President)*	1850
	(Hofmaler to H.R.H. the reigning Duke of Saxe-Coburg and Gotha)	
1854	*Sir John Gilbert, R.A., (President)* (Trustee)	1852
1858	Charles Davidson	1855
1859	*Paul J. Naftel*	1850
1862	Birket Foster (Trustee)	1860
1864	Edward A. Goodall (Trustee)	1858
1864	William Alfred Hunt	1862
1870	John D. Watson	1865
1875	William C. T. Dobson, R.A.	1870
1875	L. Alma-Tadema, R.A.	1873
1876	Samuel P. Jackson	1853
1876	Edward K. Johnson	1866
1876	Francis Powell	1867
1877	*George P. Boyce*	1864
1878	*George H. Andrews, F.R.G.S. (Treasurer)*	1856
1880	Sir Oswald W. Brierly, F.R.G.S. (Marine Painter to the Queen) .	1872
1880	*Henry Moore, A.R.A.*	1876
1880	Henry Wallis	1878
1881	Basil Bradley	1867
1881	Albert Goodwin	1871
1881	William Matthew Hale	1871
1881	John Parker	1876
1882	H. Clarence Whaite, P.R.C.A.	1872
1883	*H. Stacy Marks, R.A.*	1871
1883	John W. North	1871
1883	*Edward F. Brewtnall*	1875
1883	*Herbert M. Marshall*	1879
1883	Charles Gregory	1882
1883	Edward J. Poynter, R.A.	1883
1884	William Collingwood	1855
1884	R. Thorne Waite	1876
1886[2]	E. Burne Jones, A.R.A.	1864[2]
1886	Tom Lloyd	1878
1887	*W. Holman Hunt*	1869
1888	Sir Frederick Leighton, Bart., P.R.A.	—
1890	Mrs. Allingham[3]	1875
1890	Samuel J. Hodson	1882
1891	Charles Robertson, R.P.E.	1885

[1] The order is that of election to their respective ranks.
[2] Elected Member in 1868. Resigned in 1870. Re-elected Member, 1886.
[3] The election of Mrs. Allingham as a Member was under a new Rule of 1889, authorizing the admission of ladies to full rank in the Society. A similar relaxation was made in the Laws of the Royal Academy, but the Water-Colour Society has been the first to inaugurate the new practice, no lady Academician having been elected since the old days of Mary Moser and Angelica Kauffman.

ASSOCIATES.

Elected	Associates	Elected	Associates
1847	Miss Maria Harrison	1882	J. Jessop Hardwick
1858	Sam. T. G. Evans	1882	Miss Constance Phillott
1860	Frederick Smallfield	1883	John R. Burr, R.S.B.A.
1865	Frederic J. Shields	1883	Henry G. Glindoni
1866	Thomas R. Lamont	1883	Henry J. Henshall
1870	Arthur H. Marsh	1883	William J. Wainwright
1874	Walter Duncan	1884	Albert Moore
1874	Miss Clara Montalba	1885	Heywood Hardy
1875	Edward Radford	1886	David Murray, A.R.S.A.
1876	Robert Barnes	1886	Colin Bent Phillip
1877	Edwin Buckman	1887	Robert W. Allan, R.S.W.
1877	Arthur Hopkins	1888	Walter Crane
1877	Cuthbert Rigby	1888	Alfred Edward Emslie
1878	William E. Lockhart, R.S.A.	1888	Miss Edith Martineau
1878	Norman Tayler	1888	Arthur Melville, A.R.S.A.
1880	Walter Field	1889	Lawrence G. Bulleid
1880	W. Eyre Walker	1889	George Clausen
1880	Ernest A. Waterlow, A.R.A.	1890	C. Napier Henry
1880	Thomas J. Watson	1891	Charles E. Fripp
1881	George du Maurier	1891	E. R. Hughes
1881	Wilmot Pilsbury	1891	Thomas M. Rooke
1882	Richard Beavis		

The list of Honorary Members is now composed of the following distinguished names :—

Her Royal Highness the PRINCESS of WALES.

H.R.H. PRINCESS LOUISE, Marchioness of Lorne

The Right Hon. the Earl of CARLISLE.

The Right Hon. W. E. GLADSTONE, M.P. &c. &c.

Sir PRESCOTT HEWETT, Bart., F.R.S.

JOHN RUSKIN, Esq., LL.D. &c. &c. &c.

Herr ADOLPH MENZEL, Professor, Academy of Berlin

Sir FREDERICK BURTON, R.H.A., F.S.A.

APPENDIX

The proposal for Amalgamation made by the Institute of Painters in Water Colours to the Royal Society of Painters in Water Colours (copies of the original documents).

'Institute of Painters in Water Colours, Founded 1831,
'Gallery, 53 Pall Mall, 28th April, 1881.

'Sir,—I am desired by the President and Council of the Institute of Painters in Water Colours to beg you to lay the inclosed before the President and Council of your Society at as early a date as possible.

'I remain, Sir, your obedient servant,
'H. F. PHILLIPS, *Sec*.

'A. D. Fripp, Esq., Sec' Society of Painters in Water Colours.'

'Society of Painters in Water Colours,
'Gallery, 5 Pall Mall East, May 7th, 1881.

'Dear Sir,—The communication I received from you on the 29th ultimo bearing the signatures of the President and Vice President of the Institute of Painters in Water Colours and addressed to the President and Council of this Society was laid before the Council at their meeting yesterday and considered to be one in which they could take no step without the participation of the Society. They have accordingly directed me to convene a General Meeting at an early date to consider it.

'I am, dear Sir, faithfully yours,
'ALFRED D. FRIPP. *Sec*.

'H. F. Phillips, Esq., Sec' Institute of Painters in Water Colours, 53 Pall Mall.'

(LETTER INCLOSED IN MR. PHILLIPS'S LETTER ABOVE.)

'*To the President and Council of the Society of Painters in Water Colours.*

'Gentlemen,—Having at length practically completed the arrangements on which we have.for a long time been engaged for securing Galleries in which Exhibitions of Water Colour Art can be held on a large scale, we feel that the time has arrived for approaching your Society with the view of ascertaining whether you will be inclined to join us in the project.

'As a body we have long felt that it would be a great advantage to the Art of Water Colour Painting, and also to the interest of both Societies, if an Amalgamation could be arranged.

'For the details of the plan we would refer you to the Prospectus, a copy of which has been forwarded to every Member of your Society, and we may

II

F F

add that so many applications for shares have already been received that the financial success of the Company is practically secured.

'We have the honour to be, Gentlemen, your obedient servants

(Signed) 'LOUIS HAGHE, *President.*

'WM. LEIGHTON LEITCH, *Vice President.*

'On behalf of the Members of the Institute of Painters in Water Colours.

'Gallery, 53 Pall Mall, S.W., 28th April, 1881.'

'Society of Painters in Water Colours,
'5 Pall Mall East, May 17th, 1881.

'Dear Sir,—A Special General Meeting of the Society of Painters in Water Colours was held yesterday for the purpose of considering the letter addressed to the President and Council on the 28th ultimo by the Institute of Painters in Water Colours. I am directed to transmit to you the following Resolution passed thereon and to request the favour of your communicating the same to the President and Members of the Institute of Painters in Water Colours.

'(*Copy of Resolution.*) "That the Society having considered a letter from the Institute of Painters in Water Colours, proposing an Amalgamation of the two Societies to take the projected new Galleries to be erected by the 'Piccadilly Art Galleries Company, Limited,' the Council be directed to reply to the same respectfully declining such proposal."

'I am, dear Sir, faithfully yours,

'ALFRED D. FRIPP, *Secretary.*

'H. F. Phillips, Esq., Secretary Institute of Painters in Water Colours.'

(RENEWED PROPOSAL OF THE INSTITUTE.)

'Institute of Painters in Water Colours, Founded 1831,
'Gallery, 53 Pall Mall, 14th March, 1882.

'Dear Sir,—I am directed by the President and Council of the Institute of Painters in Water Colours to beg you to lay the inclosed before the President and Council of your Society at as early a date as possible.

'I remain, dear Sir, yours faithfully,

'H. F. PHILLIPS, *Secretary.*

'A. D. Fripp, Esq., Sec' Royal Society of Painters in Water Colours.'

'Royal Society of Painters in Water Colours,
'5 Pall Mall East, 27th March, 1882.

'Dear Sir,—In reply to your letter of the 14th inst. I beg to say that the Council of the Society met on Saturday evening last, when the communication from the Institute of Painters in Water Colours was read and referred to the Society in General Assembly for consideration.

'I am, dear Sir, faithfully yours,

'ALFRED D. FRIPP, *Sec'.*

'H. F. Phillips, Esq., Sec' Institute of Painters in Water Colours.'

(LETTER INCLOSED IN MR. PHILLIPS'S LETTER ABOVE.)

' *To the President and Council of the Royal Society of Painters in Water Colours.*

' Gentlemen,—Since we last had the honour of communicating with you, many things have occurred to show that some misunderstanding prevailed as to the nature and scope of the proposal for the amalgamation of your Society and the Institute then submitted to you.

' The consideration that this misunderstanding may have been largely responsible for the adverse result of our overture, together with the encourage-ment we have derived from observing the increased friendliness and good feeling on the part of Members of both Societies, has induced us to reopen the question. The opportunity now afforded is one that may never return, and we feel that it would be unwise and unworthy of us if we allowed it to pass without at least a serious endeavour to discover whether the difficulties in the way of such an union are altogether insuperable.

' In the friendly unofficial meetings and conversations that have taken place between Members of your body and ours, the following points have been put forward as presenting the most important obstacles : 1st. The name of the Society ; 2nd. The question of accumulated property ; 3rd. The dispro-portion between the numbers of the two Societies.

' With regard to the first of these the Institute of Painters in Water Colours would agree to give up the title it has held for so many years, and would consent that the united body should be known as the Royal Society of Painters in Water Colours.

' With respect to the second the Members of the Institute would willingly establish a guarantee fund sufficient to secure its share of the necessary Rent, on condition that a similar sum was provided by your Society.

' The third point, that of the disproportion of Members, need present no difficulty. A large number of Members of the Institute have signified their readiness to return to the rank of Associate rather than stand in the way of union.

' In thus endeavouring to meet your views we are influenced only by a sincere desire to advance the progress of Water Colour Art. We believe the present division is very detrimental to it, and that as a united body we could take such a position that ere long we should be able to do for the Painters in Water Colours what has been done for Oil Painters by the Royal Academy.

' To us this end seems so desirable that we are willing to make any reasonable concessions to bring it about, and we beg to offer the foregoing to your consideration, and if they are not found sufficient to meet all objec-tions they may perhaps furnish a basis for further negociations.

' We have the honour to be, Gentlemen, your obedient servants,

' LOUIS HAGHE, *President.*

' W. L. LEITCH, *Vice President.*

' On behalf of the Members of the Institute of Painters in Water Colours.

' Gallery, 53 Pall Mall, S.W., 14th March, 1882.'

' Royal Society of Painters in Water Colours,
' 5 Pall Mall East, April 25th, 1882.

' *To the President, Vice President and the Members of the Institute of Painters in Water Colours.*'

'Gentlemen,—At a General Assembly of the Members of this Society held this day, the letter from the President and Vice President on behalf of the Members of the Institute of Painters in Water Colours, dated 14th March last, was very carefully and respectfully considered.

' The Members of this Society while recognizing and acknowledging the friendly feeling shown in the proposal of the Institute, which they very sincerely reciprocate, regret that after mature consideration they have been led to the conclusion that the fusion or amalgamation of the two Societies presents difficulties of various kinds which they find to be insurmountable, and that consequently they are unable further to entertain the proposition which the Institute has done them the honour to make.

' I have the honour to be, Gentlemen, your obedient servant,

' JOHN GILBERT, *President.*

' On behalf of the Society.'

(*Letter from Mr. Jenkins to the President R. W.S.*)

' 67 Hamilton Terrace, N.W.
' April 24th, 1882.

' Dear Mr. President,—As I am precluded by the state of my health from attending the Special General Meeting called for to-morrow to consider a letter from the Institute of Painters in Water Colours, relating, I presume, to the proposed amalgamation of the two Societies, I venture to address a few words to you on the subject, as I conceive the views and wishes of all our Members must be desired before accepting any vital change in the constitution of our body.

' I have carefully endeavoured to consider this subject from an independent point of view, apart from all solicitations or pressure from without, in order to arrive at a just conclusion as to the possibility of our entertaining the proposition of the Institute, and I am forced to the conclusion from the calculations I have made and the evidence I have been able to sift that we as a Society can in no way benefit by amalgamation, but on the contrary we should become involved in extraordinary charges and lasting liabilities which the Exhibition receipts could never cover. If each gentleman will analyse for himself the certain expenditure and problematical income, and compare results with others and with kindred Institutions, I think that like myself they will shrink from committing themselves to an experiment involving responsibilities of which there is no seeing the end.

' I am faithfully yours,

' Jos. J. JENKINS.

' Sir John Gilbert, President Royal Society of Painters in Water Colours.'

INDEX

Artists' quarters : in Girtin's time i. 102-3, Rathbone Place and Fitzroy Square district 68, ii. 370

Art-manufactures ii. 2

Arts, Society of : *see* 'Society'

Associated Artists (or Painters) in Water-Colours : foundation and first exhibition i. 228-31, subsequent history and collapse 267-73, original members 230, changes of membership 268, list of exhibitors 271-3, exhibitors who joined Water-Colour Society 268-9, admit oils 270

Associated Engravers i. 413-4

Associated Painters in Water-Colours i. 269 (and *see* 'Associated Artists'), title revived by projectors of 'New Society,' afterwards 'Institute' of Painters in Water-colours 271 *n*, ii. 11

Associates : first creation of i. 208, of the first Water-Colour Society 417-20, number of 435, 555, summer election of, introduced ii. 301, existing 431

Astley, the circus proprietor : employs Cox i. 333, his ignorance of perspective 333

Athole, Duke of : patron of Evans (of Eton) ii. 209-10

Atkinson, John Augustus : elected Associate i. 226, Member 231, retires 409, declines re-election 432 ; exhibited works 409, engraved works 226-7, scope and quality of art 226.—*Biography* (to 1808) i. 226-7, (after 1808) 409-10 ; birth 226, practises in Russia 226, member of a sketching society 279, residence 410

Austin, Samuel : elected Associate i. 526-7, Member 527-8 ; exhibited works 526, 528, engraved works 528, scope and quality of art 527, Member of Society of British Artists 526.—*Biography* i. 526-8 ; birth, parentage and education 526, early passion for art 526, a bank clerk 526, lessons from De Wint 526, marriage 527, takes pupils 527, sensitive nature 526-7, generously treated by the Society 528, his last work 527, death 528, talent inherited by a daughter 528

BADESLADE, THOMAS : topographic draftsman i. 11

Baltimore, Lord : F. Smith travels with i. 53

Bankers, failure of the Society's ii. 10

Banks, Sir Joseph : patron of Paul Sandby i. 27, takes Cleveley to Iceland 52

Barber, Charles : elected Associate i. 234, 265 ; exhibited works 341.—*Biography* i. 341 ; from Birmingham, friend of Cox, settles at Liverpool, death, 341

Barber, Joseph : Cox a pupil at his art-school i. 331-2

Barber-Beaumont, patron of Nicholson i. 162-3

Barker, Benjamin : exhibitor at Oil and Water Colour Society i. 395

Barker, Henry Aston : his biography i. 103-5, friend of Girtin 103, with Turner at Royal Academy schools 104, his panorama of London 105, of Paris 112

Barker, Robert : founder of panoramas i. 103

Barker (of Bath), Thomas : exhibits in Brook Street rooms i. 202

Barker, Thomas Edward : panorama painter and partner of Reinagle i. 537

Barlow, J. : engraver, master of Cristall i. 187

Barlow, R.A., Thomas Oldham : Member of Chalcographic Society ii. 314 *n*., helps Palmer to learn etching 277, his kindness to Lundgren 403

Barnard, George : landscape artist, pupil of Harding ii. 179

Barralet, J. M. : teacher of Wells i. 131, 131 *n*. i

Barret, R.A., George : a foundation R.A. i. 48, exhibited and engraved works 48, 50, his panoramic views of Lake scenery at Norbury 50, scope and quality of art 50, unfairly compared with Wilson and Gainsborough 49, colours prints in Dublin 49, gains premiums 49, 50, in fashion as a landscape painter 49, patrons 49, 50, personal qualities 49, 176, insolvency 176, death 176, pension to widow 176 *n*. 1, children artists 177

Barret, George : a Member from 1805 i. 176, on Committee 277, share in founding Oil and Water Colour Society 285-6 ; exhibited works 177, 177 *n*. 1, 299, 441-2, ii. 22-3, 26, receives a premium i. 399, profits and prices i. 300, ii. 26-7, engraved works i. 444, ii. 26, scope and quality of art i. 177, 299, 300, 441, compared with Finch and Cox ii. 173, gradual growth of power 442, technique 442-3, whether his colours fugitive 442. —*Biography* (to 1805) i. 176-8, (1805 to 1820) 229-300, (1821 to 1831) 441-4, (1832 to death) ii. 22-7 ; birth and parentage i. 176, art-training 177, mode of studying nature 177 ; places of residence 176, 176 *n*. 2, 300, 300 *n*. 1, ii. 22, wife and family i. 299, ii. 22, 25, son dies 22 ; copies pictures for engraving i. 443, adds background to a Cristall 440, paints in conjunction with Tayler ii. 212, 212 *n*. 1, his treatise on painting 23-4, letter to Hewett 24-5, quotes and writes verses 23, 25, personal qualities i. 177, no secrets in art 444 ; straitened means 299, ii. 22, 25 ; last work 25, death 22, burial 25, annuity raised for widow 26, memorial tablet 26, how name spelt 27

Barret, James : brother of George Barret, exhibits at Royal Academy i. 177

Barret, Miss M. : sister to George Barret, elected Lady Member i. 432, 553, exhibited works 177, 553, scope of art 177, 553, art-training, residence, and death 553

quotes poetry in catalogue 48-9, portrait of 48, death, burial and monument 49

Dickens, Charles : his relations with Cattermole ii. 65-6, with Stone 220-2, with Topham 321

Dighton, Dennis : artist, his widow a teacher ii. 355

Dilettanti Society, Pars employed by the i. 52

Dillon, R.W.I., Frank : on committee to investigate action of light on water-colours ii. 127, with Lundgren and Boyce in Egypt 403, with Lundgren and F. W. W. Topham at Ravenna 407

Dinner : annual i. 398, anniversary ii. 97-8

Diorama : invented by Daguerre and Bouton i. 486, exhibition-room designed by Pugin 486-7

Diploma : of Membership, signed by the Queen ii. 125, drawings of Members 122

Dissolution of the first Society i. 273-5

Dobson, F.R.I.B.A., John : pupil of Varley i. 313, the first coloured architectural drawing by 9 n. 2, 313

Dodd, Thomas : patronizes young Linnell i. 375

Dodgson, George Haydock : elected Associate ii. 305, Member 305 ; exhibited works 304-5, 307, loan collection of works at the Society 308 ; sale of remaining works 308, prices 308 ; engraved works 304-5, scope and quality of art 305-7, technique and handling 304, 307 ; Member of New Water-Colour Society 305.—Biography ii. 303-8; birth and parentage 303, art training 303, apprenticed to George Stevenson 303, injures health by over-work 304, accident in a gymnasium 304, gives up engineering for art 304 ; early sketching tours 304, settles in London 304, residence 308 ; marriage 304, family 308, on a theatrical committee 321, sketching companions 226 n. 2, 314, 329, death 307-8

Dogs as sitters i. 151

Dorrell, Edmund : elected Associate i. 234, Member 234, 418, retires 413 ; exhibited works 248, 287, 413, scope and quality of art 248.—Biography (to 1812) i. 248, (1813 to death) 413 ; birth 248, original destination 248, early taste for art 248 ; residence 413, marriage 413, wife's death 413, death and burial 413

Drawing-master school : i. 70, ii. 94

Dudley Gallery : water-colour exhibitions instituted at ii. 114-5, exhibitors who joined the Old Society 115-6, æsthetic school at 117, junction with the Institute 124-5, oil exhibitions at 124

Duncan, Edward : elected Associate ii. 308, 310, Member 310 ; exhibited works 310-1, sale of remaining works 316, profits and prices 316, engraved works 309-10, 312, works engraved and litho-graphed by 309, 310 n. 1, scope and quality of art 308-12, paints in oils 310

n. 2 ; Member of New Water-Colour Society 308, 310.—Biography ii. 308-16 ; birth 308, designed for an architect 308, apprenticed to an engraver 308, practises in aquatint 309, takes to painting 309-10, influence of Havell 309, art training 308-10, places of resi-dence 314, marriage 309, artist sons 314, 316, family events 313, sketching com-panions 314-5, 380, Christmas parties 314, Member of Chalcographic Society 313, 314 n., letters to Jenkins 313-5, voyage to Holland 309 n. 2, tour to Italy 314, 407, chief sketching resorts 311, 315, personal qualities 312-3, 315-6, failing health 315, death 315

Dutton, wreck of the : studied by Prout and Haydon i. 343

Eagles, Rev. John : amateur and writer on art, a candidate for the Society i. 435

Edridge, A.R.A., Henry : his life and works i. 476-7, 479 ; birth 476, art train-ing 476, scope and quality of art 476-7, compared with Prout's 477, preceded Prout in Normandy 477, places of residence 415 n. 1, 476, sketching com-panions 476, elected A.R.A. 476, death 479, burial 476

'Effect' in landscape : wanting in early topographic views i. 13

Egyptian Hall : the Society's exhibitions at i. 402, 435 ; and see 'Dudley Gallery'

Elcho, Lord : suggests fusion of the two Water-Colour Societies ii. 113

Elections of Associates, summer : intro-duced ii. 301

Elliot, James : befriends Barret's widow ii. 26

Ellis, William Stone : friend and patron of Cox ii. 152 n.

Engravers : in 1740, i. 15, education difficult for lady- 188, water-colour copies for 443, 413-4, 414 n. 1

Engraving : in connexion with archi-tectural drawing ii. 413-4, decline of line 4, superseded by photography 4, aquatint i. 27-9, wood ii. 5

Engravings : republication of i. 15, 444, from works in the Society's gallery 554-5

Essex, Earl of : patron of artists i. 77, of Girtin 84-5, of Varley 171, of Hunt 392

Essex, Earl and Countess of : collectors of water-colours i. 436

Essex, James : architect and writer i. 495

Essex, Richard Hamilton : elected As-sociate i. 432, 495, 521, resigns 495 ; exhibited and engraved works 495, scope of art 495, death and age 495

Evans, Richard : copyist, friend of Cox i. 333

Evans, A.R.W.S., Samuel T. : son of Evans of Eton ii. 211

Evans (of Bristol), William : elected As-sociate ii. 295 ; exhibited works 295, scope and quality of art 295-6, technique

II.

Mackenzie, Frederick : elected Member i. 286, 371-2, retires 371, re-elected Associate 430, 494, re-elected Member 431, 494, Treasurer ii. 10 ; exhibited works i. 371-2, 430, ii. 84-6, sale of remaining works 87, engraved works i. 364, 371-2, ii. 85, exhibitor at Associated Painters i. 270.—*Biography* (to 1820) i. 371-2, (1821 to 1831) 494, (1832 to death) ii. 84-7 ; birth and parentage i. 372, art-training 372, residence ii. 86, marriage 86, designs memorial tablet to Barret 26, published work on King's College chapel, Cambridge 86, scheme for replenishing exhibition, 107, proposes grant to J. M. Wright 205, personal qualities 86-7, uncertain health 86, straitened means 86, death 86, family aided by the Society 86, Fielding's thoughtfulness for widow 80

McKetchnie, Mrs. : Cristall's god-daughter i. 186 *n.* 2, ii. 15, her account of origin of the Society i. 189 *n.* 2

Mackintosh, Sir James : patronizes Westall in India i. 263

Macready, the elder : Cox his scene-painter i. 332

Macready, W. C. : Cox paints toy scenes for i. 332-3

Madou, Jean Baptiste : elected Honorary Member ii. 121, death 122

Major, T. : landscape engraver i. 20

Malton, James : architectural draftsman, his engraved works i. 44

Malton (the elder), Thomas : architectural draftsman i. 43-4, his career 44, treatise on perspective 44

Malton (the younger), Thomas : architectural draftsman i. 43-4, exhibited and engraved works 44, character of art 43-4, compared with Sandby 44-5, a scene-painter 44 ; birth 43, art-training 44, teaches Turner 44 *n.*, 87

Manchester Exhibitions : Art Treasures (1857) ii. 97, Queen's Jubilee (1887) 128

Maria, de : scene-painter, Cox employed under i. 332

Marlow, William : scope and quality of art i. 45

Martin, John : F. Danby's resemblance to i. 421

Martin's Lane Academy, St. : i. 21

Mason the poet : friend of Paul Sandby i. 26

Masters, drawing : their help to pupils in Society of Arts competitions i. 162-4

Materials, artists' : early want of i. 24-5, Reeves's colours 73, old colour-box 85 *n.*, Harding's improvements in ii. 184 *n.* 2, and *see* ' Paper '

Mathews, Charles : the actor, his friendship with Pugin i. 220-2, 488

Mathews, Charles J. : the actor, pupil of Pugin i. 220, 369, employed as draftsman by him 483

Maundrell, Mr. : amateur, candidate for the Society i. 435 *n.* 2

Mead, Dr. : patron of artists i. 76

Meadows, James : panorama painter i. 538

Meadows, Richard Mitchell : engraver, his works i. 217, master of Heaphy 217

Mee, Mrs. : miniature-painter, teaches Miss Barret i. 553

Meen, Mrs. : Member of Associated Artists i. 268, 272

Meetings : places of holding Society's ii. 107 *n.* 2

Members and Associates : (1805 to 1820) i. 417-20, (in 1820) 399-401, 424, (in 1823) 432, 437, (in 1891) ii. 430-1, their number i. 234, ii. 113, 123, a recollection of the old 8

Members, Honorary : creation of ii. 121-2

Memorial to the Treasury for a site ii. 102-4

Menzel, Professor Adolph : elected Honorary Member ii. 122, exhibits with the Society 122, F. Walker studies his woodcuts 388

Metz, Conrad : gives lessons to Nicholson i. 152

Meyer, Henry : engraver, a fellow-pupil with Uwins i. 246

' Microcosm ' : Pyne's i. 139, Pugin's 363-4, Prout's ii. 54

Middiman, Samuel : landscape engraver, his art-training i. 40, contemporaries 40, skilful etcher 40, place of residence 46, his ' views ' published 46, their influence on landscape art 48, analysis of contents 49

Millais, Bart., R.A., Sir John Everett : his ' Ophelia ' admired by Uwins i. 411, originator of new style of woodcut ii. 119 *n*, E. Walker's kitten in ' The Flood ' 396, a pioneer of the Volunteer movement 258-9

Millet, Jean François : compared with F. Walker ii. 391

Milton's ' Seats ' i. 39

Miniatures : at the Royal Academy i. 133-4, painters of, at the Oil and Water Colour Society 393-4

Monro, M.D., Thomas : patron of water-colour artists i. 77-9, his drawing-classes at Adelphi Terrace 78-9, kindness to Cozens 63, 77, buries Hearne 142 *n.* 2, patron of Turner and Girtin 81-2, of Varley 171, of Cristall 189, of De Wint 254, of Linnell 376, of Hunt 392 ; descent and family 77, many of same name 77, pupil of Laporte 67, 78, imitates Gainsborough 78, collects his works 131, buys his camera 48 ; places of residence 78, Girtin's drawing of his house at Fetcham 78 and addendum, portrait by Edridge 476, opinion of Turner 83 *n.* 2, fondness for works of art 78 ; attends King George III. 77,

Montagu, Duke of : patron of Paul Sandby i. 30

Shipley, William : originator of Society of Arts i. 138, school of art kept by 138, 360

Shoreham in Kent : described by Palmer ii. 274-5, haunted by 'extologers' i. 520

Sketches and Studies, Exhibition of : founded ii. 107-8, 367, its character changes 108, 108 n. 2

Sketching Society, the : account of i. 279-81, 412, farewell to Leslie 466, Cristall's return to ii. 18, Stephanoff a member 150 ; at Bristol 87, 87 n. 2, Girtin's i. c7-100, 499

Slingsby, Sir Thomas : Nicholson defies i. 156

Smirke, R.A., Robert : his friendship with Nicholson i. 150

Smirke, Sir Robert : architect, employs F. Nash i. 249

Smith, A.R.A., Anker : engraver, grandfather of Burgess ii. 356

Smith, Benjamin : engraver, master of Uwins i. 246

Smith, Coke : Lewis draws on stone after ii. 139, draftsman of Eastern subjects 240

Smith, Francis : travels with Lord Baltimore i. 53

Smith, G. (or G. W.) : exhibitor of landscapes at John Smith's address i. 299

Smith, George : his collection of Hill's drawings i. 137

Smith, John : elected Associate i. 208, 213, Member 217, Secretary 299, Treasurer 299, 425, 438, President 299, resigns 432-3 ; exhibited works 289, 299, 433, engraved works 51, 67, 299 n. 1, 433, scope and quality of art 65-6, technique 51, 66.—*Biography* i. 65-7, 432-3 ; birth 67, goes to Italy with Earl of Warwick 51, 55, sobriquets 66, share in development of water-colour art 54, 66, 298, shy of joining the Society 143, share in founding Oil and Water Colour Society 285-6, receives premium 429, his premium work 431, places of residence 433, death and burial 433

Smith, J. Clarendon : Member of Associated Artists i. 268, 273

Smith, John Raphael : employs Turner and Girtin i. 85, master of De Wint 252-3, death 253 n. 2

Smith, Thomas Correggio : miniature painter, brother of John Raphael Smith i. 262 n. 2

Smith (of Norwich), William : promoter of National Gallery i. 160 n. 1, Nicholson teaches his daughter to copy his old masters in water-colours 160

Smith, William Collingwood : elected Associate ii. 286, Member 287, Treasurer 10, 289, Trustee 289 ; exhibited works 286, sale of remaining works 289, prices 289-90, engraved works 289, scope and quality of art 286-7, 289, paints in oils 286, last work for Queen's Jubilee

portfolio 289. — *Biography* ii. 286-90 ; birth and parentage 286, art-training 286, places of residence 287, marriage 287, letters to Jenkins 287-8, much employed in teaching 288, distinguished pupils 288, travels 287, personal qualities 286, 288-90 zeal in Society's interests 289-90, on winter exhibitions 108 n. 2, originates and manages R.W.S. Art Club, 290, verses for catalogue 288, death 289, son an artist 287

Smyth, Coke : see 'Smith'

Society of Artists, Incorporated : i. 23

Society of Arts : founded i. 21, early exhibitions at 23, and the drawing masters 162-4

Society of Painters in Water Colours : title assumed i. 175, account of it furnished to Count Persigny ii. 91-3, present condition of 429-31

Solly, of Great Ormond Street, Mr. : gives Uwins introductions for France i. 374

Somerset House, Royal Academy's rooms at i. 128-9

Spring Gardens, exhibition room at : described i. 233, early exhibitions at 23, 127, first occupied by the Society 233, Oil and Water Colour Society there 288, various shows there 401, difficulty in preserving its use for the Society 401-2, pulled down 402, its site 402-3

Stadler, J. C. : aquatint engraver i. 118

Stafford, Marquis of : collector of watercolours i. 436

Stained drawings : defined i. 5, advantages of method 125-6, suited for travellers 52, of figures 204-5

Stark, James : exhibitor at Oil and Water Colour Society i. 395, his friendship with Cotman ii. 35

Statistics of Exhibitions : (1805 to 1812) i. 266, (1813 to 1820) 397, 399, 421, (1832 to 1843) ii. 11

Stephanoff, Fileter N. : father of James Stephanoff, his art and career i. 382

Stephanoff, Francis Philip : Member of Associated Artists i. 382, exhibited works 382-3, similarity of scope of art to his brother James 382, his 'Death of Wolsey' and prize cartoon i. 150 n.—*Biography* ii. 149-50, n., residence 149, marriage and wife's death 149 n., afflicted state 149 n., musical taste 150 n., scn artistic 150 n. ; death 149 n.

Stephanoff, James : elected Member i. 383, retires ii. 149 ; exhibited works i. 382-3, 533, ii. 148-50, engraved works i. 383, 485, 533-4, ii. 149, scope and quality of art i. 382-3, 533, ii. 148-50, draws for Society of Antiquaries 149 ; Member of Associated Artists i. 382.—*Biography* (to 1820) i. 382-3, (1821 to 1831) 532-4, (1832 to death) ii. 148-50; birth and parentage i. 382, place of residence ii. 149, marriage and family 150, member of Sketching Society 150,

Lightning Source UK Ltd.
Milton Keynes UK
UKHW030933290119
336360UK00012B/1072/P

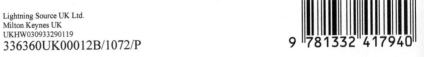